EDITED BY AMANDA SMITH

Hostage to Fortune: The Letters of Joseph P. Kennedy

NEWSPAPER TITAN

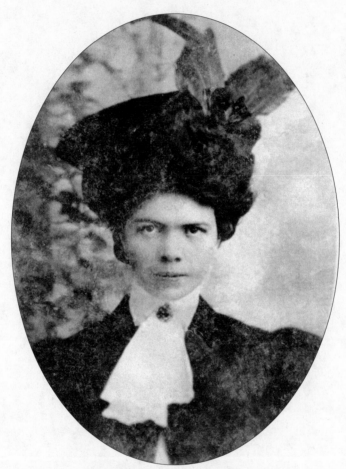

The former Cissy Patterson at the time of
her marriage to Count Josef Gizycki, in 1904

NEWSPAPER TITAN

*The Infamous Life
and Monumental Times
of Cissy Patterson*

AMANDA SMITH

Alfred A. Knopf NEW YORK 2011

This Is a Borzoi Book
Published by Alfred A. Knopf

Copyright © 2011 by Amanda Smith
All rights reserved. Published in the United States by Alfred A. Knopf, a division
of Random House, Inc., New York, and in Canada by Random House of Canada
Limited, Toronto.
www.aaknopf.com
Knopf, Borzoi Books, and the colophon are registered trademarks of Random House, Inc.

Library of Congress Cataloging-in-Publication Data
Smith, Amanda.
Newspaper titan : the infamous life and monumental times of Cissy Patterson /
by Amanda Smith. — 1st ed.
p. cm.
Includes bibliographical references and index.
ISBN 978-0-375-41100-7 (alk. paper)
1. Patterson, Eleanor Medill, 1881–1948. 2. Journalists—United States—Biography.
3. Publishers and publishing—United States—Biography. I. Title.
PN4874.P3528S54 2011
070.4'1092—dc22
{B} 2011009019

Front-of-jacket painting: Portrait of Mrs. Eleanor (Cissy) Patterson
by H. G. Cushing, 1903. Courtesy of the Chicago History Museum
Jacket design by Carol Devine Carson
Manufactured in the United States of America
First Edition

TO CARTER,
WITH LOVE AND GRATITUDE

(and may you never become embroiled in anything like
Shelton, Waldrop and Brooks v. Gizycka)

CONTENTS

ILLUSTRATIONS

ACKNOWLEDGMENTS

Like Blanche Dubois, the biographer has always depended upon the kindness of strangers. My research into the life of Cissy Patterson was responsible for introducing me to a host of people to whom I am deeply grateful for so generously sharing their time, their recollections, their mementos, their family letters and photographs, their expertise, and their assistance. I am especially indebted to Ellen Pearson Arnold, for the many hours she spent with me discussing her grandmother, her mother, and herself, for allowing me access to her family papers and photographs, and for giving me her permission to quote from those materials. I am extremely grateful also to Mrs. Arnold's children, especially the Rev. Drew Pearson Arnold, for their assistance. Alice Arlen was very generous in providing me with her reflections, advice, and suggestions. Joseph Albright also lent valuable insight on such varied subjects as Flat Creek Ranch, its first owner, and Patterson family copyrights. Tyler Abell provided me not only with his memories of his godmother and her colorful circle but moreover with a view into her intertwined personal and professional relationships with his parents and stepfather. I will always be grateful to Andrew Waldrop not only for his unfailingly good company but also for his generosity in providing me with his recollections of his father, his father's tempestuous boss, and the tenor of daily life at the *Times-Herald* at its height. Once again, I am indebted to Page Huidekoper Wilson for taking the time and care to enlighten me on the subject of another of her formidable employers. The late Oleg Cassini was kind enough to talk to me about his own family's long association with Cissy Patterson. I am deeply grateful to Countess Felicia Gizycka's editor Gene Downer, not only for his encouragement of my own writing and for furthering my understanding of his old friend, but moreover for his generosity in allowing me to quote from the unpublished work she entrusted to him after her death.

I am likewise indebted to Stacy A. Cordery for her unfailing enthusiasm, her advice and suggestions, and her insights into Alice Roosevelt Longworth's relationship with Cissy Patterson. David Nasaw provided me with a wealth of information on William Randolph Hearst, the latter's newspaper chain, and the outlandish, if supremely capable characters who made it run. Kristie Miller was extremely helpful on matters relating to the McCormick family and acted as a nexus for other fruitful sources and contacts. Earle F.

Layser illuminated the murky past of Cissy's friend Cal Carrington. Patti Layser provided new insights into Cissy's unprecedented role as a woman in the annals of American sporting history. Carrie Beauchamp gave thoughtful suggestions and commentary on Adela Rogers St. Johns. The Reverend Sally Brown and David R. Brown were generous and forthcoming on the subjects of Marty Mann, her friendship with Felicia Gizycka, and the early history of the Alcoholics Anonymous movement. Frida Burling was instrumental in helping me to understand life in Georgetown during Franklin Roosevelt's administration. I am particularly grateful to Ralph G. Martin for allowing me to make use of the papers and documents he compiled in the course of his investigations of Cissy Patterson. His interviews, particularly with members of both Cissy Patterson's social circle and her *Times-Herald* staff (all but a few of whom had died in the three decades before I began my own research), were an invaluable resource for my work and in the aggregate create a vivid, madcap picture not only of the "damndest newspaper ever to hit the streets," but of the press corps generally and, indeed, of the nation's capital during the Depression and the Second World War.

I owe a particular debt of gratitude to Arthur H. Miller, Jr., archivist and librarian for Special Collections at Donnelley Library, for the tours that made Cissy and Felicia Gizycka's Lake Forest come alive a century later. I am also extremely grateful to Mr. Miller for the invaluable assistance that he, Steve Vignocci, and the rest of the staff of Lake Forest College provided with the Patterson family papers, Nellie Patterson's scrapbook, and the many images and drawings that the Joseph Medill Patterson Papers contain. Diane Gutenkauf and Eric Gillespie helped me immeasurably with the materials at the Colonel Robert Rutherford McCormick Research Center at Cantigny's First Division Museum. Robert Ellis at the National Archives performed yeoman's work in doggedly tracking down the many lawsuits in which Cissy Patterson and her salacious *Times-Herald* embroiled themselves during their ascendancy in Washington. Leigh Armstrong saved me countless hours and provided astute advice in locating a wealth of images from archives throughout the Chicago area. I am likewise deeply indebted to Victoria Kastner at the Hearst Castle; Charles Niles and Ryan Hendrickson at Boston University's Howard Gotlieb Archival Research Center; Bertram Lippincott III at the Newport Historical Society; Susan McElrath at American University; Nicolette A. Schneider, Syracuse University Library Special Collections Research Center; Maribell Moore at 15 Dupont Circle, the present-day Washington Club; Valerie Duball at Heritage Microfilm; Janet Stewart at Newsbank-Readex; Matthew C. Hanson at the FDR Library; Matthew T. Schaefer and Lynn Smith at the Hoover Library; Margaret Harman at the LBJ Library; Rob Medina at the Chicago History Museum; and Frank Bennack and Kevin J. McCauley at the Hearst Corporation.

The strange, sad tale of Felicia Gizycka's kidnapping and return would have remained a mystery were it not for the invaluable assistance I received in locating the Chancellery for Receipt of Petitions file in the *Rossiiskii Gosudarstvennyi Istoricheskii Arkhiv* in St. Petersburg through Elena Tsvetkova and Kristin Nute at BLITZ. The work, advice, and kind suggestions of Professor Barbara Alpern Engel at the University of Colorado at Boulder made it possible to better understand the glimpse those documents permitted of the otherwise impenetrable activities and rulings of the Chancellery and its head, Baron Budberg, in the last years before the Russian Revolution. I am grateful to those who helped me make sense of the Babel of the primary documents I encountered in the course of my research: Sarah Schuchard for her German translations, Janah Putnam for her Polish translations, and, once again, Elena Tsvetkova for her Russian translations (the French translations—along with any inaccuracies they might contain—are my own). Dierdre Bair was extremely kind in suggesting sources for a closer examination of the relationship between Carl Jung and Joseph Medill's grandchildren. Mary Knill's speedy processing of previously unopened sections of the Drew Pearson Papers at the LBJ Library made possible a far closer examination of Cissy Patterson's home and family life, intimate circle, and feuds than I had imagined possible at the outset of my research. Penelope Rowlands and John Michael White were very generous with their time, their suggestions, and their anecdotes regarding Carmel and T. J. White.

I am grateful to Raymonde Pozzolano at Words Unlimited, as well as to Matthew Hogan, Nancy Mehegan, Doug Peach, Brooke Smith, Leslie Smith, Natalie Tindall, Emily Venturato, Rob Verbsky, and Hayley Wynn for their help in illuminating, organizing, and making accessible the research materials I accumulated. I am also deeply indebted to Judith H. Lanius and Sharon C. Park for their generosity in allowing me to reprint the composite map of Dupont Circle that they originally created for their fascinating and informative essay, "Martha Wadsworth's Mansion: The Gilded Age Comes to Dupont Circle."

I would also like to thank those intelligent, insightful and long-suffering friends—Alison Schafer, Elizabeth Miller, Rebecca Nicolson, and Amelia Wooldridge—who were my first readers. Kate Chartener, I couldn't have done it without you! (That's the phrase, yes?) I would also like to thank Carter, Stephanie, and Sumner for enduring the research and writing process. I am grateful (as always) to Tina Bennett at Janklow & Nesbit for her assitance, advice, and support. I appreciate all of Carmen Johnson's help at Knopf in preparing the manuscript for publication. Finally, most of all I would like to thank Vicky Wilson for her advice, support, and patience throughout the project—and for proving that once in a while, when one door closes another one really does open.

THE DESCENDANTS OF JOSEPH MEDILL

through 1948

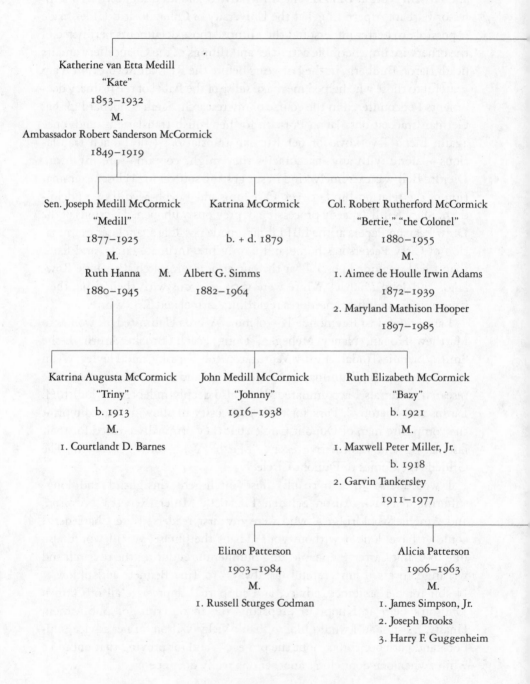

Katherine van Etta Medill
"Kate"
1853–1932
M.
Ambassador Robert Sanderson McCormick
1849–1919

Sen. Joseph Medill McCormick
"Medill"
1877–1925
M.
Ruth Hanna M. Albert G. Simms
1880–1945 1882–1964

Katrina McCormick
b. + d. 1879

Col. Robert Rutherford McCormick
"Bertie," "the Colonel"
1880–1955
M.
1. Aimee de Houlle Irwin Adams
1872–1939
2. Maryland Mathison Hooper
1897–1985

Katrina Augusta McCormick
"Triny"
b. 1913
M.
1. Courtlandt D. Barnes

John Medill McCormick
"Johnny"
1916–1938

Ruth Elizabeth McCormick
"Bazy"
b. 1921
M.
1. Maxwell Peter Miller, Jr.
b. 1918
2. Garvin Tankersley
1911–1977

Elinor Patterson
1903–1984
M.
1. Russell Sturges Codman

Alicia Patterson
1906–1963
M.
1. James Simpson, Jr.
2. Joseph Brooks
3. Harry F. Guggenheim

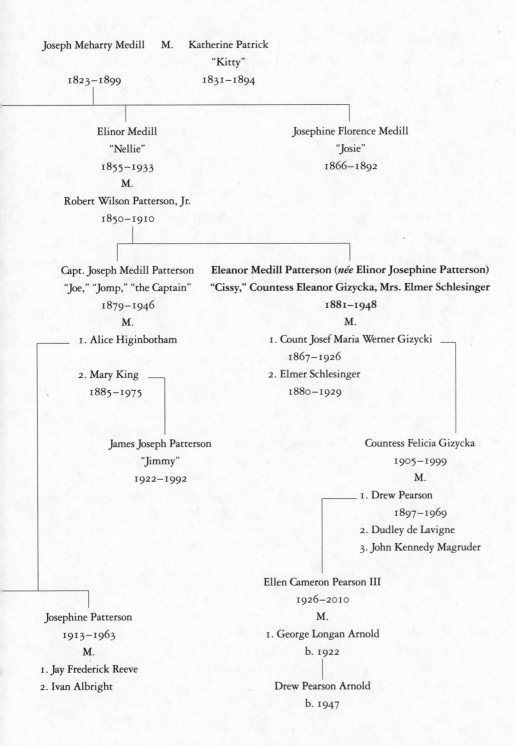

Joseph Meharry Medill M. Katherine Patrick
"Kitty"
1823–1899 1831–1894

Elinor Medill
"Nellie"
1855–1933
M.
Robert Wilson Patterson, Jr.
1850–1910

Josephine Florence Medill
"Josie"
1866–1892

Capt. Joseph Medill Patterson
"Joe," "Jomp," "the Captain"
1879–1946
M.
1. Alice Higinbotham

2. Mary King
1885–1975

Eleanor Medill Patterson (*née* Elinor Josephine Patterson)
"Cissy," Countess Eleanor Gizycka, Mrs. Elmer Schlesinger
1881–1948
M.
1. Count Josef Maria Werner Gizycki
1867–1926
2. Elmer Schlesinger
1880–1929

James Joseph Patterson
"Jimmy"
1922–1992

Countess Felicia Gizycka
1905–1999
M.
1. Drew Pearson
1897–1969
2. Dudley de Lavigne
3. John Kennedy Magruder

Josephine Patterson
1913–1963
M.
1. Jay Frederick Reeve
2. Ivan Albright

Ellen Cameron Pearson III
1926–2010
M.
1. George Longan Arnold
b. 1922

Drew Pearson Arnold
b. 1947

NEWSPAPER TITAN

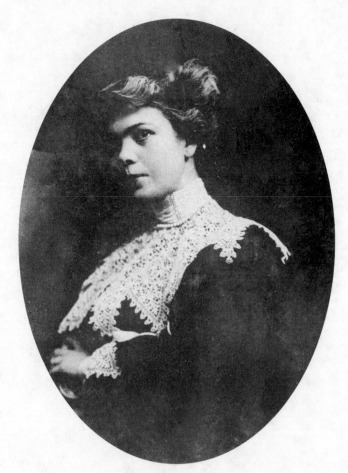

The Countess Gizycka, Chicago, 1909

PROLOGUE

When your grandmother gets raped,
put it on the front page

"Our patience has come to a breaking point," Chancellor Adolf Hitler bellowed in the frenzied crescendo of his address to the Reichstag on December 11, 1941: "a plan prepared by President Roosevelt has been revealed in the United States, according to which his intention was to attack Germany by 1943 with all of the resources at the disposal of the United States." With his declaration of war that afternoon, Hitler did not awaken the sleeping American giant; rather, the führer took the first fateful stab at retribution after discovering its stealthy predawn preparations for battle. Indeed, for several years grim auguries had reached Berlin suggesting that Franklin Delano Roosevelt was perhaps less committed to American neutrality in the face of the conflicts raging across the globe than he publicly professed to be. Having long suspected the "insane" and "particularly despicable" president of the United States of promoting the "work of hatred and warmongering" throughout the world, Hitler had recently been presented with what he took to be irrefutable proof that his mistrust had been justified.

The führer was not alone in questioning the sincerity of the president's long-expressed unwillingness to entangle the United States abroad. A week before the German declaration of war, eager to galvanize isolationist sentiment nationwide, two of the most stridently anti-administration members of the American press had jointly published, in their respective Chicago and Washington, D.C., newspapers, what appeared to be confirmation of their own fears that "President Roosevelt was lying the United States into war with Germany." This "monumental scoop" not only consisted of excerpts of the leaked top-secret "Rainbow Five" plan, the army and navy's joint estimate that the United States would be ready to launch its own multipronged assault on Germany by July 1943 but, perhaps even more damning, a copy of the president's own letter ordering the assessment. The German embassy wasted no time in cabling a copy of these astounding revelations to Berlin upon the story's publication in Washington on

December 4, 1941. A week later, Hitler would bark to the Reichstag that, despite his many peacemaking efforts, the recently published proof of Roosevelt's sneaking belligerence toward Germany left him no alternative but to declare war on the United States. On December 14, 1941, the German high command would present the führer with its radical strategic reassessments, based likewise on the "Anglo-Saxon war plans which became known through publication in the Washington *Times-Herald.*"

In November 1946, nearly half a decade after the Washington *Times-Herald*'s "Rainbow Five" revelations had been cabled to Berlin, *Collier's Weekly* magazine would venture, "One day the movies will doubtless get around to filming the fabulous life of Eleanor Medill Patterson." Earlier that fall, Eleanor Medill Patterson had been selected to fill the void left by the recent death of her brother, Joseph Medill Patterson, as chairman of the board of the New York *Daily News.* After launching the *Daily News* in 1919, Joe Patterson had made it not only the United States' first viable tabloid, but the newspaper with the largest daily circulation of any—tabloid or broadsheet—in the nation and the widest Sunday circulation of any in the world. The choice of the late publisher's sister had not been an exclusively sentimental one. In her own right, Eleanor Medill Patterson was already owner and publisher of the most widely read daily in the nation's capital, the Washington *Times-Herald,* called by many, both inside and out of the profession, "the damndest newspaper to ever hit the streets." According to popular journalistic axiom, the Pattersons, like their first cousin Colonel Robert Rutherford McCormick, had "printer's ink blood." Their grandfather, the firebrand abolitionist Joseph Medill, had been editor in chief and eventual principal owner of the *Chicago Tribune* from the tense years immediately preceding the Civil War until his death in 1899. By the mid-1940s, under nearly three decades of Colonel McCormick's sanctimonious, anti-Roosevelt, isolationist direction, the *Tribune* had grown into the most widely read newspaper in the Midwest and the most widely circulated full-size daily in the nation. Eleanor Medill Patterson, as both the youngest and the only girl of her generation among fractious boys, had been her grandfather's darling. As such, she had inherited a disproportionate share of Tribune Company stock and a considerable fortune. Bypassing Eleanor Roosevelt, Bess Truman, Clare Boothe Luce, Dorothy Schiff, Emily Post, and every other prominent American woman of the 1940s, *Collier's Weekly* contended that with her patrimony, her own attainments, and her latest accolade, "Cissy Patterson—no one calls her Eleanor—is probably the most powerful woman in America." It added, "And perhaps the most hated."

· · · ·

Her pedigree notwithstanding, Cissy Patterson, the "everlasting problem child" of American journalism, had come to publishing shortly before her forty-ninth birthday, in 1930, with almost no practical journalistic or editorial experience. Indeed, what little formal education she had received in being "finished" at fashionable New England girls' schools at the turn of the century had prepared her exclusively for a vocation of marriage and motherhood, and a place in society. Although striking as a young woman, moonfaced and pug-nosed with wide-set brown eyes, her looks had been too unconventional to have rendered her a beauty by the standards of the Belle Époque. Nevertheless, she was tall, graceful, and possessed of a superb figure, magnificent flame-colored hair, broad personal magnetism, and biting wit. Almost without exception, accounts written from Santa Barbara, California, to St. Petersburg, Russia, of the young Cissy Patterson record her unforgettable pantherlike grace.

The course of her early life might have been lifted from the pages of Henry James or Edith Wharton. Audacious and headstrong, over the objections of her family she had married Josef Gizycki, a Polish count with connections to the Austro-Hungarian and imperial Russian courts—as well as a history of incurring staggering debts and fathering illegitimate children. As predicted in the few cloudy forecasts that appeared among the otherwise glowing reports in the American press of the latest "brilliant international match" at the time of the Patterson-Gizycki wedding in 1904, the union ended unhappily. Cissy fled from her husband one night in the South of France, still bleeding from the beating he had given her, after fewer than four years of marriage. It would take another fretful eighteen months—as well as the intercession of President-elect Taft; the dowager Russian empress Maria Fedorovna; Tsar Nicholas II; European detectives; American, Austrian, French, and Russian lawyers; stealthy and sympathetic titled ladies and high-ranking imperial officials—before Gizycki would relinquish the couple's nearly four-year-old daughter, whom he had kidnapped and hidden in the interim. Returning to the United States with her toddler and concluding the melodrama that readers on two continents had followed in fulsome press accounts for nearly two years, Countess Eleanor Gizycka found herself notorious and restless. After several false starts toward acting and writing fiction, she would be drawn irresistibly, like so many members of her family before her and after, to journalism.

On August 1, 1930, Cissy took over William Randolph Hearst's foundering Washington (D.C.) *Herald* at the brokering of her friend and self-proclaimed "godfather in journalism," columnist and editor Arthur Brisbane. In a single stroke, Hearst succeeded both in nettling his old enemies of the bloody Chicago circulation wars of the 1910s, Joseph Medill

Patterson and Robert Rutherford McCormick, and in indulging those edi-
torial ambitions that Cissy had long nursed—and that her brother and
cousin had equally long dismissed. With his *Herald* running fifth in circu-
lation among Washington's six dailies during that first summer of the
Depression, Hearst had little to lose. Indeed, as a mere publicity stunt,
placing a woman at the helm might boost circulation somewhat, if only
temporarily. Thus Mrs. Eleanor Medill Patterson (as Brisbane and Hearst
suggested she rename herself) became the nation's only woman editor in
chief of a major metropolitan daily newspaper. Her negligible formal edu-
cation notwithstanding, she had inherited or absorbed from her family an
instinct for news and an affinity for controversy, as well as a rare gift for the
alchemy required for developing what was to become a spectacularly suc-
cessful newspaper.

In her on-the-job editorial education, she had tutors, allies, and enemies
perhaps unmatched in the annals of American journalism, and she was a
keen student. With the initial advice, diplomatic criticism, and gentle
rebukes not only of Hearst but of Patterson and McCormick (now resigned
to her editorial experiment), as well as some of their respective organiza-
tions' most able staff members, Eleanor Medill Patterson made her way. To
the surprise of all (especially the denizens of the *Herald* city room, who had
greeted the lady editor's arrival with eye rolling, guffaws, and the consola-
tion that her tenure was at least likely to be short), within eighteen months
the paper had dominated the Washington morning market. By 1936, the
green editor-publisher had almost doubled its circulation.

With the Hearst empire on the verge of financial collapse by the end of
the 1930s, Cissy Patterson fulfilled her long-held hope of owning her own
newspaper and assisted her friend William Randolph Hearst by relieving
him not only of his morning *Herald,* but also of the *Herald's* evening sister
paper, the *Washington Times,* in return for desperately needed cash. In 1939,
she merged the two papers and took on the position, almost unprecedented
in American history, as sole proprietor of a major metropolitan newspaper.
With ten editions daily, the Washington *Times-Herald* had become the cap-
ital's only round-the-clock paper. Over the course of her eighteen-year
career in publishing, Cissy would take the lackluster *Herald*—"a chronic
tail-ender in circulation and advertising," as *Newsweek* put it—and trans-
form it into the pugnacious, tattling, picture-packed *Times-Herald,* which
was to hold a decisive and unassailable lead in the capital market during
her lifetime. The effect of the merger in 1939 was "electric," one veteran
reporter remembered: "Washington went for the combined product like a
trout for a fly."

Although a standard-size newspaper, in its tone and preoccupations
Cissy Patterson's *Times-Herald* bore most of the other hallmarks of the

smaller, newfangled picture tabloid that her brother had transplanted to New York from London in the aftermath of World War I. By 1945, her homegrown adaptation cleared more than $1 million in profit yearly.

The salacious round-the-clock daily led the local market not only in circulation and revenues, but also in the number and size of libel judgments rendered against it. In her constant efforts to keep the paper entertaining and to boost circulation, Cissy Patterson showed much of her brother's legendary flair in devising countless beauty contests, giveaways, and publicity stunts. But it was her own capricious contributions that gave the paper much of its notorious bite and drew much of its readership.

Like her brother and cousin, Cissy Patterson was among the last generation of publishers to embody and purvey an unabashed personal journalism, whereby their own enthusiasms and prejudices engendered their papers' editorial stances. Cissy Patterson's brand of personal journalism was, if possible, even more personal than that of her relatives and cohorts. Over the course of her career she indulged a number of her piques by attacking in print old friends who had fallen away. Likewise, as her patience with Franklin Roosevelt and the New Deal wore thin—particularly as American intervention into the Second World War appeared increasingly likely—few members of the administration escaped the unrelenting excoriation of Washington's most widely read local newspaper. For their own part, many New Dealers cherished their *Times-Herald* epithets as badges of honor.

By the time *Collier's* suggested that Cissy Patterson was the most powerful and most hated woman in America, however, she was already past her zenith; the once puckish and truculent publisher was no longer herself. According to many of her friends and employees, she had grown unusually anxious about her health, about the state of her soul, about her estrangement from her daughter and granddaughter, about her belief that the Federal Bureau of Investigation had her under surveillance, about the imminence of her death. Most of all, she expressed distress about what would become of her beloved *Times-Herald* after she was gone.

As her fears for her safety mounted, by the summer of 1948 she insisted to indulgent, if surprised, friends and associates that if she were to die an untimely and peculiar death, they should suspect foul play. As mortality preyed upon her mind, her wishes for her posterity became a frequent topic of conversation. She regaled flabbergasted dinner guests with insistent talk of the terms of her current will, its provisions and bequests, its heirs and legatees, as well as any possible thoughts she had of changing it and why. Whisperings of the proposed changes, in turn, only intensified the toadyism, backbiting, bootlicking, and resentment among those who sur-

rounded her. As one friend (and eventual legatee) put it, Cissy Patterson's open talk of her will and the changes she considered making to it, allowed the members of her circle to "know when they were being favored and when they were cut out." Determined finally to act, the publisher arranged for her lawyer, former senator Burton Wheeler, to begin discussing the changes she proposed making to her will, over dinner on Sunday, July 25, 1948.

As it happened, sometime during the night of July 24, 1948, Cissy Patterson met exactly the sort of untimely and peculiar end that she had feared. She would miss by fewer than twenty-four hours the dinner meeting she had scheduled with Wheeler; the new will she had spoken about so often to so many—including those who had most to lose by the changes she proposed—would never be drafted or signed. Her death, and her daughter's subsequent legal challenge to the will presented for probate, would set in motion an uncanny series of events that would leave Washington spellbound (along with much of the rest of the nation, so lustily was the affair covered in the national press). The legal snarl over the estate would drag on from the early fall of 1948 into the winter of 1949 and entangle a broad and colorful cast of characters in skulduggery and misadventure of many sorts—among them illegal surveillance, witness intimidation, family feuds, burglary, destruction of evidence, and the deaths (themselves untimely and peculiar) of two witnesses who had agreed to attest under oath to the unsoundness of Cissy Patterson's mind and the coercion to which she had been subjected at the time she made the will in question.

According to *Time,* which carried regular, bemused updates on the legal aftermath of the mercurial publisher's death, "It was the kind of story that Eleanor Medill Patterson, who liked her news on the dramatic side, would have enjoyed telling—on someone else." And yet, for all the charges that might justly have been leveled at her as a journalist and a human being in the final reckoning, the claim that she would have resented the sensational chronicle of her death as it was hawked on newsstands coast to coast, was not wholly accurate. She was part of a family whose journalistic proclivities and achievements were as singular as their own lives were momentous. The descendants of Joseph Medill, particularly those of Cissy Patterson's generation—and particularly Cissy Patterson herself—had lived lives that made for exactly the sort of copy their respective newspapers clamored to cover. By any reckoning, she had fully and vividly lived out the Medill family's editorial motto (at least in its spirit): "When your grandmother gets raped, put it on the front page." From Cissy Patterson's infancy and in her every role—debutante, champion equestrian, heiress, marriageable ingénue, countess, spurned wife, wronged mother, actress, gay divorcée,

femme fatale, sophisticate, dude rancher, big-game hunter, novelist, reporter (occasionally undercover and in disguise), editor, publisher, animal rights activist, political gadfly, isolationist, alcoholic, embittered crone—she made news in every sense, both in international headlines and at the Washington *Times-Herald,* both in life and after death.

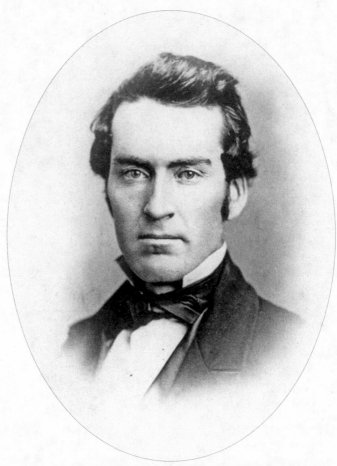

"Newspaper ink blood": newspaper editor, militant abolitionist,
and self-proclaimed progenitor of the fledgling
Republican Party, Joseph Medill, in the 1850s

I

Elinor Josephine Patterson

Go west, young man

"One winter night," Joseph Medill would recall of the evening of February 22, 1844, "I saw a light on the Western horizon, distant seven miles, and a couple of hours later learned it was my father's house and home which had made it, and there was no insurance." Although there had been no loss of life, the conflagration and the devastation it wrought would utterly change young Medill's situation, his prospects, and the course of his life—much as that Great Fire nearly three decades later would forever recast the fortunes of the extinguished prairie town of Chicago and the magisterial city that sprang from its ashes, with which Joseph Medill and his *Tribune* were to become so inextricably associated. Medill was not yet twenty-one in the winter of 1844; his plans to attend college were among the luxuries with which his family would be forced to dispense in the aftermath of the calamity. They "were left in no condition," he remembered, "to pay the expenses of a college course, or even to spare my labors on the place, as my father was bedridden by inflammatory rheumatism."

The ruined family farm, near the settlement of Massillon in Stark County, Ohio, some five miles from Canton, had not been Joseph Medill's birthplace. Despite the ferocity with which he would later champion the preservation of the Union—by force and bloodshed if necessary—and demand unsparing retribution against those who had sought to sunder it, he had not been born on United States soil. Rather, he had entered the world near the town of St. Johns, on the then-uncertain border between New Brunswick, Canada, and northern Maine, on April 6, 1823. By delineating in perpetuity the disputed frontier in 1842, in a stroke the Webster-Ashburton Treaty relegated Medill's birthplace to a colony of the abhorred Crown and disqualified the nineteen-year-old farm boy from ever becoming president of the United States.

A Belfast shipwright, Joseph Medill's father, William Madill, had been raised in austere Presbyterianism. Madill married Margaret Corbett, the daughter of a captain of the English yeomanry, and a lifelong Methodist, in 1819. A woman who "read only sensible books," Margaret Corbett Madill possessed a "vigorous and analytical mind." She held "decided opinions on all subjects that interested her" and would be noted until the end of her eighty-seven years for her "sterling moral qualities and inflexible adherence to convictions of duty and right." Almost immediately after their

wedding, the young couple cast off the yoke of monarchy and sailed west from their native northern Ireland to the New World, changing the spelling of their surname upon arrival. They would impart to their American children their intelligence, their rigor, their unbending righteousness, and with these characteristics, perhaps, some vestige of unquiet Ulster, the site and source of so many centuries of bloody strife. Although the Medills had landed and established themselves first in New Brunswick, they moved their growing family to the farm outside Canton, Ohio, in 1832. Redheaded Joseph Meharry Medill was the eldest of the nine children that his mother, "a little more than twenty years my senior," was to deliver. Of these, four boys and two girls would survive to adulthood.

What little formal education Joseph Medill obtained "came by self-denial and application." The Medill children attended the Massillon Village Academy during the winter months, but the eldest, a voracious reader with an aptitude for composition, supplemented his education with the help of a well-disposed Quaker neighbor with a good library. After school and chores, Medill walked the three miles to the neighboring farm to return the latest volume he had consumed, borrow another, and walk the three miles home again. On Saturdays he made his way to Canton to take additional instruction from a local minister in mathematics, Latin, natural law, and the sciences. He read extensively in history, philosophy, and literature and developed a particular admiration for both Benjamin Franklin's works (as well as for the man himself) and Edward Gibbon's *Decline and Fall of the Roman Empire.* If the former provided Medill with something of the pattern for the self-made man he was becoming, the latter inculcated in him a lifelong reverence for Roman order and centralized republican government.

In addition to these pursuits, the teenaged Medill became an avid reader of Horace Greeley's recently launched *New York Tribune.* With a lively intellect, a broad-ranging curiosity, and an inclination for radical politics, Greeley had thrown himself with gusto into the reform movements and iconoclastic fads of the mid-nineteenth century—vegetarianism, utopianism, Fourierist socialism, abolitionism, and many others. The *Tribune,* New York City's leading Whig daily, grew to be the most influential newspaper in the nation. Greeley would become a legendary mentor to younger journalistic talent; those he cultivated came not only from the Northeast but from the far-flung states and territories, and indeed from abroad as well. Over the course of its existence the *New York Tribune* would host an admirable and heterogeneous succession of associate editors and correspondents, Charles Anderson Dana, Margaret Fuller, George Ripley, and, briefly, Karl Marx among them. The collective efforts of hundreds like young Joseph Medill, who helped organize local readers' groups and sold

subscriptions to earn pocket money, ensured that the weekly edition of that legendary "Journal of Politics, Literature and General Intelligence" would be read by tens of thousands before their copies were passed along to still larger numbers of readers in the remotest reaches of the growing Republic.

Although the scholar's hopes of continuing his education in college had, in effect, gone up in flames, Medill adapted his accustomed academic practices to the study of law, in pursuit of a career that might eventually support him and his family. About once a month through 1845 and 1846 he walked into Canton to the law offices of Hiram Griswold, an eminence in local Whig circles, to return the law books he had recently finished studying, pick up new ones, and submit himself for recitation and examination. To help earn a living in the meantime, he sought to capitalize on his hard-won educational attainments by teaching school.

While teaching proved to be not only badly paid, but thankless, stultifying, and occasionally violent, it had introduced the handsome red-headed schoolmaster and aspiring lawyer to a pretty redheaded pupil eight years his junior, from New Philadelphia, in neighboring Tuscarawas County, Ohio. Like her admirer, Katherine Patrick was the daughter of an Ulsterman. James Patrick was a former associate judge of the court of common pleas, the local Indian agent and land commissioner, an elder of the Presbyterian church, a local Whig grandee, and editor and publisher of the county's first newspaper, the *Tuscarawas Chronicle.* He had come to New Philadelphia to become a publisher in his own right after working as a printer and compositor in Norfolk, New York. Although Judge Patrick desperately missed the comparative cultivation of Belfast, stubbornly retaining a vestigial elegance of dress and expression into old age, he had endured the discomforts of the prairie because he had fallen in love with beautiful Katherine Westfall. After bearing him six children she died when her youngest (and her namesake) was a year old.

Little Katherine Patrick, "Kitty," would be reared largely by two older sisters. All of the Patrick children would remain close throughout their lives, united in fear of their father's awesome temper. Judge Patrick had brought the children into the family business by teaching them composition and typesetting, but it was his youngest, according to family lore, who was being groomed to remain with him as "the comfort of his old age." That is, until young Joseph Medill began to take an interest in newspapers, composition, and typesetting, and came to spend a growing portion of his scant leisure time at the *Tuscarawas Chronicle* office, learning the craft under Kitty's direction—and the dubious eye of her father. When the proposal came, Judge Patrick had no intention of allowing her to marry the son of a ruined farmer, whose own prospects were at best uncertain. But he was also

unwilling to inflame youthful passion to the recklessness of elopement by responding with a flat no. Instead he demurred: the couple would be permitted to marry in the (unlikely) event that the prospective bridegroom should earn enough money to comfortably support a wife and family. "That," Judge Patrick estimated complacently, "would settle it."

Family lore notwithstanding, in old age Medill informed the *Chicago Daily News* that he had learned the rudiments of his craft not from his sweetheart at the *Tuscarawas Chronicle,* but from his friend J. T. Elliott, publisher of New Philadelphia's only other newspaper and the *Chronicle's* bitter rival. Hearing Elliott complain that the paper was short-staffed, Medill, still juggling legal studies with pedagogical duties but curious about publishing, offered to pay his own board in return for "the privilege of being taught." The work absorbed him. "Elliott had me grind off his papers and ink the rollers and set type, and, in short, I hustled for him in every sense of the word." It was as this point, Medill claimed almost half a century later (still resentful of Judge Patrick's snub), that the management of the *Tuscarawas Chronicle* "got mad and sent for me, declaring that it was only fair that I come and help them out." Not only did he effectively turn out both of New Philadelphia's rival papers, Medill professed, but over the coming months both publications would extend his duties to include drafting and typesetting editorials as well. "Well, I worked all that winter and by the time half a year had rolled away was something of a printer. I could set type in good shape, do a fairly good piece of job work, and understood much of the inner workings of a newspaper office," he recalled. "I liked it, and what I had taken up in fun proved to be my life work afterward."

Finishing his legal training in Canton in November 1846, Medill was examined and admitted to the Ohio bar. The following spring he entered into a law partnership, hung out his shingle, and began to practice in the county seat, New Philadelphia. Given William Medill's declining health, much of the responsibility for the younger Medill children had devolved to the eldest son. In an effort to establish his brothers in a career, Joseph Medill took a step that changed the direction not only of their lives but of his own as well. With some understanding of newspaper production, he conceived the idea of taking a year's leave of absence from his law partnership, buying a newspaper, setting his brothers up in business, and teaching them what he knew. In 1849, with a loan of $500* that his infirm father

*Although relative historical worth is notoriously difficult to calculate, based on the Consumer Price Index (CPI), $500 in 1849 would have been worth approximately $14,500 a century and a half later. Based on nominal gross domestic product (GDP) per capita, the figure would be the rough equivalent of $220,000. The first gives an indication of historic standard of living, a measure of the relative cost of goods and services over time; the second is an indication of economic standards, that is, a comparative measure relative to a laboring wage or more general income.

had managed to scrape together, Medill bought the weekly *Democratic Whig* in neighboring Coshocton County. Then he established himself as editor. With his brothers he arrived at an arrangement much like his own earlier agreement with Elliott. They would be, in effect, unpaid apprentices, in exchange for his instruction in their new craft. Mindful of the Roman civic virtues that had captivated him since boyhood, Medill then renamed the paper the *Coshocton Republican.*

Despite the change of name, the newspaper would reaffirm its Whig connections while repudiating any previous association with the Democratic Party. Under its new editorship the paper's relentless denunciations of slavery goaded local Whigs and Free Soilers to coalesce; the county Democratic Party suffered its first defeats at the ballot box as a result. Medill found himself called out frequently to answer for his incendiary editorial stances, occasionally with his fists. Bodily injury notwithstanding, the *Coshocton Republican* not only afforded Medill a platform on which to reinforce his journalistic inclinations, but presented him with a bullhorn for his political convictions.

One year's leave of absence from the practice of law turned to two; at the end of his second year at the *Coshocton Republican,* Medill would recall, "I was launched for life on a newspaper career." Propitiously, at that moment, a buyer in search of a country newspaper appeared bearing a letter for Medill from the editor of the Whig *New York Tribune,* Horace Greeley, who had taken notice of his younger colleague's journalistic and political exertions. Medill sold the buyer the *Coshocton Republican* "at a fairly good price," uprooted his siblings and parents, and made for Cleveland, which had grown prosperous and elegant in the two decades since the opening of the Ohio and Erie Canal. Ever watchful for far-flung and like-minded journalistic talent, Horace Greeley engaged Medill as the *New York Tribune's* correspondent in the Western Reserve and came to know the young journalist personally on his visits west. In the meantime, when the Medills discovered that Cleveland was already home to two anti-slavery evening newspapers—one Whig, the other Free Soil—the brothers made their first foray into daily (or, more specifically, morning) newspaper publishing with the launch of the *Daily Forest City* in the spring of 1852.

In establishing the *Forest City* Medill had committed the proceeds from the *Coshocton Republican* and borrowed more money from old friends and associates. As he approached the age of thirty, he was not rich or even solvent. His editorial and political successes had reinforced his native unwillingness to compromise (at the expense, perhaps, of jocularity). He had not forgotten pretty, auburn-haired Kitty Patrick back in New Philadelphia—or the obstacles Judge Patrick had laid on the path to matrimony. According to the story handed down in Cissy Patterson's branch of

the family, having waited three years, Medill returned to New Philadelphia to claim his bride. With a grim authoritarian streak and a temper to equal his prospective son-in-law's, Judge Patrick was furious, and the two men argued. On September 2, 1852, the young lovers married nevertheless. Judge Patrick refused to visit the couple afterward; Medill refused to correspond with his father-in-law for a decade. Considering the situation from more than a century's distance, one descendant maintained that in leaving her father for her husband, Katherine Patrick Medill had merely substituted one tyrant for another.

However despotic Medill might have been domestically, he devoted his editorial and political energies increasingly to the overthrow of oppression. "The honor of giving birth to the Republican Party ought to be divided between Steve Douglas and myself," he chortled later on the subject of the Kansas-Nebraska Act of 1854, its most notorious architect, Democratic senator Stephen A. Douglas of Illinois, and his own role in the political aftermath: "I began by preaching the death of the Whig party in my little Whig paper; Douglas hastened it by pulling down the bars and letting the South into the free territory."

While waging the battle for Katherine Patrick in New Philadelphia, Medill had been engaged on a second front in Cleveland, attempting to build upon the twin editorial and political triumphs he had engineered on a small scale back in Coshocton County. In the election of 1852 the *Forest City* exhorted Ohio's Whigs and Free Soilers to join in supporting both the Whig platform and the party's candidate, Mexican War hero General Winfield Scott. Scott's ignominious loss (by some thirty thousand votes in Ohio alone, despite Medill's vigorous efforts) to the dark horse Democratic candidate, Franklin Pierce, and the national calamities that were to follow under the latter's administration, however, had set in motion the fracture of the old Whig Party.

Stung personally by the defeat, over the course of the next several years Medill began corresponding with prominent figures across the country who were still in sympathy with the old Whig ideals, asking their support in the formation of a new "National Republican Party"; among them was Horace Greeley, who lent tepid encouragement. In the meantime, Medill merged the *Daily Forest City* with another of Cleveland's anti-slavery sheets to produce the *Cleveland Morning Leader* in March 1854. Later that month, while the debate raged in Congress over the Kansas-Nebraska Act, which threatened to allow slavery to extend to territories where it had been expressly forbidden since the enactment of the Missouri Compromise in 1820, Medill called a clandestine meeting of his more enthusiastic Ohio correspondents at the *Leader*'s offices to discuss his party proposals. The small and motley group that assembled consisted of some twenty assorted

Whigs and Free Soilers—as well as a few more recent converts to the cause, liberal Democrats—all united in outrage and alarm at Senator Douglas's pending bill. The meeting at the *Leader*'s offices was not the first of its kind; swelling outrage over the threatened passage of the Kansas-Nebraska legislation had given rise to a number of similar convocations both large and small throughout the Northeast and Midwest in the winter and spring of 1854. Nevertheless, Medill would ever afterward jealously maintain that it was he who had named the resulting coalition that would in turn transform the American political landscape. After considerable palaver at the *Leader*'s offices regarding the proposed party's name and somewhat less regarding its platform, a fledgling political movement rose from the ashes of the old Whig Party. Its mission was unequivocal: "No more slave states; no more slave territory; resistance to pro-slavery aggression; slavery is sectional; liberty is national." The new coalition agreed to adopt Joseph Medill's suggested title, the "National Republican Party." The name at once invoked Thomas Jefferson's earlier party of that name and trumpeted both its antagonism to entrenched, aristocratic oppression and its commitment to centralized constitutional government in the face of increasingly militant calls for states' rights.

Captain J. D. Webster, of the coarse, bustling, seasonally pestilential prairie town of Chicago, owned an interest in that city's *Daily Tribune,* one of the local news sheets that was both hostile to slavery and the Democratic Party on the one hand and almost pugilistic in its Know-Nothing nativism, especially toward Catholics and immigrants, on the other. In the course of the coming decade, Webster would rise to a general's rank and serve as Ulysses S. Grant's chief of staff at Shiloh, but in the winter of 1854–55, he was a newspaperman in search of a managing editor. Having heard of the politically active publisher of the *Cleveland Morning Leader,* Webster invited Medill to visit Chicago and offered him the position. Now the father of a toddler and expecting Kitty to give birth to the couple's second child any day, Medill was uncertain but intrigued. After returning home to Cleveland, he received another of Horace Greeley's portentous letters. It was not (as sometimes claimed, especially by early histories of the *Chicago Tribune* and Medill descendants) in fact Joseph Medill to whom Horace Greeley addressed his famous mandate to "go west, young man, and grow up with the country." Nor was it, in fact, Greeley who originated the phrase that has come to associate him so closely with the optimistic expansionism of the young republic. Nevertheless, the dictum captures the import of the letter Medill received in the winter of 1855, in which Greeley urged him to launch a penny paper in the bumptious, expanding city of Chicago with one Dr. Charles H. Ray. Another young midwestern newspa-

perman of whose talents and political activities Greeley had taken notice, Ray had put medicine aside in order to edit the Democratic, vehemently anti-slavery Galena, Illinois, *Jeffersonian.* In March 1855, the two editors met in Chicago in the rotunda of the old Tremont House. Launching a new newspaper would be considerably more expensive than buying a going concern, they soon discovered, and the two turned their attentions to the foundering *Chicago Daily Tribune.* In the late spring of 1855, go west Medill did, with his young wife, his two baby daughters, and, as ever, his three journalist brothers, to Chicago.

"Were you ever scooped very bad?" a young reporter asked Joseph Medill in 1890. Reflecting on his more than fifty years in journalism, during which he had "done everything but work the foot-press," Medill smiled nostalgically, and conceded, "I was once scooped awfully, and I have regretted it to this day." Having abandoned the "finished elegance" of Cleveland for the "turmoil of the prairie metropolis built on a quagmire," Medill purchased a one-third interest in the *Chicago Daily Tribune* in June 1855, and became managing editor and superintendent of editorial. As such, he was to oversee the paper's mechanical, advertising, circulation, and news-gathering departments. Shortly afterward, Ray bought a one-quarter share, and, as agreed with his new partner, became editor in chief. Later still, Alfred Cowles, who had come from the *Leader* with Medill to serve as the *Tribune*'s bookkeeper, would buy another third. The previous proprietors retained the remaining fraction. Beyond Chicago, the passage of the Kansas-Nebraska Act in May 1854 had given rise in effect to bloody civil war in the new state of Kansas, which in turn had inflamed sectional tensions nationally, redoubling the truculence of slavery's proponents while galvanizing passive anti-slavery sentiment and radicalizing established abolitionists. Both of the *Tribune*'s new editors continued or, indeed, intensified their personal and editorial political exertions in Chicago. Under its new management, the *Tribune*'s increasingly strident anti-slavery message found a more receptive audience. In addition to his editorial duties at the *Tribune,* Medill took up the mantle of Washington correspondent in the spring of 1856 but returned to Illinois to serve both as an official delegate and as the paper's correspondent to the Illinois Anti-Nebraska (or proto-Republican) convention in Bloomington on May 29.

There, as the *Illinois State Journal* recorded it, an outlandish convocation of old-time Whigs, newly minted Republicans, disgruntled Democrats, Know-Nothings, and immigrants, "laying aside all party differences, united together [in Bloomington] in one common brotherhood to war against the allied forces of nullification, disunion, slavery propagandism, ruffianism, and gag law, which make up the present administration party

of the country." During a lull in the assembly's proceedings, the crowd began clamoring for an observer who had been spotted in the obscurity at the back of Major's Hall. "Much against his will," the figure, gaunt and unprepossessing, was pushed forward to the dais amidst cheers and hurrahs. From there, he considered the crowd soulfully for a moment before putting on his glasses but, having no prepared text, took them off again. At last he broke the expectant silence by addressing the motley conventioneers in a nearly inaudible falsetto. "Seems to me," Medill muttered to his colleague, John Locke Scripps of the *Chicago Democratic Press,* "with so many brilliant men in the hall they might have called on a better man to talk." Having long brooded on his subject, however, at the podium Abraham Lincoln came into his own, speaking increasingly clearly and beginning to "look a foot taller" as he "shook himself loose and spoke his feelings from the heart." Lincoln heaped infamy on the insatiable aggression of "Southern slave power," denounced its groveling Northern abettors for allowing slavery to blight the once-free Northwestern prairies and called upon all friends of liberty to resist unto death. Throughout the oration Lincoln held his listeners spellbound; his audience was alternatively "dumbfounded, overcome by his eloquence," and repeatedly lifted to its feet, hats aloft, in frenzied concurrence. After closing, the Springfield lawyer and former congressman sat down quietly. The assembly breathed a general sigh and then rose again to shake the building to its rafters with prolonged, thunderous cheering.

Coming to his senses, Medill looked down to realize that he had taken no notes. "I had been so charmed," he remembered, "that I forgot my business and had listened to the man without being able to write a word." When he asked to see Scripps's notes, he found that his colleague had been similarly overpowered. The experience was universal among reporters who had come to cover the convention. Over the ensuing nine years, many who were present that day would become connoisseurs of Lincoln's enthralling oratorical powers, and many would continue to regard the Bloomington speech, though uncharacteristically belligerent, as his finest. That no verbatim copy of the oration ever came into being is an indication of the reverence in which the assembled reporters held it; to a man, they disavowed the time-worn, corner-cutting practice of filing a half-remembered paraphrase before the deadline. Still emerging the next morning from the effects of the spell Lincoln had cast, all of them filed late and even then, in effect, honored the oration by submitting only cursory descriptions for publication and posterity. "Every other newspaperman was scooped on the same thing, " Medill chuckled half a century afterward, "so I have that consolation."

Under its new management, the *Daily Tribune* abandoned (for the most

part) its former Know-Nothing xenophobia. Instead it took up the causes of extolling the virtues of temperance and abolitionism and furthering the interests of burgeoning Chicago and the new Republican Party. As sectional tensions flared over the course of the late 1850s, the paper also advocated the preservation of the Union, even at the cost of bloodshed. As at their previous newspapers, Ray and Medill championed political candidates who reflected their aspirations for the Republic and castigated those who did not. Both men attended the Illinois Republican Convention in Springfield in June 1858. Charles Ray was instrumental in securing Abraham Lincoln's unanimous nomination as the challenger for Stephen Douglas's Senate seat. Joseph Medill would not be scooped a second time; copies of the nominee's momentous acceptance speech, echoing the Gospel of Matthew in reminding the assembly that "a house divided against itself cannot stand," were supplied to the press.

If Abraham Lincoln's fortunes appeared to be rising, the *Chicago Daily Tribune*'s were not. Immediately after the Illinois Republican Convention, on July 1, 1858, the inevitable came to pass: hard-hit by the Panic of 1857, Medill and Ray were forced to merge their *Tribune* with "Deacon" William Bross and John Locke Scripps's like-minded *Democratic Press.* The *Chicago Daily Press and Tribune* had been established, Medill and Ray contended in one of the last editions of the old *Tribune,* "to put an end to the expensive rivalry which has heretofore been kept up; to lay the foundations deep and strong of a public journal, which will become one of the established institutions of Chicago; to enable us to combat more powerfully, and, we trust, more successfully, public abuses; to give us a wider influence in public affairs, in behalf of sound morality and a just Government." Making no pretense of objectivity, the *Daily Press and Tribune* would champion from its very first issue the Republican Party and its nominee for the United States Senate from Illinois.

The nation watched the 1858 Illinois Senate race with bated breath. Much as Lincoln and Douglas faced off brutally in their seven debates across the state from late August to mid-October, so too did their journalistic partisans. Initiating a practice that would become commonplace afterward, Chicago editors dispatched reporters to travel with the candidates. Republican sheets allowed slips of the tongue and scribal errors to go uncorrected in the texts of Douglas's remarks while perfecting any shortcomings in Lincoln's; Democratic newspapers practiced the reverse tactic. Once published in Chicago, the full texts of the debates (complete with sectional redactions) were reprinted nationwide. Unencumbered by the "old western style" rules of debate to which their respective Senate candidates had agreed, the Republican Party organ, the newly formed *Chicago Daily Press and Tribune,* and the Democratic *Chicago Times* faced off in a

journalistic free-for-all of hyperbole, sneering, denunciation, outrage, finger-pointing, and vilification of the opposing candidate, his positions, his supporters and his proponents in the press. In November, Douglas would be returned to Washington by a narrow margin, but throughout the North newly elected Republicans made ready to meet him there. Abraham Lincoln had become a figure of national standing, and the *Chicago Daily Press and Tribune* began to set its sights on the election of 1860.

Despite the recent merger, the editors of the *Press and Tribune* found themselves facing bankruptcy. They remained of a single mind with regard to their candidate nevertheless, going deeper into debt in order to continue to print special cheap campaign editions, provide staffing at the debates and at Lincoln's subsequent speeches and appearances, and send speakers to rally interest and support in uncertain districts. Over the coming two years, the partners managed to cajole their creditors to extend their obligations. Much of their debt had resulted from the recent purchase of a state-of-the-art four-cylinder steam rotary press. Steep cost-cutting measures and rising circulation allowed them to arrive at solvency earlier than expected, and as the general election approached the *Press and Tribune* began to prosper.

Over the same period, Medill spent crowded weeks at a time in Washington, not only as the *Press and Tribune*'s correspondent, but also in extolling to fellow partisans the manifold virtues both of Abraham Lincoln as a presidential candidate and of Chicago as the ideal site for the upcoming Republican convention. Although he prepared daily dispatches for publication, evidently Medill wrote far less frequently to Kitty, whom he had left at home with the couple's two petulant little girls. After her own subservient girlhood in the backwater of New Philadelphia, Kitty had loved gracious Cleveland and regretted leaving it for teeming, cholera-ridden Chicago. Ever after, she would be plagued by respiratory complaints (psychosomatic, one descendant suspected). "It is pleasant to know one is not forgotten," she sniffed in response to one of her husband's letters from Washington. "For pity's sakes, don't write the office that you plan to stay for six or eight weeks, my beloved," she added, and closed by demanding, "Are you demented?"

In February 1860 the editors of the *Chicago Press and Tribune* endorsed Abraham Lincoln as their Republican candidate for the presidency. In mid-May the Republican Party duly convened in Chicago in the gigantic pine-board "Wigwam," constructed for the purpose on Market Street to accommodate as many as ten thousand. In its efforts to tilt the field in favor of Abraham Lincoln (and against the other principal contender, New York's former governor William Seward), the local party machinery adopted the no-holds-barred approach that would come to typify Chicago politics. Lin-

coln boosters from around the state received discounted railway tickets to Chicago, illegitimate floor passes to the Wigwam, and strict instructions to assemble there early on the morning of May 18, before the balloting began. As the delegates from the various states, the out-of-town conventioneers, and, of course, the candidates and their supporters arrived at the Wigwam later that day, they found themselves greeted by the muffled hoots and roars of Illinois's Lincoln zealots, already packed quite literally to the rafters, within. Joseph Medill combined his official charge of arranging the delegates' seating plan with the backroom undertaking that Lincoln's strategists had entrusted to him. In an effort to keep doubtful states "as far outside of the sphere of [New York's] influence as possible," he banished Seward's partisans to a Siberian corner of the Wigwam, surrounded on all sides by like-minded delegations. At the extreme opposite end of the vast hall, Medill shipwrecked undecided Pennsylvania in a raging sea of Lincoln devotees, who were certain not only to sweep the delegation up in their ebullience for Honest Abe but, for good measure, to drown out any pro-Seward sentiment that might reach the undecided from the distant dais. "It was the meanest political trick I ever had a hand in in my life," Medill would chuckle later.

Pennsylvania duly broke for Lincoln on the second ballot. After his masterful seating of delegates, Medill's own seating came to be of paramount importance in clinching the nomination. As Medill remembered and recounted events for posterity, he made his way over to the pivotal Ohio delegation and installed himself among some old friends to do a little "missionary work" on Lincoln's behalf. One Ohioan took exception to the Illinois evangelist's presence, attempted unceremoniously to shoo him away, and made loud, disparaging remarks about his candidate for the rest of the delegation to hear. Playing for time, Medill refused to leave. His old friends came to his defense as the third ballot voting wore on. As hoped, "a nice little argument" resulted and Medill stayed. When Lincoln had 231½ votes, with 233 needed for the nomination, Medill made his move. With no authority to make deals, he leaned over to the delegation's unofficial chairman, former congressman David Cartter (who had earlier that day nominated the former Ohio senator and governor, Salmon P. Chase), and whispered with practiced sincerity, "Now is your time. If you can throw the Ohio vote for Lincoln, Chase can have anything he wants." Cartter, whose speech impediment grew more pronounced under stress, scanned Medill's face dubiously, demanding, "H-how d-d'ye know?" "I know," Medill assured him without blinking, "and I wouldn't promise if I didn't." With that, Cartter conferred with several of his delegates, clambered unsteadily onto a chair, and attempted to make himself heard above the din. "Mr. Chairman!" he spluttered, "I-I-I a-arise to announce a ch-change

of f-f-four votes, f-f-from Mr. Chase to Mr. Lincoln." According to the next day's account in the *Chicago Press and Tribune,* once the Illinois native son had been thus pushed over the top, the Wigwam became the scene of "delirious cheers, the Babel of joy and excitement . . . stout men wept like children," and the cannon on the structure's roof thundered the news to the anxious crowd outside.

The *Press and Tribune* and its joint owners and publishers redoubled their Lincoln offensive in the months remaining before the November election. John Scripps, now the *Press and Tribune's* senior editor, wrote an extensive biography of the Republican candidate, which the paper itself would reprint as one of more than a dozen pamphlets it contributed to the campaign, and which would in turn appear repeatedly in one form or another over the coming months, purloined, in newspapers throughout the North. Joseph Medill traveled east, reprising his role of evangelist and attempting to mollify and convert former Whig and recently Republican colleagues in the press who were disgruntled by Lincoln's nomination. In addition to the *Press and Tribune's* growing coverage of growing Chicago's affairs, serializations that had expanded to include the works of Charles Dickens and Ralph Waldo Emerson, thrilling crime and disaster coverage, foreign dispatches, ladies' columns, book reviews, farming and gardening tips, travel features and poetry, the paper continued to trumpet the Republican Party platform and, increasingly, militant preservation of the Union. The *Press and Tribune* resumed, or rather continued, the journalistic dogfight with the *Chicago Times* that dated from the Illinois Senate race of 1858. The *Times's* new owner—the Virginia-born multimillionaire and Cook County Democratic Party chairman, Cyrus McCormick, whose avowed agenda it was to promote the candidates of the fracturing Democratic Party (including, at various times, himself), calumniate their Republican opponents, and rout "that dirty sheet" the *Press and Tribune*—was delighted to continue hostilities through the election and on into secession, bloody civil war, and Reconstruction.

In November 1860 the *Press and Tribune* began to be published again as the *Chicago Tribune.* As the Union disintegrated, Chicago, by contrast, prospered along with the paper, which took a decided step toward indissolubility. On February 18, 1861, ten days after the ratification of the Constitution of the Confederate States of America in Montgomery, Alabama, the Illinois state legislature incorporated the Tribune Company by special act. Of the 2,000 shares issued at a par value of $100 per share,*

*That is, at roughly $2,500 per share in the first decade of the twenty-first century, based on the Consumer Price Index, or approximately $33,000, based on the nominal GDP per capita.

Medill and Bross purchased 430 each, Scripps and Ray 420 each, and Cowles 300.

Southern secession in the wake of Lincoln's victory came as little surprise. The *Tribune* continued for the most part to support the president throughout his administration despite its editorial impatience not only with the deliberate pace of his initiatives but also with his exasperating moderation. The paper clamored for intensification of the war effort, conscription, and ensuring the right to vote to Union soldiers far from home. When Dr. Ray resigned as editor in chief in 1863, Medill became his successor. Under Medill's direction, during the last years of the war the *Tribune* boasted the largest number of war correspondents in the West. The midwestern public devoured their vivid accounts from the fronts (alongside reports on the perfidies of Confederate "Secessia"), complete with extensive maps and illustrations. The paper led a variety of patriotic drives for the recruitment and equipping of troops, initiatives to boost civilian volunteerism (in which Kitty Medill participated heartily), and solicitations not only to fund medical supplies and tented mobile hospital units, but also to provide aid to Union soldiers and sailors.

Under Medill's editorship, the *Tribune* brooked no contradiction, and persecuted any dissenters from its orthodoxies. With the commencement of hostilities, the paper's unrelenting antebellum animus toward slaveholders, Southerners, unapologetic Democrats, and "doughfaces" generally found its wartime targets neatly united in the Confederacy. Nearer at hand, the paper set its sights on "Copperheads," the rebels' Northern Democratic peace-peddling sympathizers, their leaders, their candidates, their supporters, and, as usual, their local organ, Cyrus McCormick's detested *Chicago Times.* The better angels of Medill's nature were avenging rather than reconciliatory. Under his command, the *Tribune* badgered Lincoln early and relentlessly for emancipation, confiscation of Southern property, and the recruiting and arming of emancipated slaves. In the aftermath of Lee's surrender at Appomattox, Medill rebuffed any suggestion of malice toward none or charity for all. For Confederate president Jefferson Davis, he demanded summary execution; for General Robert E. Lee, prison and hard labor. Having lost two of his brothers in the conflict, for "the cruel vindictive millions who starved to death with devilish malice 25,000 of our brave Patriotic sons and brothers," Medill spat, there could be "no forgiveness . . . on this side of the grave."

At the time of their consolidation in 1858, the *Chicago Daily Tribune* and the *Democratic Press* each had a daily circulation of about 4,000. By the time of Lincoln's inauguration, the *Press and Tribune*'s circulation had risen

to 18,000. With Medill as editor in chief, the paper continued to grow dramatically. On May 12, 1864, the *Chicago Tribune* proclaimed that the previous day's run of 40,000 had completely sold out, boasting that the figure was "probably greater than the combined circulation of all the other daily papers in Chicago." As a means of flaunting the imminent arrival of its new, $30,000 eight-cylinder press with an hourly capacity of some 16,000 sheets, the *Tribune* apologized to its readership that, although pushed to maximum capacity, its six-year-old four-cylinder press had been unable to meet that morning's demand of an estimated 50,000 newspapers.*

CHEER UP.

In the midst of a calamity without parallel in the world's history, looking upon the ashes of thirty years' accumulations, the people of this once beautiful city have resolved that CHICAGO SHALL RISE AGAIN.

— *CHICAGO TRIBUNE*, OCTOBER 11, 1871

Medill's wartime tenure as editor in chief of the *Chicago Tribune* had been short-lived. In April 1865, John Scripps had left the partnership and sold his 420 shares to the paper's Washington correspondent, Horace White, who was already a minor stockholder. Discord among the partners—much of it the result of Medill's temperamental and editorial obstinacy—conspired with the new balance of power to unseat Medill as editor in chief in favor of White in August 1866. Although Medill continued as the paper's nominal superintendent of editorial under these awkward circumstances, he had been neutralized. Still fierce, in middle age his vigor had been diminished by the rheumatism he had inherited from his father, the encroachment of which had been hastened by the aftereffects of the many blows, literal and figurative, that he had given and received over the course of his newspaper career. Growing deaf, he wielded a daunting black hearing trumpet with withering passive aggression. With little ability to influence political affairs through his cherished *Tribune*, he involved himself more directly in politics. In 1869, as the *Chicago Tribune* left its home of fifteen years on Clark Street for improved, fireproof headquarters on the corner of Madison and Dearborn, Joseph Medill became a delegate to the Illinois Constitutional Convention. Two years later, he accepted

*The new printing press cost approximately $425,000 based on the CPI and roughly $5 million based on nominal GDP per capita a century and a half later.

President Grant's appointment to the first Civil Service Commission and ran an unsuccessful campaign for the Illinois Republican Party's nomination to Congress.

The summer of 1871 had been preternaturally dry and windy in the Midwest. Lagging hopelessly behind demand, construction in Chicago over the previous three decades had been vast, slipshod, and almost entirely wooden. Only seventeen horse-drawn engines and 185 firemen stood ready to protect the city's 334,000 inhabitants, who were dispersed over some eighteen square miles. While all but a small fraction of the development that made up the fastest growing city in the world cured into crisp tinder during the late summer, the pages of the *Chicago Tribune* augured the holocaust to come in its coverage of a growing number of "Fire Losses," "Conflagrations," "Fires in The Woods," "Insurance Claims," and the like. Editorially, over the same period the *Tribune* repeatedly castigated the city council for its devil-may-care approach to fire prevention and disaster preparedness, to no avail. Although the immediate cause of the Great Chicago Fire would never be determined, the indictment of Mrs. O'Leary's fitful cow was an (eventually) admitted fancy of the hated *Chicago Times*. Nevertheless, the spark, fueled by a twenty-mile-per-hour southwesterly prairie wind, had originated on the city's Southwest Side at or near immigrant Patrick O'Leary's barn on that "miserable alley," De Koven Street, on the evening of October 8, 1871. By ten thirty that night the fire was reported to be uncontrollable. By the morning of October 10, four square miles of the city lay in ruins, along with more than $200 million in property.* More than two hundred had perished; more than a hundred thousand had been left homeless.

While the fire still raged on Monday morning, October 9, Joseph Medill fought his way to the *Tribune's* fireproof "rooms" at Dearborn and Madison. To the south and west stretched a vast "scene of desolation," to the north a raging "sea of fire." Nevertheless, the *Chicago Tribune's* editorial offices, the paper would later trumpet characteristically, "stood like a mailed warrior." "Long after every other printing establishment in the city had gone down in a tornado of fire," the *Tribune's* staff had worked through the night, continuing to report on the sprawling disaster, set type, print the paper, and distribute it to a shaken Chicago desperate for news. Believing the building—constructed of incombustible materials beneath a cement roof—to be impervious, Medill's fellow owners Deacon Bross and Horace White left to ensure their families' safety and secure

*Roughly $4 billion based on the CPI or $50 billion based on nominal GDP per capita in the first decade of the twenty-first century.

what was left of their homes. There is no record of how Kitty and the Medill girls fared during the conflagration. Bross and White were unaware in leaving, however, that the fire had "crawled under the sidewalk from the wooden pavement" and ignited the woodwork in the barbershop that operated out of the building's basement. Realizing there was little time left as the presses melted, Medill began organizing for the immediate removal of the newspaper's files and whatever else could be salvaged before flames consumed the Tribune Building. By noon, Medill was already in search of a "haven of refuge" in which to continue to put out the paper. Discovering that an archaic printer's shop on Canal Street was still in existence, he bought it and quickly transferred the paper's operations, staff, and surviving equipment there. Then he ordered an old four-cylinder press, sight unseen, and arranged to have it sent from Baltimore immediately. By the time Bross and White returned that afternoon, Medill was helping to set type for the next morning's edition on the shop's old, ill-suited press.

The *Tribune* published the result on the morning of October 11, and included what was to become perhaps the paper's most famous editorial:

CHEER UP.

In the midst of a calamity without parallel in the world's history, looking upon the ashes of thirty years' accumulations, the people of this once beautiful city have resolved that CHICAGO SHALL RISE AGAIN.

Although the editorial had been unsigned, Medill's descendants would claim it—and the fortitude in the face of devastation that it embodied—for their forebear. Reconstruction at the *Tribune* absorbed all of his energies in the weeks following the fire. At the same time, a nonpartisan committee that had coalesced around the aim of securing decisive civic leadership for the reconstruction effort selected the unwitting (and initially unwilling) Joseph Medill to head its ticket as the Union-Fireproof candidate for mayor of Chicago. He was elected by a decisive majority several weeks later and took his oath of office on December 4, 1871.

Medill had reluctantly accepted the nomination on the sole condition that the state legislature amend the city's charter so as to place the various freewheeling local boards firmly under the control of the city council and the mayor. With some modification, under Medill's tenure the state legislature's new charter for the city of Chicago would eventually serve as the model for municipalities throughout Illinois. The hallmark of Fireproof mayor Medill's administration was, however, fire prevention. Chicago's new growth shot up not only with a particular vigor and majesty, but also with a newly mandated brick and stone incombustibility. Building on

Queen Victoria's gift of some eight thousand books from Britain in the aftermath of the disaster, Medill launched an extensive new public library system. A relentless crusader against corruption, waste, and embezzlement, he successfully reformed and depoliticized the fire department, but had less success in loosening the grip of cronyism over the Chicago police force. For all of Mayor Medill's reforms, as ever, his absolutism sparked controversy. Chicago's German population took particular exception to Medill's temperance initiatives. When police officials refused to enforce the mayor's orders to close drinking establishments on Sundays, he fired them, suspended the chief of police, and threatened to call in the militia. Chicago's German community reacted with mass demonstrations and the formation of the anti-Medill People's Party. The German-language *Staats-Zeitung* pronounced the authoritarian mayor "Joseph I, dictator."

Although he had endured body blows throughout his life for his incendiary editorial stances, the contumely of Chicago politics proved to be too much for Joseph Medill. In July 1873, he announced his intention to resign his post four months before the completion of his term, and sailed for Europe with his wife and three daughters. For more than a year the Medills made their way through Ireland, England, France, Germany, and Switzerland. The girls attended school in France and threw themselves open to the improvements of unfamiliar influences on their minds, of the burgeoning European fashion houses on their wardrobes, and of hobnobbing with dignitaries and aristocrats on their already robust sense of self-importance. The patriarch took the waters at the celebrated central European spas in his ongoing efforts to assuage his "old rheumatic troubles," and dispatched bulletins on his activities and meditations for the edification of the *Tribune*'s readership back in Chicago.

His relations with the paper's other stakeholders, however, continued to be troubled. The "usefulness and influence" (not to mention the revenue) of the *Tribune* as the Republican Party organ that Medill and Ray had sought to make it nearly two decades earlier had been compromised, Medill brooded, by the anti–Ulysses S. Grant stance that editor in chief Horace White had taken. For some time, Medill had ruminated on the possibilities either of selling his holdings to one of his partners and buying a newspaper he could transform into the unapologetic Republican Party organ he believed the *Tribune* should be, or of buying out the holdings of one of his partners and reasserting himself at the paper he so dearly loved. Throughout the course of his European grand tour, Medill had been in communication with an unnamed "friend" who informed him that Alfred Cowles had seen the error of his ways in allying himself with White rather than Medill in the *Tribune*'s editorial skirmishes over the previous decade, and that

Chicago Tribune editor in chief
and former "Fireproof Mayor"
Joseph Medill, ca. 1892

Cowles might be induced either to sell his holdings or to buy out Medill's. Gratified but cautious, Medill returned to the United States in October 1874 to find Cowles both less repentant and less willing to make a deal than he had been led to believe. Nevertheless, over the coming weeks, Medill managed to secure a $300,000 loan from dry-goods merchant Marshall Field; the $500 per share he was now in a position to offer eroded Cowles's and even White's reservations to sell their combined six hundred shares.*

After nearly twenty years' wait, Joseph Medill was at last in a position to take a majority interest in the *Chicago Tribune* and with it, even more desirably, unfettered editorial control. "Once more the dear old *Tribune* of former days will be itself again. The spirit of Ray, tho' dead in the body, and much of Medill, tho' long speechless, will again be felt and heard thru the columns talking to old families and friends," he crowed to an old Republican friend on November 1, 1874. "The paper passed into my hands *forever* during this mortal life and that of my family after me," he continued. "On the 9th . . . Mr. White retires and on that day one Medill resumes his 'old throne and sceptre' in the *Tribune* 'kingdom.'"

*The $300,000 Medill borrowed from Field would be worth approximately $6 million based on the CPI, some $70 million based on nominal GDP per capita in the first decade of the twenty-first century. The $500 per share that Medill offered was the approximate equivalent of $10,000 or roughly $120,000 based on the same two measures.

BEFORE THE ALTAR.

Miss Eleanor R. Medill Confers Her Hand On Mr. Robert W. Patterson, Jr., Of the "Tribune." An Unostentatious Ceremony Performed in the Presence of a Small Circle of Intimate Friends

— *INTER-OCEAN* (CHICAGO, IL), JANUARY 18, 1878

I *told you* not to marry Rob Patterson," Kate McCormick exulted in repeating to her middle sister, Nellie. The reminder was as apt a commentary on the Patterson marriage as it was suggestive of the sisterly sentiment that prevailed among Joseph and Katherine Medill's three redheaded daughters. The eldest, named, like her mother and grandmother before her, Katherine (or "Kate"), had been born in Cleveland on July 11, 1853, the elder Irish twin to the National Republican Party. As her father contemplated the possibilities presented by Chicago and its foundering *Tribune,* Elinor (or "Nellie") arrived on January 30, 1855, eighteen months behind Kate and already at the disadvantage she would always feel with regard to her elder sister. Josephine (or "Josie") was born in 1866, into an abundance, which though as yet modest, had been unimaginable in her parents'—and even in her sisters'—childhoods. Almost half a generation younger than Kate and Nellie, Josie would be afflicted with a delicate constitution throughout her short life. As her ungovernable elder sisters neared womanhood, Josie alone would escape the paternal exasperation that prompted her namesake—himself no stranger to rancor and discord—to wonder, "Is it my fault, that I'm the father of the worst two she-devils in all Chicago?"*

Joseph Medill contended he had early on "caught the smell of printer's ink which, once inoculated in the human system . . . possesses its victim until death." The susceptibility was congenital. His descendants would exhibit a fortuitous constellation of abilities, inclinations, and idiosyncrasies—whether inherited, situational, or learned—which, even when ungratified, drew them irresistibly to journalism. Nellie Patterson's descendants in particular would manifest a singular disposition for the esoteric art of publishing successful tabloids. And yet, if Fate smiled on Joseph

*Like many Medill expressions, this one would evolve as it was handed down in family lore. Cissy Patterson's daughter, Felicia Gizycka, for example, remembered a more emphatic version, in which her great-grandfather described his daughters as "the two biggest bitches in Christendom."

"Nellie": Elinor Medill Patterson,
Cissy's mother, ca. 1875

Medill's progeny by conferring on them those happy accidents that repeatedly gave rise to journalistic distinction, she perhaps played them the compensatory trick of seldom granting happy temperaments or peaceful lives.

Generation after generation, Medill's descendants would display not only persistent journalistic predilections, but traits and foibles that would lead them into uncannily similar circumstances many decades apart. More than a few suffered from melancholia, rage, and alcoholism. They were almost without exception gifted horsemen. The girls of the family were prone to running away from home, the women to battling over expensive necklaces. Grandparents would form tight bonds with their grandchildren, having been remote or largely absent when raising their grandchildren's parents. As parents, Joseph Medill and his progeny were as controlling as they had been rebellious in youth. One distinctive result of this trend would be that over the course of several generations it would become as common for the Medills to marry over blunt familial objection—or simply to elope—as to wed conventionally on hallowed ground. And there would be no evident correlation between parental blessing (or lack of it) and ultimate wedded bliss (or lack of it).

"He was a hell of a good newspaperman," Cissy Patterson would remember fondly of her father, Robert Wilson Patterson, Jr. Her elder brother, Joseph Medill Patterson, arguably the most successful American publisher of his generation, believed that his father had been an even better editor than his own august namesake and grandfather. Although not rich, Robert Wilson Patterson, Jr., had been born into a distinguished family of Chicago's South Division. In 1821, his grandparents, Scotch-Irish Presbyterian abolitionists, had been induced to move north to Illinois by "the unproductiveness of the soil in East Tennessee and their strong desire to remove their growing family from the corrupting influences of slavery." In 1842, his father and namesake, the Reverend Robert Wilson Patterson, Sr., became the founding pastor of the Second Presbyterian Church of Chicago, which, like the city itself, grew rapidly in size and prominence in the mid-

Chicago Tribune editor Robert Wilson Patterson, Jr., Cissy and Joe Patterson's father, in the 1880s

nineteenth century. In the three decades after its founding the church came to number among its congregants not only many of the city's civic chieftains and captains of industry, but also figures of eventual national and international repute like Democratic senator Stephen Douglas and, when visiting Chicago, Douglas's senate and presidential rival from the emerging Republican Party, Abraham Lincoln.

Born in Chicago in 1850, the younger Robert Patterson attended local public schools before venturing east to Massachusetts to attend Williams College. After graduating in the spring of 1871 with a degree in classics, he returned to Chicago to take up the study of law. That October, however, the Great Fire put an end to his legal aspirations, claimed the Second Presbyterian Church, and consumed much of the Patterson family's savings. Just as the course of Joseph Medill's early life had been altered by conflagration, so Rob Patterson would be forced to make his own way in what was left of the city of his birth.

In the meantime, Patterson's father moved the rest of his family some thirty miles north of the blackened ruins of Chicago to the verdant bluffs and ravines along the shores of Lake Michigan at Lake Forest, Illinois. Long planned, the relocation had only been hastened by the Great Fire. In 1855, the senior Patterson had been among a small group of Presbyterians entrusted with finding a location suitable for the construction and establishment of "an institution of learning of a high order in which Christian teaching would hold a central place," modeled along the lines of his own alma mater, Lane Theological Seminary in Cincinnati. Stirred by the fervor of the Second Great Awakening, Robert Patterson, Sr., had matriculated as

a seminarian in 1837 and became a disciple of Lyman Beecher, Lane's first president and Harriet Beecher Stowe's father. A flagrant bigot and nativist, Beecher nevertheless opposed slavery as divisive both to the Union generally and to Presbyterianism in particular. His protégé, now the Reverend Robert Patterson, adopted not only his mentor's "moderate" (or as Beecher himself put it, "expedient") abolitionism, but also the latter's disapproval both of slaveholders on the one hand and of those who championed abolitionism in its more uncompromising forms on the other.

Between the time that the elder Patterson first caught sight of the "sylvan features" of Lake Forest and his relocation there, the institution of higher learning that he and his colleagues had envisioned had duly come into being. A fashionable town with its own railway station had sprung up beyond its gates and considerable development had taken place in its environs. The Reverend Robert Wilson Patterson, Sr., became the first president of Lake Forest University.

As Chicago recovered and flourished in the aftermath of the conflagration, young Rob Patterson, unable to complete his legal training and disinclined to follow his father into the clergy, took up newspaper work. He spent several months as a reporter on the *Chicago Times,* and another year and a half as managing editor at *The Interior,* a religious weekly, before landing the position of night telegraph editor at the *Chicago Tribune* in 1873. Patterson's growing abilities and the high esteem in which his colleagues held him were evidently remarkable, inasmuch as the *Tribune* offered him the position despite his Southern roots, his father's outspoken "moderate" abolitionism, and his own earlier associations with two of the *Tribune*'s avowed enemies, Copperhead newspapers both. The confidence was well placed: Patterson would prove himself to be an able drama and literary critic and Washington correspondent before being entrusted with putting the paper to bed as night editor in 1875.

Since the Medills were in the midst of their European peregrinations at the time of Rob Patterson's arrival at the *Tribune,* it was some time before the young journalist came to the attention of the paper's reinstated editor in chief and new majority stockholder. Nevertheless, building a solid reputation and rising steadily in the *Tribune*'s ranks, Patterson eventually encountered not only Medill, on a professional basis, but also the editor's arresting Titian-haired daughters in Chicago society. By 1876, Nellie Medill and Rob Patterson had forged an adamantine romantic bond.

In 1877, the *Tribune*'s night editor respectfully approached his employer to request his second daughter's hand. Medill flatly refused him. The Reverend Robert Patterson likewise disapproved of the match—and of Joseph Medill. Thirteen years after the end of the War Between the States, the issue of slavery continued to exert division, even among old stalwarts of the

Union. Much as Rector Patterson had disapproved of the uncompromising radical abolitionism that Medill had expounded through the *Tribune,* so Medill had read in Patterson's moderate abolitionism the hallmarks of dough-faced compromise. Fearing his relentless secondborn would dragoon her suitor into eloping, and perhaps reflecting on the marked similarities between young Patterson and himself a quarter century earlier, however, Medill eventually relented. The couple married on January 18, 1878, at the Medill residence at 10 Park Row in Chicago. Despite the dissonance that had preceded the engagement, the fifty assembled guests "actually enjoyed themselves," one reporter ventured. The groom was twenty-eight, his bride twenty-three. Rob Patterson was unattended by groomsmen; neither of Nellie Medill's sisters served as bridesmaid. Forged in flirtation and annealed by parental disapproval, the romantic bond linking the couple before their marriage was to shackle Nellie and Rob Patterson together indissolubly for the rest of their lives.

Without the invigoration of forbidden love, infatuation, affection, and finally civility withered in the daily reality of the Pattersons' marriage. The couple made an effort to live for a short time on Rob Patterson's earnings, but, famously generous though *Tribune* salaries were, this proved to be impossible for Nellie. Despite being raised in an atmosphere of authoritarianism so severe that the otherwise unrestrained middle child maintained a fearful silence in her father's presence throughout her girlhood, she had been accustomed to luxury for much of her life. Soon after her marriage, her father resumed the payment of her allowance and, as of old (although not without complaint), met the substantial bills she accumulated for millinery, clothing, jewelry, entertainment, and travel. In the course of time, staggering invoices for architectural, decorating, and domestic services would follow when Nellie developed a taste for commissioning magnificent homes and keeping liveried servants. She had not, she realized soon after her wedding when the scales had fallen from her eyes, made a fashionable or distinguished match. Her handsome, gentle, if melancholic husband was a liability and an embarrassment, she felt, a "hopeless drag on her society." Henceforward, she would direct her considerable energies toward staking a place in society—the further east, the better—and began setting her sights on the social pinnacles of New York, Boston, and distant Europe, each notoriously (and the more alluringly) insurmountable to outsiders.

If Joseph Medill had not lost a querulous and profligate daughter by the Patterson match, he had nevertheless gained a kind, principled, and (it would become increasingly apparent at the *Tribune* over the coming decades) able son-in-law. Over the course of the 1880s Patterson became one of the *Tribune's* "leading editorial writers." In 1883, he rose to the position of managing editor upon the death of the editor in chief's youngest

brother, Samuel Medill, prompting a colleague as far away as Cleveland to characterize Patterson as "a journalist of a very high order of ability, [who,] possessing a phenomenal capacity for the accomplishment of work, and being a persona of thoroughly correct habits and sterling character, will wear with honor the mantle of his predecessor." Patterson sought refuge from marital disappointment—and, indeed, from his wife—in his growing responsibilities at the *Tribune.* As he neared middle age, he spent his free time at the Chicago Club, drinking introspectively and increasingly. Determined to preserve appearances in her social ascent, Nellie had early on instructed her husband "not to worry about anything but illness or *disgrace*," and put him on notice that "nothing could break me down but these." When his rising alcohol consumption began to cause comment about town, therefore, he moved his activities to the Patterson stable and continued them in peace.

Ahead of her younger sister in most things, Kate had already managed to cajole her father into letting her marry the genteel Robert Sanderson McCormick in June 1876, over Medill's objections not only to her suitor, but to the young man's family and origins. The former owner of the detested antebellum *Chicago Times,* McCormick's uncle, "Reaper King" Cyrus McCormick, had perfected and patented the mechanized, horse-drawn reaper that was to radically transform farming and agricultural economy in the nineteenth century. Robert Sanderson McCormick had been the last of his generation to be born at the family manse, Woodbridge, in Rockbridge County, Virginia, deep in the Shenandoah Valley. Shortly after his birth in 1849, his father, William Sanderson McCormick, moved the family north to Chicago to join his brothers Cyrus and Leander in building the McCormick Harvesting Machine Company. By the 1850s the success of the reaper had emboldened Cyrus, the eldest and most autocratic of the three brothers, to consider himself a public man. As such, he exercised the prerogative of weighing in—as an unapologetic Southern Democrat in a free state—on the issues of the day. Joseph Medill's *Tribune* had brutalized Cyrus McCormick relentlessly on the latter's every foray into the public arena, questioning his wartime sympathies and ridiculing his claims of being the reaper's true inventor. "Like all white trash of Virginia," the *Tribune* (then firmly under Medill's editorial control) inveighed when McCormick offered himself up as a candidate for the United States House of Representatives from Illinois in 1864, "he left the State a better friend of slavery than the slaveholders themselves."

In marrying Robert Sanderson McCormick, Kate had linked the Medills to another of Chicago's preeminent names, but not to one of its fortunes. Rob McCormick's father had died in September 1865 in the Illinois State Hospital for the Insane, having worn himself into a state of hysterical

exhaustion after three decades in harness to his grasping brothers and the McCormick Harvesting Machine Company. In exchange for $400,000,* those same brothers relieved the grieving widow and children of any future claims, either on the reaper or on the company that would evolve into the industrial giant International Harvester by 1902. Nevertheless, Robert Sanderson McCormick received a gentleman's education both in Chicago and, briefly, in Europe. Upon returning to Chicago from the University of Virginia in 1872, he set about to invest and grow the sum that he and his siblings had received from the settlement. In the fall of 1876, McCormick took his new bride to St. Louis and established himself in business with a cousin, operating a grain elevator. The economic upheavals of the 1870s, the dishonesty of a colleague, and McCormick's own mistaken judgment conspired shortly to bankrupt the concern, however. The young entrepreneur was forced to liquidate his holdings, borrow money from various relatives, and throw himself upon his father-in-law's mercy to obtain a job at the *Tribune.*

If Nellie Patterson was generally reputed to be the most beautiful of the beautiful Medill girls, the advantage was more than offset by her elder sister Kate McCormick's superior intelligence and, if possible, greater vitriol—neither of which would diminish with the passage of time. Unlike the older girls, who had come up under their mother's long-suffering tutelage, Josie had been raised largely by caregivers. Though she shared her siblings' precocious peevishness, as the little sister by more than a decade, Josie was an object of annoyance to Nellie and Kate rather than an active combatant in their struggles. "The nights she honors me with her company are intensely miserable," sixteen-year-old Nellie grumbled to a cousin, referring to five-year-old Josie's refusal to share a bedroom with a hated nanny, "for she snores like a trumpet, teases around and kicks off the covers while I lie awake and curse the fate that makes German nurses disagreeable and small children fastidious."

The competition between the two formidable elder Medill sisters would be epic and lifelong. With or without provocation, they engaged each other on any and every possible battlefield, but over the coming decades they would reserve a particular ferocity for their respective efforts to exert hegemony over the *Tribune.* With no direct ownership and no standing at the paper, however, Kate and Nellie would be forced to enact their machinations through the men in their lives, who proved to be exasperatingly insubordinate pawns. Notwithstanding Kate's repeated girlhood efforts to run away from the stark paternal discipline of her home (which Medill cor-

*Approximately $5.5 million, based on the CPI, or some $65 million, based on nominal GDP per capita.

rected once and for all by chaining her leg to a bedpost), she was her father's favorite. Kate had married first and, despite the reversal caused by her husband's pecuniary indisposition, had recovered her advantage by giving birth to the first grandchild, Joseph Medill McCormick, on May 16, 1877.

Over the course of their lives the sisters' correspondence would serve both as the record of their score-keeping and as a proven means of attack. In their rules of engagement (if any there were) no subject was off-limits: any shortcoming, any embarrassment, any loss—however painful, shameful, or enduring—was fair game for sisterly ridicule or accentuation. If ever the two were of one mind, it was typically in criticism of others. While visiting her Patterson in-laws in the wilds of Lake Forest in July 1879, Nellie confided to receptive Kate that the place made her "dreadfully squeamish." Moving on to more felicitous subjects, Nellie cooed that she had allowed her own new baby boy to fall into "very bad habits" by taking him into her bed at night to cuddle and sleep. She underscored the infant's robust health by crowing about how often he nursed. After these happy meanderings, Nellie came to her point: she had received a letter, she told Kate, from one of the McCormick ladies, "in which she said she had heard with much sorrow of your loss, & asked how you bore it. She said she hesitated to write, as she could not put into words her sympathy." Only three weeks earlier, Kate McCormick's second child, a much-hoped-for and lavishly doted-upon baby girl, Katrina, had died. She was not yet six months old. It was a blow from which Kate McCormick would never recover. Nellie concluded her bulletin by returning to the subject of her own vigorous child. Although the baby had been born nearly seven months earlier, on January 6, 1879, eleven days before his cousin Katrina, the question of his name appeared to remain open to debate. "Everyone" in Lake Forest, Nellie prattled to her grieving sister, suggested she call him Robert W. Patterson 3rd, "on account of his lovely grandfather." The Patterson baby would indeed be named in honor of his grandfather, but not that one. Not to be outdone again by her elder sister and not to allow her son to be overshadowed already by his surviving McCormick cousin, Nellie would insist that her firstborn be given the name Joseph Medill Patterson.

Having carefully saved the departed infant's layette and toys in hopes that they might someday serve a little sister (who might, likewise, bear the name Katrina), Kate McCormick gave birth to the third of the Medill grandchildren a year later, on July 30, 1880. Though unimpeachably healthy, the baby only heralded new reversals for his mother. In short, he was not the girl she had so desperately hoped would assuage her grief. The circumstances of his birth, moreover, in his aunt Nellie Patterson's home at 363 Ontario Street, served to reinforce the humbling Kate McCormick had endured in the four years since her wedding. Financial calamity in St. Louis

had not only thrown Rob McCormick on his father-in-law's charity for a job, it had deposited the young couple, their toddler, and their baggage quite literally on the Medills' doorstep at 101 Cass Street back in Chicago. Financial embarrassment, native irascibility, living under paternal authoritarianism once again, morbid fear of miscarriage, and a summertime third trimester proved to be an explosive combination. For her lying-in, Kate left her husband at her parents' and sought instead the cold comfort of the gracious home her father had built around the corner for her middle sister. With the addition to the Medill family of two in-laws named Rob over the previous four years, little Robert Rutherford McCormick would go by the nickname "Bertie" throughout his solitary childhood. Though his mother dressed him in frocks and bows until he was seven, he proved to be no substitute for his departed sister. Nor could he hope to compare favorably in his mother's eyes with his winning elder brother. Kate McCormick lavished extravagant affection on her firstborn, her father's namesake, who went by "Medill," while "sneering" at the disappointing younger child of her grief and humiliation, to whom she sometimes referred as "dirty Bertie." After him, the McCormicks would have no other children.

In the decade following the fire, the newspaper had flourished. With Joseph Medill restored to the *Tribune* kingdom's throne, the paper trumpeted his pro-business stance in the Chicago labor unrest of the of the 1870s and '80s, warning in 1875 that "Judge Lynch is an American, by birth and character . . . Every lamp post in Chicago will be decorated with a communistic carcass if necessary to prevent wholesale incendiarism . . . or any attempt at it." Nine years later, the *Tribune* would propose arsenic as the panacea for Chicago's plague of tramps and vagabonds. The paper promoted Medill's distinctive scientific beliefs and his campaign to purge the English language of redundant letters and arcane silent consonants, proposing—and from time to time adopting—such simplified "spelings" as "infinit" and "telegraf." The editor in chief would impart to his progeny his courage—or truculence—in the face of defamation, adverse legal judgments, and their associated liabilities. Learning that a $50,000 libel suit had just been filed against the *Tribune,* and ascertaining from the author that the story in question was in fact true, Medill ordered the reporter to "libel him for about $100,000 tomorrow." At the same time, the *Tribune* was better written and edited than ever and the paper's devotion to the interests of the city and the local community had in turn given rise to a devoted and growing following.

Though Kate McCormick might have disagreed, in those same ten years Joseph Medill and his family, like Chicago, had prospered. The patriarch and elder statesman had made his mark on the new, incombustible stone

and brick canyons that had risen out of the old prairie town's wreckage. He had lent something of his own pertinacity and vigor, not only to his beloved *Tribune,* but also to his beloved Chicago's growing reputation for bumptiousness. Likewise, he had stamped his progeny with his own good looks, intelligence, obstinacy, and self-righteousness. Nearing sixty, he had begun to enjoy the fruits of his labors. With the two eldest girls married, Joseph and Kitty Medill found themselves with increased time to devote to their leisure and health, traveling as far as Europe and California with delicate, unmarried Josie.

If Rob McCormick was unfulfilled in his role as the *Tribune*'s literary critic, he at least had a salaried position, well insulated from the vagaries of economic upheaval. In the McCormicks' reduced state, Kate, like Nellie, had begun to receive her allowance once again. The couple had moved from the Medill mansion with little Medill and Bertie into their own small apartment in the gloomy pile known as the Ontario Flats. Although Rob continued to borrow substantial sums from relatives and Kate was reduced to the economies of apartment living and riding public transportation, she made valiant efforts to keep up with her more affluent younger sister. Gratifyingly, Kate was generally acknowledged to dress with greater chic than either Nellie or Josie. She maintained a small staff. Like Nellie, though on more of a shoestring, Kate succumbed to the irresistible seasonal pull of the northeastern watering holes at Southampton, Newport, and Bar Harbor. There, the presumptive newspaper heiresses from upstart Chicago were less often deliberately snubbed than simply left unnoticed and uninvited by Philadelphia's Mainliners, New York's Four Hundred, or Boston's Brahmins. Both sisters found exclusive Newport to be particularly impervious to their charms. Though Kate vowed, "I am *deadly* sick of this place and don't expect to ever return" in the summer of 1881, she would revisit the resort many times during her life. Not for lack of trying, Nellie, too, would find herself "rather outside the inner circle" there, as she preferred emphatically to "associate with swells or nobody!" The sisters visited such affronts on vacationers of similarly provincial origin, regaling their correspondents back in Chicago with accounts of the astounding gaucheries perpetrated by rubes and yokels from Baltimore, Louisville, or San Francisco.

The local prominence of her patrimony, her (happily absent) husband's growing professional reputation, and a gracious home allowed Nellie Patterson to continue her social ascent more successfully in the Midwest. She orchestrated lugubrious at-homes, dinner parties, and entertainments for members of other prominent families from Chicago and, occasionally, Cleveland. She reciprocated by casting a critical eye on the hospitality she accepted as her due, while her pen chronicled the bad taste, the faux-pas,

the parochialism, she endured, seemingly at every turn. "Mrs. Nixon was ridiculous, as usual, last evening, a whole powder box on her face, rouged lips, that necklace of a few large, cheap diamonds." She subjected to yawning derision the momentous rites of passage which she was invited to solemnize: "The Kelloggs' wedding was rather theatrical, the bridesmaids . . . all in décolleté dresses & Mrs. Charley leaning on Walter Copp's arm was very low necked & short sleeved—hideous neck." Her scant approbation was grudging and barbed: "Mrs. MacVaugh dresses beautifully," Nellie admitted to her mother, "for the first time in her life, & looks very nicely." The principal repeat offender against the social code which Nellie Patterson upheld so punctiliously was, not surprisingly, her elder sister. "Kate is always so careless," Nellie complained to their mother, before leaving to accept her sister's hospitality one evening.

> Her dinners are not nearly so nice as mine. For instance, up to last night she was short two people. So she asked Munro & an Englishman named Lawther whose mother is important in London, but he lives on a ranch & stammers painfully. That makes 7 men and 5 women—not the right thing for a formal dinner.

Among the inhabitants of Chicago in the late nineteenth century, one figure almost alone seems to have escaped Nellie Patterson's excoriation. Fatigued by the society of those whom she regarded as the city's lesser nobility—the Armours, the Kelloggs, the Fields, and their like—she managed nevertheless to rouse herself to an unaccustomed vigor for self-ingratiation as a sort of lady-in-waiting to Chicago society's reigning queen, Bertha Honoré Palmer (or "Cissie" to her intimate circle), who held court in her sumptuous new turreted castle on Lake Shore Drive. Mrs. Potter Palmer's "third Thursdays" received Nellie Patterson's unprecedented and unsurpassed benediction as "brilliant successes."

"It is a long time since I have written you," Nellie fretted to her mother in a free moment, "but this is because my news would only be—changing servants, furnace not working, workmen still about, &c. It makes me cross." Despite Nellie's stock lamentations on the difficulties of finding good help, a considerable staff maintained her home, just as nannies cared for her sturdy toddler, Joe. It was into this world of discordant affluence and dissatisfied prominence that, almost a decade and a month to the day after the Great Fire, Nellie Patterson introduced the last of the four Medill grandchildren—the girl her sister had always wanted—on November 7, 1881.

Though the baby's name and its spellings would change several times over the coming decades (much as the adult would later subtract from her age by adding to the year of her birth), she began her life as Elinor

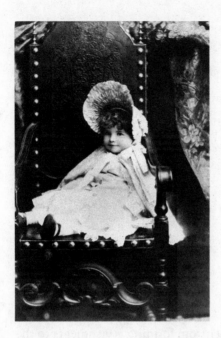

"Oh—time in your flight—": Elinor
Josephine Patterson, "Cissy," ca. 1882

Josephine Patterson, in honor not only of her mother and aunt but, once
again, of her grandfather. She had inherited the red hair of her Ulster fore-
bears, along with their strong temperament. By her own estimation, even
as a toddler she was "already *fierce.*" Though the child's disposition was a
proverbial fit with her striking complexion, Nellie Patterson was safe from
any proverbial attempt her baby daughter might have made to steal her
beauty. The mother would remain radiant for some years to come while her
little girl and namesake soon grew to display incisive intelligence, preco-
cious wit, mischief, charm, petulance, single-mindedness, and a capacity
for dogged affection that would no doubt surprise many who came to know
her later in life. For all of the child's attractions, however, she had none of
her mother's beauty, and her mother appeared to show her little interest as
a result. Dazzling, cold, distant, and only intermittently visible during her
unwavering social rotations, Nellie Patterson took on an astral quality as a
mother to her young children.

Rob Patterson, by contrast, was kind and comforting as a father. Until
the end of her life, his only daughter would fondly but wistfully remember
sitting on his lap while he sang "Tit-Willow" when she was a little girl. He
was attentive, approachable, and affectionate when present, but his mount-
ing duties at the *Tribune,* coupled with his growing alcoholism, kept him
away more and more. Both children were raised for the most part by ser-
vants. They were dressed elaborately and stiffly and educated initially, like
many of their peers, at home. With both parents largely absent, the little

Nellie Patterson's portrait of three-year-old Cissy, March 22, 1884

sister, discouraged angrily by her mother from forming attachments to the servants, cleaved adoringly to her elder brother. Joe, nearing the age of three at the time of her birth and grappling with the pronunciation of the word for this new girl relation, imparted the nickname by which she would be known to family, friends, and enemies for the rest of her life and afterward: "Cissy."*

"My worst recollections are of Cissy's pneumonia when she was five & my father's pronouncement every day, 'That little life is flickering out,' " Nellie would remember four decades later, reflecting, "She got well to give us quite a bit of trouble." As she grew, Cissy became rebellious. Seeking attention from the mother who showed her little interest beyond criticism and correction, Cissy had outbursts, threw tantrums, and concocted fantastical lies. Perhaps as the result of congenital frailty or perhaps seizing upon the deferential anxiety with which her relatives hovered about her delicate maiden aunt, Josie, Cissy quickly became "delicate" and "nervous" herself. When it came time to return home from friends' houses, Cissy would make herself sick and throw up. Stomach upset achieved something of the desired effect, at least in attracting her mother's attention: when little Cissy disgorged herself on an elegant Parisian coat, Nellie took note by slapping her across the face. By her own recollection, as a girl Cissy wondered loudly what her mother would push her to next; Nellie responded predictably and violently to her provocations.

*Inasmuch as others' spellings of her nickname varied, I have used her own choice, "Cissy," throughout.

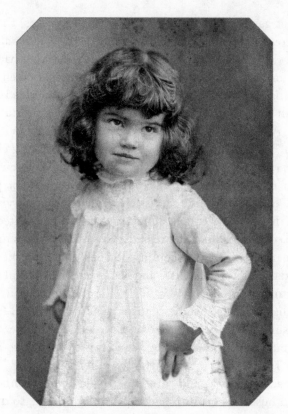

"Already *fierce*": Cissy, ca. 1884

Seeking the attentions of other adults was not only a way of nettling her mother; it served, moreover, as the means of gaining the attention and affection Cissy craved in her isolation. In middle age she would claim that the first long words she ever learned to pronounce at her grandfather's knee were "CIRCULATION" and "ADVERTISING." A noted horseman, Grandfather Medill himself taught Cissy to ride, introduced her to the wonders and delights of farm life, instructed her in the rudiments of European and American history, and set about to instill in her a sense of civic virtue, a chauvinism for the Republican Party, and a fierce admiration for the unfettered freedom of the press. At Red Oaks, the Medills' estate and working farm in Wheaton, Illinois, Cissy's days were joyous and full, and it was there that she would develop a lifelong love of animals: "My hens, my pup and my pony leave me hardly no time to go to bed." Of Medill's four grandchildren, Cissy was his undisputed favorite.

If her mother was distant, her Aunt Kate, having always wanted a baby girl, was less so. Summering with her mother and her McCormick cousins in Bar Harbor, Maine, in 1887, Cissy chronicled for her grandmother back

in Chicago her games with Bertie and Medill, their hikes, their forays to milk a local cow, and the loss of her two front teeth. Not yet able to write, the little girl dictated her musings. The pointed, slashing hand indicates that it was Aunt Kate, rather than her mother, who had taken the time to sit with her, listen, and act as amanuensis. Kate also added marginalia, which, though slight, betray an uncharacteristic, but unmistakable, levity and fondness. As Cissy closed her letter to her grandmother with the stock, late Victorian "Your affectionate daughter," Kate, apparently charmed and amused by the mistake, added her own editorial "(!)" before closing with a notation to memorialize the little author of that day for posterity as "(aged 5 yrs. 9 mos.)." Of all the correspondence that survives in Kate McCormick's hand, the letter is almost unique in being free of malice, stratagem, or complaint. In many regards, Cissy was perhaps more like her aunt than her mother. Over the coming decades, those who knew all three women would often note that Cissy and Kate were intellectual equals, possessed of a similar stinging wit, while Nellie lagged behind; "she didn't exactly win the fights," as one descendant put it. And yet, if Cissy helped in some measure to fill the void left by Katrina's death, over the coming years Kate would nevertheless be unable to resist the urge to make use of her niece as a Trojan horse in the ongoing war with her sister.

Just as the adult Cissy would turn her considerable feminine charms on the beaux and husbands of rivals she hoped to humiliate, so did she focus her adoring girlish attentions on her father and grandfather. The hallmarks of her later journalistic style, the tattled confidences designed to be as embarrassing to their subjects as they were ingratiating to her readership, were already present in her early childhood correspondence. "Bertie and I have been bad and so we are getting puniched [sic]," she confessed to her father in a careful cursive, before addressing her aunt's characteristic (but nonetheless unbecoming) rage: "Kate whiped [sic] Bertie on the hand until it bled." This preamble having piqued her reader's curiosity, the little correspondent went on to reveal her cousin's effeminacy along with one of the secrets of her aunt's toilette: "the thing that we did was to put a little of Aunt Kate's rouge on our cheeks." Cissy filled her letters to the doting grandfather who had been a martinet to her mother and aunts, with affection, exaggerated self-effacement, and detailed accounts of their common relatives' foibles and peccadilloes. "Uncle Rob took Joe and Bertie to see Medill" at his boarding school, she informed her grandfather during a visit to London, four days before her eighth birthday, "and they thought he was very affected, he is so english. So englilish [sic], you know," she added for good measure, already well aware of the old republican's unequivocal disdain for all things aristocratic and un-American. "I have written so many letters to Grandma and she hasn't written any letters to me," Medill's

informant went on to report, "tell her so. It is raining now we have nice Big Parlor and horrid little rooms."

Though not ill-disposed toward his little sister, as a boy's boy Joe Patterson had little time for her. By nature he was obstinate, intelligent, and determined. Though he shared their formidable temper, even as a child he was more reflective and self-controlled than many of his tempestuous relations. In contrast to Cissy's emotional skirmishes with their mother, Joe's defiance took more of a philosophical and aesthetic turn. In the face of Nellie's supercilious formality, he made every effort to be rugged and inelegant. In keeping with family tradition, during a visit to Nassau at the age of ten, Joe Patterson persuaded Bertie McCormick to run away with him. Hot and tired after only a few miles on the road, the boys were not particularly sorry when their mothers drove up in a phaeton. "We were glad to get in and did not mention our contemplated disappearance," McCormick would recall. For the boys of the family, their august grandsire was offered up as the pattern for the men they were to become. Medill, Joe, and Bertie would inherit and imitate many of Joseph Medill's personal, political, and editorial qualities, but over the course of their lives each would seize upon particular aspects of their exemplar—actual or mythical—to make especially his own. In Joe Patterson's case, in early adulthood he took his grandfather's fierce commitment to civic reform and righteous, deeply ingrained republican egalitarianism to a new, almost opposing extreme as an avowed socialist with deep proletarian sympathies. The same boy who had horrified his mother, ever fearful of the contagion of vulgarity, by persisting in wriggling out of his starched suits and sneaking out of the house to play with working-class children, grew up to demonstrate a legendary common touch that was at the heart of his lifelong worldview and his later unsurpassed ability to sell newspapers.

Splendid Diplomats

My parents were splendid diplomats because they had no inferiority complex," Cissy and Joe Patterson's cousin, Robert Rutherford McCormick, would inform Chicagoland as he intoned his memoirs over the airwaves of the "world greatest newspaper's" radio affiliates in the 1950s. "My father, one of the last of the pre–Civil War school, looked upon himself as of the Virginia aristocracy, the equal of any aristocracy in

Europe." In the same way that Joe Patterson grew up to make almost a populist mannerism of Joseph Medill's republicanism, so, too, did his cousin Bert McCormick revive a number of their grandfather's personal and editorial characteristics, foibles, causes célèbres, and bêtes noires. By the time McCormick saw fit to edify the Midwest with his reminiscences, he had long followed his grandfather's lead not only in taking the helm of the *Tribune* but, through it, in (attempted) king-making, relentless public excoriation of his opponents, simplified "spelings," finger-pointing patriotism, and a corresponding contempt for all things monarchial and aristocratic— especially if such things happened to be British. Both McCormick brothers, Medill and Bert, would take up their grandfather's zeal for the Grand Old Party and his veneration for the nation's founding figures and early ideals. Indeed, the posthumous reputations of all four of Joseph Medill's grandchildren would be dominated by their ferocious (and to many, infamous) insistence on upholding Washington's and Jefferson's proscriptions against entangling alliances that threatened to draw the United States into foreign wars.

More than any other member of his generation, Bert McCormick would embody the paradox his grandfather had expressed in 1874, as the lifelong republican returned from effective exile, Marshall Field's borrowed cash in hand, to take up the " 'old throne and sceptre' in the *Tribune* 'kingdom.' " From childhood, Bert McCormick would exist in a shifting no-man's-land between meritocracy and elitism, equality and hierarchy. Though second to his brother in their mother's affections, Bert McCormick was still the son of a woman who was at all times exquisitely aware of her status—in the family in which she had grown up, in the city of her birth, in the world beyond. Her standing was one of the birthrights she claimed from her father.

As Robert Rutherford McCormick's listeners patiently awaited the popular, classical programming of the *Theatre of the Air* that followed his weekly autobiographical musings, the memoirist turned from the subject of his father's nobility to the source of his mother's unassailable sense of self-importance: "Her father had been the intimate, in fact the leading individual in the nomination of President Lincoln, and also a supporter and intimate friend of General Grant." Never was Kate's conviction of her inherited entitlement more irrefutable, naked, or, indeed, affronted, than after the McCormicks moved to London in the spring of 1889, eleven-year-old Medill and eight-year-old Bertie in tow.

"The social system existing here will do as long as the servile, bootlicking British masses tolerate it but to establish it in the U.S. would lead to a civil war instantly, to cast it off," a cantankerous, sixty-six-year-old Joseph Medill scribbled to Nellie Patterson with gouty fingers from London on July 17, 1889. "It is splendid pageant," he growled, tormented by the old

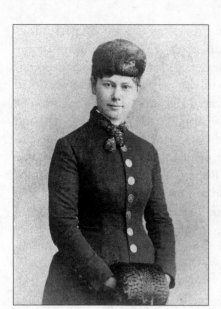

"Aunt Kate": Joseph and Kitty Medill's eldest (and by many accounts most formidable) daughter, Katherine Medill McCormick

lumbago after returning from Queen Victoria's reception for the visiting shah of Persia, "a perpetual picnic for the favorite few which our democracy would dynamite mighty quick..." The election of Indiana Republican Benjamin Harrison to the presidency nine months earlier had emboldened Kate to badger her father to seek preferment for her well-bred but otherwise underemployed and dependent husband. An appointment in the Foreign Service might ideally suit a man of Rob McCormick's genteel sensibilities and polyglot courtliness. Living in subsidized refinement, entrée into the highest circles in the various foreign capitals and opportunities for ascending the Department of State's ranks held irresistible allure for Kate—the candidate's utter lack of diplomatic experience notwithstanding. Anxious for the gratification of her unlucky firstborn, Kitty Medill worried that two obstacles stood in the way of successfully securing an appointment. First, having already granted a position to another Medill crony, Harrison would be reluctant, she feared, to recognize her son-in-law as well—"even if he was a Republican." Second, there was the problem of Medill's lack of enthusiasm, not only for the scheme but more generally for the aspirant; "he always sprinkles us with cold water," she fretted. Nevertheless, she and her other son-in-law, Rob Patterson, heartily and actively seconded the plan. Nellie Patterson lent limp nominal support. Having whispered the perfunctory request in the ear of James G. Blaine, Harrison's secretary of state, Joseph Medill considered his own role in the matter to be decisively concluded.

The principal architect of the Fourteenth Amendment, a former Speaker of the House as well as a former senator and presidential candidate from

Maine, who had previously served both Presidents Garfield and Arthur as secretary of state, James Gillespie Blaine was a towering figure in the Republican Party of the late nineteenth century, and a notorious nepotist. He had received Joseph Medill's son-in-law with dutiful bonhomie in Washington in the winter of 1889, secured the supplicant's appointment as second secretary to the American legation in London forthwith, and glibly made the "half-promise" to fast-track McCormick's promotion to the first secretaryship by the coming September. The secretary of state had neglected, however, to consult with Robert Todd Lincoln, the current United States envoy extraordinary and minister plenipotentiary to the Court of St. James's, on this new addition to the London legation's staff.

Having left Kitty behind in Illinois to nurse her multiplying respiratory and liver complaints in the summer of 1889, Joseph and Josie Medill had been the first in a procession of family members to visit the new second secretary and his family in London. September came and went without Rob McCormick's expected promotion, however. Consequently, the second secretary found himself with little "real work" to do as 1890 began. Growing impatient and sour, Kate began to exercise her formidable, if often overreaching, strategic faculties.

In late October 1889, Rob and Nellie Patterson, along with ten-year-old Joe and Cissy, who would soon turn eight, arrived in England from their travels in France, for a family visit. On the day of the Pattersons' arrival in London, however, Cissy ("she is always the one," as her mother put it) came down with whooping cough. Though Nellie pooh-poohed the danger of the illness, the British physician the family consulted on several occasions "(at $5.00 a visit)" did not, and encouraged them to abandon the foggy metropolis for "one of these fashionable, crowded and dear watering places on the southern coast." In Brighton, while Cissy convalesced Joe developed a hoarse cough, which filled his mother with "dismal apprehension, lest we be here another month." British domestics provided her with some solace, however. In the same "servile, bootlicking" propensities that her father had taken for national degeneracy, Nellie revealed that she saw the great virtue of the British working classes: "You never saw anything like English servants—they know their places and are respectful . . . My maid waits upon me and Cissy to perfection," she wrote her parents, before catching herself by adding the hasty assurance, "I like American institutions much better than anything on this side." Finding little amusement in Brighton after a few days, Rob Patterson had returned to London. There, with genuine goodwill that he would later come to regret, he began to conspire with his sister-in-law to bring about the consummation of the promotion the secretary of state had assured Rob McCormick.

Reporting on "Bar Harbor's Delights" nine months later on August 3,

1890, the *New York Times* informed its readership that that "great society man," Robert Sanderson McCormick, second secretary of the American legation in London, had recently arrived at the Maine summer colony. He would be paying his respects both to his obliging mother-in-law, Mrs. Joseph Medill, and to his sisters-in-law Mrs. Robert Wilson Patterson and Miss Josephine Medill, who happened to have taken a cottage near the summer home of the secretary of state and eminent native son of Maine, James G. Blaine. Almost a year after McCormick had been assured his promotion, he continued as second secretary. Kate chronicled her exasperation through the end of 1889 and into 1890, in the extensive battle plans she outlined to her family back in Chicago. She took it for granted that Minister Lincoln's own posting to the plum American diplomatic position abroad had come as the result of her father's catapulting his to the presidency. Little reflecting that the minister's father had, among other things, also been murdered as the result of his ascendancy or that the current first secretary's "marvelous" familiarity with the Byzantine code and etiquette of the Court of St. James's might well serve both the American minister and United States interests in general, she took the view that the younger Lincoln's obstinate insistence on maintaining the staff of his choice represented the height of effrontery and ingratitude.

"Pa is indignant at L[incoln]," Nellie allowed to Kate by way of mollification, "but thinks it is the merest folly to force him." Nellie had gone to Washington herself, she claimed, to press Blaine for the promotion, but after traveling all that distance had not troubled to meet with the secretary of state alone. To her husband, then engaged in rallying the support of important midwestern Republicans, Nellie reiterated her mother's original concern: "I don't think we had better tell Papa any of our moves as it is his disposition always to throw cold water on any scheme." In short, if Medill were to have the effect of cold water on the family cabal should he discover it, Nellie's tack—no more supportive and only slightly subtler—was to act as a wet blanket. Protesting too much that "with *all our family anxious* for Rob to have the appointment something must come of it," Nellie had little desire to witness either her brother-in-law's rise in the diplomatic ranks or her sister's welcome into European society. To Kate, therefore, Nellie offered gallingly sound counsel: remain diplomatic and do nothing. "Rob can resign, of course," she reminded her elder sister, who had by then endured more than a decade of comparative social obscurity and penny-pinching, "but then, farewell to all residence and future preferment, &c."

For the time being, Nellie would have her way. Despite the lavish entertainments to which Kitty Medill treated the Blaines during Rob McCormick's stay in Bar Harbor, despite the various opportunities for personal contact and private discussion these afforded, and despite Secretary

Blaine's resulting plea to President Harrison himself for intervention in the matter, Minister Lincoln could not be prevailed upon to make the promotion. Having forced the secretary of state into an embarrassed admission of impotence in the affair and alienated his superiors at the legation, an indignant Rob McCormick returned to London for another dreary two years as second secretary. His diplomatic time was yet to come, however. In actively supporting his in-law's promotion within the Foreign Service, Rob Patterson would realize with despair nearly two decades later, he had inadvertently set in motion events that were to have catastrophic consequences—not simply for his only daughter, but for her as-yet-unimagined only daughter as well.

BON VOYAGE, MR. MEDILL!

Chicago Wishes You a Pleasant Winter in the Earthly Paradise

— UNIDENTIFIED CLIPPING FROM NELLIE PATTERSON'S SCRAPBOOK

In the early 1890s, Kitty and Joseph Medill, both in declining health, took to spending time in California. On their maiden voyage to the Golden State in 1879, Kitty declared that she heard of "nothing" in San Francisco but the "stupendous fortunes made and lost in the stock board," which had prompted the erection of "two lunatic asylums here with 300 inmates." "This exciting life does not conduce to longevity," she concluded sensibly to Nellie. As she entered her sixties and her husband approached his seventies, infirmity and mortality weighed heavily on both their minds. Medill filled his correspondence to his daughters and grandchildren with lamentations on the old "miserable rheumatic back"; the dangers of drafty railway cars; the "old and consumptive, coughing people" whom the aging couple encountered while traveling; the sudden deaths of these, and the like.* In the interest of their health, therefore, the Medills decided to return to California for the winter of 1891–92, avoiding the unwholesome excitements of San Francisco this time—in favor of bucolic Pasadena.

*Enduring chronic pain and witnessing the effects of chronic illness within his family throughout much of his life, Medill read, ruminated, and consulted with numerous experts on the subject of how to prolong life. Over the years, he arrived at last at what one interviewer described politely as "some interesting physiological theories." Chief among these was Medill's unshakable conviction that the "superabundant" lime content of ordinary drinking water was largely responsible for an unnecessarily accelerated aging (or, rather, calcification) process. The tragic result of decades of misguided water drinking (or, as Medill put it, "liming up")? "Finally a man lies down a brittle mummy a hundred years before his time."

Young Josie Medill's own delicate health, in particular the indeterminate "throat trouble" that the Chicago climate so aggravated, had made her something of an invalid, albeit a cosmopolitan one. After being presented to Queen Victoria at court and spending the London season of 1891 with her eldest sister, the confirmed spinster had taken an apartment in Paris and established housekeeping with a small staff for the coming winter. Contemporary press accounts describe her as tall, redheaded, fine-boned, and graceful, with a beautiful figure. Likewise, they make tactful reference to her "character of unusual force," her "independence of speech," her marked cleverness, her "keen sense of humor," and her "shrewd judgment of people and things."

In Pasadena, the health-conscious Medills rang in the New Year of 1892 with disturbing news from Kate, who had crossed the English Channel to be with Josie in Paris. As her father took to his bed with the grippe on New Year's Day, a Friday, Josie caught cold on the other side of the globe. Without waiting to make a full recovery, she insisted on driving out the following Monday, January 4, to pay her usual round of social calls, bringing on full-blown influenza. Kate cabled her parents on January 6: "severe bronchitis; one lung congested; high fever; fear pneumonia," but added that Josie was attended by a good doctor and capable nurses. Whatever comfort the quality of Josie's care provided was quickly extinguished by the succession of alarming telegrams that followed over the next few days as the Medills, nearly six thousand miles away, remained powerless to help their youngest child. Two days later, Kate wired, "Josie worse, consultation, deeply anxious." Then, "Very grave pulmonary congestion both lungs." Then, "Consulting doctor says little answer." On January 10, another telegram arrived from Kate: with the unremitting congestion of her lungs, Josie had died "peacefully without pain" the previous night, shortly after ten o'clock.

On Wednesday morning, January 13, 1892, a small congregation of expatriates assembled at the American Church by the Pont de l'Alma on the windblown banks of the Seine to pay tribute to the memory of Josephine Florence Medill, who would have celebrated her twenty-sixth birthday the following month. In the front pew sat Robert Sanderson McCormick and his two sons, fourteen-year-old Medill and eleven-year-old Bertie. The *New York Herald* reported that Mrs. McCormick, eldest sister of the deceased, had been forbidden by her physicians to attend, having broken down under the strain of the past few days.

In California, the Medills received the news disconsolately—Kitty so much so that her husband feared for her life initially. Over the coming months they would seek solace from their "terrible, gnawing grief" both in constant occupation and in the hope of renewing the bonds that linked

their strong-minded surviving family members. As Josie's remains were prepared for transportation from Paris to Chicago, Kitty entrusted the funeral plans to Nellie by mail before returning to Chicago herself. There was to be a simple, Episcopal service for family intimates, with no remarks and few hymns, at the Medills' home on Cass Street. Putting aside any past differences, Kitty asked that Dr. Patterson, "that saintly old man," read the service and give the benediction. "But Nellie, she must not be buried— only put in a nice vault," the grieving mother implored. "I will build a vault for us all and in that she will lie. No, not buried—ever."

Following the funeral, the Medills returned to California. The enclave of Altadena, just east of Pasadena and at a slightly higher elevation (less foggy and therefore more salubrious to those afflicted with pulmonary ailments), had enjoyed a vogue among eastern millionaires over the previous five years. Taking advantage of the recent bankruptcy of a homeowner who had been caught in California's ongoing boom-and-bust cycle, Medill bought an elegant wooden villa, boasting electric wiring and hot and cold running water, extensive stables, outbuildings, and gardens, on five acres, in April 1892. In their efforts to assuage their grief, Medill threw himself into long-distance editorial work again, while Kitty spent her days surrounded by paperhangers, gardeners, masons, plumbers, and painters, attempting to fill all of her waking hours readying their new home. By the time of Alta Villa's completion in the fall of 1892, at an expense of some $60,000,* the Medills would take a little satisfaction from having made theirs perhaps "the nicest house in Pasadena."

Their ceaseless labors in the wake of their loss, the couple hoped, would bear the fruit of uniting their fractious progeny. "My desire is that it should be our family winter home for at least three generations of Medills, Pattersons and McCormicks," Medill explained to Nellie. "The house is large enough to accommodate comfortably all that remains of the family. When your mother and father are laid away to their last and long asleep, I want Alta Villa to remain the winter home of the next younger genera-tions." In the wake of her youngest daughter's death so far from home, Kitty Medill's concerns for her descendants focused in particular on the family's other delicate young redhead whose mother was so distant from her. After drafting and signing a new will, Kitty noted to Nellie that she intended to divide her formal jewelry between her two surviving daugh-ters, but made clear that she especially wished the three-stone diamond ring she favored for every day to go to Cissy. "I have been so depressed for a couple of days," she confessed in the spring of 1892. "Oh, my love Josie.

*Roughly $1.5 million, based on the CPI or some $11 million, based on nominal GDP per capita.

Nellie," she continued, "as your children grow up, the one who loves you best will love you most." Living daily with an unrelenting sense of maternal loss had emboldened her to give voice to a matter that had concerned her tacitly for some time: "Do be good to Sissie [*sic*]," Kitty ventured. "I think you are partial to Joe."

Whether prompted by her mother's plea or not, at about this time Nellie's interest in her daughter did appear to grow, apace, perhaps not coincidentally, with the attention Cissy was beginning to attract in society. Having turned eleven shortly before her aunt's death, Cissy was strikingly tall and fine-boned; what her face might have lacked in conventional beauty, she made up for in her captivating deportment. Clipped and pruned by her mother's unrelenting correction, she was developing exquisite manners but nevertheless managed to retain her natural, mischievous humor. Nellie Patterson had begun to apply an unsparing rigor to training her daughter's form as well. Until the end of her life Cissy Patterson would attract admiration for the feline grace of her carriage and the musicality of her low voice. Though it is unclear exactly what methods Nellie Patterson employed or which authorities she consulted in cultivating these traits (except that Cissy's sinuous walk resulted in part from the old book-on-the-head method common to ladies' posture manuals), they were as relentless, evidently, as they were expensive. When asked in her sixties, about her still-arresting grace and mellifluousness, Cissy Patterson would laugh that her walk and her voice *ought* to be remarkable; her mother had spent thousands of dollars on each.

The young girl's intellect, by contrast, was subject to less arduous cultivation. "This is the programme of the day," Nellie informed her mother of twelve-year-old Cissy's schooling. "Governess comes at 9. They go for a walk. The lessons last until lunch time with a recess at 11. This makes about 3 hours work," she estimated, generously. "After lunch Sissy [*sic*] has half an hour to herself, then she has a music lesson & she walks, goes down town to shop for me or herself, goes to the dentist or anything else she has to do." After returning home, Cissy spent her solitary afternoons and evenings drawing regal, forlorn figures, and reading voraciously those novels that her mother summarily forbade and that her aunt readily supplied. Confronted with the offending texts following Nellie's periodic ransacks of Cissy's room, Kate retorted with airy satisfaction, "There's nothing in any of those books that Cissy doesn't already know and probably practice." If the suggestion achieved the aims of rankling her sister and driving a larger wedge between mother and daughter, it had little basis in fact. Beyond Kate's louche literary influences (themselves no more disreputable in actuality than the likes of William Makepeace Thackeray's *Vanity Fair* or Guy de Maupassant's *Boule de Suif*), Cissy had little opportunity for unsuper-

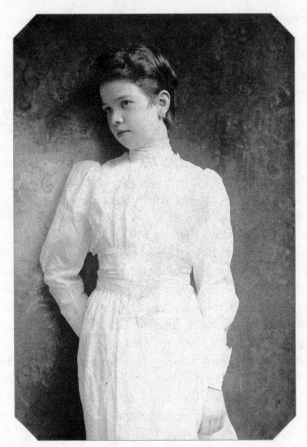

Eleven-year-old Cissy Patterson's
carte de visite, 1892

vised interaction with others, and less for corruption. As Joe had been sent to boarding school shortly before her tenth birthday, few unrelated young men entered the Patterson household during her teenage years. Her mother chose her few sanctioned girlfriends from among Chicago's first families. Nellie discouraged Cissy's participation in any activities, however innocent (setting up a lemonade stand in front of the house, for example), that she feared might smack of vulgarity or allow her daughter to interact, unchaperoned, with strangers.

By the early 1890s such austere cultivation began at last to bear fruit. At Nellie Patterson's at-homes and teas and, increasingly, at the festivities of Chicago's other prominent families — the Leiters' skating parties, the Kelloggs' nuptials — Cissy's aristocratic bearing, her lithe elegance, her shy wit, excited approval, reflecting well not only on the girl, but on her mother as well. To Nellie's gratification, by the middle of the decade the

teenage Cissy had begun to gain a toehold further east as well. "Miss Elinor Patterson, of Chicago" appeared with a growing frequency on the society pages of the various eastern newspapers—mourning a noteworthy Philadelphian, disporting herself at a Westchester country club with "a number of New York's best society people," attending Brahmin brides in Boston. The arid chill of the Patterson household had begun to force a vivid bloom.

In California, the annus terribilis 1892 would visit additional trials on the Medills, despite their efforts to keep busy in the face of their crushing New Year's loss. Their homebuilding labors complete at last, on Thursday, November 17, the couple moved into the comfortable wooden villa in which they intended to spend their old age and unite their descendants for generations to come. In the early hours of their fourth night in Alta Villa, a fitful Kitty Medill sat up in bed with a toothache. To her horror, through the east window of her bedroom she saw the glow of flames rising from the roof of the kitchen. She woke her husband immediately; Medill "saw at a glance the house was gone." The couple frantically woke the servants, dispatching one to neighbors to raise the alarm. The efforts of the coachmen and gardener to quench the flames were rendered useless by the weak pressure of the few nearby hydrants; the house continued to burn while the closest fire engine made the three-mile journey to Altadena. In the meantime, choked and blinded by billowing smoke, the Medills and their staff endeavored to save what little they could. As Pasadena did not subscribe to the fire precautions required by law in Chicago, Medill managed to escape with only the blackened nightshirt on his back, the most valuable of his papers, and an armful of underwear.

"By 2:30 a.m.," he wrote Rob Patterson at the *Tribune* editorial rooms two days later, as smoke and steam continued to rise from the sodden wreckage, "there was nothing standing or remaining of the fine house except three tottering chimney stacks and a big hole in the ground where the cellar had been, full of burning embers and our winter's supply of coal." After dinner, they discovered, the cook had carelessly emptied the ash from the stove at the foot of one wall of the newly filled woodshed. As in Chicago two decades before, the condition of the structure itself ("dry as punk"), the ready fuel of its contents, and the "gentle wind" that made Altadena so hospitable to affluent consumptives, had immediately overwhelmed Pasadena's slim fire precautions. Unlike the Medill family's Ohio farm half a century earlier, Alta Villa had at least been partly insured, although not sufficiently to cover the extensive renovations of the previous six months.

If the fires Medill had survived at the ages of twenty and forty-eight had

been harbingers of eventual, great good fortune, the conflagration he weathered at sixty-nine augured only reversal. Over the coming months his wife's health declined precipitously. Neither the wide variety of curatives she was administered nor the newfangled "ozone generating machine" dispatched from New York brought about the hoped-for improvement. Within a year of her youngest daughter's death, Kitty was entirely bedridden and so weak that she could only communicate with her husband by whispering into his ear trumpet for a few minutes at a time before falling back on her pillow, exhausted. However remote and authoritarian a husband Joseph Medill had been in the early years of his marriage, the batterings of time, circumstance, and loss had softened him. His letters to Nellie Patterson in Chicago, on the one hand, chronicle the minutiae of Kitty's care as he "grasped at every chance" to alleviate his wife's suffering and prolong her life. On the other, they attest to Medill's second-front efforts to curtail the grandiosity of Nellie's architectural plans for the new home on Astor Street that she had commissioned Stanford White to design, as he parried her requests for the payment of mounting construction bills with weary, unheeded suggestions for economies. "The remaining milestones will be few and passed at a hobbling gait," Medill wrote her on his seventieth birthday. "I am not tired of life; on the contrary, I still enjoy it and take a lively general interest in the progress of mankind and a special one in the unfolding development of the minds and characters of my grandchildren."

For their parts, the young McCormicks and Pattersons made regular, affectionate efforts to keep him and their ailing grandmother abreast of their own affairs. True to form, Cissy had reported to her ever-sympathetic and often-conspiratorial grandfather in September 1890, "Mamma is going to put Joe and I in school everyday," editorializing, "I do not think I will like it." While the threat had gone unfulfilled in Cissy's case, Joe had not been so lucky. In the fall of 1890, not yet twelve, he had been dispatched to boarding school in distant Groton, Massachusetts. Still ablebodied at the time, Kitty Medill had followed soon after, in order to ensure that her grandson had settled in and, naturally, to inspect. Groton's headmaster, the Reverend Endicott Peabody, she reported, had found that Joe possessed "an original mind and was well informed." The rector had been struck in particular by the boy's sang froid and discernment. Although among the youngest in the school, within his first few weeks at Groton Joe had spoken up intrepidly in front of the entire student body during roll call in response to the question "What is the Kingdom of Heaven like?" Granted permission to speak, he remarked that one of his grandfathers was a clergyman and asserted sagely, "That question has never been accurately determined."

The Reverend Endicott Peabody, a member of an eminent Massachusetts family and a well-respected Episcopal minister in his own right, had founded the school six years earlier. Emulating the muscular Christianity of the British boys' public schools and endeavoring to inculcate in its transcendently privileged American student body a commitment to civic duty and public service, Groton would flourish under Peabody's direction for the next fifty years. Though Joe's determined ruggedness prevented him from breaking down in tears—at least in front of his schoolfellows (even after being punched by "a big bully named Sullivan" during his first month)—his letters home make clear that boarding school life sorely tested his fortitude.

Into the Groton student body, composed principally of the scions of preeminent northeastern families—among them Harrimans, Biddles, Auchinclosses, Whitneys, Lawrences, Sedgwicks, Grews, and a constant crop of Roosevelts, not a few of whom heckled the far-outnumbered midwesterners for their accents, their provincial manners, and the comparative (or, at least, regional) obscurity of their family names—Joe eagerly welcomed his fifteen-year-old cousin, Medill McCormick, in the fall of 1892. Though they occasionally engaged in what Medill, recently returned from England, described to Cissy as "delightful rows," the reacquainted cousins were drawn together as much by a shared drive to write and a brooding religiosity as by their common lot at spartan Groton.

Both cousins devoted much of their brief spare time to writing and to publication of sorts. Jointly and separately, they wrote plays, copying the finished versions with the hectograph duplicator they had imported from home, for their schoolfellow cast members. Medill began to submit pieces to the monthly *Grotonian.* "I have just finished the best thing I have ever written and have been promised that it shall go in if there is room," he confided hopefully to his grandfather in April 1894. "Thus I am urged on to greater efforts!" Though Joe's nascent proletarian sympathies revealed themselves increasingly (prompting one master to despair of young Patterson as a "chronic revolutionary"), under the Reverend Dr. Peabody's influence he earnestly considered baptism in the Episcopal Church as well. Under Joe's sway, Medill followed suit. Joe, Medill related to the bedridden Kitty, who now spent most of her time contemplating her grandchildren and her Final Reward, "truly did convert me to confirmation & I believe it is best because if Holy Communion does anyone good I think it would me good [*sic*] & I can very seldom receive it in a Presbyterian service."

In the spring of 1894, having twice failed and twice retaken the entrance examination, thirteen-year-old Bertie McCormick would join his brother and cousin at Groton at last. Never having ascended to the first secretaryship at the American legation, Rob McCormick had submitted his

letter of resignation to Minister Lincoln in June 1891, but remained in London with his family in a new official capacity, promoting and publicizing Chicago's upcoming Columbian Exposition. In the aftermath of her sister's death, Kate McCormick had grown morbidly preoccupied with her own health and initiated the regular peregrinations to the various American and European spas that she would continue fitfully for the rest of her life. She visited her hypochondria on her sons by pulling them out of school and enrolling them elsewhere in the interest of their "health." Once ensconced at Groton, Medill would escape most of these capricious uprootings until he left for New Haven in the fall of 1896. Bertie, by contrast, found himself a student at no fewer than three English boarding schools of inconsistent caliber, as well as the *interne* of a doddering Parisian widow who instructed him briefly in French, between the time of his arrival in London at eight and his eventual acceptance at Groton at thirteen. Though the treatment he had received from his English masters and peers ran the gamut from "sadistic" to benign, it was never clear what engendered in Bertie McCormick an animosity toward Great Britain so virulent that *Time* would confer upon him the distinction of being "the world's most unrelenting Anglophobe" six decades later.

The origins of his lifelong abhorrence for the United States' Eastern Establishment would be less murky, by contrast. He loathed Groton's "caste system." He deplored the pedagogical chauvinism that promoted "sectional patriotism" within the student body; though the boys learned about Lincoln and Washington, Robert Rutherford McCormick that archmidwesterner of Southern extraction, would later allow, "all the rest of their heroes were New Englanders." As the son of an American diplomat he had been accepted in England, he felt, on an equal footing with the most aristocratic of his schoolfellows. He was astonished, therefore, to find himself looked down upon at Groton by the mere heirs to huge northeastern industrial fortunes. The counsel of his disappointed but genteel father provided solace: "Tell them they are descendants of Boston tradesmen and you are descended from Virginia gentlemen."

On May 1, 1893, Chicago at last threw open the gates of the magnificent beaux arts White City, erected along the banks of Lake Michigan as the site of the World's Columbian Exposition. Commemorating Columbus's discovery of the New World four centuries earlier, the World's Fair likewise celebrated Chicago's phoenixlike resurgence in the two decades since the Great Fire. Boasting such novelties as the first Ferris wheel, electric light, Cracker Jack, Scott Joplin's rags, a movie theater, a Midway Plaisance complete with carnival attractions and sideshows, majestic landscaping by Frederick Law Olmsted, and some two hundred buildings housing new

technologies and exhibits from nearly fifty nations, the fair would host more than twenty-five million visitors before closing six months later. The massive scale of the endeavor had forced it to open before its completion. In order to take in the full effect, therefore, Joseph Medill insisted he would not venture east to visit the white stucco dreamland before summertime. Nevertheless, he crowed to Nellie, "I am awfully proud of Chicago and will ever regret and deplore my ill health which prevented me from taking a leading and conspicuous part in the work of the last three years." He added exuberantly that "the new wild and wooly western town" had acquitted itself spectacularly in the eyes of the world, and he was unable to restrain himself from editorializing that "New York would not have done a quarter as well. New York is too lazy—loves ease too well; is too selfish; and would never have made the sacrifice of mind, muscle and money required to insure a first class A1 show as Chicago has done." With the excitement of a child, Medill prattled to Nellie that during his summertime stay in the Midwest he intended to make "three or four visits a week of two or three hours each" to the fair. He resolved likewise to hand over the editorial reins of the *Tribune* both in name and in practice to Rob Patterson at last, the better to enjoy himself in his twilight years. By early July, Kitty's health had improved sufficiently to allow her to accompany her husband to Chicago. The Columbian Exposition exceeded Medill's expectations. He was delighted with "the affair of the century" and projected that the local pluck and bravado that had produced it could not fail to make Chicago "the dominating city in the world" eighty-five years hence. "If there is ambition enough in our grandchildren," he exulted to a *Chicago Times* reporter, "they will say: 'Come, let us beat our forefathers and do something big!' "

After a lifetime of hard work that transformed Joseph Medill from an Ohio farm boy into an eminent editor and publisher, millionaire, king-maker, and elder statesman of the Republican Party, Medill had reveled deservedly in the World's Fair, the return to his beloved Chicago, and the short-lived improvement in his wife's health. On October 1, 1894, Kitty Medill's many afflictions would claim her at last.

What Is the News?

I *like the school*—& much more than I expected to; for all my saying beforehand that 'I *wanted* to go,' " fifteen-year-old Cissy enthused to her attentive grandfather in late April 1896, adding, "I suppose the family

Sixteen-year-old Cissy Patterson, as a boarder
at Miss Hersey's school in Boston

would be amused to see me tuck up my skirts, roll up my sleeves, fall to, &
make my bed. Then bustle around & dust my room, slam in drawers, put
chairs in place, hang up my things, straighten out my bureau—& all in 15
min.!" Four years later, the June 1900, edition of *Harper's Bazaar* would
caution mothers that in selecting appropriate educational institutions for
their daughters, "Friendships are often formed for life in the girls' school,
and it is wise for her parents to place her among her social equals, and
where she may develop among those of her own station." This was a con-
sideration Nellie Patterson had anticipated, however. Following her
brother and cousins east, Cissy had begun her brief formal education in the
spring of 1896 at a finishing school her mother had selected in the Athens
of America, among the daughters of the otherwise almost impenetrable
patriciate of Boston.

Shortly after arrival at Miss Heloise E. Hersey's School for Girls, Cissy
reported that she liked her schoolmates and thought they liked her. She
had begun to untangle the seeming knot of Beacon Hill and Back Bay
streets. In fine weather she liked the city, especially the expanses of Boston
Common and the Public Garden, and the green of Commonwealth Avenue;

on rainy days she found Boston to be "a damp, crowded, crooked, stuffy little place," complaining to her grandfather, "I don't like it atall atall [*sic*]." Despite the private frustrations caused by the slim figure that rendered her a "late bloomer" in her own estimation (contemporary corsetry had endowed her mother with a "fully developed" hourglass form at the same age, Cissy lamented), she was delighted to report to her grandfather that although she was the youngest of the thirty-two pupils by three months, she was already the tallest girl in the school. "Yankeeland is noted for its tall, slim girls," he responded—as ever, seizing upon the superiority of any product of Chicago, his granddaughter included—"but you do not look very tall, as you carry it off with a light step and an erect figure." As Cissy grew more comfortable in her new surroundings, she quickly became adept at participating in only those elements of the girls' closely supervised program that she enjoyed. "The thermometer stands at 91—Every girl of this house is sweltering inside Trinity Church except myself," she told her grandfather on Sunday, May 10, 1896. "I begged off." Though comfortable (if not luxurious) compared to the character-building austerities of Groton, the school and its regimen confronted the undisciplined teenager with the challenges of obedience, punctuality, and reprimand, however mild. "We are given three quarters of an hour to dress in—& ten minutes before breakfast is served a bell rings," Cissy reported.

> When prayers are begun the door is closed, so if you be late, you have to wait till all the rest are seated, then walk sheepishly down the room, make your apologies to the teacher & suddenly become very much interested in your coffee cup till the silence caused by your late-entrance is broken— Alas! I speak from experience—

Cissy's busy, happy days flew by in Boston. Before the end of her first term, like "all" of her schoolmates she declared herself "devoted" to the institution's redoubtable foundress, Miss Heloise Edwina Hersey.

The last decades of the nineteenth century were a golden age for American private education. In emulation of the pattern established by the beneficiaries of earlier fortunes, newly rich parents in growing numbers sent their sons to what F. Scott Fitzgerald, another midwesterner anxious for approval further east, would later describe as "the land of schools," New England. Endicott Peabody's Groton sought to emulate and build upon both the homegrown example of the Phillips family's late-eighteenth-century academies in Andover, Massachusetts, and Exeter, New Hampshire, and of the British public school model, particularly Thomas Arnold's Rugby. Women's education expanded as well. Vassar, modeled closely on the men's

colleges of Harvard, Princeton, and Yale, opened its doors to young women in 1861, and would be joined by its six sisters, Wellesley, Smith, Radcliffe, Bryn Mawr, Mount Holyoke, and Barnard, as each won accreditation over the next three decades. Much as the burgeoning boys' preparatory schools sought to instill manly virtue, so a growing number of girls' schools attempted to inculcate a corresponding feminine probity. The small number of females' and young ladies' academies that existed in the United States in the early and middle decades of the nineteenth century—among them Emma Willard's Troy Female Seminary in upstate New York, Abbot Academy in Andover, Massachusetts, and Sarah Porter's School for Girls in Farmington, Connecticut—rose exponentially. Though the growth of girls' education was a nationwide phenomenon (Marlborough School opened in Los Angeles in 1888), nowhere was the trend more pronounced than on the East Coast. In New York, for example, Mr. Brearley's school was joined soon afterward by institutions established by the Misses Spence and Chapin, respectively. The National Cathedral School opened in Washington, D.C., in 1899; it would be joined by Lucy Madeira's School in 1906. By the turn of the century, a clear pedagogical and philosophical dichotomy had emerged between those girls' schools that "finished" their students for lives of genteel domesticity and those that prepared them for the rigors of college.

Though as headmistress, Miss Heloise Hersey had been entrusted with the task of making ladies of the daughters of the affluent, like the growing sorority of her colleagues across the eastern seaboard (typically erudite, entrepreneurial, and unmarried) she was not herself the product of means or privilege. The daughter of a well-respected doctor from Oxford, Maine, she had served as one of two professors of belles lettres at Smith College before founding her own school for girls at 25 Chestnut Street on Beacon Hill in 1886, at the mature age of thirty-three. There she served as headmistress while continuing to teach English literature and publish criticism on the side. Though unable to vote, Miss Hersey harbored fervent Republican sentiments and unshakable opinions on local and national political matters, draping red, white, and blue bunting from the girls' windows in a frenzy of McKinleyite zeal, Cissy would report to her approving grandfather in the autumn of 1896, a few days before the presidential election.

Despite Miss Hersey's 1876 Vassar diploma and her appointment at Smith, she had revised her thoughts on the necessity of higher education for women. To be truly educated, she believed, her charges should be "skilled at the art of living," by which she meant they should develop a "sense of proportion," along with discipline, veracity, loyalty, and patriotism. Above all, the brisk spinster had concluded over the years, young ladies should cultivate the "ability to love," and be "lovable" themselves. To these ends,

therefore, Miss Hersey's pupils had little ultimate need for higher degrees, for classical languages or rigorous mathematical and scientific inquiry. Rather, they might absorb much of what they needed to know from reading the Great Books. The 1897 Annual Circular of Miss Heloise E. Hersey's School for Girls announced, therefore, that the institution was "especially intended to supply education to girls for whom a complete collegiate course is, for one reason or another, impossible or undesirable." With no opportunity to follow her male relatives into journalism—and with an ambitious mother who followed in the expanding society columns in newspapers nationwide the fortunes of American heiresses who had achieved "spectacular international matches" to titled European aristocrats—Cissy Patterson was just such a girl.

Cissy's "First Lit" class included readings from Sir Walter Scott, Daniel Defoe, Lord Byron, and William Shakespeare, which required the girls to "look up notes" in the appendices in order to explicate passages to Miss Hersey's satisfaction in class. "This may seem a slight work for five weeks' time, but in this class above all others there can be no 'shirking' or half-learned lessons," Cissy assured her grandfather, adding, "Miss Hersey pounces on the girl who gives a dubious answer & won't let her have peace till she admits her lesson is not studied." The wizened editor delighted both in his granddaughter's literary progress and in the accompanying improvement he detected in her prose. "There was a freedom and swing in the sentences indicating study and advancement on your part," he noted in response to her early letters from Boston, and reflected, "Your mother always wrote well since she was your age, better than her sister, your aunt. I am glad that your school and teacher please you. I look for more rapid progress in your studies and a fine polish in your manners, because, like rosewood and sugar maple, you have a grain that is susceptible of taking on an elegant tone."

Having arrived late in the school year of 1896, Cissy had (not unhappily) been unable to fit any of the school's gentle math or modern language offerings into her schedule, and so, when not reading Great Books for Miss Hersey, she enjoyed considerable leisure time. Cousin Medill McCormick, soon to graduate, made the trip from Groton to Boston on weekends to visit. "Or rather," Cissy confided to her grandfather after an enjoyable Saturday afternoon, "from Mr. Billing's point of view he came in to see a Latin play. Anyway, we had great fun. It didn't seem to weigh very much on Medill's conscience that he was going to be an hour or two late & of course if he didn't care for consequences I didn't either." She would maintain a particular affection for her handsome, sensitive elder cousin throughout her life. For his part, Medill McCormick had been captivated by the "*princesse lointaine*" Cissy had become during his years in England, and

returned her attachment. By contrast, Cissy's relations with "Bertie the swipe," always awkward, would grow increasingly fraught over the coming decades. Little given to romance in his own right and exhibiting still less interest in probing the affections of others, the younger McCormick would later dismiss as "pure bunkum" the suggestion that his brother had ever harbored anything more than ordinary familial attachment for the boys' alluring female cousin, scoffing, "She always thought everybody was in love with her." Nevertheless, as Cissy appeared increasingly at dances and other youthful entertainments over the course of the 1890s, her cousin Medill took to dampening the interest she sparked among his contemporaries. Though zealously defended by chaperones or watchfully attended by her cousin during her fledgling sorties into society, Cissy managed to engage in chaste flirtations with a few admirers, among them Freddy McLaughlin, the handsome, athletic heir to a substantial Chicago coffee fortune, and Blair Fairchild, a musically inclined Harvard undergraduate and old Grotonian.

Nellie and Rob Patterson arrived in Boston in early June 1896 to take their daughter to Europe, as had been their custom for the previous three summers. Along the way, Cissy kept a diary, recounting (and occasionally drawing) her already world-weary impressions of her fellow passengers and the cities she visited, her commentary on the books she read, and, less often, her reflections on herself. "Why is it that everybody else looks so comfortable?" she wondered, alluding to her increasingly characteristic restlessness, from the deck of the *St. Louis* in the middle of the Atlantic Ocean. "For a few minutes I may be contented enough, but soon a cold wind comes creeping round my back, the rug slips apart, etc. While my next-door neighbors sit quietly back for hours—always warm, always comfortable & happy!" Cissy would abandon her journal-keeping in just over a month. From Geneva, in the last entry in her own hand, the teenage diarist announced pointedly: "When I get back to Boston I will write down what I really think of things & people, but as Mamma reads this whenever she gets a chance, & writes 'When this you see, remember to be a good girl' all over the book, it would hardly pay to do so now." Indeed, afterward Nellie Patterson commandeered her daughter's gilt-edged diary entirely, maintaining it well into her dotage in the 1920s as the record of her minute account-keeping, not only for her considerable expenditures but also in settling scores with her sister Kate.

"Like most people now-a-days I have had the grippe," nineteen-year-old Cissy informed her grandfather on January 20, 1899, admitting freely, "As it curtailed my vacation at one end and I determined it should pay me at the other, so I came to Washington to recuperate *fully,* on extra leave, before returning to school." Joseph Medill's long journalistic and political

experience of dodging sudden "friends" among supplicants and office-seekers had taught him to dislike the nation's capital, itself born of fierce dispute and resentful compromise on reclaimed, mosquito-ridden swampland. "Some people love to live in Washington," he had admitted to the *Tribune*'s readership on March 17, 1861, adding, "Your correspondent is not one of this class. To him it is always an irksome place of abode." At the close of the eighteenth century, the concept of a fixed capital city as prescribed by Article One of the Constitution had provoked in some quarters passionate fear for the very survival of egalitarianism in the fledgling democracy, lest the permanent seat of the federal republic devolve into an imitation of an Old World court while giving rise to an entrenched aristocracy, fawning before a monarchial president. Others, by contrast, welcomed (and contributed eagerly to) the growth of a palatial capital and a new social elite.

During Reconstruction, the "Antiques," those antebellum Southern stalwarts of Washington society, had been swept from preeminence by waves of carpetbaggers, Union heroes, and Northern Republicans. By the close of the nineteenth century, the city was flooded with recent millionaires scrambling for the dry land of social legitimization. Washington, D.C.'s cyclical transience, the tidal regularity of the federal election cycle, and the associated ebb and flow of cabinet secretaries, staff members, journalists, and foreign dignitaries had distinguished the capital as "easy to break into" among the socially ambitious who had met with icy receptions further north.

Nellie Patterson determined, therefore, to spend the winter of 1899 in the District of Columbia for the social season. After renting a comfortable house on elegant, if unfinished, 16th Street, she began looking about her for more permanent accommodation. As the *Tribune*'s former Washington correspondent, Rob Patterson knew the burgeoning city well; he accompanied his wife at first, but soon returned to Chicago to resume his editorial duties. His father's death five years earlier had left him with an inheritance of some $100,000.* Prudent investment of the sum had liberated him from continued financial dependence on his wife. After Nellie arrived in Washington in 1899, the Pattersons grew further apart, eventually maintaining separate residences and, for the most part, separate lives. On January 20, Nellie felt herself sufficiently well established to receive "at home" for the first time, Cissy reported to her grandfather: "Many people called, and there were no end of solemn footmen gossiping about the door step while their mistresses gossiped inside." Indulging the old patriot, she

*About $2.6 million based on the CPI, or roughly $23 million based on nominal GDP per capita.

added with stock disapproval, "I fear the cockades on the hats of the diplomats' coachmen have an evil effect upon our American citizen." Having gone unnoticed in the Northeast, her mother met with immediate acclaim in Washington. The following month, Nellie Patterson's voluminous scrapbook reveals that in a city boasting "enough silk worn every winter to carpet a whole state" and "pearls by the bushel and diamonds by the peck," she was distinguished in the press as one of the two "most admirably gowned and gorgeously jeweled women" at a Supreme Court dinner over which President McKinley himself presided. "She is tall and moves with exceeding grace," another of her clippings trilled, "when she made her appearance on Wednesday, wearing a gown of white satin, made with a broad flounce of pale pink satin and with a tiara of diamonds handsomer than any thing that has been seen since Mrs. Whitelaw Reid [wife of the former United States ambassador to France] dined in the White House a few weeks ago."

"Lots of people have been asking for you and I tell them that Mamma expects you before very long," Cissy continued in the account she scribbled of her mother's triumphs for her grandfather, and closed, as ever, with conspiratorial affection: "Perhaps when you are here I may be clever enough to have another attack of grippe and come to Washington again to convalesce." After two leisurely years in Boston she had left Miss Hersey's for further refinement at her mother and aunt's alma mater in Farmington, Connecticut, in 1898. Sarah Porter had founded her school for girls there in 1843, a decade before Heloise Hersey's birth. Though Miss Hersey was no radical in her thoughts on female education or the Woman Question, Miss Porter maintained views even more staunchly traditional. She flatly opposed women's suffrage. Though she had been privately tutored by Yale professors in her Connecticut girlhood, she lamented the proliferation of female seminaries and women's colleges that she had witnessed over the course of her long pedagogical career—so much so, in fact, that she refused to hire even "*one* college trained woman" to teach at her school, complaining that she found them "*narrow*, arrogant," and unable to "infuse the spirit which I want." A minister's daughter, Miss Porter was a fervent Christian who believed it to be her duty to prepare her charges for their ordained roles as wives, homemakers, and mothers, arguing, "I do not believe we can revolutionize what God has so implanted in us as the relations of man and woman in this world."

Cissy objected less to life at Farmington than had her mother and aunt before her; upon arrival in 1870, sixteen-year-old Kate had pronounced the quaint New England village to be "without exception" one of the "worst, pokey, humdrum, disagreeable places" she had ever seen. Cissy showed little more attachment to the institution, however. Rather, her surviving cor-

respondence suggests a variety of schemes to profit by her delicate constitution in order to "convalesce" in more agreeable locations. "Ruth Hanna is going south in a week or two to Thomasville to join her family there for a short time," she informed her grandfather on March 1, 1899, adding suggestively, "I envy her the warmth and sunshine and lazy out-of-door life which she will find waiting for her."

Ailing Joseph Medill was no stranger to the charms and health benefits that had made Thomasville, Georgia, a popular winter haven among affluent, often invalid, northerners in the late nineteenth century. He had spent the winter of 1893–94 there for both personal and political reasons. Unlike the cold mists of Pasadena, he hoped, Thomasville's mild climate, its early spring, its celebrated pine-scented breezes and magnificent flowering dogwoods, would have a restorative effect on his wife's health. Moreover, the old kingmaker had come at the suggestion of his friend, Ohio industrialist and Republican Party activist Marcus Alonzo Hanna. Having masterfully orchestrated William B. McKinley's gubernatorial campaign in 1891 and more recently his reelection bid in 1893, Hanna hoped to acquaint better the principal owner of the *Chicago Tribune* with the Republican governor of Ohio with an eye to the presidential election of 1896. Still shaken by the death of her sister a year earlier and growing increasingly excitable on the subjects of ill health and cold climates, Kate McCormick had swept her boys out of Groton for much of the term, and with them joined her parents in Thomasville. The same winter, a bout of whooping cough had prompted the Hannas, likewise, to remove their daughter Ruth from boarding school, so that she might recuperate under their supervision in the South. While Mark Hanna and William McKinley courted Joseph Medill by shouting their enthusiasm for protective tariffs and the gold standard into his ear trumpet, fourteen-year-old Ruth Hanna and sixteen-year-old Medill McCormick became better acquainted as well, riding in the woods together and attending the same entertainments, dances, and picnics. Though young Medill McCormick would long afterward discourage his cousin Cissy's beaux and admirers, he himself had already formed a competing attachment.

In the wake of his wife's death in 1894, Joseph Medill's own health, never robust, declined markedly. He remained peripatetic, however, visiting the resorts of Thomasville and Palm Beach in winter to ease his rheumatism, and traveling to celebrated spas and mineral springs to alleviate his lumbago (according to habit and conviction, however, drinking only distilled water so as to forestall the ravages of "liming up"). If his body was slowing, his mind retained much of its old agility. Though he decided against a run for the United States Senate from Illinois in 1895 at the mature age of

Joseph Medill and his grandchildren in 1899, the year of his death. Standing: Cissy Patterson and Medill McCormick. Seated: Bertie McCormick (left), Joseph Medill, and Joe Patterson.

seventy-two, he continued to hold a panoramic view of the world and maintain an editor's omnivorous interest in its inhabitants, affairs, and advances. From Bar Harbor he wrote to Nellie in July 1896, on the upcoming presidential election and Mark Hanna's efforts on behalf of William McKinley, lamenting, "The Republicans have a desperate fight on their hands" to save the nation from the populist, Democratic, free-silver candidate, William Jennings Bryan, and his "bad money." In the same sitting Medill also reported on Chicago society gossip and a figure of particular interest, he knew, to his correspondent: "Mrs. P. Palmer is trying her wings at Newport among New York plutocracy."

While Cissy convalesced at her mother's new home in Washington in January 1899, her grandfather—more persuaded than ever that he was in the process of "shuffling off this mortal coil"—had arrived at the Hotel Menger in San Antonio, Texas, for the winter. Although the old man found his appetite and his strength had "faded out," preventing him from leaving his hotel room for days at a time, he maintained his accustomed vigil over national and international affairs through a panoply of newspapers. The explosion and sinking of the battleship *Maine* in Havana harbor the previ-

ous year—which the old jingoist (and indeed many Americans, Medill's colleagues in the press in particular) took as Spain's "diabolical insult" to the United States—had rekindled enough of the ferocity of his youth to invigorate him throughout the Senate's ratification of the peace treaty. Despite his growing infirmities, Medill's letters both to his family and to the *Tribune* staff ring with spry indignation at what he saw as the august body's bungling not only in concluding the Spanish-American War but in ratifying the currently debated Anglo-German Samoa Convention during the early winter of 1899. "Tell Robert," he ordered Nellie, "to take the position in the *Tribune* that it would be better for our country to abandon the Samoan islands than to have any disturbing, serious quarrel over them with our friends the Germans, cousins by blood, language, religion, literature, science, art and civilization."

Though Medill still maintained a proud independence, insisting that he needed no visitors during his sojourn in Texas, he was not in fact alone. "Bertie is here with me," he wrote Nellie in late January. Kate had pulled her younger son out of Groton during the winter of his sixth-form year and sent him to San Antonio, where he studied mathematics in preparation for joining his elder brother and cousin at Yale the following autumn. "He is good company," his grandfather had found. "I would feel lonesome without him."

Though not unexpected, Joseph Medill's end was sudden. On Thursday, March 16, 1899, he took his morning coffee and read the papers as usual, with Bertie and his doctors at his bedside. Medill's long experience and painful observation of illness and death had aligned with his old flair for phrase-making in prompting careful reflection on the composition of his last words. Dictating copy to the last, in this case for the obituaries that would run internationally in the days that followed, he looked up from the newspapers he had just finished reading and informed his private physician, "My last words shall be: 'What is the news?' " Ten minutes later he lost consciousness. The immediate cause of death, his doctors concluded, was heart failure.

Colony of Palatial Homes
around Dupont Circle

That Portion of the City That Barely Thirty Years Ago Was Laughed at Has Become One the World's Greatest Centers for Homes of Wealth, Luxury, and Refinement

—*WASHINGTON (D.C.) TIMES*, DECEMBER 21, 1902

Dupont Circle as it looked in the early decades of the twentieth century from the west, at the convergence of P Street and Massachusetts Avenue. "Patterson House," at number 15, is visible across the circle, slightly to the left, through the trees.

When Joseph Medill's will was filed at the Cook County Probate Court ten days after his death, the document revealed that, having begun his life as a poor immigrant farm boy, he had departed it nearly seventy-six years later, leaving an estate valued at some $4.5 million.* He had seen fit to make a number of testamentary gifts to charity and to relatives, and left $1,000† each to several veteran *Tribune* employees. With regard to his immediate family, despite his attempts to persuade Nellie in October 1898, that beyond his *Tribune* holdings, he had "only some cats & dogs" to bequeath to her and her sister, his daughters' equal halves of his personal property—mostly in the form of bonds and real estate—would in fact be valued at roughly $1 million each. The remainder of Medill's estate, estimated to be worth some $2.5 million, was composed of his *Chicago Tribune* stock.

Medill's careful estate planning had been driven by the objective of preserving the paper as "a party organ, never to be the supporter of that party which sought to destroy the American Union or that exalts the State above the Union." The future administration and disposition of his 1,070 (of the paper's original 2,000) shares had been the subject of some disagreement

*More than $120 million based on the CPI, and more than $800 million, based on nominal GDP per capita.
†In excess of $27,000 or more than $180,000, by the same measures.

during the last year of his life. In his declining years, Medill had hoped fervently for harmony among his four grandchildren and their progeny — vividly aware of the rancor that existed between his two surviving children. These considerations had prompted him to take steps to ensure that his majority stake would remain intact for the benefit of all of his descendants, while preventing his querulous daughters from interfering (directly, at least) in the management of his beloved *Chicago Tribune.* To these ends, Medill determined that the stock he had struggled so long to accumulate would best be held in trust for his progeny, rather than left to them outright. Initially Medill had intended to vest full power to vote, manage or sell the stock en bloc in two trustees alone: his attorney (and Minister Robert Todd Lincoln's law partner), William G. Beale, and his own son-in-law and trusted successor, both as president of the Tribune Company and as editor in chief of the paper itself, Rob Patterson. The same spirit of generosity and fair-mindedness that had earlier motivated Rob Patterson to actively support Rob McCormick's preferment at the London legation had likewise prompted him to refuse to subject his unlucky but proud in-laws to "such a mortification" as Medill's two-trustee plan implied, however. Patterson would decline to serve, he had told his father-in-law in the spring of 1898, if Medill refused to extend the courtesy of creating a third trusteeship so as to permit Rob McCormick the dignity and autonomy of representing his wife and children's interests in the administration of the proposed trust. As with his support of McCormick's promotion in London, it was a gesture Patterson would come to regret bitterly. At the time, however, his father-in-law acceded to his demand and Beale drew up the documents accordingly.

The trust would terminate upon the decease of both of Medill's daughters. Without the consent of at least two trustees, neither lady could influence the administration or sale of the stock—or, by extension, the newspaper. In fact, neither would actually own any part of the *Tribune*; the trust made Kate McCormick and Nellie Patterson and their descendants the beneficiaries of the stock's dividends without making them owners of the shares themselves. For the rest of their lives Cissy's generation would enjoy the lavish material, journalistic, and political windfalls of their grandfather's legacy, but Medill's grandchildren were not his direct heirs.

The fond old man had made one exception to this otherwise ironclad estate-planning rule, however. Alone among his descendants Medill had singled out eighteen-year-old Cissy to receive a portion of his proudest possession directly: ten shares of *Chicago Tribune* stock in her own right — over and above the rich dividends of the trust that she would share equally with the other surviving members of her generation. Joseph Medill had cherished the hope that his careful planning would extinguish the discord

between the McCormick and Patterson branches of his family once and for all upon the eventual deaths of his two daughters. The comparatively small but unmistakable token of favoritism that the gift represented (along with the disproportionate power the ten shares would later confer upon their owner at Tribune Company stockholder meetings) would serve only to awaken old jealousies and animosities, however, decades after Joseph and Kitty Medill and their captious daughters had been laid to rest in the family vault at Graceland Cemetery.

Though Nellie Patterson, like her sister Kate McCormick, would complain bitterly of being "tied up tightly" by the strictures imposed by Medill's will and the trust he had established for their (and, indeed, the *Tribune*'s) benefit, the outside observer might have arrived at the opposite conclusion: rather than constrain them in any way, their father's death appeared instead to have unleashed them. Not only could both ladies spend more lavishly—with little oversight and less complaint—than ever before, but, going forward, both were free to indulge unabashedly in pursuits the patriarch had earlier condemned as undignified, undemocratic, and un-American.

On March 30, 1900, just after the first anniversary of Joseph Medill's death and the conclusion of her own second brilliant Washington season, Nellie Patterson paid $83,406* for a lot on the capital's increasingly fashionable Dupont Circle. Charles Pierre L'Enfant's original 1791 plan for the capital showed Massachusetts Avenue, transecting the city from Southeast, near the banks of the Anacostia River, to Northwest, by the miasmal ravines of Rock Creek. The quagmire that made up much of the thoroughfare's surrounding landscape would long discourage the development of its outermost reaches, however. Until nearly the third quarter of the nineteenth century, the foggy, low-lying wilderness surrounding "The Slashes," at what was then northwestern Massachusetts Avenue's most remote "Pacific Circle," would be home only to a few sleepy country estates and occasional host to those intrepid hunters and sportsmen who were undeterred by swarming mosquitoes. In 1871, a syndicate of western speculators, among them the mining millionaire and Nevada "Silver Senator" William Morris Stewart, began buying up much of Pacific Circle and its far-flung environs at ten cents a foot. By 1873, an oasis of paved streets and sidewalks, sewage systems and water mains, had emerged from the surrounding wasteland. Soon after, the Silver Senator's huge, five-story, red-brick, turreted Second Empire mansion sprang up in solitary splendor on the north side of Pacific Circle.

*Some $2.2 million based on the CPI, or more than $14 million based on nominal GDP per capita.

By the time Nellie Patterson bought one of the remaining coveted "points" surrounding the circular park at the intersection of Massachusetts, Connecticut, and New Hampshire Avenues as well as Nineteenth and P Streets seventeen years later, the area had undergone considerable transformation. Even its name had been changed to honor Union naval hero Admiral Samuel Francis Du Pont, in 1882. Having stood in unrivaled magnificence for more than a decade, the Silver Senator's mansion (ridiculed in the longer-established neighborhoods of Capitol Hill and Lafayette Square as "Stewart's Folly") had been dwarfed by each year's new crop of opulent homes. By 1902, the *Washington Times* would contend that "of Washington's half hundred millionaires, a considerable portion lie in the traditional stone's throw radius of Dupont Circle." Inventors Alexander Graham Bell and George Westinghouse had homes in the area. Despite Dupont Circle's three-mile distance from the Capitol, a growing number of elected and appointed officials flocked to build or buy in the area, among them Secretary of State James G. Blaine, Senator Joseph B. Foraker of Ohio, and a number of "Bonanza Kings," who had been elected to Congress after amassing staggering fortunes in their home states. Phoebe Apperson Hearst—widow of mining magnate and United States senator from California, George Hearst, and mother of William Randolph Hearst, that upstart publisher who would shortly succeed in using his inheritance and his expanding newspaper holdings on either coast to launch himself to two terms in Congress from New York—lived just south of Dupont Circle. In 1899 the Silver Senator who had sparked the area's vogue would sell his home to one of the richest men in the world, the "Copper King," Senator William A. Clark of Montana, at a reported profit of 1,000 percent. By 1902, ground had been broken and construction begun on the "Colorado Gold and Silver King's Palace" at nearby 2020 Massachusetts Avenue. Born in Tipperary, Ireland, Tom Walsh had endured a life of itinerant poverty, hard labor, and fruitless gold-digging until 1896, when he struck pay dirt in the form of a gold vein three feet wide and six miles long at the Camp Bird Mine in Colorado. The following year, the "Colorado Croesus," Mrs. Walsh, and their children, Vinson and Evalyn, arrived in the nation's capital, where the generous, if unvarnished, Grand Old Party enthusiast and his family encountered a warm welcome.

"That portion of the city that barely thirty years ago was laughed at has become one of the world's greatest centers for homes of wealth, luxury and refinement," the *Washington Times* crowed in 1902. If the mounting opulence, desirability, and real estate prices of the neighborhood had decisively stifled the guffaws of its early detractors, there was nevertheless one who continued to subject Dupont Circle to loud and unrelenting derision

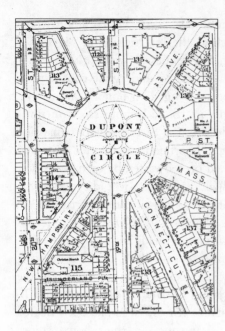

Dupont Circle at the dawn of the
twentieth century. Building on
the Circle (in square 136, lot 2, on
the northeastern side) placed socially
ambitious Nellie Patterson only steps
from some of Washington's richest
and most prominent citizens, among
them the Boardmans, the Wadsworths,
the Leiters, the Blaines, the Walshes,
and the Hearsts.

long after the turn of the century—especially within earshot of her
younger sister. As Nellie Patterson busied herself with the architectural
plans for the ornate, white marble Italianate palace she had commissioned
Stanford White to design for her plot in 1901, as she oversaw the construc-
tion and tended lovingly to the decoration that would cost her some
$181,660* over the next two years, she was harangued and taunted at
every opportunity by Kate McCormick (who did not yet own her own
Washington, D.C., home), with jibes about the "malaria swamp" at
"Dupont Circle Hollow" on which she had been fool enough to build.

However tormented by her sister, Nellie Patterson could take solace
from the new and renewed connections the neighborhood afforded. She was
not the first Chicagoan to take up residence in Dupont Circle. The spectac-
ularly successful triumvirate of dry-goods merchants, Marshall Field and
his two original partners, Potter Palmer and Levi Leiter—along with their
ambitious wives and young families—had been wintering in the capital
for the social season since the early 1880s. The Leiters, for example, had
leased Secretary of State James G. Blaine's red-brick mansion on the south
side of Dupont Circle for nearly a decade, reportedly at the astonishing
sum of more than $10,000 per year, before building their own vast white-
brick home in 1891. If the capital enjoyed a growing reputation among the

*Roughly $4.5 million, based on the CPI, or more than $27 million, based on nominal GDP per
capita.

newly rich and the socially ambitious at the end of the nineteenth century, it was beginning to capture the attention of the unmarried as well. It was the Leiters (or more specifically, their three beautiful, cultivated, monumentally dowered daughters) who contributed perhaps more than anyone else to the city's growing reputation among eligible young men, enterprising mothers, and hopeful daughters—not to mention canny adventurers and profligate European aristocrats—as an unsurpassed "marriage market." Mary Leiter, born in 1870, had married the dashing thirty-five-year-old Conservative member of Parliament, George Curzon, at St. John's Episcopal Church in the shadow of the White House, in 1895. Levi Leiter had seen his eldest off to her new home in England with a dowry widely speculated to have been between $3 million and $5 million. She would become Baroness Curzon of Kedleston and Vicereine of India three years later. Mary Curzon's younger sisters would make much-ballyhooed "brilliant international matches" as well. By the time Daisy Leiter married the Earl of Suffolk in November 1904, and the youngest, Nancy, married the British army's Colonel Colin Campbell a few weeks later at Christmastime, the staggering sum of $10 million had reportedly been settled on each.

One 1909 estimate placed the number of American "women of fortune" who had married European aristocrats since the Republic's inception at 360. Another, from 1908, contended that 150 such marriages had taken place in the previous two decades alone. Whatever the accurate figure, the number of "international matches" (according to what had become the stock term)—or as Congressman Charles Garvin of Chicago characterized them, instances "where soiled and frayed nobility is exchanged for a few million American dollars wrung from the lambs of Wall Street, with a woman thrown in"—only continued to grow in number.

Long the subject of public note and the inspiration for drawing-room farces and novels of manners in the United States, international marriages had become a matter of controversy by the first decade of the twentieth century. Though the poet and *Harper's Bazaar* editor Margaret Sangster allowed that a few such unions had been genuine love matches, she feared that "far too many foreign marriages are entered upon by our girls without serious thought and with little notion of the life that may follow them." In her "From Woman's Viewpoint" column, Betty Bradeen remarked in the Washington, D.C., *Herald* in 1906, "It is said, with some degree of truth, that the heiress who buys a title deserves whatever misfortune goes with it." Bradeen reminded her readers, however, that an heiress "always runs grave danger in marrying" any husband, foreign or domestic, and concluded, progressively, that when such marriages devolved into intolerable unhappiness—or indeed, brutality—"the remedy for future happiness is the divorce court." Novelist Booth Tarkington denounced most interna-

tional unions as "deplorable failures," and placed the blame squarely on the shoulders of "the socially ambitious American mother, who insists upon her daughter's marriage to a foreign nobleman because she aspires to social prominence." In February 1908, that self-made immigrant and philanthropic eugenicist Andrew Carnegie informed the New York Genealogical Society that he deplored the fashionable coupling of American vigor and ingenuity with European degeneracy.

Those of a patriotic, protectionist bent objected as much to the fundamentally un-American and undemocratic nature of the growing "craze for European titles" or "Europamania" as to the enormous capital flight international marriages reportedly occasioned. In his "Dukedoms for Ducats" exposé in the *Washington Herald Literary Magazine* for May 30, 1909, P. Harvey Middleton reminded his readership that "by our little fracas of 1776 we cut loose from royalty and all its insignia and set to work as plain Americans to develop the vast natural resources of our country," and lamented that no small portion of the enormous resulting fortunes had left the United States as the dowries of newlywed countesses, princesses, and duchesses from New York, Pittsburgh, Washington, and Chicago. Though Middleton acknowledged that the astonishing figure was "probably exaggerated" due to the difficulties of fact-checking matters of such intimacy, nevertheless he estimated that in total some $900 million had left the United States for Europe as part of the brisk, ongoing trade in "titles for treasure." The alarm had already been sounded on Capitol Hill. In January 1908, Representative Adolph J. Sabath of Chicago had proposed a bill to impose a tax of 25 percent on any dowries, financial settlements, gifts, or advances of any sort connected with the marriages of citizens of the United States to foreigners.

If flag-waving Americans looked askance at the flight of the nation's daughters and its capital to the courts of the Old World, unmarried European girls and their mothers were no more enthusiastic about the matter. In Munich, Bavaria, for example, a group of unattached (but nonetheless droll) young ladies offering unimpressive dowries placed an advertisement in the local *Neueste Nachrichten* for an "International Marriage Institute for Wealthy American Heiresses." It went on to offer for "sale" sundry counts, princes, officers, and grandees representing European noble houses of varying age and authenticity, some of the candidates boasting admirable abilities on the tennis court, others admitting to only "slight moral defects," all of whom might be had for what American heiresses would consider reasonable prices—in addition to the discharge of their prospective bridegrooms' gambling debts.

The domestic press covered those who left their native shores as rich girls to be received in Europe as titled ladies, in revolving-door fashion for

an American public breathless for news of their privileged compatriots abroad. For the starry-eyed girl and her sentimental mother, the society pages offered fairy-tale accounts of pampered brides, dashing grooms, and true transatlantic love under such headlines as "An American Princess," "Not Gold, but the Girl Charmed Count Széchenyi," and "She Is Now a Duchess." These included lavish descriptions of expanses of tulle and lace, sumptuous refreshments, bowers of flowers, treasuries of wedding presents, and guest lists resplendent with the glamour of grandiose titles and unpronounceable names. Along with the "society chat" of the American newspaper, the expanding photographic sections offered glimpses of the ongoing adventures of international brides of yesteryear. During Cissy's last years of schooling at Miss Porter's and Nellie's first in Washington, the American press was as full of reports and photo spreads of the Pattersons' onetime neighbor, the former Mary Leiter, the beautiful, Chicago-born vicereine of India, riding elephants and admiring the Taj Mahal. In like fashion, the statuesque and philanthropic Duchess of Marlborough, the former Consuelo Vanderbilt of New York, graced the pages of publications coast to coast, as she ministered to the poor and the sick on her husband's estate at Blenheim Palace. Nellie Patterson's contemporary, the former Jennie Jerome of Brooklyn, would continue to make international headlines until her death in 1921, as the ravishing and irrepressible Lady Randolph Churchill, rendering almost incidental the announcements of the births of her sons, Winston and Jack.

For the censorious, the patriotic, or, indeed, the envious, the latest international match inevitably provoked comment: "Is It Love or Money Wins an American Heiress?" "America's Great Loss," "Europe Gets Another Fortune," "Americans Are Mad," "Blames the Mother," "Andrew Carnegie Scores Noblemen: Says American Women Should Not Marry Worthless Foreigners." A few pages later, the headlines of the gossip column—rapidly metastasizing in publications nationwide—shouted in bold caps the cruel disappointments, the discoveries of lurid dissipations, the squandered dowries and, occasionally, the sad homecomings of the earlier-initiated members of that elite sorority of cosmopolitan brides: "Count Boni Was Expensive," "NOBLEMEN SHADOWED BY 'PASTS,'" "SEPARATION IS NEAR: Duke of Marlborough Quarrels with American Wife," "DUCHESS COMES BACK: Reported She Will Remain Until Talk Ceases. DEED OF SEPARATION SIGNED."

The surnames of American girls who had made such marriages were not only, as the *Washington Times Magazine* trilled, "synonymous with vast fortunes," they were closely associated with the history of the nation itself, among them Astor, Bonaparte, Burden, Colgate, Endicott, Field, Flagler, Grant, Goelet, Gould, Hamilton, Hale, Jay, Lawrence, Lee, Livermore,

Phipps, Phelps, Roosevelt, Riggs, Sibley, Sumner, van Buren, van Court-
land, Vanderbilt, Winans, Whitney, Wadsworth, and many others. "Of the
American women abroad to whom fate has brought fame and fortune, a
large proportion are Washingtonians by education, or adoption, if not by
birth," the *Washington Herald* boasted to its receptive readership in October
1906. Of these, perhaps no Washingtonian bride was more closely fol-
lowed, and no wedding more widely covered in the press, than that of
President Ulysses S. Grant's granddaughter, Julia, to Prince Mikhail
Mikhailovich Cantacuzène, Count Speransky, a cavalry officer of the Rus-
sian Imperial Army, in Newport in late September 1899.

The bride's aunt, the ubiquitous Mrs. Potter Palmer, had rented
William Waldorf Astor's "Beaulieu" for the summer of 1899, the better
part of which she spent "transforming" the already magnificent seaside
villa and grounds for the season's culmination in the much-anticipated
Russo-American wedding. Meanwhile, the bride, who had been born in
her grandfather's White House during the nation's centennial in 1876,
spent much of her summer in Newport contending with the rising torrent
of mail she received, much of it "full of violent praise or blame, sometimes
calling me names for abandoning my country, disgracing my Americanism
and my family by marrying a title, or else showing deep sympathy toward
me for all I must go through in darkest Russia, living under a European
ruler." Still in mourning after Joseph Medill's death the previous winter,
neither the Pattersons nor the McCormicks attended the wedding, despite
the old Republican Party ties that linked them to the Grants, and the
Chicago connection they shared with the Potter Palmers. The guest lists,
widely published, were nevertheless filled with the names of American
leaders of industry, notable statesmen, and scions of large fortunes. In addi-
tion to the Americans invited to the nuptials, there were many European
guests, most of them associated with the Romanov court at St. Petersburg,
where Prince Mikhail's father was an official, or the Hapsburg court in
Vienna, where Julia Dent Grant's father, General Frederick Grant, had
served as American minister between 1889 and 1893.

Among the glittering array of titled Europeans who arrived in Newport
in September 1899, was the thirty-two-year-old Count Josef Gizycki, an
ethnic Polish Catholic with ties to both imperial courts. With his fellow
wedding guests the count was swept up in the breathless, almost month-
long round of luncheons, teas, dinners, and dances thrown for the young
couple, and the polo matches and yachting parties associated with their
nuptials. Mrs. Francis O. French entertained them at her opulent villa,
Harbor View. Henry Walters invited the entire wedding party to dine
aboard his yacht, *Narada*. Cornelius Vanderbilt treated the young couple
and their guests to a lavish dinner at The Breakers. Besides hosting a num-

ber of celebrations at Beaulieu, Mrs. Potter Palmer devoted two of the large upstairs rooms to the display of the wedding gifts for the guests' delectation. A local policeman and several plainclothes detectives guarded the magnificent diamond jewelry the bride received from her family, the gold tableware from the Vanderbilts, the extensive silver service from the bride's maternal grandparents, the superb golden icon from Grand Duke Vladimir, the diamond-encrusted purse from Mrs. Marshall Field, the gold toilet set from Mrs. Leland Stanford, the fashionable glass lamp from Louis Comfort Tiffany, and the hundreds of other silver, gold, pearl, and jeweled articles and *objets* the couple received.

This, Count Gizycki's first visit to the United States, had brought him to the very flower (or excrescence, depending on the viewpoint) of American ingenuity, drive, rapaciousness, and superabundance; Newport in the Gilded Age was the incarnation of Thorstein Veblen's concept of "conspicuous leisure." In Newport, Count Gizycki first encountered some of the young republic's oligarchs and their heirs, and became fully aware of the extent of the staggering wealth that made possible not only the Americans' lavish entertainments and unstinting sporting activities, but also their extravagant seaside villas and chateaux, constructed with every modern convenience in imitation, seemingly, of every European architectural period and style.

Tall, dark, powerfully built, and handsome, Gizycki had inherited his title along with several sleepy but not inconsequential estates and their dilapidated manor houses in the remote Ukraine two years earlier. Almost immediately upon taking possession of his ancestral lands after the deaths of his uncle and father, he had mortgaged them heavily to finance the bachelor's life he continued to lead in Vienna, St. Petersburg, and Paris and the penchant he had developed for horses, hunting, and racing as an Austro-Hungarian cavalry officer. "Amoral and cynical" by nature (as an old friend, who would later become his mistress and bear him a child, remembered indulgently), Count Gizycki's financial predicament had lately imposed an unaccustomed practicality on him as well, by forcing him to consider alternative sources of income in order to maintain—or perhaps improve—his standard of living in the future.

For the time being, however, Newport appeared to have a disquieting effect upon the count. Perhaps the resort inspired in him something of its largesse—or vulgarity. Perhaps something about the setting or the occasion provoked the eccentricity and volatility familiar, at least, to those who knew him well. Perhaps his behavior was an early manifestation of the contempt for the United States and its wealthiest citizens that he would express with diminishing restraint over the coming decade. Though accounts vary slightly, of the many notables who assembled from around

the globe to celebrate the union of the prince and the president's granddaughter, Count Josef Gizycki would for some time be distinguished in memory and in print for his strange antics at a nuptial dinner dance at the Casino. He "caused a sensation," as the *Washington Post* put it. He occasioned "great consternation" among those who had assembled to toast the happy couple, the *Washington Times* clucked. Gizycki's astonishing behavior "nearly broke up" the festivities, the *New York Times* reported. Surrounded by the American simulacra of European hierarchies, manners, customs, sporting activities, and palaces, Gizycki made a flamboyant display of his enthusiasm for the *authentic* Viennese gavotte that the orchestra played at last, by pitching a fat wad of $10 bills into its midst.* The music ceased. The glittering assembly looked on, agog, as the orchestra devolved into pandemonium. The players had laid down their instruments, the better to scramble over, elbow, and claw their colleagues in their efforts to grab as many greenbacks as possible. "A little later," the *St. Albans (Vermont) Daily Messenger* recorded, "the count became greatly pleased again at one of the airs, but this time, not having bills of the proper denomination, he tore those he had in halves and threw the pieces at the players."

<div style="text-align: center;">

Miss Patterson, of Chicago,
Gets the First Brush

— UNIDENTIFIED CLIPPING IN NELLIE PATTERSON'S
SCRAPBOOK, CA. 1900

</div>

In midlife Cissy Patterson would insist that the only thing her mother had ever done for her was to give her "that horse." Elegant, correct, athletic, and kind, the chestnut gelding was named (fittingly for the mount of a society girl who descended from three generations of newspaper publishers) Exclusive. By all accounts, Cissy was a superb and fearless horsewoman, riding and driving equally well. Indeed, in 1904 the *Washington Post* would pay her the supreme compliment of admitting she was "good enough to be a Virginian." Though she had been taught principally to ride sidesaddle in her childhood, as she grew, she preferred increasingly to forgo that ancient guardian of maidenhood and mounted feminine propriety. Instead, as a teenager she scandalized society with a growing frequency by

*To give a sense of the extravagance of this gesture, eleven decades later Gizycki's $10 bills would be worth roughly $270 each, based on the Consumer Price Index. Based on nominal GDP per capita, relative to the musicians' annual income, each bill would have been worth something more like $1,800.

Cissy Patterson driving at the Onwentsia Club
in Lake Forest, Illinois, at the turn of the century

appearing astride Exclusive and her other mounts in the sporty equestrian
bloomers then becoming fashionable among girls of her generation. At the
turn of the twentieth century, Cissy Patterson and Exclusive would become
a familiar sight along the shores of Lake Michigan in Chicago, where they
rode out from the Saddle and Cycle Club, and in Lake Forest, where they
cut a dashing figure in the field with the local hunt and in the ring at the
Onwentsia Club's horse shows. Often (too often, for Medill McCormick
and Nellie Patterson's liking) Freddy McLaughlin, the handsome, athletic
Chicago coffee heir, accompanied Cissy on her rides. If her mother frowned
upon the attention shown her daughter by the son of a man she claimed
had delivered groceries before becoming the Midwest's Coffee King —
spying on the pair, reading Cissy's mail, hiding her riding clothes — it was
Cissy herself who put an end to the courtship, at least for the time being.
Despite the examples provided by the libertine heroines of the novels
slipped to her by her aunt, despite her own efforts to sneak out for clandes-
tine meetings with her beau, Cissy was shocked when he tried to kiss her
one day through her riding veil, and broke off contact immediately.

In the years following Joseph Medill's death and Nellie Patterson's relo-
cation to Washington, Exclusive would accompany Cissy eastward and,

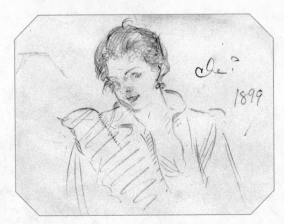

"Che?": self-portrait by Cissy, 1899

later, halfway around the world as well. In the winters of 1899–1900 and 1900–1901, he embarked by train to meet her in Thomasville, Georgia, for the season. As hoped, the multifarious nervous and physiological afflictions Cissy endured at Miss Porter's at last convinced her parents to allow her to "convalesce" in a climate more agreeable than that of Farmington, Connecticut, in midwinter. Though her condition would never be conclusively diagnosed, Thomasville's mild climate, its engaging society, and its wholesome sporting activities appear to have had an immediate restorative effect upon the patient. The fainting spells, the heart palpitations, the extreme nervousness of which she had complained at Miss Porter's dissipated miraculously in the rough-and-tumble exhilaration of the hunt field. Her mother's scrapbook recorded Cissy and Exclusive's triumphs in galloping first to the kill, for which they were rewarded again and again with foxtail brush trophies.

Cissy riding in formal attire, ca. 1900

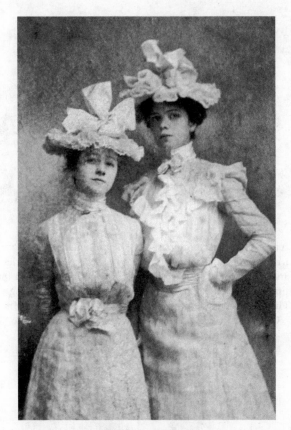

Ruth Hanna (left) and Cissy Patterson in
Thomasville, Georgia, where the latter went to
recuperate from nervous prostration in 1900.
Ruth Hanna would marry Cissy's favorite cousin,
Medill McCormick, in 1903.

For two years running, Rob Patterson rented a comfortable four-bedroom house for Cissy and her small staff at the resort, where she joined her schoolmates from Farmington, Ruth Hanna and Alice Higinbotham, who, unlike her, had come with their families. While her mother focused on her entrée into Washington society and her father sank further into alcoholism and depression in Chicago, Cissy, not yet "out" in society, spent her eighteenth and nineteenth winters in Thomasville, largely unsupervised and unchaperoned. Her diversions were simple and wholesome, apparently, and her companions almost entirely female. "The young ladies all seem to enjoy Thomasville, especially Miss Patterson, who is having a good time at outdoor exercise," J. S. Culpeper, Cissy's landlord, informed her father, adding, "She is a clever horse & wheel woman & in modesty, good sense & judgment does credit to one much older." "She seems to be in

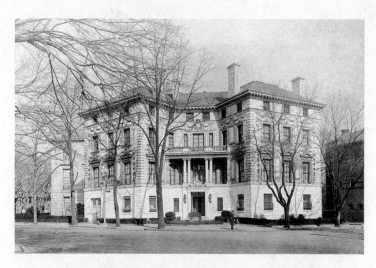

ABOVE: "Patterson House": 15 Dupont Circle, ca. 1927
BELOW: The balcony from which young Captain Charles
Lindbergh would address the throngs who came to cheer for
him in the wake of his epochal transatlantic flight in 1927.
The celebrated aviator was the guest of President and Mrs.
Calvin Coolidge, to whom Cissy, recently remarried to
attorney Elmer Schlesinger and living in New York,
loaned the mansion during the extensive renovations
then taking place at the White House.

her glory hunting, riding & making the best of the sunshine—a big ray of which she carries with her," Culpeper reported a week after she arrived for her second season in December 1900.

Cissy spent Christmastime in Chicago, where she was presented to society in pink chiffon by Worth at the Pattersons' now little-used Astor Street home, at a tea on New Year's Day 1901. Afterward she returned to Thomasville for the remainder of the season, in rude good health and high spirits, until springtime. Nellie Patterson, for her part, returned to Washington to resume her social ascent. In late April, as she and Stanford White finalized plans for the home she intended to build on her new vacant lot across from the unsightly pit that remained for decades after the Montana Copper King demolished Stewart's Folly, she received the first galling details of her sister's recently improved fortunes. "The papers all published our arrival at this hotel yesterday morning and all day long cards poured in from ambassadors and ministers," Kate McCormick reported with glib satisfaction. "There were special prayers in the English chapel where we had to go although I had not slept more than an hour in the *wagon-lit.* Today Rob has to go to the foreign office to make all sorts of official calls." To the younger sister whom she had lately taunted with unrelenting cracks on the inevitability of falling prey to malaria in that bog, Dupont Circle, Kate rendered in lavish detail the recent, dramatic improvement in her own lodgings. "I saw our home yesterday and was enchanted with it—a real palace, though not big," she added modestly:

A lovely dining room, lovely library, a dark drawing room, two small salons—silk on the walls—two bedrooms—one dark—and two spare rooms and 17 servants' rooms. Bathrooms with stoves in them for heating the water for the bath. There is a truly imposing staircase and a long handsome hall. I will have to have a man who does nothing but take care of fires . . .

Six weeks later, on June 10, 1901, the District of Columbia issued a building permit for the George A. Fuller company to begin construction on McKim, Mead & White's plans for Nellie Patterson's own white marble palace—complete with its own imposing staircase, handsome halls, public rooms, extensive servants' quarters, ballroom and garden—on Dupont Circle.

After years of envious disappointment on her part and marginalizing penury on his, Kate and Rob McCormick had managed at last to parlay their connection to the *Chicago Tribune* (however carefully limited in reality) into a plum diplomatic posting. Despite Kate's tireless efforts to relieve her brother-in-law of his position at the *Tribune,* going so far as to

hire private detectives to shadow him in an effort to find something that might discredit him in her father's eyes, Rob Patterson had supported Rob McCormick's earlier diplomatic aspirations in London and had insisted on his fellow in-law's appointment as one of the three trustees of Joseph Medill's majority stake in the *Tribune.* After succeeding his father-in-law as editor in chief in 1893, however, Patterson had come to reconsider the propriety of allowing the paper's editorial integrity to come under threat. Since the closing of the gates of the World's Columbian Exposition the same year, Rob McCormick had diminished into a genteel, hard-drinking nonentity; without remunerative employment he had been forced to depend on the $500 a month allowance his wife permitted him. With an eye to her sister's meteoric rise in Washington society, Kate McCormick had spied an opportunity to capitalize on the debt of gratitude she felt entitled to claim from President McKinley and the Republican Party on behalf of her departed father, by launching a renewed assault on the various American ministries abroad, and through them, on the courts of Europe. Professing only to hope for her husband's short-term posting at a minor European mission, "just for the experience," she pestered her brother-in-law to such an extent that Patterson put aside high-minded notions of editorial autonomy and appealed unenthusiastically to President McKinley. Leaving nothing to chance, the McCormicks took matters into their own hands as well. In lobbying various Grand Old Party lawmakers, Kate took advantage of what she knew to be their ignorance of the terms of the trust her father had established before his death. Rather than represent herself as one of the beneficiaries of the trust that held the majority stake in the *Chicago Tribune* and her husband as one of its three trustees, she gave those she petitioned to understand that she and her husband were in their own right the stalwart party organ's principal owners. After an as-yet unsuspecting Rob Patterson paid the president two more visits under duress (one of which resulted in an unsolicited offer of his own posting to Rome), McKinley relented at last. On March 7, 1901, Robert Sanderson McCormick was appointed envoy extraordinary and minister plenipotentiary to the Austro-Hungarian Empire. The McCormicks arrived in Vienna on April 23, triumphant. The new American minister presented his credentials to Emperor Franz Josef the following week, on April 29.

"In a couple of months I begin to flutter my pinions for the first time and am curious to see what I can do," twenty-two-year-old Joe Patterson wrote his mother the day before the McCormicks' arrival in Vienna, as he prepared to graduate from Yale in the class of 1901. Despite his regrets at having already wasted too much of his short life "loafing," his concerted ruggedness, his restless curiosity, his deeply rooted proletarian sympathies,

and his growing attraction to journalism had, in reality, given him a greater breadth of experience than many of his peers. After leaving Groton in 1897, he had worked as a cowboy in Wyoming before matriculating in New Haven that fall. Intrigued by the mounting sensationalism, the expanding, eye-catching features, and the increasingly colorful comics sections of the sober *Chicago Tribune*'s multiplying competitors, Joe had spent the summer between his junior and senior years in China, covering the Boxer Rebellion—for the Hearst papers. He had begun work at the very moment William Randolph Hearst had chosen to expand his growing newspaper empire by invading the Midwest, hiring away the *Tribune*'s cutthroat circulation team of Moe and Max Annenberg and their squadron of hoodlums in order to launch the explicitly Democratic *Chicago American* on July 4, 1900.

As Joe considered his future the following spring, however, he informed his mother that he intended to return to the *Tribune* fold as soon as possible after graduation, just as his cousin Medill McCormick had done a year earlier. "Aunt Kate strongly advises me not to begin during the hot weather. Whether her motives are entirely disinterested I am unable to say," Joe ventured shrewdly, foreshadowing the dynastic struggles for dominance over the paper that would prove to be as emotionally battering as the coming Hearst-*Tribune* circulation war for dominance over the Chicago newspaper market was to be bloody. As he brooded on the future, he did not think only of himself. "Don't think me fresh if I venture a few observations about Sis," he wrote his tetchy mother, "even if they have occurred to you already."

> If you leave her in Austria with Aunt Kate she will certainly be courted by some foreign nobleman under delusions as to her money. She has not, I believe, ever had a love affair; and she is 19. So she is about due for one; and the general understanding about the delayed first passion is that it comes strong to make up for the delay. As a general rule, marriages with foreigners, especially Continentals, are unhappy.

"That is all I have to say," he concluded, but then felt compelled to reiterate, "I certainly feel most keenly about it."

LABOUCHERE'S VIEW OF AMERICA

> America's worst product is its dollarocracy, whose members have literally nothing to recommend them. The odds are that either they or their parents acquired huge fortunes by the most questionable

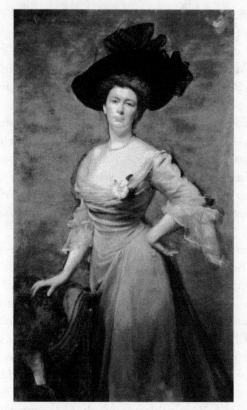

Nellie Patterson by Carolus-Duran, Paris, 1901

means. As a rule they are ignorant and vulgar, building big houses in order to dazzle by ostentatious entertainments, and buying pictures, for which they only care because they have been acquired at high prices, selling their souls to any one who will enable them to hobnob with royalties and their daughters to anyone who will confer a title upon them, despising their own country and institutions, and regarding themselves as in every respect superior to others on account of their dollars.

— HENRY LABOUCHÈRE, QUOTED IN THE
CHICAGO DAILY TRIBUNE, NOVEMBER 11, 1896,
IN NELLIE PATTERSON'S SCRAPBOOK

Vienna is the prettiest, gayest, most frivolous place one could imagine," Cissy exclaimed to her parents, from the capital of the Austro-Hungarian Empire in the spring of 1902. After badgering her brother-in-law and gloating to her sister, in the autumn of 1901 Kate McCormick had confessed to her niece that she was in reality "frightfully lonely and home-

sick" in Vienna, only six months after her arrival as the wife of the new American minister. Kate scoffed not only at the sensual decadence of the city's tight-knit aristocratic circles but at their ceaseless, lighthearted amusements as well: "No dinners, no musicales, no teas! Only balls," she repined to Cissy. The Magyar nobility was more to her taste: "The Hungarians seem to me almost of our own flesh and blood," Kate enthused in June 1901, adding without apparent irony that, as such, she found them to be "spontaneous, cordial, simple and hospitable." Nevertheless, as Christmas 1901 approached, the American minister's wife was still "awfully blue," and, with Medill traveling through the Far East as a *Tribune* correspondent and Bertie still in New Haven, she was anxious for familiar companionship.

Though both Nellie and Rob Patterson considered the McCormicks' deliberate misrepresentations in helping to secure the posting to be scandalous (for different reasons), Nellie, at least, spied a silver lining or two in the dark cloud that had materialized out of her sister and brother-in-law's dramatic rise to prominence in Europe. Now that Cissy was "out" in society and still unmarried, it occurred to Nellie that her daughter might well benefit from the polish, the cachet, the associations, that life in diplomatic and court circles in Vienna would lend. Moreover, Nellie had a new home to decorate. Soon after Minister McCormick presented his credentials to Emperor Franz Josef, she beset her brother-in-law with telegraphic commissions for the selection and purchase of objets d'art, Old Master paintings, prints, bibelots, and fine antiques which he was to procure during his travels throughout the Austro-Hungarian Empire—when not tending to statecraft or the acute attacks of gout and melancholy to which he was increasingly prone.

Over her father's reservations and her brother's objections, therefore, twenty-year-old Cissy set off for the Paris of the East in the spring of 1902. She would remain under the nominal protection and supervision of her well-disposed, if preoccupied, uncle for the next six months. In practice, however, she would become the protégée and constant companion of the aunt whom, many remarked, she resembled increasingly in intelligence, spirit, and wit, and who for so long had channeled much of her formidable energy into belittling, nettling, and attempting by any means available to confound the Pattersons. Stretching over much of the former European territories of the Ottoman Empire from the Adriatic to the Ukrainian frontier, after the Russian Empire, Austria-Hungary was the second-largest nation in Europe at the dawn of the twentieth century. With a population of some forty-five million subjects in 1900, the Dual Monarchy recognized eleven official languages, though many more were spoken throughout its vast patchwork of territories. Its dominions likewise encompassed the myr-

"Uncle Rob": Making full use of his *Chicago Tribune* connections, Cissy's uncle, Robert Sanderson McCormick, became United States envoy extraordinary and minister plenipotentiary to Austria-Hungary in 1901. In May 1902 he was elevated to the position of American ambassador in Vienna before his appointment as ambassador to Russia in December of that year. He remained in St. Petersburg until 1905, when he was transferred to Paris.

iad fault lines separating as many (often competing) ethnicities, dialects, faiths, traditions, and nationalist aspirations. Indeed, Austria-Hungary itself existed as a unit only in its relations with other countries. Internally, the empire was made up of two separate nations, monarchies, and governments. As Cissy alighted in the Vienna of Gustav Mahler, Sigmund Freud, Arthur Schnitzler, and Gustav Klimt, she had landed, too, astraddle the rumbling tectonic plates of established tradition and increasingly exuberant and militant modernity. She reached Vienna in time to witness her uncle's elevation from American envoy extraordinary and minister plenipotentiary to United States ambassador extraordinary and plenipotentiary in late May 1902.

As Cissy made her first forays into Viennese society that spring, the city was still abuzz with the details of the recent sentencing phase in the spectacular gambling scandal that had quickly echoed from court circles to the Austro-Hungarian press the previous Christmas, and from there had rapidly amplified into blaring international headlines over the winter and spring of 1902. On a late night visit to the Vienna Jockey Club on December 21, 1901, Count Josef Potocki had distinguished himself as "the heaviest player at baccarat in all Europe" to date. Though a scion of one of the multiethnic empire's preeminent Polish Catholic families, Count Potocki had become a naturalized Russian subject two decades earlier in order to

claim his ancestral estates in the "confiscated lands" of Volynia in the remote, rural Ukraine, a Russian governorate since the Third Partition of Poland in the late eighteenth century. Potocki's extensive Russian land-holdings, working farms and renowned Arabian and Thoroughbred stud farms, generated enormous income. Nevertheless, when offset against the expenses associated with running these operations—in addition to the count's penchant for big-game hunting and the lavish standard of living he enjoyed in Paris, where he spent much of the year—they yielded little, if any, profit. Anxious to raise cash at the end of 1901, therefore, Potocki sat down at the card table at that old haunt of central and eastern Europe's fraternity of aristocratic, cosmopolitan, and moneyed (though often debauched, syphilitic, and cash-poor) Thoroughbred racing and breeding devotees, the Jockey Club.

"Baccarat is a game little known in the United States," the San Francisco *Sunday Call* informed its readership in the lurid account of the affair it printed on April 27, 1902, "but in Europe it is the chief diversion of those who tempt Dame Fortune's fickle smile." In the span of four hours, seated beneath the Jockey Club card room's framed official notice forbidding games of chance by imperial order, Potocki managed to gamble away between two million and three million crowns (which the American press estimated to be worth some $500,000 to $800,000).* He dissipated the unprecedented sum piecemeal to several members of the Austro-Hungarian and Russian Empires' most ancient and prominent noble houses, as growing numbers of their brethren crowded around in astonishment and horror. Fortified by bottle after bottle of Imperial Tokay, Potocki lost half the sum in a desperate, final twenty minutes of double-or-nothing play, before staggering into the cold Viennese dawn as the game's heaviest recorded loser. "Nothing like it has ever been known," Joseph Pulitzer's New York *Sunday World* gasped, "even in this land of princely plungers." Unable to pay his huge gambling debts Potocki resolved to commit suicide and appealed to his horrified confessor to administer the last sacraments. Public scandal, legal inquiry, and the wrath of the Austro-Hungarian and Russian emperors intervened to rescue the count from insolvency, self-destruction, and eternal damnation, however—at least for the time being. On April 10, 1902, having been found guilty of gambling, nine of the Vienna Jockey Club's titled habitués (one of them, problematically, a member of the Hungarian Parliament and several more the owners and breeders of celebrated stakes and derby winners) had been fined the sum of one

*Approximately $13 million to $21 million in modern American dollars based on the CPI, or roughly $78 million to $120 million based on nominal GDP per capita.

thousand crowns each (roughly $200 at the time).* The punishments for the three principal offenders, Potocki and two other "foreigners," were considerably more severe, however, resulting in their immediate and indefinite banishment from Austrian territory.

Unlike her aunt, Cissy delighted in the whirl of balls, picnics, at-homes, dinners, opera evenings, race meetings, and shooting parties to which she was invited in Vienna and its environs in the spring and summer of 1902. Back in Washington, her mother was beginning to undergo an "odd metamorphosis: that relentless ambition of hers switched around like a spotlight from herself to her child." Fading and widening an ocean away, forty-seven-year-old Nellie pasted the society pages' reports of Cissy's mounting triumphs in Europe into the carefully kept scrapbook from which her daughter had been largely absent previously. With rigorous coaching from punctilious Aunt Kate, Cissy had not only learned but reportedly mastered "with the greatest éclat" the Byzantine etiquette of the Hapsburg court. As one American commentator cheered with something of the jingoism of a spectator at an international sporting event,

> Exquisitely bred, tall and girlish and charming to the eye, she won the complete admiration of the aristocratic dowagers of the court circle, who sat about ready to rend the American girl, who was supposed to break all the laws, human and divine, of sacred etiquette. But Miss Patterson neither talked with the officers while dancing, nor sat out dances, nor swung her arms, nor walked in the street with young men, but kept strictly to the holy conventions of the Austrian court, which dictate that no woman having less than seven generations of noble ancestors can appear before the emperor . . .

Outshining "the little countesses," her continental rivals, whom she dismissed as "a herd of simple sheep," the tall, chic American girl of the striking coloring and the presumed fortune excited the approval not only of well-born matrons but of their sons and grandsons as well. Cissy would finish out the season, according to the clippings in her mother's lovingly tended scrapbook, triumphally: "a great belle in Vienna."

To anyone curious about Joseph Medill and his descendants, particularly those who bore the name Patterson, Nellie's scrapbook offers not only a vivid glimpse of the family, their world, their causes, and the momentous events in which they participated, but also a reflection of the way she saw (or liked to see) herself and her relatives. Spanning the early 1870s to the

*Or about $5,000 based on the CPI, or some $30,000 based on nominal GDP per capita.

early 1920s, the half century between Nellie's teens and her dotage, the clippings she affixed to the book's drab, pregummed pages are at once panoramic and minutely detailed. Surprisingly few of the stories, snippets, photographs, interviews, bons mots, society columns, book reviews, comics, doggerel, drawings, and other materials she took the trouble to save originated in the *Chicago Tribune*. She gleaned the bulk of the book's content from an astonishingly broad variety of sources: American newspapers important and obscure, published in big cities and small towns from Maine to California, and occasionally from British, German, and French publications as well. So diverse was the source material from which she drew (and, apparently, informed herself), in fact, that—given the surgical precision with which she typically excised her selections from all identifiers on the pages from which they were lifted—their sources and origins, their dates and page numbers are difficult to track down and reconstruct, even in an age of admirable historical newspaper preservation, search engines, and digitized catalogs.

Nellie favored in particular interviews, eulogies, approving cartoons—in short, anything touching (favorably) upon the subject of her father. Her scrapbook's pages are filled with commentary about him ("MEDILL FOR SENATOR . . . FEARLESS, ABLE AND HONEST"), his recollections ("MR. MEDILL'S CAREER: Gossipy Sketch of How He Became a Great Editor Given by the Genial Uncle Joseph Himself"), his pronouncements and prognostications ("MR. MEDILL'S GLOOMY VIEW: The Editor Draws a Black Picture of the Consequences of Democratic Rule"), his scientific views ("Joseph Medill's Interesting Physiological Theories, and Their Effect as Applied to Himself"), and, finally, his eulogies ("Mr. Medill was the last of the great personal forces in old-time journalism," "THE PEER AND CONTEMPORARY OF GREELEY, BENNETT AND DANA"). In much the same manner, Nellie's selections chronicle the *Chicago Tribune*'s fortunes throughout the Medill and Patterson eras ("FROM TRIBUNE ARMY: Roster of Employes [*sic*] Who Served in the Civil War," "NEW HOME OF THE CHICAGO TRIBUNE," " 'TRIBUNE' AS A MODEL"). But her choices do not focus exclusively on the patriarch; they extend further back to her more distant forebears as well ("ROBUST in Manly Qualities Is Judge Patrick, Noted as 'The Old Roman' "). Nor did Nellie limit the scope of her collection to her own antecedents ("GREAT LIFE GONE OUT: Death of Dr. R. W. Patterson," "Well-Known Divine Succumbs to Grim Reaper"). However broad the divide between Nellie and Rob Patterson, it is clear that the editor's daughter took some pride in her husband's journalistic achievements—or at least in his stature and repute ("the successor of the late Samuel J. Medill as managing editor of the Chicago Tribune is Robert W. Patterson, Jr., who has filled the position

since the beginning of Mr. Medill's last illness with a very large measure of ability and success").

She carefully saved the obituary notices of her mother, whose "many sterling qualities of mind and heart," whose sacrifices and losses, Nellie would only come to appreciate, she would realize sadly, in the aftermath of the trials her own daughter was soon to face. Whatever squabbles Nellie may have had with her delicate baby sister, she preserved page after page of clippings, domestic and foreign, about Josephine Medill. The "Society Chat" of the late 1880s and early '90s ("A Prominent Chicago Young Lady") gives way suddenly to the international journalistic vigil over Josie's last illness, before tolling the sad public tidings of her death and obsequies ("MISS MEDILL'S FUNERAL," "HER FRIENDS MOURN HER," "Beautiful and Eloquent Tribute to the Memory of Miss Josephine Medill").

Naturally, Nellie preserved the milestones of her ascent in the nation's capital, just as she basked in the reflected luster of the home she was building there, which was sure to be, the local press reported, "in a class by itself." Her clippings reflect her preoccupations with her connections and their fortunes, both literal and figurative ("LADY CURZON MAR-RIAGE FUND REACHES TOTAL OF $1,543,160," "Disposition of Vast Estate of Marshall Field").

If the aggregate of mementos preserved in the scrapbook present a carefully rendered family portrait, on closer examination they serve as a clear reflection upon their compositor as well. Though only a small fraction of the material was actually written or created by Nellie or members of her family, the scrapbook is as much a mirror of her joys and hopes, her worries and schadenfreude, as it is expressive of her personal qualities, her opinions, her abilities, her penchants and piques. The album is a testament to the fact that the Medill girls, the daughters and granddaughters of editors, had early on acquired the habit of reading voraciously and widely. Its contents demonstrate also that, like so many members of her family, Nellie held her opinions fiercely and that, like them, she was drawn to express them in print. Barred both by convention and by their father's careful planning from involvement in the operation of the *Tribune,* Nellie and Kate succeeded nevertheless in making the paper an outlet, albeit a small one, for their opinions in their unrelenting letters to the editor, which a beleaguered Rob Patterson and his successors duly printed. In hers, Nellie revealed herself under a variety of pseudonyms and false initials both as an ardent champion of Chicago's abused cart horses and stray dogs and as a chauvinistic patriot, offering affronted retorts to the British Radical Liberal member of Parliament Henry Labouchère's excoriations of the United States and its vulgar "dollarocracy" (the offending text of which Nellie

commemorated in her scrapbook with an angry X scratched in black ink). Her many factual and stylistic corrections to the texts she included in the volume suggest that she was unable to stay the editor's hand that rose up in her at the sight of journalistic inaccuracy, inefficiency, or inelegance—as it had in her forebears and would again in her descendants. She devoted many pages to her son Joe's triumphs on the Yale crew and football team, to his coverage of the Boxer Rebellion for the Hearst papers, and, of course, to his earliest pieces for the *Tribune,* noting with pride in her scrawled marginalia his extreme youth at the time: "aged 22."

Though the occasional remnants of clippings torn out and pasted over suggest some editorial revision throughout the years, the pieces that Nellie saved progress, for the most part, in chronological order. Among these, Cissy makes her first appearances comparatively late (typically, dazzlingly dressed at a variety of balls, fox hunts, musicales, dinners, weddings, horse shows, and race meetings on two continents)—at the end of her teens (as she was often reported to be at the time) or in her early twenties (as she was, in fact). Cissy's contributions to the corpus are unusual, however, in that besides the printed pages in which she materializes, the rest sprang from her own hand. She had continued to draw, with growing assurance and skill, since her school days. With the exceptions of the occasional horse or male figure, the diminutive, apt pen-and-ink portraits she rendered while on her European travels with her aunt portray the languid female forms of old. With a growing regularity, however, these possess the unmistakable high cheekbones and pug nose of the artist herself—the wide face narrowed and flattered in three-quarters view. Amidst the extensive, lavishly illustrated clippings that detail Joe Patterson's November 1902 nuptials ("SOCIETY ASTIR FOR PATTERSON-HIGINBOTHAM WEDDING," "Fashionable Throng at Grace Church Witnesses the Event," "MANLY MEN IN HIS CEREMONY: Groom, His Best Man and Ushers Admired for Attributes of Mind and Muscle"), Nellie grouped a number of small pen-and-ink sketches Cissy had made before returning from Vienna in time for the festivities. One of these is particularly striking, both for the uncharacteristic force of the pen strokes that compose it and because, almost alone among Cissy's few surviving thumbnail portraits of men, it looks away in obstinate profile. At once remote and magnetic, the dark male figure of the handsome features, heavy eyebrows, and elegant mustache leaves the unsettling impression of disdainful pride and, perhaps, of cruelty as well.

In the summer of 1902, Cissy and Kate had taken a day trip at the invitation of Aristides Baltazzi. A renowned horseman whose cumulative successes in breeding for the turf were unmatched throughout the Austro-

"And again she went over, as if with
tiny brush and pencil, each detail of
his face: the intense black eyes; the
long womanish mouth; the lean
jaws, sloping down to the narrow
chin, and the jet black hair spring-
ing with odd vitality from the
pale fine skin of the forehead."
—ELEANOR GIZYCKA,
FALL FLIGHT, 1928

Sketch by Cissy

Hungarian Empire, their Anglo-Greek host was also a canny businessman.
Every summer since 1886, Baltazzi had arranged for a luxurious private
train car to carry his guests—typically, members of Vienna's notorious
Jockey Club, central and eastern Europe's leading trainers and breeders and
other assorted, horsy notables—for the two-hour journey from Vienna to
southern Moravia. Upon arrival, the guests were conducted to the tents
pitched on the lawns of Baltazzi's magnificent Napajedla Stud Farm, where
he treated them to caviar, champagne, and afternoon tea in the English
style, while they watched (and hopefully participated in) his annual year-
ling sales. Speaking English fluently, Baltazzi's seventeen-year-old daugh-
ter, May, had met Cissy in Vienna that spring. Having discovered her new
acquaintance's love of horses, she asked her father to invite the American
ambassador's wife and niece to the sales as a result. As the Napajedla Thor-
oughbred foal crop of 1901 went on the block one by one, May Baltazzi
introduced her attractive young American guest to another English-
speaker she knew, an epicurean Polish bachelor and former cavalry officer
who had come to the sales from Vienna with his Jockey Club brethren. As
it happened, the charming, cosmopolitan Count Josef Gizycki even had
some experience of Cissy's native United States, having visited Newport,
Rhode Island, only three years before as a guest at Julia Grant's wedding to
Prince Mikhail Cantacuzène.

The Bridesmaid

The last months of 1902 and first of 1903 ushered in considerable change for the Patterson and McCormick families, not least for Joseph Medill's two young namesakes. By and large, the family's female members tended to greet these ordinarily happy, natural advances of filial independence, young love, marriage, promotion, and preferment, as little more than unwelcome or, worse, long-feared upheavals. As Joe Patterson would remember these "brave days," this "period of glamour," just after graduating from Yale, "in Roosevelt's first term, life was just a succession of bridal parties of various sorts."

Recently returned from Vienna, in white liberty gauze with pink plumes in her hat, Cissy helped solemnize the nuptials of her brother as one of seven maids to his bride, Alice Higinbotham. The previous winter, observers had noticed twenty-three-year-old Joe Patterson "playing the role of shadow" to his sister's former Farmington schoolmate, not only after chancing to meet Alice and the Higinbothams on a trip to California, but back in Chicago at Mrs. Potter Palmer's sought-after "third Thursdays" as well. Rumors of the engagement of the only son of the *Chicago Tribune*'s editor to the daughter of that venerable city elder, Harlow N. Higinbotham (another of Marshall Field's partners and a prominent figure in the successful execution of the World's Columbian Exposition a decade earlier), had "sped over all sides of town as thoroughly as the Chicago fire" for much of early 1902, fanned as they were by unconfirmed newspaper speculation on the impending match and its local dynastic implications. The formal announcement of the couple's betrothal appeared in print in June. On November 19, the full choral service held at Grace Church before a "fashionable throng" of Chicago's elite was reported to be the "most brilliant as well as the most beautiful wedding of the Winter," one of Nellie's many carefully preserved clippings on the affair recorded.

"Fired, doubtless, by the success in love of this younger cousin," the Chicago society commentator "Odette" speculated amidst the journalistic excitement the Higinbotham-Patterson match had sparked, "Medill McCormick, who had been making frequent journeys to and from Washington for a couple of years, not to speak of distorting his coat pockets by photographs of the handsome Miss Hanna, decided that life all by his lonesome in the big brown stone Medill house was unbearable." "Odette" was mistaken, however: Medill's engagement had long predated Joe's. Years of deepening attachment, damped (or, rather, kindled) into clandestine engagement by parental disapproval on both sides, had prompted twenty-

One of Cissy's self-portraits from
Nellie Patterson's scrapbook,
ca. 1900

five-year-old Medill McCormick and his longtime sweetheart, twenty-two-year-old Ruth Hanna, to take their future together into their own hands several months before. In June, Medill's request for Ruth's hand had been rebuffed unceremoniously in a botched attempt to pin Mark Hanna down by surprising him at a game of solitaire. As a result, by the end of the summer Ruth felt compelled to issue an ultimatum. Having served faithfully and ably (though with little approbation and less encouragement) as her redoubtable father's confidential secretary in Washington since shortly after his election to the United States Senate from Ohio in 1897, she mustered the fortitude to demand "one good reason" for not being allowed to marry Medill McCormick. If her father could not provide one within two weeks, she continued resolutely, she would announce her engagement to the press by herself.

Within that time, another shift in status had been publicly reported. On September 26, 1902, President Roosevelt announced his decision to reshuffle six American ambassadors and ministers at important European posts as the result of the retirement of his representative in Germany. Ambassador Robert Sanderson McCormick would be leaving Vienna for St. Petersburg shortly after the New Year. Meanwhile, Senator Hanna's two-week time limit having elapsed without comment on Medill McCormick's fitness as a prospective son-in-law, Ruth duly contacted the society editor of a Cleveland paper to announce her engagement before retiring for a sleepless night. The next morning, her father greeted her sternly from behind his open newspaper: "Well, I see you got your ad in." Though the Hannas confirmed the engagement to the press with resignation, the sparse, cursory coverage that the happy couple's impending union received in the midwestern and national press in late September reflected both families' dispositions on the matter.

Kate McCormick's reactions to the transitions she and her family faced were even less enthusiastic. "Ruth, I think, is able. I know she is only too willing to do her part," Medill had written his father in a plea for the diplomat's intercession in keeping the peace during the engagement. "Mother must not only be civil to her," Medill demanded, allowing "she is

that—but she must bridle her tongue when she discusses Ruth in the family or out of it." The period of Medill's engagement was not the first time Ambassador McCormick had been called upon to bring about détente between mother and son. "My Dear Daddy," the twenty-four-year-old *Tribune* correspondent, recently returned to Chicago from Asia, had written on Christmas Eve a year earlier in a letter that served both to announce his decision to join the family paper's local staff and to make a heartfelt plea. "I have worked hard for six months," he explained to his father. "I am beginning to 'find myself'—give me time to get my balance." Though earnest and hardworking, Medill had grown up to be exquisitely high-strung. As Cissy had not yet arrived in Vienna at that point, his mother's complaints about the city and its inhabitants had prompted Kate to threaten a prolonged return visit to Chicago, which Medill begged his father to forestall. "This does not mean that my love for her is not as great as ever," he hastened to add, "but we are both nervous persons and she continually interferes." In the quarter century since Kate had christened her sensitive firstborn, conferring upon him (if not burdening him with) his grandfather's name, she had expressed her relentless desire to make Medill the *Chicago Tribune*'s heir apparent. His work for the paper since graduating from college—and particularly since his cousin Joe Patterson's recent (but already, Medill admitted, "very competent") employment there—had impressed upon him more forcefully than ever the staggering weight of his mother's vicarious ambitions.

The McCormicks' Austro-Hungarian hosts were widely reported to have graciously expressed "much regret" at the departure of the American ambassador and his wife. The emperor himself offered warm personal regards and gratitude by presenting Rob McCormick with a signed photograph in a handsome gilt frame in exchange for the outgoing ambassador's letter of recall. According to "Odette," in departing Vienna, Kate expressed "some regrets" too, though principally at having spent $5,000 "brightening the faded glories" of the palace she and her husband would now be forced to vacate before their lease had expired. Back in Chicago for her nephew's wedding, Kate insisted on assuming the grim task of similarly brightening the old Medill mansion at 101 Cass Street for occupancy by her doted-upon firstborn son (whom she saluted routinely as "Darling Flirter" in the relentless correspondence with which she bombarded him during their separations) and his chosen bride (of whom she had disapproved since Ruth was literally still in braids). As autumn turned to winter, the many society columns, features, and photo spreads devoted to Joe and Alice's wedding sparked greatly reinvigorated and expanded national coverage of Medill's engagement to the "popular," "handsome," "tactful," "intelligent," "modest," "charming" youngest daughter of one of the nation's most pow-

erful lawmakers. Meanwhile, preparing to embark for St. Petersburg just after the holidays, Kate held forth to friends, acquaintances, and reporters alike with characteristic—if not enhanced—candor on her displeasure at her husband's new posting in distant "darkest Russia." "The McCormicks do not seem to be looking forward to their sojourn at the most brilliant court in Europe with as much joy as they might," the omniscient "Odette" reflected. "Mrs. McCormick dreads the cold and the isolation of St. Petersburg in the north and declares that nothing will console her for going such a distance from home but having Sissy [*sic*] Patterson to stay with her all winter."

"Watch the way that girl moves," Theodore Roosevelt was said to have remarked to his daughter Alice of her cohort, the only granddaughter of that Grand Old Party founding father, Joseph Medill. "She moves like no one has ever moved before." If the young president was charmed by Cissy Patterson's sinuous grace, as many had been before and would be afterward, he was unfavorably impressed by the influence she exerted over his irrepressible eldest child. Inevitably, Cissy had been introduced to the most prominent of her Washington contemporaries while visiting her ambitious mother during school holidays, convalescences from her elusive and protean ailments, and, more recently, interludes between her travels abroad with her aunt and uncle. Foremost among the members of Cissy's Washington set was the ebullient first daughter, Alice Roosevelt, who had emerged from the maelstrom of McKinley's assassination and her father's swearing-in in September 1901, a seventeen-year-old overnight sensation and international fashion plate. "I can be President of the United States," Theodore Roosevelt confessed famously to Owen Wister, after Alice had burst in on her father and the writer several times in a row, her "affectionate" pet garter snake, Emily Spinach, twined around her arm, "or—I can attend to Alice. I cannot possibly do both!"

Convivial, irreverent, and magnetic, Alice Roosevelt and Cissy Patterson had a great deal in common—most particularly, perhaps, a shared sense of humor (or "detached malevolence," to use Alice's phrase). Though both had been only haphazardly educated, both were keenly intelligent and largely self-taught, and both read voraciously. Each had been brought up in a climate of patriotism, partisanship, and privilege. The material abundance both girls had always known belied the emotional deficiencies with which each had contended in childhood, as well. Alice's mother had died of renal failure two days after her birth, only eleven hours after Theodore Roosevelt's own mother had succumbed to typhoid under the same roof. Alice spent her first three years in the loving care of her "Auntie

Bye," TR's sister Anna Roosevelt, before being torn away to live with her now-unfamiliar father and his new bride. Theodore Roosevelt's ineffable grief at the double tragedy that had attended Alice's birth conspired with Edith Carow Roosevelt's jealousy of her beautiful predecessor to ensure that neither would ever speak to the child about her departed mother and namesake. Alice had grown up, therefore, with an adored but remote father whose vigorous attentions were occupied elsewhere and a "withdrawn, rather parched" stepmother who cared for her dutifully, if disapprovingly, while generating and nurturing her own sizable brood. Like Joe Patterson before them, in early childhood the five younger Roosevelts knew their arch, unruly half sister by the nickname "Sissy." And like Cissy Patterson, Alice exhibited a penchant for acting out, though not with her friend's tempestuousness; intentionally or unintentionally, Alice's notoriety, her iconoclasm, her eccentricities, her contrarian humor and indeed, her choice of companions were effective means not only of commanding her busy father's attention, but (gratifyingly) of rankling him as well.

"Our friendship had the violence of a bomb, the duration of a sky-rocket," the Countess Marguerite Cassini recalled of her own camaraderie with Alice Roosevelt in Washington during the first years of the twentieth century. The seasonal addition of Cissy Patterson to this explosive admixture yielded a combination the local society reporters delighted in describing as Washington's "Three Graces." Classically demure though the sobriquet might suggest they were, in reality the girls and their circle shared "a common taste in fun and pranks, a delight in flouting the conventions, in mockery, in outrageous behavior generally." Their antics ran the gamut from the brazen (public displays of gum chewing, nose powdering, and cigarette smoking), to the iniquitous (enthusiastic betting on games of chance), to the unladylike (unchaperoned jaunts in Maggie Cassini's "machine" through the streets and around the circles of the capital at breakneck speeds approaching fifteen miles per hour). "I pray for *money*!" was a familiar refrain in Alice's diary by late 1902, her gambling and dressmakers' debts having mounted astronomically since Maggie and Cissy (who drew far larger allowances) had entered her orbit. At the girls' widely reported antics and growing profligacy, "the President scolded," Maggie Cassini reminisced, "my Father raged."

Though not fully aware of it, Washington's Three Graces were united also in the sadness—and anger—that lay at the heart of their home lives. Employing every possible stock Victorian euphemism, the American press had characterized Miss Marguerite Cassini variously as the "adopted daughter," "ward," "niece," or, occasionally, "grandniece" of Arthur Paul Nicholas, Marquis de Capuzzuchi di Bologna, Count de Cassini, since the

pair had landed in the United States in 1898, governess in tow—he, to serve as the first imperial Russian ambassador; she, though sixteen years old, to play the role of official hostess at Nicholas II's embassy in Washington. There, Miss Cassini befuddled strict adherents to diplomatic protocol, who puzzled over how to correctly place the unmarried, teenage official hostess of the Russian embassy according to rank at the ceaseless functions she was required to attend. From the day of their arrival the ambassador and his ward regularly made front-page news, "so everything we said, wore, did or did not do was spied upon, commented upon, torn to shreds," she recalled. "Yellow journalism was very yellow and nothing was sacred."

Rewarded with their hereditary Russian title for an ancestor's aplomb in a late-eighteenth-century Maltese naval battle, generations of the Capuzzuchi-Cassini family's firstborn sons had left Italy to study at the elite Imperial Lyceum in St. Petersburg before entering the service of the tsar. An ugly public divorce from his first wife, a Russian princess, in St. Petersburg in the 1870s had served to make "an elaborate charade" (as Cassini's grandson, Oleg, would later put it) of Count Arthur's wayfaring domestic arrangements afterward. In 1880, fearing the ill effects of further scandal on his diplomatic career, the elder Cassini had secretly and morganatically remarried, this time to "the White Cat," Dada Van Betz, "a Vaudeville performer of the very first order" with whom he had become besotted after hearing her sing at a command performance at Grand Duke Vladimir's palace in St. Petersburg. Having given up family, friends, and the conviviality and comparative freedoms of bohemian life along with a promising career on the stage, Cassini's "legal but unacknowledged wife" never accompanied her husband on his official visits to St. Petersburg. Rather, she "lived beyond the eyes of the world in a realm of her own—of her music, her beautiful jewels, her continuous games of solitaire." When their daughter, Marguerite, was born in 1882, her mother took on the public role of "Mme. Schalle, constant companion since birth" and "governess" to the count's "pretty niece" during the family's various postings around the globe. The deception and the resulting "near ruin" of her mother's life was for Maggie "a cloud that hung over us everywhere we went, a mystery I was able to understand only as I grew older . . . It robbed me of a normal childhood and girlhood, set all diplomatic Washington by the ears and kindled and perpetually fed in me a wild resentment on my mother's behalf."

In the fall of 1900 all diplomatic Washington (along with prim followers of society gossip and diplomatic affairs in newspaper columns across the United States) had indeed been set on its ears by the renewed whisperings of scandal that surrounded the Russian ambassador's celebrated eighteen-

year-old "ward" after she returned from her holidays as "Countess Cassini." That summer, during his audience with the tsar, the ambassador had screwed up the courage to stammer a confession of his secret marriage and the true identity of his "niece," when the "Little Father" cut him short. " 'I know, I know,' " the tsar assured him sympathetically, "as if for years the Emperor had been waiting for this. 'And now let us think what we can best do for Marguerite.' " Though Nicholas duly legitimized Maggie by imperial ukase shortly afterward, the gesture had the unintended effect of perpetuating the family's painful ruse in Washington. "During his stay in Russia last summer," the *Washington Evening Times* reported in its "Social and Personal" column on October 30, 1900, Count Cassini had "arranged for the legal adoption of his grandniece . . . as a daughter. Mlle. Cassini will become the heiress of her distinguished uncle's large estates, and is entitled to the privileges of a daughter, including the title of Countess Cassini."

Though the legitimization/"adoption" had not publicly resolved the dolors of Mme. Schalle's domestic situation, it came in time to open previously inaccessible matrimonial prospects to Maggie. Marriage occupied an ever-larger portion of the consciousness, hopes, and fears of the still-unmarried Three Graces, as their friends, relatives, and contemporaries entered into the institution in ever-larger numbers. Indeed, for the first years of the new century, more than any other consideration, marriage—both others' and Cissy's own—had served Nellie Patterson as the central organizing principle around which she had orchestrated her daughter's plans. With Cissy no longer in school but not yet part of a family of her own, her time had been devoted to attending the weddings of her friends and relatives, with an eye to the ultimate fulfillment of the imperative for which she had been cultivated all her life. After returning from Vienna for her brother's wedding, Cissy served as a bridesmaid at the nuptials of an old family friend in early December 1902, before joining her mother in Washington for the holidays. Though the north wing of Nellie's nearly completed home on Dupont Circle had suffered fire and water damage when paint cans stored in the attic had combusted four days before Joe's wedding, the damage would be repaired and the home completed and ready for occupancy by Christmas. Cissy was to spend a month with her mother in the capital, reacquainting herself with her circle of friends there, before setting off to join her aunt and uncle in St. Petersburg until springtime, when all three were to return to the United States in time to attend Medill's wedding to Ruth Hanna.

"In those days the moment one had been 'out' for two or three years one was expected to marry," Alice Roosevelt recalled. "If you didn't you ended

up with a thermos of tea in your room, alone, like my poor Aunt Emily" (namesake to the White House snake). In emulation of European court custom, "society's arbiters" in the United States at the turn of the century prescribed that girls should typically mark their transition to womanhood and their availability for marriage by making their "first appearance in society" at the age of seventeen or eighteen. When Cissy had been presented in Chicago on New Year's Day 1901, she had already celebrated her nineteenth birthday. Further east, this initial, midwestern début had been obscured, conveniently, by the far more spectacular presentations that followed for the next three years. Having curtseyed before Emperor Franz Josef at court in Vienna the previous spring of 1902, she would be presented to the Emperor and Autocrat of All the Russias and his Empress Consort in St. Petersburg shortly after joining her aunt and uncle in the winter of 1903. A year after that, in February 1904, to the musical accompaniment of the Marine Band Orchestra, Nellie would inaugurate the magnificent ballroom of her home on Dupont Circle with a lavish dance to introduce her daughter—officially this time—to Washington society. Cissy's repeated débuts in disparate locations created at least the appearance of turning back the clock on her marital prospects. Though only twenty-one as she prepared to set off for St. Petersburg, she was already self-conscious about her advancing age. Over the past few years she had served as bridesmaid to a number of old family friends as well as to many of her schoolmates from Boston and Farmington. Having recently attended Alice Higinbotham, Cissy would again wear bridesmaid's pale green a few months hence when her beloved cousin Medill married Ruth Hanna. If Cissy's contemporaries were becoming engaged and marrying in growing numbers, her slightly younger Washington intimates were still unattached. She was a year older than Maggie Cassini, and though two and a half years older than Alice Roosevelt, she pretended (to Alice's enduring mirth) to be two years younger. Indeed, the addition of several years to Cissy's birthdate and its resulting subtraction from her actual age would persist from this period until the end of her life with ironclad uniformity on her official documents.

With marriage an increasingly urgent imperative, the three fast friends and the other girls of their Washington set faced the perplexities and piques of fishing from the same pond. "It became more and more fun to tease my friends by trying to take their beaux away from them," Maggie Cassini recalled merrily. Each of the Three Graces, having known distant or problematic relationships with their respective fathers, seemed to prefer the company of older men. Alice recalled being bored by the "frightfully nice

and proper and respectable" prep school boys and college men she encountered at dances up and down the eastern seaboard. This was an era "before deodorants," she lamented; "being clutched in one's partner's arms and whirled around a stifling room could be a heady experience." The men of their Washington set answered, therefore, the requisites of maturity, joviality, and status. Among them there were a number of up-and-coming young European diplomats a decade or more the girls' seniors, like the newly arrived Portuguese minister, Viscount d'Alte; the French embassy's Viscount de Chambrun; and those two "young and popular bachelors," the Austro-Hungarian embassy's Count Hoyos and Baron Rubido-Zichy (the latter, a superb horseman and a member of Vienna's Jockey Club).

"My father wanted me to meet all kinds of people but not to marry them," Alice reflected. Abhorring the current rage to unite ill-gotten American lucre with unearned European distinction, TR had impressed it upon his eldest that, her shenanigans and flirtations aside, in choosing a husband, "a foreigner would have been bad, except perhaps an Englishman." Indeed, as the infallible Mrs. E. B. Duffey had warned in the peremptory "Washington Etiquette and Etiquette of Foreign Courts" section of her 1877 *Ladies' and Gentlemen's Etiquette: A Complete Manual of the Manners and Dress of American Society* (which would remain in print well into the coming century as the girls considered their prospects for the future),

> Titles in continental Europe are so common and so frequently unsustained by landed and moneyed interests that they have not that significance which they hold in England. A count may be a penniless scamp, depending upon the gambling-table for a precarious subsistence, and looking out for the chance of making a wealthy marriage. It is sorrowful and humiliating to know that there are many American girls who are willing to forgo the right of being republican queens and to sell themselves and their fortunes to a foreign adventurer for the privilege of being known as countesses or baronesses.

Luckily, therefore, the girls' set included a number of eligible young Americans, as well. Among these was White House chargé d'affaires Major Charles McCauley; a promising young lawyer, Dick Merrick; and, as the Fifty-eighth Congress made ready to convene in the winter of 1903, a number of newly elected representatives as well, among them Butler Ames of Massachusetts's Fifth District.

"Cissy was an enchanting creature," the elderly Alice would remember of the "great friend" of her late girlhood. "She had a tall, slim figure, great

elegance of line, masses of red hair, brown eyes set very far apart, and a foolish little nose." Alice's mature recollections of Cissy hint that perhaps the seeds of rivalry existed between the two fast young friends from the start, however: "Everybody said, 'How charming she is,'" Alice recalled, "'despite her looks.' Well, today she would doubtless be called a beauty. She wasn't by the standards of the time anyway. But she had an attraction and charm and vitality, which was much more important." Cissy's unorthodox face notwithstanding, her alluring vim, her beautiful figure, her sensual grace had succeeded in captivating the attentions of another newly elected, newly arrived, and eminently eligible congressman in the capital that winter, this one from Ohio's First District, Nicholas Longworth IV. "If any man ever caused trouble between Cissy and me," Alice Roosevelt Longworth mused long after, "it was . . . Nick. He adored her."

"To the disappointment of everyone Miss Patterson has decided to go to St. Petersburg to spend the winter with her relatives, our Ambassador to that country and Mrs. Robert McCormick," the *Philadelphia Inquirer*'s Washington society column lamented on January 28, 1903. "She will enjoy the gayeties of a Russian Winter." That evening, at a small dinner at their Washington home, Senator and Mrs. Hanna made the formal announcement of the engagement of their youngest daughter, Ruth, to Ambassador and Mrs. McCormick's elder son, Medill, the cousin for whom Cissy had long harbored a particular affection. But as Washington's Union Station receded behind her one day and New York's Statue of Liberty the next, Cissy regretted leaving family members, recent friends, and new beaux at home perhaps less than she looked forward to rekindling an old flame abroad. Since their meeting the previous summer in Moravia, Cissy had seen more of the magnetic and enigmatic Count Josef Gizycki. In the combined frivolity and matrimonial focus of the past few months, she had allowed him the liberty of corresponding with her and had taken the liberty of responding. Her family was aware of the count's attentions. Indeterminate whisperings had reached them, too, of his reputation as an infamous "bad egg." Aunt Kate had left the United States for Russia several weeks before, livid at the prospect of the long, dark winter among "primitive" strangers that stretched before her, and distraught at the inevitability of her return home in the spring to witness the loss of her darling eldest son to a daughter-in-law she could not accept. In this spirit she had dismissed Rob and Nellie Patterson's anxieties about the possible admission of an undesirable in-law to their own family circle with impatient, parting assurances that, should the McCormicks meet Count Gizycki again in St. Petersburg, she would have only to "drop him the hint" that Cissy "didn't have a cent of her own in the world" in order to dispense with him.

AMERICAN GIRL'S SUCCESS

Niece of U.S. Ambassador
Having Huge Time in Russia

—*PHILADELPHIA INQUIRER,* MARCH 1, 1903

In late December 1936, while carefully organizing and preserving old family papers and mementos in Chicago, the fifty-six-year-old Bert McCormick waxed nostalgic about his father's diplomatic career and the ravaged glories of turn-of-the-century St. Petersburg. As General Secretary Stalin embarked on a new, more expansive and bloodthirsty phase in the prosecution of purgative "revolutionary justice" throughout the Soviet Union, McCormick contacted his exotic cousin to encourage her to record her recollections of the extinguished Russian Empire. "I think you owe it to yourself and to history to do this work," he suggested gallantly. Although she thanked him for the compliment, Cissy deflected the suggestion, claiming, "The truth is I just didn't have the brains to make even superficially interesting observations at that time." Her response was as diffident as it was in many respects untrue. Eight years earlier, in 1928, her second novel, *Fall Flight,* had spent many weeks on best-seller lists across the United States. Though the novel had otherwise been received enthusiastically by critics and general readers alike, the *New York Times,* despite allowing that "the author's description of the Tsar's court and of Russian Society are expert and entertaining," had dismissed the work as "valuable chiefly for its picture of pre-war Russian society." It was not simply the pomp of the Russian court at its twilight that Cissy had rendered faithfully, however. Whatever the novel's stylistic merits or shortcomings, so closely do the verifiable details of her own experience resemble many of the incidents rendered in *Fall Flight* that the book's claim to being a fictional account amounts to something of a fiction in its own right.

As a child, *Fall Flight*'s heroine, Daisy Shawn, is "tiresome, tiresome, tiresome" to her mother. If possible, beautiful Susan Shawn has even less patience for Daisy's father, a luckless, tubercular dentist with whom she had run away from her native Cleveland at an early age, to marry against her parents' wishes. As Jack Shawn's Chicago practice languishes, Susan Shawn inherits a substantial legacy from her grandmother in California. Her new affluence engenders in her a twinned aspiration and contempt (with which Kate McCormick and Nellie Patterson might well have empathized). As "Mrs. Shawn's reasonable ambition to get along in the world developed overnight into an obsession," she begins at the same time "to despise her

husband with a pitilessness which turned finally to hate: because he was reflective and lazy; because he drank too much; and because he was affectionate and tenderhearted and she could so easily hurt him." Conveniently, Jack Shawn dies soon afterward, releasing his wife to pursue her social ascent, encumbered now only by her slim, redheaded, adolescent daughter whose "nose turns up so much," one character cracks, "I fear she suffers when it rains." In her climb, Mrs. Shawn is delighted to meet "*the* Mrs. Rutherford" at a Chicago ladies' luncheon. The fabulously wealthy social arbiter of international repute is touched by the ravishing widow's practiced stoicism and studied deportment and takes the younger woman under her wing. Unloaded on an amiable, "respectable" family of lodgers on Chicago's North Shore while her mother travels with Mrs. Rutherford in Europe, Daisy receives a cablegram one day, informing her that she has a new stepfather: one Oliver Redmond, the recently appointed American ambassador to Russia. Several months later, the new Mrs. Redmond sends for her now-marriageable daughter, and Daisy embarks for St. Petersburg . . .

Bert McCormick's wishes to read his cousin's firsthand reflections on late imperial Russia were as long held, evidently, as they were quick to be dismissed. Thirty-three years before entreating Cissy to write her memoirs, the awkward Yale senior had importuned his sought-after younger cousin to grace him with her impressions of St. Petersburg during her sojourn with his parents. "I would be glad to get your opinion of the people you meet and would be honored if you take me into your confidence," he ventured in the winter of 1903. Indeed, he had had no direct word from any of his relations since their arrival in the imperial capital several months earlier. "I have been complaining for some time that the only word I get from St. P. comes via the daily press. This is not as it should be," he chided Cissy in an unaccustomed stab at levity: "People who withdraw themselves from their relations in order to shine in foreign courts should at the very least recompense the deprived ones with accounts of their doings." If, in her scanty spare time, Cissy was moved by her cousin's pleas to respond, no record survives. While Bertie (unlike his brother Medill) would be forced to content himself with following his relations' Russian movements in newsprint rather than in their own handwriting, society and diplomatic correspondents in publications across the United States ensured that no interested reader would go long without news of Ambassador and Mrs. McCormick and their popular niece, Miss Patterson of Chicago, during the winter and spring of 1903.

Amidst mounting imperialist tensions between Russia and her eastern neighbors over Manchuria and the Korean peninsula, the American press noted that the tsar and tsarina had received the incoming American ambas-

sador with unusual consideration at the imperial family's magnificent eighteenth-century country estate, Tsarskoye Selo, outside of St. Petersburg, on January 12. The couple had even condescended to grant McCormick an unusually long interview of some twenty minutes in their private apartments. Nicholas and Alexandra had graciously rearranged their busy official schedules, it was noted, to permit the new ambassador to present his credentials in time for him to be included in the traditional Russian New Year's reception two days later. In the meantime, Empress Alexandra and her mother-in-law, dowager empress Maria, had continued to favor the envoy by inviting him to lunch at the Gatchina Palace the following day. In short, the American press agreed unanimously with the plainspoken *Decatur (Illinois) Herald* when it contended that "Tsar Nicholas Was Real Nice to Ambassador McCormick." Such conspicuous tokens of imperial goodwill—favoritism even—toward the ambassador, and by extension the United States, could only bode well for Russo-American relations. Or did they?

"Cables to the AP and Hearst papers announce that you are brilliant and gay and that the ambassadorial uniforms (at which the press pokes fun) are as modish and becoming as Mrs. McC's are gorgeous," Medill teased his father on February 16, some six weeks after the latter's arrival in St. Petersburg. The initial unanimous and widespread American press reports of the tsar's "good will," "most cordial welcome," "friendship," and "very marked attentions" toward the new American ambassador had done less to elevate Robert Sanderson McCormick's reputation at home than they had to raise the hackles of patriotic egalitarians among his countrymen. Could one so lavishly favored represent American interests in St. Petersburg—or was the democracy's representative poised to become a fawning pawn of imperial autocracy in his reports back to Washington? The debate over McCormick's loyalties and judgment, which would dog him for the rest of his diplomatic career, began as a spirited examination of his official sartorial choices almost immediately after he presented his credentials.

Amidst the blazing array of medals and decorations, cockades, sashes, swords, plumes, and spurs of the officials, officers, and foreign envoys, Ambassador McCormick, clad in the sober morning suit of the American diplomat, had been mistaken for a waiter during his first official sortie into society. Shrinking at the thought of having "the finger of conspicuousness pointed at him" a second time, he took the imperial chamberlain's advice and appeared in Russian court dress at his next outing—without first consulting Washington. The following morning, the miracles of electromagnetic telegraphy made it possible for the dots and dashes that composed the special dispatch on the subject of the American ambassador's wardrobe to crackle their way along the wires from St. Petersburg, to Paris, to Ire-

land, through the frigid depths of the Atlantic Ocean via sunken cable, to Newfoundland, to New York, and across the central plains of the United States to the receiver at the offices of the *Globe-Democrat* in St. Louis, Missouri. "McCormick's cocked hat is a dream, his sword is 3 1/2 feet long, and there is as much gold braid upon the coat as upon that of a French General," the paper's St. Petersburg correspondent chortled. "The costume is gorgeous enough to make him persona non grata to the Tsar." The revelation, much quoted in the days and weeks that followed, sparked both hilarity and outrage nationwide. "It occurs to us," the *Washington Post* ventured, almost audibly choking back laughter in its editorial, "Ambassador McCormick's Legs," that "Mr. McCormick's costume may easily have led to jealousies and heartburnings at the Russian capital." Many other publications, like the Cedar Rapids, Iowa, *Evening Gazette,* refused to take the affront lying down, and parried with indignant headlines: "AMBASSADOR APES ROYALTY," "American Simplicity Offended," "Congress May Act."

If young Bertie had heard nothing directly from his busy relations in St. Petersburg, the Pattersons, by contrast, had been favored with at least a little news. "As I prophesied from the day of our arrival here, nothing would now induce Kate to return to Vienna except a brief visit," the favored envoy reported on February 12, 1903, the morning after returning from a court ball of legendary magnificence at the Winter Palace. "The Russians are so much more sympathetic and we are treated with the most marked consideration," he added. The hearty welcome was extended to the entire family. Even before Cissy's arrival in St. Petersburg in early February, Ambassador McCormick had requested a private audience with the tsar's wife and mother for his own wife and niece. The request was granted immediately, thus clearing the way for Cissy's presentation at court shortly afterward. In the meantime, within her first week in St. Petersburg, the engaging young American had been swept up seamlessly in a whirl of what her uncle described as "balls, calls and 'ice hilling' " (or tobogganing). Within three weeks, the *Washington Post* noted that like her aunt and uncle, "Miss Eleanor Patterson, of Chicago, the Ambassador's niece, is received with marked attention at the court balls and in society generally." Within her first month, a *New York Herald* special cable featuring Cissy herself announced that she was having "the time of her life" in St. Petersburg. The same society pages in which the Pattersons, mother and daughter, had followed the fortunes of their compatriots Daisy Leiter, Consuelo Vanderbilt, Julia Grant, and their like in years past now added Cissy's name to their European chronicles with a growing regularity. "Wonderful fancy dress balls, suppers and wondrously brilliant court entertainments at the most

sumptuous court in the world, all are hers," the *Philadelphia Inquirer* panted in early March 1903. "She has danced with many grand personages and has had opportunities of enjoying society at St. Petersburg such as come to few of her countrywomen."

Indeed, at her first court ball barely a week after her arrival, Cissy had floated into the "front rank without effort," her uncle boasted. The newly arrived Americans' introduction at court during "the 1903 Ball"—in fact, a pair of period-costume galas that the tsar and tsarina threw at St. Petersburg's Winter Palace on February 11 and 13—was an event the splendor of which would go unsurpassed not only in the short remaining history of Nicholas II's reign, but also, by many accounts, in the annals of the entire Romanov dynasty. Though the occasion was originally conceived of as the bicentenary of St. Petersburg as Peter the Great's exuberant, cosmopolitan window on the West, Nicholas II had other ideas. As the ongoing Russian pursuit of a warm-water Pacific port heightened tensions with China and Japan to the east, the tsar determined to make the festivities honoring the empire's splendid western port city a celebration of inward-looking Russian traditionalism. To this end, Nicholas and Alexandra had decreed that their guests were to dress in the manner of the seventeenth-century Muscovite—the same traditional ethnic garb, indeed, that Peter had summarily banned two centuries earlier in the name of Westernization. For the occasion of the 1903 court balls, however, guests dutifully obeyed the reigning monarch's edicts.

After months of planning, secret keeping, consulting historical sources, designing, and fitting, high-ranking scions of ancient military families arrived at the Winter Palace as chain-mailed knights, velvet-swathed Cossack chieftains, and court falconers resplendent in embroidered festival dress. Princes, dukes, and counts joined them as fanciful boyars and peasants in fur-lined, gold-tasseled brocade, and spectacularly embroidered traditional felt boots. Grand duchesses and princesses tottered under the heft of the many layers of their pearl- and gem-encrusted *boyarinya* costumes while struggling valiantly to remain squarely beneath the prodigious jeweled *kokoshniks* glittering atop their heads. For the three nights preceding the first of the balls, Carl Fabergé had sent his son to complete Princess Nadine Nabokov Wonlar-Larsky's costume by sewing both her own and her husband's family jewels directly onto her garments and their matching headdresses. At first, the maid of honor to the tsarina (and aunt of three-year-old Vladimir Nabokov) found the combined weight of the gemstone-encrusted articles intolerable, but with practice accustomed herself to the challenge in time to heft them across the threshold of the Winter Palace. Ambassador McCormick, less of a stranger to opulence than in former days,

rewarded her endurance and the unsparing efforts of the other assembled guests with the assurance that "in his wildest dreams he could not have imagined such a sight; the jewels alone were a revelation."

Though her *Fall Flight* protagonist, Daisy, "never could bring back a clear memory of her first—and as it turned out her last court ball," Cissy managed to record the event in vivid detail, even after the lapse of a quarter century. After the "long waiting in an impatient line of carriages and sleighs," guests pour from the frigid darkness into the blazing Winter Palace along the banks of the Neva, where they form two lines on either side of the big hall outside the emperor's private apartments to await the sovereigns. With three taps of his staff on the floor, the Grand Master of Ceremonies silences the vast assembly, whose members bow their heads "in silent unison . . . like a wheatfield before the first imperious gust of storm" in anticipation of the opening of the golden door. From behind it appears Nicholas II, emperor of Russia, king of Poland, and grand duke of Finland:

> A man below middle weight, the shortness of his legs accentuated by blue, baggy trousers tucked into high boots . . . just an average kind of man—bearded, with Slavic cheek bones, a short inadequate nose, and full-lidded, kind and faithful eyes.

His empress consort is, by contrast,

> taller than he, a vision in flashing jewels, swathed in white and silver. She wore a mask upon her face, a mask borrowed from ancient times and thrust at birth into her baby hands—a mask fashioned when the kings of this earth made themselves into images of unjust and fearful and capricious gods: images too terrible to look upon with the naked eye, to be approached blindly and groveling upon the ground. A face from which every vestige of human expression had been stricken, as if frozen out. A beautiful face, pale beneath the weight of its glittering crown.

Indeed, the same shy, fragile "Alexandra of the stricken face" that Cissy described in *Fall Flight* had in real life confessed to a lady-in-waiting that such occasions made her "long to disappear under the ground." Burdened in their progress along the receiving line as much by the architecture of their costumes as by the ponderous demands of protocol, the fictional empress, the other royal personages, and their entourage make their slow approach toward the nervous Americans while Daisy comes "close to tears at this figure, glittering, strangely beautiful and still, like a waterfall frozen in the moonlight." After a stilted exchange of pleasantries in English between the two parties at last, the American ingénue is amazed to

find that the trembling German-born tsarina appears to be "as scared as we are!"

In the days that followed the Winter Palace ball, Medill McCormick would read of the affair in the American press. His free time filled with the arrangements for his upcoming wedding and (judging by the volume of love letters he generated during the period) his romantic thoughts unwaveringly on his fiancée, the *Tribune*'s Washington correspondent displayed none of the old jealousy toward his attractive cousin's admirers. "We even learn that so distinguished a [personage] as a Grand Duke is charmed by Miss P's red hair," he reported amiably. Like Cissy, at court Daisy, too, dances with the tsar's playboy cousin, that "terror of jealous husbands as well as of watchful mothers," twenty-five-year-old Grand Duke Boris Vladimirovich. After a subsequent *contredanse* with Boris's younger, less notorious brother, Grand Duke Andrei, Daisy spies another familiar, dissolute face approaching through the crowd and is "afraid to believe he was really coming for her."

Since she was introduced to the infamous Prince Serge Slavinsky by Varia, Duchess of Bramtemberg, at an earlier party, Cissy's fictional alter ego, Daisy Shawn, has been unable to stop thinking about him. At the time, she is disconcertingly, though not unpleasantly, aware that "he meant to touch her, take her in his arms, maybe kiss her and she craved with queer, sudden anguish to be taken"—despite her simultaneous consciousness of the "repellent chill of the man's inner nature." Much as Cissy had sketched Count Josef Gizycki during her stay in Vienna, so Daisy repetitively, almost morbidly, goes

> over, as if with tiny brush and pencil, each detail of [Slavinsky's] face: the intense black eyes; the long nose and cruel nostrils; the flexible, womanish mouth; the lean jaws, sloping down to the narrow chin, and the jet black hair springing with odd vitality from the pale fine skin on the forehead.

Though the self-professed snob Susan Redmond is impressed initially by talk of Slavinsky's "two or three big estates in Volynia," she and her husband quickly grow alarmed at the middle-aged bachelor's attentions to their daughter. Ambassador Redmond's "inner being swell[s] with prejudice and loathing" at Slavinsky's vanity, self-importance, condescension, and artificiality; in return, Slavinsky voices a sneering ennui on the subject of American husbands. Investigating the prince's background, the Redmonds discover him to be "an awful gambler and terrible with women and never pays his bills." Worse, it emerges that the same Varia Bramtemberg who introduced Slavinsky to Daisy is, in fact, the prince's mistress. Since

the duchess is married herself, the Redmonds suspect that she hopes not only to continue the dalliance under cover of Slavinsky's being "nicely married" in his own right, but moreover to free her lover from his mounting financial embarrassments. "Remember this," the ambassador warns Daisy, "no foreigner of Slavinsky's type marries an American girl, except for money."

In writing of Daisy's courtship a quarter century after her own heady introduction to Count Gizycki, Cissy naturally stylized and streamlined, drawing on her past as observed through the unoccluded prism of experience. In St. Petersburg in 1903, however, the future she envisioned (or, rather, blindly desired) for herself was far from crystalline. Count Gizycki's then well-muzzled "eccentricities" notwithstanding, she knew, or at least believed, only that she was in love with him and that he loved her—or would come to love her—in return. "You see," she would later explain, "he was always different. You never saw anybody like him. I never saw anybody like him. He was—I was used to his being strange and queer from the very start."

The same May Baltazzi, later Countess von Wurmbrand-Stuppach, who had originally introduced Cissy to Gizycki, recalled that her old family friend was "extreme" in his dogged pursuit of self-gratification and a sensualist in all things. "Most of all he was sexual," she would recall fondly as a Monte Carlo octogenarian. Though it is unlikely that she and Gizycki were lovers at the time that she introduced him to Cissy in 1902, twelve years later, while married to one of his close friends, she would bear him a child. "I think it was the main interest of his life—the pleasuring of women in a physical way," she observed, adding, "he was a marvelous lover." Gizycki pursued Cissy relentlessly, not only in Vienna, but by post during her stay in the United States and again in St. Petersburg—though with unaccustomed gallantry; merely seducing her, according to his established habit, was out of the question. The prominence and popularity of the well-connected, unsullied American girl in both Vienna and St. Petersburg and the impossibility of long keeping secrets in either city's tight-knit court circles would have assured a scandal of proportions sufficient to "ruin him," as his intimate, Countess von Wurmbrand-Stuppach, later put it. Although in reality the evaporating liberality of the count's disgruntled creditors had begun to curtail his grand lifestyle, talk of his "splendid castles" and estates in the distant Ukrainian oblast of Volynia satisfied casual observers that his interest in the nubile, apparently fantastically wealthy American girl was not (at least principally) pecuniary.

As Nellie and Rob Patterson came to see it, the McCormicks, the very flesh and blood to whom they had entrusted their unprotected only daughter abroad, were foremost among those who had taken too lightly the

threat Gizycki posed to Cissy's safety, welfare, and future happiness. In fictionalizing her own experience in *Fall Flight,* Cissy conflated her mother and father with her aunt and uncle in many regards. In reality, however, Gizycki's courtship of Cissy had pitted one couple against the other to a greater degree than ever before. If the McCormicks occupied the Redmonds' roles as *Fall Flight*'s American ambassador and ambassadress in St. Petersburg, it was the Pattersons who had in fact raised the fictional couple's objections to the ingénue's *"beau ténébreux."*

The Pattersons were not alone in their dismay at Ambassador McCormick's judgment during his posting in St. Petersburg. With the exceptions of the Hearst papers and Associated Press accounts, the opulence of the Winter Palace ball and the fact that several thousand guests had attended in lavish, scrupulous period costume attracted little notice in American newspapers. Ambassador McCormick's enthusiastic efforts to reciprocate his hosts' warm welcome by entering fully into the spirit of the occasion had not gone unremarked, by contrast, and quickly became the subject of redoubled merriment and outcry from Maine to California. Just as the recent controversy over "Ambassador McCormick's gold and lace toggery" and "offended American democratic simplicity" had begun to die down in mid-February, the president's representative in St. Petersburg was reported to have appeared at the recent court ball attired in a fashion more sumptuously un-American than ever—this time, astoundingly, in seventeenth-century Muscovite raiment. Reports of the formal reception he gave to the diplomatic corps and Russian official society a month later, on March 13, 1903, only lent further credence to the impression that McCormick was rapidly and blithely going native. Imperial diplomatic protocol dictated not only that foreign ambassadors adhere strictly to the guest lists provided by the Office of Imperial Ceremonies but that their official residences be of a grandeur sufficient to accommodate at least one thousand seated guests and the two hundred footmen required to serve them. This news, reported on the other side of the globe the following day, aggrieved republican sensibilities anew. "THE RUSSIAN WAY: Ambassador McCormick's Guests Invited by Someone Else," the *Montgomery (Alabama) Advertiser* charged on its front page. "Ambassador McCormick Gives a Function at Which the List of Guests Is Made Out for Him," the *Charlotte (North Carolina) Observer* scowled. "AMBASSADORSHIP HAS DRAWBACKS" the *Philadelphia Inquirer* observed dryly.

In the meantime, the spring of 1903 brought Count Josef Gizycki to the American ambassador's residence in St. Petersburg for a personal interview with Mrs. McCormick, at which he made a formal request for her niece's hand in marriage. Though it was rebuffed by Cissy's parents when they

learned the news, the fact that Gizycki's proposal had come at all served only to confirm the Pattersons' fears that in their absence Aunt Kate had left unfulfilled her glib parting promise to put an end to the count's attentions to Cissy. By late March, Cissy's family appears to have made a concerted if belated effort to separate her from the object of her affections. She and her aunt traveled beyond Russian dominions for much of the springtime before returning to St. Petersburg to repack in anticipation of returning home shortly afterward for Medill's wedding.

However controversial, Ambassador McCormick's haberdashery and parties were of little concern compared to his consistent—and accumulating—official lapses. In early April, the unseasoned diplomat had cabled Washington his good-faith acceptance of the official Russian denial of the recent, savage pogrom in Kishinev, Bessarabia. The orgiastic looting, arson, and slaughter had, in fact, left some 120 dead, among them children and babies, and several hundred more injured and homeless while imperial authorities looked on without intervening for three days. In late April, the Russian government issued a list of eight new demands to its Chinese counterpart in Peking, among them the immediate cessation of the opendoor trade policy then in effect in Manchurian ports. In Washington, Secretary of State John Hay took the Russian posturing as an explicit threat to American trade interests in Asia. "In an apparent desire to prove his friendship for the Tsar," however, the *Boston Daily Globe* lamented, "Mr. McCormick went farther than the rules of diplomacy laid down by Mr. Hay permit." En route to the United States for his son's wedding with his wife and niece, McCormick dismissed concerns by repeating to the American press the "emphatic" assurances of Russian goodwill toward the United States and its diplomatic and trade interests that had been conveyed to him personally before his departure from St. Petersburg. Misjudging growing anti-Russian sentiment in the United States, he went on to assert that Russia would remain in Manchuria to protect her growing railroad and shipping interests, and suggested, in effect, that her doing so was not the concern of other nations. Pasting the *Chicago Tribune*'s report of her brother-in-law's statement into her voluminous scrapbook, Nellie Patterson scrawled a complacent "Unwise" across the top. "Ambassador McCormick is in a kind of trance," the *Philadelphia Inquirer* fretted on June 4, as the envoy, his wife and niece, disembarked in New York: "The Russians have hypnotized him." Paying his respects to an irritated secretary of state in Washington the following day, the ambassador stammered protestations of misquotation in his own defense, astonished to find himself chastised for his impromptu remarks. "When Mr. McCormick left Mr. Hay's office," the *Boston Daily Globe* observed, "he declined to be interviewed."

"Probably not in the history of the country did such a distinguished gathering attend a wedding," Joseph Pulitzer's *New York World* proclaimed on Wednesday evening, June 10, 1903, as Mr. and Mrs. Joseph Medill McCormick drove away from the Hanna residence in Cleveland, a throng of notable well-wishers cheering and pelting the young couple's vehicle with shoes for good luck. Indeed, in the weeks leading up to his nuptials the groom had only half joked that he was likely to go unnoticed between President Roosevelt and the celebrated bride. Though the Hannas had sent 5,000 invitations, St. Paul's Church could only accommodate 1,200 of their guests. Those lucky enough to find seating for the noon service included a pride of senators, a gaggle of the nation's most prominent hostesses and "society leaders," and a large herd of McCormicks. They were joined by the entire cabinet, an exotic assortment of diplomats, and, as Pulitzer's *World* put it, "scores of men to whom millions are trifles."

The affair was rife with political portent on many fronts. In light of the current Russo-Japanese tensions and the domestic outcry over the father of the groom's bumbling diplomatic pronouncements, Countess Marguerite Cassini was relieved that her father, Ambassador McCormick's opposite number, had allowed her to celebrate the wedding of her dear friend Ruth Hanna. The father of the bride (who had remarked famously on the occasion of Roosevelt's nomination as vice president three years earlier that "there's only one life between this madman and the Presidency") had hesitated for a variety of reasons to importune President Roosevelt with an invitation. TR, however, anxious to secure—or dragoon—Senator Hanna's crucial support in 1904, had invited himself. He and Alice, who knew the bride very little at that point, arrived by special overnight train the morning of the ceremony to be greeted by large crowds and general hullabaloo.

The auguries on the home front were more ominous. After leaving Washington, the McCormicks had stopped in Chicago to see their sons; from there they planned to travel to Cleveland *en famille* for the wedding. Once at home, however, Kate learned that her unpretentious future daughter-in-law had politely declined the cavernous grandeur of the old Medill mansion, which Kate was determined to redecorate and impose upon the couple as a wedding gift. The residence at the corner of Cass and Ontario Streets would be sold the following September, therefore, to be remodeled into a three-hundred-room hotel. Professing illness after traveling nearly five thousand miles in three weeks, the mother of the groom never completed the last leg of her journey to Cleveland to celebrate her firstborn's wedding. Cissy, so like her aunt in many regards, brought something of Kate's spirit to the festivities, nevertheless. In her bridesmaid's

dress of white and pale green silk, Cissy looked on smilingly as her school-mate and family friend married her cherished cousin at last. She would only reveal her true feelings about the bride over the coming years, claws bared.

Ruth Hanna McCormick was "more 'dog' than anyone I knew," Eleanor Hard Lake observed, in keeping with the fanciful (though, in this case, entirely apt) taxonomy she had developed of finding people to be essentially either canine or feline. A generation younger than Ruth and Cissy, the lifelong Washingtonian and mother of President Clinton's national security adviser, Anthony Lake, nevertheless knew both women well. Ruth was by nature loyal, honest, straightforward, and kind. Medill, sensitive, nervous, and increasingly troubled as he grew to adulthood, had fallen in love in part with her strength and steadfastness; Ruth had reciprocated with the nurturing, constant, almost maternal love that he had never known. Cissy, by contrast (as many besides Eleanor Lake remarked), was proverbially "all cat." Lithe, graceful, and fastidiously soignée, for all of her charm she could be aloof, fickle, and, indeed, catty—increasingly so as she grew older. Though Medill had married Ruth, he and his feline cousin would nevertheless maintain a mutual fascination for years to come. The emotional access Medill reserved for Cissy would permit her wide latitude to pounce, unchecked, and toy with the couple as it suited her purpose or whim.

Doubtful now of Kate McCormick's chaperonage, the Pattersons were unwilling to allow Cissy to return to Russia with her aunt and uncle. Count Gizycki was not so easily deterred, however, and wrote Nellie directly in Lake Forest that summer, to once again request Cissy's hand in marriage. Though Nellie rejected his suit a second time with accusatory allusions to his reported dissipations and profligacy, the count's ingratiating letter had the effect of softening her resolution against him. It began to occur to Nellie that her sister might be up to her old mischief. What if Kate's vague reports of Count Gizycki's reputation were—as usual—concocted to thwart her, this time by manipulating her into denying Cissy the distinction of a title? The daughter's summerlong demands for at least a visit to Paris succeeded in overwhelming the mother's dwindling resolution at last. "Mrs. Robert W. Patterson and her daughter, Miss Eleanor Patterson, sailed yesterday on the *Kaiser Wilhelm der Grosse* for Europe, where they will spend the next six months," the *Washington Times* noted in its "Social News and Gossip of the Day" column on September 2, 1903.

In Paris, Nellie met the count at last. He was on his best behavior; she found him charming, urbane, and flattering. Though her defenses against

the handsome aristocrat had been further compromised, she remained unpersuaded as to his suitability as a husband for her daughter. While Cissy spent her days with girlfriends from Chicago and Boston (when not meeting clandestinely with Gizycki in parks and under the hushed arches of the city's churches and cathedrals), her mother took tea or dined at fashionable Voisin's, Paillard, or the Tour d'Argent with the girls' mothers and aunts, who clucked disapprovingly at the proposed international match. Their disdain was sufficient to convince Nellie to dispatch her daughter to a succession of fashionable spas and watering holes. At these, Cissy was accompanied and supervised by one of the many maiden cousins from New Philadelphia, Ohio, to whom Nellie referred openly as her "poor relations" and who served as a ready source of inexpensive labor—and surveillance.

Flattered, cajoled, and harangued, Nellie remained doubtful and demurred when repeatedly pressed for a wedding date by the eager count. "I just saw Mama," Gizycki wrote Cissy in Baden-Baden, from the Elysée Palace Hotel in Paris. "I suppose she just had some letters, etc., as she told me the marriage in any case ought to be in two months and not now in one month," he added impatiently. "There is nothing more idiotic," he complained, than such parental pleas for time not only to examine the character and background of the prospective bridegroom but also to allow a couple to become better acquainted before the irrevocable step of matrimony. Resenting the feeling of being placed on display as if in a "menagerie," he went on to fulminate that such scrutiny, intended as it was to find fault, could only succeed in its aim. Preparing Cissy to doubt any of her parents' unflattering revelations while simultaneously attempting to infect her with his haste to become legally united, Gizycki insisted that if his observers perceived anything in his behavior to be unbecoming, it was their own fault:

The bridegroom—having less control than the bride and generally brought directly from the wilderness of the jungle to the narrow menagerie cage—bites now and again its Keepers. Oh Lord! The visitors roar with horror; how nasty he is, what a vile nature he must have— imagine how beastly he will be afterward when he is obnoxious even now—we pity the poor bride.

I did not bite anyone yet, and I am not going to do so as I look forward to you, my little filly, and long for the moment to escape together in the open free jungle! But I really dare try. We ought not to make our menagerie time last long—especially as though I am not going to bite my keepers, I am far from willing to learn anything during my captivity . . .

Had Nellie contrived to kindle the count's ardor for her daughter, she could not have done so to greater effect. Delighting in the pursuit of delayed gratification, after meeting a beleaguered and recently arrived Rob Patterson, to whom he promised documentation of his net worth and proof of his solvency, Gizycki followed Cissy from one grand hotel, spa, and tourist site to another, ever more determined to have her at last.

In the meantime, the Pattersons began to make their own investigations into the count's background. Though Nellie mistrusted her sister, she asked her brother-in-law to make inquiries within his circle of acquaintance in Vienna. On October 16, 1903, Ambassador McCormick duly pronounced himself "satisfied after thorough inquiries"—that is to say, the single interview he had conducted with his single source, Count Eugen Kinsky. His own scandalous marriage to an opera singer and his conviction the year before in the infamous Vienna Jockey Club gambling scandal notwithstanding, Count Kinsky endorsed his old friend Count Gizycki, whose education, appetites, and proclivities he shared. As a result, "income sufficient, position good, etc., etc." was McCormick's verdict as to Gizycki's fitness as a lifelong partner for his niece. Cherishing mementos of her joys and triumphs as carefully as she preserved documentation of the McCormicks' follies and embarrassments, Nellie later scrawled across the bottom of her brother-in-law's telegram: "Robert McCormick's opinion of Gizycki was later changed." In the autumn of 1903, the Pattersons remained unconvinced by Ambassador McCormick's breezy, telegraphic assurances, however, and sought further consultation, this time from professionals.

After making discreet inquiries and interviewing both Count Gizycki and his lawyer in Vienna, Henri Cachard, of the Paris office of the New York law firm of Coudert Brothers, returned his findings on December 5. Thirty-six-year-old Josef-Mary-Werner Michailovich-Faddeevich Gizycki had been born in 1867 in Lemberg, the capital of Hapsburg Galicia, the Dual Monarchy's northeasternmost province and, until the outbreak of the First World War, the poorest region in Europe. His mother, the former Countess Ludmilla Zamoyska, a lady-in-waiting to Emperor Franz Josef's mother as well as a gifted pianist and well-regarded amateur composer who had studied under Franz Liszt, descended from an ancient and noble Slovakian family. His father, a member of a similarly old and eminent Polish Catholic family, had enjoyed a wide reputation as a cranky and reclusive eccentric until his death in 1898. Perhaps not surprisingly, Gizycki's parents had lived apart for much of their marriage. Young Josef had attended the Theresianum in Vienna until the age of sixteen, when, already an avid horseman, he entered cavalry cadet training and was deemed fit for military service upon reporting to the Austro-Hungarian Uhlan (or Polish

lancers) Regiment No. 2, two years later, after graduation in 1885. He had risen through the ranks of the Dual Monarchy's cavalry until late April 1891, when he was placed on unpaid leave for two years for reasons that would remain murky for some time to come. In November 1893, Gizycki was transferred to the unit's reserves, but withdrew from the Austro-Hungarian cavalry entirely in July 1897 in apparent anticipation of his father's imminent death, in order to become—like his friend, the high-rolling Count Josef Potocki—a Russian subject as the requisite first step to claiming his ancestral estates in the formerly Polish Ukraine.

Gizycki was not, as it turned out, the millionaire he had told Cissy he was. The lavish sums with which he had pelted the orchestra and scandalized his fellow Grant-Cantacuzène wedding guests in Newport in 1899 had been acquired on credit. Having spent the modest fortune his mother left when she died in 1889, within a year of claiming his patrimony (under unorthodox circumstances) in 1898, Count Gizycki had begun to mortgage both of the "splendid castles" he had inherited, his father's estate of some 9,625 acres at Novosielica in rural Volynia and his late uncle's slightly smaller concern of some 6,480 acres at Janalec in even more remote Podolia. Gizycki had continued to borrow against these properties periodically and heavily in Kiev—as recently as a few weeks before, when his pursuit of Cissy through the resorts of central Europe had prompted him to pledge an "important sum." As a result, he had plunged himself into debt to a new depth of some 420,000 rubles.* The count's yearly income from the rents, timber, and stud fees he collected on his estates amounted to some 59,000 rubles.† This figure, even his lawyer admitted, was an optimistic one, however, in that it made no allowance for the vagaries of agricultural fortune ("bad debts, arrears in the payment of the farm rents, repairs, etc.")—or, indeed, for the vicissitudes of the gaming table and the turf. As to personal matters, in his interview Count Gizycki admitted to having an illegitimate daughter. "In jest," he claimed to have fathered many other children as well, before apparently thinking better of the statement under the circumstances, and retracting it.

In light of these revelations, mother, father, and daughter (in first class) and "poor relation" (in second) sailed promptly for home, ostensibly to spend Christmas in Washington. Whether the Pattersons revealed the full text or import of the Coudert Brothers report to their daughter goes unrecorded,

*Or nearly $832,000 according to contemporary exchange rates, a sum amounting to roughly $21 million based on the CPI or a staggering $120 million based on nominal GDP per capita.
†Or approximately $117,000 in 1903, nearly $3 million in modern terms based on the CPI, or roughly $17 million based on nominal GDP per capita.

although in *Fall Flight,* Ambassador Redmond's investigations into Prince Serge Slavinsky's background unearth letters Daisy Shawn "would not read, copies of debts and mortgages she refused to understand, and photographs from which she turned her eyes." Likewise, Nellie Patterson's dark admonitions that Count Gizycki was known to be "very eccentric" met with little more than annoyance from Cissy. Once back in Dupont Circle, Nellie appears to have spared no effort or expense to make her daughter at home again among her fashionable friends and eligible countrymen. The Italianate mansion was ablaze with festivity in Cissy's honor for much of the winter and early spring of 1904. On January 16, the local society pages noted, Mr. and Mrs. R. W. Patterson gave a "small dance" at home for their daughter Eleanor, who had enjoyed recent, brilliant "triumphs" at the courts of Vienna and St. Petersburg. At the end of the month, Nellie hosted a tea at 15 Dupont Circle to introduce Cissy once again to her Washington friends. Though Cissy was now twenty-two, on February 4 the Pattersons inaugurated their magnificent ballroom by presenting the veteran debutante for the fourth year in a row at a lavish cotillion in her honor. Winning, attractive, and amusing, she was much sought after as a guest as well. Cissy appeared not only at the small White House dinner party on Alice Roosevelt's birthday on February 13, but also at a number of dances, diplomatic functions, balls, teas, and musicales, typically in the company of her intimate circle, Countess Cassini of the Russian embassy, Baron Rubido-Zichy of the Austro-Hungarian embassy, Viscount de Chambrun of the French embassy, Miss Evalyn Walsh, her Dupont Circle neighbor, and, once again, that amiable, unattached bon vivant, freshman congressman Nicholas Longworth of Ohio.

As Cissy had begun to speak openly in Washington of her engagement to a Polish count, her renewed flirtation with Nick Longworth irritated her friends Maggie Cassini and Alice Roosevelt more than it eroded her feelings for the distant Count Gizycki. On February 21, the Washington society columns, as well as publications as far-flung as the *New York Times,* noted that "Miss Eleanor Patterson, daughter of Mr. and Mrs. Robert Patterson, of Dupont Circle, and one of the belles of the recent season, has gone to Chicago for a short visit." When mother and daughter arrived, letters from Gizy (as Cissy had come to call her pursuer affectionately) awaited them both. The count thanked Nellie (to whom he already referred in his correspondence with Cissy as "Mama") for "saving his life," apparently by allowing him time to combat the "awful difficulties" of securing official documentation to disprove the Coudert Brothers' report of the several staggering mortgages outstanding on his estates. There was only one, he insisted. The affidavits were forthcoming, he claimed. The Pattersons' objection to his suit had therefore been dispensed with, he argued. Not

bothering to await documentary confirmation, Nellie cabled him her consent to the marriage—beleaguered by months of relentless entreaties and cajoling, relieved to avert the looming scandal of elopement, and, indeed, not entirely unhappy to acquire a titled son-in-law. Rob Patterson, who had found the count to be "conceited, overbearing, very susceptible and devoid of our ideals of manhood" during their stiff introduction in Paris, was unable to reconcile himself to the union. As her own and her children's incomes came to them indirectly through Joseph Medill's Tribune trust, Nellie was in a position to settle only $10,000 on Cissy as a yearly allowance.* In a final attempt to force Gizycki's hand, Rob Patterson, as Cissy's father and trustee, attached the caveat to Nellie's consent that the bridegroom would receive no dowry.

Gizycki called his bluff. Rather than bolt, the count greeted the news with lavish assurances that he would marry Cissy "with only the dress on her back," having just witnessed the power of concerted wheedling over Nellie and betting that Cissy stood to inherit a fantastic sum upon her mother's death. "Most Americans," Maggie Cassini observed, "find the attitude of Europeans about the bride's dowry hard to understand and in the matches of titled foreigners and American heiresses especially are repulsed by what they consider sordid bargaining." The countess's years in the United States had little altered her outlook on the unabashedly commercial aspects of contemporary international matrimony. "I must say, I think the European idea is better," she insisted,

> —to make life agreeable to young people if possible. Why should a girl brought up in luxury have to wash dishes and scrub floors when she is so unprepared for it, while her husband struggles for ten years to make a success? What difference does it make if they have a little comfort and pleasure while he is struggling?

"Someone has to have the money," the practical countess concluded. At the dawn of the twentieth century, judging by the animated public debate on the subject, what Americans objected to was the appearance (or, indeed, the reality) of the American girl's underwriting her European husband's life of leisure, thereby perpetuating an aristocratic and unmanly aimlessness. "I must confess I am relieved," Count Gizycki wrote his betrothed immediately after receiving Nellie's telegraphed consent. "It is all very well to play the smart but sensitive flirt, in cold blood, but this time, all the time since I left you, I wasn't a moment happy or content, though I had

*About $250,000 in modern terms, according to the CPI; nearly $1.5 million based on nominal GDP per capita.

arranged and managed my little affairs perfectly," he confessed, leaving it unclear—as does all of his surviving prenuptial correspondence—whether his late anxiety had sprung from the absence of his beloved or from the uncertainty of ever consummating the deal.

Merry Party of Girl Friends Bid
Countess Gizycki Godspeed

—"IN SOCIETY'S CIRCLE," *WASHINGTON TIMES,* APRIL 15, 1904

On March 2, 1904, Count Josef Gizycki embarked first-class for New York aboard the *Kaiser Wilhelm II.* The ship's Manifest of Alien Passengers recorded that the Russian Pole had characterized himself as unmarried, literate, and in possession of a sum greater than $50. He had never been in prison. He practiced neither polygamy nor anarchy. He was not "Deformed or Crippled." He did not intend to remain in the United States to work (indeed, he listed no profession), and he characterized the state of his mental and physical health as "good." To the question of whether he intended to join relatives or friends in the United States, the count responded, "No."

Awaiting Count Gizycki's arrival in Washington, Cissy continued her giddy social whirl of luncheons and dinners, teas, dances, and diplomatic receptions. On Wednesday and Saturday mornings, that "daring, if not reckless, follower of the hounds" joined the Chevy Chase Hunt's first field, galloping over the rolling hills of Maryland in the company of her fiancé's Vienna Jockey Club chum, Count Ivan Rubido-Zichy of the Austro-Hungarian embassy. In the coming weeks the Washington society pages would lead the national press in heralding the latest "brilliant international match" in headlines trumpeting "American Bride for Count," "Miss Patterson to Wed," and "Russian Noble Wins One of the Fairest Belles of Washington," among many others. Though its contemporaneous coverage of the details of the sudden engagement, the hurried festivities, and, eventually, the simple ceremony was starry-eyed, the *Washington Post* would later take a more jaundiced view of Count Gizycki and his dubious economies as the day of his wedding approached. "During his visit to Washington," the *Post* would cluck retrospectively years afterward, "Count Gizycki was not invited to the Patterson home, but remained at the New Willard, where he occupied a room on one of the upper floors and in the least desirable section of the house. He was attended by a man servant who came to the hotel when needed." If Gizycki was not welcome at

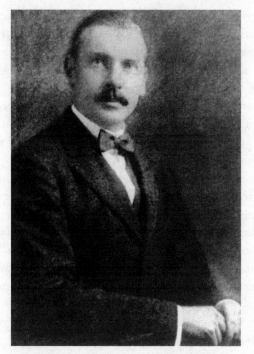

Count Josef Gizycki (1867–1926)

15 Dupont Circle until the day of his wedding (and not even then by Rob and Joe Patterson), he was received elsewhere in Washington—albeit tepidly, given the widespread rumors both of Nellie Patterson's long hesitation to give her consent to the union and Rob Patterson's outright (and growing) hostility toward the bridegroom. Gizycki attended Maggie Cassini's birthday party, as a Russian subject and the fiancé of the countess's close friend. Mindful of the Viennese connection, Austro-Hungarian Ambassador and Baroness Hegenmuller threw a small engagement party for the couple in early April.

In the winter of 1904, as Cissy's path to marrying Gizycki cleared at last, her McCormick relatives confronted a variety of new obstacles. Ambassador McCormick's conspicuous absence from his post during the surprise Japanese torpedo attack on several imperial Russian ships at Port Arthur in early February had further exasperated Washington, especially after it emerged that the American representative in St. Petersburg had been on leave in Berlin at the time, consulting a specialist for his worsening gout. Amidst persistent rumors of Rob Patterson's imminent retirement from the *Tribune,* Bert McCormick confessed to his parents, "I gave up my journalistic ambitions some years ago when I saw that I would

not be welcomed in the office and that my presence there would cause friction." Instead, he had taken to politics and was currently running a boisterous campaign for the 21st Ward seat on the Chicago City Council. For their part, newlyweds Ruth and Medill McCormick had been cast into mourning by the death of Senator Mark Hanna. If the younger McCormick, barred from journalism, had taken up politics, the elder, trapped in journalism by vicarious ambition, had begun to see politics as a possible escape route. "I have been surprised to learn that the government of the United States is an oligarchy tempered by the veto," Medill mused in a letter to his parents on March 9, 1904, as he made ready to leave Washington after Senator Hanna's death. The two months Medill had spent in the capital during the vigil for his father-in-law's final illness had taught him more about the workings of the federal government—the Senate, in particular—than had his years as the *Chicago Tribune*'s Washington correspondent. "If I were not going to be a newspaper person, earning a living for myself and my employers," he ventured in measured terms, conscious of his mother's overweening desire for his ascendancy at her father's *Tribune,* "I should like to be an oligarch. It is an easy life and a proud one." Two weeks later, Medill reported his safe arrival back in Chicago ("though sorely needed in the Tribune & by Burt [*sic*]") to Ruth, who had remained behind, both to help her widowed mother and to prepare for her role as matron of honor at Cissy's imminent wedding. "Gizycki is in Washington," Medill reported, "& Uncle Rob here—very much depressed, I am told."

By early April, having endured nearly a month in the American capital—tiny and provincial compared with Vienna, St. Petersburg, and Paris—Count Gizycki was growing impatient. His attempts to revisit the subject of the dowry had succeeded only in further alienating the father of the bride and in inflaming his own sense of resentment at the insult he believed himself to be sustaining daily at the hands of his rustic American zookeepers. While Cissy made a "flying trip to New York" to amass a hasty trousseau, Gizycki set about to prod the wedding preparations along. Though Rob and Joe Patterson by then agreed on little, they were united in their aversion to Count Gizycki. Rob was barely on speaking terms with his future son-in-law. To Joe's personal and ideological contempt, the aristocrat responded with bemused—if studied—deprecation. Gizycki therefore conducted his communications with the Patterson family through Nellie, ever receptive as she was to flattery and titled condescension. He wished to be married in the faith of his forebears, and had found a Catholic priest willing to unite the mixed-faith couple on unconsecrated ground. "I have seen Father Thomas Lee, Rector of St. Matthews Church, who will be pleased to celebrate the Catholic ceremony according to your wishes at

15 Dup. Circle," he informed Nellie on Friday, April 8. "I am very pleased to leave today in good spirits as I think we do now really agree—and I parted with Joe on the very best terms. He is a very splendid boy," the count noted sardonically of his twenty-five-year-old future brother-in-law, "& I hope we understand each-other always." The wedding date was set for the following Thursday, April 14.

As the day drew near and the verbal and telegraphed invitations were extended (too little time remained to have them printed and sent), the family made their last entreaties to Cissy to reconsider. According to the wild, variant stories members of Cissy's circle would tell decades later, her mother offered a variety of blandishments—from magnificent jewels to six-figure payoffs—through the locked door of the bride's bedroom the night before the ceremony. Cissy remained deaf to her family's entreaties and insensible to her mother's enticements, however. Resigned, Nellie sent in Ruth Hanna McCormick, as Cissy's "closest friend." Absent Cissy's change of heart, Ruth was to instruct her about the facts of life. To her matron of honor, Cissy declared that she knew about Gizycki's past, about his mistresses, his conquests, and his illegitimate child—and professed insouciance. "Suppose he is marrying me for my money and my virginity," she declared, "I love him." Having failed to dissuade Cissy, Ruth, ever reliable and modest, moved on to the agreed-upon contingency plan. "My God, of all the people to instruct anybody on sex life!" Cissy would later snigger in recollection, keenly aware that Ruth had learned what she imparted from beloved Medill.

The following day at noon, a defeated Robert Patterson accompanied his only daughter to the "improvised chancel" in the library at 15 Dupont Circle, before an intimate gathering of some thirty-five guests made up of family, close friends and high-ranking members of the Washington diplomatic community. Whether the assembly noticed or not, the father of the bride refused to speak to, or shake hands with, the groom. The white marble mansion had by all accounts been transformed by lavish floral arrangements, though the preponderance of white lilies lent an unintended funerary air to the proceedings. Cissy, in "a girlish affair" of liberty gauze over silk and chiffon trimmed in duchesse lace, carried a loose bouquet of white roses. She was attended by Ruth, who retired immediately after the ceremony, still deep in mourning for her father. Count Gizycki was seconded at the makeshift altar by his best man, Count Ivan Rubido-Zichy.

Following the ceremony, guests were invited to a nuptial breakfast, the gaiety of which was dampened by the palpable tension between the Pattersons and their new relation. Catherine Eddy, a friend of Cissy's and an all-American girl from Chicago, noted, "Mrs. Patterson had quite properly

done everything in her power to prevent the marriage." Ever irreverent, Alice Roosevelt was among the minority of Americans in attendance who liked the dashing "rounder" Cissy had married. He cut a picturesque figure, she thought, as if sprung from the pages of *Anna Karenina;* given the cool reception the count had received from Washingtonians generally, it was perhaps not surprising that Alice found him "so *friendly*"—and he had given her a cigarette case. For the delectation of its readership the *Washington Times,* like many of its local and national rivals, recast the sad, hurried event as "a quiet affair, unattended by the slightest ostentation," but nonetheless "one of the most brilliant and perfectly arranged weddings ever seen in Washington."

Indeed, to achieve this effect the *Times* was forced to go some distance into the realm of invention with a fanciful account of the bride's charming attendants taking advantage of her changing into her traveling costume to make a lavish, surprise floral display of the carriage that was to convey the happy couple to Union Station: "It was a merry party which bid the pretty American bride God-speed to her Russian home." The bride's girlfriends would long remember the occasion differently, however. As Maggie Cassini put it, when Cissy went upstairs to change clothes and Gizycki left for the Willard to collect his belongings, "the fireworks began."

The groom never returned for his bride. "We waited and waited and waited—the time seemed interminable," Catherine Eddy confided to her diary. After no little time and confusion, an embarrassed Ivan Rubido-Zichy was dispatched to find his friend, whom he eventually located at Union Station, ready to depart. "I always felt that Cissy, who was proud, held it against me that I had been a witness to this humiliating page of her life," Maggie Cassini maintained, reporting in her memoirs the astonished whisperings that spread among the wedding guests, of Gizycki's parting demand to be paid a dowry or he would leave the bride (not to mention her mother) mortified and brokenhearted. "Of course, from Gizycki's point of view, a bargain is a bargain: his chateaux needed repair; in return, he was offering an illustrious and ancient name and an enviable social position. It was a fifty-fifty affair," his compatriot Countess Cassini insisted. "But he had to be sure there was no slip."

In reality, though Nellie doubled the yearly allowance she had settled on Cissy to $20,000,* Gizycki's brinksmanship only served to cement Rob Patterson's determination to withhold a dowry. In what Alice Roosevelt described as the wedding's "depressing climax," the twenty-two-year-old Countess Gizycka set off for Union Station in her bridal carriage, not accompanied by her husband but rather comforted by her mother and jeal-

*More than $500,000 based on the CPI and almost $3 million using nominal GDP per capita.

ously watched over by her brother. Catherine Eddy recorded in her diary that evening that as the straggling guests watched the carriage pull out of sight in the lengthening shadows along Massachusetts Avenue, Joe stood "white with rage, on the box beside the coachman, with the evident intent of killing Gizycki when he should see him!"

"Darling, remember," Nellie insisted with unaccustomed, if belated, tenderness, before handing her younger child into the care of her new husband at Union Station, "you can always come home."

"Cissy—by herself," ca. 1900

II

The Countess Gizycka

AN INTERNATIONAL ROMANCE

Newly Wedded Couple Leave for New York En Route to Europe
Home Wedding Witnessed by Diplomatist Friends
of the Groom and Relatives of the Bride

—"SOCIAL AND PERSONAL," *WASHINGTON POST,* APRIL 15, 1904

Although no record survives either of the tone of the leave-taking at Union Station or of the tenor of the newlyweds' first train ride together as a married couple, the groom's behavior on their wedding night suggests that he remained in the mood in which he had left 15 Dupont Circle. After dinner that night in the sitting room of their suite at the New York Ritz, Cissy found herself at a loss for words when her husband put down his coffee cup and sent her to bed, telling her as he went out, "Perhaps I will see you later." Obeying nevertheless, she undressed and got into bed expectantly, two years of anticipation now nearly at an end. Once again, however, she waited and waited for Gizycki to reappear, uncertain as to where he had gone or why. After a muffled tittering in the hallway outside had risen and died out sometime in the early hours of the following morning, the count returned to the bridal suite and undressed. In the semi-darkness he threw back the bedcovers unceremoniously. Scowling at the graceful, nude form of his young bride, he set upon her with a grunt and held her down until he had finished. In *Fall Flight,* it dawns on Daisy long after a similar wedding night that Prince Serge "had taken her as he preferred to take the young peasant girls on his estate in the Ukraine, silently, without a word or caress; like a panther rutting in the dark, and she had cried out in fright and pain."

Two days after their wedding, on Saturday, April 16, 1904, the Count and Countess Gizycki set sail for Cherbourg while the American press weighed in on the latest international match. The *Washington Post,* at pains to heap faint praise on the affair in its lengthy *postmortem,* could only note in summation that Patterson House had been "the scene of an interesting marriage." "Miss Eleanor Patterson has successfully married Count Gizycki without impairing the minister's organs of speech," the *Los Angeles Times* cracked amidst the litany of national and international gripes it published under the headline "Bad Business." The Gizyckis stopped first at the

count's old haunt, Paris, where Cissy, like her fictional alter ego, Daisy, began to remark that those ladies who numbered themselves among her husband's "old friends" treated him with unusual familiarity. The couple traveled next to Vienna for the horse-racing season. "The newly married Countess Gicizky [*sic*] is very much admired and seems to feel quite at home already in Vienna," Nellie Patterson's scrapbook exclaimed in its May 1904 "Vienna Society at the Races" clipping; "She was in a box with Princess Carl Trauttmansdorff." If Cissy's position seemed enviable to others, perhaps most of all to girls such as she herself had been only a short time before, the reality of her married life veered from the ideal from its very start.

"Well, the first trouble was about six weeks after we were married," Cissy recalled, the pronounced changes in her husband's behavior toward her since their wedding day notwithstanding. As dawn broke over Vienna early one morning in late May, Cissy, who had slept fitfully all night, wondering where her husband had gone once again, was jolted awake by a frenzied banging on her door. The count had returned. He had been out gambling, he told her feverishly, and had lost a "very serious" sum. "Of course I can get some money. I can get it, but it is very difficult," he hinted desperately, adding, "I will have to have it tomorrow morning." Believing it to be more convenient for Cissy to set up housekeeping by buying what she needed in Europe than by bringing domestic items with her from the United States, the Pattersons and McCormicks had pointedly given the bride (rather than the couple) wedding presents amounting to some $12,000 in cash.* To calm her frantic husband, Cissy offered the entire sum—all the money to which she would have access for some time as well as the last vestige of her independence—without hesitation. "Just give it to me for a few days, and save me time," the count suggested hastily as he pocketed the bills.

In June 1904, the Gizyckis made at last for the count's storied ancestral lands, castles, and "model dwelling houses for the people employed there," in the rural Ukraine. Alighting in the Proskurov (later Khmel'nyts'kyy) railway station in the rural oblast of Podolia, Cissy was disconcerted by the small crowd that assembled to meet the master of one of the nearby estates and take the measure of his American bride. They clutched at her sleeves and dropped to their knees to kiss the hem of her dress, while Gizycki, inured to such adulatory and beseeching greetings, put his hands in his pockets and elbowed forward, expertly repulsing "the touch of dirty fingers." In her bewilderment, Cissy thought she imagined, too, that one of

*Worth, in relative terms, nearly $300,000, based on the CPI, or roughly $1.8 million based on nominal GDP per capita, a century later.

the small children pushed forward from the throng by his mother looked uncannily like her husband.

At twilight, after a dusty five-hour drive northward into the region of Volynia, they came within sight of Gizycki's ancestral lands at Novosielica. As the couple's wickerwork *britzska* swayed closer, the estate's surrounding "villages" to which the count had so often referred emerged into clear view. Utterly devoid of the rustic charm Cissy had imagined, these settlements were in fact a small grouping of "miserable mud and thatched huts lean[ing] forlornly as if utterly cowed, one against the other." The Gizyckis trotted down the muddy main road, past the scavenging dogs, the ragged children (in a number of whom she would later notice a resemblance to her husband as well), and their impassive mothers, onward to the gates of the park. From there they would at last cross the drawbridge into the midst of the battlements and pointed turrets, Cissy presumed, of the marvelous castle that had been the subject of so many of her romantic reveries and about which her husband had told her so much. Once through the gates, they passed the low stables from which several barefoot village boys, who served as grooms to the count's hunters and racehorses, looked out shyly as their master and his new bride rolled by. "Coming around a corner, screened by an avenue of beautiful poplar trees and clumps of enormous blooming lilac, the castle revealed itself," to Daisy in *Fall Flight,* as "a wide bare white

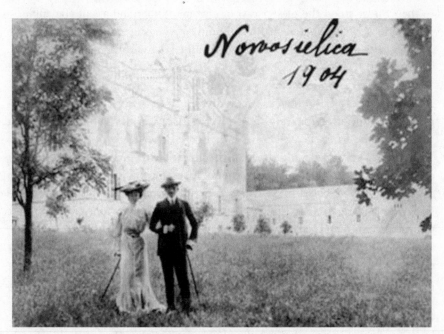

The newlywed Count and Countess Gizycki
during their first summer at Novosielica

building, gaunt and dignified . . . Uncurtained, unshuttered windows. The general impression of a building left unfinished but long since begun. 'Castle?' Daisy wondered . . ."

The interior of Novosielica, a similarly unadorned, boxlike structure, held still greater challenges to Cissy's prenuptial fancies. After meeting the household staff—several menservants, several local boys, and an ancient butler, in addition to the count's estate manager, an Englishman who also oversaw his stables and broke and trained his horses—she was given a tour of her new home. The house was not simply unfinished, incommodious, and dank, but "tumbling down." As Gizycki led her through its bare rooms, the wallpaper hanging in strips where the plaster was not starkly whitewashed, the few frilly or comfortable details she noticed caused her to shrink with a fascinated nausea at these certain hallmarks of a woman's touch. The count's room was consistent with the rest of the building in its austerity, with the exception of the broad table by the window, which Cissy found to be

> covered to the last inch with framed photographs of women dressed in every variety of costume. Court dress, street dress, mourning dress, ball dress, fancy dress, silken tights and ballet dress, riding habit, undress. Bold signatures flourished across the shiny cardboards from side to side, or initials, or dates, or monograms upon the various frames. Elevated in their midst stood the plaster cast of a woman's foot and about the ankle hung loose a tiny golden chain. A plump coquettish foot, a wise frivolous foot, baby soft and satin smooth it breathed a living presence into the room.

Alone on the table in Gizycki's bare dressing room stood one more photograph, this one affectionately signed in English, of a slim woman holding a toddler in her arms.

Agonized now by sickly dread, Cissy mounted the ramshackle stairway connecting her husband's suite to the rooms that would be hers. At the top of the stairs she steeled herself before crossing the threshold. Though she had been told repeatedly by her desperate relatives and many others about Gizycki's conquests, about the Englishwoman he kept at Novosielica, about the child she had borne him, Cissy's determined indifference only now crumbled. Gizycki's mistress of some five years had been dispatched, along with their small daughter, shortly before the newlyweds' arrival. Her rooms—now Cissy's—had been left exactly as before. The previous inhabitant's bed was made up as she preferred; her pillows and flounces, her trinkets and bric-a-brac and even a few hairpins and the sliver of her soap bar remained. Taking the blotter from the writing table, Cissy held it up to the

mirror and read her predecessor's last letter. "Why, that is cruelty," she would reflect more than a decade later. "If he had had any kind feelings at all he would have had that house cleaned." As a twenty-two-year-old bride far from home, however, Cissy was stricken at the recollection of the steps she had taken to arrive at this point. She reeled at the unblinkered prospect of the married life that stretched before her.

In July, the Gizyckis made for Jalanec, the slightly smaller estate the count had inherited from his uncle six years earlier, in rural Podolia. If Novosielica was "exceedingly run down and out of repair," Jalanec was flatly "unfurnished & uninhabitable." There, nonetheless, Cissy began to assume her duties as the count's hostess at the hunting, shooting, and house parties he organized—a role to which she quickly discovered she was unequal. "You know, I'm not an *all-day* girl," she confessed to her uncle, ". . . and I can't say I'm thinking of my guests too tenderly!" In the meantime, having learned of the austerity of Novosielica, Nellie had dispatched some old furniture and several boxes of books in English to the Ukraine. The items' entanglement at customs provided Cissy with a welcome pretext for making contact repeatedly with her Uncle Rob at the American Embassy in St. Petersburg. Though ostensibly written with the aim of laying hold of her much-needed household items (she had refused to move into her suite at Novosielica until the rooms had been entirely redecorated and refurnished), the better part of this correspondence—which rings with desperate cheer—is instead occupied with cajoling Ambassador McCormick (though she would have settled, evidently, for any relative) to visit as soon as possible. "*Do please come!*" she pleaded repeatedly, adding, "I wish I could entice dear old Bertie away from his court in *Chicago*!" By way of apologizing for any trouble she and her furniture might have caused, she insisted, "Since becoming a respected married woman I do really try to keep my business in order."

And yet her business, like her life, was becoming decidedly—even dangerously—disordered. Within a few months of loaning her husband the $12,000 she had received in wedding presents, he began to insist that she guarantee his other debts as well. "I thought that was very wrong, being brought up an American. I thought that was a terrible thing to do," she admitted later. "But I did it, nevertheless, and I have no idea what I signed up, as you call it, on notes for him."* Gizycki's creditors were conveniently ignorant of the fact that he had been unsuccessful at securing a

*At the time, under both Russian and Austrian law, women retained exclusive rights over their own property after marriage. Wives could only be made liable for their husband's debts or relinquish control of their property with their express consent—by becoming signatories to their husband's debts, for example, or by entering into legal agreements ceding property to him.

dowry from the Pattersons. In light of his recent marriage to an American girl of storied wealth (indeed, she was the niece of the same Ambassador and Mrs. McCormick who had made no secret of their ownership of an important American newspaper during their postings in Vienna and Petersburg), his lenders appear to have extended additional credit, the count's existing heavy mortgages and unpaid debts notwithstanding. Drawn up for the most part by banks and moneylenders in Kiev and Odessa, Gizycki's new loan agreements, to which Cissy pledged her name and her marriage portion (though her husband already claimed half of the annual $20,000 she received from her mother), were in Russian, of which she had only a cursory understanding and which her husband forbade her to perfect. Further, she discovered abruptly in the first months of her marriage, "he did not like me to read. He would take books out of my hand. He did not like me to think. I could not order a carriage from the house. I could not order the servants. He did not want me to learn Polish." Soon, she found, "I was nothing at all in the house."

Cissy discovered, too, that her husband drank considerably more than she had imagined previously, starting before lunch with heavy quantities of brandy, continuing through the afternoon and late into night. Unleashed by marriage and accentuated by drink, the "eccentricities" of which she had been warned soon reigned over the Gizycki household. Tall and powerful, the count was given to unpredictable "furious fits of temper." Though his old charm occasionally reappeared, he passed through sudden storms of abuse and violence, punching his coachman in the face if displeased, for example, or taking a horsewhip to the barefoot stable boys with little or no provocation. Count Gizycki's mysterious absences from his young wife rapidly grew more protracted as well. The hours, and then nights, he had left Cissy alone initially soon stretched to days and even weeks at a time away from lonely Novosielica, with little or no warning, explanation, or suggestion of the time of his return.

Whatever the strains of their domestic and financial arrangements, the couple continued to be united in their love of horses and sport, however. They spent active, sociable seasons at a variety of Austro-Hungarian and Russian race courses. Though it is unclear whether Gizycki actually used Cissy's (unrepaid) $12,000 to settle the late-night gambling debt he had incurred in the first weeks of their marriage, shortly after bringing his bride to the Ukraine he made arrangements to import a pack of English foxhounds with an eye to establishing a local hunt in the grand English style at soon-to-be refurbished Novosielica. During the summer following the Gizyckis' wedding another import had arrived as well. Cissy's horse Exclusive, hoisted blindfolded aboard ship, had crossed the Atlantic and

changed trains several times after passing through customs and veterinary inspections upon landing in Europe. Finally, led behind the Gizyckis' *britzska,* he had walked and trotted the last leg of his five-thousand-mile journey to rejoin Cissy. Though Cissy was widely regarded to be "one of the most daring and accomplished horsewomen" in the eastern half of United States, her husband, with his rigorous Uhlan cavalry training, saw much in her equitation to criticize and correct. Cissy and Exclusive, like her other mounts, spent monotonous, joint-grinding hours in the schooling ring, describing at every gait circles and drills around Gizycki, who little hesitated to reinforce his barked instruction with the long, stinging lash of his longe whip.

"Dear Mama," Gizycki wrote Nellie in the fall of 1907 in one of the ingratiating bulletins he regularly dispatched as his notes came due. As part of the amiable account he presented of the couple's sporting activities, their travels and their plans, he reported that they were currently entertaining house guests at Novosielica, though "very few," he lamented, "as Cissy quarrels with all the she-males of the country—except Helene Potocka." Indeed, if Cissy had grown shrill and jealous at the unladylike attentions some members of their circle paid her husband, she had found a lifelong friend, by contrast, in her neighbor, the Countess Potocka. Though closer to Gizycki's age than Cissy's, the countess had quickly taken the young American under her wing.

In the wake of the Vienna Jockey Club gambling scandal of 1901–1902, the tsar had banished the principal offender, Josef Potocki, to Antoniny, his estate in southern Volynia, not far from Novosielica. At this oasis rising out of the inhospitable steppe, Count Potocki duly served out his sentence. There, his neighbors Count and Countess Gizycki—like a wide variety of statesmen, aristocrats, sporting enthusiasts, celebrities, and diplomats from around the globe, along with the occasional American multimillion-aire and African tribal chieftain—clamored to visit him in sumptuous exile. In 1909, five years after Cissy's first visit, the seventeen-year-old Vita Sackville-West would also be a guest. As she described Antoniny Palace and its denizens in her diary:

> Here we found, besides our host and hostess, about twenty Poles we had never seen or heard of before, but they were all very friendly and the life there was magnificent. There were eighty saddle horses, a private pack of hounds, carriages-and-four, Cossacks attached to one's particular service and sleeping across the threshold of one's door, hereditary dwarfs to hand cigarettes, a giant, and Tokay of 1740. Not the least part of it was the host, who had a European reputation as a gambler before he foreswore

cards; he had teeth like a wolf (in fact he was not unlike a wolf altogether) and when he danced the Mazurka, as he did invariably after the 1740 Tokay, they snapped, and seemed to increase in number and prominence.

In addition to these wonders, the "very elaborate French Château" in the rural Ukraine boasted the most modern conveniences, extensive art galleries, an important collection of Sèvres porcelain, a library consisting of tens of thousands of volumes, magnificent grounds, spectacular gardens, and hundreds of trophies of the rare game that Count Potocki, a noted white hunter, had shot during his travels in Africa, India, and Ceylon. The count devoted some six thousand hectares of the estate to the fenced wild-game reserve that was home to a variety of rare and non-native fauna—bison, camels, and antelopes from the Gobi Desert among them. The staggering expense of maintaining the palace, its surrounding park and its inhabitants, human and otherwise, was borne largely by the forests and sugar beets (or rather, the huge lumber and sugar revenues) of Potocki's other estates. Antoniny's own particular revenue-generating crops were the renowned Thoroughbreds and still-legendary Arabian horses that the lord of the manor bred there.

Hunting of one species or another—pheasant, wild boar, duck, roebuck—continued almost year-round, but most coveted were Potocki's invitations for the *chasse à courre,* stag hunting on horseback, in the autumn over what Cissy described as Antoniny's "miles and miles of open, rolling, magnificent country." Sporting guests assembled for the hunt breakfast in the smartest formal English riding attire. To the consternation of his London tailor, Gizycki preferred to have his pink coats, like his breeches, cut too tight for comfort so as to emphasize his still lean, powerful physique as he approached his fifth decade. Cissy typically ate very little on these mornings, "for hunting over that vast country with its yawning ditches and muddy banks was no child's game." Though she rode equally well astride, on formal occasions such as these she and all other ladies rode sidesaddle, their skulls protected from possible concussion only by the gleaming black silk and cardboard of their bowlers and top hats; their eyes and faces from airborne mud and stones only by the tulle netting of their veils; and their spinal cords and vital organs from impact by the silk, cotton, and wool of their corsets and habits. "How I hated the first run through the forest, when the trees rushed by like live, crazy things, and my horses always got away from me!" she recalled of galloping behind Antoniny's pack of English hounds at full cry in pursuit of "the stag, speeding like an arrow, true and straight, over that enormous dreamlike land to certain death . . . One did crash into a peasant's hut for sanctuary and fell dead there on the threshold."

The hunt in the grand English style was followed by afternoon tea in the grand English style (if served from samovars by mustachioed Cossacks), either in Antoniny's magnificent library or in its stables' commodious tack rooms. Cissy felt the rivalry in tea gowns to be fierce. Dinner in the palace was followed by charades, music, and dancing, during which, in consummate Edwardian fashion, one of the ladies might drift out of the room, followed shortly afterward by one of the yawning, stretching gentlemen who professed fatigue after the exertions of the day. "And when this interesting double maneuver had definitely been accomplished," as Cissy put it, "everybody smiled at everybody else, perfectly delighted."

In Gizycki's lengthening absences from Novosielica he left Cissy occasionally in the care and companionship of Hélène Potocka at Antoniny. Insofar as he provided his wife with reasons for these journeys, he alluded nebulously to "business" in Kiev, Warsaw, Odessa, or Vienna, connected with the improvements he planned for their shared home. If the Potockis followed the English model of hospitality, entertainment, sporting activity, and, perhaps most of all, horsemanship, Gizycki, for his part, aspired to follow the Potockis' example in such matters. He engaged the Potockis' Vienna architect to draw up blueprints for improvements to Novosielica. He determined to make the estate's small-scale breeding operation into a noted stud farm. He had already begun to launch a Novosielica Hunt. In *Fall Flight,* Prince Serge Slavinsky embarks on a similar project, and it is during one of his pack's outings that Daisy and her imported Irish mare, Nora, find themselves lost and alone on the vast steppe. While Nora tries to rejoin the pack in one direction, Daisy spots the stag in the other.

Although set out of balance by Daisy's frantic sawing on her left rein, the mare made stubbornly after the pack, while Daisy clamped herself in the saddle, put her back to it, and fought for control. But Nora buckled her neck, snatched at the reins and went her way. They came to a wide ragged ditch, Daisy still pulling at the reins, and the mare, out of her stride, took off too late. On the rise Daisy saw a green boggy patch on the far side. The mare saw it, too, and high in the air seemed to make a supreme effort to propel herself across. They landed. Nora's forefeet plunged in, stuck fast. The great body lurched over in a complete somersault and lay still. Daisy came to in between the four hairy legs. The big belly with its queer-looking girths seemed enormous, grotesque, within a few inches of her eyes. She pulled herself up and began stupidly to wipe the slime and mud from her eyes and mouth. A sickening, gurgling sound, a choking grunting groan. Daisy watched the luminous eyes glaze over, saw the massive clean-hewn legs shudder and lie still . . .

Then she sat back in the mud and gazed with horrified realization at the swelling bulk beside her . . . And she sat there, incapable of moving, as if drowning in despair, in the mud, motionless.

More than an hour elapses before Daisy is able to rise to her feet and find help or realizes that Nora has died in the mud beside her, of a broken back.

Though influenced by Cissy's beloved Tolstoy and his account of Count Vronsky's pulse-quickening ride (or more particularly, by the sad end of Vronsky's imported English mare, Frou-Frou, after breaking her back) in the officers' steeplechase in *Anna Karenina,* her rendition of Nora's death in *Fall Flight* was also drawn from life. In March 1935, Bert McCormick, ever more consumed with the preservation of Medill family memorabilia, sent Cissy a photograph of herself riding three decades earlier, along with a cover letter inquiring gallantly, "Who is the daring, dashing horsewoman?"

"It was sweet of you to send me the picture of me (oh dear!) and my darling and best-beloved of all horses—Exclusive. You know, I took him with me when I went to Russia," she responded sadly, "and broke his back going over a fence. He is buried in Novosielica and there is some kind of story that a legend has grown up about his tombstone, and that the peasants, although they burned down the 'castle' and stables and destroyed everything else they could get their hands on, left his grave intact."

EUROPE APPREHENSIVE OF RUSSIAN REVOLUTION

Momentous Political Consequences Looked for by the Powers
AFFECTS WHOLE HEMISPHERE
Profound Sensation in the Balkans Caused by Port Arthur's Fall—
Other Ominous Signs in Near East

—*NEW YORK TIMES,* JANUARY 23, 1905

Married only a few months, Cissy had insisted on leaving Russia even before the dawn of the annus terribilis that would be 1905. By January of that year, the decisive humiliation of the imperial army and navy at the hands of the Japanese in Manchuria had set the match to the vast tinder box that economic decline, mounting unemployment, state-sponsored repression, labor unrest, and agrarian discontent had made of the Russian empire. The growth of increasingly radicalized and widespread opposition to tsarist autocracy had long since spread to Russia's ethnically heterogeneous border regions, so that as the Imperial Guard fired on the peaceful

workers' procession outside of the Winter Palace in distant St. Petersburg on January 22, strikes, ethnic unrest, community action, and demonstrations had already broken out in the furthest reaches of the empire, not least in the Polish Ukraine.

By the late summer of 1904, however, amidst growing domestic discontent of a more personal nature, Cissy had insisted on leaving Novosielica to spend the coming autumn and winter in Vienna. Despite the difficulties and revelations of the first months of her married life, Cissy would later confess to Tsar Nicholas II, "I still continued to believe in my husband and to defend him against my family." Privately, however, her native conviviality made the isolation of Novosielica almost intolerable; her husband— absent or present—did little to assuage her loneliness. However painful her wedding night had been,

> it was only their physical union which gave her any—however brief— sense of reality. When he lay relaxed in her arms sometimes she believed that she at last possessed him. He belonged to her then, she felt, and to her alone, those last few short minutes before he turned from her to fall asleep—into that sudden sleep of his, profound, grave, infinitely remote.

Cissy found it daily more difficult to deny either that she knew her husband no better than on the day they had met or that he showed any sign of wishing to remedy this state of affairs. Like Daisy and Slavinsky, Cissy and Gizycki had become "neither true lovers nor true friends."

As discontent reverberated throughout the empire in January 1905, in other Russian news the American press reported that the Countess Gizycka, so spectacularly married in Washington less than a year earlier, had been taken dangerously ill, and that her mother, brother, and sister-in-law had sped from Chicago on January 7 to take up the vigil at her bedside in Vienna, where she was undergoing "treatment by the world's best physicians." Though these were only hinted at in print at the time (when they were noted at all), European cable dispatches to newspapers across the United States cited "rumors of dissention" within the newly established Gizycki household, prompting quiet speculation that the young countess might return home with her mother in the wake of her convalescence. And yet Nellie, who would remain in Vienna for some months, reported herself relieved to find her earlier anxieties about Cissy's married life unfounded. "How I did worry about Cissy . . . it *broke me down*," she reminded her daughter-in-law, noting instead (while she doled out some $15,000*

*A century later, nearly $375,000, according to the CPI, or roughly $2,250,000 based on nominal GDP per capita.

piecemeal to furnish Gizycki's rented flat during the course of her stay) that "so far as I can see Gizy is a kind husband with a sense of obligations & I have no reason whatsoever to worry . . . I shall try to get on with him. We understand each other better. The thing I object to is *dining at* 9 when I am up before 6 a.m.!"

Count Gizycki's "old friend," the former May Baltazzi, had a different impression of the couple she had brought together. In her estimation, by the time of the Gizyckis' winter sojourn in Vienna, "the physical sex had quieted" and the count seemed bored with his young bride, who, by contrast, remained painfully eager to please her husband. Though Cissy's condition was reported to have been serious enough to require surgery, neither the press nor the Pattersons' correspondence recorded a diagnosis. It would soon become clear, however, that the acute phase of her illness had coincided with the first weeks of pregnancy.

Among the irrevocable changes that the events of 1905 would set in motion was Ambassador McCormick's reassignment from St. Petersburg to Paris, where his blundering but unabated pronouncements on geopolitical matters were less likely to cause harm. In explaining the move to Nellie Patterson, however, he claimed that "the climate of St. Petersburg would have about finished me in another winter and it was for this reason that I let it be known that a transfer would be more than acceptable." The Gizyckis remained in Austria throughout the spring of 1905, while the international press reported vicious pogroms in Volynia, the occupation and sack of rural manors and estates, mob violence, murders of aristocrats, discoveries of bomb-making materials in workers' homes, contagious revolutionary sentiment, widespread arrests for sedition, and many other "serious agrarian outrages and disorders" throughout the Ukraine generally. While the *Washington Post* noted in early June that Ambassador McCormick was headed to a German spa for a month's rest in the wake of his near dismissal from the diplomatic service by a figure no less senior than President Roosevelt himself, Nellie Patterson's scrapbook remarked that the Countess Gizycka bore no obvious trace of her recent illness at the start of the Vienna horse-racing season; "Rumor says that an interesting event will take place in the Gizycki household at the end of the Summer."

As the end of the summer approached, however, continued unrest in the Ukraine and reports of mounting cholera deaths in "Russian Poland" generally and Volynia particularly made it impossible for the Gizyckis to return to Novosielica for the birth of their child. Instead, with Nellie and their household staff in tow, they remained in Austria-Hungary and took up residence at Blansko Castle in southern Moravia, in anticipation of Cissy's confinement. Though they expected her labor to begin at almost any time, Gizycki persisted in his unpredictable absences. During the last

week of August, while Cissy neared the end of her third trimester feeling
especially poorly and excitable, Gizycki announced that he had "urgent
business" in Vienna and made ready to leave immediately despite his wife
and mother-in-law's pleas to stay.

Distraught and suspicious after the count's tight-lipped return four days
later, Cissy ransacked his desk and discovered diaries he had kept through-
out 1904 and 1905, which settled conclusively the mystery of how he spent
his time away from her. In these volumes, in a (necessarily) minuscule hand,
he had detailed in French all of his conquests, all of his dalliances, every
occasion on which he had exercised his droit du seigneur over the maidens of
his "villages," and, most recently, the particulars of the "urgent business" he
had transacted repeatedly over the past three days at the "house of ill-
repute" operated by the infamous Madame Rosa in Vienna. Cissy was partic-
ularly devastated to learn from the 1904 volume that her husband had
remained faithful to her for fewer than six months after their wedding.

Frantic with shock and anguish, ill and heavily pregnant, Cissy took
both volumes to the village post office in an effort to mail them to one of
her faithful "poor relations" in New Philadelphia, Ohio, for safekeeping.
Soon after, Count Gizycki's discovery of Cissy's discovery provoked a vio-
lent confrontation. He demanded to know why he shouldn't take up with
any attractive, disease-free girl who pleased him, insisting that all hus-
bands did so. Moreover, he appeared to have intercepted Cissy's incriminat-
ing package at the village post office in time to prevent its dispatch to the
United States; the diaries never arrived in New Philadelphia and Cissy
never saw them again.

On September 3, 1905, Cissy went into labor, attended only by a "rather
ignorant" local midwife. After the strain of the past few days and a lifetime
of discord with her mother, Cissy felt Nellie would provide little assistance
and stood only to make her "more nervous" as the contractions grew closer
together. Surviving accounts differ as to whether Gizycki remained in a
room down the hall, deaf to his wife's screams, or whether he was elsewhere
entirely while she struggled to deliver their child. Wherever he was, she
insisted, "he knew that I had no doctor, that I was in great danger, that I
was absolutely alone, and that I was very frightened." Though she pleaded
with her attendant to call for her husband, according to his habit he did
not come. Cissy endured five hours of agonies the likes of which she was
unable to imagine soldiers surviving on the battlefield, but then, as she
would later tell her daughter, "You slipped out like a rubber ball."

Though her name suggested happiness, the little Countess Felicia Elenora
Ludmilla Hedviga Gizycka would be neither solace nor recompense to her
mother for everything the latter believed she had lost (or rather, all she had

come to the irrefutable realization she had never had) as a result of the discoveries that preceded the child's birth. When Felicia's parents struck the fashionable bargain so often deplored in the contemporary press, neither had been straightforward about their hopes or expectations. By the time Felicia arrived nearly seventeen months later, both felt themselves to have been shortchanged. Despite Gizycki's protestations to the contrary, he resented deeply the Pattersons' refusal to provide a dowry, but had contented himself at the time with the prospect of wheedling funds piecemeal out of Cissy and Nellie, until the latter died and the former came into her inheritance. For her part, Cissy had frankly delighted in taking her husband's name and, even more, in assuming his title. If she had professed indifference at the suggestion that the dubious foreigner she barely knew might be marrying her for her money and her virginity, she had insisted, starry-eyed, that she loved him nevertheless. Much as Gizycki had quietly aspired to future *Chicago Tribune* windfalls, so Cissy had held out the girlish hope that her husband would return her feelings and come to love her for herself in the course of time.

"It was first in September 1905 that I began to see clear," she would later admit. Having until then defended her husband's behavior to her family and rationalized it to herself, the undeniable evidence of his many infidelities had in a single blow forced upon her the acknowledgment that he had never cared for her and confirmed her family's dire warnings that he had been attracted only by the prospect of her fortune. If the regret, self-doubt, and shame Cissy's realizations had sown further blighted her marriage, they would also have lifelong, almost organic consequences for her relationship with her daughter. The shock of these discoveries so soon before Felicia's birth had prevented a normal postpartum recovery, Cissy believed, relegating her to "wretched health" for several years to come. Felicia's arrival would remain inextricably tied to emotional torment as well in that "from the moment of my daughter's birth," Cissy held, her life with Count Gizycki became one of unrelenting strife.

In striking the bargain that had united them, the couple had entered into the unbreakable sacrament of marriage, however, and to outward appearances the Gizyckis continued on as before. Indeed, in the first decade of the twentieth century, Nellie Patterson's scrapbook filled with glowing, polyglot bulletins of the popular Countess Gizycka's appearances in the highest circles and among the best-dressed ladies at the courts, glittering capitals, and fashionable watering holes of eastern and central Europe. In the wake of Felicia's birth, in December 1905 the Gizyckis attended the nuptials of Princess Marie Auersberg and Count Karl Trauttmansdorff at Vienna's Auersberg Palace, Cissy in gray silk, her white straw hat trimmed with a

black velvet cockade. Shortly afterward, the Count and Countess Gizycki (the later suffering from anemia and the renewed, indeterminate nervous complaints of her girlhood) left their infant in the care of a nurse at again-peaceful Novosielica in order to travel to the United States for Alice Roosevelt's wedding to Congressman Nicholas Longworth in the winter of 1906. Back in Vienna, the "Grafin Gizycka" would excite admiration at the 1907 Mardi Gras *Hofball* in a princess dress of white panne velvet over a rose-colored petticoat trimmed in silver, with large embroidered butter-flies of pearl and emerald adorning her chest and back. "Comtesse Gizycka," *"en toilette de serge blanche, chapeau feutre de même teinte orné de feuilles rougeâtres,"* was reported to be much admired *"à Varsovie,"* in Warsaw, as well.

Increasingly the reflection of gratified maternal pride and joy, Nellie's scrapbook was equally the representation of her suspicions and fears. While the volume swelled with intimations of a brilliant future for Cissy in European society, its entries began to offer up darker auguries as well. Shortly after Cissy's marriage, Nellie's clippings, previously devoted exclusively to news of people known personally to her, began to include reports not only of mere acquaintances, but of strangers as well. In particular, she allotted

The Washington, D.C., residence of Ambassador and Mrs. Robert Sanderson McCormick at 3000 Massachusetts Avenue, NW

more column space to clippings on imposture and deception of one sort or another, among them "Dancing Girl's Son Made Prince," "Eleanor Beattie, Accused of Larceny, Charmed Fellow Passengers on Voyage Home," and "Austrian and Prussian Titles Are Investigated." The last noted that the Austrian and Prussian commission empowered to establish an official record of nobility had determined that in the Austro-Hungarian Empire alone there were currently "some thousand Polish nobles, who for centuries have borne titles without any right at all."

In the summer of 1907, while visiting Novosielica, Nellie Patterson gossiped to Alice Higinbotham Patterson back home about Kate McCormick's plans to build her own imposing mansion in Washington, D.C., on a lot at 3000 Massachusetts Avenue, even more remote from Capitol Hill and the White House than "Dupont Circle Hollow." Still smarting at her elder sister's digs about contracting malaria in the fashionable swamp where she had chosen to build, Nellie revelled in the news of the ground-breaking as a long-awaited opportunity to chuckle that Kate was likely to be murdered in her bed out by far-flung Rock Creek Park. "Cissy's baby is no longer neglected," she also remarked enthusiastically to her daughter-in-law of her granddaughter, twenty-one-month-old Felicia:

> She has strength of character, intelligence & courage & although shy—seeing so few people she naturally is frightened of strangers—she is not affectionate, wants to play but never to be kissed. If one opens the door of

Twenty-two-month-old Countess Felicia Gizycka, Novosielica, July 1907

the nursery and finds her amusing herself with the nurse she impatiently waves her hand and says by-bye! I think she is quite Gizycki but Cissy says she shan't be. She wants her to be exactly like Joe—frank and natural . . .

Since late 1904, when not traveling or visiting, the Gizyckis had lived between their well-appointed rented flat at Hoyosgasse 5, between the Belvedere Gardens and the Karlsplatz in Vienna, and their estate in Novosielica. In the interest of both Cissy's and Felicia's health, however, in November 1907, the couple decided to spend the coming winter in the South of France in the elegant Gascon resort town of Pau.

PATTERSON, JR., BELIEVES HE HAS TOO MUCH MONEY
And So Have the Vanderbilts and Such People
FANATICISM, SAYS FATHER

—*NEW YORK TIMES*, MARCH 4, 1906

On Thanksgiving Day 1907, a beleaguered Robert Wilson Patterson wrote a farewell letter to Medill McCormick at the *Chicago Tribune* from the Hotel Touraine in Boston. "I am to be 56 years old tomorrow," the elder man reflected, "and I think I have earned a little rest." Patterson planned to sail two days later for Cherbourg. After spending a few weeks in Paris, he proposed to drift to the Azores, Gibraltar, and Naples, and from there on to Greece, Egypt, and Constantinople, "where I have never been." He assured his nephew, however, that he would return to Chicago for the *Tribune*'s annual directors' meeting in the spring, at which he intended to "either resign or hold on temporarily, as the directors may desire. It is a matter of complete indifference to me. The situation at home is for me at present not very inviting. I cannot say more." Though the two had often differed vociferously on journalistic matters at the *Tribune*, Patterson harbored a sympathetic affection for his nephew nevertheless, acutely aware as he was from personal experience of the handicaps Medill faced not only in occupying so much of Kate McCormick's caustic attention and in grappling intermittently with deep melancholia, but moreover in attempting increasingly to find solace from these trials in drink.

In the past, when exhausted by the family infighting that had for decades complicated his management of the *Tribune*, Rob Patterson had occasionally and with little warning sought peace and quiet by sailing for

Europe alone. By late 1907, he had added to the sadness of his marriage and the injury of his in-laws' ambushes the heartache of his grown children's waywardness. If Kate McCormick had failed to put an end to Gizycki's attentions, Cissy's own long-indulged willfulness had imprisoned her in the sham marriage he had so clearly foreseen. Rob Patterson's relationship with his only son had been another deep source of disappointment, frustration, and pain over the past several years.

After his election to the Illinois House of Representatives as a Republican in 1903 at the age of twenty-four, Joe had been anguished to learn from his father that his nomination had been rigged by the local GOP. He promptly resigned from the house, but maintained his place at the *Tribune* long enough to attempt (to his father's consternation) to reroute editorial policy ever more firmly leftward. Returning from Cissy's bedside in Vienna in early 1905, Joe resigned from the *Tribune* as well (to the delight of his aunt) to become Chicago's commissioner of public works under Democratic mayor Edward F. Dunne, newly elected on the municipal-ownership platform that the *Tribune* had abominated editorially during the campaign. In this capacity, Joe's native bluntness and imperviousness to the blandishments of patronage or bribery made him a variety of enemies. While the Gizyckis visited the United States for the Roosevelt-Longworth wedding in the winter of 1906, Joe made headlines nationwide when he tendered his resignation as commissioner to Mayor Dunne in Chicago on the stationery of his mother's mansion on Dupont Circle in Washington on February 28, taking advantage of the opportunity to publicly declare himself a Socialist. His father, breaking with his long practice of quiet forbearance in the face of Medill willfulness, truculence, or outlandishness, retorted equally publicly that he believed such extreme views to be rank fanaticism. At the time the news broke, Rob, Joe, and Cissy had been set upon by the press while staying at the Holland House in New York. Asked cheekily whether the *Tribune* would support his son's candidacy for mayor of Chicago on the Socialist Party ticket, the conservative editor snapped, "It most certainly would not, if I am still on the paper."

Nellie's scrapbook naturally made careful note of national reaction to her family's public contretemps. Though she could not deny her son's fearsome ideological professions or her husband's uncharacteristically vitriolic repudiations, she drew the line at the New York *Examiner*'s passing assertion that "young Patterson appeared with his valet at 11 o'clock in the lobby of the Holland House" by scrawling an affronted "had no valet!" across the top of the offending column. "Joe has a touch of genius (geniuses are not easy to live with) and now remember what I say. He will leave his mark on the world. He has *force* and brains. But he will not be governed by conventional rules," Nellie insisted, while taking the waters in Carlsbad the fol-

lowing summer. Maternal indulgence notwithstanding, Joe's disaffection, his abrupt departure from the *Tribune,* and the extremity of his political views had left Nellie inwardly distraught. Frantic, she had consulted a fortune-teller who imparted the murky assurance that "he will come back through the soil." It was perhaps not coincidental, then, that when Joe abruptly determined to change course once again by taking up farming and writing fiction and drama full-time, Nellie without hesitation advanced him some $20,000* from Europe to relocate his young family to rural Libertyville, Illinois, not far from Lake Forest. "I do get so angry with him and he is so bland and rude to me at times," she admitted to her daughter-in-law, adding nevertheless, "When I see self-seeking and policy and the small natures that sneer and criticize, gossip and envy and carry tales and think of Joe's courage, simplicity, democratic spirit and real goodness—he never did a mean or dishonorable thing in his life—I am satisfied with him."

The former Alice Higinbotham's reaction to these maternal effusions goes unrecorded, but after five years of marriage to Joe Patterson it was unlikely that she agreed wholeheartedly. He was, as his mother claimed, courageous, unpretentious, and radically democratic. Alice, for her part, was prim, conventional, and (later accounts would suggest) very angry. Joe's early fascination with the workingman had continued and deepened over the years; the boy who snuck out of his mother's mansion to play with the sons of laborers had grown into a restless, tousled heir apparent to a large fortune, who frequented Chicago's poorer quarters and leapt enthusiastically into barroom brawls. Freely admitting in his widely read and ferociously assailed "Confessions of a Drone" of August 1906 (first published in the leftist New York *Independent* and the *Hobo Review* before being reissued as part of the Pocket Library of Socialism series in pamphlet form) that he was like all "idle, rich young men" in producing nothing, he denounced his own class—though without joining the rank and file he so admired, his agrarian experiments in Libertyville notwithstanding. If a foolish consistency is indeed the hobgoblin of little minds, young Joe Patterson's mind was as broad and original as it was untroubled by the looming bugaboo of hypocrisy. He attended the opera, it was often repeated, in rumpled tails and muddy boots, and continued to keep a staff and play polo avidly despite the prominent place he occupied on the national executive committee of the American Socialist Party.

For all of Joe Patterson's turbulence, willfulness, and absolutism, he possessed at least an equal measure of charisma. At the podium, he was a consistently brilliant public speaker in the service of his causes. If he held a

*Some $470,000 a century later, according to the CPI or roughly $2.4 million in terms of nominal GDP per capita.

persuasive appeal to men in the public arena, tall, muscular, and square-jawed, he exerted an undeniable magnetism over women in private. By the summer of 1907, Alice was no doubt moved to disagree with her mother-in-law's contention that Joe had never done a dishonorable thing in his life when she was reminded by one of Nellie's blundering European bulletins that "poor Minna [Field Gibson] is divorced." Though Joe had denounced Marshall Field's will and real estate trust in the *Saturday Evening Post,* publicly excoriating "the two little Field boys" for the tens of millions they inherited off the "perpetual mortgages" of the poor, he had privately taken a different attitude toward the late merchant's pretty, married niece. Amidst the journalistic furor over the announcement of his conversion to full-blown Socialism in 1906, Joe's name had also appeared prominently in print alongside those of Mr. and Mrs. Preston Gibson, after the several occasions on which a distraught Gibson had called the captivating young Socialist to answer for the role he had played in the alienation of Mrs. Gibson's affections.

Never alluding to her son's role in the affair, Nellie continued to prattle to her daughter-in-law that she pitied the young divorcée's mother, who now faced the opprobrium of Chicago's highest circles. Their mutual friend, one Mrs. Page, she reflected, had always harbored a "special abhorrence" for "*divorced* people." In fact, Nellie enlarged with characteristic tactlessness,

> Mrs. Lathrop told me that only two years ago Mrs. Page was at a luncheon
> and in speaking of one of the guests remarked, "I did not know she was

Competitive cousins: Joseph Medill Patterson (left) and
Robert Rutherford McCormick, Lake Forest, Illinois, 1907

divorced. I have never *knowingly sat at table with a divorced person.*" Not only Minna but her Irish cousin Ethel Beatty are in that category now.

" 'Judge not,' " Nellie concluded with unaccustomed (if fortuitous) clemency. "How foolish to lay down laws for other people. We need only care for our own conduct."

Cupid in Mourning

—*LOS ANGELES TIMES*, APRIL 25, 1908

In late December 1907, the Count and Countess Gizycki and two-year-old Felicia, along with their household staff, arrived in Pau to take up residence for the coming winter in their rented villa. The few days they had spent in Paris before embarking for the South of France had been neither as festive nor, from Gizycki's perspective, as successful as hoped. Despite the ingratiating correspondence he had conducted with his mother-in-law in the weeks leading up to his family's arrival to meet her in the French capital, Gizycki's unabated and mounting demands for cash had met at last with Nellie's resolute refusal, reinforced by the glowering presence of Rob Patterson.

Although Gizycki already helped himself to somewhat more than half of the income Cissy received from her mother—demanding $10,000 outright from each annual wire transfer when it arrived in Vienna and then leaving his wife to pay for their joint household expenses as well as other bills he incurred—after three years of marriage he was determined to make the arrangement official. In May 1907, Gizycki's Viennese lawyer, Dr. Otto von Reich, drew up an agreement for the couple, whereby each spouse pledged to contribute $10,000 annually toward their shared expenses.* Within six months, however, the count had defaulted, informing his wife airily that his pressing need for cash made it impossible to pay his share. The state of his affairs was such, he insisted further, that Cissy would need to wire her mother yet another "urgent request"; by way of justification, Cissy could only tell Nellie that her husband "needed the money," uncertain herself as to the reason. Nellie had duly wired a draft for some $30,000 to Vienna.† Whatever remained of her tolerance for her son-

*More than $250,000 a century later, measured by the Consumer Price Index, or nearly $1.2 million, measured by GDP per capita.
†Roughly $700,000 a century later, measured by the Consumer Price Index or roughly $3.5 million by nominal GDP per capita.

in-law's extravagance was snuffed out when she learned that much of the sum had been used to pay the outstanding debt on Gizycki's imported pack of hounds. By late October 1907, therefore, the Pattersons had taken measures to assure Cissy a small, regular income of her own, by placing $100,000 in trust in Chicago and wiring the $72 it yielded in interest to her personal account in Vienna weekly.* Only two months later, Gizycki approached his mother-in-law once again, with a Christmastime plea to forestall the seizure of his Ukrainian estates by paying off the very mortgages he had assured her the Coudert Brothers' investigators had ascribed to him in error almost four years earlier.

Having tried and failed to touch his mother-in-law for additional funds, by all surviving accounts Gizycki arrived in Pau at the end of December in a "beastly temper." Felicia's English nanny, Ethel Gernat, noticed both that the countess cried on several occasions after talking with her husband and that the count, for his part, seemed angrier and drank more than he had previously in Vienna or Novosielica. During the day, he spent much of his time riding. At night, according to his custom, he went out without notice and stayed away as long as he pleased. Cissy, listless from the acute anemia for which she was receiving treatment from a local doctor and despondent over the state of her marriage, found that her husband maintained an obstinate silence in her presence, when he was not moved to insult or berate her at the least provocation.

Of still greater anguish was the discovery in early January that since their arrival her husband had continued his infidelities and daily subjected her to general ridicule by taking up with the "very pretty" Madame R., with whom he rode, drove, and dined publicly, while Cissy remained ill at home. Her refusal to submit to her husband's demands that she invite his mistress to dine at their villa marked a turning point in their relationship. Though Gizycki had blighted his wife's self-regard over the four years of their marriage, he had not yet subjected her to the physical force he reserved for his servants and the peasants on his estates. While giving Cissy his orders for the dinner party he planned to host several evenings hence, Gizycki grew exasperated at her defiance. As Felicia toddled into the villa from her afternoon walk with her nanny, she watched her father wrench her mother out of the dining room by the arm, slam the door, and lock it after them. Once in his sitting room, he threw Cissy down violently on the sofa. Outside the door, Miss Gernat hurried Felicia away from the sound of her mother's cries.

*The trust would have been worth nearly $276,000 or almost $12 million, according to the CPI and nominal GDP per capita, respectively; Cissy received some $1,600 or nearly $8,500 in interest per week by the same measures.

Current affairs only conspired to inflame the count's festering sense of injury at the Pattersons' unyielding hands, when news reached the Gizyckis from New York of the most recent brilliant international match, this one between Gladys Vanderbilt and Count Laszlo Széchenyi, on January 27, 1908. Though much ballyhooed in the international press, the fact that the twenty-eight-year-old Hungarian nobleman, rich in his own right, had married the staggeringly wealthy American heiress without a dowry had evidently escaped Count Gizycki's notice. Having professed four years earlier that he would have married his own undowered American bride with "only the clothes on her back," Gizycki became "perfectly furious" at the announcement of the Vanderbilt-Széchenyi wedding. "Look what I have got: Nothing. Look what that boy has got," he railed continually at Cissy for weeks afterward. "Look what I have got: Nothing."

In the early morning hours of February 20, 1908, Miss Gernat awoke in the darkness to the sounds of argument and slamming doors. Soon these were followed by screams of "Oh, don't! Oh don't! You are hurting me!" Tiptoeing to the landing, she thought she heard the sound of blows issuing from the count's study downstairs. The evening before, the count had informed the countess that, as usual, he would be dining out. When she asked with whom, he no longer bothered to conceal his actions or companions, but responded simply: Madame R. "The game was up. There was no money and nothing to it," Cissy reflected. "He had lost his liberty and hadn't got anything in return." Though stricken, she resigned herself to dining with some of her own friends. When Cissy returned home in the early hours of the morning, she found that her husband had arrived about ten minutes earlier. At that point he appeared to be in high spirits while he admired himself in the mirror, wondering, "Aren't you pleased to have such a handsome husband?" Further, he bantered that he would be leaving only a few hours later to go stag hunting—once again, with Madame R. When Cissy implored him not to, he exploded.

Without warning, he began slapping her across the face and neck. Still coiled on top of her head, her thick mane of red hair offered Cissy a little protection from the impact of her husband's fists against the back of her skull, when she fell to her knees on the floor. The count pulled her up again, however, and continued to pummel her, jerking her back to her feet repeatedly each time she fell under the force of his blows, as she had seen him do with the stable boys at Novosielica. Growing tired at last, he flung her into the hallway, slammed the door, and locked it behind her. From the upstairs landing, Ethel Gernat saw the countess emerge dazed and shaking—her clothing torn, her hair pulled out in clumps, her face bruised and bloodied.

Staggered, Cissy composed herself sufficiently with Miss Gernat's help to awaken her maid and tell her to begin packing. The count's unpredictability, she feared, made it life-threatening for her to remain in the villa until morning. Swollen, bruised, and still bleeding, Cissy made instead for a nearby hotel.

"I am going now," she called, closing the door behind her.

"I am only too glad to get rid of you," Count Gizycki shouted after her.

"Well, you see I was really very much under his influence, I am sorry to say," Cissy remembered of the distraught three weeks she spent in London in March 1908. After the sun had risen in Pau and the count had left the villa to go stag hunting with Madame R., Cissy, her French maid, and Miss Gernat packed the last of their belongings and left for Biarritz, some sixty miles away, with Felicia. From there, Cissy cabled her father, who had stopped in London while returning to Chicago from his wanderings, and her mother, who wired her $2,000. Rob Patterson met his daughter and granddaughter in Paris several days later to help them cross the Channel to England. There, Cissy stayed with her father at the Savoy Hotel in London and visited Felicia daily by taxi at Miss Gernat's family home near Hampton Court Palace, twelve miles away. The child had been placed in the country in the interest of removing her from both the city's unwholesome fog and, the Pattersons' lawyers had urged, her father's reach. Though Count Gizycki had not, in fact, bothered to find out where his wife and daughter had gone, Cissy spent the weeks after she left him "perfectly distracted" with aimlessness, shame, obliterated self-esteem, fear of the stigma attached to broken marriages, and guilt at having provoked her husband into attacking her. Eventually, too, she felt a growing ray of hope that she might be able to repair the breach.

To this end, she had begun corresponding with Gizycki and, with the intervention of counsel on both sides, at last persuaded him to meet her in Paris to discuss reconciliation. Against her father's advice, therefore, she set out for France, unaccompanied even by her maid, and arrived at the Elysée Palace Hotel on March 20, 1908. She stayed with her husband for several days and cobbled together an agreement to live together once again, though the count's behavior suggested he had little desire to reunite and still less to change. He continued to drink heavily, come and go as he pleased, and conduct himself with fluctuating charm and menace. In his temperamental oscillations and drinking bouts, he grew morbidly jealous and began to imagine his wife's many infidelities during the weeks she had spent in London. Late one night, he let himself into Cissy's room. Her demands to know where he had been collided with his own accusations of adultery to ignite an argument that rapidly became violent. Before Cissy

was aware of what was happening, Gizycki had leapt onto the bed and pinned her chest with his knee. As his hands closed around her throat he hissed in German, "Now I am going to kill you. Now I am going to kill you." But as she struggled, gasped for air, and began to choke, he threw her aside just as suddenly, growling, "Why should I go to jail for you? For a thing like you?"

"It is impossible," Cissy sobbed when she had recovered sufficiently to speak. "I can't go on." Inwardly, however, she was less resolute: "I was so distracted and so broken up, and my health gone, everything had gone. I do not know what I did." Indeed, in an earlier, more amicable moment during their stay at the Elysée Palace, Cissy had given Gizycki Felicia's address at the Gernat family's home near Hampton Court. When he announced after sunrise that he was leaving immediately for London, she was overwhelmed by the full force of the imminent disintegration of her marriage and only gradually came to perceive the other, still preventable calamity threatened by his departure: "He knew it was to be, he knew that the game was up, and knew the child was the only hold he would have on my family, and the only way of getting anything." Distraught, Cissy dressed and fixed her hair as best she could without a maid to help her through the combing, pinning, layering, lacing, and buttoning that composed the fashionable Edwardian toilette, and followed her husband. "I was in a distracted frame of mind. I saw I was to be left again alone, my life just up in the air."

Disheveled, bruised, and hysterical, Cissy made a public spectacle when she collapsed to her knees, "like a fool crying there," before her husband at the Gare du Nord. Though by her own admission this was more a desperate last effort to prolong her doomed marriage than a ploy to buy time to shield her child from her husband's capriciousness and greed, she pleaded with the impassive count to "drop all this and try to begin over again" in America. She implored him tearfully to stop drinking, philandering, and committing the many other omissions and cruelties "it was impossible for me to stand." Stifling her appeals impatiently with the vague assurance that he would bring Felicia back with him to the Elysée Palace Hotel when he returned to her, Count Gizycki left his wife sobbing on the platform and boarded his train for the coast.

"The match was as unsuccessful as those who had sought to halt it feared it would be," the *New York Times* later declared. In its death throes, however, the Gizycki marriage was shortly to take a turn not even its most cynical spectators had envisioned.

The following day, Ethel Gernat was astonished to answer a knock at the door of her family's home and find a cordial Count Gizycki standing on the

threshold. His differences with the countess had been resolved, he informed her. She was to pack Felicia's things immediately and accompany both father and daughter to Paris. From there, they would travel back to Pau, where the countess awaited them at the villa. The three duly made for Folkestone that afternoon, crossed to Dieppe, and traveled by train to Paris, where they spent the night in a suite at the Hôtel Vendôme—not far from the Elysée Palace Hotel, where the child's mother awaited them distractedly. At ten o'clock the following morning, while Miss Gernat was packing for the anticipated railway journey to Pau, the count came to take two-and-a-half-year-old Felicia for a drive.

"Shall I put my hat and coat on and go with you, because I generally go," Miss Gernat offered.

"Don't trouble," the count returned amiably, "she is a big girl; she will go with me."

At dusk, Gizycki returned to the suite at the Hôtel Vendôme and locked himself in his room. Expecting that Felicia would be hungry, Miss Gernat knocked and asked if she should take the child. "Felicia is all right. She is with her mother," the count called through the door, to the nanny's bafflement. Sometime later that evening, Gizycki emerged to inform her that he was sorry, but the family no longer required her services. He intended to bring his daughter up as a Roman Catholic, and to that end he had decided to place her in a convent; a Protestant governess was of no further use to him. Astonished, Miss Gernat stammered that it was very unusual to give no notice, asked for a reference, and insisted that he pay her wages and some additional compensation for the sudden loss of her position. He complied obligingly. She spent the rest of the evening trying to contact the countess by calling the villa in Pau and a number of hotels in Paris without success. She returned to England the following day, troubled by the count's peculiar story and uneasy about her former charge. Once at home, she persisted in trying to contact the countess.

In the meantime, at Elysée Palace Hotel Cissy nursed her injuries and her pride while awaiting the count's arrival with Felicia. Only after eight fitful and silent days did she receive the message the Pattersons' London bankers had forwarded from an anxious Miss Gernat, explaining what had happened. Count Gizycki's letter of March 30, sent directly to the Elysée Palace Hotel from the Vienna Jockey Club, followed soon afterward:

My Dear Cissy,

Before leaving Vienna I want to inform you I hope you will understand that after your behavior during my last stay in Paris, and especially the charming plans you explained to me at the *Gare du Nord* it is quite impos-

sible for me to live with you any longer. I took the baby away from London as the most important point in that whole business is to secure for that child a decent future, and I don't wish Felicia to have that kind of education of which, my poor Cissy, you are yourself a victim. For the final settlement of our affairs please apply to my lawyer, Dr. Emil Frischauer, Wien, Whiplin Strasse 6.

Good bye. And last love, good bye and last love last time.

Yours,

Gizy

So complete had her husband's domination over her been that in response to this parting blow Cissy could only reflect, "I knew exactly what he meant."

I bored him. I was absolutely distraught. I suppose I cried a great deal. I may have made scenes. I was anything but pleasant . . . I bored him. I reproached him naturally for his treatment of me. I was jealous, and I cried. I was not the pleasant, easy companion he cared for.

Despite her despondency, Cissy managed to hire both English and French detectives at once. The loss of more than a week in the discovery of Felicia's disappearance, however, had left the child's trail cold.

COUNT GIZYCKI ASKS SEPARATION; WIFE WAS WASHINGTON BELLE

Former Eleanor Patterson Said to Be Accused of Fondness for Wine While She Claims Husband Lives like Bachelor

— *WASHINGTON (D.C.) TIMES*, APRIL 25, 1908

In early April 1908, Rob Patterson accompanied his daughter to Vienna both in pursuit of Count Gizycki and in hopes of gaining some news of little Felicia. By April 23, newspapers across the United States and Europe reported that the colorful young Socialist Joe Patterson had sailed to rally behind his titled sister. Meanwhile, opposing camps had begun to form — the Pattersons headquartered at the Hotel Sacher, Gizycki at the Grand Hotel — for the looming legal battle that promised to unfold shortly for the titillation of a wide readership on two continents, eager for news from the glamorous front in Vienna. In marshaling its forces, each side had enlisted formidable generals, strategists, and foot soldiers. Count Gizycki's

lawyer, the *Los Angeles Times* noted breathlessly in its especially lavish coverage of the affair, was reputed to be "the most sensational" in Vienna.

True to form, Dr. Emil Frischauer set about immediately to sully the Countess Gizycka's reputation in the international press by planting lurid accounts of her (and indeed her family's) unbecoming fondness for drink, the unbridled spending on her wardrobe and toilette that had threatened to bankrupt the plain-living count during their cohabitation, and her machinations to marry the unnamed "English statesman" with whom she had taken up in London after leaving her husband and kidnapping their child. Skilled at igniting controversy though he may have been, Dr. Frischauer had misjudged not only the enemy but the field of battle. On the American front, in attacking the former Miss Patterson of Chicago, Gizycki and his advisers had provoked not only her family—a foe that could justly boast a long and victorious dynastic record of swaying American public opinion—but more broadly, a nation of editors, reporters, and readers primed by decades of disparaging coverage of international matches to leap collectively to the defense of their countrywoman. The American accounts of the abuse Cissy had suffered at her husband's hands over the four years of her marriage were overwhelmingly sympathetic. By and large, they ring with a patriotic outrage that both ennobled and, indeed, beautified their heroine. If the reports acclaimed Cissy's long-suffering forbearance of the "titled rake" she had married, the popular debutante and glamorous bride whose unorthodox looks had handicapped her in print as merely "handsome" or, at best, "very attractive" four years earlier, became a celebrated international beauty overnight upon the disintegration of her marriage.

The Washington papers, in whose society and diplomatic columns Cissy had been such a prominent fixture before her wedding, took an especially chauvinistic view of the affair. "Society never fancied Count Gizycki," the *Post* sniffed on April 28, for example, amidst the numerous lurid contemporaneous accounts of the foreigner's seemingly bottomless depravity, "although Eleanor Patterson was one of its greatest pets. That the beautiful Titian-haired countess will find her old place waiting for her here, there is no doubt," it added indulgently of the prodigal bride. Dr. Frischauer had also bandied it about that the count had initiated proceedings to divorce his dissolute American wife. As Nellie Patterson saw it back in Washington (and many agreed), these inventions were a collective ploy to draw her to Europe to settle generously with her son-in-law in order to quash further scandal. She was, however, unruffled by the threat.

In Vienna, the Patterson camp began to plot guerrilla tactics. By April 27, 1908, through their respective emissaries, Cissy had managed to persuade

Gizycki to allow her to see the child of whom she had had no word in more than a month. Gizycki had been warned by his legal team to be on guard against surprise, however. Jealously vigilant for suspicious activity on nearby thoroughfares, the count's team sped off when they noticed two automobiles filled with figures they believed to be the Pattersons' detectives and henchmen idling in the vicinity of the designated meeting place, ready to snatch Felicia. The debacle and its resulting charges of bad faith on both sides would further sour relations between the Gizyckis and postpone indefinitely any possibility of a mother and child reunion.

Uncertain now as to when Cissy or any of the Pattersons might ever see Felicia again—let alone gain custody—Nellie made arrangements to sail for Europe in May, but only after meeting with Secretary of State Elihu Root to secure a letter of introduction to Ambassador John Wallace Riddle, her brother-in-law's successor at St. Petersburg. If Felicia had disappeared from Vienna without a trace in the wake of the botched meeting, so too had her father. "How can I do anything but stay by Cissy? Not that she appreciates it!" Nellie complained to daughter-in-law Alice in November, having had no news of Felicia in months.

> Sometimes (that is, for a few moments) I think she might as well go back and stand him and have a settled home and position as stay about pale and worrying with an objectless life. As for me, I really can't forever live in hotels in Europe! And she is too young and unprotected to be left alone, so I have to stay.

With no idea what to do next, Nellie and Cissy spent the summer and autumn of 1908 in an excruciating state of aimlessness and anxiety, wandering from one European capital, resort, and spa to another in an effort to repair the younger woman's frail health and frayed nerves while the elder aggravated her with ceaseless impolitic prattle and unsought advice.

In the meantime, Rob Patterson set out to appease Count Gizycki and reestablish dialogue. The count was reported to be unwilling to enter into negotiations until his wife's family retracted the "slanderous" reports he believed Joe Patterson had planted about him in the American press. Rob Patterson, the *San Francisco Call* reported, was unable to comply with the count's wishes for "family reasons": he was "hardly on speaking terms" with Joe. The *Chicago Tribune* editor "regretted his son's foolish attitude, but fear[ed] spoiling his daughter's case if he showed to the public that the family was not united." Nevertheless, on June 1, 1908, an Associated Press report off the European wire, citing as its principal source an unnamed "member of the Countess's family," appeared in newspapers across the

United States. "The girl's family are loath to blame the Count personally," the inside source insisted obsequiously. Rather, they considered

> the cause of the break the natural incompatibility of a freedom-loving, high strung American girl and a nobleman bound by old-world traditions. The family still remembers the Count as a strong, manly, out-of-doors sort of man "with no more vices than most, and better than the average," as the informant put it yesterday.

The AP story, along with others like it that Rob Patterson planted over the next few weeks, had the desired effect of massaging the count's injured sense of pride sufficiently to render him receptive once again to negotiation.

On the afternoon of June 16, 1908, Rob Patterson reported wryly, if wistfully, to Nellie that he had just finished an " 'amicable' enough" meeting with Count Gizycki, who claimed

> to be deeply aggrieved by the newspaper reports which he imputes to Joe that he is a "blackmailer." He had seen the reports given out to the American papers. They make a "peaceable" settlement, he says, impossible. He holds Cissy and "the family" responsible for them. What one says (he holds) we all say.

With regard to the couple's future, Gizycki professed "to be anxious for a 'divorce' and nothing but a divorce—a divorce by agreement on both sides—a sort of 'friendly divorce,' " which his father-in-law, though admittedly no expert on international law, thought so unlikely in any jurisdiction as to be absurd. "In spite of his talk he seemed to me not sincere—I thought he was bluffing and lying all the time," Patterson observed, having long ago concluded, "The truth is not in him." Understandably, it was the count's characterizations of his daughter that Patterson found most offensive: "He said Cissy was constantly trying for a reconciliation, yet she did not offer the *basis* for a reconciliation, and a willingness *to beg his pardon* and promise in future to be an *obedient wife*." Like the fictional Prince Serge Slavinsky, Count Gizycki protested that he was " 'not an American husband,' and did not wish for a wife according to American ideas of what a wife should be." Nevertheless, "in spite of his ugly talk he was not ugly in his manner nor was I," Cissy's beleaguered father concluded, adding only, "But at the end I let drop an idea that he might *force* us to go to law in Russia and that might prove embarrassing."

However mild-mannered or diffident Rob Patterson continued to

appear, he had lost all patience with his in-laws' rapaciousness. On June 20, 1908, therefore, he began to make good on the quiet, departing threat he had issued by applying to the American embassy in Vienna for an emergency passport to enter the Russian Empire. One particular complication the Pattersons faced in bringing the count to heel, regaining access to Felicia (if not full custody), and arriving at a legal resolution to the Gizyckis' broken marriage, was the knotty issue of jurisdiction. Cissy had married, in a Catholic ceremony in the United States, an ethnic Pole and Russian subject who had been raised in Austria-Hungary, and the couple had lived jointly in Vienna, Austria, and Novosielica, Russia, throughout their cohabitation. Like all American women who married foreigners before 1922, on her wedding day Cissy had been automatically stripped of her native citizenship, becoming instead a Russian subject like her husband. Though Austrian law took a denominational view of marriage and its dissolution in denying Catholics full divorces, it did allow for a form of civil separation. Should the count successfully separate from her in Vienna, as he threatened to do, Cissy faced the real possibility not only of the loss of any claims to Felicia or legal protections in her own right under Austrian law, but of statelessness as well. In addition, under canon law she would continue to be regarded as Gizycki's wife.

On the other hand, now that Cissy no longer had contact with her husband or child, Gizycki had lost access to his wife's pocketbook. If the elusive count could be brought within Russian jurisdiction, the fact that his income had suddenly dwindled to the paltry rents he drew from his mortgaged Ukrainian estates might be brought to bear in exerting leverage over him. Armed with Nellie's letter of introduction from the secretary of state, by July 6, 1908, Rob was already in St. Petersburg, where he hired Russian counsel and availed himself of the assistance offered by the well-disposed American embassy. Though (Nellie later claimed) the Russian foreign minister, Alexander Izvolsky, obligingly "offered to steal the child from the nunnery" in Austria where it was believed she was being held, Rob Patterson demurred in light of the obvious international complications this course of action was likely to engender. Instead, the aggrieved father began to investigate the possibility of seeking redress for his daughter through that mysterious supralegal body whose power devolved directly from the tsar himself, the Imperial Chancellery for Receipt of Petitions.

In his growing exasperation with human (or, more accurately, his in-laws') folly and self-interest, Rob Patterson had been driven not only to action, but to denunciation as well. He had taken care not to involve the McCormicks in Cissy's situation despite the extravagant popularity they had enjoyed in Russian court circles only a few years before. On August 15,

1908, he would make his reasons (along with his overflowing bile) abundantly evident to the Republican presidential nominee and former secretary of war, William Howard Taft:

Dear Sir—

Mrs. Robert McCormick has formally proposed to my wife to help my daughter with the Russian Government in some of her domestic troubles, if I will agree in writing to assist McCormick to get another Ambassadorship. The suggestion is also that if I do not support her for an Ambassadorship, she will oppose my daughter at the Court of Russia.

I shall do nothing of the kind. On the contrary, I protest against the appointment of McCormick to office, if his appointment is supposed to be by way of recognition of the Chicago Tribune. I am the editor-in-chief of the Tribune and President of the Tribune Company, and I know that three-quarters of the shareholders in the paper do not wish it to be represented in office:—

1. Because it is degrading to the paper and injurious to its standing with the public to have it supposed that it is a constant applicant for official favors;

2. Because office holding on the part of one of its stockholders destroys its influence with the public, as it is then supposed when it supports the Administration to be earning a bribe that has been given to it.

Mr. McCormick failed disastrously in business twenty-five years ago, and has since been dependent on his wife. He has no independent status, and no merit, except that he is "the husband of one wife"; certainly he has no qualification for an important diplomatic office.

He has never written a line for the Tribune, never made a campaign speech, nor ever given a dollar to the campaign fund; nor has his wife, unless she has done so this year "in the lively expectation of favors to come."

McCormick and his wife were disloyal to President Roosevelt and to their own country when they were in St. Petersburg during the war with Japan. They wrote home in violent terms concerning their own countrymen and especially of President Roosevelt and Secretary Hay. They said of Mr. Roosevelt, whose personal representatives they were supposed to be, that he was "a madman in the White House" and of Mr. Hay that he was "giving an exhibition of shirt-tail diplomacy." Yet, they were in a particular sense the personal representatives of the President and Secretary Hay in St. Petersburg during the war.

They seemed to imagine they were sent there to represent the Russian Government and not our own. The letter I refer to is still in existence.

President Roosevelt told me that he was compelled to remove

McCormick from St. Petersburg during the peace negotiations because he was incompetent and "a stronger man" was needed there.

I enter this protest at an early day to the appointment on account of the Chicago Tribune because he was appointed the last time through a misunderstanding and by "a fraud on the court."

The McCormicks represented in Washington that they were the chief owners of the Tribune and that the other shareholders would be gratified by their appointment. Neither of these statements was true. Mrs. McCormick inherits under her father's will a small fraction more than one-quarter of the stock of the paper, and that stock in the hands of trustees, of whom I am one. She does not control it nor vote upon it.

As for the wishes of the other stockholders, I think I may say that they are unanimous in not wishing to have the influence and character of the paper pawned in order that the McCormicks may enjoy a social distinction which they have done nothing to deserve.

I shall send copies of this letter to Secretary Root, Senators Cullom [of Illinois], Hopkins [of Illinois] and Lodge [of Massachusetts], to Governor Deneen [of Illinois] and to Speaker Cannon, and you are at liberty to show it to either or both of the McCormicks at your discretion.

I should consider the appointment of McCormick to office as the price of supposed influence exerted by him on behalf of my daughter with the Russian Government, a discreditable and almost a corrupt transaction, and it would be to me a personal grievance.

. . .

If he is sent because you consider him, apart from his relationship by marriage to the Chicago Tribune, a proper person to represent the United States abroad, that again is a matter with which I have nothing to do.

I do not dispute your right to exercise your own judgment—free from personal solicitation or opposition—in making appointments to office.

Only, I am determined that this time he shall not be appointed as he was the last, under a misapprehension arising from a misstatement of the facts.

> Yours respectfully,
> Robert W. Patterson

Rob Patterson's generous efforts two decades earlier to help launch Rob McCormick's diplomatic career in London and his sense of fair play in insisting that Joseph Medill make both sons-in-law trustees of his *Tribune* holdings had nurtured the presumption by which his in-laws had launched themselves to diplomatic prominence. Indirectly, he despaired, the McCormicks' exploitation of his goodwill had shackled Cissy to a brutal adventurer and prompted the loss of his grandchild.

The unrestrained nature of the elder Patterson's vitriol toward the McCormicks was perhaps not unrelated to his rising exasperation with his son's latest Socialist effusions. Though the *New York Times* critic (like many of his colleagues in the mainstream press) attacked Joe's first novel ("CHARACTERS ARE NOT REAL; the Socialist Author Doesn't Even Know Why He Called It 'A Little Brother of the Rich' "), when it was published in the United States in late August 1908 the work became an overnight nationwide sensation. Within the first month of its publication it had gone through six printings and sold a hundred thousand copies. Joe immediately followed up the release of *A Little Brother of the Rich* with the publication of the Socialist Party campaign book ("a slender, red-covered edition, which may easily be carried in a pocket") in early September. For this volume he had not only edited the essays submitted by the likes of Clarence Darrow, H. G. Wells, and the party's presidential candidate, Eugene V. Debs, but had included his own unsigned excoriation of the Republican nominee, William Howard Taft.

In the meantime, public sentiment continued to mount against Count Gizycki, not only in the United States but in Europe as well—and not exclusively among gawking strangers. Over the course of the summer and fall of 1908, Gizycki's "Old Aunts and Uncles," as Nellie described them—the former as devout in their Catholicism as the latter were intimately acquainted with titled penury and crippling gambling debts—urged the couple to reconcile. Cissy's female contemporaries within the extended family, by contrast, emphatically did not. Count Gizycki's first cousin, Princess Maria Lubomirska, had implored Cissy never to return to her husband and confessed that if she did, many feared *"un très grand malheur"* would certainly befall her. Though Gizycki had always been somewhat singular after the manner of his eccentric father, ever since the serious fall from a horse that had suspended his early cavalry training, the princess reflected, *"Joseph n'a jamais été normal."* Indeed, "everybody in Poland" had taken Cissy's side in the affair; even Gizycki's relatives conceded him to be " 'cracked,' 'crazy,' 'eccentric,' " Nellie reported to Alice back in Libertyville in November. "Also a beast," she added for good measure. A number of titled Austrian, Hungarian, Russian, and Polish ladies rallied around Cissy in a collective gesture of solidarity that she would remember until the end of her life. "In my whole experience," as she would put it in middle age, "I have never known stauncher, truer, or more generous friends."

In September 1908, Felicia's third birthday passed with no sign of the child. On October 29, a proposed "Obligatory Contract" between Count Gizycki and the Pattersons—intended to formalize custody arrangements, outline a philosophy for Felicia's education, and place a dowry of

$100,000* from Nellie in the hands of the child's godparents, who, though Polish, were trusted by both parties—fell through in Paris to renewed recriminations on both sides. As Cissy's own twenty-seventh birthday came and went in November, and Christmas approached with little prospect of accurate news of Felicia, Cissy traveled to St. Petersburg. Although her father had both laid careful groundwork in Russia for a possible resolution to the affair and deliberately excluded the former American ambassador and his wife from the process, Cissy was accompanied by Kate McCormick rather than Rob Patterson. Indeed, the plan the editor had outlined to his nephew and temporary replacement in November 1907, of resigning from the *Tribune* had been derailed as well when Medill McCormick himself had been forced to take a leave of absence in November 1908. Patterson's reactions to the prospects of returning to the "not very inviting" situation he had left behind in Chicago and giving Kate McCormick the opportunity to meddle once again in Cissy's future go unrecorded. No record survives, either, of his thoughts on the fact that Robert Sanderson McCormick would never again hold a diplomatic position—or, indeed, any position at all, relegated as he was by then to a "retreat" in his native Natural Bridge County, Virginia, with debilitating "melancholia." Kate, unable to obtain compensation for her efforts in the form of diplomatic preferment for her husband, was not above accepting cash. Nellie's financial diary indicates that she paid her sister some $2,000[†] both for her own and Cissy's expenses and for the service generally.

That "Baltic Chancellery Type" Baron Budberg

To the extent we were able," Vasilii Mamantov recalled of his service in the first two decades of the twentieth century at the Imperial Chancellery for Receipt of Petitions, as assistant and eventual successor to its director, Baron Aleksandr Aleksandrovich Budberg, "we helped render mercy and justice to those whom fate had made unfortunate, and who had placed their hopes in the emperor's protection." At once retrograde and progressive—in its paternalism, secrecy, and seemingly capricious enforcement of the tsar's supreme will on the one hand, and in its forward-looking

*Some $2.4 million a century later, based on the Consumer Price Index, or nearly $14 million according to nominal GDP per capita.
[†]Roughly $48,000 or $275,000, by the same standards.

sympathy for the plight of women on the other—the chancellery had been established in 1884 primarily to settle marital and family disputes. Indeed, the same body that had enacted Nicholas II's ukase to legitimize Cissy's friend Marguerite Cassini a decade earlier also sought to circumvent the existing Russian law forbidding marital separation even in cases of extreme or dangerous incompatibility involving spousal violence, dissipation, drunkenness, neglect, abandonment, infidelity, and the like. Though it intervened and issued rulings in child custody cases as well, it typically left attendant issues such as support to the courts to decide later. In those instances in which it sanctioned separation, the chancellery made it possible for women to obtain the passports required domestically for employment, lodging, and education, and abroad for foreign travel. Before 1914 married women could otherwise only obtain such passports with their husband's permission. In performing these functions, the Imperial Chancellery for Receipt of Petitions took its authority not from Russian civil law but directly from the tsar himself.

It was to investigate the possibility of the chancellery's jurisdiction in the Gizycki case that Rob Patterson had devoted much of the time he had spent in St. Petersburg the previous summer. When all other methods of seeking Felicia's return and resolving the couple's marital impasse had failed six months later, Cissy duly set to paper the story of her marriage and petitioned the tsar: "I beseech Your Imperial Majesty to lend Your all-powerful aid toward the discovery of my child; to give my little girl back to me, & to allow me to keep her at least until the courts have decided the case." The chancellery received such written pleas from all strata of Russian society, overwhelmingly from women, and reviewed them for the autocrat's express, written approval. If granted, "His Majesty's Orders" authorized Baron Budberg and his staff to proceed with the case. All of the body's dealings—its preliminary efforts at reconciliation and negotiation, its evidence gathering, its deliberations, its enforcement measures—were conducted in the strictest secrecy. The chancellery's rulings, likewise, were made known only to the emperor, the participants, and the officials who delivered the verdicts. All parties were required to maintain their silence regarding the proceedings afterward as well.

Once Cissy submitted her petition to the chancellery, she and Kate set about attempting to assure its acceptance by any and every possible avenue. First, through the lawyer Rob Patterson had retained in July they instituted separate legal proceedings against Gizycki in St. Petersburg for repayment of his most recent debt, $30,000 to Nellie. Then, with the help of the American embassy, Princess Cantacuzène (the former Julia Grant had become a popular St. Petersburg matron since her marriage in Newport a decade earlier), and a number of high-ranking imperial officials and

well-connected fixtures at court on whom the former American ambassador's wife and her niece called, the two ladies managed to secure an audience with the tsar's mother, Maria Fedorovna, during the first week in January 1909.* Whether Kate ultimately attended this interview or not is unclear; she had received word of the grave illness of her elder son shortly before the meeting was scheduled to take place and made arrangements to go to him.† Nevertheless, according to family lore the dowager empress was deeply moved by Cissy's account of the brutality of her marriage and the disappearance of her child. Maria Fedorovna pronounced Gizycki's behavior "a disgrace," and gave her assurance that she would speak to her son about it immediately.

In the meantime, the lobbying effort to reunite mother and child continued on the other side of the globe. Having returned to the United States when her sister arrived to accompany Cissy to St. Petersburg, Nellie paid a visit to William Howard Taft, to whom she confided that "my daughter is in despair over this situation. I fear for her sanity." By January 15, 1909, the Russian imperial foreign minister reported to the acting American ambassador in St. Petersburg that the president-elect's letter from Washington, urging immediate intercession on behalf of the three-year-old countess, whereabouts unknown, had reached the tsar in Tsarskoye Selo.

"Make urgent arrangements to find the child and return her to the mother," Nicholas II commanded Baron Budberg in his own hand across the top of the Chancellery for Receipt of Petitions report on the Gizycki matter, on January 21, 1909. A consummate "Baltic chancellery type" (as Count Sergei Witte, the first imperial prime minister and memoirist of the ebb of the Romanov dynasty, described him), Budberg was one of three faithful advisers whom the tsar had consulted in drafting the October Manifesto in the recent revolutionary turmoil of 1905. The baron's work at the chancellery brought him into close, regular contact with the emperor, with whom he shared a Victorian reverence for domesticity and marital felicity. So helpful to Countess Gizycka's cause would he be, and so far-reaching were his powers to compel, that Count Gizycki would soon fulminate that the fifty-five-year-old Baron Budberg was "very much in love" with the count's twenty-seven-year-old estranged wife.

*All dates have been converted to New Style.
†The surviving documentation indicates only that Kate made frantic arrangements to leave Russia in order to minister to Medill in the latest of his increasingly alarming psychiatric crises, but gives no indication of when she planned to depart, whether she remained long enough to be present when Cissy pleaded her case before Maria Fedorovna, or whether Kate left St. Petersburg at all at that time.

In apparent anticipation of the tsar's reaction to Cissy's petition, Budberg had, in fact, already begun compiling evidence in the case and negotiating between its parties. Once the Pattersons' legal suit for the repayment of Nellie's $30,000 had drawn Gizycki to St. Petersburg in mid-January, Budberg had interviewed him, as he had Cissy and others familiar with the case, in hopes of assessing the situation and negotiating a rapid settlement in the all-but-certain event of the chancellery's intervention. In defense of his behavior toward his wife during these *"conseilles intimes,"* Gizycki had denounced Cissy's flightiness, her "unwillingness" to contribute to the couple's joint expenses, and her claims that ongoing ill health made it dangerous for her to bear any more children for the time being. To justify concealing Felicia from her, Gizycki protested to Budberg that the toddler would receive a superior, European education in his care. As to a settlement with the Pattersons, in return for the outlandish sum of five hundred thousand rubles* (which he described as an eventual "dowry" for Felicia, though he proposed to use the sum to pay off his mortgages right away) Gizycki agreed to seek an annulment and share custody of the child with her mother (six months with each parent), with the stipulation that she never be taken to America.

Though Cissy agreed to these terms in principle (adding the caveat that she would need to consult with her mother as to the sum), her aunt took umbrage at them. On January 23, 1909, bearing out Rob Patterson's earlier doubts about her good faith, Kate McCormick prefaced her imperious retort to Gizycki's demands with the gratuitous (and, indeed, false) assertions that "my sister feels very little personal interest in her daughter's child" and "for the rest of Countess Gizycki's family, the child hardly exists." Conveying her counteroffer through Baron Budberg, the hard-nosed negotiator offered only $50,000† "down" and the return of Gizycki's $30,000 note in exchange for Felicia. Further, though Kate agreed to allow her great-niece to be brought up as a Roman Catholic in Europe, she refused to give Gizycki custody for more than four months of the year.

Whether Kate and Cissy knew it yet or not, however, three days earlier, on January 20, Count Gizycki had composed a letter to Baron Budberg from the Grand Hotel in St. Petersburg, expressing in terms at once flowery and snide his disdain for the chancellery's proceedings and recent *"conseilles intimes"* and concluded with a flourish by listing his forwarding

*Some $970,000 at the time, or nearly $24 million according to the CPI, or $125 million in terms of nominal GDP per capita in the first decade of the twenty-first century.
†Some 25,750 rubles, or the modern equivalent of about $1.25 million according to the CPI or nearly $6.5 million by nominal GDP per capita.

address as the Vienna Jockey Club. Thus, the following day, almost as the tsar penned the very command to return Felicia to her mother that sanctioned the chancellery's intervention in the matter, the preliminary, negotiation phase of the proceedings came to an abrupt halt when the count bolted from Russian dominions.

Henceforward, the chancellery's role in the affair would be principally one of enforcement of the tsar's "Supreme Will." To this end, Baron Budberg promptly set out to follow up on all possible leads as to Felicia's whereabouts. Explaining the situation to the chief of the Volynia provincial police and notifying him of the tsar's authorization, Budberg ordered an urgent investigation to determine whether Felicia was concealed at Novosielica, stressing repeatedly the need for the strictest discretion in conducting inquiries so as not to arouse Gizycki's suspicions.

Budberg was quietly but spontaneously assisted in his efforts by a number of Cissy's staunch allies, Gizycki's female "cousins" of varying degrees of consanguinity. In fact, several months earlier, in mid-November, Budberg had received an affectionate note from the Countess Gorska, reporting whisperings she had heard in Polish circles that Felicia was being hidden southeast of Trieste, at or near the resort town of Abbazia on the charming, rocky shores of the Adriatic, in the care of a wily English nanny named Miss Bride. The countess urged the baron to make inquiries through the Russian consul at nearby Fiume, though in absolute secrecy, because she understood the Englishwoman to be extremely wary, and feared that if surprised the latter might make off again with the *"petit chou de trois ans."* Enlisting all of her *"diplomatie féminine,"* Countess Gorska had continued to keep Baron Budberg abreast of any news she heard of the child. When chancellery officials followed up on the information she provided, they quickly discovered that Miss Bride was still Felicia's likely companion, that the pair changed residences often to avoid discovery, and that Gizycki had hired the English nanny from an employment agency in Vienna with which she continued to be in intermittent contact. Another of Gizycki's relatives, the Countess Sofia Zamoyska, likewise took it upon herself to assist the chancellery. She had come close to bribing one of Count Gizycki's footmen in Vienna for Felicia's address, but the servant, who apparently shared his master's instinct for opportunism, sold his silence to Gizycki for a higher price. In spite of these efforts, spring approached along with the anniversary of Felicia's disappearance with no concrete news of her whereabouts or well-being, and no change in the Gizyckis' domestic situation.

Really a quite disagreeable complication

Fate, which evidently loves crazy games, has just at this time deposited on my doorstep a well known American (friend of Roosevelt and Taft, proprietor of several big newspapers, etc.) as a patient," the thirty-three-year-old, but already internationally known, Dr. Carl Jung crowed to his colleague and then mentor, Dr. Sigmund Freud, on March 7, 1909. "This case has interested me so passionately in the last fortnight that I have forgotten my other duties."

Ruth and Medill McCormick's five years of married life had not been easy. With one eye always focused on the rapid advancement of his gifted cousin Joe Patterson, Medill had risen through the ranks of the *Tribune* to be elected treasurer in 1904. Although the flamboyant young Socialist's resignation the following year might have appeared to assure a McCormick victory in the struggle to control the paper after Rob Patterson's long-anticipated departure (particularly in light of Medill's ascension to the posts of auditor and assistant to the editor in chief in 1908), human frailty intervened.

In marrying Medill, Ruth had quickly and disconcertingly discovered that hers was "a relationship of protection and mother" to her husband. Though the couple lived together companionably, Medill had proved to be more high-strung, more susceptible to extreme oscillations between melancholia and euphoria, and more sensitive to family and work pressures than Ruth had imagined before their marriage. Whatever relief he was able to obtain came increasingly from alcohol. "The doctors do not think well of your condition," his mother had informed him bluntly in the fall of 1908. "They do not tell you so—but they tell me—You are nervous, unstable, strung up, over tired. Don't forget the horrid possibility—which unfortunately all the McCormicks have to face—Hereditary tendencies are *hereditary tendencies!*" she reminded him, in light of his paternal grandfather's death in Illinois State Hospital for the Insane forty-five years earlier and his father's growing peculiarities. If Kate had disapproved of her daughter-in-law before the marriage, she deplored the bohemian, reform-minded life her beloved firstborn had lived afterward. By late 1908, Kate made ready to lay the blame for the calamity she foresaw at Ruth's feet. "It is astonishing to me that you seem so unaware of Medill's physical condition," she scolded Ruth in an especially pointed and slashing hand:

I was terribly distressed when I saw him last week. You assure me that "Medill doesn't drink"—Why, my dear child, he drinks *all the time! . . .*

He never stops the *whole day!!*—His nervous system is completely degenerated by alcoholic poison. You, my dear, are now face to face with one of two certainties: Either a crazy husband or a dead husband—Don't any *longer* close your eyes or only think what you *want* to think.

In order to preserve some possibility of Medill's eventual ascendancy at the paper, Kate and Bert (now a young lawyer engaged in founding the firm that would become known as Kirkland & Ellis, the *Tribune's* counsel) bore down on him to seek psychiatric treatment on the pretext of taking a business trip to Berlin in late November 1908, while Rob Patterson was safely preoccupied with the Gizycki affair. "We don't want him to see you as you are now," Kate prodded.

By the dawn of the New Year, Medill had recovered sufficiently to resume his position at the *Tribune.* Returning to almost unchanged pressures and triggers in Chicago, however, he quickly relapsed, just as Cissy and Kate attempted to make their case to the dowager empress in St. Petersburg. In early 1909, the young McCormicks sailed again to Europe, where Medill checked into the Burghölzli clinic in Zurich. The canton's insane asylum had been established in 1860 and rapidly developed a reputation for the progressive and humane treatment of mental illness according to the most modern methodologies. By the end of the century, the Burghölzli Mental Hospital enjoyed international stature for its practice of the newfangled talking cure, "psycho-analysis." The intense, dry weeks in March 1909, during which Medill McCormick became the exclusive patient of Dr. Carl Jung, would have life-changing consequences for both men. The troubled young American journalist's resulting "cure" would be the promising young Swiss psychiatrist's first "so-called brilliant case."

With psychoanalysis still in its very infancy, its practitioners had not yet arrived at standards and practices for ensuring clinical distance between doctor and patient. Nearing the end of his treatment, Medill wrote Ruth on March 10, 1909, to say that he had received an "almost affectionate" invitation to accompany Dr. Jung on a bicycling trip in April, less in the interest of the former's ongoing "cure" than in support of his "future intellectual development and attitude toward life." Jung would be alarmed to discover that after declining the wholesome pleasures of cycling in Italy, upon discharge his seemingly "delicate" patient succumbed to an immediate "resistance." In only a few short weeks, Medill managed to become embroiled in some sort of "dangerous situation" in Paris. The patient then hurried to Venice. It is unclear whether he actually made the journeys to Budapest and revolutionary Albania that he proposed excitedly in his correspondence. Nevertheless, Medill managed to eke out some time to relax at Carlsbad with his wife before precipitously moving on without her to Russia.

Marriage, it seems, had not extinguished the romantic sentiments Medill had long harbored for his attractive cousin; rather, his state of mind appeared to have inflamed such feelings. Having learned something of Cissy's situation after he left the Burghölzli, he dashed to St. Petersburg amidst his wanderings to implore the Chancellery for Receipt of Petitions to seek the tsar's intercession on her behalf. When he discovered that the chancellery had already become involved and that Cissy and her father were then in Vienna consulting with attorneys, he sped gallantly to her side (where Ruth eventually found him) and placed himself at her service. According to Nellie, Cissy and Ruth ("both at that time nervous & high strung" as the result of their respective trials) quarreled bitterly. Though the specific source of their conflict went unrecorded, Medill's chivalrous attentions to his cousin in light of his wife's steadfast attentions to him appear to have increased family tensions.

As part of what William McGuire, the editor of Jung's collected writings, describes as "a most unconventional method of analysis," Jung added to the many roles that the versatile Ruth Hanna McCormick would play over the course of her life that of deputy psychiatrist to her troubled young husband. In light of Medill's euphoric wanderings of the spring of 1909, Jung wrote frequently to Ruth in order to impart the ongoing strategy for treatment that she was to carry out in the doctor's absence as the couple made ready to return to the United States. In these communications, Jung naturally related his diagnosis as well. While Kate McCormick scapegoated her daughter-in-law as the cause of Medill's dipsomania and emotional fragility, Jung took a different view. From Medill's account of his relationship with his mother, the doctor had drawn a portrait of Kate as "a power devil of the very first rate." The protean "demon" that tormented her husband, Jung revealed to Ruth, " = infantile relations with the mother." Medill's complete emotional subordination to Kate had metastasized over the course of his life into an overwhelming tendency toward self-destruction. In youth, this demon had led Medill to "a wild and immoral life." When he had settled down to marry, "the devil became more decent," laying subtle siege with "alkohol." More recently, "the devil whispers foolish ideas of dangerous adventures into his hear [*sic*]." "*Au fond*," Dr. Jung insisted in summation to Medill's young wife, "this desir [*sic*] for adventures does not mean anything else than a hidden desir for women."

Writing on April 2, 1909, that he hoped Medill's "disease [was] not too heavy" in the wake of his recent, unsettling adventures, Dr. Jung confronted his patient with the observation that the St. Petersburg escapade had sprung from a "resistance" that suggested an unresolved, underlying "complex." The doctor closed by drawing attention to what he described as

Medill's "resistance against analysis" in general and asking repeatedly (if ruefully) if the latter had something to confess.

Such was Dr. Jung's discomposure when the Countess Gizycka (in whom many saw a younger version of her aunt, Kate McCormick), paid him a surprise visit in Zurich on April 15, 1909, that he failed initially to recognize that his patient's mysterious "resistance" had in effect materialized on his doorstep. Even after receiving an (evidently dubious and unsympathetic) explanation of the alluring visitor's presumed motives from Ruth, the doctor little imagined that the countess might gingerly have been seeking his professional ministrations for herself in the wake of the brutality and emotional devastation she had endured over the previous five years. Instead, in responding to Ruth, Jung pronounced himself to be "very suspicious" of "Madame," in that he could conceive of no reason for her presence in Zurich—other than to meddle somehow in his patient's treatment. It was Medill's unconscious that had driven him to St. Petersburg to assist his cousin. "Now his former resistance will be reinforced again by Madame," Jung complained to Ruth, adding, "I think he does not entirely examine his feelings about Madame."

Medill, it seems, was not alone in failing to fully acknowledge his feelings about "Madame" and the "resistance" she aroused. The doctor's assessment in the most modern, dispassionate clinical terminology ("resistance," "complex," "unconscious," and the like) might have been conveyed with equal accuracy by substituting laymen's terms of more ancient coinage ("jealousy," "lust," and "competition," for example). "Madame has an enormous secret influence upon men and a remarkable lack of moral consciousness," Dr. Jung observed with a wary, if less than clinical, fascination. Jung, by no means impervious to feminine charm, had only recently disentangled himself from a "vile scandal" involving a female patient. With regard to the Countess Gizycka, he observed that "her influence upon Mr. McCormick and myself seems [to] me to be bad; that seems [to] me to be proved by the fact, that we both (Mr. McCormick and I) felt a strong mutual resistance after Madame left." If Ruth found herself jealous it would be understandable, Jung wrote sympathetically, confessing that he found himself "hurt in the same way."

Long after Cissy ceased to be an apple of discord within the therapeutic triad of Medill, Ruth, and Jung that had developed in Zurich, her unsettling influence on the McCormicks' marriage persisted following their return to the United States. Indeed, even after Medill's death years later, Cissy's relations with her former schoolmate and maid of honor would preserve something of the tensions of the spring of 1909. "She is really a quite disagreeable complication," Dr. Jung concluded portentously of the Countess Gizycka.

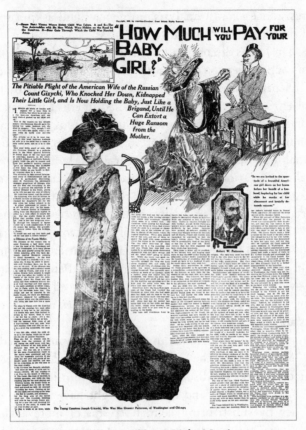

From the *San Antonio (Texas) Light,* March 21, 1909

HOW MUCH WILL YOU PAY
FOR YOUR BABY GIRL?

— SAN ANTONIO (TEXAS) LIGHT, MARCH 21, 1909

For Cissy, the spring and summer of 1909 were characterized by "endless negotiations, money and trouble and traveling around." On May 18, Nellie reported to Alice from Paris on Cissy's emotional and physical decline: "She is so worn out & anaemic but *says nothing* about her feelings or the baby. If she were emotional & could talk about it [it] would be better." In the meantime, after learning from the provincial police that Count Gizycki had quietly returned to Novosielica in early May, Baron Budberg determined to take action. By absconding from St. Petersburg in January and unilaterally ending the chancellery's efforts at negotiation, Budberg

explained to the Kiev chief of police, Major General Leontiev, Gizycki had flouted the imperial will. On May 19, therefore, Leontiev dispatched a local policeman to Novosielica to "invite" Count Gizycki to present himself immediately at the Starokonstantinov Police Department, eleven miles away. There, the count was to receive the official announcement of the imperial order of January 21, at which point he would be permitted the opportunity to make the binding, written reply by which he would affirm his readiness to obey the tsar's will and return his daughter to his estranged wife. To the befuddlement of officials from the Ukraine to St. Petersburg, however, Gizycki, professing illness, refused to leave his estate.

The following day, therefore, Major General Leontiev himself made the long, dusty journey to Novosielica, where he arrived at last after nine o'clock at night. After officially announcing the imperial command to the lord of the manor, the Kiev police chief politely but firmly requested Gizycki's written response, affirming his willingness to comply. Waffling and evading late into the night, the count refused to put pen to paper, eventually asking that the meeting be adjourned until the following morning, citing extreme fatigue and the necessity of "thinking over his situation." Upon awakening, he resumed his evasions and excuses afresh. He would willingly obey any official *legal* judgment in the matter. He was engaged in ongoing but as yet unresolved negotiations with his wife through lawyers in Vienna that made compliance with the Tsar's order premature. His estranged wife was *not* unaware of the child's whereabouts or well-being, he claimed, because he provided her faithfully with the weekly updates he received from the sister in whose care Felicia was living in Paris. Despite Leontiev's unwavering arguments that the tsar had already ruled on the matter, that the Imperial Will had the force of law, that as a loyal subject the count was compelled to obey, and that there would and could be no other outcome, Gizycki continued to evade all efforts to induce him to sign any statements expressing a willingness to comply.

Instead, Gizycki provided Leontiev with written affirmation that he had the honor of being a loyal subject of the tsar, that he obeyed Russian law "absolutely in everything," and that he was ready to provide his version of events directly to the Chancellery for Receipt of Petitions in St. Petersburg, where he intended to proceed immediately. Three days later, on May 24, the Volynia police department reported to the chancellery that Gizycki had duly left the province, although not for the capital but rather for Odessa.

Late on the evening of June 2, 1909, a bewildered Cissy reported to Baron Budberg that "the whole affair is taking on its chronic chaotic form." She was currently the guest of the Sobański family at their magnificent chateau, Guzów, some twenty-seven miles east of Warsaw. The Countess Sobańska, Felicia's godmother and one of Cissy's staunch female allies,

had met with her cousin Count Gizycki in the city earlier that day and reported him to be ready and willing to obey the imperial order and return the child to her mother, though on somewhat different terms than he had required previously. From Carlsbad, in the midst of taking the waters, Nellie reported anxiously that the ever-evolving demands proposed by the wily Dr. Frischauer on Gizycki's behalf were different still. In Warsaw and in aristocratic Polish circles generally, Cissy ventured, "Public opinion is rather high against Gizycki, which has also its influence." For that reason, she urged Baron Budberg to administer an imperial "crack of the whip" from St. Petersburg as soon as possible.

The chancellery's general investigation of the situation had served in part to confirm Nellie's earlier suspicions of the validity of her son-in-law's title, which although legitimate in Austria was not recognized in Russia. Increasingly irritated with his slippery defendant, Budberg duly ordered the Warsaw chief of police to find the "nobleman Gizycki calling himself a count" and remind him of his duty to fulfill the imperial order within ten days or else the tsar himself would be notified. Like his colleague in Kiev, however, the Warsaw chief of police learned that Gizycki had once again departed for Odessa "on private business" before he could be prevailed upon to comply. Gizycki had left word nonetheless that immediately afterward he intended to travel to Vienna to sign a final agreement with his wife and mother-in-law.

By mid-June 1909, it had become clear that Gizycki was attempting to remove the matter from the Chancellery for Receipt of Petitions' supralegal jurisdiction in Russia and have it settled to his greater advantage under Austrian law. With an eye to raising desperately needed cash and dissolving all civil and financial ties to Russia—along with any obligations due the tsar as a loyal subject—Gizycki had gone so far as to quietly put his Ukrainian estates up for sale. In fact, he had already entered into hushed, unorthodox negotiations to sell Novosielica to his neighbor and fellow horseman, Count Potocki, as a stud farm. Setting aside Count Gizycki's subordination of his small daughter's welfare to his own desperate demands for cash, legally he had a point. Having no basis in civil law and undermining a domestic patriarchy that was otherwise almost unchallenged, the chancellery's secret decisions had occasionally come under successful legal attack in Russia. No Austrian equivalent to the Chancellery for Receipt of Petitions existed; settling the case in Vienna, therefore, would permit the Pattersons no means of appealing to a higher, imperial authority who might help them circumvent a civil code that overwhelmingly favored paternal rights. And so long as the count had a claim to Felicia, he was in a position to force a financial settlement with the Pattersons.

Arriving in Vienna and resuming negotiations in mid-June, Count

Gizycki presented the opposing party with yet a new set of demands, first among them that Cissy never return to Russia, and second that "all future differences shall be tried solely before Austrian courts." On July 1, 1909, the reminders and implied threats that the Russian ambassador in Vienna issued to the tsar's wayward subject met with little more success than had the provincial officials' earlier efforts. To Baron Budberg's own telegraphed orders to report to St. Petersburg at once, the peripatetic Count Gizycki responded with assurances of his *"sincerité incontestable"* and languid regrets that ill health made it impossible to travel. On July 14, Baron Budberg dispatched a blistering rebuke to Count Gizycki at the Weiner Cottage Sanatorium, remarking that the count's "maladies" served him conveniently and well, and imputed bad faith to him throughout the proceedings. Further, the baron reminded the count that the imperial order to return the child to her mother had the force of law. No contingencies or negotiations affected its inexorable implementation; after compliance the parties would be free to arrive at custody, divorce, and financial arrangements among themselves in whatever jurisdiction they chose. Finally, Budberg warned Gizycki that in thwarting the supreme will he courted supreme displeasure and risked "compromising" his position as a Russian landowner.

The letter made so strong an impression that it prompted Gizycki to take a new tack. Recalling perhaps the success of his face-to-face charm offensive in overwhelming maternal resistance five years earlier, on July 20, 1909, Gizycki proposed that Nellie meet with him alone at the Weiner Cottage Sanatorium as the most expedient manner of resolving their differences once and for all. Two days later she dispatched a sheepish letter to Baron Budberg, explaining that in volunteering to give her son-in-law three hundred thousand rubles rather than the two hundred thousand recently under discussion as Felicia's "dowry," she had hoped to tempt him to settle the affair as soon as possible. In a weary hand, Budberg scrawled the draft of his telegraphic response, in which he observed that the more she offered the more Gizycki was likely to demand, and counseled strongly against any further direct negotiation.

"I sometimes wonder if Cissy will die," Nellie ventured to Alice from Warsaw on July 26, 1909, "never out of the strain imposed by that horrible man who they say is 'furious.' I will show you his telegram & letter saying the child is 'at my disposition in Vienna' & he only earnestly begs one more *'entrevue'* first." The trials of attempting to secure Felicia's safe return had changed Nellie. In her unaccustomed helplessness in the face of Gizycki's whims, Nellie had suffered keenly and had taken on a becoming humility and a new awareness of the sufferings of others, particularly those who had lost children. "My mother means more to me now than she did when I had

her near me and I was young and did not feel that I needed her," she realized. "*No one* loves as a Mother loves." Nevertheless, Nellie remained entirely herself in keeping minute accounts not only of expenditures on travel, lodging, fees for lawyers and detectives associated with the affair, and the details of her piques with Kate (and, more recently, Ruth) McCormick, but also of the windfall Gizycki was likely to reap over and above any settlement the opposing parties might reach. "G. took my silver tea set," she complained to Alice during the months of fruitless negotiations, false hopes, and manifold fears. "I wish I had my tea set back."

"Everyday [*sic*] when we thought a thing would be settled something else would change over again," Cissy remembered of the bewilderments of the summer of 1909. "It was always this question of money, and I wasn't concerned in it." Despite Gizycki's desperate attempts to wrest financial concessions from his mother-in-law face-to-face, Budberg's veiled threat that the count was in danger of compromising his position as a Russian landowner combined with the promise of access to ready funds from Nellie if he complied, eventually proved persuasive. At last, at the end of July, Budberg received a wire from Gizycki containing the assent that had been so long in coming: "I submit to the order of His Majesty . . ."

On Saturday morning, August 1, 1909, Count Gizycki duly restored Felicia to her mother and grandmother though, as Nellie reported it in her distinctive Franglais, "with a very bad grace & some *menaces*." Upon handing Felicia over, the count issued the dire threat that his wife would "never again have a pleasant time in Warsaw." He had apparently discovered his cousins' intrigues on Cissy's behalf and assured her that henceforward no member of his family would receive her ever again. Hinting that he had not yet abandoned hope of pursuing the case in the Austrian courts—or, indeed, of simply snatching Felicia once more—he went on to insist that he had been compelled to give up his child and that he reserved his paternal right to "act" in the future. He heaped calumnies on those who had forced his hand, fulminating ominously—if presciently—that "the Emperor of Russia will not live always" and that "the Baron de Budberg might receive a *coûp de pistolet*." Despite these treasonous maledictions, Gizycki declared that he did not wish to be divorced from his wife and believed that she did not wish to be divorced from him. Having spoken his piece, he appeared to be relieved "& made himself conciliatory, amusing & most agreeable." Now on "excellent terms" with his mother-in-law, the count insisted before they parted that she pay Felicia's "dowry" immediately. As Budberg had predicted, the sum Gizycki demanded had risen by this time to four hundred thousand rubles (to which he claimed Nellie had

agreed privately in late July), only slightly less than the half-million rubles Kate McCormick had rejected nearly seven months earlier.

Although little record survives of the mother and child reunion itself, that afternoon at the chancellery in St. Petersburg, Baron Budberg was inundated with telegrams from Vienna. A deflated Count Gizycki sent one that was entirely devoid of the sneering bravado that had characterized his earlier communications, which reported simply, "Child delivered today [to] opposing party." Cissy telegraphed that her baby had been returned to her that morning and that she had no words to thank the baron. Nellie, likewise, wired her profound gratitude and asked Budberg's advice. Despite Gizycki's best efforts, no contract regarding Felicia's future had yet been signed by either party. The nervous grandmother was in a quandary as to whether to make the astronomical agreed-upon payment to the count before the terms of Felicia's custody had been firmly established and ratified by both parties.

In the meantime, Cissy had received a telegram from her attentive cousin, offering to place himself at her disposal. She accepted readily and Medill hastened to her side in Vienna once again, Ruth in tow. The family had not yet seen the last of Count Gizycki, however. Having relinquished Felicia, he had little leverage left to exert. Moreover, now that he had fulfilled the imperial order, the chancellery took a more passive role in the matter going forward. Gizycki would receive minimal assistance from Budberg in encouraging the Pattersons to cooperate or even in keeping him abreast of their whereabouts. The tables had turned, and the count now found himself the reactive party, uncertain whether he would ever get hold of what he so desperately sought. This state of affairs appears to have prompted him to keep a constant, anxious watch over the opposing party.

When Medill arrived in Vienna, he found his aunt in a quagmire of nervous indecision. Central to her anxieties was the payment of Felicia's "dowry," or, as Medill described it, the four-hundred-thousand ruble "subterfuge" or "technicality" intended to allow Gizycki to save face; while publicly denying that he had sold his child he would receive sufficient cash to discharge some of his many pressing obligations. If Nellie gave in to the count's constant pressure to deposit the "dowry" in his Odessa bank account, he would suddenly find himself in a position to claim both the money and Felicia under Austrian law. To settle the matter, "I wrote a form of receipt for the Count to sign," Medill explained, "which in effect was an agreement that having received the money he relinquished his claim to the child." When Nellie presented the Count with the document, he became enraged and, once again, refused to comply.

Perhaps in an effort to promote a spirit of reciprocity, Gizycki did return Nellie's lamented tea set, however. One afternoon shortly after Felicia's return, Medill was alone in his aunt's sitting room at the Hotel Bristol when Count Gizycki, in a "furious passion," burst in "with an armful of tea silver" and proceeded to hurl the articles across the table and floor with a volley of "adjectival embellishments in French" before dashing out again. "I was so overwhelmed with the shower of silver teapots that I had no time to have a conversation," Medill recalled. Cissy, too, received a disconcerting parting visit from her husband when she returned to her hotel room on August 3 to find herself suddenly alone with him. "He was amiable as pie, rather flirtatious—well, of course, he was crazy, that is all I can say." His motives were by now transparent to her: the "negotiations for all this money [were] going on then, and he was very amiable indeed." Though "very frightened," she did her best to appear nonchalant. After some ten minutes of "sort of walking around" while they chatted, she pretended to need her maid's assistance in removing her hat and called for help, at which point Count Gizycki quickly departed. It was the last time she would ever see him alive.

In the wake of this interview and in light of Gizycki's nebulous threats, Cissy pronounced herself *très inquiétée* in a telegram to Budberg later that day. The following morning, immediately after receiving from the Russian embassy the tsar's ukase that was to serve her and Felicia as a passport for foreign travel, she took her daughter and made surreptitiously for Paris with Medill and Ruth. Once there, she took rooms at the Hôtel de Crillon under the name Madame Durand. Shortly afterward, Nellie departed Vienna for Warsaw, having neither concluded an agreement with Gizycki nor deposited the four hundred thousand rubles in his Odessa account. Despite the count's strange visits to Cissy and Medill, despite his efforts to press Nellie for payment, despite perhaps the spies the Americans believed him to have employed at their Vienna hotel, his wife, mother-in-law, and daughter had at last escaped from his grasp.

After a confused series of telegrams to Baron Budberg over the days that followed, protesting the departures of the ladies and demanding to know their whereabouts, on August 7, 1909, Count Gizycki fired off the first in a series of angry letters to the chancellery. He railed against the injustice of his situation and accused Baron Budberg and the Pattersons of propagating lies and plotting intrigues against him. Though he had until this point behaved agreeably, he maintained, he protested "most decisively against being the pawn of hysterical women" and would be forced to insist upon his paternal rights unless Cissy and Nellie returned immediately to conclude the settlement. Writing on the stationery of the Vienna Jockey Club (whose mounting bill he was unable to pay) rather than that of his recent

residence, the Weiner Cottage Sanatorium, he insisted that the medical treatment he was undergoing made it impossible to travel. The ladies must, therefore, return to Vienna to accommodate him. The following day, he dispatched another screed to Baron Budberg after learning that Cissy and Nellie had fired Felicia's nanny, Miss Bride—evidently with little more ceremony than he had shown Miss Gernat eighteen months earlier. Further, having neglected to bring Miss Bride's wages up-to-date himself, he complained that his wife and mother-in-law had underpaid the "first-rate" governess for much of the period during which she had so deftly concealed Felicia from them.

For some time Baron Budberg had been trying to persuade both parties that it would be most expedient to come to St. Petersburg to conclude their agreement. By August 8, 1909, Budberg succeeded at last in dispensing with Gizycki's professions of ill health and fear of contagion by convincing him that the widely reported local cholera outbreak was in abatement. Only the day before, Cissy had wired Budberg that she planned to sail for New York with Felicia on Wednesday, August 11, but that she could instead send her daughter ahead with her cousins the McCormicks if the baron required her presence, in addition to her mother's, in St. Petersburg to sign the agreement. A resolution to the painful, protracted imbroglio appeared imminent at last.

On Monday, August 9, 1909, Gizycki wired Budberg that he was on his way to St. Petersburg to finalize the protocol with the opposing party. Later that day he wired again, from the Austro-Russian border station of Granitsa, to say that he was still on his way—but that he had been arrested. Though he had fulfilled his duty to the emperor ten days earlier, an old arrest warrant for his failure to comply had not yet been lifted. By the time the chancellery telegraphed authorization for his release, Gizycki had spent two long nights in jail. Discovering once he had been set free that Nellie was by now in Munich and Cissy (as best he could make out) in Paris, Count Gizycki returned to Vienna on Wednesday, August 11, and dispatched another impatient telegram to Baron Budberg, reiterating his demands to settle the matter. He added that the ladies of the opposing party were likewise growing impatient and likewise wished to sign and settle immediately so as to return to America as soon as possible. He proposed, therefore, to meet them in Munich at once. Having had no actual contact with his wife or her family, what Count Gizycki had not yet realized was that at that moment, the bargaining chip he had held so tenaciously for the previous year and a half was slipping out of his grasp forever. That very day, more than eight hundred miles away in Cherbourg, France, the cherubic three-year-old Countess Felicia Gizycka boarded

Czar of Russia
Versus
American Mother

CHICAGO.—The czar of Russia will try to take an American child from its American soil, according to a dispatch from St. Petersburg.

Is it likely that the czar of Russia will succeed?

The child is the daughter of the Countess Gizycki, who has separated from her husband, Count Joseph Gizycki, and is living in this city. She is a daughter of Robert M. Patterson, the well-known local newspaper proprietor, who died suddenly in Philadelphia the other day.

The countess secured her child from her husband after an extraordinary series of thrilling adventures, kidnappings at midnight and on Monday and wild automobile rides.

In these violent encounters her husband was the victor. Two countess was only able to obtain her child in the end by getting a written order from the czar and paying $100 000 for it.

Now it is said that one could not sign the order, that it was forged and that he knew nothing about it. Therefore, he proposes to take the child back to Russia, as she is a Russian subject and was taken away by trickery.

Certainly this case was a very mysterious one, even before the latest revelation was made public. The American newspapers contained very sympathetic accounts of the countess' cruel treatment by her unworthy noble husband, the agonies of a mother's heart deprived of her child and her desperate efforts to gain possession of the little one.

President Taft Interested.

It was announced that the countess' uncle, Robert McCormick, formerly United States ambassador to St. Petersburg, was using his influence in that capital to obtain the child for his niece. It was said that President Taft was interested in the case.

Then the countess made a flying trip to Russia. A cablegram soon announced that she had secured her child, but had been compelled to pay $100,000 for her. Fresh thrills of indignation in the United States!

The countess came back to the United States with her little daughter, escorted by her cousin, Joseph Medill McCormick. They tried to escape observation. When cornered by the reporters the countess would merely say:

"I can say nothing as to the arrangements by which I obtained possession of my little girl."

She would not even say whether she had paid money or not.

Why was the countess so reticent and so mysterious? She had won a victory over a husband whose conduct she had frequently denounced. Why not publish the details to the world?

The explanation, as it has been printed in a Vienna newspaper, adds a new and highly dramatic chapter to this romance. Count Gizycki, we are told, was frantic with rage when his little daughter was last taken from him. He started on a sleuthing ex-

pedition and discovered, that fraud had been practiced on him.

Count Says He Was Tricked.

The count states that when he last obtained possession of his daughter he left her on one of his estates in the interior of Hungary and then went to Vienna. At his hotel there he found an order from the Russian ambassador, saying that he was wanted in St. Petersburg immediately. As he was a Russian subject with an important position and estates in Russia he obeyed the official order, without stopping to inquire what was wanted of him. Twenty-four hours later he awoke in St. Petersburg.

Next day a great carriage drove up to his hotel and a man wearing the splendid scarlet and gold uniform of an imperial court marshal stepped out. The official gave the name of one of the numerous court marshals of the czar.

"His majesty," said the court marshal, "has been very much distressed at the trouble in your family, especially as your wife was a niece of the late American ambassador. Such incidents create ill feeling between the two countries.

"I advise you to return your child to her or his majesty may compel you to do so."

"I will never give my child up unless I am forced to do so. I would not give her up for a million roubles," said the count. "I will not give her up without a written order from the czar."

An acrimonious dispute followed between the two men and the court marshal went away.

The next day he returned with an order signed by the czar, ordering him in the most positive manner to restore his child to the custody of the mother. Disobedience to this order would have entailed loss of property and other serious consequences in Russia.

Restored Child to Mother.

The count therefore promised to obey, returned to Hungary and received his child to her mother who was waiting in Vienna. She sailed immediately for the United States with the little girl.

The count went back to Russia. After he found that he had been tricked he informed the Grand Duchess Sergius of the episode. As soon as she told the czar about the case, he remembered, of course, that he had signed no order to the count.

The czar was indignant. He ordered Baron Fredericks, minister of the imperial household, the highest official of the court, to make a searching investigation and find out the name of the counter, or whatever he was, who forged the order in Count Gizycki's name. Gizycki has been ordered to remain at the disposal of the czar and the court of inquiry. As soon as the culprit is found and the details of the crime established, the Russian minister of foreign affairs will communicate with Washington with a view of having the little Countess Leonora Gizycki returned to her father.

The Russian government will claim

that Count Gizycki's daughter is a Russian subject; that her father is her proper guardian, and that as she was taken from him in the manner described, the United States should return her to him.

Count's Accession to Wealth.

Count Gizycki at the time of his marriage was very poor, being largely dependent on his salary as a captain in the Austrian cavalry. The family was of mixed Polish and Hungarian extraction, and one branch was settled in Russia.

Soon after his marriage, the count inherited large estates from an uncle in Russia, including several thousand acres and three villages. As foreign-born cannot hold property in Russia, Count Gizycki had to give up his Austrian citizenship and become a subject of the czar.

Before he left Austria he and his wife had had serious quarrels. She found him entirely uncongenial and very overbearing. It has even been stated that he struck her and knocked her down.

She could not obtain a divorce from her husband abroad. To obtain one in America would give her no right over her child in Russia or Austria. Her only resource was to run away with the little one.

So one day the countess packed up a few of her belongings and, with her little girl, fled to London. She let it be known to the count's household that she had gone to Paris in order to throw him off the scent as long as possible.

Kidnaped by the Father.

One day, a week or so later, while the little girl was out for an airing with her nurse, a big touring automobile, which was seemingly speeding along, came to a sudden halt. The countess, while making her headquarters at the Savoy, in town, had requested the child to a cottage at Campden Hill, one of the suburbs of London, to charge of the nurse, whom she trusted implicitly. Three men jumped out of the auto, and one of them engaged the maid with some questions about the route to the neighborhood. The two other men—one of them wrapped up to a big motoring coat and cap, whose face was half concealed by a motoring mask—interested themselves with her little charge and set the "choo choo" going to amuse her.

While the nurse was good naturedly trying to explain to the very agreeable stranger the little she knew about Campden Hill, and while the baby was gleefully chuckling over the noise the motor made, something strange happened. The agreeable man, without so much as an apology, made a sudden jump and leaped into the automobile, and before the poor, dumfounded nurse girl could rub her eyes, the big machine was speeding over the hills and far away with him, the other two men—and the baby.

Detectives under the immediate guidance of the count held tracked the countess at every step she had made since her flight, and the man in the big furs and the motor mask who had kidnaped the baby was the count himself.

The vain and venturous heart to locate the baby, and the poor young mother's distracted efforts to have her little one restored to her, is a long story.

Offered to Return to Husband.

Lawyers were secured, all influence possible to secure was brought to bear on the case, and all Russia, Poland and Austria were ransacked by searchers to find the baby's hiding place. The countess, who is passionately fond of her baby, at last was at her wit's end. Every resource that had been suggested had been tried—but hopelessly.

Then came a bitter pill to swallow. In her intense love and longing once more to hug the child to her bosom, the miserable mother finally consented to the humiliation of promising that she would go back to her husband if only he would share the baby with herself.

During these negotiations, in which the count pretended to be agreeable to a reconciliation, arrangements were made by the lawyers on both sides for the mother to see the child, first, in a house near Vienna. The countess, her heart beating high with expectancy, arrived to an automobile at the place at two o'clock in the afternoon, the hour appointed.

But the child was not there. The countess, torn between conflicting anger and chagrin, saw in this cruel episode another wound from the count to torture her, and hardly the role away again to hide her anguish.

The countess aware that never again, after this display of deceit to just torture and insult her, would she think of a reconciliation or ever see him face again. The count retorted that he was the father of the child and its natural guardian, since its mother had seen fit to leave the protection, and that he would keep it till he saw fit, for sufficient reason, to change his mind.

The countess returned to America, and after having consulted with all her powerful relatives and friends in this country, secured her child from this count, as already told.—Chicago American.

One of the many sensational, largely invented accounts of Felicia's kidnapping and recovery that appeared internationally between 1908 and 1910. This one, from the *Olean (New York) Evening Times,* was published the night after she landed in New York Harbor, safe at last.

the *Kaiser Wilhelm der Grosse* and set sail for her new home in the United States.

CHICAGO COUNTESS WILL RETURN HOME

The Countess Felicia, golden haired and blue eyed, was the life of the ship, winning her way to the hearts of all.

— CHICAGO *INTER-OCEAN,*
AUGUST 18, 1909

What did Felicia understand of these matters? Or, perhaps equally importantly, what did she believe she knew of the events of her first years of life, and how did she interpret them in retrospect? As an octogenarian, she would attempt to reconstruct her momentous childhood and make sense of the path it had set her on, in a careful hand in a series of ruled school notebooks that would become the manuscript of her memoirs. The task she had set herself was as arduous as it was impossible to complete, however, due both to the relative inaccessibility of preverbal memory and the fact that, with the exception of Felicia herself, the principals in the affair had died long before. Though Felicia had no recollection of Vienna or Novosielica from the first two years of her life, she was aware of the comfort and privilege in which she had lived (her father's precarious finances notwithstanding)—of being well fed and

well dressed, of being shy of strangers and cared for, like many of her privileged contemporaries, by nannies. She knew also that with the violent demise of her parents' marriage, "this whole world was torn away from me."

Her recollections of the eighteen months during which she had been hidden from her maternal relatives—and indeed, with the exception of her father, from everyone familiar to her—were understandably disjointed, almost dreamlike and apparently much commingled with information she had gleaned from old clippings on the affair. "I don't remember being snatched," she reflected, "and I don't know who snatched me. Perhaps my father took me from my nannie [*sic*]. I don't know." Though conscious that the event must have been extremely traumatic, in attempting to conjure it from memory she found herself able to generate only a "phantasy." From the time of her kidnapping in the spring of 1908, the international press covered the Gizycki affair relentlessly. Sacrificing accuracy to mawkish sensationalism, newspapers across Europe and the United States borrowed indiscriminately from one another, collectively compounding their errors and corroborating their inventions. In the silence that reigned among the principals once the chancellery became involved in the case, the most widely propagated rendition of the protracted melodrama cast the count as the stock villain whose henchmen and spies had pursued the wronged wife, eventually hatching a conspiracy to waylay the governess, snatch the child, and hold her for millions of dollars in ransom. Curiously, Felicia's "phantasy" would bear a far closer resemblance to the aggregate newspaper saga than to the accounts provided by her family and other witnesses in the official, if secret, documentation that the chancellery compiled shortly after the events occurred or to the sworn testimony that would be taken on the matter in the Cook County court system in the coming decade. As she imagined it,

> I am on a street corner in Vienna, and it's dark. I am with someone I'm used to, some nannie [*sic*], but not an English speaking one. I am suddenly lifted up by a strange man, who smells unfamiliar. He holds me, over his shoulder and starts running. I scream "Fraulein! Fraulein!" Or the name of my nannie. The man keeps holding me and running. But now he puts his hand over my mouth to stop my screams.

Even among the chancellery's meticulously investigated findings, no definitive record survives of Felicia's whereabouts during the time she was hidden from her maternal relatives. Felicia thought that after her abduction she traveled by rail with two unfamiliar adults, who did nothing to comfort her or shield her from the terrifying shrieking of the locomotives outside the window of their compartment. She believed herself to have

been held at an Austrian convent in the midst of a magnificent field of red poppies and blue bachelor buttons. She retained impressions of listening to the fascinating cackling of the resident madwoman, whose "screams of laughter punctuated the music" during mass. She had been the charge, she thought, of an Englishwoman. "I didn't love the woman, whoever she was, and she did not try to ingratiate herself." Indeed, in Felicia's reconstruction of the period, the faceless adults around her were devoid of affection and unresponsive to her emotional needs. However vaguely, she remembered these figures much as she felt they regarded and treated her—without humanity.

> Everybody else was very tall. I didn't know who I was. The tall people just did things to me, because they had to. They did things to my body, without consulting me. I was washed, dressed, and undressed, put in bed, taken out of bed, and my teeth were brushed. I was fed and put on the potty.
>
> It seemed as if nobody really noticed me, they were doing all these things with their minds on other things, and they spoke to me only to order me to cooperate.
>
> Or to say, "Don't do that!"

The single figure from this period in her life to distinguish himself as an individual was her father. Felicia recalled his visit to the convent, however, as "shocking." His disruptive presence in that otherwise feminine sanctum, his talking about her within her earshot, his taking her on his knee "without any preliminaries" to reacquaint himself with her, were to Felicia unwelcome intrusions. When he broke the hush of the cloister with a song, the toddler promptly ordered him, "Stop singing!" This would remain, she held, her single memory of her father. In retrospect she mused, "I bet I'm the only female who ever rejected him."

Though Felicia had no memory of being reunited with the mother and grandmother from whom she had been forcibly separated for more than a third of her short life, she did recall something of her voyage home aboard the *Kaiser Wilhelm der Grosse*. For the rest of her days she would think back gratefully on Ruth Hanna McCormick. That "marvelous, intelligent, happy woman" had been kind to her in the confusion of her abrupt reunion with a family of strangers. On one occasion aboard ship, Felicia remembered sitting with Ruth in deck chairs while a steward passed a tray of hors d'oeuvres at which the three-year-old turned up her nose and shook her silvery ringlets, scowling, "Nasty meat-meat!" Having read for nearly a year and a half the breathless international accounts of the tiny countess's disappearance, her mother's plight, and her family's desperate efforts to retrieve

her, Felicia's fellow first-class passengers were apparently charmed by her every move, and received the little celebrity's petulance with a chorus of delighted laughter. Felicia was not pleased with the attention; "I didn't feel cute," she recorded in her memoir, adding unexpectedly, "I didn't know what a mother and father were supposed to be. I was very small."

Felicia would retain no memory, either, of docking in New York Harbor at last. She would wonder for the rest of her life whether her mother had been there to greet her. "Did she pick me up in her arms and hug me and kiss me?" Never having received a definitive answer from her family, apparently, she would draw the inference, "I rather think not." Cissy, Felicia would come to suspect, had "certainly paid" for Ruth and Medill McCormick to bring her home. In light of the relationship mother and daughter were to construct from their fractured beginnings together, Felicia would conclude, "It was like Mother to have someone else bring me from Europe, instead of bringing me back herself."

THE TITLED MATCH

Countess Has Won Her Fight
Child of Gizyckis Secured by Mother
Joseph Medill McCormick Sails from
Cherbourg with Daughter of His Cousin,
Formerly Miss Eleanor Patterson,
Kidnapped by Father in Vienna in Spring of 1908

—*LOS ANGELES TIMES,* AUGUST 12, 1909

Not yet aware that the Atlantic Ocean yawned ever more widely between himself and his principal remaining source of income, in the second week of August 1909, Count Gizycki continued haggling as desperately as before. His anxiety to conclude the chancellery's brokered agreement (or "protocol") with the Pattersons—though on his particular terms—appears to have been heightened as much by the recent change in Felicia's custody as by the growing number of moneylenders who closed their doors to him. Inasmuch as the chancellery's proposed protocol granted uninterrupted custody of Felicia to Cissy, Gizycki ratcheted up his own demands for the child's "dowry" proportionately. In less than a month, the 400,000 rubles he had demanded in July ballooned back to the 500,000 he had insisted upon in January. Even this staggering sum would be insufficient to cover his debts, however. During the summer, Nellie had engaged a detective to investigate the current state of her son-in-law's

financial affairs. Since the last report nearly six years earlier, the mortgages on his estates had more than doubled to some 860,000 rubles. Moreover, this figure did not include the 905,000* rubles he owed to various banks, merchants, and moneylenders throughout Russia and Austria. This knowledge only served to heighten Nellie's fears that not even a protocol signed by both parties and given the force of law in Russia by supreme order would be likely to prevent Gizycki from making himself "difficult" again in the future.

In the meantime, despite the precautions the Pattersons and the McCormicks had taken—both to cloak Felicia's movements from Gizycki and to uphold the chancellery's secrecy requirements—news of the kidnapped child's recovery had begun to emerge. By August 10, tales of international marriage gone awry, titled brutality, kidnapping, blackmail, imperial and presidential intercession, hundreds of thousands—if not millions—of dollars in ransom, and maternal forbearance rewarded at last appeared in vivid purple prose across the United States and Europe. On August 12, the *Los Angeles Times* broke the news that Felicia had been spotted embarking for the United States the day before with her mother's cousins. The story formed part of the larger, garbled saga presented in international headlines of Medill McCormick's ultimate triumph in retrieving the child with the assistance of those "authorities" in St. Petersburg whom he had alerted to the Countess Gizycka's plight during a detour from a "business trip to Berlin" the previous March. "The present whereabouts of the Countess Gizycki [*sic*] are unknown here," the *Times* noted (and many of its competitors quickly repeated). Further illustrating the lengths to which Felicia's maternal relations had gone to protect the child before she sailed, the *Times* story closed by adding, "Neither [the countess's] name nor that of her child appears on the passenger list of the vessel, which is due to reach New York in the middle of next week."

During Felicia's six-day sea voyage, her father, too, remained uncertain of her mother's whereabouts. Count Gizycki inundated Baron Budberg with communications by post and wire, insisting that he meet with "the ladies" wherever convenient as soon as possible to sign the protocol. In keeping with his earlier machinations, to spare them the trouble of traveling to St. Petersburg, the count offered to appear at any location they chose and listed several options—all of them outside of Russian dominions. From his previous dealings with Gizycki, Budberg had foreseen this ploy, however, when he warned Cissy by wire on August 9 to prevent her mother

*His outstanding debts amounted to some 1,765,000 rubles or nearly $3.5 million in 1909, a staggering $85 million according to the CPI or some $460 million by nominal GDP per capita.

from entering into further, direct negotiations in which she might be bullied by her son-in-law. In the same telegram, addressed to "Madame Durand" at the Hôtel de Crillon in Paris, Budberg had also answered Cissy's urgent question as to whether to send Felicia safely ahead to the United States in the care of her cousins while she made for St. Petersburg to sign the protocol. If the countess would provide her address in America, the baron would simply forward a copy of the agreement for her signature. Mindful, no doubt, that the tsar's supreme will was unlikely to withstand legal challenge in the dominions between the Russian Empire and the Atlantic Ocean, Budberg had urged Cissy unequivocally to sail from Europe—and from Gizycki—at once with Felicia.

Cissy had therefore immediately stolen westward from Paris to Cherbourg. Meanwhile, some 650 miles to the east, the count had hastened from Vienna toward Petersburg in eager anticipation of his reward. Though Gizycki expected that both members of the opposing party would meet him there, Budberg had permitted Nellie to remain in Berlin, inasmuch as the baron had no doubts about her willingness to endorse the document outside of his compelling presence. The surviving documentation suggests that the bureaucratic failure to lift Gizycki's arrest warrant at the Russian frontier had resulted from genuine oversight—though perhaps Budberg's lethargy in freeing him had not been accidental. The two nights Gizycki spent in jail had conveniently furthered Baron Budberg's apparent design to draw the attention of the opportunistic count away from his small daughter while she slipped out of his reach. Although the international press had been unable to find any passenger listed under the name "Gizycka" on the manifests in Cherbourg, immigration records compiled upon landing in New York made clear that not one but two Countesses Gizycka—mother and daughter, both traveling on a single Russian passport—had set sail aboard the *Kaiser Wilhelm der Grosse* on August 11, 1909, to begin life together anew in America.

"I am weary," Cissy told a *New York World* reporter in the sitting room of her cabin shortly before landing on her native soil. "I do not wish to talk of the past. I wish to forget it. Now that I have my baby I am satisfied." The *World* noted that the countess "placed her arm caressingly about the child," and that Felicia clung "closely to her mother" in return. Amidst the many journalistic inventions on the subject of the Gizycki affair, it is impossible to determine the accuracy of such reports. "I am here on six months' visit to my former home in Chicago," Cissy informed the throng of reporters who awaited her comments on the affair that had "furnished a sensation on two continents," as the party disembarked in New York Harbor on August 17, 1909. "Now that I have my baby again, I am happy. I am almost afraid to

let her out of my sight," she added. "I will stay at the home of my father, Robert W. Patterson, while I am in Chicago, and on my return to Europe will live in Vienna." The Countess Gizycka was unwilling to confirm or deny any of the details of her flight from her husband, the kidnapping of her daughter, the process by which the child had been returned, or any sums involved. Cast in the unsought role of hero by Cissy's reticence, Medill found himself an unwitting family spokesman. Though he would divulge little more than Cissy had when the Pattersons and McCormicks were besieged by reporters over the coming weeks, Medill skirted the chancellery's rules by admitting that "inasmuch as the regular tribunals had no jurisdiction in the matter . . . the Tsar, through the Imperial Chancery of Requests [*sic*], deigned to recognize the Countess's claim and ordered that she be protected in the Russian domain in so far as lay in the power of the Russian diplomatic representatives." Nevertheless, he emphatically denied the wild rumors that the count and countess might now reconcile after all, or that the Patterson family had paid Gizycki as much as $500,000 for the child. "Not one cent changed hands," he insisted. And, for the time being, the statement was truthful.

Felicia would never know there had been a definitive answer to the question that haunted her into old age: Not only had her mother been present when she landed in New York Harbor as a toddler in August 1909, but moreover, Cissy had sailed with Felicia after taking careful steps to protect her from falling into Gizycki's hands ever again. Both Ruth and Medill McCormick had provided invaluable assistance in assuring Felicia's safe return, but Cissy's cousins had not, as it had been reported internationally (and as Felicia came to believe), been the catalysts in resolving the affair. Acting in concert, uncounted individuals—royals; high-ranking officials on two continents; rural policemen; urban detectives; lawyers across Europe; benevolent, stealthy highborn ladies; an anxious nanny—had sought to right the wrongs Count Gizycki had inflicted upon his wife and child. No one had done more to retrieve Felicia, however, than her maternal relatives. "I sincerely hope that this is the beginning of a condition in which you will continue to enjoy your grand child and that your daughter will derive the happiness that a mother feels in the custody of her dear ones," President Taft wrote on August 19, 1909, in response to Rob Patterson's letter of deep appreciation. Felicia's grandfather had laid the groundwork for the invaluable intervention of Baron Budberg and the Chancellery for Receipt of Petitions. Her grandmother had provided the funding for the operation and, for all her bumbling, had done her best to prop Cissy up in the process. Cissy, for her part, had by many accounts lost her health and

nearly lost her sanity in the effort, but had refused to leave Europe until she had recovered her child.

How was it, then, that Felicia knew so little of the painful, protracted efforts her family had made on her behalf? At a moment before the European or American general public had become accustomed to the degree of intimate self-revelation that the talking cure would popularize both inside and out of the psychiatric context, perhaps the Pattersons had been seized and silenced by the same spirit of reticence that had prevented Theodore and Edith Roosevelt from ever speaking to TR's daughter Alice about the tragic circumstances surrounding her birth. Perhaps the Pattersons' silence resulted from an overzealous observance of the chancellery's rules regarding secrecy. Nevertheless, though Felicia knew very little about her kidnapping and almost nothing, evidently, about the process by which she had been returned, her mother and grandmother would over time impart a variety of colorful facts about her father, very few of them flattering. Cissy had shed her prim girlishness as a bride in Europe and returned to the United States far more saltily outspoken than she had been when she left. By the time Felicia was a teenager, her mother had informed her repeatedly, for example, that her father frequented whorehouses, adding with a flippant wave of the hand "in the after*noon!*"

Felicia had been hidden from the age of two and a half until a month before her fourth birthday. Without the input of those who had participated in her return or access to accurate information about the affair, her understanding of the momentous events of her early childhood was, at best, incomplete and confused. At the same time she was saddled with the emotional legacy of having had all of the bonds she had formed with the familiar figures in her life abruptly severed before her third birthday. According to her grandmother, even during the comparative calm of the Gizyckis' last months of cohabitation at Novosielica, Felicia had been an aloof child. Whether this was a consequence of the "neglect" Nellie had lamented during Cissy's postpartum despondency, it is impossible to tell. Similarly, it is impossible to assess whether Felicia's failure to recall her mother's presence aboard ship came as the result of normal infantile amnesia (the adult's inability to recall the events of early childhood), of her understandable failure to distinguish the woman who was her mother from among her other by then unfamiliar relatives, or perhaps of Cissy's unavailability due to some sort of emotional or physical collapse aboard ship that had likewise prevented fellow passengers from informing the press of her presence.

Whether remembered accurately or not, the events of Felicia's traumatic first four years would have a profound, even transgenerational, impact on

the relationships she formed as she grew older. It remains unclear why Felicia was told little of the year and a half during which she was lost to her mother, and almost nothing of the lengths to which the Pattersons went to assure her recovery. Though the silence that surrounded the affair would not be the cause of the tempestuous mother-daughter relationship that was to develop, it would have the tragic consequence of cheating Cissy of Felicia's fully informed—and perhaps better—ultimate opinion of her, and Felicia of any comfort the knowledge that Cissy had cared enough to fight for her return might have provided in the midst of their later troubles.

THE MOST KIDNAPPED
CHILD IN THE WORLD

How the Little Countess Gizycka Has Been Buffeted by Fate, Captured and Recaptured by Her Divorced Parents and Is Now Held by Her Mother in Dread of Another Separation

— *THE SUNDAY OREGONIAN*, OCTOBER 8, 1916

"My mother drifted past me in beautiful clothes and jewels, bored with me," Felicia would recall of the childhood she resumed in America. "I was ashamed of being alive and getting in her way." Mother and daughter retreated to Lake Forest, Illinois, in the wake of their ordeal, as their Patterson forebears had done for three generations in the aftermath of their own trials. Though she had gained the overwhelming sympathy of the American public, the Countess Gizycka found herself somewhat notorious upon her return to the United States. Intelligent if untutored, restless if world-weary, she had been derailed from the course she had foreseen for herself when she left home six years earlier and now found herself at loose ends. What would she do with the rest of her life? Her marriage had disintegrated but would not be legally settled for some years to come. She had been raised and educated to be well married, but remarriage was, at least for the time being, impossible. For the previous year and a half she had devoted herself to recovering Felicia and had nearly lost her physical and mental health in the process. Having little experience of maternal participation in her own lonely childhood, however, she quickly became a remote figure to the daughter she had brought safely home.

In the half century since Cissy's great-grandfather, the Reverend R. W. Patterson, had first viewed the meadows, ravines, and wooded bluffs thirty miles north of Chicago, Lake Forest had become an exclusive, if still bucolic, enclave. Offering to Chicago's most prominent families a haven

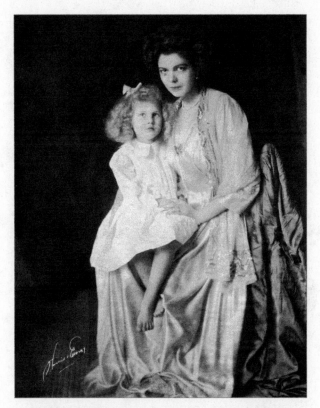

The portrait of the two Countesses Gizycka (Felicia,
four, and Eleanor, twenty-seven) that appeared in the
international press at the time of their arrival in
New York Harbor in August 1909

from the trials of modern urban life—its conflagrations, its riots and labor
unrest—the town had grown into a series of elegant estates centering, lit-
erally and socially, on the Onwentsia Club. There, some of the United
States' wealthiest citizens enjoyed golf, polo, fox hunting, and horse shows.
Though Exclusive had not survived to accompany Cissy back to the Mid-
west, she had brought her other horses with her from Novosielica. She
became an active Onwentsia member, schooling her mounts in the club's
rings, hunting behind its pack of hounds, and engraving her name on its
trophies after the dust from its horse shows had settled. Her brother and
cousin were stalwarts of the club's polo matches, and through them she
became reacquainted with her former beau, Freddy McLaughlin. As of old,
the two rode out and hunted together often, and resumed their romance.
Upon his father's death in 1905, McLaughlin and his brother had taken
over the family coffee business and become millionaires in their own right.
A thirty-three-year-old bachelor in 1910, Freddy McLaughlin was dark,

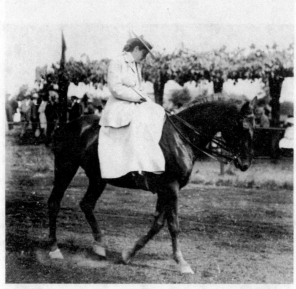

"Mrs. Medill McCormick riding Tribune" in the 1907
Lake Forest Horse Show. Cissy's former Farmington
schoolmate, Ruth Hanna, had married her
favorite cousin in the spring of 1903.

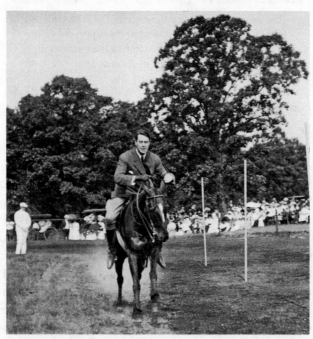

Robert Rutherford McCormick at one of the Onwentsia Club
horse shows in the first decade of the twentieth century

handsome, domineering, and temperamental, but had by many accounts had the good grace to make fun of himself.

While Cissy was reestablishing herself in Lake Forest, it was Nellie for the most part who attempted to conclude negotiations with Count Gizycki. In the month during which she had remained in Europe after Cissy and Felicia's departure for the United States, Gizycki had succeeded in meeting with her alone at last, despite Baron Budberg's warnings. Though Nellie and Cissy had already signed the chancellery's protocol, during his *"pourparler"* with Nellie in Paris in late August 1909, Gizycki continued his efforts to renegotiate terms before signing. He agreed verbally to a definitive termination of the marriage and insisted that the Pattersons engage a German-speaking, Catholic governess for Felicia. Nevertheless, he objected to Cissy's sole custody and attempted, as usual, to wrest ever larger sums for Felicia's "dowry" from the Pattersons. Gizycki's persistence in trying to persuade Nellie to return his $30,000 note as part of the bargain had succeeded only in convincing her that the debt might be used to exert long-term leverage over him. She began to consider forgiving the loan in her will—after her death. With both parties now well beyond Russian dominions, Baron Budberg found it increasingly difficult to impose the supreme will upon either one. After meeting Nellie in Paris, Gizycki reported terms renegotiated much to his advantage to Budberg and demanded that the protocol be redrafted to reflect them. After consulting with Levy Mayer of the law firm of Mayer, Meyer, Austrian & Platt once back in Chicago, however, Nellie took it upon herself likewise to dictate new terms and refused to pay Gizycki a penny until her daughter's divorce had been finalized.

"I am not sure your legal friend, L. M., is a good adviser," Nellie complained to her nephew Medill in the summer of 1912. "His advice to me has been '*Don't pay G.*' So I have broken my word, deeply offended Budberg . . ." Indeed, three years after Felicia's return, the affair was no closer to resolution; rather, it had devolved into a series of retaliatory international lawsuits, salacious newspaper condemnations, and scurrilous counter-charges. Gizycki complained to the tsar himself of the favoritism Baron Budberg had shown in pressing him to return Felicia without likewise compelling Cissy and Nellie to make the promised deposit to his Odessa account. The count renewed his threats, first among them that he would be forced to "tell the truth" about Cissy without regard to the consequences for her reputation. Stories sympathetic to Gizycki, resuscitating charges of Cissy's fondness for drink, her profligacy, and her maternal unfitness, began to appear in the Austrian press. Reinvigorated by the cash he had received from quietly selling Novosielica to Count Potocki, Count Gizycki resumed his Austrian citizenship and secured a legal decree of separate maintenance,

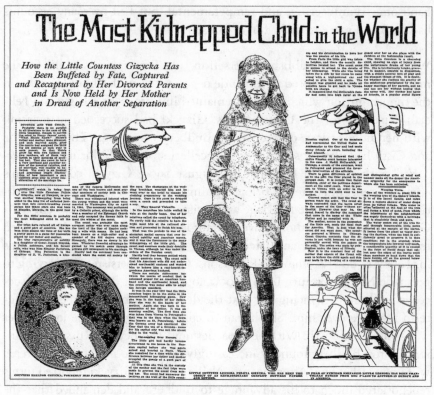

Sunday Oregonian, October 8, 1916

which in effect removed "the protecting arm of a husband from his wife," in Vienna in September 1910. His next step, Nellie feared, might be an Austrian legal custody battle or, worse, another attempt simply to snatch Felicia. In January 1911, therefore, to renewed sensational international press coverage, Cissy parried by filing suit for divorce in Cook County, Illinois.

It was against this backdrop that novelist and journalist Arthur Meeker remembered, of the otherwise idyllic summers he spent in Lake Forest during his childhood in the first decades of the twentieth century, that "when we played hide-and-seek the game lacked *entrain,* as a detective had to hide with Felicia." Nevertheless, Felicia and her Lake Forest contemporaries recalled her bodyguard as a delightful companion who threw them in the air, pulled coins from behind their ears and out of their noses, and carried them obligingly on his back. Early on, Felicia had taken Arthur Meeker as her only "bosom companion" outside of her family. "Our weekly programme," he recalled of their busy summers, "was studded with croquet tournaments and outing classes, fancy dress parties and amateur theatri-

cals, to say nothing of the statutory excitements offered by Onwentsia," among them golf tournaments and polo and lawn tennis matches, followed by iced tea and lettuce sandwiches in the club's pavilion.

"I adored our place in Lake Forest," Felicia remembered of the sprawling "cottage" on Ahwanhee Road along the edge of the Onwentsia golf course that meatpacker Louis Swift had commissioned architect Howard Van Doren Shaw to design for his daughter. Cissy rented the house for a year before buying it in 1912. The Pattersons found that Felicia ran screaming from strangers and was fascinated by American flush toilets, whose *whoosh* and vortex she delighted in provoking repeatedly with a pull of the chain. She had pet dogs, fish, and rabbits, and her screened porch twittered with uncaged canaries. Felicia spent most of her time in the care of her body-guard and her succession of Catholic, German-speaking nannies (one of the Pattersons' few concessions to Gizycki's demands), stealing away as often as she could to be with the Shepherds, her "surrogate parents," the caretakers who lived above the stables. In her eighties she would recall the exhilaraton of escaping her nanny by running away through a meadow of wildflowers. And indeed, there was good reason for eluding some of her Frauleins. One "hauled off" and struck her across the face while she was singing a song one day. Another nanny was given to holding her down on the bathroom floor by sitting astride her torso and pinning her arms to her sides, the better to beat her "black and blue where it didn't show," afterward threatening to kill her if she told her mother. Cissy, who lived on the opposite side of the house, never heard Felicia's screams and only fired the nanny when Freddy McLaughlin discovered the abuse and informed her.

Indeed, just as Nellie had been a remote figure to Cissy, so Cissy quickly became a distant, tempestuous, glamorous presence in Felicia's early life. Despite Nellie's earlier maternal insouciance, she both deplored Cissy's lack of attention to Felicia and underscored it by referring to her grand-daughter as "poor little orphan." Felicia remembered few gestures of affec-tion from her family. She would always be grateful to her grandmother for the simple attention of covering her with a blanket while she napped one day, to her great-aunt Kate for administering a dose of castor oil with mer-ciful speed, and even to her uncle Joe for showing enough concern to spank her for some forgotten infraction. Her mother, she felt, was uncomfortable with demonstrations of affection and only made mute suggestions of her feelings with expensive gifts. Felicia had only one memory of the "heaven" of sitting in Cissy's lap. Although she was under strict orders as a child never to awaken her mother, she burst into Cissy's bedroom one night, sob-bing, with the accusation "You don't want me. You wanted a boy!" Gather-ing Felicia in her arms Cissy answered, "I wouldn't trade you for all the

boys in the world—all the fat little boys and all the red headed boys, or blond boys, or the dark boys!" Though Felicia was unconvinced, "it was so wonderful being on her lap."

Shortly after her arrival in Lake Forest at the age of four, Felicia met her American cousins in nearby Libertyville, where they made faces at her across the dinner table when the attention of the adults was otherwise engaged. After the initial hilarity of her foreign accent and quaint manners wore off, Elinor and Alicia Patterson would become her closest friends. Indeed, because they accepted her almost as a sister, Felicia would later contend, "My God, they probably saved me from serious psychological problems!" When Alicia had been born at her parents' farm in October 1906, three years after Elinor, Joe Patterson had been so frustrated and disappointed that he stormed out of the house, slamming the door behind him. His third daughter, Josephine, would arrive in 1913. "He had wanted a boy, instead of three daughters in succession, and that meant one of the Patterson girls would have to be his substitute son," Alicia, the tomboy of the family, would later explain. Accompanying Elinor and Alicia on their rough-and-tumble rides, romps in the woods, and fishing excursions with their father, Felicia drank in her first taste of family life and, like her cousins, began calling her Uncle Joe "Poppy." "He was the closest thing to a father that I ever had."

Early on, Elinor, Alicia, and Felicia "joined forces against all the female adults." They hid from their Frauleins and Mademoiselles. They hurled themselves into Uncle Joe's wheat fields, enjoying the sensation of mashing the crop and admiring the look of the holes and corridors they made in its undulating surface. They rode their tricycles over the peony bushes in the gardens. In Felicia's memory, Alice Higinbotham Patterson—her face craning around a doorway, slathered in beauty mud—was "forever giving us hell for something." Felicia overflowed an upstairs bathtub at Libertyville, dribbling water onto the guests and musicians her aunt had assembled for the stiff musicale below. Alicia and Elinor took to teaching their baby sister to say "Damn!" as soon as Josephine was able to speak. They had learned the oath from their irascible grandmother: " 'Damn,' " Grams would say to herself, if she thought we children weren't listening," Felicia remembered. "Damn is French for a lady," Nellie Patterson insisted when caught. "*Une dame.* It is a perfectly proper word to use, if one knows French. My French is fluent." "Grams' French is perfectly terrible," Cissy contradicted her. "It gives me a headache." To Aunt Alice's "disgrace," the cousins were given to sneaking over to the neighbors' pool and stripping down to their bloomers to swim—until the caretaker frightened them off with a formidable guard dog and a gunshot in the air. Visiting Dupont Cir-

cle one Christmas, the girls again stripped to their underwear, wound up the Victrola, and pranced about the magnificent ballroom with abandon while the household staff gathered around the doorway to watch. "Shame on you!" their grandmother bellowed when she arrived to investigate, halting the girls in their tracks and scattering the servants. "Stop that music at once! Stop that! Dancing in your underwear! Shame! Shame! Before men servants! Men! Shame!"

"I was a stranger in a strange land," Felicia concluded of her American childhood. "Naturally, since I wasn't loved, I thought I was unlovable." Or rather, as she put it another time, "Cissy hated me because I was Gizy's and loved me because I was hers." Projecting her low self-esteem, she later ventured, she drove away playmates as she would friends, relatives, and romantic interests decades afterward. And yet, the accounts that survive of Felicia Gizycka throughout her life consistently diverge from her impressions of herself. The reminiscences of those who knew her in childhood are unanimous in their fondness for her, notwithstanding a certain abashedness in the face of the tragic glamour that surrounded their playmate. As she grew, others would take what she felt to be her social awkwardness for quiet charm, what she saw as her ungainly figure, round face, and unruly hair for a startling beauty and voluptuousness that transcended the reigning fashion for the flapper's angularity. When she was in her teens and twenties, even her protective girlfriends would admit to jealousy of the allure Felicia held for men, a quality of which she appeared to have been largely unaware: she recalled the same interactions with perplexity and embarrassment. Indeed, only in her last years would she realize that she had handicapped herself throughout her life with an "extraordinary inability to accept affection or praise."

If Felicia was less than accurate in her perceptions of her own effect on others, her observations of her family comport with others' recorded views. Her American relatives were predictable perhaps only in their tempestuousness. "Overhead was the constant thunder and lightning of quarreling adults" throughout Felicia's childhood.

Though Felicia was unable to remember a "decent word" her mother and grandmother ever said to each other or to Aunt Kate, or many occasions on which her aunt Alice failed to scold her and her cousins, there was one relative she recalled differently, however dimly. "I remember Grandfather Patterson being in Dupont Circle exactly once, a kindly remote figure with a white moustache who said those careful formal things to me that adults say to a strange child. Again, I was not hugged or kissed. I was smiled at pleasantly."

Felicia would never have the chance to know her grandfather better.

Only six months after the little countess's arrival in the United States, an exhausted Rob Patterson traveled to Philadelphia to be near his dying mother amidst renewed Medill family squabbles amplified by widespread agitation among the *Tribune*'s minority stockholders to sell the paper. On April 2, 1910, newspapers across the United States reported not only the death of the eighty-six-year-old Julia Patterson, but that of her fifty-nine-year-old son, Robert Wilson Patterson, as well. Published reports insisted the eminent *Chicago Tribune* editor's death, his attentive wife at his bedside, had come as the result of sudden and unexpected apoplexy. "I've just heard R.W. is dead—alone, of course," Kate McCormick commented to Bertie shortly afterward.

"He died from an overdose of Veronal. I send this {note} in case I do not go to Chicago. I don't want to!" Despite her disinclination, the sister-in-law of the deceased did finally venture to the Midwest for the double funeral. Unaccompanied at Chicago's Second Presbyterian Church by her own husband (who had slipped since the end of his diplomatic career from eccentricity into full-blown dementia, brought about not only by "hereditary tendencies" but by advanced, although as-yet-undiagnosed syphilis), Kate was overheard during the service to grumble, "Nellie sure got ahead of me that time!"

Though Cissy's return home as a morose "neurasthenic" had been difficult, she admitted in the update she sent Baron Budberg on black-bordered mourning paper in the autumn of 1910, "I feel good and even quite happy in those calm moments when Gizycki's attention is drawn away." She found herself something of a lightning rod for public criticism of fashionable international matches, but was glad to consider herself an American citizen again. Her view of her family life, as she reported it to Budberg, differed considerably from Nellie's and Felicia's recorded impressions. Cissy declared that she believed she could face almost anything with the help of her close-knit family. She had learned to drive an automobile. She continued the sporting activities she had always loved, and could be found in the stable when not in Felicia's nursery. Soon she discovered a new avocation to occupy her time.

"I think Cissy had better never try any more theatricals. She is not calm enough to go through it and seems paralyzed with stage fright. She is a poor nervous high strung (& high tempered) being," Nellie fretted to Alice on Valentine's Day 1912, the scheduled opening night of the Aldis Playhouse's four "society playlets." Playwright, poet, and arts enthusiast Mary Reynolds Aldis, the wife of Chicago real estate developer Arthur Aldis, had recently established a community theater on the couple's Lake Forest estate, where they sponsored and hosted a number of notable artists and lit-

erary figures. Dozens of American plays and translations from Europe premiered at the Aldis Playhouse over the coming decades, with the actors drawn from the local community and the audiences both from the area and, indeed, from around the world. Whether or not with false modesty, Cissy pronounced her performance in the dress rehearsal before the Chicago visiting nurse society to be "rotten." Nevertheless, she mastered the leading role in her brother's one-act *By-Products*—and other parts as well. Indeed, nearly a year later, when the Abbey Players arrived in Lake Forest from Dublin to perform John Millington Synge's *The Shadow of the Glen* along with several of the Aldis Playhouse's most popular pieces, Cissy reprised her performance in *By-Products* to repeated ovations and curtain calls. In the years following her return to the United States, Cissy began to divide her time increasingly between Lake Forest and Newport in the summer and Chicago and Washington in the winter. So strong had the pull of the stage become for her, however, that in early December 1913 she declined the coveted invitation to Ambassador and Countess von Bernstorff's annual tree-trimming and holiday dinner at the imperial German embassy in Washington in order to perform with the Lake Forest Players in Boston instead. For her roles in August Strindberg's *The Stronger* and, once again, *By-Products* Cissy would be acclaimed as "admirable" and called back for repeated curtain calls.

The Countess Gizycka (left) as aspiring actress with Mary Ollivant,
in George Middleton's *Tradition*, 1913

Whiskered Saboteur

Travellers intending to embark on the Atlantic voyage are reminded that a state of war exists between Germany and her allies and Great Britain and her allies; that the zone of war includes the waters adjacent to the British Isles," the imperial German embassy in Washington announced in the black-framed notices it placed in a variety of newspapers across the United States on April 22, 1915. In many instances these warnings appeared on the same page as the Cunard Line's advertisements for the scheduled May 1 departure and May 29 return voyage of the "largest and fastest steamer now in Atlantic service," RMS *Lusitania.* "Vessels flying the flag of Great Britain, or any of her allies, are liable to destruction in those waters and . . . travellers sailing in the war zone on the ships of Great Britain or her allies do so at their own risk," Ambassador Count Johann Heinrich von Bernstorff warned.

At 2:10 on the afternoon of May 7, 1915, a torpedo launched from a German U-20 tore into *Lusitania*'s hull, off the southern coast of Ireland. Fifteen seconds later, survivors would remember with horror, a devastating second explosion shook the passenger steamship. *Lusitania* sank within eighteen minutes. When the screaming died out, 1,198 of her 1,959 passengers floated lifeless in the dark waters off Kinsale—among them 128 noncombatant Americans and more than 100 children.

The following day, the German government issued an official statement justifying its attack on the civilian passenger ship with claims—vigorously denied by the British and American governments—that like British mercantile steamers, *Lusitania* had been fitted with concealed guns and was transporting American materiel as part of her cargo. Documentary and archaeological evidence discovered over the course of the coming century would suggest that the second explosion had more likely resulted from the ignition of the American-made ammunition, shrapnel, and fuses secreted in *Lusitania*'s hull than from a repeated German torpedo strike. In the second week of May 1915, however, despite the United States' continued official neutrality, American public sentiment against Germany turned vitriolic in response to the seemingly unprovoked strike.

In Washington, diplomats of Allied nations had already begun to avoid Ambassador von Bernstorff, and their stauncher American partisans "cut" him when they met in public. Such were the attractions of the imperial German envoy, however, that his popularity with many of the capital's most prominent hostesses was undiminished by mounting international tensions. "Mrs. Townsend's dinner on Saturday night was marvelous, as her parties always are," Nellie prattled to Alice on February 16, 1915; "72 at

dinner in the dining room at 3 big round tables . . . Bernstorff at her right & Dumba (Austrian) ambassador at her left showed where her sympathies are," she remarked, adding insinuatingly of her sister, "Kate went out with Dumba."

Unbeknownst to Washington's "society leaders," their husbands, or, indeed, to Ambassadors von Bernstorff or Dumba, a week after *Lusitania*'s sinking President Wilson authorized the surveillance of German and Austro-Hungarian embassy officials and the wiretapping of their telephone lines. In an effort to glean crucial intelligence, the stealthy band of Secret Service agents, stenographers, and translators who worked in a rented Washington apartment in relays around the clock, eavesdropping on diplomatic telephone calls, inadvertently stumbled upon—and recorded for posterity—Ambassador Count von Bernstorff's prodigious juggling of some of the capital's and, indeed, the eastern seaboard's most prominent society matrons.

Though Cissy had been stunned and affronted by the impropriety of Freddy McLaughlin's kissing her through her riding veil when they had parted more than a decade before, she had shed the Victorian prudery of her girlhood along with her idealized visions of monogamy in Europe and (despite—or perhaps because of—Gizycki's infidelities) returned home with more modern, fluid notions of romance and sexuality. For the rest of her life she would be linked romantically (and sometimes simultaneously) with men from so wide a variety of backgrounds that the only attribute they appear to have shared was marked expertise or aptitude—virtuosity even—in their chosen fields. Whereas Freddy McLaughlin had been Onwentsia's (and indeed the Midwest's) only internationally regarded six-goal polo player, Cissy's next dalliance proved to be a prodigy of finesse and suave duplicity, likewise on an international scale.

Though little documentation survives to illuminate the details or extent of Cissy's involvement with Ambassador Count von Bernstorff (who was nearly two decades her senior), Secret Service chief William J. Flynn's wiretap records from 1915 and 1916 make clear that the two were on intimate (though not exclusive) terms. No evidence survives to confirm or deny, for example, rumors of a jealous Freddy McLaughlin's accosting the titled pair with a riding whip on a secluded Lake Forest lovers' lane during one of the many trips the German ambassador made to Chicago in the course of his posting. Similarly, the surviving hints and recorded gossip that Nellie Patterson had been one of her daughter's predecessors in the envoy's attentions reflect perhaps more accurately the tenor and intrigues of society life in Washington during the First World War than they do the virtue or attractions of the chatelaine of 15 Dupont Circle.

Imperial German ambassador Johann Heinrich von Bernstorff (on dais at left), Chicago, 1914

. . .

Count Johann Heinrich Andreas Hermann Albrecht von Bernstorff was born in London in 1862 during his father's posting as imperial German ambassador to the Court of St. James's. He remained in Britain until he was six, which accounted in part for the flawless English ascribed to the "successful after-dinner speaker and witty conversationalist" later in his own diplomatic career. In 1887 Bernstorff married Jeanne Luckmeyer of New York, and with her had two children. He entered the Imperial German Foreign Service in 1899, and rose rapidly through its ranks as a result of his work in Constantinople, Belgrade, St. Petersburg, London, Cairo, and finally Washington. "Above middle height, but of slight figure" with a receding hairline and a blond moustache, Bernstorff was urbane and intelligent, and quickly became a sought-after guest not only in Washington but in the eastern part of the United States generally. In short, as one fellow partygoer remarked, Bernstorff was "an extremely good mixer." His great diplomatic strength, it was widely noted among his colleagues, was his willingness to allow himself to be bored. Indeed, so popular was Bernstorff before the outbreak of war in Europe that in the first four years of his tenure he was awarded no fewer than seven honorary degrees from American universities.

In the wake of the assassination of the Austrian archduke Franz Ferdinand by a Serbian Slav nationalist on June 28, 1914, Germany honored its promise to back Austria in punishing Serbia, which in turn pitted both

states against the mutual interests and preexisting diplomatic, strategic, and commercial entanglements of Russia, France, England, and Belgium. Bernstorff was recalled to Germany shortly after the assassination, but returned to his posting in Washington in August to find himself, if possible, even busier than before.

While in Berlin, Bernstorff had received secret orders to promote the German war effort from within Washington by any and all possible means—among them, espionage, propaganda, sabotage, forgery, and fomenting revolution in Allied dominions and counterinsurgency in Mexico. To further these aims, the ambassador had been provided with a generous secret slush fund. In his machinations to keep the as-yet neutral United States from joining (and American armaments from reaching) the Allies, Bernstorff was assisted enthusiastically, if clumsily, by a variety of assistants, among them the imperial German embassy's naval attaché, Captain Karl Boy-Ed, and its military attaché, Captain Franz von Papen, who would become the Third Reich's vice chancellor under Adolf Hitler in 1933. Between late 1914 and Bernstorff's recall in the spring of 1917, dozens of suspicious fires and explosions would damage transport ships, railway lines, munitions factories, and depots across the United States. In the midst of the intricate plots and dark conspiracies that would gradually come to light and prompt the prosecution or expulsion of many of his associates, Bernstorff maintained an unruffled façade, continuing almost unabated not only his busy official social schedule but his equally vigorous telephone flirtations and amorous activities as well. Mrs. Robert W. Patterson's friend and neighbor, Mrs. Richard J. Townsend, "a lovable, matronly woman who had the desire, the time and the money to entertain," was in her own right a particular friend, confidante, informational nexus, and matchmaker to the married ambassador. The peripatetic socialite both eagerly fed him useful political and diplomatic tidbits and provided her (reputedly haunted) mansion at 2121 Massachusetts Avenue, around the corner from 15 Dupont Circle, as a "sanctuary" for his trysts beyond the prying eyes of local gossips, angry husbands, or eavesdropping Secret Service men.

The Countess Gizycka met with Ambassador Count von Bernstorff there throughout 1915 and 1916. She received his calls and attentions and returned his compliments coquettishly. Both were legally married; much as she was aware of his other interests, so she made hers clear to him. Whatever the degree of Cissy's (or indeed her mother's) involvement with the kaiser's representative, Bernstorff's continued warm welcome at 15 Dupont Circle, even after the sinking of *Lusitania,* resulted in a trailing off of social calls from the Russian, British, French, and Belgian ambassadors and their staffs to Patterson House. If the wartime guest lists at

15 Dupont Circle suggested its inhabitants' sympathies, Nellie herself was explicit on the subject—at least at the outset of World War I.

"As I was in Munich when war was declared by England I *know* the surprise and dismay of Germany. The Kaiser had established such friendly relations he had no idea that England would come in," Nellie blustered to Alice on September 4, 1914, a month after Britain declared war on Germany. "It is not war—five nations against two," Nellie had clucked.

> It is not "cricket," as the English say: But their fears or jealousy of Germany's commercial success & colonial growth has made them unite to destroy her. I never cared much for the war lord but could not be in Germany without admiration of the Germans—& such an army!

In January 1917, British cryptographers intercepted the fateful telegram that German foreign secretary Arthur Zimmermann had transmitted through the imperial German embassy in Washington for forwarding to the German minister in Mexico, Heinrich von Eckardt. The cable authorized Eckardt to propose a military alliance to Mexico in return for German assistance in reclaiming territories previously ceded to the United States. The changing tone of American public opinion caused Nellie to reconsider her public expressions of German sympathy long before the revelation of Ambassador von Bernstorff's central role in the transmission of the Zimmermann Telegram prompted President Wilson's severance of diplomatic relations with Germany and the United States' entrance into the war alongside the Allies in April 1917. Sometime during the winter of 1915–16, Nellie sent her own communiqué to the suave imperial German envoy, informing him, "I didn't want him to come to my house any longer" to visit her or her daughter, as she would later attest anxiously under oath. When, exactly, this severance of relations took place, and whether Cissy likewise subscribed to it, is unclear; the Secret Service recordings note Cissy's contact with Bernstorff as late as January 1916, in the immediate aftermath of the suspicious sinking of the British passenger liner S.S. *Persia* in the Mediterranean. If that notorious scandal sheet *Town Topics* is to be believed, Cissy's compromising relationship with Bernstorff continued until February 3, 1917, the very day on which he and his disgraced embassy colleagues pulled out of Union Station on the first leg of their return voyage to Germany, in a private train car adorned with American Beauty roses reportedly sent by the Countess Gizycka.

The attraction that Cissy Gizycka, Nellie Patterson, and Kate McCormick held for the unctuous diplomat would later be popularly ascribed to the "whiskered saboteur's" schemes to sway the editorial policy of the influential *Chicago Tribune,* particularly among midwesterners of

German descent. Indeed, it was exactly this impression of personal and geopolitical "pro-Germanism" on the part of Joseph Medill's descendants that auto manufacturer Henry Ford sought to exploit and broadcast in the sensational, million-dollar libel suit he brought against the *Tribune* and its principal stockholders, Elinor Medill Patterson and her sister, Katherine Medill McCormick, in May 1919. Three years earlier, on June 2, 1916, a *Tribune* editorial had asserted that pacifist "Henry Ford Is An Anarchist" in light of what the paper characterized as his unpatriotic refusal to hold jobs or make provisions for dependents of National Guardsmen about to be deployed to Mexico. Ford's chief litigator would retort that the editorial had been published because the industrialist "stood in the way of efforts of the owners and editors of the Tribune to make money out of corporation holdings through fomenting war with Mexico in aid of Germany." If the jury awarded damages of only six cents at the end of the titanic court battle, which left Judge James G. Tucker feeling "talked almost to death," it found the *Tribune* guilty nevertheless. The verdict also convicted the paper's principal stockholders, Joseph Medill's descendants, of "pro-Germanism" in the popular imagination, a charge that, coupled with their vociferous isolationism, would resurface two decades later, with far graver consequences than the loss of a few pennies.

No doubt the canny Bernstorff (who had succeeded in stealthily buying a pro-German weekly in New York under the name of one of the many duped husbands he would leave in his wake) did see in Joseph Medill's female descendants a likely means of rousing pro-German sentiment in the Midwest. Indeed for similar reasons, it would emerge, he had cultivated a friendly working relationship with William Randolph Hearst. In return for the German ambassador's assistance in securing access for Hearst's International News Service (INS) correspondents and cameramen to German officials and battlefronts, the publisher had disseminated the German point of view through his chain of newspapers across the United States. Unbeknownst to Hearst or to his management at the time, the INS employed a German agent, William Bayard Hale, as its correspondent in Berlin. The public outcry against the Hearst papers' largely pro-German editorial stance, their initial anti-interventionism, their excusing the sinking of the *Lusitania,* their faked anti-British war news—much of it orchestrated and written by the publisher's lieutenant and columnist (and owner in his own right of the Washington, D.C., *Times*) Arthur Brisbane— resulted in plummeting circulation, nationwide boycotts of the chain, burnings of its papers, and denunciations and hangings in effigy of Hearst and Brisbane. In short, wartime suspicion of "pro-Germanism" in general and association with Ambassador von Bernstorff in particular provoked vehement recriminations and held far-reaching personal consequences.

In the frenzied congressional investigations and public scrutiny of the imperial German envoy's intimates and associates that followed his recall, it emerged that before public sentiment turned hostile to Germany, Bernstorff had been surprisingly unguarded about his aims. "You told me once," Cissy had reminded him in January 1916, "that you knew you could manipulate these amateur diplomats if you ever had to, and I see you have had your own way . . . and I don't like it." Unbeknownst as yet to the Washington gossips who closely surveyed her movements and interactions, Cissy appears to have seen in the diplomat a means to her own ends, in that their surviving conversations refer in large part to her concern for a British suitor and her efforts to extract promises and develop information from Bernstorff to protect him. On Saturday, June 19, 1915, amidst Bernstorff's vehement public denials of his involvement in a recently uncovered German espionage and arms buying conspiracy, the ambassador found time for a telephone chat with Cissy. For her part, while she commiserated with "my poor little darling, with your sweet face," she also pressed the German ambassador for information of vital importance to her unnamed English beau. Refusing to admit to Bernstorff that her other suitor might be a British recruiting agent, she was less flirtatious when, five weeks after the *Lusitania* disaster, she brought up the subject of the Englishman's upcoming transatlantic voyage. "I want to tell you, if that steamer is attacked, I shall never speak to you again in all my life," she warned Bernstorff abruptly. "Oh, you may be sure that passenger steamers will not be attacked any more," the ambassador replied glibly and inaccurately, if not deceitfully, but added that he knew British recruits would be embarking soon on a White Star Line steamer. Half an hour later, Cissy called the ambassador again to say, "I am sorry, I am afraid I disturbed you, you are so busy, I know, but it is only that I am worrying about that ship all the time. I can't help worrying." Bernstorff reassured her there was no danger.

Whoever Bernstorff's rival was, it appears that (besides the Secret Service) the ambassador may have been the first to learn of Cissy's interest. It also apears that the Englishman survived his sea voyage and continued to occupy a principal place in her affections six months later. On New Year's Day 1916, in the course of relating gossip she had heard during the festivities of the evening before, the garrulous Mrs. Townsend prattled to Count von Bernstorff that she had heard talk of the Countess Gizycka's interest in "that Englishman"; Nellie Patterson had complained that he had "one bad leg, no money, no sense, and a child fifteen years old" and had refused to support any more "helpless husbands" for her daughter. Only upon hearing this idle gossip about the Countess Gizycka's possible remarriage did Bernstorff realize why it was that Cissy, her protracted divorce still unresolved, had recently asked him to make inquiries of Count Gizycki. Her

estranged husband had reenlisted in his cavalry regiment in October 1914, at the age of forty-seven, Bernstorff had learned, but faced little danger in the reserves, where he had ultimately been assigned. "She seemed so disappointed," the ambassador reflected.

A pearl of a summer

S o she sold it without telling you, you poor little orphan," Nellie commiserated when Felicia discovered that Cissy had sold the "cottage" on Ahwahnee Road in Lake Forest in late 1915. Cissy had spent the better parts of the summers of 1915 and 1916 in Newport with Felicia, and the majority of the winter and spring social seasons of those years in Washington, at close quarters with Nellie at 15 Dupont Circle. In November 1916, therefore, Cissy rented a narrow red-brick house of her own on the corner of 16th and R Streets, whose many flights of stairs, she hoped, would discourage visits from her now elderly mother and aunt. Though Nellie and Kate persisted in calling on her whenever they pleased in any case, Cissy purchased the house at 1601 R Street in August 1917. Whatever became of her Englishman or their quiet romance is unclear, except that no mention of him recurs in the surviving documentation after early 1916.

The opprobrium Cissy weathered for her less discreet interactions with Ambassador von Bernstorff in light of the almost daily revelations of the envoy's skulduggery following America's entrance into the European conflict was only amplified by the salacious retelling of the breakdown of her marriage and loss and recovery of her child in the international press as her divorce was finalized in the Cook County Circuit Court during the spring and early summer of 1917. For six years Count Gizycki had not responded to the official

Nellie Patterson with her granddaughter, Countess Felicia Gizycka, Newport, Rhode Island, ca. 1916

notices of the suit pending against him. In his absence, therefore, after hearing testimony from Cissy, Medill, Miss Gernat (who appeared in a wheelchair after a recent fall down an elevator shaft), and others, the court finally dissolved the Gizyckis' marriage and awarded sole custody of Felicia to her mother. As was typical of her divorced contemporaries, Cissy kept the surname she shared with her daughter. Despite her patriotic protestations from the stand that she wished to drop her title and be known henceforward as "Mrs. Gizycka," in practice both the press and Cissy herself appeared to prefer the cachet of "Countess" and both persisted in using the title without interruption afterward. For her part, Felicia was devastated by the loss of the only home she could remember, in Lake Forest. Believing she was of little account in the formation of her mother's plans, she was astonished when Cissy gave in to her pleading to go out West at the end of the summer, where, unlike in clubby, tale-bearing Newport, they knew no one.

After a long, dirty Union Pacific railway journey from Chicago to Salt Lake City, followed by an even dustier ride on the newly completed Oregon Short Line to Victor, Idaho, the recent divorcée, her eleven-year-old daughter, and their French maid crossed the threshold of the Killpack Hotel in August 1917.* Beneath the sign informing them they had entered the "Loby" of the town's most luxurious hotel, they found themselves in the company of a number of local cowpokes chewing tobacco before a long line of spittoons. After an inedible dinner and an uncomfortable night, the trio met their wagon team outside the Killpack the following morning and set off for the Bar BC Ranch, across the Teton Pass in Jackson Hole, Wyoming.

Given the weight of Cissy's seven steamer trunks—crammed with English tweeds; high-laced walking boots, and several pairs of other boots appropriate to riding either sidesaddle or astride, and formal habit and headgear for each; wide-brimmed hats to guard Cissy's pale complexion from the ravages of the western sun when unmounted; an array of lotions,

*Though Felicia's several published accounts of her first visit to Jackson Hole at the age of eleven list the year as 1916, her friend and contemporary Louise Ireland Grimes Ireland, who wrote a detailed account of what was her own first summer in Wyoming, records the date as 1917. It appears that Ireland was correct. In "Jackson Hole, 1916–65: A Reminiscence," which appeared in *Vogue* in 1966, Felicia recalled that "we had spent the two preceding summers at Newport." Considerable surviving documentation indicates that those summers were, in fact, 1915 and 1916. The *New York Times* society pages, like similar reports from papers across the United States, listed the Countess Gizycka as part of Newport's "smart set" during both summers. Nellie's financial diary likewise records that in 1916 Cissy rented Pinard Cottage No. 2 in Newport from June 24 to September 27, but was forced to leave at some point—not for Jackson Hole, but rather for New York Hospital for unspecified reasons. While Felicia had indeed been eleven for most of her first trip to Wyoming, as she recalls in all of her written accounts, in 1977 she noted in "Cissy Patterson: Countess of Flat Creek" in *Teton* magazine that during the first pack trip she took with her mother she caught twelve fish on her twelfth birthday: September 3, 1917.

cosmetics, creams, and curatives; evening gowns and day dresses with their own matching hats; and the Mannlicher rifle (of the sort favored by the Austro-Hungarian military and professional elephant hunters) that she had brought from Novosielica—it was impossible for the passengers to ride all the way, especially on the steepest grades. Cissy strode ahead of the struggling team in long Parisian skirts and custom-made hobnail boots, her copper hair gleaming in the sunlight. Felicia followed, delighted by the magnificent vistas that surrounded her. The French maid straggled along the dusty trail behind them.

Typically, guests of the Bar BC would arrive from their daylong journey as the sun set majestically over the Tetons. By the time the Gizycka party reached the ranch, however, it was already dark and a cold, driving rain had begun to fall, turning the thick dust on their faces to mud. They were greeted heartily at the door of the main cabin by Katherine Burt, the proprietress, who exclaimed, "I'm a cavewoman." Expecting a hot bath, room service, and clean sheets after hours of walking uphill and down, Cissy found instead that they had arrived in the middle of a rustic costume party. Moreover, she discovered to her mounting consternation that there was no electricity or running water and the ranch was inaccessible to motorized vehicles. If the countess wished to leave, she would have to wait until the team was sufficiently rested to haul her trunks back over the steep pass to Victor, while she followed behind, once again, largely on foot.

"My mother was spoiled, willful and bad tempered but this time she knew she was licked," Felicia recalled. The following morning, Cissy made arrangements to send her maid back to Washington with six of her trunks. She and Felicia would remain, however. The Bar BC was the second of the establishments in the Jackson Hole area to capitalize on the burgeoning eastern rage for a taste of the vanishing Wild West. Romanticized by dime-store novels, popularized by the exploits of easterners like Teddy Roosevelt and Owen Wister, and driven by a nostalgia for an American frontier that the historian Frederick Jackson Turner had pronounced closed as long ago as 1893, the lifestyle of the old-time American cowboy became accessible, however briefly each summer, to growing numbers of greenhorns, tenderfeet, pilgrims, dudes, and, indeed, dudines over the course of the first decades of the twentieth century. The Bar BC had been founded in 1912 by a pair of well-to-do, well-educated Philadelphians, Struthers Burt, who had graduated from Princeton five years earlier, and his partner, Dr. Horace Carncross, a student of Sigmund Freud. As Burt's son Nathaniel put it, among comparable dude ranches—already an incongruous commingling of wilderness and urbanity—the Bar BC was a particular "bastard of East and West." The ranch's clientele reflected its ownership in that it tended to attract aesthetes, poets, and gentleman scholars. To its privileged guests it

offered hunting, camping, fishing, cow-punching, horse-wrangling, trail riding, pack trips, rodeos, and wholesome grub at the end of the day.

Felicia made a lifelong friend that summer. At first glance, there could hardly have been a girl who had more in common with her than Louise Ireland. Two months older than Felicia, Louise had been born at her grandfather's summer home in Bar Harbor, Maine, while her mother undertook to divorce her father, a well-bred and well-connected, if profligate, New Yorker. Though Arline Davis Ireland was herself connected by blood or marriage to some of the most prominent families on the eastern seaboard (the eminent editor of the New York *Sun,* the late Charles Anderson Dana, was a cousin), she took Louise to Florence, Italy, shortly after her birth in an effort to raise the child without the stigma of coming from a broken home. Mrs. Ireland never spoke to Louise of Mr. Ireland, except to instruct her to say he was dead, should anyone ask: "He might as well be dead as far as you're concerned." After the death of Louise's grandfather when she was five, Louise's grandmother, Louise Dana Kidder Davis, had moved to Europe to assist in her upbringing. Despite the tensions that invariably arose between the devoutly Presbyterian grandmother and the divorced mother who devoted much of her time to artistic and social pursuits when she wasn't foxhunting, the three had remained in Italy together until the early days of the Great War. In 1917, after several years in California, Louise's mother decided to move the trio to Washington, D.C., and it was on the instructive tour they made of the American and Canadian West during their journey eastward that they stopped at the Bar BC Ranch.

"That was a pearl of a summer," Louise would remember fondly. For the first time in their lives the two girls were free of governesses and chaperones. They rode out alone together after breakfast, exploring the valley, racing bareback across the range or paddling in washtubs in the surrounding irrigation ditches, and fishing in the Snake River until suppertime, when they rejoined their mothers and sang songs around the campfire until bed. For all that the two girls had in common, however, Louise reflected of her new friend, "I was puzzled by her relationship with her mother, so different from mine. Her mother always seemed displeased with her, becoming really unpleasant in later years."

Cissy had been advised by the Chicago friend who had recommended the Bar BC to accept no one but the ranch foreman, Cal Carrington, as guide on her de rigueur pack trip into the wilderness. Although the Irelands had already engaged him, the cowboy was immune neither to the countess' charms nor to her bribery. One morning in late August, therefore, Cissy rode out behind Cal. Though she had sent six of her seven trunks home, she left the Bar BC with ten pack horses in a string behind the camp cook. Felicia lagged behind on her pony, sulking in their dust. Three days later, once

they set up camp at the headwaters of the Buffalo Fork of the Snake River, in what would later become the Teton Wilderness, Cissy spent most of the day out hunting with Cal, who helped her gradually perfect the marksmanship she had begun to cultivate in Europe. Meanwhile, Felicia, left alone in camp with the taciturn cook, spent her days making fudge with their supply of chocolate, and trying to fish. After dinner and during the several days when they found themselves unexpectedly snowbound, the small party huddled together around the stove in Cissy's tent, the two cowboys and the little countess enraptured by her readings from Tolstoy. After three weeks, Cissy returned with the first of many trophy bull elks. In the process, the world-weary titled divorcée whose delicate constitution and nerves had relegated her to a life of neurasthenia, doctors' visits, rest cures, and newfangled diets, had become not only a convert to the way of life she discovered in Jackson Hole, but a zealot. The following summer she rented the White Grass ranch and Cal Carrington's property at Flat Creek the year after, before eventually pestering and cajoling him to sell it to her—and persuading him to stay on to manage it. Like Felicia, Cissy made lifelong friends in Jackson Hole.

That summer, Cal Carrington, for his part, would come to regard the Countess Gizycka and her daughter (whom he had taken to addressing with gruff affection as "*Little Feller*") as "*his* dudes," and even as his family. Though Carrington's murky past appears to have been further muddied by his own deliberate embellishments and omissions, he was born Enock Kavington Julin in Orebro, Sweden, on February 10, 1873. Impassioned by their religious conversion, his parents gave their eldest child to Mormon missionaries when he was five or six, promising to follow him to distant Utah later. When it came time for the proselytes to leave, Enock's mother knocked him to the ground to loosen his terrified grip on her. So began the boy's long, bewildering journey to America in the hands of fervent strangers—and his lifelong animus toward his family. After crossing from Liverpool with the other European converts, he traveled west across the continent by train from New York. Though he had been adopted by Albert Carrington, an eminence in the Church of Latter-day Saints—indeed, one of its twelve apostles, a presiding authority over its European mission, and a confidant to Brigham Young (as well as an unrepentant polygamist who would eventually be excommunicated)—the child would in fact be farmed out to a foster family upon his arrival in Utah. Subjected to unrelenting hard labor at an early age, he received little education and less affection. His foster father's brutality left him with a lifelong mistrust of men. "At sixteen I beat the hell out of the S.O.B. and run away."

For years he drifted throughout the West, changing his name and its spelling several times ("Eunuch" proved to be a particularly unsatisfactory variation) before finally settling on "California," in honor of a cowboy he

admired, or "Enoch Cal Carrington" for formal occasions and legal documents. At the same time, he developed a reputation as a leading horse breaker, bronc rider, and cowhand. "Lank, sardonic, prune-faced . . . profane and dictatorial," as Struthers and Katherine Burt's son, Nathaniel, remembered him, Cal Carrington was "surrounded by the aura of glamour and expertise." Ranking among the best western horsemen of his generation, he "treated horses with a mixture of affection, callousness, care, amusement, irritation," and conducted himself with "grave deliberation in all movements derived from dealing with spooky animals; the quiet quick sureness in each act of horse catching, saddling, mounting—precision, economy, grace, effectiveness." When Cal first crossed the Teton Pass into Jackson Hole in 1898, the area was a notorious haven for horse thieves, outlaws, and desperadoes. To what degree Cal himself contributed to Jackson Hole's rough reputation—specifically, whether he was part of a rustling ring at his homestead at Flat Creek, from which "he could see the sheriff coming and going"—remains a matter of local debate. Nevertheless, he worked a variety of legitimate jobs in Yellowstone and as a forest ranger in the Teton National Forest while attempting to establish squatter's rights in the Teton Valley. Eventually, "it was time to get respectable and go into dudin'," Cal decided. "There wasn't a horse he couldn't break and gentle, and not a wild animal he couldn't outwit," Struthers Burt found, and hired Cal to oversee pack outfits at the Bar BC in 1914.

Cal Carrington

Though Felicia (and, later, her daughter) would deny that the lifelong, often tumultuous friendship that formed between the handsome cowboy and the charming countess was anything more than platonic, Jackson Hole locals were not convinced. If Felicia protested that her mother was too particular in her toilette to have tolerated close contact with an unkempt outdoorsman who seldom bathed (and then only under protest), Cissy herself would rhapsodize on the subject of "strong, healthy and unwashed men" in her first novel, *Glass Houses,* which, like its successor, *Fall Flight,* was unmistakably autobiographical. Over the years, the pair would spend many nights in the wilderness together, during which others in camp would occasionally observe Cal dragging his saddle into her tent after dark and staying until dawn. As Nathaniel Burt put it, the relationship between the countess and the cowboy "certainly appeared to be one of the Hole's more flamboyant dude-cowboy affairs." Each, by all accounts, was both fascinated and educated by the other. Indeed, under Cal's guidance and tutelage Cissy would become perhaps the best female shot and one of the most successful big-game hunters of either sex in the United States. He found her an unflappable mount, Ranger, who would come to rival Exclusive in her affections. Because of Cissy, Cal would later travel to Europe to see the sights and to Africa as a white hunter. Cal, like his fictional counterpart, Ben, in *Glass Houses,* was protective of *his* dude and aggressive toward rivals. "Cal would openly mock Cissy's suitors, mount them on dangerous horses, spit contemptuously when they tried to shoot, and make slighting references to their virility," Nathaniel Burt remembered. Cal managed Cissy's ranch, he would later claim, to prevent anyone from taking advantage of her. At a dance in Jackson Hole early on in their acquaintance, the cowboy monopolized her with such ferocity that another reveler was overheard to have remarked that the countess was a great lady, "but my God, *the count!*"

On another occasion during their first summer in Wyoming Cissy and Felicia made the seventeen-mile ride into the town of Jackson to sample the noted cuisine of Ma Reed, proprietress of the Reed Hotel. Though their meal was delicious, they discovered after dinner that the accommodations were less than satisfactory. The thin walls of the hotel did nothing to muffle the rowdy homecomings of the other patrons from the local saloons (many with impromptu companions), making it impossible for Cissy to sleep. If Ma Reed enjoyed a wide reputation as a cook and folk healer, she was also known to carry brass knuckles. When Cissy refused to pay the dollar she demanded for the "indiscretion" Felicia had committed in the bathroom overnight, the two countesses were told to "git out." Their belongings were unceremoniously bundled into a sheet and pitched onto the front porch after them.

. . .

When mother and daughter returned the following summer, they discovered that Rose and Henry Crabtree had taken over the hotel. Ma Reed had originally hired the young couple as help, but when she left them in charge during a two-week vacation from which she would not return for seven years (she had been caught skimming from the grocery store next door), the Crabtrees took over the hotel and made it a going concern. Maternal, witty, and unaffected, Rose Crabtree would become another of Cissy's lifelong friends—and one of the few with whom she would not eventually quarrel. "A handsome young woman with a broad, candid brow like a Madonna," Rose Crabtree was practical and capable. She would also provide Cissy with the material for her first published newspaper story, in the *Omaha World-Herald,* when she beat out her husband two to one in the 1920 town elections for a seat on the now all-woman town council. "The men had made just a mess of running this town," Cissy quoted Rose as saying. "Seven hundred and fifty dollars in debt and nothing to show for it. Keeping town is like keeping house . . . Who ever heard of a good man housekeeper? Why, look at the old bachelors around here. Most of them live like wild animals."

"Back East," Felicia would reflect after the passage of half a century,

> my mother was considered a fascinating lawless creature, a charmer, and a menace. Nobody could oppose her without getting hurt. Out here she was a source of constant entertainment. People weren't afraid of her. Jackson Hole used to be full of characters, who could be themselves without benefit of psychiatry or interference from the law.

World's Greatest Newspaper

R ob Patterson's untimely end in the spring of 1910 had not pitched the management of the *Chicago Tribune* into disarray. Rather, the death of the editor in chief had only served to enliven the confusion and dispute that already reigned among the paper's owners and officers. In an uncanny foreshadowing of his daughter's death while at the helm of the Washington *Times-Herald* nearly three decades later, the ultimate ownership and fate of the *Chicago Tribune* would likely have been entirely different had Rob Patterson survived only one day longer. Confirming Kate McCormick's suspicions of her brother-in-law's machinations to "dethrone our family forever" in Joseph Medill's old Tribune kingdom, Rob Patterson had been per-

suaded by the emotional fragility of the paper's heir apparent, Medill McCormick, the agitation of the minority stockholders, and the increasingly fierce competition in the local morning market presented by the Hearst papers to entertain the sale of the paper to Victor Lawson, publisher of the rival *Chicago Record-Herald.* When Bert McCormick arrived at the editor in chief's office the morning after his uncle's death, he managed to persuade the nervous stockholders and trustees who had assembled there to delay the sale.

Though Rob Patterson's demise had at last cleared the way for Kate and Nellie to assume active roles in the operation of the paper as trustees and directors in their own right, in reality it brought neither sister nearer the vicarious editorial control each had sought for so long through their respective firstborn sons. The month before, Medill McCormick had succumbed once again to some sort of "paralysis or mania" followed by a frenzied jaunt into the Smoky Mountains of Tennessee—Dr. Jung, by then, in hot pursuit. Dr. Freud would later offer his young colleague wry congratulations on "the rich yield of your trip to America" while a resentful Medill McCormick would be rewarded with permanent exclusion from the management of the *Tribune* as the result of the medical certificate Jung had issued, declaring the patient an incurable alcoholic unfit for the strains of newspaper work. Nellie, for her part, asserted she no longer felt any "particular obligation" toward her own exasperating elder child with regard to

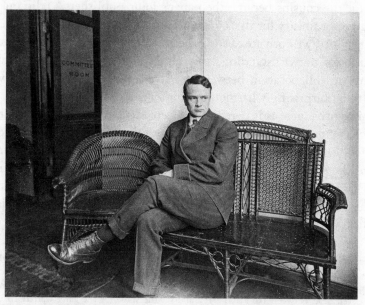

The flamboyant young Socialist Joseph Medill Patterson, Chicago, 1909

the paper. Experience had convinced her that any attempt at continued Medill family management was predestined to fail by the inevitability of infighting and acrimony. And yet, for the first time in many decades (perhaps ever) a Patterson and a McCormick were in agreement about the future of the *Tribune* and the ongoing participation of Joseph Medill's descendants in its management—if only their mothers and the minority stockholders would allow them to make the attempt.

"In the year 1909 I was accustomed to box at the Chicago Athletic Club and afterward take a plunge in the swimming tank," Bert McCormick recalled. "One day a friend told me there was a man in the hot room, evidently intoxicated, signing *Tribune* checks." This generous habitué of the club's sauna proved to be none other than the newspaper's treasurer, whom Rob Patterson shortly replaced with his nephew Bertie. In February 1909, as Joseph Medill's old Republican Party organ began its lavish commemoration of the centenary of Lincoln's birth (during which it would crown itself "World's Greatest Newspaper"), Joe Patterson, now beginning to outgrow his more extreme views, had been tepidly welcomed back into the *Tribune* fold as secretary. In March 1911, as competition between the local morning papers devolved into a series of bloody skirmishes on the streets of Chicago, the *Tribune*'s board of directors named Joe Patterson its chairman and Bert McCormick (recently voted out of his Sanitary District presidency by a Democratic landslide) acting president and chief executive officer until a permanent replacement for his uncle and brother could be found.* In 1914, the cousins became the paper's joint publishers, codifying their shared responsibility for the *Tribune* with a written "ironbound agreement last[ing] until we both are dead." Their diametrically opposed philosophical outlooks notwithstanding, this almost unprecedented personal and journalistic collaboration between a Patterson and a McCormick would prove to be surprisingly harmonious for a decade and a half.

"If inventive genius is hereditary," Bert McCormick would later reflect with characteristic humility, "I got it from the McCormick side. None of the Medills knew a fence from a lawn mower." In their ascendancy at the *Tribune* the cousins played to their respective strengths. "Born to understand why people behave as they do; why they laugh and cry and hate and love; and why they buy some newspapers and ignore others," as his daughter Alicia would later put it, Joe Patterson revolutionized the content of his

*Characterized by bribery, intimidation, beatings, armed news-truck hijackings, and, whenever possible, dumpings both of the rival newspaper's latest edition to prevent sales and of each side's own paper to report higher readership figures, the Chicago circulation wars left as many as twenty-seven dead between 1910 and 1912 and set the stage for the gang warfare that would plague Chicago a decade later during Prohibition.

father's sober *Tribune* while Bert McCormick launched a commensurate technical and mechanical metamorphosis and initiated the process of vertical integration. To this end, Bert began acquiring huge virgin tracts of timberland in eastern Canada, constructed paper mills in Quebec and Ontario, and assembled a fleet of vessels to transport the newly dry newsprint through the Great Lakes to the *Tribune*'s presses in Chicago.

Under Joe's tenure, the *Tribune*'s features—advice, health, beauty, and child-rearing columns; titillating crime and divorce reporting; and color comic strips—expanded and flourished. He demonstrated a particular affinity for the comics and contributed to the creation of a number of the *Tribune*'s most popular Sunday offerings. Nellie Patterson's peevish refrain "Don't be such a gump!," so familiar to Joe and Cissy throughout their childhoods, would lend the name for the strip Sidney Smith created and whose advent Joe Patterson had overseen, *The Gumps*. The back-alley automotive tinkering Joe had witnessed during his ongoing wanderings throughout working-class Chicago prompted him to suggest the *Gasoline Alley* strip to cartoonist Frank King. Later, "Skeezix," the waif whom *Gasoline Alley*'s main character found on his doorstep, would grow to adulthood and old age over the decades almost in real time before readers' eyes. The serialized escapades of Patterson's other cartoon brain-children, "Moon Mullins," "Smitty," "Harold Teen," and later, their younger siblings, the working-girl "Winnie Winkle," detective "Dick Tracy," and "Little Orphan Annie," attracted and held a loyal, affectionate, and ever-growing following. Working closely with editor Mary King and pioneering the use of rotogravure printing, Joe Patterson attempted to transform the *Sunday Tribune* into a sort of comprehensive magazine composed of such a wide and absorbing variety of reading materials that eventually its readership would need no other publications. The *Tribune* began paying the highest journalistic salaries and offering the unprecedented benefits of medical insurance, liberal sick leave, credit, death benefits, pensions, and dental care to its employees. To streamline day-to-day decision making and operations the cousins split their editorial duties; with the tempered Socialist alternating in the role of publisher on a monthly basis with his conservative cousin. Only love and war would threaten their ongoing successes.

"According to its traditions," an announcement in the August 23, 1914, edition read, "The Tribune has made arrangements, regardless of cost, to procure and present to its readers the most complete and authentic news of the war that it is humanly possible to obtain." To ensure the most accurate coverage of world events, it continued, in addition to the paper's Associated Press service and its arrangements to share coverage with such notable publications at the *Times* of London, the *New York World,* and the New York

Joseph Medill Patterson, co-publisher of the *Chicago Tribune,* with his dog, Billy, 1914

Sun, the *Chicago Tribune*'s exclusive correspondents were currently en route to Europe, among them Joseph Medill Patterson, who would be covering the German army. "That the people of Chicago and vicinity have grasped the significance of Tribune service at this time is clearly shown by the fact that our circulation is now in excess of 350,000 DAILY and 500,000 SUNDAY," it continued, concluding, as ever, with a boast: "Pre-eminent always among the newspapers of the world, in times such as these The Tribune has the unique pleasure and satisfaction of serving others besides its regular readers."

"Things seem more or less dull & gloomy today, tho' the sun is bright without. I am tired of life," Joe Patterson had confessed to his cousin Medill ten days after his father's death in 1910. He had been on the wagon since then: "I guess that's my record for the past 10 years," the thirty-one-year-old added. "I don't mind especially & when there's work to do, can do it better—when there's not I'm more readily bored." Indeed, Joe had thrown himself into his duties at the *Tribune* after the funeral, all the while continuing to work on his muckraking dramas. *Rebellion* opened in Kansas City in May 1911. *By-Products,* featuring the Countess Gizycka, premiered four months later at the Aldis Playhouse in Lake Forest. *Dope* was produced in London in October 1913. *Brotherhood* ("dealing with what in the South is still called the 'nigger question,'" as the *Tribune* put it) opened in Chicago early the following year. A "filmization" of *A Little Brother of the Rich* appeared in August 1915. In the meantime, Joe spent the spring of 1914 in Vera Cruz, Mexico, covering the American military occupation, as Pancho Villa advanced on Mexico City. In August he embarked for Europe and began filing a series of unapologetically pro-German dispatches,

impressed as he was by the country's comparatively extensive social welfare services. After a second voyage to Europe to cover the Allies in 1915, he began the *Tribune* series "Note Book of a Neutral," which would be published in book form the following year.

Though Medill McCormick had been barred from continuing his unhappy ascent at the *Chicago Tribune*, an alternative career path had presented itself to him on the political field. "You've now a splendid chance to be a politician," Kate McCormick wrote her darling firstborn in January 1916. Though she would continue her efforts to control and direct him according to her own lights ("Make friends with every one and think only of Medill McCormick"), politics offered Medill a degree of freedom from her grasp that he had never before known. After recovering from the episode that had prompted his permanent departure from the *Tribune*, Medill had become vice chairman of the Progressive Party's national campaign committee in 1912. Though Theodore Roosevelt and the Bull

Congressional candidate Medill McCormick,
October 9, 1916

Moose ticket lost to President Taft in November, Medill won a seat in the Illinois House of Representatives. Despite a temporary return to journalism as a war correspondent in Mexico for *Harper's Weekly,* he was reelected to his seat two years later. Although his marriage had been strained by his emotional upheavals and his continued drinking (he was arrested in upstate New York for public intoxication one evening in August 1913), to most outward appearances Medill McCormick had begun to flourish. Resigning from the Progressive Party in 1915, he rejoined his grandfather's Republican Party. The following year he became chairman of the Illinois State Republican Convention and was elected congressman-at-large from Illinois to the Sixty-fifth Congress. In 1918, pointing to Democratic mismanagement of the war effort, he entered the Illinois Republican senatorial primary, and won.

Meanwhile, on February 20, 1914, the former Amie Irwin filed quietly for divorce from Edward Adams, her husband of twenty-one years, in the Cook County Superior Court, ostensibly for the heavy drinking that rendered him either "entirely befuddled and dull" or "very giggly [and] silly," when he was not flatly abusive toward his wife. "There are so many things I wanted to talk about," Nellie Patterson wrote Alice Higinbotham Patterson six months later, "About Bertie—." Breathless for news of what had developed into a resounding scandal in Chicago and Lake Forest and enthralled by the implications for her sister, Nellie bombarded her daughter-in-law with questions: "Did Ed Adams make his intentions public? How did Kate know it? Is it a big sensation? Poor Bertie—Amy [*sic*] seized him when he was barely 23 & very immature for his age & she fascinated him ever since . . ."

Nearly a decade earlier, in the summer of 1905, as his parents made ready to assume their posting in Paris under the darkening cloud of presidential disapproval and his elder brother occupied his time with his new bride and his rise at the *Tribune,* Bertie McCormick began spending his otherwise solitary evenings in the company of his cousin Ed Adams and the latter's wife, Amie, at the couple's modest Chicago apartment. Not unlike Ambassador McCormick, the genteel Adams had failed in business and was given to drink. Twelve years her husband's junior and ten years Bertie's senior, the still-handsome Amie had been deeply disappointed by the parsimony, lovelessness, and brutality of her marriage. Nevertheless, the Adamses offered something of a home to the lonely young Chicago alderman. In this atmosphere, Bertie soon began to loan money to the unlucky stockbroker; by the end of the decade he was cuckolding his cousin as well.

To complicate matters, in May 1914, while revolution took Joe Patterson to Vera Cruz and scandal prompted Kate McCormick to "blackmail"

her younger son with disinheritance if he married his mistress, managing editor James Keeley defected from the *Tribune* in order to join Victor Lawson's *Record-Herald*. What seemed initially like a disastrous reversal for the *Tribune* in the cutthroat Chicago morning market instead assisted in the cousins' transformation of the newspaper. "By getting a lot of new blood in place of the old blood we are printing a better paper than before, and are printing a much better paper than the Herald," Bert informed his mother nearly two months later. "We are also selling two papers to every one the Herald sells, and in Chicago are selling three papers to every one the Herald sells." Keeley's perfidious departure notwithstanding, May 1914 had proven to be the most profitable month in the *Tribune*'s history.

If the newspaper's rising fortunes and revenues pleased Kate, the widening scandal in her younger son's private life did not. In late September 1914, Ed Adams publicly retaliated against his cousin with a $100,000 suit charging alienation of affection. Bert McCormick parried by calling in the nearly $40,000 in loans he had made to Adams during the last years of his marriage. Seeking to remove her youngest both from the glare of opprobrium and what she insisted were the grasping clutches of his paramour, Kate arranged for Bert to be "invited" to cover the Russian front by applying pressure on Nicholas II's ambassador in Washington. Though Robert Rutherford McCormick would loudly proclaim both his isolationism and his staunch republicanism throughout his life, in early 1915 his fascination with warfare and his sneaking admiration for aristocratic Russian officers prevailed. After using suddenly laudatory coverage to cajole the same Democratic Mayor Dunne whom the *Tribune* routinely lambasted to issue an honorary commission in the Illinois National Guard, Bert McCormick sailed for Europe in early February. Fearing that she might never see her younger son again, Kate nevertheless took solace from the fact that " 'she' did not go," not yet realizing that at the end of the month the recently divorced Amie Adams was to set sail for Southampton in her own right.

"I've been terribly upset for the past three days about that Adams woman following Bertie to Europe. If he marries her he is no son of mine," Kate continued to rail to Medill a month later, on March 10, 1915, the same day that Amie Adams became Mrs. Robert Rutherford McCormick in St. George's Chapel in London.

"My sister did not receive my gentle consolation gently—*au contraire*," Nellie Patterson complained to Alice, "but that is her way of accepting a blow. If thwarted she must punish. But I am deeply and truly sorry for her. It *is* a terrible blow." The elder sister's injury was one the younger would persist in inflaming for some time to come, with relentless unsought bromides on forgiveness and unconditional maternal love. In Chicago, one of

the prominent McCormick ladies had decreed that her door was barred to anyone retaining an acquaintance with the infamous newlyweds; Kate, for her part, vowed to follow the lead of that distant relation and definitive social arbiter by likewise ostracizing her younger son and his new wife. Although the mother of the groom had resolved never to refer to the bride as anything but "the former Mrs. Adams," she quickly lapsed into describing her daughter-in-law almost exclusively as "the old tart" or occasionally "the old strumpet" instead. Only after the passage of nearly a decade had Kate McCormick's anger cooled sufficiently to allow her to mention Amie McCormick as merely "the female inmate" of her son's home.

On May 1, 1915, during a leave to St. Petersburg from covering the Galician and Carpathian fronts, Bertie wrote a dutiful, if pointed, response to his mother's screeds: "Death is very easy in that environment and also battle fascinates me." The lonely, long-ignored younger son closed by saying, "Please bear with me. I can't live without my mother's affection— don't want to." Reporting a few days later that he was due to return to war-torn Galicia, he confessed that he felt depressed, but added, "Thank heaven I get over that feeling when in action," a sentiment with which his bellicose mother was no doubt familiar given the many domestic fronts on which she herself had been engaged over the course of her life. His last thoughts were of the *Tribune*. If he should die, he asked, "Let Joe run the paper without interference . . . Unharassed, he is entirely qualified . . . He is fully imbued with the knowledge which most newspaper heads lack, namely that all energy must be devoted to the paper's success, not the editor's ego."

Bert McCormick would return safely to both the United States and the *Chicago Tribune* nevertheless. In 1915, he published his observations as *With the Russian Army*. The stalwart anti-interventionist's appetite for combat had been whetted by his vicarious experiences on the battlefield, however. As the *Tribune* trumpeted neutrality—with preparedness—in the growing likelihood of American intervention, Bert McCormick joined the First Illinois National Guard, a ragtag if genteel cavalry unit, and was elected a major. His cousin and co-editor, thirty-six-year-old Joe Patterson, enlisted in the Illinois Militia, true to form, as a private. In the summer of 1916, both were mobilized to Texas as part of Brigadier General John J. Pershing's punitive efforts to quash unrest on the Mexican border. Joe Patterson was rapidly promoted to corporal and then sergeant. Ever hyperegalitarian, however, he refused a second lieutenancy in favor of a younger man he believed had worked harder for the commission.

The German resumption of unrestricted submarine warfare in February 1917 prompted the *Chicago Tribune* to reverse its vociferous long-standing

objection to American involvement in foreign hostilities, just as it led the paper's fervently anti-interventionist co-publishers to seek active engagement. Both patriotic cousins shipped out in 1917.

Though Bert McCormick would be promoted to the rank first of lieutenant colonel and then of colonel (the title he would retain insistently for decades to come), the means by which he was deployed and decorated, as well as exactly how much action he saw, especially at the Battle of Cantigny, would long be fodder for dispute (and hilarity), even within his family. "You said last spring Pershing had *sent for* B. out of a clear sky, to be on his staff," Cissy hissed at her aunt in early 1918, piqued as much by some unspecified attack Bertie had made on her as by her cousin's characteristic "pompous pretense." "As a matter of fact, & as is only natural, B. pulled wires till he got the job & then couldn't keep it," Cissy revealed she had learned from a high-ranking member of the army general staff who had recently returned to Washington from France. If Kate had taken her prodigal son back into the fold sufficiently to boast that his performance during the punitive Mexican campaign had prompted General Pershing to single him out for a place on the staff of the American Expeditionary Force in France, Bert himself would rewrite and rework his account of his summons to active duty—and indeed his participation in the war generally— carefully and repeatedly over the course of his life. Likewise, he would pooh-pooh any public doubt about his military service as "certain asparagus cast on my army life." Like his ambitious, if undiplomatic, parents before him, Bert McCormick had enlisted his *Tribune* connection and his newly elected brother on Capitol Hill to secure his promotion. "Vanity, as you said today," Cissy reminded her aunt, "is B's weakness—Vanity led him to seek an empty title, which will finally make him ridiculous—"

There was little question of Joe Patterson's service, by contrast—and it was perhaps for this reason, as much as her ongoing effort to foment discord between the *Tribune*'s co-publishers, that Kate would wrongly ascribe to her nephew the jealous "slander" of diminishing Colonel McCormick's heroism. During Joe's training in the summer of 1917, he had been twice promoted, and he sailed for France in October as a first lieutenant. He was made acting captain and placed in command of Battery B of the 149th Field Artillery, Rainbow Division, in January 1918. He and his men would spend more than four continuous months in the trenches along the front lines, during which time they came under fire and were gassed repeatedly. Captain Patterson's lack of pretense and his willingness to subject himself to the same conditions, privations, and dangers faced by ordinary soldiers would inspire the unwavering loyalty and affection of his men.

Despite the absence of its co-editors, the *Tribune* continued to flourish. In 1911, at the outset of their collaboration, the paper had been in decline

and was running third in the Chicago market, with a daily circulation of slightly more than 240,000 and a Sunday circulation of just over 350,000. By the end of the war, the *Tribune* led the field, boasting a daily circulation of more than 400,000 and a Sunday circulation of more than 600,000 throughout the five-state region it served and would soon christen "Chicagoland."

On July 20, 1918, Colonel McCormick met Captain Patterson in a farmyard at Mareuil-en-Dôle in Picardy (the cousins would later disagree as to whether they had in fact been seated atop a steaming pile of manure) and struck something of a codicil to their earlier "iron-clad agreement." Upon returning to the United States, with a modest loan from the Tribune Company (dubious Nellie and Kate, now Medill trustees in their own right, could not be prevailed upon to be more generous) Joe Patterson would launch a newspaper in New York City modeled on the newfangled, picture-packed British tabloids. While on a furlough in London, he had sought out Lord Northcliffe, whose *Daily Mirror* fascinated him and closely reflected his own editorial sensibilities. The New York *Daily News* (or the *Illustrated Daily News,* as it first appeared on June 26, 1919), was an immediate sensation, selling out its first day's press run of 150,000. The tabloid's diminutive size, sensational subject matter, and punchy headlines gave free rein to Joe's particular genius for intuiting the appetites and preoccupations of his reading audience. Adapting the British tabloid to the American market, at the *Daily News* Joe expanded upon the lavish halftone photo spreads, comic strips, advice and gossip columns, lurid crime and sex stories, beauty pageants, contests, coupons, publicity stunts, and circulation-boosting giveaways that had been his forte at the *Tribune.* After a halting start the *News* turned a profit by the fall of 1920, and shortly afterward retired its slightly more than $1 million debt to the Tribune Company.

The *News* would hold vast appeal for the growing ranks of commuters generated by the bounding postwar economy, who found themselves with time on their hands to read in the crowded train and subway cars they rode to and from work, but without space to unfold a standard broadsheet. By 1922, the *News's* daily circulation had surpassed 400,000 and Joe had launched a wildly popular Sunday edition. By 1924, the *News* could boast the largest circulation of any newspaper in the United States, 750,000; it launched *Liberty* magazine as a weekly competitor to *Collier's* and the *Saturday Evening Post* the same year. Since the inception of the *News,* Joe Patterson had continued to live in Chicago, but as the paper's daily circulation approached 1 million in 1925, he finally moved to New York.

At the time of his death in 1946, the *News* boasted a daily circulation of more than 2.2 million, the largest of any newspaper in the country. Sunday

circulation, some 4.4 million, would be the largest of any in the world. "His Harun-al-Rashid sojourns in Bowery flophouses and two-bit movie theaters were not eccentricities," the journalist A. J. Liebling observed; "he studied people as closely as the Plains Indians studied the buffalo herds— and for much the same reason." When the newspaper erected its new Art Deco headquarters at 220 East 42nd Street between 1929 and 1930 for the appropriately monumental sum of more than $10 million, the legend carved into the building's façade would echo Abraham Lincoln: "God must have loved the common people, He made so many of them."

<div align="center">

And what's more,
I'm going to seduce your sister!

</div>

I am impressed with the fact that *all the Medills think alike* on public questions," Nellie Patterson wrote Senator Medill McCormick in September 1919. "It is impossible for me to have any other point of view than Grandpa had, from Slavery down to Keeping the Philippines, & I know what he would say today, is what you are saying," she added in hearty concurrence with her nephew's outspoken objection to the Treaty of Versailles and its proposed League of Nations. Emphasizing Democratic bungling of the American war effort, Medill had been elected to the United States Senate at the age of forty-one, in 1918. Once seated, the junior senator from Illinois joined his colleagues Henry Cabot Lodge of Massachusetts and William Borah of Idaho in vociferous opposition not only to the upper chamber's ratification of the treaty, but to the diplomatic and military entanglements to which it threatened to commit the United States abroad.

As one of the Senate's "Irreconcilables," Medill campaigned against President Wilson's peace plan, arguing that it would only engender a "new imperialism." He took particular exception to the "war guilt" clause, Article 231, of the Treaty of Versailles, which, in punishing Germany, he believed would likewise cost the United States crucial exports. In the Covenant of the League of Nations, he and his fellow Irreconcilables saw the makings of an international superstate that threatened to subvert American autonomy. They feared the rise of imperial Japan and mistrusted Wilsonian internationalism generally. By the spring of 1920, with the Senate's decisive refusal to ratify the treaty, the Irreconcilables were victorious. With Warren Harding's landslide in November, Senator Lodge crowed to

his young protégé, Senator McCormick, "We have won the fight. We have destroyed Mr. Wilson's League of Nations and, what is quite as important, we have torn up Wilsonism by the roots."

Immediately after the election, as a member of the Senate Foreign Relations Committee, Medill sailed for war-ravaged Europe to study economic conditions. In Vienna, Senator McCormick did not reply to Count Gizycki's ingratiating overtures to renew their acquaintance. In Zurich, he astonished Dr. Jung with his apparent triumph over the troubles that had afflicted him a decade earlier (or, as Medill himself put it, with "my respectable and seemingly formidable self"). The dynamic freshman senator from Illinois excited growing approval within the GOP, not only for his decisive leadership in the anti-League fight, but moreover for his domestic initiatives to create a Bureau of the Budget, end child labor, crack down on lynching, conserve forest land, and (with his personal history) rally behind Prohibition. As the youngest senator thus far to be seated on the Foreign Relations Committee, he contributed to the formation of a Czechoslovak state and encouraged Irish home rule. In Republican circles across the United States, Senator McCormick, though green, began to attract notice as presidential timber.

"More than any other comparable group," journalist Jack Alexander would venture in the 1940s, "the descendants of Joseph Medill qualify as the royal family of American journalism." The diminishing "comparable group" of press barons in the first decades of the twentieth century conducted their daily operations and their relationships in an almost feudal manner, reminiscent of the very courts of Old Europe that they typically excoriated in print. The ever-fewer, ever-expanding newspaper empires that technology, competition, and attrition wrought over the first decades of the century were headed by autocratic editor-owners who dictated internal policy while attempting to sway national politics. They held court in lavish hilltop castles, sprawling estates, and soaring gothic towers. Each newspaper fiefdom had its own chamberlains, chancellors, clerics, and fools. Each had its own *noblesse d'épée,* trusted officers, strategists, crusaders, and pawns, who fought fiercely not only to scoop one another in print, but to launch territorial incursions and circulation turf wars on street corners across the country. These newspaper dynasties had their own orders of succession, heirs apparent, grasping younger sons, regents, would-be usurpers, consorts, and mistresses official and unofficial. Eventually, a pact between traditionally warring factions would allow a queen to emerge in her own right. A constant state of mobilization, punctuated by intermittent, uneasy moments of peace, produced ambassadors, spies, mercenaries, and turncoats as well.

. . .

"Dear Mr. Patterson," a vengeful Walter Howey, lately the *Tribune*'s city editor, goaded his former assistant, Frank Wesley Carson, to scrawl unsteadily one evening in early 1917. The admiration that Joe Patterson's common touch typically inspired among his subordinates, whether in a foxhole or in the city room, was not unanimous. "I address you as 'Mr.' because your phony pretensions of democracy, urging the help to 'Just call me Joe,' turn my stomach, as they do all who must lick your boots for pay," Howey prodded Carson to continue. Not long before, co-publisher Patterson had publicly questioned Howey's professional judgment, and the two men had quarreled. In a move that would become legend, even in bumptious Chicago journalistic circles, Howey had put on his hat, turned on his heel, and announced across the city room floor to his former boss, "And what's more, I'm going to seduce your sister!" Then he stormed out of his $8,000-a-year city editor's position at the *Tribune* and made straight for the offices of the archrival *Herald-Examiner,* where a delighted William Randolph Hearst not only hired him on the spot but promoted him to the position of managing editor for an annual salary of $35,000. Annoyed that his old assistant had remained behind at the *Tribune* instead of following loyally to the *Herald-Examiner,* Howey plied Frank Wesley Carson sufficiently with drink and a job offer one night shortly afterward to persuade him to take dictation. "You are a common panderer, catering to the meretricious tastes of the masses," Howey pressed Carson to continue in his lengthening screed to Joe Patterson. "Thank God, now that I have been given a contract as City Editor of the *Herald-Examiner,*" Carson concluded, "I shall be able to use your paper daily for the purpose I have long felt it was meant—in the men's room of the Hearst building. Sincerely, Frank Wesley Carson."

Howey himself would become legend in journalistic circles, first in Chicago and later nationally. After 1928, he would also become the layman's archetype of the hardscrabble, stop-the-presses! newspaper editor when he was immortalized as the model for Walter Burns, the central figure in Ben Hecht and Charles MacArthur's runaway best-seller and Broadway comedy, *The Front Page.* If theatergoers suspected the authors of exaggeration in their portrayal of rough-and-tumble Chicago "jazz journalism," MacArthur insisted that "the play was an understatement of that era."

Born in 1882 in Fort Dodge, Iowa, the young Walter Howey had been expelled from military school in Missouri for selling his horse. His stint at the Chicago Art Institute, between 1899 and 1900, ended with his withdrawal after only a few months—and his dissipating what remained of his tuition to host classmates on a steamship jaunt about the Great Lakes.

After returning home, he took a job at the local *Fort Dodge Chronicle,* realized he had found his calling, and quickly rose in the paper's ranks. It would be some time before his father, a Fort Dodge paint, wallpaper, and pharmaceutical merchant, revealed that he had been forced to pay Walter's salary out of his own pocket at first, in order to persuade the paper's editor to take on the apparent ne'er-do-well. The younger Howey married a local girl, Elizabeth Board, in 1900; the couple would have no children. In 1901, he succeeded in orchestrating his first national scoop. Having bribed a servant at the wounded William McKinley's bedside, Howey set about typesetting a tear-jerking account of the president's tragic end. Once the call came, Howey was able to go to press before any of his rivals had even begun writing. He spent a brief period in 1903 at the *Des Moines Daily Capital.* "I was not much of a writer nor much of a news-getter but I loved this new and fascinating art so much that I worked longer and harder than anybody else on the paper," he remembered of the few months he spent there before heading for bigger things. In 1903, he "roared into Chicago like thunder out of China," as Charles MacArthur put it.

Embellishing his newspaper experience, Howey talked his way into a job as a reporter on the *Chicago Daily News.* His first big story resulted from his chancing upon a sooty, armor-clad knight and three winged elves emerging from a manhole on December 30, 1903. Although Howey initially suspected that these were hallucinations brought on by hunger pangs, it turned out they were in fact actors making a desperate underground escape from the raging conflagration at the nearby Iroquois Theater, which would leave more than six hundred dead. Howey was the first reporter on the scene and the first to file, by calling his editor at the *News* (who assumed he was drunk) from a nearby saloon and bribing the bartender to clear the phone lines for him indefinitely. He was hired by the *Chicago American* in October 1904 and became its assistant city editor within two weeks. In 1906, Chicago's *Inter-Ocean* lured him away to make him the youngest full-fledged city editor in the country, at twenty-four. As one colleague remembered him, Howey was "a silent, tight-lipped prowler in the underworld who had made himself familiar with the ward-heeling politicians, gangsters, and crooks," and who "knew the best sources of news involving murderers, bandits, racketeers, and their women." Assigned to dig up dirt on the *Tribune's* favored candidate, Mayor Fred A. Busse, Howey succeeded (after what *Time* would describe as "two months of burglary, bribery, and tireless sleuthing") in accumulating a black suitcase full of incriminating material, which the *Inter-Ocean* disseminated before Busse's untimely death shortly afterward. The following year, with no apparent hard feelings, Rob Patterson quadrupled Howey's *Inter-Ocean* salary in hiring him away as the *Tribune's* new city editor.

After his quarrel with Joe Patterson, Howey would flourish within the Hearst organization, and it was at the *Chicago Herald-Examiner* that the young Hecht and MacArthur came to work under him. Alone among Chicago's newspapers, the *Herald-Examiner* championed the flamboyant William Hale Thompson's mayoral reelection bid in 1919. Safely returned to office, "Big Bill" rewarded the paper's managing editor with what MacArthur described as a "newspaperman's dream": in the city room two uniformed police patrolmen and a sergeant stood ready, willing, and authorized to take orders from *Herald-Examiner* reporters. "We went out and arrested people whenever we had to," MacArthur recalled fondly. "Our policemen" forcibly prevented rival papers' photographers from taking crime-scene photos. The scoops that Hearst's *Herald-Examiner* was able to wring from interrogating its captive sources in hotel rooms near the paper's offices became the envy of the competing Chicago dailies. Their myriad complaints to public officials fell on deaf ears, inasmuch as years of skulduggery and dirt-digging had reportedly permitted Howey to accumulate a pile of resignation letters, each signed by a Chicago official, to be used at the editor's "convenience." If Howey was, as *Time* would later describe him, "a profane romanticist, ruthless but not cruel, unscrupulous but endowed with a private code of ethics," he would also make good on his parting promise to Joe Patterson.

When the Republican National Convention convened in Chicago on June 8, 1920, it became, as novelist and United Press Association correspondent Edna Ferber reported it, "as poisonous a political mess as any party stirred up in the history of the United States." For Cissy, the convention would be fraught not only with the excitement of new opportunity and acquaintance, but also with rivalry and rancor—all of which would coalesce to alter, if not direct, the course of her life. After making much of her Omaha *World-Herald* piece on the female civic leadership of Jackson Hole, Walter Howey hired Cissy to cover the Republican National Convention for the Chicago *Herald-Examiner* and to report her big-game hunting exploits later in the summer of 1920. Over the course of numerous rendezvous at Schlogl's, a Chicago bar favored by the city's hardscrabble reporters, Howey began to expose the Countess Gizycka to a side of journalism with which she had had little contact, despite her heritage. "The top editor who ever was," as the journalist Westbrook Pegler described Howey, introduced Cissy to a cadre of hardworking, hard-drinking practitioners. He revealed the even more lurid stories behind the lurid headlines. The man William Randolph Hearst regarded as the "cleverest editor in the newspaper business" imparted his recipe for success as nine-tenths entertainment and one-tenth information. He enlightened her about

circulation-boosting tactics and techniques. "Every reporter must have the heart of an editor and some of the understanding of one if he expects to be a good reporter; and unless you are prepared to put a lot into journalism, you will never get much satisfaction out of it," he told her, passing along advice he had received as a cub reporter from a widely respected editor. "What you must put into it is an understanding of the desires, the frustrations, the longings, the emotions and the hopes of the people you expect to read your stuff."

Howey brought the Countess Gizycka into the enemy camp like a trophy. William Randolph Hearst and his editor, executive, and columnist, Arthur Brisbane, greeted Joseph Medill's granddaughter and Joseph Medill Patterson's sister with a courtly solicitude befitting a foreign dignitary. All four attended the convention together and socialized in the evenings. The formidable editorial triumvirate also oversaw, gently corrected, and approved the green political correspondent's work, which appeared in the *Herald-Examiner* daily during the Republican National Convention, under the byline Eleanor Gizycka—along with the pointed biographical note, "Sister of the Editor of the *Chicago Tribune*." If Cissy had campaigned for Republican presidential candidate Senator Hiram Johnson of California the previous spring, and daily championed his nomination in print, she was nevertheless partial (politically and otherwise) to the dark horse candidate, Senator William Borah of Idaho. Borah had thrown his support behind Johnson's nomination on the fifth ballot, after falling out of contention on the fourth. "Every one loves courage. A crowd loves courage most of all," Cissy gushed the following day in a *Herald-Examiner* story headlined ELEANOR GIZYCKA ADMIRES BORAH. The senator had "faced his difficult audience like a lion, a good-natured and experienced lion," as she put it. "And pretty soon he picked up and held that audience in his hands as expertly and delicately as a woman might hold a peevish child." When the cub reporter asked the senator whether he had been nervous before winning the crowd over, or whether addressing a large, divided audience was "just fun" for him, "the great senator smiled a heavenly smile. 'I can't say that I objected,' " he admitted.

"Although ostentatiously avoiding the flesh-pots of Washington society," *Vanity Fair* would confide about the same Senator Borah in 1932, "he is secretly addicted to being pursued by feminine lion hunters, to a degree which has exposed his and their good names to mean-spirited gossip." Since his election in 1906, the "Lion of Idaho" had established himself as perhaps the upper house's finest orator, routinely filling the galleries to capacity when he held forth—especially with female listeners, among

them Alice Roosevelt Longworth and Cissy Gizycka. Born in Illinois in 1865, William Edgar Borah had endured an unhappy childhood, an incomplete education, a stint as an itinerant Shakespearean actor across the American prairies, and ill health, before being admitted to the Kansas bar in 1887. Hard hit by the midwestern agricultural depression, he made his way westward in 1890, settling in Boise, Idaho, where he made a name for himself as a prosecutor (Clarence Darrow rated him the "ablest man" he had ever opposed in a court of law). In 1895, Borah married Idaho governor William J. O'Connell's daughter, Mary. The union was childless and tense, strained by decades of Borah's notorious womanizing. Handsome if shaggy, Borah had a brilliant, agile mind. A civil libertarian in his domestic views, he had led the Senate's Irreconcilables in their recent repudiation of the League of Nations. The fight had brought him into increasingly close contact with Alice Roosevelt Longworth, who was likewise ardently opposed to the Wilsonian peace plan—and likewise unhappily married. By the time of the Senate votes on the League in the spring of 1920, the senator and the former president's daughter had begun an enduring love affair.

"I have divine rooms here—on the lake, quiet as the grave. Slept 10 hours last night & 9 the night before—the air is *alive* here. Feel ten years younger," Cissy had announced to her Aunt Kate from the Drake Hotel in Chicago more than a year earlier, in the spring of 1919. "Have about come to the conclusion I *cannot* live in Wash. My blood pressure is abnormally low—only 98–99—& that dead air kills me." If Cissy found the climate of Washington stifling, the city's foremost social and political doyenne had succeeded in making the atmosphere uncomfortable for her as well. Alice Roosevelt Longworth, Cissy would soon complain openly, was determined to ostracize her in Washington social circles.

Returning to Washington unattached, though not yet divorced, in 1910, Cissy had sensed (and willfully contributed to) a growing distance between herself and her old friend. The specific reasons or incidents that finally led Cissy to break flamboyantly with Alice went only scantily recorded, though at bottom the two were perhaps too much alike to remain close. The initial strain may have resulted from a political parting of ways during the war, in light of the accusations of pro-German sentiment within the Medill family generally and the open secret of Cissy's compromising intimacy with Ambassador von Bernstorff specifically. Certainly, the memory of the social isolation provoked by Cissy's suspected wartime sympathies would long remain with her.

"During the last World War a beautiful, securely placed, rather rich and *very* young lady arrived in Washington. She rented one of those charming

'little houses' in Georgetown—an adventure in itself at that time," Cissy would write in the Washington *Times-Herald* in January 1942. "She became the fashion. She was tops. She was IT. Her 'little house,' on such nights as she received at home, was crowded, standing room only, with the most powerful people in Government, the most celebrated men and women of that day. She was an intimate of the White House; she was the most admired young woman in town." Here, in "Singing for Their Supper," Cissy ostensibly underscored the similarities between two desirable, unattached young women she had known—May Ladenburg during the First World War, Inga Arvad during the Second—whose highly placed lovers had unwittingly, if ruinously, subjected their personal lives to minute scrutiny and their loyalties to widespread suspicion. The It Girl Cissy described also bore a resemblance to the heroine of her first (largely autobiographical) novel, *Glass Houses*—and, indeed, to an idealized Cissy herself. Her newspaper account, betraying anger nearly a quarter-century old, may shed light on the demise of her girlhood friendship with Alice as well.

> So what happened? The inevitable. A few of the older, better established hostesses in Washington quite naturally turned sick and green with envy.
>
> Have you ever heard the rattle-snake's rattle? As a matter of fact, it's not a rattle at all. It's a steady, level, deadly his-s-s-s-s. Well, then, this deadly hiss-s-s-s-s rose up one fine day right in the middle of this young lady's primrose path. "S-s-s-Spy-s-s-s." Ss-Spy . . . s-s-s-. From here, from there, from everywhere it came. Nobody ever knew its origin.
>
> The young Secretaries and Attaches of the British Embassy, more important in high sassiety then than today, formerly her eager guests, were forbidden to pass her threshold. "Friends" began to look askance at this girl as she passed by. Mere acquaintances, long miffed because they had not been on her dinner list, cut her dead. And pretty soon all of Washington society followed suit. Her house became as malodorous as though the word SMALLPOX had been painted in large yellow letters on her front door.

Although Cissy never mentions herself in the piece, her vituperation twenty-five years later suggests that she identified and empathized with the outcast. Neither had she forgotten the role her old friend and more recent rival Alice, one of the "older, better established hostesses in Washington," had played in the Craufurd-Stuart affair, or in helping to plant listening devices in May Ladenburg's house during the First World War.

In the summer of 1917, the Washington society belle May Ladenburg had broken off an affair with Major Charles Kennedy Craufurd-Stuart of the

British embassy and taken up instead with Bernard Baruch, the chairman of the United States War Industries Board. In revenge, Craufurd-Stewart had implicated Ladenburg as a German spy, committed to wheedling war-time secrets out of her new lover. Bearing in mind the fruitfulness of the earlier Bernstorff wiretaps, U.S. military intelligence chief Brigadier General Marlborough Churchill appealed to Assistant Secretary of the Navy Franklin Delano Roosevelt and his irrepressible cousin Alice to engage in some patriotic spying on Alice's beautiful young friend. "We were doing a *most* disgraceful thing," Alice later admitted; "it was sheer rapture!" Whatever Alice's reaction to Cissy's involvement with Bernstorff or the latter's apparent wartime sympathies, the cooling of relations between the two was certainly connected to at least two of Cissy's other liaisons. The relationship was likely further chilled by Alice's close friendship with Ruth Hanna McCormick, whose own interactions with the alluring Countess Gizycka had only stiffened in the years since the tense spring and summer they had spent in Europe in 1909, attempting to retrieve Felicia.

Whether true or not, town gossip of the tensions between the countess and the former president's daughter would eventually be immortalized in print in 1931 by the muckraking political journalists Drew Pearson (who had heard it from Cissy herself) and Robert Allen. In Pearson and Allen's version of the tale that had circulated throughout the capital for more than a decade, after dinner one evening at the Longworths' Cissy was said to have "monopolized" in a secluded upstairs room the "young nobleman" who had been Alice's dinner partner. The following morning, as the columnists described it, Alice sent Cissy a note informing her that "upon sweeping up the library this morning, the maid found several hair-pins which I thought you might need and which I am returning." Cissy was reported to have replied: "Many thanks for the hair-pins. If you had looked at the chandelier you might have sent back my shoes or my chewing gum." Other versions of the story substituted Cissy's garters or underpants for her shoes and chewing gum, and Alice's husband, Congressman Nicholas Longworth, or lover, Senator William Borah, for the "young nobleman" whom Cissy "monopolized" in the upstairs library. Perhaps tellingly, the detail of leaving hairpins for Alice to find (the very objects that had first forced the sickening reality of Count Gizycki's libidinous escapades on Cissy herself when she arrived at Novosielica as a new bride) is one of the few consistent elements of the tale's many variations.

Though Alice would insist that the rumor, printed or not, had no basis in truth (and Cissy would occasionally concur), similar stories persisted as well. Turning on the light in her bathroom at another party, Alice was reported to have happened upon her husband in flagrante delicto with her

old friend. On a separate occasion, Alice was said to have suspected Congressman Longworth of hiding in her rival's carriage. "Washington is only a little village, and everyone knows everyone else's business," Cissy contended in her 1926 novel, *Glass Houses,* which served to inform the capital of Cissy's version of the Longworth-Gizycka rivalry for Senator Borah's attentions, without forcing her readership to read too deeply between the lines. The beautiful heroine, Mary Moore, is a tall, slim Georgetown resident who enjoys big-game hunting at her Wyoming ranch in the summertime. Though admittedly "handsome," Mary Moore's archrival, the Washington social arbiter Judith Malcolm, is by contrast "mature," "false," "insatiable," and "unhappy" (not to mention unscrupulous in her personal habits). At issue between the two women is the handsome and magnetic, if cruel, western senator Bob Millar. Mrs. Malcolm will stop at nothing in her efforts to win Senator Millar, and sets out to ostracize her adorable rival for his affections within Washington society. Mary Moore appears to triumph when Senator Millar chooses to accompany her to Wyoming for a hunting trip, only to discover—after their tryst in a mountain forest—that Millar is a base cad. When Mary Moore's jealous cowboy guide, Ben, discovers the couple's intimacy and the senator's treachery, Millar disappears mysteriously into the mountains without a trace, never to return. If Cissy hoped to suggest to Washington that she had not only won, but had then chosen to reject Borah's attentions thereby incurring Mrs. Longworth's enduring jealousy, columnists Pearson and Allen would, once again, later recount a different version of events.

An irreparable "breach" between Countess Gizycka and Senator Borah had taken place at the Republican National Convention of 1920, the journalists would assert eleven years later. If Cissy had triumphed over Alice (who was also in Chicago during the proceedings) in securing Borah as her guest in the well-appointed house she had rented for the week, she had badly overplayed her hand in publishing "Eleanor Gizycka Admires Borah" in Hearst's *Herald-Examiner.* Feeling compromised by her effusive account of his heroism on the floor, the senator "cautioned her against any repetition of the flattery." "Senator Borah seems in a threatening mood," the *Chicago Tribune* clucked on June 13, 1920, immediately after the close of the convention in an editorial headlined, BORAH AND BOLT. "Mr. Hearst has been talking third Party for months . . . Senator Borah seems to be sympathetic," the old Republican Party organ mused with the pique of a woman scorned: "Perhaps he ought not to remain any longer; he is so uncomfortable. Perhaps it is time for the party to say to this bellicose member: 'Must you be going? Here's your hat.' " The senator's suspected infidelity to his party had perhaps resulted from his coming under a new, untoward influence: "Has the siren (in the sense of foghorn) voice of Mr.

Hearst enchanted him? Are we to expect a third ticket, Hearst and Borah?" the Patterson-McCormick *Tribune* wondered. Though both Cissy and Joe would insist that she had had no connection with the piece, Borah and "Alice Longworth, even then one of his most intimate friends," Pearson and Allen contended suggestively, "thought she had. They never forgave Cissie [*sic*]."

If Senator Borah and Congressman Longworth had become apples of discord between two of Washington's three former graces, Ruth Hanna McCormick appears to have reinforced the estrangement. Although Ruth was not yet intimately acquainted with Alice when she married Medill in 1903, President Roosevelt had encouraged a friendship between the two young women, hoping that something of the levelheadedness he had admired in Senator Hanna's daughter would rub off on his own intractable eldest child. In the wake of Mark Hanna's death and Cissy's marriage and departure for Europe in 1904, Alice and Ruth had become close friends. More recently, they had both played an active role in the fight against the League of Nations. The relationships between the three women had long been barbed with vestigial adolescent jealousy. If Medill's gallant attentions to his cousin in Vienna had stirred tensions between Cissy and Ruth in 1909, Cissy's deliberate, taunting intimacy with the men in Alice's life would end amicable relations between the two girlhood friends in Washington by the early 1920s. Although there is no evidence to suggest that Ruth Hanna McCormick contributed intentionally to Cissy's hostility toward Alice, she appears to have had a destabilizing effect on the already disintegrating friendship.

By the time of the Republican National Convention in the summer of 1920, Cissy's subsequent life had begun to take shape. She would continue to make Washington her home, notwithstanding the occasional threats she made to leave. Though William Randolph Hearst would dispatch Walter Howey to Boston to prop up the ailing *Boston American* in 1922, during his affair with Cissy, Howey had furnished her with an outlet for her native attraction to journalism, and she began to cultivate the skills upon which she would draw when she eventually made the transition from reporter to editor. The introduction he had given her to the Hearst organization—and particularly to both Brisbane and Hearst himself—would mature into long-term alliances and blossom into genuine friendships. Her growing pique with Alice Roosevelt Longworth would fuel Cissy's literary efforts by providing material for her fiction and a bogey to attack, repeatedly and gleefully, when at last she became a publisher in her own right. Over the course of the new decade she would maintain her friendship with Senator Johnson and extend her circle to include Senators Burton Wheeler of Mon-

tana and Henrik Shipstead of Minnesota along with others who were like-minded. Increasingly politically active and aware, Cissy tended to absorb her opinions from the men around her. Like the rest of her family, she had inherited her grandfather's noninterventionist views on foreign policy. The members of the Republican senatorial coterie with whom she would surround herself hailed for the most part from the vast American West that she so loved. Liberal, progressive, populist, and even laborite in their domestic outlooks, they, too, fervently opposed American entanglements abroad. Hostile to the League of Nations in the wake of the First World War, they would rally as the most adamant—and most reviled—congressional proponents of isolationism before the Second, just as Joseph Medill's surviving grandchildren would come to be broadly excoriated as the "Three Furies of the isolationist press."

Mais vous n'avez pas changé du tout!

In June 1921 Joseph Medill's two daughters, both now in their midseventies and in precipitous mental and physical decline, met in Paris en route to their annual European rest cures. "Her continued sobbing and crying is not natural—nor the self-reproaches," Nellie Patterson, recovering from a recent heart attack, wrote Medill McCormick of what she described as his mother's "weeping—hysteria—self-reproach—cackling." Five days later, safely arrived at Carlsbad to take the waters, Kate McCormick wrote her daughter-in-law that she had been "disturbed" to see Nellie's physical condition in Paris: "she weighs *clothed* 123 lbs—a year ago she weighed 176 lbs on my scale." Shortly afterward, Kate wrote Ruth again to gossip that the doctor she shared with her sister had just divulged Nellie's deterioration to be the result of advanced alcoholism. Kate was unconvinced, however, offering her own self-referential diagnosis instead: "I believe it is the result of the violence of bad emotions which has done her—Long, intense jealousy of me . . . hatred, envy (of me) . . . eternal quarreling with all her family. Her mind is worn out with excess of emotions." Inevitably, the elderly sisters' care had fallen increasingly to their adult children to organize and oversee. Of the cousins, Cissy was the most vocal about her dismay at this state of affairs and the most deliberately elusive in the face of the trials it presented. If the men of the family had journalism or politics to occupy their attentions and limit their participation in their mothers' maintenance, Cissy's deepening interest in writing and publishing held the

additional attraction of providing reasons to "duck out" (as Felicia put it) when overwhelmed by Nellie's mounting needs.

While Nellie and Kate were in Europe, Cissy had spent most of July 1921 in Idaho with a small party of friends and guides, navigating the rapids of the Salmon River in a shallow scow while she prepared a short diary of her trip for publication. At night, the pampered countess slept beneath "a vast sky hung with big stars and powdered with little ones." With Cal Carrington as her guide and a "devouring sun" overhead, she supplemented the party's rations by hunting during the day. "There is always something mystic, remote, yet infinitely appealing about animals unsuspecting and undisturbed in the wild," she reflected on her love of the hunt and the attraction of the unspoiled American West, while lying in wait.

> I laid my rifle on the ground and sat down to watch, a lump in my throat. For the passion for the chase lies deep beneath the conscious lust to kill. To the natural born hunter the mere sight of game stirs to the roots an ancient, fundamental instinct, inherited throughout he ages, probably from the days when a fight between man and beast was a fight on both sides, of deadly consequence. It is the same animal instinct which throws a setter-dog, for instance, into a trembling ecstasy at the sight or scent of a grouse.

Her "Diary on the Salmon River" would appear as a two-part series in *Field & Stream* two years later, in May and June 1923.

Cissy tried her hand at fiction as well. In December 1921, *Harper's Bazaar* published the Countess Gizycka's "Polonaise," in which the handsome but dissolute Count Casimir sets about to use the beautiful ingénue, Princess Natalie, to his own ends. To his surprise, Casimir becomes jealous over the princess's compromising flirtation with Prince Antoine, and requests her hand in marriage instead, prompting his sensitive rival to commit suicide. Delighted with the story, *Harper's Bazaar* then dispatched the author to "Vienna and Warsaw (by way, quite naturally, of Paris) to visit the grandeur of other days—frayed and tattered now, alas—to revive old friendships and to write her post-war impressions." While sixteen-year-old Felicia spent her holidays at the Drake Hotel in Chicago with her cousins and one of their "poor relations" as a chaperone, Cissy, accompanied by Cal, sailed for Europe to spend Christmas at the Hôtel de Crillon in Paris. To her consternation, while there it was necessary to check on her mother as well. Nellie, she reported to Rose Crabtree in Jackson Hole, "is worse than I expected—mind and memory quite gone." Though Rose also learned from Cissy (but did not entirely believe) that hardboiled Cal had

been moved to tears by the sight of the "majesty and beauty" of Napoleon's tomb, the attractions of Paris were not sufficient to keep the cowboy from lighting out for Italy alone. Once Cissy had arranged for another "poor relation" to escort her mother home to Washington, she was free to set out in fulfillment of her *Harper's Bazaar* assignment as the year 1922 began.

"I boarded the night train for Warsaw, heavy with doubt and apprehension of the visit before me," Cissy confided to her readers. "Thirteen or fourteen years in actual time since I had left Poland . . . a very long *entr'acte.* The stage setting would be about the same, and the same characters would reappear, most of them, but with a complete change of costume, wigs and make-up." And yet, of all the changes that been visited on Poland since her last visit in 1909—electrification, the arrival of the motor car in place of the old rattling *droshky,* war, renewed occupation, Bolshevism, hunger and poverty—Cissy, now forty years old, appeared to be most apprehensive of the encroachments of age and the ravages of time. An old family friend of Count Gizycki's (and, by Cissy's account, an ardent admirer of his young American bride), Count Michele Komorowski met her on the glacial Warsaw railway platform. Clasping hands, they exclaimed in unison, " *'Mais vous n'avez pas changé du tout!'* But even in that instant, I noticed the gray at his temples and myself regretted not having troubled to put on a veil." More than three years after the armistice, Warsaw, which appeared to Cissy now as "a beautiful piece of tarnished silver," was still teeming with refugees. During her stay she reunited with other old friends, like the Countess Sobańska, Felicia's godmother. At a luncheon in Cissy's honor at Count Potocki's Warsaw Palace, the reformed gambler reported that his magnificent estate and park at Antoniny had been sacked and burned to the ground by Bolsheviks, who had slaughtered its exotic game and its renowned Thoroughbred and Arabian breeding stock. Many of their Volynian neighbors had been executed by radicalized Ruthenian peasants. "It was a long and horrible list of murdered people I once knew and of beautiful homes burned and pillaged, of prosperous farms and factories rotting in ruins."

Well versed in her brother's political opinions, Cissy wondered with rhetorical bluntness before old friends who had lost much over the previous decade:

> "Didn't you feel the revolution coming in Russia and the Ukraine?"
>
> "No," [Potocki] answered, "not until it was too late."
>
> "But don't you think now that it had to come? That the contrast was too great? On one side of your wrought-iron gates a fairy place, on the other side people living like vermin."
>
> "Yes," he echoed, "the contrast was too great."

Helping herself to a second serving of kasha, Cissy reflected:

"But you aren't suffering exactly"—I smiled and indicated the luxurious dining room.

"No. I was comparatively very rich. Now, I am comparatively a poor man," Potocki admitted. "I was exceedingly lucky to have some of the fortune outside of Volynia."

Sipping tea around the fire after lunch, Cissy marveled at the aristocratic Polish ladies she had known when they were "very young and very ignorant of realities above or below the pleasant surface of things, and the spiritual change in them was far more noticeable than the physical." And yet the same steely resolve that had prompted several of them as young women to attempt clandestinely to reunite the tiny Countess Felicia Gizycka with her mother had more recently called them to work at the front or in typhus camps among former prisoners of war as Red Cross nurses, or to sell their remaining jewels and belongings in support of the newly established Second Polish Republic.

Although Cissy made no mention of Count Gizycki in the travel diary she submitted to *Harper's Bazaar,* he was evidently much in her thoughts. Her article, "And Now," which appeared in the August 1922 issue, devotes considerable space to her reflections on cultural differences between Poland and the United States, particularly on the subject of matrimony. "Between Polish men and women, even in marriage, there is a shade of reserve which we don't find in this country," she observed.

He goes his way, or at least thinks he does. She watches, says very little, and doubtless goes her own. Marriage is indissoluble in Catholic Poland. And when two people know from the beginning that they are bound for life, the ghastly explanation, the fatal breaking through to the rock-bottom of things, seems a primitive form of self-indulgence, of no practical value to any one concerned. It is Polish nature to avoid frank and hair-splitting expositions of the truth, while on the contrary, this type of interpretation is one of the favorite indoor sports of our Anglo-Saxon race.

If she regretted a lack of stick-to-itiveness among American spouses, she observed that Polish manhood had already been profoundly changed by the autonomous government established in the wake of the war. "The young men I personally knew, who in the past divided their time between an animal existence in the country and a periodic dive into the stupid debauchery of Warsaw, have now almost without exception taken firm hold of a productive, useful life," she reflected. "Some are banking, some trading in

wood or alcohol—some are in the army, or diplomacy, some few in the Government. They are working to build up a better life for their children than they have lived themselves." Despite the loneliness and brutality of her marriage, "And Now" conveys a wistful, wishful sense that perhaps under other circumstances and at another moment in time her relationship with Count Gizycki might have had a different outcome.

Having left her own jewels and furs behind in Paris in deference to the privations her Polish friends faced, she returned both to retrieve her belongings and to report on spring fashions. "Paris has changed. I thought at first it was just myself grown old, but the French people themselves are the first to proclaim it," the Countess Gizycka observed in the *Chicago Tribune.* "The sparkle and nip have gone. Restaurant life, for instance, is flat like corked champagne." Although she lamented the gloom of the postwar Parisian wardrobe, she noted that sleeve lengths now allowed for the show of bare arms "up to and above the point of the shoulder." Stockings were "gossamer thin" and "of grey beige, never black," that spring. There was "nothing extremely new in hats." Bobbed hair, she pronounced, was "no longer in vogue," just as "shorn locks [were] passé." "No one wears face veils any more," she reported, and gloves were "uncommon" that season. "Chanel makes the most becoming clothes I have seen. They are soft, they are coquettish, they are wise . . . Chanel considers the fashion, certainly, but she considers the woman first." Weary, and deeply affected by the changes she had witnessed in her Polish friends—and by extension in herself—she likewise found France "convalescent" in the aftermath of the Great War.

From Paris, Cissy moved on to London. On March 10, 1922, she wrote Francis Warren, one of the western senators whose company she favored in Washington, from Claridge's. In introducing Cal Carrington, she urged the senator (and current chairman of the Committee on Irrigation and Reclamation of Arid Lands) to assist his fellow Wyomingite in homesteading the land on which he had been squatting, fifteen miles outside of Jackson. Since she had first seen Flat Creek Canyon, where Cal had grazed (and possibly hidden stolen) horses since the turn of the century, Cissy had pestered him to sell it to her. The laconic cowboy had always demurred; in fact, as part of the Teton National Forest the land was not his to sell. The 1906 Forest Homestead Act had opened arable land within the reserves to settlement, but only on a case-by-case basis, at the discretion of the secretary of agriculture. On March 11, Cissy's letter of introduction to Senator Warren in hand, Cal sailed from Le Havre aboard the French liner *Rochambeau.* Upon landing in New York he set off immediately for Washington, where he made the case for his homestead at Flat Creek before the National Forest Service and paid his respects to Senator Warren. After crossing on the *Mau-*

retania and arriving at the St. Regis in New York on April 1, Cissy found a letter from the senator, reporting that Cal's lobbying efforts were progressing smoothly.

Attesting that he had more than fulfilled the 1912 Homestead Act's three-year residence requirement by squatting at Flat Creek since 1901, surveying the 141 acres in 1918, and making improvements to the land since 1920, Cal submitted his claim in June 1922. His application would spend the summer mired in federal bureaucracy, however. Although the parcel had no agricultural use as the law required it to have (and a local Forest Service official's assessment that rather than tilling the land, Cal had simply cut hay that grew wild on it), Senator Warren nudged the matter toward approval and announced to Cissy in late November that the patent had been granted on the Carrington homestead at Flat Creek. Although the Homestead Act was more typically misused to obtain water, timber, or oil rights to national forest land, Cissy and Cal had in effect enlisted the law in the unorthodox acquisition of a summer home. In February 1923, Cal sold the land to Cissy for $5,000,* and would receive an annuity until the end of his life fifty-six years later for staying on as its caretaker.

"Yes—yes—yes, I want a good dance floor in the living room," Cissy exclaimed to Rose Crabtree on March 2, enumerating the improvements she intended to make to her new property. "I want a big brick fireplace in it too—a *big,* huge one—I want a barn painted red. I want the road to go up the creek on the left side, going up to avoid the swampy places. I also want a little cabin for myself to write in . . ."

Debut Is Declined by Felicia Gizycka:
Daughter of Countess Refuses to Leave Job
in San Francisco

—*WASHINGTON POST,* JANUARY 15, 1925

What can I tell you about my winter?" Cissy mused to Rose Crabtree in February 1924, seizing eagerly upon the subject of the recent holiday season: "I had a perfectly vile time in Chicago between my poor, sick mother and Felicia, who is about as easy to drive as a team of young bull moose." Many had remarked that over the previous decade and a half Cissy had taken on a number of her former husband's characteristics—

*In excess of $63,000 according to the Consumer Price Index, or nearly $310,000 by nominal GDP per capita.

a growing reliance on alcohol, a quickening temper, a mounting volatility—but none more vividly than her own mother. "Cissy went to Poland a sweet young girl," Felicia recalled Nellie saying, "and came back home to Washington, D.C. a horrendous bitch." If Cissy had received little maternal nurture in her childhood, she had passed on perhaps less to her daughter. Like Nellie before her, Cissy underwent the same "odd transformation" that prompted her to take a sudden interest in her daughter as the latter approached adulthood, an introduction to society, and marriage. And like Cissy before her, accustomed until then to being little regarded, Felicia resented her mother's attentions, seeing them as nothing more than aggravating intrusions. Cissy, in turn, resented Felicia's lack of appreciation. Ill at ease in the role of caregiver (particularly to her female relatives), Cissy bridled at the additional burden of responsibility she faced as her mother's mental and physical health deteriorated.

If tensions were on the rise among the three by the middle of the 1920s, it had not always been so. Much as Felicia was by her own admission a poor judge of the affection or regard in which others held her, so she tended to erase her own lightheartedness in retrospect. Although she remembered her youth as belittling and combative, the reflections she recorded at the time offer a brighter view. She and her grandmother had early on formed the proverbial alliance against the common enemy who linked them. Felicia's childhood letters to Nellie make clear that their bond was a tight and affectionate one, though based in some measure on commiseration over Cissy. Closing characteristically with the likes of "six kisses—XXXXXX" or "Lots of love and eighty-one hugs," Felicia detailed for her stiff grandmother the course of her childhood and youth. She recounted her afternoon jaunts with her Bar BC friend (and afterward Washington neighbor and schoolmate) Louise Ireland, their roller-skating excursions up and down 16th Street, their daredevil climbs on the nearby Masonic Temple, their riding lessons and trail rides in Rock Creek Park. She counted the days until she could return to Chicago to see her cousins and grandmother for the Christmases she so loved. Occasionally in verse and often with accompanying illustrations, she kept Nellie abreast of her travels to Wyoming with her mother each summer, reporting minutely her continued wonderment at the beauty of the country, the results of their hunting expeditions, the sights and sounds of the annual rodeos, and news of Cissy: "Mama loves it here." At fifteen, Felicia spent a "wonderful" summer at camp in Maine, where she won the awards for "excellency" in swimming and paddling, and shed tears upon her departure, she reported at length to her lonely grandmother. Although little of Nellie's side of the correspondence survives, she shared (if not engendered) Cissy's inclination to express affection in material form and established a modest trust fund of $1,200 for her twelve-year-

old granddaughter in the summer of 1918—without mentioning it to her daughter.*

From the vantage point of old age, however, Felicia would recall the same period in her life as a bleak and painful one, empty of affection, full of correction and derision, and characterized generally by failures, mishaps, and reversals. When notified that Felicia, then nine years old, was gravely ill with pneumonia, Cissy telegraphed from wherever she was to ask whether the situation was in fact serious, noting that she refused to come home on some "wild goose chase" if it was not. Although Cissy often promised to have dinner with her, Felicia was unable to remember that her mother ever kept her word. Instead, as a girl she recalled spending many successive evenings dining alone, listening only to the sound of the starched shirtfront of the footman (who stood behind her and with whom she was not permitted to converse) popping in and out with his every dozing breath. Though Felicia appreciated that her mother had inspired her with a love of horses, she noted that Cissy had never given her one. The single occasion on which she remembered Cissy taking her out for ice cream had resulted from Felicia's falling from a horse and bursting both of her eardrums. She recalled a single occasion on which her mother complimented her on her riding, but later came to suspect that Cissy had watched her that day only to determine whether to buy the horse for herself. Cissy had, she allowed, rented a horse for her to ride once she left home to board with her cousin Alicia at sporty Foxcroft School, in Middleburg, Virginia, in the fall of 1921. Cinnamon Witch (so named by the tittering riding master to convey that the animal was a "son of a bitch," without offending young ears) "pulled like Hell," however, terrifying Felicia by dragging her pell-mell up and down the Virginia Piedmont at an unbreakable gallop.

Determined that her seventeen-year-old daughter "should see more young people—particularly make friends with some boys her own age" in anticipation of soon making her début, Cissy resolved to take Felicia, along with her cousin Elinor Patterson if necessary, to Santa Barbara, California, in July 1922. "It's time for her to hold her own with [boys] and not be so shy. She looked lovely in Chicago by the time she went back to school," Cissy observed, adding an increasingly characteristic caveat: "But had the awfullest clothes when I came home, poor child." Once in California, Cissy was "pleased and satisfied and also scared to death" to find that both girls attracted ardent admirers. She was also flatly surprised, given that she found her niece (and namesake) to be "much more attractive" than her own

*About $17,000 based on the Consumer Price Index, or roughly $77,000 in terms of nominal GDP per capita nine decades later.

Felicia Gizycka as a teenager in the 1920s

awkward daughter—an impression she conveyed bluntly to Felicia. Soon Cissy grew piqued as well: "Felicia's friends look on me as a kind and consumptive old party easily disposed of," she complained to Rose Crabtree only half jokingly while attempting impatiently and unsuccessfully to persuade the teenagers to leave convivial Santa Barbara with her for the desolation of the Sierra Nevada. In August 1922, Cissy managed at last to light out for the wilderness and spend two weeks in Jackson Hole, writing Rose shortly before her arrival amidst a flurry of last-minute directives that this year she would be accompanied by "a Jew."

Elmer Schlesinger had been a young partner at the Chicago law firm of Mayer, Meyer, Austrian & Platt in late 1910, when his uncle, Levy Mayer, one of the firm's founding partners, began to represent the glamorous, if somewhat notorious, Countess Gizycka in what would turn out to be her protracted divorce proceedings in the Cook County Court system. Born in Chicago in 1880, Elmer Schlesinger was the son of a German immigrant who had become a wildly successful local merchant. The younger Schlesinger graduated from Harvard College in the class of 1901, and from Harvard Law School in 1903. Five years later, he joined his uncle's law firm and was eventually made partner. In 1911, he married Halle Schaffner, the daughter of a successful Chicago clothing manufacturer, and had two children with her. Over the course of their eleven-year marriage,

the Schlesingers lived at the lavish, newly opened Blackstone Hotel on Michigan Avenue, where both of Joseph Medill's now elderly daughters chose to stay during their protracted visits to Chicago from Washington. The Schlesingers had separated in 1920, when their daughter was ten and their son not yet four. In June 1921, Elmer was appointed vice president and general counsel of the United States Shipping Board and left Chicago for Washington. There he gravitated toward his old friend Medill McCormick, to whom he was said to bear a close resemblance, and through the senator renewed his acquaintance with the Countess Gizycka. The following year Schlesinger returned to private practice, this time in New York as a partner at the firm of Stanchfield & Levy, and began to serve on a number of corporate boards, including those of the *Chicago Tribune,* the New York *Daily News,* and *Liberty* magazine.

Though Cissy protested that she found Elmer Schlesinger ugly (despite his resemblance to her cherished cousin) and objected bluntly to his ethnic origins, she had difficulty ascribing other faults to him. "I must say," she had written Rose in December 1923, "he is the cleverest man in some ways that I have ever known." In February 1924, Cissy reported that she had begun to see Elmer with some regularity. He had recently given up drinking and was "much improved" mentally and physically as a result (she had been unable to follow his example, however, she added). "He is so smooth and sure of himself that it is quite impossible to ever get mad at him," she reflected with amazement, "and with my kind of a disposition these are very unusual characteristics." By May, Cissy revealed that Elmer Schlesinger had become the "most interesting" man in her life. He arranged everything for her, sorted out her troubles, helped her make decisions.

For the previous year, the disposition of 15 Dupont Circle had generated rancor within the Patterson family. "After keeping a few engagements I shall return to Chicago & never return here," Nellie had pronounced to Alice in February 1923, amidst a litany of complaints about the insomnia induced by the ceaseless late-night traffic and constant jazz-age revelry that had transformed once-sleepy Dupont Circle. Since Joe had no use for a Washington home, Nellie had prepared a deed giving Cissy the mansion, "in consideration of love and affection and the sum of ten dollars . . . together with all household furniture and effects of every character and description contained therein, with the exception of silver and gold plate." Adjusting the elderly lady's estate planning to make equal provision for Joe in light of this monumental gift to Cissy, proved to be more complicated, however. By the summer of 1923, the proposals for an equitable resolution and counterproposals of new appraisals and alternative outcomes offered by

Cissy, Joe, and their respective counsels had come to a standstill. Protesting his sister's insinuations that he was attempting to "skin" her in their negotiations, ever-neutral Joe declared, "It is more important for us not to scrap than to win a scrap, just as peace is often better than victorious war and always better than unsuccessful war." "I am not suspicious of you," Cissy shot back, adding suspiciously, "I firmly believe you are anxious to close a deal more advantageous to you than to me; that's all." The wrangling between brother and sister continued until March 1924, when Cissy took possession of Patterson House at last.

In the meantime, Cissy's sudden show of interest in her teenage daughter coincided, not surprisingly, with the outbreak of Felicia's "open rebellion" against her mother. Though Felicia had demonstrated no enthusiasm at the prospect of being presented to society, demurring indefinitely when pressed for a date to make her début, Cissy persisted over the course of 1923 in trying to force her to be more sociable and vivacious as she approached her eighteenth birthday. On March 31, the *New York Times* remarked in its "Social Notes" from the capital that Mrs. Robert W. Patterson had hosted a small dance "for sub-debs and the younger dancing men" in honor of her granddaughter, the Countess Felicia Gizycka. To encourage Felicia to take a more active role in society, Cissy busily signed her up for charitable committee work and attempted to interest her in the whirl of balls and parties associated with the début that her attractive cousin Elinor Patterson was to make in Chicago at Christmastime. So preoccupied was Cissy with the subject that even in the midst of her wrangling with her brother over the transfer of 15 Dupont Circle she managed to pepper her accusations and suspicions with parenthetical references to Felicia "(who is not fit to come out)" and her own anxieties about ultimately marrying her daughter off—"God willing."

Though Felicia had been unswayed by the festivities she had attended in her cousin's honor, after her own eighteenth birthday in September 1923, she could at least begin to make herself useful at her mother's parties. The following spring, shortly before one of the first dinners at Dupont Circle over which Cissy presided in her own right, the nervous hostess discovered that "a woman had fallen out" due to illness. To preserve the seating arrangement, therefore, she forced a sullen Felicia to fill in, placing her according to protocol next to the second-least-senior guest (who had likewise replaced a sick husband at the last moment). "I don't know how much was the glamorous background," Felicia would later reflect of Drew Pearson, the ambitious journalist and lecturer who was her dinner partner that evening. "I wonder if he ever loved me just for me. I'll never know."

· · ·

On his way out west to Salt Lake City in the summer of 1924, the aspiring political reporter received a letter from an old school chum, teasingly addressed to "Drew Pearson, Special Correspondent in the Far East and Australasia; special correspondent of some dozen available ladies and co-respondent of as many others; purloiner of maidens' hearts; insidious despoiler of feminine peace of mind; and much more that might be censored . . ." As he rose to become the most influential investigative journalist and, after Walter Winchell, the second most highly paid columnist in the United States by midcentury, many of Washington's most notable figures would devise their own epithets for him as well. Pearson would declare himself to be the "voice of the voiceless." To millions of readers and listeners he was an "enemy of rascals," a "champion of the masses," a "watchdog of virtue," a "national ombudsman," and a tireless crusader against corruption and graft. Many of those he covered, by contrast, would regard him as little more than a self-righteous character assassin and a base scandalmonger. Though Pearson was decidedly and consistently liberal in his views, Harry Truman would label him an "S.O.B." (a title the columnist would cherish). Even Franklin Roosevelt, whose domestic and foreign agendas Pearson championed, would complain that the columnist was a "chronic liar." Elaborating on President Roosevelt's sentiments, Senator Kenneth McKellar of Tennessee would label Pearson not only "an infamous liar, a revolving liar, a pusillanimous liar, a lying ass, a natural-born liar, a liar by profession, a liar for a living, a liar in the daytime, a liar in the nighttime," but moreover "a dishonest ignorant corrupt and groveling crook." Those who came to know Drew Pearson over the ensuing decades—whether in person, in print, or over the airwaves—would likely have been surprised to learn that the hardnosed, dirt-digging muckraker (and widely reputed ladies' man) had been a confirmed romantic in his youth.

Born in Evanston, Illinois, in December 1897, Andrew Russell Pearson had grown up in Swarthmore, Pennsylvania, where his father was a professor of speech and English and the founder of the local Chautauqua association. Modeled after the New York Chautauqua Association's quasi-religious educational summer camps of the late nineteenth century, Paul Pearson's Swarthmore Chautauqua became one of the traveling "tent Chautauquas" that flourished in the early decades of the twentieth century by bringing edifying lectures, stirring concerts, and wholesome entertainment for the whole family to a circuit of often-isolated small towns, in this case across the East Coast. After graduating from Phillips Exeter Academy in 1915, Drew Pearson had returned home to attend Swarthmore College. As a Quaker, he was moved to join the American Friends Service Committee after graduation, and spent two years in Serbia and Montenegro performing relief work in the aftermath of the Great War and ministering to

the heartache of his unrequited love for a British nurse. Returning to the United States in 1921, Pearson taught geography at the University of Pennsylvania, but ventured abroad again the following year to pursue the call of journalism. In a promotional pamphlet, "Drew Pearson on the Orient of To-Day," which he circulated to any newspaper or magazine editors who would meet with him during 1922 and 1923, he proposed to write a series of twenty-six human interest stories on subjects inspired by his upcoming travels through "all the countries of the East," "by steamship, airplane, ox-cart, automobile, on camel, on horse and on foot." Having enjoyed a little journalistic success covering the Washington Arms Conference and interviewing "Europe's Twelve Greatest Men" in 1922, from the Orient he attempted earnestly to write freelance pieces for American publications—often by candlelight, his typewriter perched on benches or open drawers for lack of proper writing surfaces—on such colorful topics as "Banditry—China's National Sport," "The Most Useful Language in the World," "Does the World Hate Americans?" and "Japan's Emperor Will Be Real Human Being." During his travels Pearson had labored to express himself in a "more correct newspaper style" along the lines of the "Sunday supplement stuff" practiced so masterfully at the *Chicago Tribune* and more recently expanded at the New York *Daily News* by that editorial wunderkind, Joe Patterson. With the dogged determination Pearson would exhibit in every aspect of his life from work to love, he refused to be deterred by his early failures, declaring from New Zealand in 1923 that he could not agree with his editor that the material he had sent was "poor." When he filled in for dinner at 15 Dupont Circle, he had recently returned home to the United States to teach geography at Columbia, while he continued to lecture for the Chautauquas across the country and freelance for newspaper syndicates.

Eighteen months after she had wrangled a summer home on magnificent national forest land, the improvements and renovations Cissy had ordered to Flat Creek Ranch were largely complete, making it possible to accommodate growing numbers of her greenhorn guests from the East. One of the tenderfeet who visited in the summer of 1924 was Elmer Schlesinger. Although Cissy had written Rose Crabtree glowingly and often over the previous two years about the considerate suitor who arranged everything for her, Rose had had her own taste of Elmer's ardor even before meeting him. Inasmuch as Flat Creek Ranch had no telephone, it had fallen to Rose at the Crabtree Hotel to channel his deluge of telegrams to Cissy. Fed up, Rose had finally wired back, "Oh shut up!" Although Rose would come to enjoy Elmer's company upon meeting him in person, other locals were less receptive to the debonair tennis-playing Harvard man who arrived in Jack-

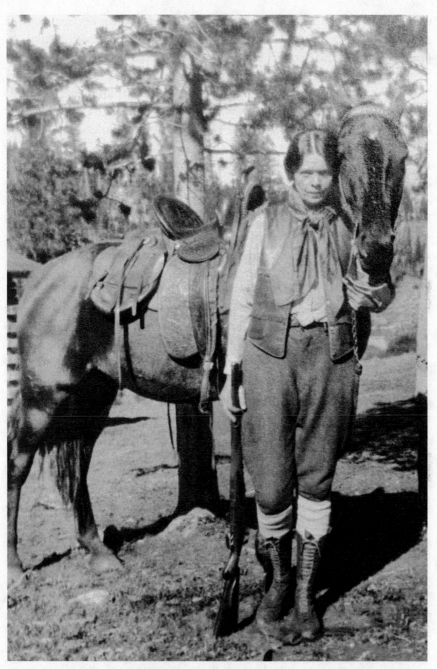

"The Countess of Flat Creek"

son Hole accompanied by his English valet. Still a dude in her own right (if an unusually able rider and marksman), Cissy pronounced Elmer *her* dude—to the glowering consternation of that "old bear," Cal Carrington. If other cowboys, guides, and ranch hands suffered the effete New York lawyer chiefly for a share in the crate of Scotch he had transported anxiously over the Teton Pass, the rustic attractions of the West held little charm for Elmer either. He did not share Cissy's love of riding. Neither did he revel in blood sports. When Elmer accused their guide of being "a crazy man" for inducing them to scramble up a steep, wooded grade during a hunting trip, Cissy dismissed her suitor's gashes and bruises with countercharges that he was a "big sissy." Although she was solicitous when Elmer fell ill at Flat Creek, it was perhaps a relief to both that he was prescribed rest for several days—allowing the hostess to set out on a hunting trip while her guest recuperated at her ranch and giving her the opportunity to reflect, "Just think—I had almost thought of marrying that man!"

By this time, too, relations had deteriorated markedly with an ever-angrier Felicia, whom Cissy now excoriated both behind her back and to her face as not only "self-indulgent, pleasure-mad, without any sense of obligation to *anyone,* tricky & wild" but generally "headed straight for big trouble!" Cissy attributed these growing tendencies not to the licentiousness so often lamented of Felicia's generation, or indeed to a pertinacity learned or inherited from her maternal relations (and particularly from her mother), but rather to the girl's patrimony. Cissy distilled everything that most exasperated her about Felicia into the shorthand "her elusive, Slav way." If Cissy had been unable to persuade her sulky daughter to make a début, she still had it quietly in mind to " 'put her on the market,' so to speak, . . . in the way of an early, &, as near as possible, safe marriage," she confessed to her brother. In hopes of throwing the eligible young people together again, Cissy invited Drew Pearson to Flat Creek Ranch that summer. Already besotted with Felicia by the time he arrived, the up-and-coming journalist would leave Wyoming in September, delirious under the "disconcerting, inspiring influence" of the beautiful young countess, which prompted him to "forget most everything except that the world is a pretty good place to live." For her part, Felicia lamented, "Cissy never invited the people I wanted."

"She has grown enormously fat & heavy, complains of this all the time, & yet indulges her enormous appetite precisely as Mamma did, seemingly unable to resist food of any kind at any time," Cissy added to the litany of complaints she lodged with ever-neutral Joe about Felicia. "In consequence she has lost her looks, & a kind of coarseness has come into [her] face, which worries me frightfully." Surviving accounts and photographs sug-

gest that Cissy may have been alone in finding fault with Felicia's appearance. By the age of eighteen, the young countess had grown tall and striking. The candy-floss hair that had charmed the passengers of the *Kaiser Wilhelm der Grosse* fifteen years earlier had darkened to gold and was now cropped into a gleaming, waved bob. Many noted that Felicia had inherited her father's classical features rather than her mother's unorthodox upturned nose and round face. Though she had much of her mother's height, Felicia had not inherited her mother's sylphlike form. Rather, of all of Felicia's physical attributes, it was her buxom figure that she remembered her mother teasing her for, drawing attention to, and criticizing most pointedly. "What's that in your pocket?" Felicia recalled Cissy wondering aloud in front of several of Flat Creek's guests, while gesticulating theatrically at her ample bosom. "Oh—that's the way the poor child was built," Cissy answered herself. If the gesture was a mean-spirited effort to punish the "insolent boredom" that characterized Felicia's attitude, it was also a self-revelatory one. Since her return to Poland two years earlier, Cissy had written Rose Crabtree several times of the "queer, ghastly change of the body. Indication of old age and death . . . I (once) had a silly, fat, perfectly round face. And now I'm all wrinkled up . . ." "I've gained ten pounds," Cissy reported on another occasion, after one of her many convalescences, "—quite a bust now! Which is what I always wanted."

"She left Banff dressed in buckskin and wearing a wide brimmed Mexican hat," the *Washington Post* reported as front-page news on August 21, 1924.

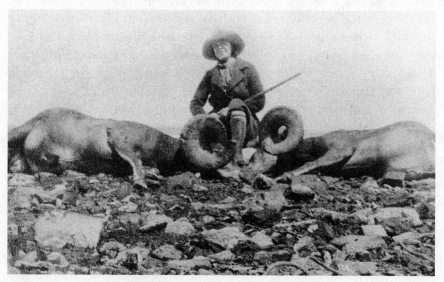

The Countess Gizycka hunting in the 1920s

In the wake of her recent travails, Cissy had suddenly abandoned Jackson Hole a few days before, for what she hoped would be a relaxing hunting trip in the Canadian Rockies. "What I wanted was a change from Flat Creek & worry," she repined to her brother. "Have had drunken cooks, wrangling maids, unpleasant visitors all summer. Flat Creek camp was a heavenly spot. Flat Creek Ranch is getting to be as restful as the corner of 16th and R, Washington D.C.," Not even Cal Carrington, whom she had taken to Calgary as her guide, could mollify her. In fact, she said, "I really think this will be my last hunt with Cal," complaining to Rose Crabtree of what she characterized nebulously as the cowboy's "light-fingered" treachery toward her.

The recrimination between mother and daughter had recently come to its breaking point. "I have been deeply hurt by Felicia's behavior naturally these last twelve months," Cissy insisted to her brother ten days after Felicia's nineteenth birthday, in a defensive letter from Calgary. Fed up with Felicia's "laziness, trashiness, selfishness & self-indulgence," Cissy unburdened herself of her worries about her daughter's future, only skirting the painful subject of the rupture that had taken place. Felicia had refused to "come out." She had lost all interest in sports. She showed little inclination to involve herself in any of the Republican women's committees Cissy had signed her up for—or even in Senator Medill McCormick's reelection campaign. She had not finished any of the literary works that Cissy had pressed on her to improve her mind or cultivate the interest she professed in writing fiction. Preferring the company of friends her own age, Felicia had arranged to stay at the lively Bar BC while in Wyoming that summer, and only slept in the cabin Cissy had built for her at isolated Flat Creek during her brief, increasingly tense visits. When she took the trouble to visit Felicia, Cissy complained, a violent spat had erupted: "she told me I was a liar & had stolen her necklace, whereupon I smacked her face—& can't help regretting that . . ."

In a "stormy" interview a few days later, Cissy informed her wayward daughter that they could no longer live together because Felicia refused to acknowledge Cissy's authority over her and consistently rejected any and all maternal advice. Since Felicia "yearned 'to live her own life & be at last free'—there was a simple course open," Cissy threatened: "Get out, leave home & work for her own living." Uncle Joe would give her a job which would instill the discipline Cissy felt Felicia so desperately required. Felicia retorted with her own vaguely formed plan, however. "She would get away from the family—the family which, she said, she hated & which had made her so unhappy (!)," as Cissy recalled it indignantly. And, indeed, Felicia had done just that: storming away from Flat Creek and heading

east, Cissy presumed, to be indulged as usual by her grandmother. The prodigal would be forced to reflect upon her actions and their consequences until after Cissy's hunting trip in the Canadian Rockies. "Now she can stay with Mamma till I come." Then, Cissy urged Joe, "put her to work at *once.*"

Predictably, Felicia would recall the events that surrounded the open rupture with her mother differently.* As family tensions mounted, Felicia discovered during the last of her few, short visits to Flat Creek Ranch that her mother had fired the Swedish maid, but had refused to give the girl a horse to ride into town until a replacement domestic arrived. Already bristling at the whimsical autocracy Cissy exerted in her own life, Felicia informed her mother that "this was hardly the dark ages, or even Russia before the Revolution." The mother-daughter dispute quickly devolved into one of what Felicia had come to call their "roundups." This particular "pitched battle" was "a knock-down drag-out fight, which included hair pulling and clothing tearing." Inspired by Cissy's threats to force her to earn her own keep, Felicia called her mother's bluff and announced that she was leaving home for good. Unable to persuade Aasta, the hapless Swedish maid (by now in "floods of tears"), to leave with her, and unwilling to take anything that belonged to her mother, Felicia tacked up the green pony that Cal had given her, fashioning a makeshift bridle out of her own cotton stockings. With all of her "worldly possessions fore and aft in duffel bags," she rode bareback out of Flat Creek Ranch "in a rage"—albeit at a walk. As she later explained, "I'm not a great horsewoman."

Felicia's caution was justified by the pony's bucking off one of her bags during their slow flight into town. Uncertain she would ever be able to get back on if she dismounted, Felicia left the duffel where it lay on the trail and continued her deliberate progress into Jackson Hole. Surely Cissy "would send someone down to catch me and bring me back," she worried. "As I rode down to town, I didn't see my future very clearly. It was like a kaleidoscope, with an ever changing pattern. I was running away from something with no idea where to go." After covering the "long, long" fifteen miles into town, Felicia dropped her pony at the local livery stable and made for the Crabtree Hotel. Well aware that Flat Creek Ranch still had no telephones, Rose was unconvinced by Felicia's claim that her grandmother was gravely ill, and skeptical of the girl's desperation to travel east. "How

*Just as Felicia recorded the first summer she spent in Jackson Hole at the age of eleven as 1916 rather than the actual year, 1917, so she appears to have missed by one the year of her first break with her mother. In "Cissy Patterson: The Countess of Flat Creek," which appeared in *Teton* magazine in 1977, she would write, "In the late summer of 1923, I left Jackson Hole forever, so I thought. I was eighteen years old." In fact, Felicia was eighteen (and would turn nineteen at the end of) the following summer, 1924. The surviving correspondence, newspaper accounts, and civil documents confirm that the later date is the correct one.

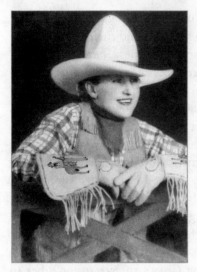

Rose Crabtree

did you get the message? By Ouija board?" Rose wondered. Nevertheless, Hank and Rose Crabtree put Felicia safely on the stagecoach to Victor, Idaho, the following morning.

Intimates would later recall that Cissy delighted in matchmaking. In the late summer of 1924, apparently neither rage nor ambivalence toward Felicia would deprive her of that pleasure. As Felicia had feared, Cissy had dispatched someone to "catch" her and bring her back home. It was with redoubled dismay, therefore, that Felicia greeted Drew Pearson on the train from Victor to Salt Lake City. "Now I've got to shed him!" she thought. His uninvited flirtations provided the pretext. Pretending to be "terribly shocked" when the reporter regaled her with "a very mild naughty story," Felicia changed her seat, told him not to bother her again, and forbade him to follow her once they arrived in Salt Lake City. "You bore me," she announced for good measure, "and the more I see of you the more bored I get." Once in Salt Lake City, she boarded an eastbound train and mailed a letter to her mother from one of the stops, informing Cissy that she intended to spend some time with their "poor relations" in New Philadelphia, Ohio. Confident that she had thrown both Drew Pearson and her mother off her scent, Felicia then backtracked on a westbound train and made straight for Hollywood.

"You're very pretty," the studio executive told her during what seemed to be a promising first interview. Still smarting from her mother's jibes about her buxom figure, however, Felicia abandoned the thought of going into the movies entirely when he went on to ask to see her in a bathing suit. Instead she thought she would try her luck in San Diego. After only a few days there, however, reality began to intrude upon the runaway heiress's Capra-esque bid for freedom. She had left Wyoming with $300* from the trust fund her grandmother had set up for her as well as a small sum she had earned from investing in Liberty Bonds. Even the YWCA would be too expensive for any length of time, so Felicia rented a small room for $12.50†

*Some $3,600 by the first decade of the twenty-first century measured by the Consumer Price Index, or roughly $18,000 by nominal GDP per capita.
†About $150 or $750 by the same measures eight decades later.

a month under the name "Marion Martin" in a boardinghouse, the majority of whose other inhabitants seemed to be navy wives awaiting their husbands' next shore leave. The landlady, a former opera singer, struck Felicia as a "big jolly soul." Thinking of Cissy in her growing loneliness, Felicia took some comfort from the thought that "at least Mama would approve of where I'm living. With this nice clean motherly type."

Finding work presented more of a problem. Felicia had never held a job. Indeed, until recently she had always been attended by the members of her mother's extensive, liveried domestic staff and as a result had never been asked to perform any chores at home. She realized suddenly that she had no knowledge of how to sweep a floor, sew on a button, or cook a meal. At Foxcroft she had been required to wait tables, however, so she set about to find a job in a restaurant. A "grey-faced, bespectacled woman" known as "Ma" hired "Marion Martin" to work at her Sailors' Hash House, but only after satisfying herself that the candidate had not "run away from some man"; it was clear from the girl's refined bearing and her clumsiness with mops and dishtowels that she had never worked a day in her life. Ma proved to be both a demanding employer, one who little hesitated to raise a hand in threat when displeased, and an enterprising one, who conducted a bootlegging operation out of the back door of the Sailors' Hash House. Felicia returned from the unrelenting drudgery at Ma's to her rented room at night exhausted, her arms and hands ulcerated by the lye in the dishwater. Ma's clientele (as the name of her establishment suggested, mostly sailors on leave) was invariably rowdy and, in Felicia's limited experience, shockingly forward.

"I didn't run away from Cissy in order to be an underpaid scullery maid with an abusive boss," she resolved eventually. Over the course of the six months Felicia spent in San Diego, the pretty, voluptuous blonde found greater success selling newspaper subscriptions in office buildings across the city. She took a second job serving lunch at the Quiamaca, a genteel downtown men's club, and with the small sums she was able to save, began to attend secretarial school in hopes of gaining more lucrative employment—and eventually, possibly pursuing a career in writing. When she was taken to the doctor for stitches and was forced to wear a sling after accidentally putting her hand through the kitchen window one afternoon, the Quiamaca provided workman's compensation, though not enough for her to get by on. Unable to work or type, therefore, Felicia accepted when her jolly, opera-singing landlady offered to make her into something of a rental agent for the boardinghouse by paying a dollar for every new tenant she could bring in. "In some ways I was as innocent as a three-year-old," Felicia reflected afterward. "We told naughty stories in

boarding school, but I thought that sex outside marriage was something that happened in books or on the stage." She was scandalized, therefore, to return to the boardinghouse several evenings in a row to witness one of the renters she had brought in silhouetted in the window clad only in a slip and a male embrace—"without her dress on!"

Soon Felicia began to hear that a number of the other young women who lived in the boardinghouse had no visible means of support. "My education finally began. But this was just the beginning." The next girl to whom she rented a room quickly became a friend. Eighteen-year-old Alice was engaged to a chief machinist's mate currently at sea, and intended to take the room only until his next leave, when they would be married. "Marion, you're too innocent to live in this town alone," she observed one day before proceeding to enlighten her new friend about their neighbors. "Don't you know that all these girls in this house just live with sailors when the fleet's in? Those wedding rings are from the five and dime. When the fleet pulls out they shave off their eyebrows, paint false ones, paint up their faces and work in the dance halls." It was only then that wide-eyed Felicia realized fully that they were living in "the next best thing to a whore house," that their jovial landlady was a flesh peddler and that she herself had "rented a room to a couple of whores and made just one buck."

After Alice's wedding to her machinist, Bob Green, Felicia moved in with the couple and slept on their pull-out couch for the same rent she had been paying at the flophouse. Though she was nineteen and had never been kissed at the time of her arrival in San Diego, she began slowly to have some experience of men. A marine she met through the Greens fell in love with her. "Finally he grabbed me and kissed my face and said 'I love you. I do! I do!' and I don't know what I told him, but it was no. And I wasn't nice about it. I'm sure of that." She began going to the movies with a young sailor on shore patrol. Eventually she allowed him to walk her home, and after a time she let him kiss her. Their growing intimacy emboldened him to confess the deep sense of isolation he felt in the navy; "this was a cry from the depths of him, something I could hear and understand out of a wealth of loneliness in my own past." Nevertheless, she felt there was little she could do to help him. Despite her reduced circumstances, they had little in common. One evening when the Greens were out, the lonely young sailor made the coy suggestion, "Let's act like we're married." Felicia was flabbergasted and affronted, just as her mother had been at the same age when Freddy McLaughlin had tried to kiss her through her riding veil. "I handed him his little white sailor hat and said, 'Out! Go!'"

"I had no empathy with either of these men. No kindness, no understanding," she reflected later. Despite the fact that she had landed on her feet and had been able to support herself, despite the kindness of the few

friends she had made, her loneliness and isolation were difficult to bear. Though she had taken pains to hide her identity and confuse her mother as to her whereabouts, Felicia had not severed all contact with her family. She had written her Uncle Joe to let him know she was all right. Having been drawn to write early in his own life, he encouraged her burgeoning literary efforts and sent her a copy of Edna Ferber's recently published collection of short stories, *Gigolo,* which Felicia loved and emulated. "If you ever expect to write," he told her, "what you are learning about life now, will come in handy some day." Having long experience of the trials of living harmoniously with their hardheaded relatives, he respected Felicia's request not to reveal her assumed name or address to her mother.

Cissy's hunting trip to the Canadian Rockies in September 1929 had supplied the material for her latest big-game hunting article, "Who's the Goat?" which would appear in her brother's *Liberty* magazine in October 1925. The six weeks she had spent in the wilderness had not, however, provided the hoped-for respite from her vexation with Felicia or her domestic annoyances. Cissy was ill at ease throughout the expedition and found toward the end that a profound change had taken place within her. Spotting a magnificent specimen of mountain goat, she was surprised to find that her former zest for the kill had left her. "Somehow I felt depressed . . . I didn't really want him. Yet, mechanically, compelled by the habit of years," she pursued the animal and shot him repeatedly, but succeeded only in wounding him badly as he continued to elude her. "The animal stirred a little and began to moan—sobbing and choked sounds. He was fighting for breath. I felt very sick indeed . . . Satiety—I thought to myself—the thrill has suddenly quite all gone."

Cissy returned from the Canadian Rockies to discover that Felicia had not, in fact, been brought around by several weeks' contemplation of gross filial ingratitude or the horrors of the working world. Nor had she ever made contact with her "poor relations" or her doddering grandmother, let alone kept an anxious vigil at the elderly lady's bedside. Further, Felicia had managed to elude Drew Pearson's attentive pursuit, leaving no trace and little means of learning her current address without employing private detectives. In his clandestine correspondence with his niece, Joe Patterson confided also that in spite of Cissy's feigned public indifference at losing Felicia a second time, it was clear to him that his sister's heart was breaking. Indeed, in the midst of her ongoing dispute with him over the valuation of their mother's jewels and furs (an offshoot of their recent quarrels over 15 Dupont Circle), Cissy had nonchalantly asked Alice Patterson to let her know if ever young Elinor had "any news." Using an unaccustomed phrase in the latest argot, she added "as Felicia would say," and inquired

ardently whether her sister-in-law and nieces might join her for Christmas at Dupont Circle, "for certainly I will be lonesome in that big house, all by myself. History repeats itself!"

Cissy would later claim that she had learned Felicia's address from one of her daughter's friends. Other accounts contended that she had hired private detectives. Nevertheless, although the telegram itself does not survive, as Felicia remembered it six decades later, "At Christmastime I got a wire from Cissy saying 'Merry Christmas. We've known where you are for some time.' Acting superior getting the jump on me." Felicia's correspondence from the winter of 1924–25, by contrast, suggests a sense of relief that the estrangement from her mother was over. "I always tell [friends] how charming you are and what a lovely figure you have, and they say they'd like to meet you," she gushed to Cissy on January 15, 1925, in response to her mother's communication and its accompanying packet of much-needed clothing and mail that had been accumulating for months. "I hope when I grow up, I'll be as attractive. Honestly!" Felicia was delighted by her mother's recent publishing successes too, exclaiming, "I am so proud! We get along awfully well with a continent between us, do we not?"

And yet, Felicia would reflect from the vantage point of old age, she had not begun to consider her future until she received her mother's Christmas greetings. Cissy had not yet ventured to San Diego, but instead had sent Cal to check up on Felicia; it would only be a matter of time before she arrived herself, likely to bring Felicia home. "Now I was nineteen, but in those days anybody under twenty-one was a minor," Felicia explained. "Cissy could get me back. I knew I could not appeal to her reason for long. She would not let me live away from home. Not indefinitely. She'd snatch me back. What to do? I didn't know."

By Christmas 1924, Felicia's long absence from Washington—the subject for some months of perplexed murmurings within her intimate circle and repeated, embellished, and misconstrued by those beyond it—had become public news as well. With no concrete information to contradict her, the *Washington Post*'s "Dolley Madison" treated the subject of the reluctant debutante authoritatively on December 28. "Pretty Felicia Gizycka was originally listed as a debutante a year ago, and then she decided to put off the evil day," the society reporter's "Intimate Comments" confided.

Washington was a bit disappointed, but her mother was quite satisfied. Time enough, for daughter was indeed rather young. But this year she was surely to make her debut, and quite early in the season her mother reserved December 23 at Grasslands, the most exclusive country club around Washington, as the date of her debut ball. But several weeks ago

that was canceled. Miss Felicia still did not want to come out. She played around a bit with the debutante set, and was unfailingly amiable, and much sought out. But somehow it didn't appeal to her. She went out west, and has been busy and happy out there in YWCA work. Her mother has gone to Chicago to pass the holidays with relatives out there, and to see if she can not persuade her daughter to return with her after the first of the year, and even if she draws the line at a formal debut, at least to come in for some of the gayeties of the latter part of the season. But so far as one can see, the social whirl does not seem to appeal in the least to Felicia Gizycka.

If even Felicia's closest friends were uncertain of her whereabouts, there was one figure in Washington who could (and did) boast that he had known with certainty for some time.

In the meantime, Louise Ireland had also become a working girl, albeit in a setting more genteel and stimulating than her friend Felicia's. In the winter of 1924–25, Louise had taken a part-time job that exposed her "to a different side of Washington, including events like visiting the White House to hear President Calvin Coolidge give his weekly talk to the press," as an assistant to the journalist Drew Pearson. At a dance one evening early in 1925, Louise was surprised to find her boss cutting in on her. She was even more astonished when Pearson told her the story of Felicia's angry departure from Flat Creek Ranch the summer before and went on to brag that he knew where she was. He was leaving the following week for San Diego, he informed his now slack-jawed dancing partner—and he intended to marry Felicia.

"How do you know she will marry you?" Louise demanded, offended by his presumption.

"She's poor, she has a dull job and I will tell her the fascinating job I have which will take me traveling around the world. Of course, she will marry me," he replied. Distraught at the thought of "such an obvious mismatch," Louise was nevertheless powerless to prevent it, having no control over her employer and no means of warning her friend.

Indeed, such had been the extent of Felicia's loneliness in San Diego that, despite her claims that the wiry, moustachioed twenty-eight-year-old freelance journalist with the receding hairline inspired only her boredom and her physical revulsion, she had written to Drew Pearson several weeks after her arrival—with pleas not to reveal her address to her mother. The possibility was a real one inasmuch as Cissy and Drew had stayed in close contact after leaving Jackson Hole the summer before. Though there is no evidence to corroborate the untoward rumors that the relationship between

the aging socialite and her daughter's ardent admirer was a carnal one, the pair had begun to form a tight bond that would last until the Second World War. For Cissy, Drew Pearson fit the mold of the up-and-coming young man whom she tended to cultivate. For Pearson, the Countess Gizycka provided an entrée into the Washington social, diplomatic, and congressional circles that were to become the subject of his life's work, and for the aspiring young journalist she held irresistible attractions as a member of what was becoming perhaps the preeminent American journalistic dynasty.

Pearson was surprised and flattered—in short, delighted—at the trust the younger Countess Gizycka had apparently placed in him. Through the fall of 1924 and the winter of 1925 Felicia and Drew corresponded regularly about their hopes and fears, the perils of poverty and loneliness, and their shared ambition to write. Drew's letters grew more ingratiating, familiar, and suave with each posting. He also sent the typewriter that she confessed she longed for and was saving up to buy. "You're a crazy little fool, Felicia, and my admiration for you has gone up 100%," he told her on October 29, 1924, shortly after receiving her first communication since they had parted in Salt Lake City; "Also my love," he added. Though he had been in contact with Cissy and had promised to relate any news he might receive of Felicia, he applauded both his correspondent's flight and her independence: "I'm glad you did it. Stick to it." Having also promised Felicia not to reveal her whereabouts to her mother, he confessed that he had intended to visit Cissy in Chicago during his upcoming midwestern lecture tour, "but it won't be wise now. I would have to lie like a trooper and," he assured her, "I'm not a very adroit lier [sic]."

One day in early March 1925, Felicia was walking home from the bus stop when she saw a man standing under a tree outside the Greens' apartment door. It was Drew Pearson, who asked if he could take her out to dinner. Over their meal, he raised the issue that had been troubling her since Christmastime: "Your mother will get you back."

"I know and I don't know what to do!"

"Marry me!

"No!"

Still in the middle of a Chautauqua lecture tour, he told her that he would be forced to leave town for a few days, which would give her time to consider his proposal. Since her school days, Felicia had imagined the "dream prince" she hoped to marry. He was nothing like Drew Pearson, whom she did not love and "didn't want to kiss, even." And yet, her suitor presented her with what she described as "an out": "I could marry this

man and escape Cissy forever." Drew was well aware that Felicia did not love him, but was "confident in my youthful conceit that given time, she would."

By the time Drew returned to San Diego on March 12, 1925, he was willing to sweeten the deal: "You're nineteen now," he reminded Felicia, once again over dinner. "Marry me until you're twenty-one and I'll let you go then if you want to go." She was still unconvinced.

"Come on!" he urged.

"Oh well. All right. If you'll really let me go."

Although Felicia would later be unable to remember whether they had even finished eating, an ebullient Pearson called for the check. Before she knew it, they had secured a marriage license from the county clerk's home that evening and shortly afterward Felicia found herself in a superior court judge's living room, reciting vows. "The ceremony was performed," the *Los Angeles Sunday Times* reported three days later as front-page news, "with a taxi-driver as a witness." Afterward, the newlyweds took in a movie. Numb at the step she had taken, Felicia stared blindly at the screen. In their hotel room that night, she asked her husband not to touch her. "I hated the wedding night and I hated him and myself."

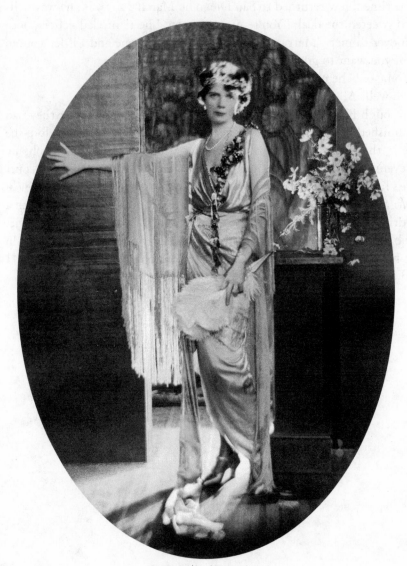

Cissy in the late 1920s

III

Mrs. Elmer Schlesinger

HEIRESS IS WEDDED AFTER ADVENTURES

Dashing Dorothy Gizycka Tires of Being Biscuit Shooter and Marries

— *NEW YORK WORLD*, MARCH 15, 1925

Alright I think its all for the best Will have nice dignified story," Joe wired Cissy on March 13, 1925, after learning of Felicia's sudden marriage. "Miss Gizycka Weds; Career Is Romantic," the *Chicago Tribune* applauded the following day, taking a few colorful liberties nevertheless. "As she grew up the glamour of a prospective society life in Washington and Chicago dimmed, the thought of being merely a debutante palled," the *Tribune* assured Chicagoland about the latest of Joseph Medill's strong-minded descendants to come into her own. "She wanted to do something worth while. She wanted, not wealth and position, but—a job . . . It was when she was at last installed in the club restaurant, waiting on table, carrying trays, hustling to and from the kitchen, that she was happiest." In "Felicia Gizycka Becomes Bride" the Hearst papers observed a deferential decorum in reporting the recent nuptials of the only daughter of Mr. Hearst and Mr. Brisbane's particular friend, the Countess Gizycka.

In the days that followed, newspapers across the United States clamored to cover the affair, the Pulitzer papers scrambling and sacrificing accuracy to the ostensible charm of the love story between the unconventional aristocrat and the "corking reporter." " 'MOST KIDNAPED GIRL IN WORLD' IS A BRIDE: Dorothy [*sic*] Gizycka Wedded to New York Writer in California," the *St. Louis Post Dispatch* noted. "HEIRESS IS WEDDED AFTER ADVENTURES: Dashing Dorothy [*sic*] Gizycka Tires of Being Biscuit Shooter and Marries," the *New York World* exclaimed. Confused about which of the titled Gizyckas had so precipitously wed, a number of papers included photographic portraits of the well-preserved mother of the bride as "Countess Felicia."

"My Pa-in-law sent two clippings this morning," Felicia wrote Cissy (at Drew's urging that she turn over a new leaf and "be good to" her mother) after their honeymoon in Long Beach, Catalina Island, and Los Angeles. "One was a picture of you—a lovely one—beneath which was enscribed [*sic*]—Mrs. Drew Pearson. The other, from another paper, was one of me

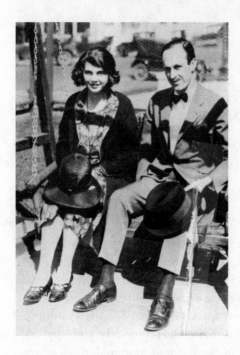

Newlyweds Mr. and Mrs. Drew Pearson,
San Diego, California, March 1925

looking like a bull. Well, my Pa-in-law wanted to know *which* was me.
Yours is so lovely. I'd deceive him if I thought I'd never see him." Felicia
added, "Well, you know when I'm not busy hating you, I love you a lot.
Even though I ran away."

The Pearson family responded to the telegraphed news "from the moun-
tain of elation," although Drew's gentle Quaker father confessed to won-
dering momentarily if the young couple's announcement, which had
arrived in Swarthmore on April Fools' Day, was a joke. If Joe and Cissy were
determined to put a smiling public face on the rash step Felicia had taken,
other family members were less sanguine. Drew had encouraged Felicia to
reach out not only to her mother but, for the first time in her life, to her
father. Although only fifty-eight years old, Count Gizycki was in rapidly
declining health, his once-handsome face bloated almost unrecognizably
by declining liver function. By 1925, he was living in reduced circum-
stances in a small Vienna apartment among some of the books, furnishings,
and paintings he had managed to wrest from his creditors. He had received
the cabled news of his daughter's marriage silently, but with a dismis-
sive wave of the hand. "Dearest Boy—," seventy-two-year-old Kate
McCormick wrote her son Colonel McCormick, who was now in her
superlative good graces by default, notwithstanding the scandal of his own
impulsive marriage a decade earlier. "Cissy telephoned yesterday that Feli-
cia had married—a newspaper man called 'Drew Pearson,' " Kate scoffed.
"I feel it is not our affair," she declared before elaborating:

Cissy pretended she was "delighted," certainly she got a grand surprise. But there may crop up complications. If you object, Joe is very likely to want to put [Drew Pearson] into the paper. I'm sure in time Cissy will want it unless we seem not to care . . .

Of course there is a very likely possibility of a smash up in F's matrimonial venture. She is a Pole & likely soon to fall in love with another man—well, that won't concern us either.

Concluding these benedictions for the young couple, the bride's embittered great-aunt closed by revealing, "Ruth left this a.m. She made me cry the whole day."

News of Felicia's whirlwind courtship and marriage had come as an additional shock to Joseph Medill's descendants, following the untimely death two and a half weeks earlier of the eldest of his grandchildren in a Washington, D.C., hotel room. Medill McCormick's meteoric rise to national prominence had halted suddenly when he lost the Illinois Republican primary in the spring of 1924. The opposition of Illinois Progressive elements, the "prodigal and corrupt state machine," and the local Ku Klux Klan, he believed, had been fatal to his Senate reelection bid. Moreover, he insisted, the fault lay partly within his own family: "a lot of good church people . . . fought me in order to punish Bert and Joe because the *Tribune* fought the Eighteenth Amendment for which I had voted." Bearing in mind his newspaper and political background, William Randolph Hearst and Arthur Brisbane had made overtures to hire Medill as editor in chief of the Hearst papers' floundering *Washington (D.C.) Herald.* The outgoing-senator's appointment to an ambassadorship seemed another likely, if vague, possibility after his term expired in March 1925. On the verge of losing the anchor that elected office had provided for more than a decade, Medill was still casting about dejectedly for what to do next as he left Chicago in late February to conclude his Senate business in Washington.

Ruth Hanna McCormick awoke in Chicago on the morning of February 25, 1925, with an overwhelming sense of dread. She did not call her husband in Washington, however, because he had told her he hoped to sleep late that day. Colleagues who had seen him at the late-night session on the Senate floor on the 24th recalled that he had complained of feeling ill and appeared to be "in distress." At about 8:30 on the morning of February 25, a maid at the Hotel Hamilton heard the senator stirring through the door of his room. At about 9:00, after several unsuccessful attempts to reach Medill by telephone, journalist and family friend William Hard became concerned. Receiving no answer when he arrived at Medill's hotel room, he grew alarmed and called the manager to remove the door by its hinges. Hard found Senator McCormick in bed in his pajamas, lying on his

side with his hand over his face. Not yet forty-eight years old, Medill had died "in the act of endeavoring to stop the gush of blood from his mouth," the *New York Times* reported. Learning the news over the telephone from Bill Hard, Ruth made for Washington at once while Joe Patterson remained behind for the time being with the McCormicks' three children. Medill's body was removed, prepared for burial, and taken to 15 Dupont Circle, where the funeral was held the following day, as dignitaries all over the world expressed their shock, telegrams of condolence poured in, and press reports began to emerge, listing the cause of death variously as gastric hemorrhage, myocarditis, acute dilation of the heart, the lingering effects of influenza, and "nervous indigestion."

When Ruth arrived at the hotel room where her husband had died, she opened his trunks and found they contained several empty vials of barbiturates. "She believed this was his way of letting her know what he'd done," the couple's granddaughter, Kristie Miller, would later explain. "He knew no one else would be able to open the trunk because he had arranged an elaborate set of keys for each of them." Although this fact would be known only to Ruth for decades to come, the couple's thirteen-year-old daughter, Triny, suspected her father's suicide nevertheless. "He kept referring to his great love for me, how talented I was," she reflected of her last parting from her father. "Sort of a farewell speech."

"I was walking on air in Denver—made no difference that I could not sell anything to the *Denver Post,*" Drew Pearson would recall almost a quarter century later, of meeting his new bride on an early morning train from Los Angeles in late March 1925. After their honeymoon, the newlyweds had parted temporarily in the interest of economy. Nearly twenty-five years later, Drew would also admit in his memoir that when Felicia alighted on the platform in Denver after wrapping up her affairs in San Diego, "she wasn't particularly anxious to see me," but would add immediately, "It was too early in the morning." In Swarthmore, Pennsylvania, the kindly Pearsons welcomed Felicia lovingly. By early April, the newlyweds had rented a small apartment in Manhattan near St. John the Divine, as Drew resumed his commitments as a lecturer in commercial geography at Columbia and Felicia attempted to establish housekeeping and cook for two, with only middling success by her own account.

Felicia would remember her second reunion with Cissy at the age of nineteen no better than she remembered her first, shortly before her fourth birthday. Although she had married in an effort to escape her mother, in practice the drastic step she had taken only served to tie her more tightly to Cissy through Drew. As Felicia herself put it: "Cissy got us back as if we were two pieces of fluff sucked up by a huge vacuum cleaner." So close had

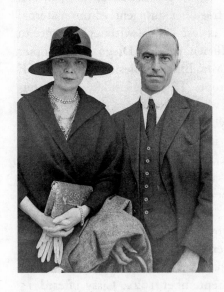

Mr. and Mrs. Elmer Schlesinger, dis-
embarking in New York from their
European honeymoon, August 8, 1925

Drew and Cissy become during Felicia's absence that on April 11, 1925, a
mere thirty days after the young couple's marriage, Drew woke Felicia with
astonishing news. He had acted as witness at Cissy's own impromptu wed-
ding earlier that morning in the chapel in the License Bureau of the New
York City Municipal Building, to Elmer Schlesinger. Seeing her mother
and new stepfather off on the *Conte Verde* for Naples later that afternoon,
Felicia noticed that "Cissy kept hugging me and holding onto me, as if she
didn't want to go off with him."

Given the reservations Cissy had expressed about her new husband during
their on-again, off-again courtship, friends and relatives were astonished at
the step she had taken. "He was crazy about her, and she was blowing hot
and cold as usual," Felicia (who did not subscribe to her mother's preju-
dices) observed; "He was Jewish and she hated that and said so, often."
According to Schlesinger family lore, Colonel McCormick (who emphati-
cally shared not only Cissy's bigotries in general, but her contradictory
respect and affection for Medill's old friend Elmer Schlesinger in particu-
lar) was moved to say that his tempestuous cousin's new husband was the
only Jew for whom he had ever felt sorry. Many of Cissy's friends speculated
that the marriage was a loving if passionless one, built largely on Elmer's
tireless patience with her whims and unflinching solicitude in the face of
her many needs. Others, less well disposed, suggested that Cissy could not
permit herself to be upstaged by Felicia's recent wedding. Drew contended
that his mother-in-law had married because she was bored. Felicia recalled

her mother saying that she had finally accepted one of Elmer's many proposals because he flattered her and told her she was beautiful. Cissy herself maintained that Felicia's marriage had freed her sufficiently from maternal responsibility to permit her to remarry at last—this, without reference to her daughter's recent display of self-sufficiency in San Diego. "I'm happier than I ever was before," the newlywed Mrs. Elmer Schlesinger told a small crowd of reporters before sailing for Europe. "He is the kindest, most intelligent and most patient man in all the world," she reported to Rose Crabtree from Versailles in June. And yet, years later Cissy would reflect to an old Chicago friend on her reasons for marrying Elmer Schlesinger, "I've thought—and thought—and thought, and, you know, I haven't a clue."

In the heady whirl of her long European honeymoon in the spring and summer of 1925, Cissy assured Rose, "Felicia is really happy too. If she isn't it's her fault, for she has a lovely boy." As the Schlesingers planned to live primarily in New York, where Elmer had gone into the practice of corporate law as a partner at the firm of Chadbourne, Stanchfield & Levy after leaving the U.S. Shipping Board in September 1922, Cissy offered 15 Dupont Circle to Drew and Felicia when the young couple moved to Washington the summer after their wedding so that he could become a full-time freelance political journalist. Having married to disentangle herself from her mother rather than for love, within months Felicia found herself living in her old bedroom, with a husband for whom she felt nothing, under her mother's roof once again. Back in Washington, she renewed her friendships with Louise Ireland and other schoolmates, and began to take on, and be adopted by, "numerous surrogate mothers." These older women—some of them girlfriends' mothers, some older female relatives like Ruth Hanna McCormick and Rob Patterson's sister-in-law Mary Patterson, others family friends who had known Felicia since her childhood—not only offered kindness, concern, and advice, but in the aggregate set about to expand her education, not only with cooking and gardening lessons but by furthering her acquaintance with literature and poetry. In the process, they braved her mother's jealous ridicule. Under their influence and at their parties, Felicia began to expand her circle of acquaintances as well. An aspiring writer, she was delighted to meet Sinclair Lewis at Dean Acheson's one night, and would never forget (although she would admit she had some difficulty following) his advice: "Apply the seat of the pants to the seat of the chair!"

At last Felicia began to assume the sociability her mother had prodded her to display for the previous several years. She came of age at the height of Prohibition. Taking effect in 1920, the Eighteenth Amendment prohibited the sale, transportation, and manufacture of intoxicating liquors—but not their possession or consumption. The loneliness and awkwardness

Drew and Felicia Pearson, ca. 1926.
"She had fled to escape her mother . . .
She married me as part of the escape.
I, knowing that she did not really love
me, but confident in my youthful conceit
that given time, she would."

—DREW PEARSON, "Memoirs"

of Felicia's childhood and adolescence melted in Washington society. "My whole idea was to go to parties and have fun," she recalled of her return to the capital as a married woman who was invited now to adult parties. "It was the day of stag lines. The men stood in line and came and cut in on you. I found that if I had a drink or two, I could relax and dance, laugh, joke. And feel popular. Feel accepted."

For his part, Drew "didn't really like this kind of thing." Felicia, by contrast, had "no interest in his work, or in politics, I liked novels and poetry." She was undisciplined, directionless, and disengaged from her husband; mounting tensions prompted the newlyweds to fight. Drew was desperate to "hang on" to his young wife, but after only a few months of marriage Felicia was "waiting for the day when [she] could get away" from her husband, at twenty-one. One night in the midst of a squabble, Drew tore apart a faux pearl necklace of Felicia's and threw it into the toilet. Shortly afterward, she left him. He tracked her once again, this time to a hotel in New York and persuaded her to go with him to East Asia, where he intended to write a series of articles on the growing influence of Communism. "I had induced her to go in an effort to save our separation," he admitted later, "although she did not realize that was the primary purpose at that time."

The couple crossed the Pacific in a small steamer in the fall of 1925. Accompanied by two American women they had met in Peking, Felicia was struck by the "deep silence" of the border guard at the frontier between

The aspiring writer working aboard ship. "Our boat landed us after an eleven-day voyage across the Pacific. The morning that we came into the harbor I leaned across the railing smelling the wonderful and magical spiced smell of the orient. I was enchanted. But I couldn't share this with Drew."

— FELICIA GIZYCKA, "Book Redo II," unpublished memoir, August 1988

China and Mongolia, who sat above them on a platform meditating before being moved to issue a visa to the American journalist and his "three wives." While the presumption of the mystical bureaucrat became fodder for ongoing chuckles among the four traveling companions, Felicia continued to be fascinated for years afterward by the official's contemplative serenity. She was similarly moved in Kyoto, where she considered the high point of their stay to be a visit to an ancient temple, "so beautiful, swarming with visitors, and yet I felt something I had not felt before, a transcendent sense of peace. Like the patina of thousands of years of prayer. It was my first real spiritual experience." Inasmuch as her religious upbringing in the Catholic church had been a perfunctory concession by her mother's family to her father's demands, carried out only haphazardly by "wretched" German nannies, she had had little feeling for religion until then. She was "enchanted," by contrast, with China, the Gobi Desert, Tibet, and India, but again, "I thought that I couldn't share anything like this with [Drew]. And I never tried." Returning through Europe in the last days of 1925, Drew urged Felicia to make contact with her father. She refused; however, she later reflected, "This is something I will always regret. Cissy and Grams had managed to poison my mind and alienate me from him."

"Felicia still seems to be O.K. although worn out after a dance she went to last night. She is now resting in bed," Drew wrote Cissy on January 21, 1926, shortly after the Pearsons return to Washington, where his recent work on Asia had secured him a place on the staff of the newly launched *United States Daily.* "I'm not sure that I'll let her go to many more such

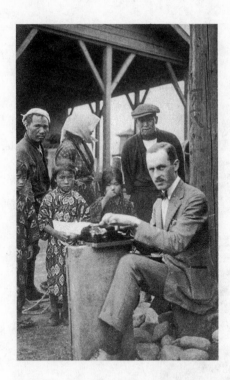

Drew working during the Pearsons'
Asian travels of late 1925

affairs," he reflected. If the couple had had little in common when they sailed the previous autumn, they returned home with an unanticipated bond: Felicia was pregnant, "something I certainly hadn't intended," as she put it. The baby was expected in July 1926, a few weeks before Felicia was to come of age. "Now Drew said, 'You have to stay with me.' I told him that this wasn't fair. That he had promised to release me when I was twenty-one."

After their honeymoon, Cissy moved into Elmer's apartment at 1010 Fifth Avenue in New York. Leaving her Washington feuds behind temporarily, Cissy joined her husband's social set and found herself hobnobbing with the likes of their neighbor, the eminent publicist, journalist, and recipient of the first Pulitzer Prize for reporting, Herbert Bayard Swope, at their country estate on Long Island, and the members of the Algonquin Round Table in Manhattan. She began psychoanalysis. She continued her efforts to write, and leased a pied à terre at 19 East 57th Street, which she converted into her studio. She and Elmer traveled widely.

While Felicia and Drew were in the Orient in the fall of 1925, Cissy and Elmer returned to Europe for a sort of second honeymoon. After several weeks in Florence and Paris, where they "tore around to restaurants and theatres seeing our friends—up all night and shopping all day," the Schlesingers returned to New York in mid-January 1926, shortly after the

"We stayed in Tokyo a while, and Drew talked to some newspapermen, both American and Japanese. I was so out of it. I never shared his career with him. Never talked about it, or asked questions. And then we went to Kyoto. I loved it. I'm sorry I never went back there."

—FELICIA GIZYCKA, "Book Redo II," unpublished memoir, August 1988

young Pearsons returned to Washington. In the small hours of the morning of January 25, 1926, Cissy awoke suddenly, to her astonishment, to see Count Gizycki standing at the foot of her bed in his pink hunting coat— "bright as Technicolor," she would later insist. Then, just as suddenly, he vanished.

The following morning, she received a telegram from Vienna, informing her of Count Gizycki's death from cirrhosis of the liver at the "exact moment" at which he had appeared in her bedroom. Later, she opened the *New York Times* to discover that "the Count, who was long noted for his amours and eccentricities, ordered in his will that he be buried in his red riding cloak."

"Payments charged against my mother which were made to him should now cease and are not payable to his estate," Joe Patterson informed the Union Trust Company in Chicago immediately upon learning of the

count's death. Although Medill McCormick had assured the American press in August 1909 that no payments had been made to Count Gizycki in return for Felicia, over the course of Cissy's long divorce proceedings Nellie had evidently arrived at her own arrangement to keep the child's father safely at bay.

By 1925, as the New York *Daily News* reached nearly one million readers every morning, Joe Patterson moved from Chicago to New York. The proximity of her brother offered Cissy an additional inducement to make Manhattan her home. Alice, Joe's wife of nearly twenty-three years, did not accompany him, however.

"I got your letter asking for an extension of your leave of absence," Joe had written two years earlier, in January 1923, to Mary King, the talented editor with whom he had worked closely on the *Tribune* and the *Sunday Tribune.* "This is to state that you may have up to one year's leave of absence without interfering in your 'seniority rights.' " King had been an invaluable asset to the *Tribune,* as she would be later both to the *News* and to *Liberty,* and it was in the best interests of all three publications to accommodate her request for a sabbatical in distant London. Indeed, "I never had a good idea in my life," Joe later reflected, "that she wasn't at least the first half of it." Unbeknownst to their journalistic colleagues, Mary King was also carrying Joe Patterson's child; her time abroad was in effect her maternity leave.

Alice Higinbotham Patterson was unwilling to grant her husband a divorce until 1938. As Mary King was a devout Catholic and an unwed mother, little James Patterson, or "Jimmy," spent the first years of his life unacknowledged publicly by either of his parents. Though well cared for by Mary King and her three sisters as well as by nannies and governesses in Riverdale, New York, he recalled never being told as a child explicitly who his mother was, although he suspected. He made similar assumptions about Joe Patterson, whom he resembled closely: "I always thought of him as a father." After Joe Patterson commissioned architect Raymond Hood to build a deliberately unadorned, utilitarian home in Ossining, New York, that made it appear as if the client "didn't have any money," he and Jimmy moved in together in the early 1930s. Mary King dined with her son there on most evenings, afterward returning home to Riverdale. In 1938 she married the recently divorced Joe Patterson and moved to Ossining herself. The three Patterson girls remained ignorant of their half brother's existence until several years after his birth.

In late February 1926, Minton, Balch & Company published "Eleanor Gizycka's" first novel, which she dedicated

TO
A.B.
J.M.P.
W.H.
WHOSE FAULT IT IS

Many readers, including the *Washington Post*'s Arthur Train, took these to be Arthur Brisbane, Joseph Medill Patterson, and William Hard (the old family friend who had discovered Medill McCormick's body). Others assumed W.H. was Walter Howey or, possibly, William Randolph Hearst. Whatever its paternity, *Glass Houses*'s gestation had been a long one. "I read your story last night with a great deal of interest," Joe had written Cissy of a draft more than a year earlier, on New Year's Day 1925. "It is unusual. It is not like anything else that I can think of. It might be said to approach in some ways, Mrs. Wharton's stories, but it is not a Wharton story. You may not sympathize deeply with any of the characters, but you are interested in them all," he mused. After making a few editorial suggestions, he returned the manuscript to her, noting, "It is extremely well written. I believe you can do this work and should devote yourself a great part of each day to doing it."

"Novel finished," Cissy had reported to Joe from the Princess Hotel in Paris two years earlier still, on January 1, 1923. "I feel very upset about it."

Novelist Eleanor Gizycka,
ca. 1925

Still smoldering with anger at Alice Longworth and Bill Borah, and emboldened by her mounting literary successes, Cissy had decided to spend the winter of 1922–23 in Paris, writing. Since the Republican National Convention of 1920, she had been contemplating the roman à clef of Washington life and its attendant social and political intrigues, which would become *Glass Houses*. Once in France, however, Cissy had been so entirely consumed by the social life she led between Paris and the Riviera among celebrities, radicals, and literary American expatriates that that she had found little time to write. "I fell in love too," she confessed to Rose Crabtree.

Although little more than those words survive to document Cissy's involvement, the man in question appears to have been William Christian Bullitt, Jr., a Main Line Philadelphian nearly ten years her junior who had moved to Paris in 1921, his personal and professional life in tatters. Earlier that year, Bullitt's wife of five years, the former Ernesta Drinker, another aristocratic Philadelphian, had left him, charging neglect. Although only thirty at the time, Bullitt had already seemingly dashed his prospects to continue on the meteoric diplomatic and political trajectory on which he had been launched during the Wilson administration. Some of the fascination he held for Cissy was due, no doubt, to his commonalities with Joe Patterson. A Yale man of the class of 1913 (who had been voted "most brilliant" by his classmates), Bullitt had reported on the Great War from Germany and had been appointed Washington bureau chief of the Philadelphia *Public Ledger* in 1916, before becoming an assistant to Wilson's secretary of state, Robert Lansing. During the Paris peace talks, Wilson's right-hand man, Colonel Edward M. House, had made Bullitt part of a small secret delegation to Bolshevik Russia to investigate Lenin's receptiveness to Allied peace overtures. Traveling as part of a small party that included the muckraking American journalist Lincoln Steffens and the Swedish Communist Karl Kilbom in February 1919, Bullitt was electrified by what he saw of the infancy of Russian Communism and, although exceeding his mandate, arrived at a tentative peace acceptable to the Bolshevik government.

Though he would be branded a radical and a Bolshevik at home, Bullitt was a progressive liberal and, it would emerge, more of a Wilsonian internationalist and idealist than Woodrow Wilson himself. When the president repudiated the fragile Russian peace offer and refused to recognize the Bolshevik government, Bullitt accused Wilson of betraying the same "new international order" that the president professed to champion, and resigned his State Department position in May 1919. In early September, Bullitt testified before the Senate Foreign Relations Committee, not only on the subject of his own reservations about the Treaty of Versailles, but

also about private conversations in which high-ranking members of the administration had expressed their own grave doubts about the president's peace proposals.

Branded a liar and an extremist at home, separated but not yet divorced, Bullitt rented novelist Elinor Glyn's home in Paris, lived in epicurean splendor, and set about to write a novel of his own. He was "handsome, urbane, full of charm and enthusiasm, a product of Philadelphia society and Yale but with a considerable European residence and with a flamboyance of personality that is right out of F. Scott Fitzgerald—a man of the world," as the diplomat and historian George Kennan remembered him. In Paris and Antibes in the early 1920s, Bullitt formed part of what Kennan called "that remarkable group of young Americans," which included Cole Porter, Ernest Hemingway, and Archibald MacLeish—and extended to James Joyce, Lincoln Steffens, Ezra Pound, and Gertrude Stein.

To assure the progress of her novel in spite of Paris's many distractions, Cissy had, true to form, hired help. "Leclartier is a pin-head—It serves me right tho' for jumping with a partner ship of this kind without any real reflexion [sic]," she confessed to Joe on the subject of her local co-author. The two collaborated in her hotel room on the awkward task of spinning an authentic tale of Washington social intrigue, Wild West outdoorsmanship, and murder—in French. She and Leclartier "fought over every simple word." He was "mean & rotten about America!" He even became "savage and tore up my very best tea gown" and "said he was going to commit suicide and could not live without me." She was delighted to report that her editor at the *Revue de Paris* had found Cissy's western contributions *"admirable,"* but had pronounced Leclartier's Washington political section to be *"moins beau."* The work was published in French in 1923. Afterward, she told Rose Crabtree, "I will translate it back to English as soon as I have the courage to look at it again." It was perhaps in part for this reason that the reworked American version would not appear as *Glass Houses* until three years later.

By all accounts, Bill Bullitt had also fallen very much in love during his heady sojourn in Paris—although not with Cissy. A fervent admirer of the late American Communist John Reed, whose firsthand account of the Bolshevik revolution had appeared as *Ten Days That Shook the World* in 1919, Bullitt had become besotted by Reed's widow, Louise Bryant, in her own right a noted radical and an eminent foreign correspondent for the Hearst papers. As Cissy finished her novel of manners and revenge in Paris in January 1923, Bryant achieved the unprecedented coup of publishing the first exclusive interview with Italy's new Fascist prime minister in Rome. During much of the time Bryant spent in Italy doing research and attempting to prevail upon Benito Mussolini to speak to her, Bullitt had followed her

doggedly—as he did typically when she traveled on assignment throughout Europe. Whatever the extent of Cissy's involvement with Bill Bullitt, if she attempted to cause trouble between him and Louise Bryant for her own gratification, she apparently enjoyed little success; Bryant and Bullitt would marry within the year. In confessing to Rose that she had fallen in love as she embarked for New York aboard *Olympic* on February 6, 1923, Cissy added that she was leaving "just in the nick of time." However she and Bullitt parted, he did not provoke the vengefulness she had displayed toward Senator Borah. Instead, she told Rose as she sailed for home, "I didn't suppose this world held anyone as fascinating—just for me—as that man."

. News of the literal incarnation of the Countess Gizycka's humiliating loss of Senator Borah to Mrs. Longworth appears to have provided the novelist and translator with additional impetus to disseminate her version of what had taken place between the three of them. In December 1924, at the same moment that Cissy succeeded in selling the American rights to *Glass Houses* to Minton, Balch & Company, newspapers around the country began reporting the news that had already unleashed a quiet scandal in Washington. After almost nineteen years of childless marriage, Speaker and Mrs. Longworth were expecting their first child in February 1925, prompting local wags to wonder whether the baby would be christened "De-Borah," after her presumed father.

With Alice a new mother and her rival and contemporary Cissy soon to be a grandmother, Minton, Balch released *Glass Houses* in February 1926, to encouraging reviews and brisk sales. "My book is an outgrowth of an article I wrote for 'La Revue de Paris,' " Cissy told the Hearst papers' *Washington Herald*. "My purpose was to paint a picture of society and politics here as they actually are. I may have been a bit mean in places, but those in the know will recognize the truth of the story." Fanny Butcher's assessment for the *Chicago Tribune* ("Judged by any standards which I have ever known, 'Glass Houses' is a remarkably good first novel") was perhaps not dispassionate. Nevertheless, the *New York Times* observed that "few people are as competent as the Countess Gizycka . . . to write a satirical novel of Washington society" and alluded to the work's seeming basis in fact, noting that " 'Glass Houses' suffers as a novel by the very fact which gives it the greatest interest as news." The *Washington Post* declared that the work had "many astounding virtues . . . In the first place, it arouses and keeps curiosity active, always a ten-strike for this type of novel." By March 6, the *Chicago Tribune* reported that Eleanor Gizycka's *Glass Houses* had shot to the top of its fiction best-seller list, ahead of John Dos Passos's *Manhattan Transfer,* DuBose Heyward's *Porgy,* and Ford Madox Ford's *No More Parades.* It would remain in the list's upper reaches for several months. By April, it

would go into its fourth printing, just as the skewering, autobiographical roman à clef of Philadelphia society life that William C. Bullitt had written in Paris was released as *It's Not Done!* Encouraged by her success, by summertime Cissy had informed Joe, "Have started work on novel—" This one was an account of an American ingénue's abusive marriage to a Russian aristocrat at the turn of the century. "God, how I hate it," she lamented of the writing process.

From Maryland comes word that
Mr. and Mrs. Drew Pearson are the parents
of a baby girl . . .

— NANCY R——, "FINDS ENCOURAGEMENT TO
CAREFUL DRIVING IN VISIT TO CEMETERY,"
CHICAGO TRIBUNE, JULY 28, 1926

In the summer of 1926, as Felicia's third trimester drew to an end, she and Drew rented "Spruce Cabin" in rustic Bethesda, Maryland. He would remember the last weeks of her pregnancy as the happiest of their marriage: "She was a little lonesome during those days, which flattered me when I came home in the evenings for I thought I was really missed." He was "so in love with her and so proud and happy" that he "could have sworn" she loved him in return. Felicia agreed that she was lonely in the country by herself that summer, adding that she was perpetually "boiling hot." The baby was late in coming and, exasperated, Felicia harangued Drew to drive her down an unpaved road, which had the desired effect of lurching her into labor at last. At Women's Hospital in Baltimore, she refused to allow her husband into the delivery room, preferring the company and support of one of her "surrogate mothers" instead. At last, on the morning of on July 27, 1926, Felicia gave birth to a six-pound baby girl whom the couple named Ellen Cameron Pearson III, in honor of a line of her Scottish forebears.

As the proud father commemorated the event for little Ellen,

I can't conceive of ever being happier than the moment your mother put her arms around me and cried out that she had a baby girl. The most beautiful baby girl, she said, who had cried to her. "She gave a little cry, and then they took her away."

Your mother had wanted a boy, but when you came out she said, "I brought you a girl. A teeny little girl. I'm so glad I have a girl." And she

said this over and over again, with her arms around me and her tousled beautiful hair buried in my hair. She would not let me go—not even to send telegrams to your grandparents and all the host of relatives and friends who were waiting to hear of your arrival. All that day she would hardly let me out of her sight.

As Felicia remembered Ellen's birth, "I had wanted a boy. Drew immediately took possession of her. The first thing I knew, he was standing there holding her as if he were both father and mother." His all-encompassing adoration of their daughter would be fortuitous inasmuch as Felicia insisted, inwardly at first, "I didn't want to suckle this child. I didn't want Drew's child."

"Felicia had little girl at nine oclock this morning everything all right Elmer and I are leaving for Baltimore at one oclock today," Cissy wired family members. "So glad to hear the good news have been thinking of you all the time best love to you Drew and my great grand daughter," Nellie Patterson telegraphed from Chicago. "My warmest congratulations to you and little Ellen, dear Felicia," Uncle Joe wired Women's Hospital. From Paris, Felicia's glamorous cousin Elinor Patterson sent "delighted love and kisses." Still reserving a warm place in her cold heart for baby girls, evidently, even Kate McCormick was moved to offer felicitations, along, of course, with advice: "Much delighted over new baby must get her [a milk] cow soon as possible hope she will be as good looking as her mother and as sweet much love Aunt Kate." Senator Henrik Shipstead of Minnesota ventured to say that if the baby was "half as charming as her mother and clever as her grandmother she ought to be President of the United States some day."

The period between the repeal of the federal gift tax in 1926 and its reinstatement in 1932 presented a golden opportunity for America's wealthiest citizens to convey vast fortunes to the next generation intact, entirely tax-free. With death-tax rates of as much as 20 percent on estates greater than $10 million (as Nellie Patterson's was expected to be) during the same period, it had become advisable for the rich to divest themselves of their wealth while still alive.* Throughout her life Nellie Patterson had kept even her grown children on rigid (if, by any standard, lavish) allowances, the better to exert some measure of control over her unpredictable progeny.

*The progressive rate structure of the income tax, by which higher tax rates were imposed on those with greater incomes, added to the incentive to transfer wealth. By shifting revenue-producing property to their children (who presumably commanded more modest incomes), a parent could reduce the family's overall income-tax liability by many thousands of dollars per year per child.

Although Nellie covered her $6,641.28* in overdrafts as well as her taxes in 1920, for example, Cissy barely maintained herself that year (and rancorously, at that) on the $43,853† she received in *Tribune* dividends and gifts from her mother. Since Nellie's heart attack in 1920, the elderly lady had been in mental and physical decline. Corpulent in middle age, she lost weight alarmingly as she entered her seventies in the mid-1920s, when she grew incapacitated and incontinent. In light of the impending demise of one of the two beneficiaries of Joseph Medill's Tribune Trust and the advantageous circumstances presented by the absence of a federal gift tax, counsel advised that Nellie Patterson begin at once to convey her considerable wealth to her two children. Accordingly, in early 1926, Joe and Cissy began receiving equal, substantial cash gifts from their mother on a constant, if haphazard, basis: $35,000 each one week, for example, $25,000 three weeks later, $75,000 the following month, $15,000 as a "Thanksgiving Day present," followed by $50,000 three months after that. As Nellie's death appeared to loom nearer, the sums transmitted to her children grew apace, reaching $50,000, $75,000 or even $100,000 at a time.‡

The huge influx of cash that coincided with her marriage to Elmer Schlesinger brought about a commensurate change in Cissy's lifestyle. In the 1930s she reportedly chastised a newspaper reporter who asserted that she enjoyed $1 million a year in income: "Why, that's the most ridiculous thing I ever heard! The best year I ever had I didn't get more than $800,000." By the late 1920s, Cissy's annual income, not only from her mother's colossal gifts but also from *Tribune* dividends and her own investments, had climbed to between $600,000 and $700,000.§ Although her allowance had always been both generous and generously adjusted for the evolving exigencies of her life, Cissy had typically spent it quickly and objected volubly to the oversight it afforded her mother. Freed as much by Nellie's incapacity as by the deluge of her five- or even six-figure checks, Mrs. Schlesinger began living more lavishly than ever before. Elmer and Cissy traveled to celebrated prizefights, horse races, and polo matches. They entertained fashionably and flamboyantly: "Sunday night we had a big party," she told Rose Crabtree shortly after her forty-fifth birthday.

*Nearly $60,000, as measured by the Consumer Price Index, or some $366,000 by nominal GDP per capita in the first decade of the twenty-first century.

†More than $450,000 or some $2.4 million by the same measures.

‡By the first decade of the twenty-first century, according to the Consumer Price Index and the nominal GDP per capita, respectively: $15,000 in 1926 would equate roughly to some $200,000 or $850,000; $25,000 to $300,000 or $1.4 million; $35,000 to some $425,000 or almost $2 million; $50,000 to $600,000 or nearly $3 million; $75,000 to $900,000 or more than $4 million; and $100,000 to about $1.2 million or more than $5.5 million.

§A figure in the range of $7.5 to $9 million measured by the Consumer Price Index, or as much as $35 million to more than $40 million according to nominal GDP per capita.

Cissy in fancy dress in the 1920s

The Schlesingers had hired "three quadroon girls and men and a big band to do the 'black bottom' dance after dinner. One girl wore an enormous wig and nothing on but a few bananas around her waist. When she came in I thought I'd die of shame. But everyone got used to it mighty quick." In some instances, Cissy's friends were the beneficiaries of her windfalls. She bought Rose the only pair of diamond earrings in Jackson Hole. She financed Cal Carrington's expedition to Africa after witnessing with him the first of the titanic struggles between heavyweight champions Gene Tunney and Jack Dempsey in Philadelphia in late September 1926. She confessed to Rose, "Elmer got [Cal] a cabin on a freight boat for nothing. (I guess he would have *bought* him a ticket to get rid of him!)." But it was Cissy who footed the bill for the cowboy's two years in the African bush.

Though a decade earlier she had been relegated to her narrow, "undistinguished" red-brick house at 1601 R Street in Washington, by February 1927, Cissy found herself in a position to buy "Harbor Acres," Vincent Astor's forty-seven-acre waterfront estate in Port Washington, Long Island (from which Elmer commuted to work in Manhattan by motorboat), and make extensive improvements to the buildings and grounds. Though she had used 15 Dupont Circle little since her second marriage, she kept the

white marble mansion even after the young Pearsons moved out. With three other residences by February 1927, Cissy offered her Washington home to President and Mrs. Coolidge as the "New White House" during the six months that the executive mansion on Pennsylvania Avenue was undergoing modernization and repair. It was outside the portals of Patterson House in Dupont Circle, therefore, that a throng of thousands gathered to greet the dashing, twenty-five-year-old Colonel Charles Lindbergh with "roars of enthusiastic acclaim . . . cheers, hats thrown in the air and shouts of 'Good Boy, Lindy!' " when the aviator became President and Mrs. Coolidge's houseguest in June 1927, three weeks after the pioneering nonstop New York to Paris flight aboard the *Spirit of St. Louis* that had excited the admiration of the world. In 1931, Cissy would add a fourth residence to her real estate holdings: "Mount Airy," a seventeenth-century hunting lodge built by Charles Calvert, the third Lord Baltimore, in Prince George's County, Maryland, outside Washington. In previous years, the lodge and estate had been operated as a fashionable restaurant under the name "The Dower House," but had been the apparent victim of arson shortly before Cissy purchased the property. She restored its buildings and stables meticulously and added a guest house along with the modern conveniences of a swimming pool and a greenhouse devoted to the cultivation of orchids.

Cissy's significant purchases were not limited to real estate, however. Strolling by the Cartier window one day in Manhattan, she spied the same spectacular set of black pearls she had admired nearly a quarter century earlier in St. Petersburg, around the white throat of the tsar's niece, Princess Irina Youssoupoff. When informed apologetically by Pierre Cartier that the necklace had not yet been valued due to its unsurpassed quality, Cissy simply issued a blank check to stake her claim. In 1929, she bought a private train car (a rough precursor in opulence, personal convenience, and expense to the private jet), which she named after the cow pony Cal had found for her. The *Ranger,* complete with three berths, was decorated lavishly according to the changing seasons, and on it Cissy, her guests, and her growing pack of poodles were attended by a full-time staff of two, a steward and an assistant steward, in addition to the chef, maid, and secretary who accompanied her on her journeys. The transfer of much of her mother's wealth, tax-free, between 1926 and 1932 would also eventually put her in a position to assist her friend William Randolph Hearst in averting his looming bankruptcy, and eventually permit her to indulge her growing hankering to own a newspaper.

The softening of Nellie Patterson's mind in old age had wrought a corresponding softening of her temperament. While the younger of Joseph

Medill's two surviving daughters was homebound at the Blackstone Hotel in Chicago by the mid-1920s, her elder sister was not. In nearly three-quarters of a century of infighting between Kate McCormick and Nellie Patterson, seemingly any pain, embarrassment, or bereavement—from the death of a child to public scandal to suicide—had been ready fodder for ridicule, deliberate irritation, or scorn. Something of the same spirit that had prompted Bert McCormick to confess to his mother that his feelings of depression dissipated on the battlefield appeared to affect Joseph Medill's female relatives on the domestic front; Kate, Nellie, Cissy, and to some degree Felicia were drawn together by the strife they created for one another. "The family fought all the time," Felicia reflected, "but they also stayed together."

> That is, my Grams and my great aunt Kate and Cissy—lived in Washington DC, and stayed at the Blackstone Hotel in Chicago together and bought or rented houses in Lake Forest near one another. In order, you'd honestly think, to shout at each other, scream at each other, trying to get the last word—and then going around quoting what they had said, proud of themselves, laughing.

If infighting did not exactly approximate affection within the Medill family, it was nevertheless something that Kate, Nellie, and Cissy appeared almost to enjoy. Indeed, it was in the flaccid hand that had replaced her earlier, spiked penmanship that Nellie lamented in May 1926, "Kate is soon going to Carlsbad & I shall miss her—my only sister."

If Kate McCormick's grasp on reality was likewise slipping by the mid-1920s, she had lost comparatively little of her native pugnacity. She continued to hold unshakable opinions not only on the intertwined subjects of family relations ("Joe is a pure Patterson—just like Cissy—jealous, vain and treacherous") and publishing ("I can't bear the 'Liberty' it offends my taste"), but on the broader matters of politics and foreign affairs as well. The steady hand in which she attacked those subjects that captured her imagination, indignation, or admiration remained as pointed and stabbing as ever. "Sir—" the fiery abolitionist's seventy-four-year-old daughter addressed Governor David Bibb Graves of Alabama, on October 17, 1927, "we of the North read in the newspapers with distinct horror of the way you are treating Negroes . . ." She laid down the gauntlet: "It would be a satisfaction to us to whip the whole South again." She was captivated by young Colonel Lindbergh, by contrast. "Someone remarked to me that your father was a pro-German," she wrote the aviator from Paris in September 1927, by way of thanking him for a signed photograph that Colonel McCormick had procured—and ingratiating herself with a com-

monality she believed she had with the young celebrity. "My reply was 'so am I a pro-German, except that I despise the Kaiser and everybody belonging to him,' " she continued, musing, "I like the idea of the smaller countries joining together against France and England," before closing with uncharacteristic levity: "My son the Colonel will see that this note will get to you—but I charge you not to take him out in a flying machine!" Although Kate was still comparatively able-bodied, like her sister she was tended to increasingly by companions and minders, who busily intercepted the correspondence she dashed off to public figures, whether congratulatory or combative, for forwarding to her surviving son at the *Chicago Tribune* instead.

Just as Joseph Medill had resumed Nellie's allowance after her wedding and Nellie had in turn kept Cissy on an allowance long after she had married, so Cissy's new financial independence prompted her to offer Felicia the generous (if obligating) sum of $1,000 a month after Ellen's birth.* Anticipating the friction that such payments had caused in previous generations, Felicia declined the regular deposits and returned the additional $1,000 check Cissy had sent to help the young couple defray the expenses associated with a new baby. "I really think that in the future we would all of us be happier if things are once and for all *severed*," she explained bluntly.

> From now on Drew and I will accept *no* money, and I will ask for no clothes or presents.
> I see quite plainly that that is the only thing. I am, after all, grown up and married and your responsibility has (fortunately for us both) ceased. There will not be any discussions about our plans. Drew and I will do very well on whatever salary he makes, plus my present from Grams— the trust fund. There are many young couples with babies who get along on 1/2 Drew's salary.

Felicia's refusal reinvigorated Cissy's squabbles with Joe over the distribution of family heirlooms that had begun with Nellie's departure from Dupont Circle three years before. "It never occurred to me that you might walk off from Mamma's with a night-pot under one arm & maybe a bottle of shoe polish under the other," she proclaimed to Joe in a fit of pique over the disappearance of their grandmother's spinning wheel from the Black-

*Roughly $12,000 according to the consumer price index or more than $55,000 measured by nominal GDP per capita.

stone Hotel, complaining, despite (or because of) her daughter's unwilling-ness to accept either maternal generosity or obligation, "Felicia (the proud) doesn't scruple to loot Dupont Circle continually."

In any case, by November 1926, Felicia was beginning to earn a little money of her own as a *Washington Post* movie columnist. Drew proudly sent copies of his wife's column to her illustrious uncle at the New York *Daily News.* The rising *United States Daily* reporter was delighted with his grow-ing family and with his life in general. "He finds it entirely impossible to get mad at anyone any more or to nurse a grouch [*sic*]," he wrote of himself to baby Ellen, "because he had so many happy things to think about, that they crowd all the ugly things right out of his life."

> And your mother! Even before you came, you had made her so thoughtful and generous and beautiful. And now she grows ever more so. You have put a wonderful light in her eye and given her such tenderness, such sym-pathetic understanding that everyone becomes more and more in love with her. I used to be in love with her myself and consider her beautiful when she was rather pudgy and somewhat opinionated little person. But now either she has changed or I have changed or we both have changed until the only thing we have left to argue about is prohibition. And I am more in love with her than ever.
>
> You have given me new inspiration too, my daughter. Where I once was an office drudge, with a blank and cob-webby mind, you have made me brush away the cob-webs and think harder and work harder and love life all the while.

As a working writer at last, Felicia was loath to assume any additional responsibility or obligation—to her mother, her husband, or, indeed, even to her child.

Felicia had been largely deprived of critical maternal engagement in her own infancy, the impact of which had only been exacerbated by the sudden interruption of all of the relationships she had formed by the age of two and a half. Two decades later, the tragic deficiencies of Felicia's first years began to visit themselves on Ellen. "For most of my life," Felicia would later admit, "I've hated it when a baby squalls and is picked up and com-forted." Having enjoyed little experience of maternal affection or interac-tion, she came to believe as an octogenarian, "I wasn't able to do this for my own daughter, and that is in great part is why I've never liked or loved my own daughter and cannot get on with her to this day." If Felicia's birth had heralded the disintegration of her parents' marriage in coinciding with her

mother's discoveries of her father's infidelities, Ellen's arrival marked the beginning of the end of her parents' union for the opposite reason: her father's satisfaction that the child's arrival had cemented the family together only served to redouble her mother's mounting desperation to escape.

In the meantime, Cissy continued her attempts to write and publish. In May 1927, Joe Patterson gave her the opportunity to become a crime reporter, however briefly, by allowing her to cover the celebrated Ruth Snyder murder case, which would serve as the inspiration for Billy Wilder's *Double Indemnity* of 1944. The result, Eleanor Gizycka's "What Do You Know of the Soul of an Indian?," of May 3, 1927, fit in with the New York *Daily News*'s mixture of juicy celebrity gossip, lurid crime reporting, color comic strips, limerick contests, "Embarrassing Moments," breathless sports coverage, and "Real Life Stories," all lavishly interspersed with "peppy" rotogravure photography. In 1925 Ruth Snyder had enlisted the help of her lover, corset salesman Henry Judd Gray, to chloroform and garrote her husband for his $48,000 life insurance policy. By 1927, the lovers had been parted by the first-degree murder charges they faced in the Long Island City Courthouse, and each accused the other of committing the fateful act.

In her article, a colorful scramble of pop psychology, anthropology, physiognomy, zoology, and eugenics, Cissy cited a particularly painful Native American coming-of-age ritual, noting authoritatively that "you and I could not stick it out at all. We have not got that kind of a nervous system. They are a different kind of an animal." Much as she had painted the Ruthenian peasant of the Ukraine as a sort of tuber ("a dim-living kind of serf . . . rooted along with the potatoes and the carrots deeply in the soil") in her reflections upon returning to Poland five years earlier, so she characterized Ruth Snyder of the "wolfish jaws" as something other than human. Snyder's lover, Judd Gray, took on a more simian cast in Cissy's eyes. The dense hair on his head "grows thickly down the back of his head into his collar," she noted, dutifully following Arthur Brisbane's editorial exhortation to aspiring reporters to *make them see it.*" "Probably," she added speculatively to color the scene, "he has hairy arms and a hairy chest. He has a long upper lip, a jutting chin and a short, passionate nose." Closing the subject of Ruth Snyder's inscrutable sociopathy, she wondered grandly, "What do we know of the soul of an Indian?"

Although the press was barred from photographing the killers' eventual executions, by smuggling in a specially devised miniature camera strapped to his ankle *Chicago Tribune* photographer Tom Howard would capture the

last moments of Ruth Snyder's life in Sing Sing's electric chair for the New York *Daily News* front page on January 13, 1928, to enduring controversy.

"I don't mean to be unkind—am I?" Felicia wrote Drew from New York in late February 1927, during a short break from their mounting domestic troubles. "A situation like ours is very hard on the human soul." In a second attempt to enlist the romance of travel to hold his marriage together, Drew brought Felicia with him when he sailed for Europe in June to cover the Three-Power Geneva Naval Conference. "Felicia after a two month silence wrote to say she was sailing Sat. & would like me to take Ellen for 2 months & is sailing anyway whether I take little Ellen or not," Cissy complained to Joe on June 8. When the Pearsons returned in August, Felicia went to stay with her mother on Long Island instead of returning to Washington with Drew.

Learning something of the couple's difficulties from Felicia, Cissy wrote to assure Drew on behalf of herself and Elmer, "We both want to tell you to remember that we are your faithful friends—Please remember too that you are always welcome any time—day or night—we both think the child [Felicia] may be talking thru' her hat. In any case, our affection & regard for you will not alter." It was a promise she would keep for almost a decade and a half (for the most part) until her son-in-law began to display his own resolute independence from her, at the approach of another world war. Just as Nellie had clucked at Cissy's "neglect" of Felicia two decades earlier in Novosielica and Lake Forest, so Cissy now deplored Felicia's maternal indifference, "dumping" Ellen on her mother's bed when Felicia preferred to sleep late and doing "everything" to make Felicia feel guilty about her behavior toward her child. In late August, Drew himself arrived in Port Washington to discuss the couple's future, not only with Felicia, but with that able attorney and family adviser, Elmer. On parting after these depressing conferences, he told Felicia disconsolately, "I love you worse than ever."

On her twenty-second birthday, September 3, 1927, Felicia wrote Drew to confirm what he already knew: they had reached "infinity" in their discussions and, while she bore him no ill will, their marriage was over. Her tone was ostensibly one of dispassionate concern for his happiness, although she experienced only indifference: "I really felt nothing. I didn't pity Drew nor was I really angry with him. I didn't miss Ellen. I wasn't upset that she would now have parents who were separated." Addressing his apparent concern about keeping up appearances for the time being, Felicia assured him she had told very few people about the failure of their marriage. Beyond her mother and stepfather, only her cousin Elinor and

the couple's close friends, Amy and Walter Charak, knew that the couple would soon be seeking a Reno divorce. Three days later, Drew rented a modest house in Georgetown, big enough to accommodate his young daughter for the six months she was to spend with him every year. He remained fixated on Felicia, however. "I continued to live in Washington," he recalled years later, "hoping she would come back."

"After the divorce or during it, I don't remember exactly because that period of my life now seems like one long blur, I made love to all of Felicia's friends and tried to marry at least two of them," Drew admitted in the memoir he began late in life. "They were too wise . . . to take me on the rebound." If Felicia's old schoolmates Louise Ireland and Winifred West politely deflected his ardor, Amy Charak, by contrast, eagerly welcomed her friend's soon-to-be ex-husband and her husband's soon-to-be ex-friend into her bed. By early October 1928, Drew Pearson and Amy Charak had embarked on a torrid long-distance affair, meeting in hotel rooms between Washington and New York every few weeks. During their separations, Amy flooded Drew's Georgetown home with love letters in exuberant imitation of the latest literary fashions—erotic haiku and reams of trailing stream-of-consciousness explorations of the effect her lover exerted over her body and soul. Much of this torrent arrived written in violet or emerald ink. All of it was disguised (more in the interest of titillation, apparently, than as a precaution against discovery) in envelopes purloined from shops, hotels, and businesses around the Charaks' Lower East Side apartment. Meanwhile, unsuspecting Felicia took up residence in a well-appointed rental apartment on the Upper East Side, with Ellen and a nanny, on a lavish allowance from Cissy. Following her regular luncheon dates with Felicia, Amy bombarded her lover anew with envious screeds ridiculing Felicia's complaints about her estranged husband's unwelcome and unrelenting efforts to win her back.

With Felicia unreceptive to his overtures, Drew addressed his heartache to his tiny daughter instead. The custody arrangements not yet finalized, he wrote two-year-old Ellen, "I have decided that you are to have a father and that you are to know your father. If your mother had only had a father, I think you might have had one too," he ventured on October 14, 1927, upon returning home from a tryst with Amy Charak. "So I am going to write to you and tell you about myself so that wherever I may be, even if I have left you altogether, you may have these letters and know that you had a father." The result was his own desperate torrent of letters—never ultimately sent to, or seen by, their intended recipient—in a lurching scrawl, at the darkest moments in the aftermath of losing Felicia. "To-night I came home after a very foolish evening; it was 3:30 a.m. I was enraptured with a

girl about your mother's age," he confided to his toddler on October 21, 1927. "Just a slim slip of a girl that made me think of your mother on that glorious summer you came—when the meadows were so green and the flowers so gay and the moon so bright and I worked so hard and used to live for the evenings when I came back to live with your mother . . ." A seeming brush with injury or death might attract his wife's (or others') attention, he mused during the holidays.

> I went out to-day to look at the Potomac. It was much too cold. Large chunks of ice floating under the Key Bridge. Yellow water. I shall wait until the water is warm. July 4 would be a good day. Only the news might get crowded off the front page by all the fire-cracker deaths and auto accidents.
>
> In cold weather I should be so anxious to get out of that cold yellow water that I should swim ashore. But then there would be a pretty good chance of pneumonia. In July I should probably swim ashore too. The water would feel too lovely to waste on anything else.

"I suppose I should have to wait on the shore in wet clothes until someone sent for an ambulance," he reflected, however, "That would be disagreeable."

By March 1927, canny Nevada businessmen had successfully lobbied the state legislature to reduce the required residency period for those seeking to file for absolute divorce from six months to a mere ninety days. At the same time, the Silver State expanded the already unsurpassed panoply of grounds upon which divorce might be legally granted within its borders, by adding insanity to adultery, impotence, abandonment (for two years), failure to provide (for one year), conviction of a felony or other "infamous crime," habitual gross drunkenness (commenced after the beginning of the marriage), and extreme cruelty. As a result, Nevada successfully held the upper hand in the campaigns it had waged against Arkansas, Idaho, and Wyoming since the turn of the century, in courting "divorce tourism," thereby preserving, even enhancing, its well-deserved reputation as the divorce capital of the United States.

"I have seen your fine photo in the paper and the picture of your fine baby. I feel sorry for you but far more for Baby," an anonymous correspondent informed Felicia on March 20, 1928. " . . . One consequence of your action will be to give Baby a mother-complex, which will cause Baby either not to marry or else be unhappy in marriage," he (or she) chided, adding recommendations for readings in the fields of biology, psychology, and eugenics as Felicia made ready to leave for Reno with friends, who

Cissy insisted accompany her for the sake of propriety. In granting rapid "Reno-vations," Nevada's competitive, comparatively user-friendly divorce laws also offered wide latitude for abuse, collusion, fraud, and perjury on the part of petitioners. "I hope you will not think me too inconsiderate if I balk at the 'extreme cruelty' charges," Drew wrote Felicia on June 8, both of them still undecided as to the most expedient and least publicly embarrassing grounds to end their marriage. "I am now working for the *Christian Science Monitor* which is extremely meticulous about the domestic lives of its staff," he explained apologetically, "and I know that the charges you have outlined would not appeal to my editors at all." On Monday, June 25, 1928, the *Reno Evening Gazette* reported that earlier that day Felicia Pearson, the former Countess Gizycka, had filed suit in the local district court against her husband, "war correspondent" Drew Pearson, for failure to provide. The same day, in Washington, the up-and-coming *Christian Science Monitor* political reporter released a statement that he and his soon-to-be ex-wife were parting as "the best of friends." Their small daughter would divide her time equally between them. Once officially divorced, Felicia resumed her maiden name.

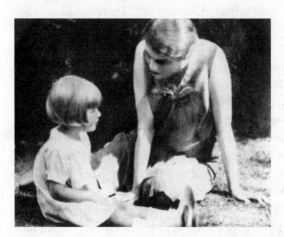

Mother and daughter: Felicia Gizycka and Ellen Pearson, ca. 1930

Maybe I'll have a happy and useful old age

Now what shall I do?" Cissy asked Joe on May 1, 1928, reporting with satisfaction that she had finished the last chapter of her second novel the night before. The question was a rhetorical one. She had been hatching a plan for some time: to buy the Hearst Papers' *Washington Herald* "for

myself," she insisted, although she admitted that neither Elmer nor the Hearst organization's Arthur Brisbane (who had firsthand knowledge of the particular difficulties of publishing a newspaper in the nation's capital) was enthusiastic about the venture. She had turned to her brother, therefore, in hopes of a more favorable response, "plenty of advice," and assistance. Hearst might refuse to sell the paper, of course, but then again, his increasingly dire financial predicament had forced him to disentangle himself reluctantly from a few of his "failures" across the country. If Joe would help her assemble an able staff and agree to sell her some New York *Daily News* and *Chicago Tribune* features—"(take them away from the Wash. Post principally)," she ventured—"Maybe I'll have a happy and useful old age."

Joe was no more sanguine than her earlier advisers had been, however. Admitting that he knew the *Herald* only by reputation, he assured her diplomatically, "it is hard to turn any paper from a loser to a winner." And indeed, running fifth among the District's six dailies, Hearst's morning *Herald* was no winner. With a daily circulation of 51,861 in 1929, it beat out only the *United States Daily* (which had hired Drew Pearson at its inception two years before) with 33,041. Leading the capital's pack was the venerable evening *Star,* founded in 1852, with a daily circulation of 99,559 (105,604 on Sundays) by the end of the 1920s. Hearst's local evening paper, the *Washington Times,* bought from Arthur Brisbane himself in 1922, trailed in second place with 86,763. Edward B. McLean's morning *Washington Post* followed with 73,200 daily and 81,327 on Sundays. In fourth place, slightly more widely read than the *Herald* was the Scripps-Howard papers' evening *News* with 54,935.

Taking advantage of the postwar boom and the new Harding administration's falling tax rates, in the early 1920s William Randolph Hearst had borrowed heavily to extend his nationwide newspaper empire. He had bought not only the *Washington Herald* and two other established newspapers, but launched three new dailies in 1922 alone—having already acquired three established broadsheets only the year before. Dangerously overextended by the start of 1923, the Hearst Corporation teetered on the edge of bankruptcy. Unrealistic cost-cutting and erratic management had produced little in the way of circulation or advertising gains at the *Washington Herald* over the course of Hearst's ownership.

Despite his dramatic successes at the *Chicago Tribune* and the New York *Daily News,* Joe Patterson, for his part, was not unfamiliar with red ink. *Liberty* magazine was foundering; before Bernarr Macfadden, publisher and father of the physical culture movement, took *Liberty* over in 1931, the Tribune Company would sink $14 million into it. Joe urged Cissy to scrutinize the *Herald*'s books; as sole owner its losses would be her personal liabilities if she were to acquire it and he worried that the paper would

consume much, if not all, of the novice publisher's considerable income.*
In general, her brother warned, Washington, D.C., was a "publishers'
graveyard."

On May 7, 1928, Brisbane reported that he had spoken to Hearst about
selling the *Herald* to Cissy. Despite the paper's losses and his larger finan-
cial predicament, however, the Chief, like everyone else she had consulted,
"did not seem very enthusiastic." Hearst newspapers, they themselves
often proclaimed, were emphatically "not for sale," literally or figuratively.
On July 7, to buoy Cissy's spirits Brisbane wrote again to say, "Take the
advice of an old man who has some wisdom . . . if you bought the *Herald,*
which I would never encourage, you would literally lose millions."
Deflated, she wrote her cousin Bert, whose advice she had also sought on
the purchase of a Washington newspaper, "What's the use?" but then
reflected of Brisbane, "Maybe the old scallywag has some idea of his own
up his sleeve."

By 1928, the old scallywag or that "queer duck," as Cissy described him
to Joe, was a little past his prime. Nevertheless, at the height of Brisbane's
abilities five or ten years earlier, the Hearst public-relations machine
touted him as the best-known and best-paid columnist and managing edi-
tor of his generation. The "To-Day" columns that he barked into the Dic-
taphones installed in his office, his limousine, and his home ran on the
front page of the major Hearst papers in addition to being syndicated in
more than two hundred dailies and some eight hundred weeklies by the
early 1920s. He had been born in 1864 in Buffalo, New York. Independ-
ently wealthy as the result of vast real estate holdings, his father, Albert
Brisbane, had become a disciple of Charles Fourier in France during the
grand tour of his youth and had returned to the United States an ardent
proponent of utopian socialism. Raising his children on a large New Jersey
estate, where they ran free and wild according to his precepts, the elder
Brisbane insisted that his offspring consume only yogurt, vegetables, and
watered-down red wine, and forbade them to receive haircuts, or formal
education of any kind—until his remarriage when Arthur was fourteen, at
which point the Brisbane children were promptly dispatched to boarding
schools in France and Germany.

Young Arthur had returned to the United States in 1883, fluent in
French and German, but largely unlettered in his native English, forcing
him to write his earliest pieces as a cub reporter in New York in French and
translate them back into English using a pocket dictionary. Later, Bris-
bane's loyal readership would celebrate the "foreigner's objective view of

*Nearly $200 million according to the Consumer Price Index, or more than $1 billion based on
nominal GDP per capita.

America" that he purveyed. His detractors, by contrast, sneered at his unsophisticated prose, which they charged with being "deliberately cultivated to appeal to the simplest mind." Brisbane had worked for a legendary succession of publishers: Charles Anderson Dana, Joseph Pulitzer, and William Randolph Hearst—or rather, each had hired the journalistic wunderkind away from his predecessor. Brisbane's work was synonymous with huge circulation gains and breathtaking technical innovation. Indeed, his involvement in the introduction of color to the comics section of Pulitzer's *New York World* in the early 1890s had engendered the term "yellow journalism," which characterized the very journalism of the age—the irresistible sensationalism of Brisbane's widely imitated brand of jingoistic, "crime, underwear, pseudoscience" reporting. In the summer of 1900, Hearst had dispatched Brisbane to Chicago to launch the *American.* Sharing not only young Joe Patterson's socialist leanings but many of his journalistic preoccupations and talents (and delighted to rankle a rival editor), it had been Brisbane who sent Rob Patterson's rebellious twenty-one-year-old son to China that summer to cover the Boxer Rebellion for the Hearst papers.

As a high-ranking strategist within the Hearst camp, Brisbane had long trained his spyglass with particular scrutiny on the enemy presented by the Medill family during the Hearst chain's first incursions into the Midwest, and more recently in New York, where Joe Patterson's *Daily News* had claimed the mantle of circulation supremacy that William Randolph Hearst's *Journal* had wrestled in turn from Joseph Pulitzer's *World,* which had earlier claimed it from James Gordon Bennett, Jr.'s *Herald.* Ever on the lookout for journalistic talent to lure away from the competition, just as he himself had been successively bought over the course of his career, Brisbane had a particular penchant for hiring radicals and leftists because of their ability to connect with the common reader. In short, Joe Patterson's abilities and proclivities made him exactly the type that Brisbane sought to bring within the Hearst fold; Joe's heritage and loyalties presented a stumbling block, however. Displaying both his characteristic unctuousness and his habit of baldly discussing how much money he and others made, Brisbane had informed Nellie Patterson as long ago as October 1916 that her son and her nephew were producing "the best newspaper work that is done in the United States," and that "Mr. Hearst would be very glad to pay them each $50,000 a year *today,* if he could move them from the *Tribune* to the *Examiner.*" Brisbane added, unsolicited, that "Hearst pays me $104,000 a year regular salary. And to say that your son and his cousin together are worth as much as I am alone is putting a very low estimate on their value."

If the *Chicago Tribune*'s seed money, however grudging, and the New York *Daily News*'s eventual success had prevented any renewed defection

from the family fold that Joe might have contemplated, it did not prevent Brisbane and Hearst from continuing to attempt either to enlist him or to buy him out. In June 1917, while still working for Hearst, Brisbane had embarked on a sideline venture of his own in buying the *Washington Times*. "It is no joke to make a paper pay in Washington," he admitted. "This particular thing . . . loses a great many thousands of dollars a week—and that has got to change." Assuring "the two young Tribune Geniuses, My dear Patterson and My equally dear McCormick," that Hearst himself had no ownership stake in the paper, Brisbane proposed for the first time an alliance in Washington of the same Hearst and *Tribune* interests that had been violently at odds in Chicago only a few years earlier and would soon be pitted against each other in New York. Desperate for cash, Brisbane magnanimously offered to allow Patterson and McCormick to take "one, two or a dozen pages of the *Washington Times* in which to impress upon the lawmakers the *Tribune*'s opinions on public questions." When this gesture was politely refused in Chicago, Brisbane begged plainly for *Tribune* advertising, again to no avail.

Brisbane would make his next proposals to Patterson and McCormick in New York. Although there had been murmurings in newspaper circles throughout the 1910s that the city was ripe for the launch of a British-style tabloid—and that it would likely issue from the Hearst camp—the Hearst forces were slow to mobilize. Instead, as Patterson and McCormick's *New York Illustrated News* sold out its initial run of 200,000 on June 26, 1919, Hearst dispatched Brisbane, then editor of his *New York Evening Journal,* to offer the Chicago cousins $50,000 to cease publication of their upstart picture-packed tabloid. Although they had rebuffed the Hearst payoff, Brisbane made a second attempt six months later, despite the precipitous, interim decline in the *News*'s sales that appeared to forecast its demise. Nearly a decade later, when Joe Patterson's *News* led not only New York but the nation in daily circulation, Hearst would be moved to complain to Brisbane, by then editor in chief of his *New York Mirror* (the rival tabloid they finally launched in 1924), "You are now getting out the worst newspaper in America." Nonplussed and, as one veteran *Mirror* reporter remembered it, "somehow offended" at his own lackluster circulation statistics in the face of Patterson's unparalleled success, Brisbane snapped at his staff, "Patterson is no genius. In some ways he isn't even bright. And we are letting him get away with this."

"Eleanor Gizycka's Second Novel Is Vividly Alluring," the *Chicago Tribune* crowed on October 6, 1928, of the publisher's cousin's latest literary effort. "When a second novel shows such a marked improvement over a first as Eleanor Gizycka's *Fall Flight* shows over *Glass Houses* and when that first

novel was in itself a first book of unusual skill and brilliance, the author may be said to be established as an American novelist of note." The *New York Times* assessment that "the effect of 'Fall Flight' is a little trite and not altogether satisfactory," was more in keeping with the work's general critical reception:

> It holds the interest without, at the same time, doing better than that and quickening one's pulse and arousing one's sympathy. Daisy is more of a symbol than a character and her foreign husband, for all his villainy is far more real than any of the other somewhat indefinite characterizations. As an example of international marriage it is interesting, but as a study of the moral problems inherent in such a marriage it is without substance.

For a limited edition of five hundred copies that Cissy reserved for friends, editors, and others she hoped to impress, she had asked her psychiatrist, Dr. Alvan Barach, to write a preface.

Cissy had come to know Barach socially, both on Long Island at the sumptuous parties thrown by the Schlesingers' neighbor, Herbert Bayard Swope, and in Manhattan, through a number of the members of the Algonquin Round Table with whom Elmer was friendly. Eventually, Cissy also began seeing Barach therapeutically, if haphazardly, throughout the late 1920s and into the 1930s, to pursue the talking cure that had so profoundly (if temporarily) helped her late cousin Medill. Medill had undergone the rigors of analysis with Dr. Jung, one of the young field's titans, but Cissy undertook intermittent therapy sessions with a garrulous bon vivant and self-described "pneumonia specialist," who dabbled in the ever more fashionable field of psychoanalysis on the side. Although Barach would later claim to have destroyed his notes and records in an effort to safeguard his psychiatric patients' privacy, he glibly dropped the names of the "Algonquin wits" (Dorothy Parker, Heywood Broun, Alexander Woollcott) and other luminaries (Herbert Bayard Swope, Evalyn Walsh McLean) whom he treated, gabbing about their neuroses and complexes, their sexual impulses, their drinking habits, their relationships with their parents. He delighted in the sobriquet Heywood Broun had devised for him, "Court Physician to the Swopes." He regaled listeners with the story of one of Dorothy Parker's "bright remarks, which was widely quoted," on the subject of his therapeutic suggestion that she make an attempt to write six hours per day. "Now I know why," Barach chortled, quoting his patient, "I got his bill."

In Cissy's case, he committed similar indiscretions to paper, for publication, at her request. "The dramatic conflict inherent in the story is initiated by the mother's attitude toward her daughter. As the story unfolds, her dis-

torted emotional development creates the dramatic events," Dr. Barach declared in his preface to Cissy's thinly veiled autobiographical account of her childhood, coming of age, and first marriage. "Made continually conscious of her physical unattractiveness by a mother whom she originally loved," he went on to declare of Cissy's fictional alter ego, Daisy Shawn, that

> she developed first of all a feeling of inferiority, which tended to remove her from the world of reality, leaving her with an exaggerated respect for power no matter how acquired. Riches, pomp and rank were influential with her, far more than she could understand or prevail against.

If Barach's exegesis was informed not only by his reading of the novel itself but by his assessments of the intimate revelations its author had made to him in the privacy of his office, it was also influenced by his familiarity with the author-patient's daughter. Living in New York after her separation from Drew Pearson, Felicia Gizycka had consulted Dr. Barach as well.

> Perhaps more important in this early influence was the mother's cruel indifference to the love of her daughter, with its inevitable arrest of emotional development. Instead of the child growing up to put faith in loving others, she curbed her feelings, being sure only of the rewards of loving herself.

If Cissy had hoped somehow to lend *Fall Flight* literary legitimacy and cachet by including a preface written by a figure ostentatiously linked to the luminaries of the "Vicious Circle," she would come to regret it. "What a fool I made of myself, letting him write that," Felicia recalled her mother saying. *Fall Flight* would be Cissy's last attempt at publishing fiction—or, more accurately, literary fiction.

Despite the discouraging news from all corners about the *Herald,* Cissy was determined to become a Washington publisher one way or another. Over the course of 1928 she investigated (or rather, enlisted the formidable journalistic triumvirate of Brisbane, Patterson, and McCormick to investigate for her) a variety of possibilities. Other than the *Herald,* the *Post* appeared to be the most likely candidate for sale. Its owner and publisher, Edward Beale McLean, was the scion of another originally midwestern publishing family. His grandfather, Washington McLean, a co-founder of the *Cincinnati Enquirer,* had made his fortune not only in newspapers, but in shrewd investments in public utilities, and had moved to Washington in the 1880s, where he had acquired the *Post* and become an éminence grise in the

Democratic Party. Born in 1886, Edward, or "Ned," McLean had grown up among Washington's Bonanza Kings. He wintered in Palm Beach, summered in Newport, and, beyond sporadic cub reporting for the *Post,* had taken little interest in his father's newspaper properties.

In 1908, Ned McLean had eloped with the good-natured if impulsive Evalyn Walsh, the only surviving child of gold-mining magnate "Colorado Croesus" Thomas F. Walsh. It was during the young McLeans' honeymoon around the world that the bride acquired the 94-karat Star of the East, the first of the important diamonds she would collect throughout her life, for $120,000.* Evalyn Walsh McLean had declined to buy the Hope Diamond at the time because the legendary jewel had reputedly been cursed to bring doom to all who touched it in retribution for the sacrilege of its theft from the head of an Indian idol. According to legend (which some attribute to jeweler Pierre Cartier's efforts to create a colorful sales pitch for the stone), Jean Baptiste Tavernier, the French gem merchant who had originally brought the stone from the Orient, had been torn limb from limb by wolves in Russia after selling the roughly cut, steely blue diamond to Louis XIV in 1668. "The French Blue," as it was then known, passed to the Sun King's descendants until it was confiscated after Louis XVI and Marie Antoinette's ill-fated attempt to flee from France in 1791. Claimed by the successive revolutionary assemblies, it disappeared during the sack of the former royal treasury in Paris the following year. Outlandish tales place the recut but still intensely blue stone that resurfaced years later in the hands of such diverse figures as George IV of England and the same star-crossed Tsarina Alexandra Fedorovna who had so warmly greeted Ambassador Robert Sanderson McCormick at Tsarskoye Selo in the winter of 1903. After Evalyn Walsh McLean returned to the United States from her honeymoon, Pierre Cartier at last persuaded her that the malediction had been lifted by a priest's blessing and she bought the stone for $154,000.†

Although the tragedies that seemed to follow Evalyn Walsh McLean would often be ascribed to her acquisition of the accursed gemstone, they had begun years before she ever laid eyes on the Hope Diamond. A car accident in the summer of 1906, two years before the McLeans' marriage, had killed Evalyn's elder brother Vinson and broken her leg badly, leaving her with not only a limp but a lifelong dependence on opiates. While Ned and Evalyn McLean attended the 1919 Kentucky Derby, their nine-year-old eldest child, "hundred-million dollar baby" Vinson (named for his late

*Nearly $3 million according to the CPI or some $17 million measured by nominal GDP per capita.

†More than $3.5 million or almost $21 million by the same measures.

uncle), eluded his bodyguards, only to be run over and killed by a car out-side of their Washington estate, Friendship. By 1927, the unhappiness of the couple's marriage, her addiction, and his "spectacular" alcoholism and mounting infidelities had prompted their separation. If he had been neglectful of his wife, neither had McLean shown much interest in his newspaper properties, preferring, as ever, Newport and Palm Beach to Washington or Cincinnati, and the golf course and the turf to the city room. In short, under the leadership of Ned McLean (whom Alice Roo-sevelt Longworth dismissed as a "pathetic man with no chin and no charac-ter"), the *Washington Post* had languished.

"Although realizing 'puffickly' that my judgment is based on next to noth-ing of knowledge or experience I still think the small 'class' paper my best bet," Cissy wrote her humorless cousin, Colonel McCormick, on July 11, 1928, in what Felicia had come to describe as "that sweet intonation, pre-saging an onslaught." As the result of her investigations regarding the *Post*, Cissy had learned that the inquiries she had made among her friends and family members in the publishing industry had sparked their own interest in the paper—despite the authoritative warnings she had received from all quarters against entering the field in Washington. If she was piqued to find, after consulting with Arthur Brisbane, that William Randolph Hearst had tried to buy the *Washington Post* from Ned McLean, she was livid at the discovery that her cousin had been similarly intrigued—with-out mentioning it to her during their recent discussion in her New York writer's studio on the possibility of her buying the paper. She had just learned from her brother of yet another agreement he had struck with their cousin, this one (ultimately unsuccessful) to use the profits from *Liberty* to allow Joe to start a tabloid in Los Angeles and Bert to "go into" Washing-ton. "I told Joe how friendly you had been, and that you had offered to 'make up the books,' or rather have them made up for me; given me several valuable tips and suggestions—names of managers—and most important of all, promised me the inside track with the 'contracts,' " she spat, aban-doning the Pollyannaish tone with which she had begun her letter, before building to a crescendo of insinuation: "Gee Bertie! What does it all mean?"

Unperturbed, Colonel McCormick wrote back on July 18, 1928, with-out apology—or, indeed, acknowledgment of any attempt to buy the *Post* out from under his cousin. He reported only that he had conceived of the idea of the *Tribune*'s acquiring a Washington paper during a recent stop in the capital, when he had been struck anew by how flatly "bad" Ned McLean's *Post* had become. He presented his conclusion to Cissy as an almost elemental journalistic insight: "if I could buy the Washington

POST, which is made up almost entirely of Associated Press despatches, I would only have to add the Tribune Foreign News Service and one or two brilliant political writers to make it an outstanding newspaper in Washington." He had abandoned the idea, however, upon learning that McLean was unwilling to sell. Further absolving himself of any underhandedness, the colonel went on to offer prescient and, as it would turn out, critical advice:

> I cannot conceive of a newspaper of general circulation succeeding in Washington without Associated Press membership. The Associated Press is much more necessary to a Washington newspaper than to one in any other city, because the Associated Press collects practically all the news of Washington and furnishes it to its Washington members while in all other cities the local newspapers collect the local news and furnish it to the Associated Press. I imagine that is what Brisbane has in mind when he advises you to buy the POST or the STAR or not to go into the newspaper business in Washington.

Although he assured Cissy, "I am out of the Washington field. It is open to you," the colonel continued to dissuade her from buying a newspaper there, with renewed warnings about expenses. Instead, estimating that there were more outsize personalities in Washington than anywhere else in the nation except perhaps hated Manhattan, he encouraged her to consider launching a "snappy weekly" along the lines of the *New Yorker*.

Despite Cissy's irritation with her cousin, his idea of launching a Washington weekly did hold appeal. *Glass Houses* had whetted Cissy's appetite for political satire—or, more specifically, for settling scores publicly. Indeed, so seriously had she taken the suggestion, apparently, that in August 1928, Bert informed his mother that the first number of Cissy's new magazine was imminent: "I don't know what the name of it will be, but we will know in a short time, as she is all ready to launch it." "I am very much amused at Cissie's [*sic*] venture in journalism," Kate McCormick chuckled in response. "I think her principal object is to secure some revenges. Her social position in Washington is pretty well smashed by the scandals which she has brought on her family."

To her aunt's disappointment, no doubt, Cissy's magazine did not appear. Instead, the *Washington Post* reciprocated Cissy's recent interest; the paper that had so minutely covered her whirlwind engagement and glamorous marriage a quarter century earlier followed up with an interview. Modern girls were bearish on once-fashionable international matches, the *Post*'s Sunday magazine declared on January 13, 1929, under the title,

TITLES SLUMP IN MARRIAGE MARKET

Bartering of Gold by American Heiresses for Coronets
of European Nobility on the Decline, according to
Countess Eleanor Gizycka Because of Lack of Common
Viewpoint on Ideals of Matrimonial Alliance

"International marriages are decreasing because the brilliant and glamorous European courts are gone. The wealthy American girl realizes that she will get very little in exchange for what she gives. Titles are hollow-sounding these days," the Countess Gizycka, or rather Mrs. Schlesinger, declared. Five years of loneliness, neglect, abuse, kidnapping, and blackmail notwithstanding, in hindsight (and in impersonal terms) Cissy suggested that she had not erred in marrying Count Gizycki. Rather, she had made the mistake of making herself vulnerable to him: "If an American girl enters into a marriage with a European without love she has a chance to be happy for she will not be disillusioned."

But if she is filled with ideas of romance and truly loves the man she marries, her marriage is bound to end disastrously. She will simply not be able to tolerate it. For the American girl who remains an American girl in spirit and demands her husband's undivided attention, love and fidelity just won't get it, that's all.

Reiterating the wistfulness she had expressed in her *Harper's Bazaar* account of returning to Poland seven years earlier, she opined about the incompatibilities between European and American attitudes. "We marry, as a rule, for love and for egotistical reasons," she declared of her compatriots. "Thus our marriages are more selfish. We are considering always our individual happiness. We do not look at marriage in a broader, more universal way. We want personal happiness, and if we don't get it in marriage, we dissolve it." Despite the emotional and physical damage she had endured with Count Gizycki, she lamented the readiness with which Americans divorced. The breakdown of Felicia's marriage a year earlier had affected her deeply, apparently.

How often, over here, do you hear an impetuous and ardent wooer exclaim to his vacillating beloved who is uncertain whether or not to take the leap: "Just try it, darling. If you don't like it, I give you my word of honor I won't stand in the way of your securing your freedom."

How can one expect marriage to last when it is entered into in this spirit? Necessarily it must be not only a temporary experience; and experiment, to be canceled at will.

"We actually have trial marriages over here, and plenty of them, though I do not think as yet we realize it," she assured the reader. And yet, did she refer simply to Felicia's intemperate matrimonial bargain with Drew Pearson, or was she reflecting on her own impetuous marriage to Elmer Schlesinger as well?

Five weeks later, on the afternoon of February 20, 1929, Cissy was in Washington when she received a phone call from New York stockbroker and society figure Philip Livermore in Aiken, South Carolina, where her husband had been spending the week. Elmer had fallen ill on the Palmetto Golf Course earlier that afternoon, Livermore stammered. Having thus prepared the scene, "all in the space of about two minutes" the caller stopped beating about the bush and came clean. Elmer had collapsed upon returning to the clubhouse. He was not actually sick, Livermore confessed. He was dead. Only forty-eight years old, Elmer had been the apparent victim of undiagnosed heart disease. Flabbergasted, the widow departed Union Station for Aiken immediately aboard the *Ranger*.

Some friends and relatives would later contend that Cissy had grown tired of Elmer and was contemplating divorcing him at the time of his death. Some members of her staff would go further, to gossip that shortly before he died she had found a cache of letters revealing not only his involvement with another woman, but proof that he had only married Cissy for her money. Any posthumous reputation Elmer developed as an adventurer appears to have been undeserved, however, in that his $2,250,000* estate—though considerably smaller than Cissy's net worth—was nevertheless substantial. If her efforts to buy a Washington newspaper (and the likely return to 15 Dupont Circle from 1010 Fifth Avenue that such a step would entail) appear to lend credence to the rumors of her imminent divorce, other intimates recalled that Cissy threw herself into histrionic mourning in the wake of his death. She hired Raymond Hood (co-architect of Chicago's gothic Tribune Tower and its rectilinear New York cousin, the Daily News Building) to design a fitting tribute to her late, beloved husband in the form of a magnificent mausoleum. She had had little contact with Elmer's children during her marriage (Halle was seventeen and Elmer Jr. only ten at the time of their father's death)—the result, some contended, of their close resemblance to the first Mrs. Schlesinger and the jealousy this provoked in the second. Although the Schlesinger children would agree that they had seldom seen their father after his remarriage, neither described any rancor on their stepmother's part. Rather, in the

*Roughly $28 million according to the CPI or as much as $125 million by nominal GDP per capita.

excitement that his rare visits to 1010 Fifth Avenue occasioned, Elmer Jr. recalled vaguely that Cissy cut a cinematic figure, who typically "patted me on the ass and gave me two bucks." As Elmer had died intestate, in April 1929 his estate was divided equally among his widow, his son, and his daughter. Her lavish grief notwithstanding, Cissy spent much of the following summer in a pitched legal battle with her late husband's minor children, enlisting witnesses and compiling documentation to prove that she had paid for much of the Astor estate in Port Washington, and arguing that she alone should keep it.

In the immediate aftermath of the Wall Street crash, Bert McCormick received word from that old mercenary of the Hearst-*Tribune* circulation wars (and more recently the publisher of the *Daily Racing Form*), Moses Annenberg, through Ned McLean's attorney, that the *Washington Post* might be available for sale. Chastened by Cissy's earlier censure on the subject of that very newspaper, the colonel placed the former circulation gangster (a close Brisbane associate over the years) and other able *Tribune* staff members at his cousin's disposal to investigate further. In the meantime, Arthur Brisbane continued to correspond with Cissy, opining on various subjects—topical, personal, and journalistic—and offering unsolicited advice on many more. Above all, he urged her to continue writing and in particular to reconsider abandoning autobiographical fiction. "Write a book called 'Spilling the Wine.' Let it be the story of a woman's life, thrown away here and there, with laughs and a good deal of sadness scattered through it. Imitation laughs, and real sadness," he suggested on Christmas Eve 1929. "Then, if you can, make a climax that would make the life and all its disappointments well worth while. And afterward, make it real in your own existence." At the same time, Brisbane encouraged her not to abandon hope of newspaper publishing. When her renewed negotiations for the *Post* fell through again in March 1930, he attempted to buoy her spirits by assuring her that the venture would have been unsatisfactory in any case, and asked to be remembered to her brother. "Tell him that in his next 'cycle' when he turns radical again, he and you and I will buy a paper, run it anonymously and have some fun with it," Brisbane teased. "Then you will be able to do anything you like with Alice and Ned's wife and your other little *bêtes noires*."

Although Evalyn Walsh McLean was nearly five years younger than Cissy, "Ned's wife" had come of age near 15 Dupont Circle at 2020 Massachusetts Avenue, which the Walshes, newly fabulously wealthy and recently arrived in Washington, completed shortly after construction concluded on Patterson House in 1901. In the wake of young Countess Gizycka's departure for married life in Europe in 1904, Evalyn had replaced

Cissy and joined Maggie Cassini and Alice Roosevelt on the local society pages as the third of Washington's Graces. Whatever had reduced Evalyn Walsh McLean to one of Cissy's bêtes noires by March 1930, the ill feeling was temporary. Cissy had been close to Evalyn before (Felicia had reported to her grandmother that "Mama was very very sad" and had lent support to her old friend in the wake of little Vinson McLean's death in May 1919) and would be again (by the mid-1940s Cissy would number the mining heiress among her closest friends). By contrast, Cissy's girlhood cama-raderie with Alice Roosevelt Longworth, demolished years before by jeal-ousy, competition, and intrigue, would never be fully repaired.

"It's so difficult to *deal* with you atall [*sic*]," Cissy complained to her brother of his galling counsel to cultivate a more neutral attitude toward her rival. "The situation is simply this," she persisted:

> Alice Longworth is trying to "Gann" me out of Washington Society. She can't do it, of course, but she can succeed in making me uncomfortable.
> She has always been the attacker—please don't forget that.
> And this is all I have to say on the subject to you.

The election of Charles Curtis as Herbert Hoover's vice president in 1928 had unleashed an unprecedented furor in Washington political, diplo-matic, and social circles. When the vice president had arrived on Capitol Hill as a freshman Kansas congressman twenty-five years before, he had been accompanied by his half sister Dolly, later Mrs. Edward Everett Gann, who would serve Curtis as personal secretary throughout his politi-cal career. After Curtis was widowed in 1924, Mrs. Gann assumed her late sister-in-law's social role in her brother's life as well. Once Curtis became vice president, Mrs. Gann's rank and status became a question of endless confusion and dispute in the capital. As *Time* magazine put it:

> Her opponents argued that, in the absence of President Hoover's wife, top rank at the dinner table belonged to Alice Roosevelt Longworth, wife of Speaker of the House Nicholas Longworth and daughter of Teddy Roo-sevelt. Official hostess or not, they declared, Dolly was only the Vice Pres-ident's sister, and should sit below the wives of foreign ambassadors.

Although both Mrs. Gann and Mrs. Longworth insisted privately that there was in fact no protocol feud between them, it was widely believed and broadly reported for years afterward that "the leaders of this [anti-Gann] school of thought were the Longworths." Living in New York and maintaining a hostile silence toward Alice while official Washington was gripped by the unfolding protocol kerfuffle, if Cissy was aware of the

absence of malice between the two ladies in question she chose instead to read into reports of Mrs. Gann's plight the persecution she herself claimed to have suffered at Mrs. Longworth's hands.

On March 31, 1930, Cissy went on the offensive. Without salutation, she launched into an epistolary attack on her old friend and rival. In New York the night before, Cissy informed Alice in Washington, she had seen Elmer's old Algonquin chums Heywood Broun and Alexander Woollcott, who had mentioned "they had seen you & how you looked & what you had said—and I said yes, you were this & you were that. But also you were the bitch of all the world—which, of course, didn't interest any of us because it's such an old story." Cissy went on to make a strange confession and an even stranger offer: "the result of it all was that I got a kind of homesick feeling for you. You have said all the filthy things you could think of about me . . . Would you like to shake hands & call it a day?" She concluded with a veiled threat: "Alice, my dear—I am writing you on an impulse based on our old admiration and affection. Take it or leave it. I am absolutely serious." Alice left it, evidently, in turn leaving Cissy in a state of reinvigorated animosity and anxious, once again, for a public airing of her grievances.

"I enjoyed seeing you, and seeing your brother, who, by the sheer power of his sincerity and simplicity seems to exercise such an influence on the human race," Arthur Brisbane wrote Cissy on June 10, 1930. His wife and daughter, he added, had praised Joe Patterson "in a way that I almost resented, not being averse to praise myself." As William Randolph Hearst had begun to reconsider his stance on the *Washington Herald,* Brisbane had met with the Pattersons in New York for a discussion exploring the possibility of Cissy's leasing the paper. "I have a terribly fine trader for you, from no less a person than W.R. You must have taken a lot of trouble with him last night," Brisbane revealed ten days later, the morning after the lavish dinner dance that Millicent and William Randolph Hearst had thrown at their (or, more accurately, her) home at 137 Riverside Drive in Manhattan, in honor of Dr. Julio Prestes, president-elect of Brazil. Another idea had occurred to Brisbane regarding his correspondent's publishing career: "How would you like to be the co-editor of the Washington Herald with a modest salary and no expense? That would be better than being owner with no salary and a gigantic loss."

Although Hearst had turned down Cissy's earlier offers to buy or lease his *Washington Herald,* Brisbane's most recent suggestion had succeeded in eroding some of his reservations. "If she wants to go into the newspaper business in Washington," the Chief ventured, "tell her I'll give her a job." On July 8, Hearst himself wired Cissy: "I would be delighted and honored

1317–1321 H Street, NW, Washington, D.C. (center), ca. 1930.
The offices of William Randolph Hearst's two losing newspapers in
the nation's capital: the morning *Herald* and its evening rival, the *Times*.

to have you edit Herald hope you will be as much pleased as I am." The
next day, Arthur Brisbane followed up with a letter outlining the terms.
For the next three years she would be under contract to edit the paper "in
accordance with the views of Mr. Hearst, the proprietor." The Hearst orga-
nization would pay her $10,000 per year plus one-third of all net profits,
and provide her with an expense account of $200 per week. "The 'hiring' is
rather a formality," Brisbane would explain to Democratic presidential
nominee Franklin Delano Roosevelt two years later, "since each trip to see
Mr. Hearst in California in her private [train] car costs her as much as she
earns in a year." Nevertheless, as of August 1, 1930, she became the United
States' only woman editor in chief of a major metropolitan daily newspaper.
At the age of forty-eight, Cissy embarked on the Washington publishing
career she had long dreamt of, quite literally with a vengeance.

New Editor-In-Chief

—From a Drawing by Neysa McMein

MRS. ELEANOR MEDILL PATTERSON, who will become
Editor-in-Chief of The Washington Herald, August 1. Her
appointment was announced yesterday.

ANNOUNCEMENT

*The Washington Herald makes the following
announcement:*

Mrs. Eleanor Medill Patterson, beginning August 1,
will assume the direction of The Washington Herald, as
editor-in-chief.

Mrs. Patterson and her family have long been known in
Washington in official and other circles.

The new editor of The Washington Herald comes natu-
rally by journalistic ability. Her grandfather was Joseph
Medill, founder of the Chicago Tribune, and she has been
very successful as a writer of novels and signed articles.

Mrs. Patterson is a first cousin of the late Senator Medill
McCormick, and of R. R. McCormick, publisher of the Chi-
cago Tribune. She is the sister of Joseph Medill Patterson,
publisher of the New York Daily News and Liberty Maga-
zine.

Mrs. Patterson has long been anxious to engage in active
newspaper work which has occupied members of her family
for three generations.

For a long time she endeavored to purchase The Wash-
ington Herald, of which she now becomes the active editor.
But, Hearst newspapers are not for sale.

Mrs. Patterson will work as editor of The Herald under
the regular Hearst newspaper contract.

Mrs. Patterson, who was formerly the Countess Gizycka,
and who subsequently married the well known lawyer,
Elmer Schlesinger, at her mother's request has resumed
her maiden name which is the same as her mother's, Elea-
nor Medill Patterson.

Mrs. Patterson's mother is one of the two daughters of
Joseph Medill.

The Washington Herald feels sure that Mrs. Patterson,
who, in accordance with Galton's law, inherits the genius
of her grandfather, will be very successful and INTER-
ESTING as editor of a Washington daily newspaper.

The announcement that appeared on the
front page of William Randolph Hearst's
morning *Washington Herald* on July 23,
1930, notifying its readership of the im-
minent change to its masthead and the
arrival of the nation's only female editor
in chief of a major metropolitan daily.

IV

Eleanor Medill Patterson

INTERESTING, BUT NOT TRUE

— ELEANOR MEDILL PATTERSON, *WASHINGTON HERALD,*
AUGUST 4, 1930

Looks like final repeal prohibition comes on your birthday," Joe wired Cissy on November 7, 1933, the dawn of her fifty-third year. "Double event for celebrating." The 1930s would usher in many changes for the Pattersons and their surviving McCormick cousin, not all of them cause for festivity. Two months earlier, on September 5, Cissy and Joe had received a telegram that their mother had died "very suddenly and peacefully" early that morning in Chicago, at the age of seventy-eight. As in so many matters, Nellie Patterson lagged behind her elder sister in reuniting with their departed relatives at Graceland Cemetery. Fourteen months before, as the hoopla over Franklin Delano Roosevelt's nomination at the Democratic National Convention died out in Chicago, Kate McCormick expired on July 5, 1932, at the Trianon Palace Hotel in Versailles, France. Closing her eyes forever on the sight of one of her long-suffering attendants bending over her bedside, she uttered her last acerbic words: *"My God,* what a bottom!"

In anticipation of the deaths of Joseph Medill's elderly daughters, already in May 1932 majority directors Captain Patterson and Colonel McCormick had elected to keep their grandfather's original 1,070 shares of *Chicago Tribune* stock in trust. Although Cissy eventually joined them on the directorate of the new McCormick-Patterson Trust, she took little interest in its administration once the staggering tax burdens of her mother's estate had been discharged. Indeed, until the late 1940s the origins of Cissy's wealth were of far less interest to her than the possibilities her substantial income presented. Her *Tribune* and *News* dividends would eventually permit her to gratify her long-held desire to buy a newspaper of her own. Liberated by the end of the decade from philosophical and stylistic subordination to William Randolph Hearst, Cissy would cast her editorial lot with her brother in favor of his fellow old Grotonian, now the new president and his New Deal. As the conflicts expanding across the globe threatened increasingly to envelop the United States, however, both Pattersons would join in unaccustomed unanimity with their dour cousin. Together, Joseph Medill's grandchildren would unleash the combined vit-

riol of the *Chicago Tribune,* the New York *Daily News,* and the Washington *Times-Herald* upon the commander in chief who did not share their suspicions of entangling foreign alliances. All three would seal their posthumous reputations by vociferous opposition to Franklin Roosevelt and the United States' entrance into the Second World War.

There was an old story that circulated within the rumpled fraternity of early-twentieth-century American sportswriters, the details of which would be published only after Arthur Brisbane's death on Christmas Day in 1936. In light of the ever-evolving wonders of modern technology and scientific inquiry, Brisbane was "irked" by the inconsistent success of handicappers at picking winning racehorses. As a result, the editor called the sportswriter Hugh Fullerton, widely regarded for his accuracy in determining World Series champions based upon careful statistical analysis, to his desk one day to insist that there must also be a rational scientific method for winning at the track. "Why, it's simple as the A, B, C's. You can tell a winner by his heart," Brisbane declared as he saddled Fullerton with the burden of securing X-rays of the heart and lungs of every colt and filly nominated for a major upcoming race—and the implied threat of unemployment if he came back empty-handed. Fullerton, who "stood popeyed and did his best to stifle a smile," dutifully headed for the track, fully aware that few owners, particularly of successful animals, were likely to cooperate with the experiment. As the legend went, a friend came to Fullerton's rescue by producing a "broken down horse" whose heart and lungs a cooperative veterinarian X-rayed many times over, from every possible angle. Back in his office, Brisbane scrutinized and compared the various films the sportswriter had presented, each labeled with the name of a horse entered in the major race the following day. Selecting the one that most magnified the old horse's heart, Brisbane declared the entry whose name appeared on the X-ray to be the winner, and began barking his predictions into his Dictaphone as part of his column on the infallible, scientific selection of winning racehorses that was to appear in the Hearst papers nationwide the next morning. As it happened, Fullerton would cackle in the retelling for years afterward, the following afternoon Brisbane's pick won the race.

On Friday, July 23, 1930, William Randolph Hearst's *Washington Herald* announced its imminent editorial shake-up as front-page news: "Mrs. Eleanor Medill Patterson, beginning August 1, will assume direction of The Washington Herald, as editor-in-chief." To settle any confusion, the notice went on: "Mrs. Patterson, who was formerly the Countess Gizycka, and who subsequently married the well-known lawyer, Elmer Schlesinger, at her mother's request had resumed her maiden name which is the same as

her mother's, Eleanor Medill Patterson." However touching the elderly lady's wishing her daughter to resume their shared (although by now differently spelled) name might have appeared to the *Herald*'s readership, in 1930 Nellie Patterson was almost beyond recognizing her grown children, let alone the new milestones in their lives. In reality, it was Arthur Brisbane's suggestion (heartily endorsed by the Chief) that Cissy rename herself in an effort to capitalize on the editorial cachet of her connection to her illustrious grandfather and to underscore that a member of the same family who published both the *Chicago Tribune* and the New York *Daily News* now worked for William Randolph Hearst. Although Cissy's name would not be legally changed in the Cook County Circuit Court until nearly two months later, she embarked on her newspaper publishing career under what was for the time being her nom de plume.

Although unsigned, the front-page announcement closed with a distinctly Brisbanian touch: "The Washington Herald feels sure that Mrs. Patterson, who, in accordance with Galton's law, inherits the genius of her grandfather, will be very successful and INTERESTING as editor of a Washington daily newspaper." Inasmuch as Arthur Brisbane peppered his correspondence and his wildly successful "To-Day" columns with folk wisdom, epigrams, political commentary, and bombastic moralisms on thrift, clean living, and self-improvement, so he also filled them with glib allusions to the theories, axioms, and pseudoscience that he had absorbed in the course of his haphazard education and which one observer distilled as the eminent commentator's "systematized ignorance." Where Cissy was concerned, Brisbane often made reference to Charles Darwin's cousin, the eugenicist, psychometrician, and statistician Sir Francis Galton, and the latter's pronouncement that genius was inherited through the maternal line. Indeed, if Brisbane had long watched Joseph Medill's descendants with the shrewd, appraising eye of the field marshal surveying the enemy on the battlefield, so had he also scrutinized them much as the wizened bettor pours over *Racing Form* pedigrees. Since the turn of the century Brisbane had made many attempts either to harness Medill's progeny to the Hearst machine by hiring all three of his grandsons at one time or another or to remove their manifest talents from the competition entirely by buying them out. Occasional envious disparagement aside, Brisbane had taken a particular interest in Joe Patterson's many editorial triumphs over the years, especially his unbeatable circulation numbers in New York. Might a similarly bred editor—by Robert W. Patterson (an eminent editor in his own right), out of a daughter of Joseph Medill—have similar talents, even if she wasn't a man? Based not only on his intuitive appraisals of journalistic ability but also on the logical, "scientific" principles to which he subscribed, Brisbane had picked winners before.

. . .

In any case, a woman editor, well bred for the position or not, could hardly make matters worse at what the *American Magazine* described as Hearst's "groggy *Washington Herald,*" now limping along in fourth place by a slim margin in the six-paper capital market. Indeed, merely as a publicity stunt, Hearst's hiring Eleanor Medill Patterson might boost circulation, however briefly. In 1930, there had been no women editors in chief of metropolitan dailies for so many decades that published reports often characterized Cissy as the first in American history. In fact, there had been several women editors in chief and, indeed, publishers and owners (typically by inheritance) as long ago as the colonial era. Cissy even had a predecessor in the nation's capital itself. In 1831, Anne Royall began publishing her own Washington journal, *Paul Pry* (later *The Huntress*), which permitted the aging widow to eke out a living for more than two decades. Anticipating the journalistic brush Cissy was shortly to have with Albert Einstein and bearing out her own reputation as an implacable harpy, the widow Royall reportedly sat on the pile of clothes that John Quincy Adams had left on the banks of the Potomac while swimming one day, refusing to relinquish them until the president—cold, wet, and naked—responded satisfactorily to all of her questions. More recently, Cornelia Walter (whom Edgar Allan Poe skewered as a "pretty little witch") edited the abolitionist *Boston Transcript* ably and courageously between 1842 and 1847. Eliza Nicholson became editor and publisher of the *New Orleans Picayune,* the South's largest daily, in 1876. By the mid-1930s there would be an estimated three hundred women editors and publishers of small-town newspapers across the nation, not including an even larger estimated number of wives who published local papers jointly with their husbands.

Nevertheless, from the time of Cissy's arrival at the *Herald* in August 1930, it would be nearly a decade before any other women followed her to the editor's or publisher's offices of major American metropolitan dailies. In 1939 Dorothy Schiff would buy the majority stake in the *New York Post,* becoming publisher in her own right in 1942. As vice president and advertising director of Ogden Mills Reid's *Herald Tribune* (and of its predecessor, the *New York Tribune,* since 1918), Helen Rogers Reid had had a profound impact on the editorial tenor and makeup of her husband's paper and was largely responsible for its impressive advertising linage and revenues. Mrs. Reid would not, however, become president in her own right until her husband's death in 1947, and she would never be the *Herald Tribune*'s editor in chief.

Cissy arrived in the *Washington Herald*'s city room on the first, sweltering day of August in 1930, therefore, with few predecessors and no current peers to find the curmudgeons of the existing Hearst crew buttoned with

grudging politeness into clammy suits, despite their general "disgust" with the new arrangement. "I suppose you think this is just a stunt," she said, surveying them coolly. "Even if you do, let's all try to put it over. And you don't need to wear coats when I'm around, either."

"You will have to work hard, but I think you might make a real success," Brisbane had encouraged Cissy three days earlier, on July 28, 1930. "It would however annoy your friend McLean, and peeve your little playmate Alice. What will you do about that?" Three days after her arrival, Cissy published a signed front-page editorial on the United States Senate candidacy of her cousin's widow, Ruth Hanna McCormick, which some (who had not yet read it) characterized as seemingly innocuous. "Interesting, but Not True," it declared:

> The news is that Mrs. Alice Longworth will be not only confidential advisor to Mrs. Ruth Hanna McCormick, but that she will campaign publicly for her life-long friend. Interesting, but not true.
>
> Mrs. McCormick takes no advice, political or otherwise, from Mrs. Longworth.
>
> Mrs. Longworth gives no interviews to the press.
>
> Mrs. Longworth cannot utter in public.
>
> Her assistance, therefore, will resolve itself, as usual, into posing for photographs.
>
> (signed) Eleanor Patterson

"Washington gasped," one commentator exclaimed, "then laughed. The tea tables buzzed with excitement." The wire services transmitted the astounding editorial across the country, making it fodder for scandal and mirth nationwide for days to come. "Coming out of the blue, this bolt set social Washington to gasping and spread excitement quickly, even to those groups summering at near and far resorts," a breathless *Los Angeles Times* reported on August 5, 1930, venturing further: "But for the barbed final sentences the statement might have passed as a routine denial in behalf of all concerned, but taken as a whole the announcement is interpreted as a declaration of war." In the days that followed, newspapers nationwide were rife with headlines shrieking, "Barbed Phrases," "Mrs. Patterson Slurs Mrs. Alice Longworth," and

AMAZONIAN WAR LIVENS CAPITAL:

Feminine Editor Challenges "Princess Alice"
McCormick Alliance Denial Barbed with Venom
Official Washington Waits Longworth Comeback

Encouraged by the national notoriety the piece had brought the *Herald* as well as by the boost it had prompted in local circulation, Arthur Brisbane cautioned Cissy nevertheless: "Be careful not to let the Herald become a woman's paper. Scrapping with Alice is all very well, but you must keep the high Joseph Medill level." In light of both national economic trends in general and the *Herald*'s steady losses in particular, he urged her to pursue additional advertising linage and revenues above all else. Further, as the Medill-connected-woman-editor publicity stunt appeared to be bearing fruit, he encouraged Cissy to expand upon it by hiring Felicia as a reporter—unaware, apparently, of the rancor that characterized mother-daughter relations at 15 Dupont Circle. If Cissy ever responded to this suggestion, no evidence appears to have survived. The novice editor had been not only enlivened by her sudden success, but emboldened to go above Brisbane's head to suggest to Hearst himself some changes she was determined to make to his *Herald*—beginning with a greater focus on Washington on the paper's editorial page, traditionally the site of the chain's national editorials, and often the Chief's own pronouncements. She closed her telegram to her employer (then taking the cure at Bad Nauheim in Germany) by drawing his attention both to her recent editorial coup and to her pique at his editor's qualified approval of it: "I wrote a little piece about Alice which to my surprise ran like wild fire all over the country even Ruth approved it I have her telegram stop only King Saul Brisbane took a slam at me."

Although newspapers all over the country reported on the "feud" between Mrs. Longworth and Mrs. Patterson, and pointed to the romantic tensions described in *Glass Houses* as suggestive of the genesis of the quarrel, the response from the Longworth camp itself was disappointing. The *New York Times* (like a number of other press outlets nationwide) had reported only that "Dig Amuses Friends of Mrs. Longworth." Indeed, Ruth Hanna McCormick had, as Cissy put it, "approved" the piece, despite her many other pressing concerns.* Alice herself let it be known around Washington that she, like her friends, professed to find the editorial "very amusing."

In an effort to provoke a more gratifying response, therefore, the *Herald*'s new editor in chief wrote privately to her old admirer, the Speaker of the House. Insisting that she owed Nick Longworth ("one of my oldest friends on earth") an explanation, Cissy launched into a protracted, if

* In 1928 Ruth Hanna McCormick had been elected congresswoman-at-large from Illinois, and in January 1930 she had announced her candidacy for election to her late husband's Senate seat. Ruth's handy victory in the Illinois Republican primary on April 8 had attracted the notice of Senator Gerald P. Nye, Republican of North Dakota and chairman of the Select Committee on Senatorial Campaign Expenditures. Between May and July the straightforward daughter and widow of the committee members' former colleagues found herself repeatedly called upon to

unspecific, attack on his wife: "There isn't any use in my going into my long quarrel with Alice excepting to say that she attacked me *first*. Long before I knew about it she was treacherous and vicious about me behind my back." Cissy could not be held responsible if the piece had attracted far greater notice than she had dared to hope:

It has been said that I "seized the first opportunity" to attack Alice in the Washington Herald. I didn't "seize" any opportunity. The thing came up. I wrote that entire article on a telephone book & five minutes later telephoned it to the office—as a matter of fact I didn't have the newspaper sense to realize that the story would burst like a bomb around the world.

It was August; Washington was empty, of my friends at least. I wrote the truth and the temperature was 102. That is the explanation in a nutshell. Had I thought that my entire editorial was to be printed in the four corners of the globe I might have hesitated—but out of regard for Alice, I haven't any, but on your account, a man, in a case like this, must stick to his wife—I know that I have necessarily lost your friendship. I am truly fond of you, devoted to you, & it is going to be a real loss.

"But remember, my dear, that if ever I can help you or your friends or do anything for you I'll be right there," Cissy concluded. "You know that." Indeed, eventually she would make good on that promise. In the meantime, her willingness to sacrifice one of her "oldest friendships" to her most galling rivalry suggested that wounding Alice rather than winning Nick had been Cissy's priority all along.

On October 4, 1930, as election day approached, Mrs. Patterson launched a second editorial assault on Mrs. Longworth, this one aimed nearer the heart. "Will She? Can She?" the *Herald*'s editor wondered of Mrs. Longworth as the Senate threatened to deny Mrs. McCormick her seat in the event of her victory at the Illinois polls. "Some weeks ago I wrote that Alice Longworth has no real gifts to bring Ruth Hanna McCormick's campaign. Ruth Hanna McCormick is Alice Longworth's close friend," Cissy began, confessing, "I was in error. I spoke hastily. In ignorance."

Senator Borah, another *close* friend of Alice Longworth's has said that if Ruth McCormick is elected he will vote to unseat her because of her

answer accusations that she had committed outrages ranging from "wholesale corruption" to spending an alleged $1 million on her primary campaign to being an associate of Al Capone. Although exaggerated when not wholly invented in Ruth's case (several historians have made persuasive arguments that misogyny lay at the heart of Nye's allegations), such charges were not unprecedented. In the previous decade alone, several senators had been forced to resign or had been denied their seats by their colleagues, for excessive campaign expenditures.

excessive campaign expenditures. Mrs. Longworth may now present her real gifts. She may use her political influence, of which the country has for so long heard so much. She may soften this decision of the frugal gentleman from Idaho.

Senator Borah is also a close friend of Mrs. Ruth McCormick.

They are all close friends.

But it is for Alice to come now bearing her offerings.

Will she? Can she?

Eleanor Patterson

In the renewed, nationwide hullabaloo that followed, Cissy waited eagerly for a response from Alice. She never received one.

In the midst of the furor and hilarity that Cissy's outlandish Alice Longworth pieces generated, her statement of purpose as the new editor of the *Washington Herald* went comparatively unnoticed. The chronology of her boxed, signed, front-page editorials was perhaps suggestive of her priorities in taking up newspaper publishing. Eleanor Medill Patterson's first pronouncement, "Interesting, but Not True," was followed three days later by "Answers," in which she delineated her editorial philosophy and objectives. "All kinds of people ask me if I intend to change the policies of the Washington Herald. I would not if I could. I could not if I would." Referring to her contractual obligation to edit the paper "in accordance with the views of Mr. Hearst, the proprietor," she continued:

Everyone should understand from the beginning that Mr. Hearst is first, last and all the time his own editor.

Aside from this rock-bottom fact, the other newspapers with which my family has for so long been associated stand today with the Hearst papers on nearly all of the major issues. AGAINST prohibition. AGAINST the League of Nations. AGAINST the World Court. AGAINST the recent naval treaty. FOR an adequate defense and FOR the general debunking of our foreign relations.

Although these were true statements in 1930, time and events would conspire to strain this initial harmony between the lady editor's legal obligations, personal loyalties, and inherited political inclinations. She dismissed public doubt about her ability to hold sway over a staff composed almost entirely of men: "Men have always been bossed by women anyway although most of them don't know it." What were the journalistic goals to which she aspired? "The ideal of all true newspaper folk, regardless of sex, is to keep a paper interesting, inspiring, honest, and successful." Considering her plans for the paper's future, she reflected upon her own past: "I've

only to remember the first two long words I ever learned to say. And I learned them most likely sitting on my grandpa's knee—CIRCULATION, ADVERTISING."

Taking seriously his duties as Cissy's self-proclaimed "journalistic godfather," Arthur Brisbane set about to shape the green editor. In this capacity, he assumed not only the role of schoolmarm, but those of stage mother and cheerleader as well. He had already condensed what were in effect his Ten Commandments of Journalism into a King Features pamphlet, "How to Be a Better Newspaperman," whose "Most Important Rules" included "No fancy writing," "Write with difficulty," "Make them see it," "Read the ancients," and the like. For Cissy he created a personalized course that he and his pupil conducted, in effect, by correspondence. "I would use no slang, no language that Coolidge would not use," Brisbane insisted in his appraisal of Cissy's exuberant first month's work, on August 30, 1930—in effect, "making her see it" by invoking the tight-lipped former president, "Silent Cal," who had decreed that executive pronouncements "ought not to be used indiscriminately." Brisbane would have considerable difficulty persuading the *Herald*'s editor in chief to abandon the use of argot entirely, however. "I think you are wise not to use slang at all unless in quotation marks," he gently reminded her in January 1933 (illustrated with a reproving frowny face), "BUT, there is something more terrible than that, and that is your string of double negatives . . ." Cissy was astonished, her limited formal education having left her unaware even of the extent of her ignorance on many subjects: "I never was taught a thing about grammar, but I did think I had a pretty good ear," she confessed, before agreeing: "Yes, that double negative was terrible, but the worst of it is that I would never have known it had you not told me. It was not careless, however. I worked that 'darned' piece over and over."

At once a flirtatious and an avuncular correspondent, Brisbane became a sort of journalistic Polonius, writing Cissy almost daily during her first years at the *Herald* with largely unsought (although often invaluable) advice for improvement in every area. He sent her long-winded homilies on pithiness, platitudes on thrift, edicts to write at least eight hundred words every day in an effort to make up for her lack of practical experience, constant reminders not to allow the *Herald* to devolve into a mere "woman's paper," intermittently repeated (although never heeded) suggestions to hire Felicia, and many directives to focus her energies, abilities, and ambitions on something higher than attacking the capital's other grandes dames.

In the midst of these mandates Brisbane sent unstinting advice on increasing circulation numbers and advertising linage, and imparted some of his own most controversial—and foolproof—tricks of the trade. Dur-

ing the First World War, when he had owned and published the *Washington Herald*'s evening sister paper (and bitter rival), the *Times,* Brisbane had come under congressional scrutiny and had faced widespread denunciations for "pro-Germanism" when the New York *Evening Sun*'s Washington correspondent revealed his financial involvement with, and apparent editorial favoritism toward, one Christian Feigenspan, a New Jersey beer brewer "of German extraction." The *Sun* charged that Brisbane's editorial espousal of temperance—specifically, his opposition to the sale of hard liquors while permitting only the manufacture of beer and wine—had had the effect of surreptitiously promoting the product of one of the *Times*'s principal financial backers, brewer Christian Feigenspan. At the time, Brisbane had proclaimed his patriotism with indignant denials of the mercenary editorial bias of which he had been accused. In March 1934, however, in an effort to make more profitable the ever-expanding cooking and food features that Cissy published (Brisbane's disparagement of "woman's papers" notwithstanding), he urged his protégée to "get somebody that can tactfully, insidiously, and with nobody but the advertisers knowing it, write things that will be pleasing to them, the freshness of goods supplied by those that buy in great quantities, and so on."

All the while, Brisbane set about to boost the editor's self-confidence amidst her intermittent doubts. "There is nothing to worry you. There is, especially, no possibility of 'humiliation.' Mr. Hearst, as you know, wants you to run that paper, and you are able to do it. Don't let any inferiority complex creep in," he pressed at a low moment in July 1931, adding presciently, "I think you will be running the paper for ten years, that is, if it continues to interest you." When Cissy grew self-satisfied, then Brisbane took it upon himself to keep her ambitious and hardworking. "You have real talent, very unusual," he observed in March 1931. "Too bad you're rich."

The relationship between one of Hearst's most senior editors and his most junior would develop into a genuine friendship. Cissy regularly sent copies of the latest book she was reading and gratified Brisbane's vanity by seeking (although not always heeding) his advice on a wide range of matters, not only professional but personal as well. By Christmas 1930, Cissy hosted a lavish dinner dance at 15 Dupont Circle for Brisbane's teenage daughter, Sarah. Cissy sent the *Ranger*—or, as Brisbane insisted on calling her luxurious private railway car, the "chintz chariot" or "chintz boudoir on wheels"—to fetch the Brisbane family in New Jersey for the occasion. Whatever her relations with her own daughter, Cissy took an interest in the Brisbane children, corresponded with their father regularly, and asked considerately after their mother. She would also show a particular (and unac-

customed) solicitude for the elder statesman of yellow journalism during his final illness.

William Randolph Hearst was a more distant, though no less favored, figure in Cissy's life during these early years of her editorial career. If Brisbane was her self-styled "godfather," she treated Hearst with the affectionate deference she had reserved previously only for her own illustrious grandfather. In the early 1930s she visited her employer several times a year on the California coast at San Simeon amidst the Ozymandian splendor of La Cuesta Encantada, his aptly named "enchanted hill" of some 270,000 acres, complete with private zoo, indoor and outdoor swimming pools, movie theater, and buildings constructed in emulation of so broad a sweep of European historical styles that their principal architectural commonality was perhaps their grandiosity. Less often, and later in the 1930s, she visited Wyntoon, Hearst's other California estate, a sort of fairy-tale Bavarian village near the Oregon border at the foot of Mount Shasta. On these visits (during one of which Hearst greeted the *Ranger*'s arrival with a brass band), Cissy hobnobbed with members of the Hollywood film colony and the other celebrities, magnates, and luminaries who congregated there.

She would become an intimate of Hearst's mistress, Marion Davies, much as she was friendly with Hearst's wife, the former Millicent Wilson, on the East Coast. Whether Cissy was aware of it or not, she also served the Chief as an authoritative source of information on one of his bitterest rivals, her own brother. Among the Hearst organization's editors and executives who assembled at San Simeon was Cissy's old flame, Walter Howey, whom Hearst himself would congratulate on April 8, 1931, for having performed

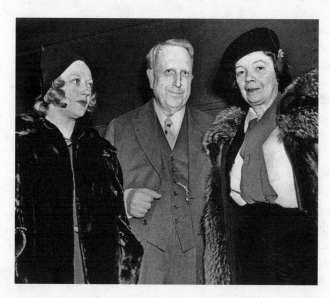

Cissy (right) with Marion Davies and William Randolph Hearst in the 1930s

one of the most dramatic turnarounds the publisher had seen in his long career: putting his *Boston Record* back in the black. Nearly eight months later, in the wake of a visit from the lady editor of the *Washington Herald,* the Chief would write his legendary fix-it man for ailing newspapers again, this time to complain to Howey that the same "good little tabloid" ran "a little too much 'battle, murder and sudden death' " and could stand further improvement "by issuing some of the orders that [Joe] Patterson is reputed to have issued on the New York Daily News." Over the course of her stays, Cissy would also kindle a romance with another of Hearst's storied (and married) executives, Thomas Justin White.

On her first visit to the Hearst Castle at San Simeon in the winter of 1931, Cissy stopped at various points along the way to California, both coming and going, to try her hand, once again, at reporting. On a detour to Miami, out of curiosity she instructed her chauffeur to drive by Al Capone's bungalow. Gawking as they passed, Cissy suddenly realized from "the scar on his cheek, like the welt from the lash of a whip," that the figure standing on the sidewalk outside was none other than Scarface himself. Ordering her chauffeur to pull over, she sprang out and approached the gangster, introducing herself as the sister of the publisher of the New York *Daily News.* Although Capone appeared to be little impressed by his new acquaintance's connections, it turned out that he was house-proud: he offered to show her around. "And in I went," she reported. The wrought-iron gate closed heavily behind them and Capone began his tour. They passed the long, deep swimming pool, the bathhouse, and the attendants, at once menacing and unobtrusive, who lurked in the shadows of the palm trees.

> I got one good look at Capone himself right out in the sunshine. He has the neck and shoulders of a wrestler, one of those prodigious Italians, thick-chested, close to six feet tall. The muscles of his arms stretched the sleeves of his light-brown suit, so that it seemed to be cut too small for him.
>
> Once I looked at his eyes. Ice-gray, ice-cold eyes. You can't any more look into the eyes of Capone than you can look into the eyes of a tiger.

"Capone sat impassive as a Buddha, yet you began to sense the painful nervous tensity [*sic*] under the stolid exterior." The Washington editor and hostess found her host's management of his staff to be admirable. "Without raising his voice or looking around, he called for a servant. A man in a white apron simply tore into the room. 'My goodness,' I whispered, 'I wish I could get service like that at home.' " Cissy ordered a shot of whiskey, as much to steady her nerves as to gain the confidence of her subject. "He

went on to tell the story of his arrest in Philadelphia for carrying a revolver," she reported.

> Capone's eyes are dime-novel gangster's eyes . . . I could feel their menace. The stirring of the tiger. For just a second I went a little sick. I had to fight the impulse to jump up and run blindly away . . . I had struck full on the sensitive spot. I had aroused Capone for the moment to a flash of real hate and rage.

After a discussion of his tax woes and recent arrests, the gangster and the lady said their good-byes. She had been captivated by him and bade him good luck, generalizing, characteristically, about her own predilections: "It has been said many times, with truth, that women have a special kind of sympathy for gangsters. If you don't understand why, consult Dr. Freud."

Before departing California a month later, in February 1931, Cissy set her sights on even more elusive prey. While relaxing in Palm Springs she learned that Albert Einstein was staying nearby. Emboldened by her good luck in finding Al Capone a willing subject, she marched to the estate where the reclusive world-renowned Nobel Prize–winning theoretical physicist was a guest and asked the butler where she could find him. Directed to a trail leading to a steep, rocky grade, she began climbing, "looked up—and bang! There was Einstein." He sat surveying the "wide and lovely silent desert," wearing nothing more than a handkerchief knotted around his head. "Evidently, the professor was taking a sun bath, whilst contemplating, for he was relativity in the nude," she reported, abashed. "I couldn't go up, so I had to come down, crestfallen and wondering what a regular determined go-getter she-reporter would do under the circumstances." Cissy encountered Einstein again three nights later at the local movie palace, when he and his shock of gray hair sat in front of her through Charlie Chaplin's *City Lights,* which left the celebrity physicist mopping his eyes with yet another white handkerchief.

> There didn't seem to be much need after that in trying to get an interview with Professor Einstein. Why ask him if the universe, space, and time are finite or infinite? Isn't it more interesting to know that Einstein, who understands better than anyone else the sublime arrangement of the universe, can also understand, and weeping, see the heartbreak of a little clown?

If Brisbane wired congratulations on the "wonderful Einstein story" that was in reality more of a nonstory, he also teased her in his "To-Day" column that Nellie Bly (an earlier protégée) would have run for a blanket to cover

her subject for an interview, despite his nakedness. Hearst wrote encouragingly of her humor and pathos: "People read your stuff and enjoy it, and talk about it. These Pattersons surely have a strain of genius."

Expanding her repertoire of subjects had not caused Cissy to forget her old preoccupations or piques once she returned to the capital, however. "My colleagues: I need not say that I am profoundly grateful for this demonstration of your affection," Nicholas Longworth told the House of Representatives fondly at the adjournment of the Seventy-first Congress on March 3, 1931. "Perhaps this is the last time that I will address you from this rostrum," the Speaker continued, to bittersweet applause. "I do not mean to insinuate that I regard it as a probability, but I must admit it is a possibility. The decision lies with none of us here. It is a decision that lies with an all-wise Providence." In the wake of the election of 1930, the new Democratic majority had ended Longworth's unusually lengthy two-term speakership. Feeling run-down in the wake of the session, recovering slowly from a recent illness, and suffering the effects of years of alcoholism generally, he traveled to Aiken, South Carolina, at the end of the month to recuperate, ostensibly while visiting his old friends Mr. and Mrs. James F. Curtis.

While Alice sought refuge from her incompatibility with her husband in her relationship with Bill Borah, Cissy had not been Nick's only extramarital entanglement. Indeed, only two years earlier, Nick Longworth had uttered the notorious one-liner that both characterized his dry wit and lampooned his amorous reputation. One day in the House library, only a few short weeks after the Seventy-first Congress had convened, the Speaker found himself unexpectedly patted on the head by a wiseacre freshman congressman who had already succeeded in making himself generally obnoxious to his colleagues. "You know, Mr. Speaker, that feels just like my wife's behind," the jokester cracked as he stroked the honorable gentleman from Ohio's bald pate. Putting aside what he had been reading, Longworth reached up to run his own hand across his scalp before reflecting, "By golly, it does, doesn't it." As a congressman, the patrician violin virtuoso and bon vivant had by and large garnered the respect, if not the affection, of his colleagues on either side of the aisle. Longworth had also captured the attentions and affections of a number of Washington matrons, known collectively to local gossips (and readers of Eleanor Medill Patterson's *Herald*) as "Nick's Girls." One of these was Laura Curtis, the outgoing Speaker's Aiken hostess.

The mild South Carolina climate had done nothing to improve Nicholas Longworth's health during his visit, however. Rather, within a week of arrival he developed full-blown pneumonia. Learning of her husband's condition, Alice (who had come to terms with his extramarital activities in the

years since his involvement with Cissy) left to be by his side in Aiken. When Cissy heard that one of her "oldest friends on earth" was gravely ill with pneumonia, by contrast, she promptly called her psychiatrist in Manhattan. During those hours when Dr. Alvan Barach was not engaged in the Freudian analysis of millionaires and literary celebrities (or chatting glibly about them to others), he was a pulmonary specialist whose research into "inhalational therapies" had led him to develop the first viable portable oxygen tent. At Cissy's request and expense one of these was dispatched to Aiken forthwith. On April 7, 1931, the *Washington Post* reported, the sixty-one-year-old former Speaker of the House was in "a serious condition," prompting his physicians to administer oxygen throughout the night. Although "oxygen was administered to him all day in a tent-like cover over his bed" all the next day as well, his doctor announced that the patient had "grown rapidly worse," adding that "the outlook is extremely unfavorable." Nicholas Longworth died the following morning, April 9, 1931.

On April 14, 1931, Cissy wrote to grief-stricken Laura Curtis on black-bordered mourning stationery. "I want to send you a word of explanation & sincere regret," she began, adding, "not apology. One might as well apologize for slipping on a banana peel." Three days earlier, amidst its lavish, maudlin coverage of the former Speaker's "Life and Romance," his final illness, and his death, the *Washington Herald* had printed suggestive tidbits on a few of the many "Friends Who Will Miss Nick Longworth" in "Peter Carter Says," the paper's newly launched "effervescent, not too malicious intimate feature" on Washington politics and society. The late statesman would be irreplaceable, of course, to the "FORTY-SIX REPUBLICAN CHAIRMEN OF HOUSE COMMITTEES," to President Herbert Hoover, and to old friends like journalist Bill Hard. Others would feel his loss keenly as well, "Peter Carter" contended. Among these the columnist listed "LAURA CURTIS, social whip-cracker at whose house Nick finally died," before naming several other prominent (not to mention "beautiful, debonair," or "coquettish, charming") Washington ladies, both married and unmarried, who had enjoyed unusually close "friendships" with "Nick."

In writing her note of nonapology to Laura Curtis, Cissy admitted that the "Peter Carter Says" piece had been in "such disgusting bad taste that *everyone* on the editorial side was thoroughly upset." At the same time, however, the *Herald*'s editor firmly repudiated any personal responsibility for its appearance in print. "People seem to think that the editor of a paper knows about every scrap of news content or feature stuff as it goes to press each day," she lamented. "This, of course, could not be true." The copy had

come in so late that particular evening, she went on to explain, that the society editor had already gone home. Unfortunately, the managing editor was "on a slight 'toot'—(still is)." Inasmuch as there had been no one in the city room "with either the sense or authority to put the brakes on," the column had gone straight down to composition to be set up and printed. Emphasizing breezily how hurt she herself had been by the piece in light of her own *long* intimacy with the deceased, Cissy insisted, "Nick would understand if I could only tell him."

On April 24, 1931, having received no response from her correspondent, Cissy took up the gauntlet. Claiming to have heard the rumor that after reading the *Herald*'s "Friends Who Will Miss Nick" piece, Laura Curtis had had the effrontery to declare she would never again set foot in 15 Dupont Circle, Cissy leapt to insist that she had no intention of inviting her in any case. In fact, for some time she had given her correspondent no thought whatsoever until hearing of the Speaker's recent illness. "If you believe that I had previous knowledge of the 'Peter Carter' article," Cissy reasoned indignantly, her recent condolence letters not only to Laura Curtis, but to Nick's other lovers (whom she enumerated just as "Peter Carter" had done) must necessarily have been "dishonest." In that light, "you have proved yourself as singularly lacking in both intelligence and good taste," she informed the grieving mistress. If Cissy protested perhaps too much and too spontaneously that she had had no foreknowledge of the offending article, she would never volunteer the true identity of its author. Although there would be a succession of *Herald* scandalmongers who likewise took refuge behind the pseudonym "Peter Carter" over the course of Cissy Patterson's tenure at the paper, the first of those she quietly hired—and the

The only woman editor of a major metropolitan daily newspaper in the United States: Eleanor Medill Patterson of William Randolph Hearst's morning *Washington Herald,* December 1931

one who had shown no compunction about slinging mud at the dearly departed former Speaker was none other than the editor's close friend and former son-in-law, Drew Pearson.

Washington Merry-Go-Round

Y ou remember that when we were married we used to talk sometimes about a possible reunion?" Drew Pearson wrote Felicia Gizycka on April 9, 1930, from London, while covering the latest naval conference. "I confess that I had completely put this out of my head and rather expected that you would get married rather soon," he continued disingenuously. "That is, up until very recently. Recently I have been wondering about it." He assured his ex-wife that he had become self-sufficient in every regard since their divorce. He had a housekeeper to provide the "comforts of home." He was working hard and rising in the ranks of the capital's journalistic community. He had become involved with a number of other women. He had reached a state of equanimity—or, rather, he was of two minds on the subject of his immediate matrimonial future: "As I told you, I have been thinking of getting married. Actually I have been rather enjoying single life." In short, he had arrived at the ideal moment to extend a dispassionate offer to Felicia that would benefit all involved, their daughter Ellen most of all. He had recently bought, and was refurbishing, two houses next door to each other in Georgetown on Dumbarton Avenue. He proposed to rent Felicia the larger of the two, in which she could live with Ellen, while he took up residence in the smaller. The arrangement would permit him to assist his aging parents with their mounting financial difficulties, and Ellen would grow up with both of her parents. "I have a lot of things cut out for the next year and will be leading my own life very strictly," he assured Felicia to assuage any suspicion she might have of his lingering determination to resurrect a romantic relationship. Although it appears he never sent this proposition (or the new draft he wrote two days later) for striking a second domestic bargain with his ex-wife, two years after their divorce he had not moved on to the degree that he professed.

Felicia, by contrast, had begun to live the life of the unattached modern girl that she had missed by marrying at nineteen. Although she would later recall herself as "divorced, and really directionless," she continued to write, and managed to publish a few short stories. The week after her mother took the helm of the *Washington Herald,* Felicia had been delighted

to watch a woman laughing heartily on a New York train while reading her own wry short story, "Oh Gee, I Forgot," in Joe Patterson's *Liberty* magazine. With the generous allowance Felicia received throughout the Depression, Arthur Brisbane's lamentations about wealth threatening to stifle literary ability and ambition were as applicable to the daughter as they were to her mother. Still in her twenties, Felicia continued to live in a handsome, well-staffed apartment on Gracie Square in Manhattan. She traveled extensively, finally venturing to central Europe in 1932 to meet her paternal cousins (whom she liked very much, it turned out) and at least one of the half sisters Count Gizycki had sired.

Even by the standards of her fortunate peer group Felicia was unusually privileged. Her income allowed her to vacation at a variety of fashionable resorts. In the summer of 1929 she rented a cottage with Louise Ireland near the beach in Southampton, New York. There, Felicia remembered watching her friend playing with Ellen, lifting her high in the air while the two laughed together without restraint. "I realized that I never really played with her like that," she reflected. "But this didn't make me change." After Drew arrived with presents, paper hats, and party favors for Ellen's third birthday in late July, Felicia resolved to throw her own small celebration for her toddler, with toys and cake, the following day. Echoing Felicia herself in the nursery at Novosielica more than two decades earlier, Ellen responded only by saying, "Go away!" before bursting into tears. "I

"Pretty": Ellen Pearson,
Southampton, New York, 1929

left her alone," Felicia remembered; "the gulf between us widened." She asked Drew not to come for Ellen's fourth birthday the following year.

After meeting the ubiquitous Dr. Alvan Barach at one of Cissy's parties in Port Washington, Louise Ireland had become interested in psychoanalysis and was in the process of working toward a degree in Manhattan while commuting to Long Island on weekends. "Felicia was tough competition for me as she stayed in Southampton and looked and felt great, while I was on the tired side after my week of work at Barnard," Louise lamented in retrospect. One of their weekend guests that summer was Averell Harriman, whom the two friends had met at one of Cissy's parties in Port Washington. The not-yet-divorced thirty-seven-year-old railroad and shipping magnate had been "charmed" by Felicia and reciprocated by inviting both young women to "Arden," his magnificent estate on the Hudson River near Newburgh, New York, early in the fall of 1929. In the course of the tour he gave his colorful group of houseguests that weekend, Harriman remarked that the attic was reputedly haunted, and added that no one dared sleep there. Taking up the challenge, rational Louise determined to test the superstition and volunteered to spend the night upstairs, watching for ghosts—after putting on her "best negligée" for the occasion. "Pretending" to have been frightened in the middle of the night, Louise ran downstairs in the darkness, shrieking, "Ghosts, ghosts!" She had forgotten, however, that on that warm evening the louvered summertime door to her bedroom was closed, and she collided with it in the darkness, head first at a full run, prompting a real nosebleed and genuine tears on the heels of her purported encounter with the supernatural. "When I reached Felicia's room . . . the other guests who had followed me thought that something had really frightened me badly. Several of the guests had suspected that Felicia might be entertaining Averell in her bedroom. I hoped to prove them wrong," Louise remembered, "and was delighted when she came out alone." Indeed, Felicia's romance with Averell Harriman did not last; he would remarry the following spring.

Felicia drifted over the course of the 1930s. In 1932 she published her first novel, *The House of Violence,* a complicated domestic drama, much influenced by modernism and surrealism, which follows a pair of sisters who marry brothers in a lavish Washington society double wedding and afterward set off on their honeymoon as a foursome. It emerges during the couples' wedding night that one of the sisters is in love with her brother-in-law. The novel's descriptions of inebriation are especially vivid, and indeed, alcohol intervenes to complicate the paternity of the children born to one of the couples as all four settle down to married life. Both pairs divorce, and out of the wreckage of her home life the child of one of the

unions (a "little lost debutante, abused, misunderstood and running wild") eventually comes into her own, in stark contrast to her mother, who descends further into alcoholism and dissolution. The book received encouraging notices, but little of the fanfare that had attended Cissy's *Glass Houses* or *Fall Flight*. "Haven't you done enough?" Cissy demanded when the novel (and its portrayal of maternal dissolution) was released, before returning to 15 Dupont Circle to shout, "You're a terrible girl!" at the portrait of Felicia that hung over the grand staircase. As Felicia herself put it in retrospect, "The reading public said—So what? I did not see that the book dripped with self-pity."

Felicia spent much of late 1931 and 1932 living in Geneva, Switzerland, writing another novel and drinking increasingly. Since Ellen had reached school age, the child's health, development, and education had been among the few sources of dispute between her parents. During the months Felicia had Ellen in her custody in Europe she sent insistently glowing reports back to Drew in Washington ("she is alert and bright, and a hundred times improved in every way! And her French is getting good"). While pleading to keep the child with her longer than their custody agreement permitted, however, Felicia expended much of her time, effort, and seeming maternal concern in investigating a Swiss boarding school that friends had spoken of enthusiastically. "I will miss her terribly as she is the grandest companion now," Felicia insisted in August 1932. Nevertheless, shortly after her fifth birthday, Ellen found herself deposited at a spartan, if genteel, mountain boarding school in Gstaad. After Felicia visited several weeks later, she professed not to understand why Ellen burst into tears at the thought of returning to the school's vigorous, outdoorsy program and apple-cheeked companions several years older, who taunted her in German and French. It was best, Felicia concluded, not to return to see her daughter for some time. While she wrote her ex-husband of their child's new milestones, encouraging weight gain, and unprecedented good health, Felicia also offered good wishes that made clear there was no hope of reconciliation. "I do wish you'd get remarried and be happy. Why don't you? You're the sort of man who ought to be married. I am expecting news of a wedding every day. How about it?"

Although Felicia's name would be linked romantically to a number of up-and-coming, or already eminent, statesmen and diplomats over the course of her life, she believed she had at last met her "dream prince, the answer" in Washington after her return from Europe in 1933. A year older than Felicia, Roger Mellor Makins—later the first Baron Sherfield and British ambassador to the United States—was at the time second secretary of the British embassy in Washington. "I, who did not know how to give love, was head over heels 'in love.' I wanted him to love me and make up to

me for everything. He was brilliant and ambitious. He was well behaved and idealistic where women were concerned," she recalled. Makins had been troubled, however, by Felicia's treatment (or, rather, what he saw as her flagrant neglect) of Ellen, whom she relegated to the care of nannies during much of the time they spent together. He noticed, too, that Felicia drank too much—or as she put it, "got tight in his company and told him naughty stories, so I made them naughtier. He finally decided that he did not love me enough, and soon he told me so and said he was engaged to another girl.

"Even then I knew in my heart that I was unfit for the very things I wanted most, a happy marriage, security, a home and love," Felicia admitted. Stunned by the breakup and confirmed in her suspicion that she was a bad mother, she told friends that she intended to get "dead drunk that very night, and stay drunk for a month." Instead, the binge would last a decade. "I think I had the physical allergy right away," she reflected later of the growing reliance on alcohol she developed over the course of the 1920s and '30s.

> A drink never gave me a normal, pleasant glow. Instead it was like a tap on the head with a small mallet. I was a little bit knocked out. Just what I wanted. I lost my shyness. Five or six drinks and I was terrific. Men danced with me at parties. I was full of careless chatter. I was so amusing! I had friends.

After the dinner party on the evening Roger Makins left her, Felicia blacked out for the first time. Never settling long in any of the European or American cities where she lived during the period, in 1933 she rented a house from friends in the Virginia hunt country near Warrenton. She had chosen the area not for love of the chase, but rather, to accommodate her mounting dependence on alcohol. Like the other members of her "hard-riding, hard-drinking" set, she carried the traditional flask into the field on mornings when she rode out. "I merely endured the fox hunting so I could start drinking at lunch time. I would pull out early, and go to the hunt-breakfast and the flowing bowl of milk-punch. By two-thirty in the afternoon I was always tight." She had an affair with a married man from her sporting set. She saw less of old friends like Louise Ireland, but visited her mother at 15 Dupont Circle occasionally, when she ventured into nearby Washington. Drinking heavily during dinner (a "butler or a footman would serve us champagne in vast beautiful silver goblets"), mother and daughter quarreled bitterly. As of old, Cissy attacked Felicia and her friends as lazy, feckless, and directionless. Infuriated, Felicia fought back until one of them grew tired and staggered off to bed. "Cissy very often felt

good the next day and seemed to rather like me. She'd say, with satisfaction. 'Didn't we have a knockdown drag out fight?' " Felicia remembered. "Once or twice I'd get the best of her, and she'd go and hide in The Dower House for a few days."

"Luvie has a surprise for thee when thee comes home," Drew Pearson, still a Quaker, wrote five-year-old Ellen as the child set off for her alpine boarding school in the summer of 1932. Despite her parents' comparatively amicable divorce and her father's expressed and unexpressed hopes of reconciliation in the years since, Ellen's education had been one of the few matters that had generated rancor between Drew and Felicia. In allowing her to remain in Switzerland, Drew had shown himself to be unusually amenable to Felicia's request to temporarily alter their custody arrangement. Sparing Ellen months of suspense before her return to Georgetown, Drew revealed that the surprise awaiting her was "a tiny baby boy."

> He was born just a week ago and he is very round and pink and he has no hair on his head at all. He reminds me of thee when thee was a little baby. Only he is even smaller than thee was. He came while Luvie was at the hospital, and now he is back with his mother and they are staying at my house for a while because my house is cool and theirs is very hot. The little baby is sleeping in thy room with his nurse and I am sleeping in Nanny's room, and Luvie is sleeping in my room. The baby sleeps in a big clothes basket and all he does is sleep and eat. He doesn't cry much—not nearly as much as thee did.
>
> I got thy old baby carriage . . . so that Tyler—that is the baby's name—can sleep in it.

"By the time thee comes home they will have gone back to live at their house, but thee can go and visit them," he assured Ellen.

Luvie Butler Moore, an old schoolmate of Felicia's, had married George Abell, a great-grandson of the founder and publisher of the Baltimore *Sun* and a friend and colleague of Drew's, in Lausanne, Switzerland, in January 1930. After returning to the United States later that year, the Abells settled back in Washington, where they lived briefly with their bachelor friend Drew Pearson in Georgetown before finding their own place nearby. Their marriage had been a rocky one. George Abell's work as a political and diplomatic "Capitol Capers" gossip columnist for the Scripps-Howard papers' *Washington Daily News* had imposed on his home life the strain of late nights on the Washington social circuit—to collect gossip and other material for work, he protested—along with attendant temptations and flirtations. Luvie left him as their second year of marriage began, although

George managed to bring about reconciliation with promises of temperance and renewed fidelity.

Soon afterward, news that Luvie Abell was expecting a baby spread throughout Washington. George (whose reputation ran the gamut from "amusing and delightfully eccentric" and "bohemian" to "obnoxious drunk" and associate of "fast, loose and strange people") had had difficulty keeping his promises to his wife. Luvie's was a difficult pregnancy, and as her due date drew near in the sweltering summer of 1932, George set off on a jaunt to Cuba, returning only the day before the baby's birth. The Central American honey bear he had acquired during his travels ate raw eggs off the Abells' floor and generally "caused considerable commotion in the community," as one of Luvie's friends later clucked. In the meantime, because the Abells' small home was unbearably, if not dangerously, hot, Luvie and her newborn returned home from the hospital to Drew Pearson's slightly cooler, larger house down the street. Two weeks later, leaving his wife and son in Washington, George set off anew, this time for New York to reconnect, he told chums, with a girl he had met in Havana. In the meantime, Luvie returned home to the Abells' with baby Tyler and his nurse. Inasmuch as she was still bedridden after the delivery and George had left the whimpering honey bear tied up beneath her open window, Luvie's recovery was a slow and fitful one.

"I have achieved some reputation—I can travel in various parts of the world from Singapore to Paris and my name is fairly well known in the journalistic field," Drew Pearson reflected at the close of 1930, as he approached his thirty-third birthday. Conscious of the ephemeral nature of journalistic renown, he ventured, "The only thing I can point to is that I have some slight influence—probably overestimated in my own mind—on the affairs of the nation" as a result of Federal Power Commission accounting irregularities he had recently exposed in print. He had continued to freelance during his tenure as the *United States Daily*'s foreign editor, and it was in the course of writing pieces for the Baltimore *Sun* that in 1929 he had been hired on a more permanent basis to report on Washington generally and the State Department and American foreign affairs particularly. In the early years of the Depression he was earning a steady if modest income, which he hoped to supplement with continued freelancing. "I rather enjoy being in debt because it makes me work harder," he assured his parents. "I am getting a little outside work done. I feel very much like one of the bankrupt Latin American governments I have been writing about."

Since his divorce in 1928, his "chief joy" in life was Ellen, he told the woman he never named, but referred to in his correspondence as his "Euro-

pean mistress." He had been involved with a variety of women, proposing unsuccessfully to a few, and conducting affairs with others. Like his "European mistress" (whom he had met while covering the successive naval conferences of the late 1920s and early 1930s) and Amy Charak (who "deserted" him in the spring of 1930, only to resurface looking for a loan of $1,500 once he achieved national notoriety two years later), the women with whom he became physically involved were typically the wives of his friends or colleagues. And, although he was gradually giving up hope of a reunion with Felicia, he corresponded with her fondly and offered advice on her literary career, suggestions for stories she might write during her travels, and contacts among editors to whom she might sell them—their intermittent squabbles about Ellen notwithstanding. "I am having the publishers send you a copy of another book, which may interest you," he wrote his ex-wife in Geneva in the summer of 1932, shortly after she published *The House of Violence.*

The volume Felicia received, *More Washington Merry-Go-Round,* was the hastily prepared sequel to the anonymous compendium of gossip that had swept the best-seller lists the year before. In the weeks after the original *Washington Merry-Go-Round* had been published in the summer of 1931, headlines across the country shouted, "Washington Exposed," "Washington Rocked by . . . Book of Biting Portrayal of Personages," and "Capital City's Chief Figures in Bold and Pitiless Expose." "Perhaps the fact that Congress is in long recess is responsible for this gush of unfathered gossip about politicians," the *New York Times* Washington bureau chief, Arthur Krock, mused. "The author finds few in Washington who are not hypocrites, boobs, saps, climbers or pompous pouter pigeons."

"His whole record throughout the great national disaster is unbelievable or is abysmal incompetence, do-nothingness and reactionary stultification," *Washington Merry-Go-Round* declared of the chief executive who had presided over the Wall Street crash. Of the president personally, the book went on to assert, "perhaps the most important answer to Herbert Hoover's failure is that deeply ingrained in his makeup are two unfortunate characteristics, fear and vacillation, which, coupled with a petty, personal temper, sorely try even his most loyal friends." Capitol Hill was no safer from *Washington Merry-Go-Round*'s barbs than the White House was. Republican senator Henrik Shipstead of Minnesota was a "big, husky, pompadoured Norwegian dentist, rais[ing] the cry of Bolshevism." Shipstead's honorable colleague from Idaho, Senator William Borah, was "individualism in all its glory and all its futility." The book pronounced Senator Burton K. Wheeler of Montana to be "lazy": "He rarely prepares himself for a fight, depending on his sharpness of wit and his many friends, particularly the correspondents, to supply him with information."

Much as the book covered the members of the Senate in its "Sons of the Wild Jackass" chapter, so it characterized the venerable lower chamber of the Congress of the United States as "The Monkey House." "Debate in the House is indescribable," the author (or authors) insisted. "It is a shambles of low humor, impossibly absurd assertions made as statements of fact, violent partisanship, clamor, confusion, and burlesque." In general, *Washington Merry-Go-Round* did not spare the press either, although a few of its members managed to escape unscathed — if not vindicated and applauded:

> Drew Pearson, the *Sun*'s expert on foreign affairs, has the reputation of knowing more about the State Department than most of the people who run it, and to a considerable extent this is true. He has been a fixture at the State Department for so many years that few people realize he was once a . . . vagabond journalist working his way around the odd corners of the world. He was, that is, until he married Countess Felicia Gizycka and came to Washington to get a veneer of respectability. Divorced some years later, Pearson stuck it out in Washington and takes cynical delight in lampooning some of the diplomats who once high-hatted him when he enjoyed less fortuitous circumstances. He is the State Department's severest critic, yet because its members either fear him or value his opinion, he is taken into their confidence on many important international moves.

"Because of his independence he is either loved or hated," *Washington Merry-Go-Round* concluded importantly, "there is no middle ground of affection where Pearson is concerned."

The book was no less pugilistic toward the prominent female members of society in the nation's capital. *Washington Merry-Go-Round* portrayed the vice president's sister, Dolly Gann, whose disputed social rank and purported feud with Alice Longworth had made her a fixture in Hoover-era headlines, in unsparing (if not ungentlemanly) terms, as "well over two hundred pounds . . . arrayed like Solomon when in all his kingly glory" and "determined to have her rightful place and there is no squeamishness about her as to how she gets it."

Washington Merry-Go-Round treated the capital's "half dozen middle-aged or aging ladies who absolutely dominate the social stage" in its "Boiled Bosoms" section. Among the most powerful (that is, the "most fawned upon") of the Washington hostesses and social arbiters the book numbered Alice Roosevelt Longworth, who "through the prestige of her position and the vitriol of her tongue dominates the ultra-fashionable official group more completely than any other whip-cracker." Another of the most prominent of the "Boiled Bosoms" belonged to Mrs. James F. (Laura) Curtis: "Although she left her husband, only to take him back again,

Jimmy has gone to live in New York, from which point of vantage he supplies the cash and watches her crack the whip over her little clique as relentlessly as she once cracked it over him." Among these august ladies Eleanor Medill Patterson also ranked. Although "one of the most gifted women in Washington," the *Herald* editor had unfortunately "dissipated her gifts for the most part on trivialities." The work expounded upon what it called the "Patterson-Longworth War," presenting a version of events that did not comport with the scenario suggested in *Glass Houses,* but rather, one in which Senator Borah rejected the cloying attentions of the former Countess Gizycka in favor of his "intimate" friend, Mrs. Longworth. Eleanor Patterson's "Interesting, but Not True" front-page skewering of Alice Longworth had been "a wow" as a circulation-booster, *Washington Merry-Go-Round* admitted. As Mrs. Longworth had not deigned to respond, however, the editor in chief of the *Herald* had been forced to "be content with giving pretentious dinner parties for Mrs. William Randolph Hearst, interviewing Al Capone and Dr. Einstein, and pretending to enjoy coarse newspaper revelries at which she tries hard to be one of the gang."

"The evaluations, while showing spotty bits of real insight and acumen, are not really evaluations but broadside attacks," the *Charleston (WV) Gazette* complained of *Washington Merry-Go-Round* in general; in particular, it lamented that "the writing is slapdash and irritating in its carelessness and lack of polish." In making similar charges, a number of publications across the country decried *Washington Merry-Go-Round*'s lack of an index (the better to examine the book's stylistic deficiencies, no doubt). On August 13, 1931, George Abell of the *Washington Daily News* revealed that President Hoover had ordered the Secret Service to investigate the authorship of the volume and that a congressional inquiry was likely to follow, as influential Republicans believed the volume to be the work of hostile Democratic agents. By the first week in October, Democrats on Capitol Hill countercharged that the *Washington Star*'s recent refusal to print an advertisement for the best-seller was evidence of an effort at concerted suppression directed from the Oval Office itself. Citing the recent dismissal of Robert Allen from his position as Washington bureau chief of the *Christian Science Monitor* on the presumption of his having contributed to *Washington Merry-Go-Round,* Republican New York congressman Fiorello LaGuardia thundered, "The wrath visited upon writers merely suspected of having written part or collaborated in that book raises an interesting public question. Are we to have unofficial effective censorship notwithstanding the expressed guarantee of free speech in the Constitution?"

Indeed, from the moment of its publication, *Washington Merry-Go-Round*'s anonymous authorship provoked almost as much chatter as its scurrilous content. Like LaGuardia, many took the dismissal of Bob Allen

from the *Monitor* as confirmation of his involvement, but at least as many suspected that Allen had not written the book alone. "The actual author of 'The Washington Merry-Go-Round' has not been definitely discovered," the nationally syndicated gossip columnist Walter Winchell observed. "The best opinion you get from the Washington lads, however, is that it is a symposium of five or six fellows . . . Consensus of opinion is that Paul Anderson of a St. Louis rag, and Drew Pearson of a Baltimore sheet are two of the gangsters," was all Winchell, a prodigious dirt-digger in his own right, had been able to uncover by the end of July 1931, however. Nevertheless, the columnist ventured knowingly, "Whoever wrote the press chapter probably will have his throat cut when nailed." Arthur Krock of the *New York Times* was of a similar mind, suggesting that the denizens of the press gallery should look to the colleague who ranked among the "few approved in the chapter on Washington correspondents" as one of the culprits. "But this crusader, whose daily boast is of his own courage and purity as contrasted with the pusillanimity of his co-workers of the press, would of course have boldly signed his name. Or would he?" Krock wondered shrewdly.

Once Felicia Gizycka received Drew Pearson's gift of *More Merry-Go-Round* (which had been hastily slapped together to capitalize on the runaway success of its predecessor) a year later in Geneva, she experienced none of the confusion that had reigned on the Washington cocktail-party circuit as to its authorship. "If you are sincere in trying to help change our government," she challenged her ex-husband thoughtfully, "perhaps you will soon begin to write constructively."

> Then your friends and enemies will know that you didn't write scandal just to make money. I don't know what your plans are, nor do I really know what lies at the bottom of your external actions. I think you are a very complicated character, and perhaps you cannot understand your own self.
>
> Since being over here, I have pursued thoughts which were started at home a year ago. I think America is a great nation but I think *she* needs everyone's help. By which I mean, every American (I haven't got an eraser, so my last unclear sentence has to stand!). People who are influential, like you, ought to take a certain pleasure in doing good. The word "good" at home is becoming unfashionable, and the romantic and successful words are "smart," "crooked," "slick," "tough," "amusing." This holds true in all forms of society—people who are these things are the heroes of the hour . . .
>
> Uncle Joe is cynical, and he laughs down the word "good." He thinks

everyone has ulterior motives. He almost forces ulterior motives upon people. There are lots of influential men like him, and it is too bad.

You are becoming well-known and if, as you have once told me, you intend to be useful to the country, I think it would be a good thing. I would like to see Ellen grow up with assets in her surroundings, rather than liabilities. I know you agree with me.

If Felicia was unimpressed and felt Drew might use his talents to greater purpose, her mother was not so forgiving. "About the libel suit which you have in mind . . .," Arthur Brisbane cautioned his protégée on September 8, 1932, "it would create a tremendous amount of publicity, all sorts of guessing and gossiping among people that know nothing about the miserable little book." Cissy had opened her copy of *More Merry-Go-Round* aboard the *Ranger* on her way home from a trip to Chicago, arriving at Union Station in Washington "mad as a snake" at the outlandish tale it presented about her. In the fall of 1931, *More Merry-Go-Round* confided, George Abell had slightly rewritten a society blurb from the New York *Herald Tribune* for his *Washington Daily News* column that impugned Eleanor Medill Patterson's hands-on approach to editing the *Washington Herald*. *More Merry-Go-Round* characterized Cissy as "flouncing" through the rival *News*'s city room and into the office of its managing editor, Ralph Palmer, where she abused that "witty social satirist" George Abell in "language which would have brought blushes from a stevedore and which stopped every typewriter in the room."

At this stage in the narrative, *More Merry-Go-Round* took a decidedly louche turn. The unusually personal nature of Cissy's reporting had prompted her at one point to reveal in passing to the *Herald*'s readership the fact that she slept on peach-colored crêpe de chine sheets. The *News* managing editor, Ralph Palmer, had not only read the suggestive references to Cissy's favored bedclothes, but happened also to be a man who "did not suffer from suppressed desires." Shortly afterward, Palmer reportedly called his female colleague at the *Herald* to tell her both of his "great admiration for any woman with her command of profanity" and of his "overwhelming curiosity to come into closer contact with those embroidered crêpe de chine sheets." For this, he was rewarded with an invitation to the upcoming Christmas party at 15 Dupont Circle. Palmer appeared on the appointed evening and whispered suggestively to his hostess that he had come " 'both prepared and determined to enjoy the exquisite luxury of those sheets.' Whereupon he pulled up his trousers, exhibiting underneath a silken cerise pajama leg." Quaking with stifled hilarity, Cissy dragged her newly arrived guest over to the courtly (and soon-to-be-scandalized)

Senator Arthur Capper, Republican of Kansas, to announce " 'Mr. Palmer has come to sleep with me,' " before "assisting in the ceremony of pulling up the trouser leg."

Having failed to enjoy the peach crêpe de chine sheets on the occasion of the Christmas party, Palmer reportedly returned to 15 Dupont Circle, uninvited, some evenings later. The lady of the house was out to dinner, so Palmer made himself at home, chatting with the butler while enjoying several highballs. Time dragged on, and even the butler eventually retired to bed, *More Merry-Go-Round* reported. "Now was the time, if ever, at least to see those famous embroidered crêpe de chine sheets." Tired of waiting for Cissy to return, Palmer lurched upstairs and wandered into a bedroom duly made up with embroidered silk sheets (albeit green ones) on top of which was laid a pair of silk pajamas and matching negligée. Growing tired, he sat down to "renew his vigil" for his hostess. Finding himself uncomfortable, he took off his coat and lay down on the bed. He took off his collar because it irritated his neck. Only after *More Merry-Go-Round* saw him stripped down to his BVDs for the sake of comfort did it suddenly occur to Palmer that he might appear ridiculous should anyone happen upon him. To cover his near nakedness, therefore, he put on the ladies' negligée laid out on the bed (despite its being too small to cover his belly), whereon he lay down and fell asleep. "How many hours elapsed, Ralph never knew. He awoke to hear a woman's voice. It was pitched in a high key, obviously irate," and it was shrieking to two lower-pitched voices about the uninvited overnight guest in Felicia's room. " 'Yes, Madame,' " and " 'We'll get him out,' " the lower-pitched voices responded. "The embroidered crêpe de chine sheets, both peach and green, retained their pristine purity," *More Merry-Go-Round* concluded.

Shortly after *More Merry-Go-Round*'s publication in August 1932, Drew Pearson was fired from his job. His role as Robert Allen's co-author of both *Washington Merry-Go-Round* and *More Merry-Go-Round* had come to the attention of his managing editor, who shouted, "The *Sun* is not a keyhole paper!" before handing him a month's pay and showing him the door. By early September, the identity of the second author had made its way into salacious headlines to revived charges (and renewed, blustering denials) of attempted censorship on the part of high officialdom. In Washington, Drew found himself confronted by angry colleagues, politicians, and diplomats, as well as "Boiled Bosoms" swelling with indignation—most particularly his former mother-in-law's. Cissy had offered him eternal friendship in the wake of his divorce and extra income as "Peter Carter" in exposing "Nick's Girls" to the glare of publicity a year and a half earlier. Little had

she realized that Drew was capable of turning a poison pen on her, when cloaked in opportunistic anonymity.

Although the skewering personal attack had already become her own editorial hallmark in the two years since she had taken the helm of the *Herald,* Cissy distinctly resented receiving similar treatment at the hands of other writers. On September 21, 1932, notwithstanding the recent death of her aunt Kate McCormick, she wrote her cousin Bert to remonstrate with him for the "sympathetic" tone of the *Chicago Tribune*'s reporting on the Pearson affair. "For a long time, Drew denied his co-authorship of the first 'Merry-Go-Round' but this time he was bolder and liked to boast about it," she sniffed.

> Of course, I am pretty mad about the story which Drew wrote about me. Possibly you didn't read it. He describes his own wife's bedroom, and an alleged conversation between Senator Capper, a drunken newspaper man, called Palmer, and myself. Senator Capper has never met this man Palmer—never spoken to him—never heard of him until the publication of the book. The whole story was a tissue of lies.

In an effort both to ingratiate herself with the ever more pompous Colonel McCormick and to guarantee the *Tribune*'s loyalty in the future, she closed by remarking, uncharacteristically, how much she admired her cousin's recent political pronouncements—and her cousin himself. "Nothing that our Mothers' have 'put over' in the past, has ever destroyed the roots of my original . . . affection for you," she assured him. "Somehow, I feel (rather than think) now that Aunt Kate has gone and my Mother no longer seems to care, our relationship all around should go back to what it was originally, one of loyalty and affection." Bert McCormick's response to these heartfelt sentiments was nothing short of blasé. The *Tribune*'s pieces on Drew Pearson's ignominious departure from the *Sun* had struck him as neither sympathetic nor unsympathetic. He had read neither of the books in question ("I am not much interested in the 'Petite Noblesse' of Washington"). He offered himself as an example to his thin-skinned cousin, of how to deal with controversy. "When I hear of unamiable things said about me I try to comfort myself with the thought that 'gossip is the conversation of inferiors about their superiors,' " he informed her before closing with a cursory "Yes" to her professions of family feeling.

Inasmuch as Cissy contended that Drew had been self-serving and "smart enough to put out a story that he was dismissed at the request of Secretary [of War Patrick J.] Hurley, and so martyrized himself to the public," so Drew held that the *Sun* had retaliated against him for his long

deception by calling the quality and accuracy of his work into question. "There is only one thing I hate more than being accused of being a poor reporter and that is being made out to be a liar," he complained to Felicia. The down-and-out newspaperman rationalized his plight in terms worthy of his former mother-in-law, whom he held partly responsible, along with his insistent publisher—and even the long-departed Joseph Medill. "I wanted to take out the part about Palmer and your mother," Drew protested to Felicia, "but the publishers and some of my other associates were all for keeping it in. Remembering the Medill motto I had heard her quote so often of 'When your grandmother gets raped, put it on the front page,' I finally let it stay in, after trimming it down considerably." He also described to Felicia the first glimmerings of the silver (or, as it would turn out, gold) lining of the cloud under which he and Bob Allen found themselves. The controversy had generated some "orders for important magazine articles and . . . a bunch of telegrams from places as far west as Omaha wanting me to speak."

Together, *Washington Merry-Go-Round* and *More Merry-Go-Round* would sell some 190,000 copies by 1940. Pearson and Allen would begin producing a "Washington Merry-Go-Round" political gossip column, syndicated by King Features, in the last months of 1932. The lingering resentment about the two books (and the fears of costly libel judgments they generated among editors) made the column slow to take off, however. Nevertheless, whereas only 18 newspapers subscribed nationwide at the beginning of 1933, some 270 were printing it by mid-1934. At the outset of the Second World War some 350 newspapers across the United States were subscribing. In September 1932, Drew succeeded in placating Cissy with profuse apologies and assurances that the Palmer story would be bowdlerized from subsequent editions. He made good on his word; the offending anecdote was removed in the next edition (although the unexpurgated *More Merry-Go-Round* had already enjoyed three printings in its first month of publication alone). Apparently his apology had been accepted; Drew continued to be Cissy's close friend. Indeed, the *Washington Herald* was the first newspaper to subscribe to the new "Washington Merry-Go-Round" column. Even so, another intimate would venture, in the wake of the controversy Cissy "showed a certain amount of distrust for his motives coupled with a considerable estimate of his ability." During the 1930s, as war approached and Pearson and Allen came to be read (and eventually heard) by an ever-wider audience, Cissy would again take violent exception to the content of the "Washington Merry-Go-Round," this time with vitriolic reminders to her former son-in-law that she had "made" him. And, indeed, in many ways she had.

A Pound of Flesh

In late January 1932 Cissy returned, once again, from a trip to California. By way of thanking William Randolph Hearst for the magnificence of his hospitality at San Simeon, she sent him a Madonna panel for his collection by the fourteenth-century Sienese master Segna di Buonaventura. Even by Hearst's lofty standards as a collector the painting was a treasure, and one which he apparently cherished, inasmuch as he had it hung on the wall of his own bedroom in the castle. More than a gift for her host, the diminutive masterpiece (which Cissy insured for some $20,000* while it was in transit) was also a measure of her gratitude for the opportunity with which he had presented her.

As she approached her eighteenth month on the job as the *Herald*'s editor, Cissy had enjoyed far greater success than anyone could have foretold, or even hoped. On the anniversary of her tenure in August 1931, she was reported to have pronounced, "I'd rather raise Hell than raise vegetables." Aside from either the Hell or the eyebrows she had raised with her editorials, she had performed admirably in pursuit of her stated goals of raising both advertising linage and revenues and, in particular, circulation numbers as well. A year after her arrival in the editor in chief's office (which she had had made over in chintz to the renewed bewilderment of *Herald*'s old guard) Hearst wired Brisbane to tell Cissy: "She is not only our star editor but our star business manager." He was not patronizing her. In late September 1931, Brisbane passed along the supreme compliment that Hearst himself did not believe "Mrs. Patterson could do any better if she were a man or that any man could do better than Mrs. Patterson." By early October, the *Herald* had taken the lead in the morning market, Cissy informed the Chief in ebullient telegraphic capitals:

WE ARE RUNNING REFINED BUT SENSATIONAL FRONT PAGE STREAMER TOMORROW MORNING & FOREVER AFTER QUOTE LARGEST MORNING CIRCULATION IN THE NATIONS CAPITAL UNQUOTE SHELTON OUR CIRCULATION MANAGER VERY CONSERVATIVE MAN SAYS WE ARE EASILY TEN THOUSAND AHEAD OF OUR COMPETITOR AND GOING UP STOP

*The $20,000 she paid for the painting in Siena in 1927 would be the rough equivalent of some $2.4 million according to the Consumer Price Index or $11.4 million based on nominal GDP per capita seventy years later.

By the time the Buonaventura Madonna arrived at her new home in San Simeon in late January 1932, the *Herald*'s lead in the morning market had widened to a small but growing margin of more than 5,000. Moreover, since Cissy's advent as editor in chief, the paper had added more than 11,000 new readers and climbed to third place among the capital's dailies, with 73,923 in circulation. The *Herald* still trailed behind Washington's two leading evening papers, the *Star* and the *Times* (which commanded 108,689 and 100,136 in daily circulation respectively), but had finally surpassed the evening *News*'s 68,830, having already eclipsed the flagging morning *Post*'s 66,743 the previous autumn; the *United States Daily* remained, as ever, in sixth place with 40,058. By April 1932 the *Herald*'s daily average circulation had climbed higher still, to 78,343 and 143,131 on Sunday; Cissy boasted justifiably to Hearst that these figures were the highest ever for any Washington morning newspaper.

As the *Washington Post* teetered on the brink of bankruptcy in 1932, for sentimental as much as for circulation-boosting reasons Cissy made a bid to take over the *Chicago Tribune* comics and features that Ned McLean's paper published exclusively in the capital. When a crestfallen Cissy telegraphed the West Coast to report that she had been unsuccessful, Hearst responded (for equally personal reasons) that he was "perfectly satisfied" not to have the *Chicago Tribune*'s or New York *Daily News*'s offerings in his Washington papers, but added, "do not think Post will amount to anything unless they get our editor and publisher." Moved and astonished at the suggestion that she take on the additional post of publisher, Cissy scribbled a fluttering "How, how do I act?" across the bottom of his telegram. She responded finally by thanking Hearst once again for his many kindnesses. "You know I love to try to be a good editor," she told him, adding, "I would like to be publisher too if you want me to be." Her

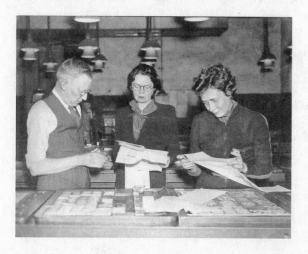

Washington Herald publisher Cissy Patterson with mechanical superintendant J. Irving Belt (left), attending to typesetting issues in the 1930s. Belt would go on to become one of the "seven dwarves," the *Times-Herald* executives to whom Cissy would make the unprecedented posthumous bequest of the newspaper.

leadership had placed the *Washington Herald*'s circulation on an ever-upward trajectory. By 1936 the paper's woman editor in chief and, more recently, its publisher, would more than double its circulation.

Enlivened and emboldened by her early successes, Cissy set about to widen her lead in the morning market and close the general daily circulation gap between the *Herald* and both the *Times* and the *Star.* Like any ambitious editor she sought to achieve her goals by keeping the ablest members of her existing staff and purloining the best talent from elsewhere. At the time of her arrival in August 1930 the *Herald*'s managing editor was Mike Flynn, "a genial, soft-spoken Irishman in a job which had traditionally called for bluster and volcanic indisposition." Flynn had arrived at the *Herald* at the age of nineteen in 1907, straight out of high school in Ellicott City, Maryland, and despite brief stints at the *Star* and the *Post,* had returned to the *Herald* to become the paper's city editor at twenty-one. When Hearst acquired the *Herald* in 1922, he had made Flynn managing editor, the position the latter had retained after Cissy's arrival in 1930. As the *Herald*'s circulation continued to mount over the course of the decade, Stanley Walker, a veteran reporter in his own right, would write in the *Saturday Evening Post* in 1939 that, day to day, "Flynn, it is probable, has taught her more about the technique of getting out a paper—and the art of not making mistakes—than any of her other mentors, amateur and professional, unless it is Brother Joe." Flynn's characteristic lack of bluster had prevented him from joining his frowsy, hard-drinking *Herald* colleagues in snickering disbelief at the advent of a woman editor in chief, and he would come to demonstrate a genuine admiration for Cissy's raw abilities, attesting that she learned quickly and eagerly and was "a natural newspaperwoman with good judgment of her own."

Indeed, she had benefited from the collective mentorship of some of the most successful, experienced, farsighted (if in some cases notorious, even infamous) figures in early- and mid-twentieth-century American newspaper publishing—many of them storied (like Patterson, Hearst, Howey, and White), although many more (like Flynn) were not. Although Colonel McCormick could be elusive on those occasions when Cissy sought his aid, she knew she could depend on her brother in New York (the most successful publisher in the United States in terms of circulation numbers for a single newspaper), for advice, staffing solutions, and, as the New Deal expanded and war loomed closer, content. Brisbane, of course, had taken an active role in her tutelage and Hearst a more distant but no less enthusiastic one. The Chief was an indulgent boss to his lady editor, (almost) without exception delighting gallantly in her every editorial suggestion or improvement to the *Herald,* so much so that early on Brisbane began teasing her about the apparent role reversal: "I can see that you are HIS boss."

Among the windfalls of Hearst's indulgent fondness for Joseph Medill's coddled granddaughter was her entitlement to lay claim to the most capable members of the Hearst organization.

Although Cissy was the first and only woman editor of any newspaper in the Hearst chain, she was by no means the Chief's sole female employee. The son of a formidable mother, William Randolph Hearst himself did not share the low estimate of feminine competence that his *Washington Herald* staff had betrayed when Cissy invaded their city room. Indeed, he had entrusted the design and construction of his estate at San Simeon to architect Julia Morgan and the management and oversight of his extensive European holdings to British executive Alice Head. Never immune to the publicity value of the unusual, he had cultivated a number of crack female reporters, Elizabeth Meriwether Gilmer (alias "Dorothy Dix"), John Reed's widow and Bill Bullitt's second wife Louise Bryant, and Adela Rogers St. Johns, among others. Indeed, Hearst dispatched Adela St. Johns, fresh from her triumphs reporting on the Leopold and Loeb murder trial and the Dempsey-Tunney "long-count" fight, to Washington after Cissy became editor of the *Herald.* During her extended stay at 15 Dupont Circle the "World's Greatest Girl Reporter" (as the Hearst chain billed the youthful grandmother) set about to cover American politics in the same self-referential purple prose that had earlier succeeded in making St. Johns not only "Hollywood's mother confessor," but perhaps the nation's leading "sob sister" as well.

After Cissy hired Jackie Martin away from the Scripps-Howard papers' rival *News,* the superb young photographic and art director would often be credited over the course of the 1930s, with almost single-handedly transforming William Randolph Hearst's tired *Herald* into what was to become Cissy Patterson's sleek, eye-catching *Times-Herald.* Jackie Martin and her staff "of over twenty men" (as *Photography* magazine trumpeted in 1939) shot all of the decade's political conventions and presidential inaugurations, the Lindbergh baby trial, the visit of the king and queen of England to the United States in 1939, the World's Fair, Washington diplomatic receptions, congressional swearings-in, local football and baseball games, tennis and boxing matches, and, naturally, those *Herald* staples, "fires, murders, fashion shows and sudden death," as she recorded it in her résumé.

Given Felicia's diminishing presence in her mother's life over the same period, Cissy developed an unaccustomed reliance on and almost maternal concern for her talented art director. Cissy and Jackie traveled together to the Deep South to cover the plight of the destitute sharecropper while writing and shooting their "Dixie's Dead End" series, which was inspired by James Agee and Walker Evans's *Let Us Now Praise Famous Men.* In 1939,

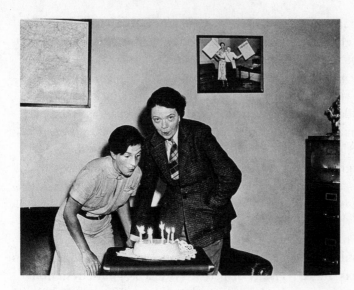

Jackie Martin and
the publisher, who,
according to her
custom, had arrived
at the office fresh
from a ride in
Rock Creek Park

they flew to Atlanta in a chartered plane to report on the premiere of *Gone with the Wind*. Their travels together were not exclusively business-related. When Jackie was recuperating from surgery and the general fatigue occasioned by the demands of her job, Cissy took her to the Bahamas for part of the winter of 1938–39.

Cissy did not simply reinvigorate the *Herald* by borrowing talent from Hearst or poaching it from her Washington competitors, however. Nearly three years to the day after she herself arrived in the *Herald*'s city room, she hired an up-and-coming young journalist named Frank Waldrop. In the course of the next twenty years he would hold "every editorial job open on the paper except in the women's department, photographic shot and in sports, which last has always seemed to me the dullest and least rewarding work on Earth. But on the city side there was absolutely nothing that I missed," he would say decades later,

> and little else of such sordid supplementary work as promotion, planning, budgeting, hiring and firing. My duties ranged from that of reporter to editor of the paper. I defended its character and existence in a strange variety of lawsuits involving not only the government of the United States but numerous private complainants including a fight over the last will and testament of the paper's most unusual owner.

After attending West Point, Columbia University, and Andrew Jackson Law School in Nashville, Frank Campbell Waldrop worked on the *New York Evening Journal* and the *Nashville Tennessean* before arriving at the

Washington Herald in 1933. Born in Veto, Alabama, in 1905, he was the same age as Felicia. As relations between mother and daughter deteriorated, Cissy would come to rely on Waldrop as the son she never had (a few quickly retracted firings notwithstanding).

While the United States languished in the depths of the Depression in mid-1932, *Editor & Publisher* ("The Oldest Publishers' and Advertisers' Journal in America" and the industry standard) reported, remarkably, that daily newspaper sales had fallen less than a fraction of 1 percent overall; in fact, morning and Sunday circulation had risen. With few exceptions, newspaper advertising rates had remained almost unchanged since their peak in 1929, despite a loss of advertising volume of more than 30 percent. In order to maintain circulation rates in the current economy, publications across the nation were forced to undertake unsparing economies. Even so, *Editor & Publisher* predicted, "the profit prospects of most papers are close to zero." Hearst had been willing to sustain the *Herald*'s and the *Times*'s steady annual hemorrhages of some $1.5 million throughout the otherwise profitable 1920s for the sake of maintaining what were in effect morning and evening bullhorns for his views in the nation's capital or, more specifically, on Capitol Hill and Pennsylvania Avenue.* In the early years of the Depression, the employees of the *Herald* were forced to accept no fewer than three 10 percent pay cuts. While Cissy was Hearst's employee (and spending the Chief's money, as Brisbane put it baldly) during the darkest years of the financial cataclysm, she was less concerned about revenues than she was to become later. Indeed, if Brisbane had echoed her grandfather in pushing her hard to increase advertising linage and circulation numbers, in giving advice her brother Joe had set the bar for measuring her success considerably higher—by placing the *Herald* in the black at last.

This was a goal she would reserve for later, however. In the meantime, given that advertising linage and revenues were likely to show few gains, Cissy took particular pride in steadily beating her competitors and improving the *Herald*'s numbers on the more flexible circulation front. To this end, she set about reshuffling the existing staff and seeking outside assistance. Currently running Hearst's Boston holdings, Walter Howey, the old flame who had brought her into the Hearst camp originally, loaned her (at least at first) the means to bring about the gains in readership that she envisioned.

Harry A. P. Robinson had been born in Russia in 1890. After emigrat-

*In 1929 dollars, worth roughly $18 million in the first decade of the twenty-first century according to the Consumer Price Index, or nearly $81 million in terms of nominal GDP per capita.

ing to Boston, the scrappy urchin supplemented his family's income by defending a prime street corner on which he hawked the *Boston Traveler*. When his family moved to Chicago in the first decade of the twentieth century, he became a newsboy for the *Tribune*. Learning from the masters, the *Tribune*'s infamous, brutal, and relentless Moe and Max Annenberg, "Happy" Robinson became a foot soldier in the bloody skirmishes between Joe Patterson and Bert McCormick's *Tribune* and William Randolph Hearst's *Examiner* for dominance over daily circulation in Chicago. Robinson followed the Annenbergs when Hearst poached them from the *Tribune*, and the young tough soon found himself at Hearst's *Boston American* as circulation manager. Relentless, remorseless, and, it was rumored, vicious, Robinson's methods had been so successful that, as he matured, he became a roving circulation fix-it man throughout the nationwide Hearst chain. For the rest of his career Robinson would leave a consistent impression. "Happy came out of those old Chicago circulation wars. Had machine-gun scars all over him," one colleague maintained, adding darkly, "Any problems you had, you'd call Happy, and his thugs would take care of it." "He impressed me as a gangster. He was tough," a female Washington *Times-Herald* reporter would later whisper. "I been tru dis before," yet another Washington colleague was not surprised to hear Robinson remark during a routine staffwide security fingerprinting.

Informed by Howey and no less a figure than the Chief himself that he would have to uproot his wife and move to Washington to help the *Herald*'s new lady publisher, the unvarnished circulation hustler responded flatly, "I'm not going. Then one day," he remembered as an octogenarian, "I look up, and hear this voice saying, 'Hello Happy.' " It was Cissy Patterson, who had come to Boston to plead her case in person. Together, Hearst, Howey, and Cissy persuaded Robinson to serve as the *Herald*'s circulation manager for six months. After the period elapsed, with considerable difficulty they cajoled him to stay in Washington for good. What clinched the deal (besides Mrs. Robinson's grumbling agreement to relocate) was that Cissy promised " 'I'll never interfere with you; I give you my word. I'll never interfere with you in circulation.' And she kept her word," he would recall fondly five decades later.

Cissy developed an indulgent fondness for the old gangster. When she discovered Happy Robinson on the loading dock one day playing craps with his burly circulation crew, rather than fire them all summarily (as was her wont), the publisher got down on her knees and began betting. Trusting Robinson's instincts, she asked his advice when she was uncertain about how to proceed in circulation and other matters. Trusting her instincts, his counsel was always the same: Continue on, or, as he put it, "Folly tru," a phrase she would eventually engrave on a gold watch for him. Through the

nearly two decades they worked together, "the Lady" (as Cissy came to be known among the more deferential members of her staff) inspired an almost chivalric reverence in the battle-scarred veteran of the circulation wars. "She was tops," Robinson would remember with admiration. "What guts she had. She would take on anybody. You couldn't beat her."

Although she had agreed not to interfere in Happy Robinson's vigorous circulation-stimulation program, she did take an active role in observing Arthur Brisbane's commandment to promote advertising gains. The readership of the two dozen Hearst papers published in eighteen cities from New York to California by the beginning of the 1930s was characteristically urban and blue-collar. In Washington, D.C., however, the near-total absence of an industrial working class clamoring for the chain's titillating crime and Hollywood reporting, thrilling features, colorful comics, and editorial jingoism conspired with the open rivalry the Hearst organization encouraged locally between the *Times* and the *Herald* to hobble both papers' advertising and circulation gains—accounting in part for their heavy annual losses. To combat the *Herald*'s reputation in status-conscious Washington as a mere Hearst rag, or as a "backstairs paper" read principally by servants, therefore, Cissy duly threw herself into the fray by offering not only the lowest advertising rates in the capital, but something else no other publisher in town could provide (for the time being, at least): the cachet of the millionaire. "I am very imprudent mentioning your great fortune," Brisbane confessed to Cissy in late May 1931, before elaborating on how her millions might be used (rather than spent) to the *Herald*'s advantage: "it inspires respect in the Washington advertiser which is what you want." And, indeed, Cissy exploited her role as one of the town's most prominent society matrons in the initial, almost effortless task of luring a loftier class of advertiser (local department store and supermarket owners, real estate agents and bankers, along with hairdressers, upscale dressmakers and milliners, caterers, florists, stationers, and jewelry shop owners hoping likewise to curry favor with their hostess) to magnificent 15 Dupont Circle to enjoy her champagne and hors d'oeuvres while rubbing elbows with senators and cabinet secretaries, titled diplomats, movie stars, press barons, social arbiters, nubile post-debutantes, and, occasionally, cowboys. Once her more mercantile guests had been thus lubricated and gratified, they proved (somewhat) more likely to reciprocate by diverting their advertising dollars toward the *Herald* and, indeed, away from the *Star,* the *Times,* the *News,* and the *Post.* Throughout Cissy's publishing career, raising advertising linage and revenues would prove to be consistently more difficult than raising circulation, initially because of general Depression-era tightfistedness on the part of merchants and business owners, but increasingly—especially as war approached—because of intensifying philosoph-

ical division on the issues of the day, most of all, American intervention into the conflicts spreading across the globe.

By way of congratulating Cissy on the *Herald*'s most recent circulation numbers (a "perfectly phenomenal" 96,000) in late July 1933, however, Brisbane admitted that she had come so far so fast that she no longer needed his " 'help' in Washington, unless it should be in the getting of advertising." Resuming his journalistic tutorial now only in the field of advanced advertising, the wily old preceptor urged his pet student, "I should, every single day, proceed to hammer that lead in circulation into the minds of the readers." Her goals of increasing circulation and advertis-

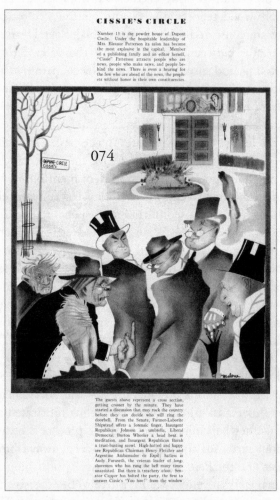

"Cissie's Circle": From Hearst's *Town & Country* magazine, April 1935

ing and, eventually, of making the *Herald* solvent if not profitable, were inextricably linked. "The merchants really know," Brisbane contended, "that they are buying circulation and nothing else, although some of them do not like to admit it. Circulation means PEOPLE, and People buy goods."

The *Washington Herald*'s rapidly rising circulation numbers did not result entirely from Happy Robinson's rough-and-tumble ministrations or Cissy's lavish hospitality, however. Inasmuch as Cissy had begun to bear out Brisbane's pseudoscientific prognostications of her innate editorial abilities, so she had also made good on his forecast that the *Herald* would be "INTERESTING" under her editorship. Within two weeks of taking the helm in 1930, she protested to Hearst himself that the editorial page was "FLAT DEAD," in that it was made up typically of the Hearst International News Service's "CANNED STUFF," reflecting the concerns of working-class readers in far larger, more industrialized cities like New York, Pittsburgh, Chicago, Detroit, San Francisco, or Los Angeles. With little experience to rely on at the time, Cissy's initial instinct to make her paper a reflection of Washington itself would remain with her until the end of her life. In her efforts to "stir up local interest," she made use of the capital's wealth of "excellent writers outside our own staff" (including her own friends, secretaries, cooks, and, eventually, stable managers) to contribute news items, columns, features, and—most especially—local gossip. In short, despite Arthur Brisbane's and Joe Patterson's injunctions against allowing the *Herald* to devolve into a mere "woman's paper," Cissy's steering a course in exactly that direction would prove to be fortuitous, if not farsighted, in light of brewing world events and the radical demographic changes that these would in time force upon Washington. She increased the number of features and columns devoted to domestic subjects (as well as to beauty, lavish photo spreads, society tidbits, local intrigue, Hollywood news, pets, and fashion) almost surreptitiously at first, justifying to Hearst and Brisbane the growing number of what she called her women's and food pages, for example, with allusions to the *Herald*'s rising opportunities to gratify the sought-after local advertiser with the "insidious" editorial product placement that Brisbane both practiced and preached. Feeling vindicated by the end of 1935, Cissy came clean, admitting to Hearst at the end of a list of substantial changes she had brought about at the *Herald,* "We have done our darndest to tie up our women readers to the *Herald.* In time I believe we should considerably enlarge this field. Response so far has been excellent." She justified her delay in informing her boss with characteristic deflection: "I would have submitted these pages to you before, but each week something went wrong . . ." Three weeks later she would sub-

stantiate her hunch. "Happy Robinson says we have gained over 5,000 . . . since putting on women's pages," she telegraphed Hearst on October 3, 1935, adding triumphantly:

WE ARE NOW RUNNING 118,000 DAILY OVER 58,000 CITY HOME DELIVERY TOTAL CITY ABOVE 85,000 STOP FIRST NINE MONTHS OF 1935 HERALD HAD LARGEST GAIN IN PERCENT OF FIELD IN LOCAL ADVERTISING OF ANY WASHINGTON PAPER BOTH DAILY AND SUNDAY ALSO LARGEST GAIN IN TOTAL ADVERTISING DAILY AND SUN- DAY AND SEPTEMBER WAS OUR BEST MONTH OF ALL . . .

If the *Herald* was gradually becoming more of a reflection of Washington and its readership, it had likewise been made over in the image of its tempestuous, attractive, vindictive, generous, witty, petty, glamorous, contrarian, energetic, mendacious, tattling editor and publisher.

Cissy had followed her notorious skewerings of Alice Longworth with material that was as deeply felt, albeit more pragmatic, civic-minded, and humane. Indeed, since her hunting trip to Calgary the summer Felicia ran away, Cissy had retreated and eventually recoiled from her former enthusiasm for blood sports. As her contact with Felicia dwindled, Cissy surrounded herself with animals, almost at all times. "I would rather have a dog like yours than anything I can think of right now," Cissy wrote her cousin Colonel McCormick in September 1939, in response to his offer to send her a "serious-minded lady police dog" of the sort he himself favored, as he grew more fearful for his personal safety with the approach of war. "But I already have two female poodles. One, thirteen years old, probably won't outlast the winter. But the other is only five or six and utterly devoted to me. She is nervous, inbred, jealous, and nasty to all strange bitches," Cissy said with regret. From the late 1920s onward, Cissy was typically accompanied—in her various homes, aboard the *Ranger,* along the banks of Washington's Tidal Basin during her vigorous daily walks (disguised, she believed, from gawkers eager to catch a glimpse of the capital's notorious lady publisher), and even to her office at the *Herald*—by her beloved poodles. Their numbers had dwindled to only two by September 1939, but they had been so numerous before (and would be so again) that they were widely and warily described by others as a "pack." Whatever their number at any given moment, Cissy's poodles maintained an aggregate consistency of temperament. According to the virtually unanimous recollections of Cissy's circle and her household and newspaper staffs, the dogs were almost interchangeable in their nervousness, jealousy, unruliness, ferocity, and single-minded devotion to their mistress.

The publisher demonstrated (in black-and-white) that her own hair and the coat of one of her poodles were of a similar, vivid red.

. . .

In spite of her new career, Cissy still made time for the horses she had always loved. Learning that Tim McCoy's Traveling Wild West Show had gone bankrupt during its engagement in the capital in the summer of 1938, she went to the local stockyards to investigate the welfare of the show's three hundred horses, which were soon to be auctioned off to the highest bidders. There she discovered not only the former star attraction, the magnificent palomino stallion War Chief, but also his trainer, Dave Nimmo, a trick-riding cowboy from Wyoming and a superb all-round horseman, now stranded, penniless, fifteen hundred miles from home. She rescued both immediately. She bought War Chief to perform his act free of charge for children at local schools, playgrounds, and horse shows. As the new barn manager at the Dower House, Nimmo continued working with the stallion and introduced Cissy's coddled hunters and show horses to a life more spartan than they had previously enjoyed. Desperate to find someone to save her beloved mount, Lindy, when local veterinarians had failed, Cissy consulted a highly regarded young horsewoman in Prince George's County, Maryland. So impressed was she at the rejuvenating effects of Rhoda Christmas's ministrations on the ancient gelding, that she hired Christmas (much to the latter's astonishment) to author the *Herald*'s new equine and equestrian column in 1938.

The *Herald,* in turn, took up antivivisectionism, animal-rescue fund-raising campaigns, and, indeed, individual animals. In February 1932, when Cissy learned that N'Gi, a six-year-old African gorilla, was languish-

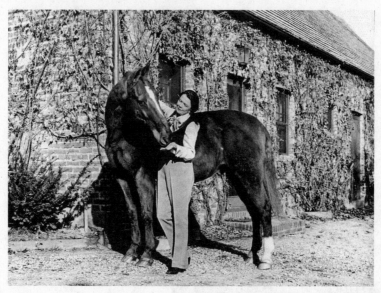

Cissy with the revivified Lindy outside the Dower House stable, 1938

ing near death at Washington's National Zoological Park with bronchial pneumonia, she promptly contacted that sociable psychiatrist–cum–pulmonary specialist, Dr. Alvan Barach, in New York. "N'gi Aided by Oxygen; He Eats a Hearty Meal: Doctor Treating Gorilla for Pneumonia at Capital Finds Heart Is on Right Side," even the *Herald*'s rival *Washington Post,* like papers nationwide, cheered on February 28, 1932. Cissy had paid for one of Dr. Barach's oxygen tents to be dispatched to Washington overnight. Encouragingly, on February 29, N'Gi reportedly stood up and hugged his keeper. The gorilla was well enough to consume a meal of fruits, vegetables, and several lumps of sugar, which he washed down with "two toddies, each of heroic proportions, . . . compounded with two table-spoons of port wine from a bottle sent him by Herr von Prittwitz und Gaffron, the German Ambassador." Despite the careful ministrations of the zookeepers, the get-well-soon cards and calls that poured in by the thousands, and the concern and donations of well-wishers like Cissy, the Barachian oxygen tent would prove no more effective in saving the juvenile gorilla than it had been for the Speaker of the House the year before. N'Gi died in late March 1932.

Given to generalizing about the human condition based on her own atypical experiences, Cissy weighed in on the lurid custody battle raging over little Gloria Vanderbilt in 1934. "With that amazing chameleon-like gift of the American snob, the Vanderbilt clan took unto themselves their dis-

tinguishing characteristics of Old World aristocracy. They acquired a sense of special privilege," the former Countess Gizycka clucked:

> They became saturated with a thoroughgoing belief in the supremacy of their own particular class and kind. Now Mrs. Gertrude Vanderbilt Whitney, great-granddaughter of ferryman Vanderbilt, is convinced that it is not only her duty but her right to take little Gloria unto herself and away from her mother. For you see, little Gloria is a Vanderbilt child. To cut short: The odd thing about the whole affair is that Mrs. Whitney and her clan appear to have lost sight of the fact that Gloria Morgan Vanderbilt is the mother of this child. Flesh of her flesh, blood of her blood, bone of her bone. Born of her loins in anguish and fear. If old ferryman Vanderbilt were alive today, would he not feel pretty disgusted over the whole sorry spectacle?

Although now on distant terms with the daughter for whose custody she had fought so bitterly a quarter century before, Cissy concluded, "Don't you think he would say, along with the rest of plain honest-to-God men and women, 'A Child Belongs to Its Mother'?"

In the depths of the Depression, Eleanor Medill Patterson told *Herald* readers of the night she left behind the luxury, warmth, and safety of her mansion on Dupont Circle (along with her peach crêpe de chine sheets) in old clothes, with little more than a toothbrush and eleven cents in her purse. "Through the glass door, you could see a small light in the little hallway. You ring a short timid ring. You wait. Now you can't put your finger and keep it there, as you usually do," she reflected. "You've got to wait a long time before ringing again. You're Maude Martin. It's 11:45 at night. You're frightened. You're asking for charity." Anxious about the plight of the rising numbers of the destitute, especially women, Cissy disguised herself, assumed the name "Maude Martin" (which, many noted, resembled Felicia's San Diego pseudonym, "Marion Martin"), joined the ranks of the unemployed, sleeping in a Salvation Army women's shelter, eating handouts and applying for jobs whenever possible. Well aware that she was merely "play-acting," the episode nevertheless impressed upon her the widening gulf between wealth and poverty in the United States. Although she had grown by all accounts increasingly punitive and difficult to please in the decades since her return from Europe, she would remember until the end of her life the kindness of the Salvation Army matron who told her, "We never refuse anybody." Cissy examined conditions in the District's public schools in a series called "Suffer the Little Children," which resulted in a hot lunch program that would eventually be federally funded but

which she herself would underwrite in the interim. She investigated the squalor to which the tattered Bonus Marchers had been reduced on the Anacostia Flats of the Potomac, where the penniless World War I veterans waited in vain for the immediate redemption of the certificates that promised deferred compensation for their military service more than a decade before. She pushed for the cleanup of the Potomac River and for the protection of fish and wildlife in the local watershed. The abolitionist's granddaughter excoriated the Jim Crow south.

"Please let me tell you that I am proud to know you, proud to work for you and proud to agree with everything you say in your editorial," Cissy wired Hearst on October 27, 1931, as the country slid further into economic crisis and unemployment crept toward 25 percent. The *Herald*'s editor had been moved to these effusions by the Chief's editorial, "Create Work for Americans, Mr. Hoover: Forget Europe's Troubles," which had appeared on his editorial pages nationwide the day before, demanding that the ineffectual president abandon the recent stab he had taken at the Gordian knot of European war reparations to focus instead on America first and foremost. "You are the only leader the country has got," Cissy insisted devotedly to her boss. "Maybe I am tiresome but I certainly am sincere." Although Hearst himself would be mentioned as a possible candidate for the presidency in 1932, the Chief informed his editors and publishers nationwide that he was "very much interested" in Speaker of the House John Nance Garner of Texas. On January 29, 1932, Edmund F. Jewell, general manager of the *Washington Herald*'s evening sister paper, the *Times,* responded that he had gone so far as to make contact with the unvarnished Texan, but that "Cactus Jack" was unwilling to announce his candidacy until the close of the congressional session in June. "He seems to be a somewhat colorful character," Jewell ventured dryly of the plainspoken future vice president who would later complain that the second-highest office in the land was "not worth a warm bucket of piss." In this light, Jewell suggested, it might be "a good thing for the Chief to furnish a good publicity man at some time to take care of the publicity of Mr. Garner's campaign until he is willing to accept that responsibility himself."

"I am glad that you decided to go," Arthur Brisbane wrote Cissy on July 5, at the close of the 1932 Democratic National Convention in Chicago, as ever, lending gravitas to the obvious: "It seems to me important for the editor of a newspaper to appear at such a function." Over the previous six months, Speaker Garner's refusal either to promote his candidacy or even to cooperate with his booster at San Simeon had done nothing to deter Hearst's support. "If we want to accomplish anything for him we have got

to do it ourselves and in our own way," the publisher had decided. If the kingmaker was unconcerned about his candidate's aloofness, there was an eager rival for his attentions—or at least for his newspapers' neutrality. A number of emissaries from Franklin Delano Roosevelt's camp had approached Hearst but had been unsuccessful in persuading him that the governor of New York and Wilson's former assistant secretary of the navy was not the dubious internationalist the press baron made him out to be. By early February, the Chief had effectively forced the governor's capitulation to his own isolationism in a speech before the New York State Grange in which Roosevelt repudiated his earlier support of the League of Nations and contradicted his previous statements on European war debts. Publicly and privately, Hearst nevertheless continued to suspect Roosevelt of surreptitious Wilsonian internationalism and remained unconverted for months, until the early morning hours of July 1, 1932. Shortly before the Democratic National Convention's fourth ballot was scheduled to start in Chicago, Joseph P. Kennedy, a Boston-born financier and old Hollywood associate of Hearst, managed to persuade the publisher to throw his weight behind releasing Garner's delegates to Roosevelt. "It makes little difference," Arthur Brisbane wrote his wife of Franklin Roosevelt's resulting nomination on the fourth ballot in Chicago; "neither party shows any intelligence in dealing with this situation."

"I am so glad that Jesus loves me and that you came out today, kerplunk, for the Democratic Party," Cissy had gushed to Hearst at the time of the 1930 midterm election. "It makes life simple, gay and a whole lot more interesting around the office." By April 1932 she wrote the Chief in even more enthusiastic terms: "I love you next best in the world to Joe [Patterson] and for the same reasons. You are the two grandest men I ever knew . . ." Although she continued to think of Hearst fondly, if not reverently, by the end of the decade her contractual obligations and her personal loyalties, tightly entangled as they were with her political convictions, would prompt mounting tensions that only redoubled her long-held desire to publish a paper of her own. As she learned her way around not only the *Herald* but the newspaper industry generally, she took increasing liberties. However reluctantly Hearst had supported Roosevelt in 1932, he would not do so again. Scenting rank Communism in the administration's proposed wealth and inheritance taxes, its support of labor unions, and its efforts to regulate business, by 1935 the Chief had instructed the newspapers in his chain to refer to the New Deal as the "Raw Deal."

Headstrong and ungovernable, Cissy nevertheless followed her brother's example on political matters. Both Pattersons abandoned their grandfa-

ther's Republican Party before the 1932 Democratic Convention in Chicago to lend their support to Franklin Roosevelt (urging the candidate, however, to repeal Prohibition). Nevertheless, on March 6, 1933, the first working day of the Roosevelt administration, the New York *Daily News* made the extraordinary pledge to withhold even "constructive criticism, to give the new leader a chance" in light of the unprecedented difficulties he faced, "for a period of at least one year from today; longer, if circumstances warrant." On March 6, 1934, the *News* reported that "we have never regretted that pledge" inasmuch as "we have been in sympathy with almost everything the President has done or tried to do or proposed to do . . ." Following suit editorially for the most part, Cissy placed herself at philosophical odds with her employer, testing the limits not only of Hearst's indulgent patience, but also of her contract to edit the *Herald* in accordance with his views. Inasmuch as Cissy harbored a modicum of Joe's old socialism, so she generally approved both publicly and privately of the first New Deal (although less so of the second) and, like her brother, would support Roosevelt's reelection bids editorially in 1936 and 1940 as well, despite their growing doubts about the president's professed neutrality in the face of the multiplying threats to democracy beyond American shores.

At the *Herald,* Cissy began to chafe, too, at the restraints placed on her editorially and aesthetically by the established Hearst formulas. In her ongoing efforts to keep the paper lively, eye-catching, and fresh, she hoped to bring her family's *News-Tribune* features to Hearst's *Herald* throughout the 1930s, without success—and, indeed, without any legal right to do so. At the same time, Hearst, plagued by ill health, faced the ever more likely prospect of bankruptcy and the humiliating loss of the sprawling newspaper empire he had assembled much as he avidly collected important antiques and lavish estates and castles. News that a rival had invaded the sanctum of his editorial pages in Washington was therefore particularly unwelcome. "I am afraid that you have been very mad at me for running Joe's editorials," Cissy wrote Hearst on March 25, 1937, after a distinctive trailing off in the Chief's regular correspondence and an unmistakable cooling in the tone of those few communications he had addressed to her. Notwithstanding her obligation to edit the *Herald* in accordance with Hearst's views, she mustered her formidable powers of wheedling and cajolement to insist to the old publisher, "But that is not fair." As usual, the fault was not hers:

Don't you remember one night during the *entre'acte* at the play, I asked you what you would think of a "Sale" of the Herald to me, complete separation from the Times; separate building, different type dress. "And," I

said, "let's even turn the paper a shade New-Dealish. We could run some
of Joe's editorials." You certainly appeared to be listening to me.

"You were looking right at me," she persisted to the elderly, ailing pub-
lisher, "and two or three times you nodded your head in apparent
agreement."

"I am not mad at you at all or in the least for ANY reason," Hearst
sniffed unconvincingly in response. "I did want to warn you not to overdo
the *News* editorial policy, because it does not gee [*sic*] with ours. I definitely
am NOT a New Dealer or a *News* dealer," he scolded, adding tersely, "I
admire Joe and respect him as an OPPONENT."

If the New York *Daily News* editorials were a source of rancor from
within the Hearst organization, the *Chicago Tribune's* comics and features
became a source of heated dispute from without. Disappointed that her
earlier efforts to buy the *Washington Post* had fallen through, Cissy contin-
ued to keep abreast of the paper's status through her Hearst, *News,* and *Tri-
bune* connections. In November 1930, Brisbane wrote her of renewed
rumors that the *Post* might be for sale in light of the suit for separate main-
tenance and charges of adultery that Evalyn Walsh McLean had recently
brought against her husband, the paper's owner, Ned McLean. His "wild
behavior," Evalyn McLean would later dictate to her ghostwriter, "was at
last revealed to be a progressive madness caused by dissipation." By March
1931, Brisbane had had another idea on the subject of Cissy's eventually
publishing the *Post:* "The great thing now is economy, and economy
always helps a newspaper's circulation." He was proposing not only to con-
tinue using the Chief's money rather than her own, but also, in effect, to
promote economy among Washington newspapers in the form of consoli-
dation. If Hearst bought the *Post,* merged it with the *Herald,* and allowed
Cissy to edit the resulting publication, the paper would have no competi-
tion in the morning field and, as an employee rather than a boss, Cissy
would remain hardworking and ambitious, Brisbane contended: "When
you don't use the owners' money you are obliged to use your brains. Brains,
not money, make a paper."

"I am afraid that the chance to get the *Post* is gone now," Brisbane
lamented to Cissy two years later, in late March 1933, as the paper entered
receivership and the lurid details of Evalyn and Ned McLean's troubles and
dissipations issued from the several jurisdictions where they now faced
each other in court on matters ranging from the dissolution of their mar-
riage to Evalyn McLean's efforts to salvage control of her husband's woe-
fully mismanaged Washington daily for their minor children. "Somebody
will have intelligence enough to know how useful that paper could be
made," Brisbane reflected shrewdly, very likely "one of the cowed Wall

Street crowd." It was "a great pity" not to have been able to acquire the *Post,* he ventured to Cissy, ignoring their boss's mounting financial troubles. "I could have got it, raised the money most easily, but I could not interest Mr. Hearst in the proposition. I don't quite know why, since I wanted to turn it over to him, and combine it with the Herald."

"I am sure that you are interested and pleased now that the cat is out of the bag and that our friend Eugene Meyer appears as your morning rival in Washington," a sporting Brisbane wrote Cissy on June 15, 1933. "Since we could not have the Post for ourselves, I am glad that he has it, for he is an extremely fine young man with plenty of ambition, and he will give you a run for your money, which is important to YOUR ambition." As Brisbane had surmised, a member of the "Wall Street crowd" had indeed seen the value in the *Post* and had acquired it at public auction two weeks earlier. Only the month before, Eugene Meyer had resigned as chairman of the Federal Reserve Board. The financier had immigrated alone to the United States from France at the age of sixteen, eventually earning a fortune in securities and buying a seat on the New York Stock Exchange before coming to Washington as a dollar-a-year man in 1917. There he served first under Bernard Baruch at the War Industries Board, later as Wilson's director of the War Finance Corporation and in other government capacities before Hoover appointed him chairman of the Federal Reserve in 1930. Cissy had known both Eugene Meyer and his wife, Agnes, since their arrival in Washington and had maintained the friendship with them in New York, where the couple kept a home in Mount Kisco. "Pugnose, red hair, a ready wit and charm, what more can a woman have?" Agnes Meyer wondered in her diary shortly after meeting the Countess Gizycka at the McLeans' estate, Friendship, during the First World War. In the same entry, Agnes Meyer also sized up her captivating new acquaintance astutely: "As she is extremely feline I shall see to it that I do not get scratched but with that in mind I intend to see what there is in it."

Like Cissy, Eugene Meyer had been attempting unsuccessfully to buy a Washington newspaper since the late 1920s. And like her, he had made not only a number of overtures to William Randolph Hearst regarding the *Herald,* but also several attempts to rescue the moribund *Post* from the dissipated Ned McLean. In 1929, Meyer had offered $5 million to the paper's trustee, the American Security Trust Company. In 1931 he had twice offered $3 million. In the spring of 1933, Cissy paid the recently retired Federal Reserve chairman a visit in Mount Kisco, demanding to know if he intended to make a renewed bid to acquire the now-bankrupt *Post* at auction on June 1. Much as her earlier investigations into purchasing the paper had sparked the interest of those relatives and friends she had con-

sulted (and provoked her rage as a result), so her anxious, testy consultation with Meyer—just as he began to look about him for what to do next— rekindled his interest in going into newspaper publishing. As Meyer's daughter Katharine Graham later put it, in the spring of 1933 Cissy Patterson "knew one important thing: that her future depended on who owned the *Washington Post.*"

On June 1, 1933, a large, colorful crowd of spectators and potential buyers duly assembled at the steps of the *Washington Post*'s offices at Pennsylvania Avenue and E Street. The president and business manager of the *Washington Star* were there, along with representatives of the Gannett chain and some of the capital's other dailies. Representing the Hearst papers were general manager T. J. White; the *Washington Herald*'s editor in chief and publisher, Eleanor Medill Patterson; its business manager, William Shelton; and their counsel. Mary Harriman Rumsey had arrived to bid on behalf of Vincent Astor and her brother, Averell Harriman. Evalyn Walsh McLean had arrived in the company of her sons and her friend Alice Roosevelt Longworth.* Reports on the auction differ as to whether Mrs. McLean—dressed in black, her hair dyed a seasonal pink—had pawned the Hope Diamond to raise cash for her own bids or whether the nearly egg-sized stone blazed ominously at her throat in the spring sunshine. Ned McLean, now committed to psychiatric care, was not present. Eugene Meyer was likewise absent, although for different reasons. Wary of inflating the ultimate sale price in light of his earlier repeated offers of several million dollars, Meyer (in hiding at his Washington mansion on Crescent Place) had instead empowered his lawyer to bid as much as $1.7 million anonymously on his behalf. By the time the bidding reached $600,000, Evalyn Walsh McLean had dropped out, leaving only two parties— Hearst's representatives and the lawyer for the anonymous bidder—to continue. At $800,000 Cissy pleaded for a delay (as she would do twice more) in order to call Hearst in California and beg him to go higher. She was unsuccessful, however (and once again crestfallen), leaving the anonymous bidder the *Post*'s new owner for a price of $825,000—a considerable savings over Meyer's earlier offers.

"That we have not got the paper is something for the new owners of the Post to worry about," Hearst wired Cissy that afternoon, no doubt relieved

*Indeed, two summers earlier, Arthur Brisbane had written Cissy to say that he had just received a telephone call from Mary Harriman Rumsey in Newport, reporting that "Alice seemed very much interested in the Washington Post, about which she had long talks with Mrs. Ned McLean," adding, as if to inflame Cissy's jealousy, "It would be very interesting if you should find yourself as editor of the 'Herald' competing with 'Alice' and 'Mary' as editors of the Washington Post."

to have been spared the expense of a third Washington paper in view of his darkening financial outlook. "Certainly we need not worry as long as you direct the policies of the Herald."

If Cissy had been again disappointed in her ambition to publish the *Post*, she had at least been able to fulfill her sentimental hope of bringing *Chicago Tribune* and New York *Daily News* features to the *Washington Herald*—or so she thought. She presumed that the Chicago Tribune Company's five-year contract to provide features to the *Washington Post*—including the wildly popular comic strips *Gasoline Alley, Winnie Winkle, The Gumps,* and *Dick Tracy* (most of which had been engendered by Joe Patterson himself)—had been voided by the bankruptcy and, as a result, had not been transmitted to Meyer along with the rest of the *Post*'s assets. The day after the auction, therefore, Cissy arranged to have the comics transferred to the *Herald* as of July 15, 1933. On June 26, the newly revealed owner of the *Post* wrote Arthur Brisbane to warn that the matter was already in the hands of the paper's lawyers, but that he hoped to settle it in a "friendly way" instead. In light of her close connection to the *News* and the *Tribune,* Brisbane responded curtly, Mrs. Patterson would not welcome his "meddling" in the matter. At some point, Cissy herself called Meyer to insist not only that she had acquired the exclusive legal right to publish the comics in Washington, D.C., but that she had a nebulous familial entitlement to them as well; in short, she would fight any attempt Meyer made to reclaim them.

"It is a great opportunity for E. to be a dominant influence in this formative period of the new America," Agnes Meyer reflected of her husband's bid to buy the *Post,* and indeed, Eugene Meyer had embarked on his new venture in much the same spirit in which he had left banking for his government jobs: publishing a reliable newspaper, he believed, was a form of public service. With far less experience of the carnivorous nature of American journalism even than Cissy had had when she entered the field three years earlier, however, Meyer was only just beginning to understand the extent of the devastation that Ned McLean's neglect had visited on the property he had acquired—or the importance of the popular *Tribune-News* syndicate features in keeping what little readership the *Post* could still command. On July 15, 1933, *Gasoline Alley, Winnie Winkle, The Gumps,* and *Dick Tracy,* along with Westbrook Pegler's and Dr. Evans's syndicated political and medical columns, duly appeared in the *Washington Herald*—and in the *Washington Post,* now trailing far behind its rival with some 59,000 in daily circulation to the *Herald*'s 96,000. "Everybody is happy except Meyer," Hearst snickered to Cissy by wire, adding, despite his usual unwillingness to allow opponents' material to appear in his papers, "I know I am."

The triumph was short-lived, however. Meyer filed suit immediately in

the Supreme Court of the District of Columbia. Two weeks later, on July 28, 1933, the court ordered the Chicago Tribune Syndicate and Press Service to continue providing its comic strips to the *Post.* The decision did not prevent the *Herald* from buying the syndicate's features and comics and continuing to publish them simultaneously, however. In order to forestall this scenario, Meyer filed suit again, charging that the *Herald* had induced the *Chicago Tribune* to "cut off The Post's supply of comics." Two days later, on August 1, the court granted a temporary injunction suspending the *Herald*'s publication of the comics. For nearly two years the matter would go unresolved as both publishers filed an almost constant volley of suits and countersuits in New York and District of Columbia courts.

As the publishers' former friendship deteriorated into bitter animosity, their squabble manifested itself in the pages of their respective newspapers. Few inaccuracies or typographical errors escaped without bluster in the rival publication amidst ceaseless snide cracks, journalistic taunts, and mutual recriminations. The *Herald* caricatured the *Post*'s emblem, the crowing cock. Cissy ridiculed her rival's nearly reporting an erroneous verdict in the lurid 1935 Lindbergh kidnapping case under the banner headline HAUPTMANN GUILTY BUT ESCAPES ELECTRIC CHAIR. Although Bruno Richard Hauptmann had been convicted of kidnapping, extortion, and first-degree murder, for which he had in fact been sentenced to die, and although the *Post*'s editors had caught the mistake before the edition hit the streets, the *Herald* had purloined a scuttled copy nevertheless—publishing a facsimile on its own front page under the embarrassing banner headline FALSE VERDICT FOOLS READERS — WRONG AGAIN! In her next attack, headlined YOU ASKED FOR IT EUGENE, Cissy responded to the *Post*'s claims that teenage hooligans had stolen and dumped thousands of its recent editions by accusing her enemy of engaging in an old, fraudulent, and widely used circulation-boosting practice instead—adding that she (and the authorities) had the photographs to prove it. "Dear Eugene," she began in one of her venomous front-page editorials:

Would you be terribly surprised to learn that none of those papers were ever stolen by the Washington public, in whom you have so little faith?

But, as a matter of fact, were they ever intended for the public? Has the thought never occurred to you that they were probably never out of the hands of your own employees?

You have so little faith in human nature, Eugene, that you may not believe me when I tell you that thousands of other copies of the *reliable* Washington Post were dumped at the same time in other localities. We have photos of those other ones also. Would you like to see them?

Were those thousands stolen by the Washington public, as you have

said, Eugene, or were they "dumped" papers which the Washington Post in its circulation figures claimed as not paid? I wonder if the Audit Bureau of Circulation will not permit you to call this paid circulation.

Characteristically, Cissy did not add that she and Happy Robinson were intimately acquainted with this time-honored journalistic practice, not only as a result of the Hearst-*Tribune* Chicago circulation wars of the 1910s, but more recently from personal experience. As witnesses would later attest under oath, the *Herald* was not above dumping bundles of its own editions in its efforts to maintain dominance over the morning market in the nation's capital. "Cissy, if you don't stop lying about me," Meyer informed his rival over the telephone at one point, "I'm going to start telling the truth about you." Finally, when the United States Supreme Court refused to hear Cissy's case on April 8, 1935, Meyer and the *Post* won the exclusive rights to the *Tribune* comics in Washington—that is, until the contract elapsed two years later, at which point Cissy wasted no time in snapping them up.

In the meantime, however, the *Post* trumpeted its victory with a six-column, front-page cartoon of its own, showing a Supreme Court justice issuing the order, "To Your Post!" to Andy Gump, Winnie Winkle, Skeezix, and Dick Tracy. Although the *Herald* duly abandoned the strips on Thursday, April 11, 1935, the morning after the permanent injunction went into effect, Cissy contacted Meyer to ask permission to publish the color comic strips in the *Herald* one final time that Sunday, inasmuch as they had already been made up and would be expensive to change. On the advice of counsel to "be nice" in the wake of the recent unpleasantness, Meyer agreed, insisting, however, that the *Herald* acknowledge the unusual editorial courtesy in Cissy's particular sanctum, a front-page box. Cissy never called back to agree. Exasperated with his competitor, Meyer ordered that the *Post* publish its own front-page notification that the disputed comics would appear one last time in the Sunday *Herald,* special courtesy of the *Post.* In the meantime, unbeknownst to Meyer, Cissy had acquired replacement comic strips and features from another syndicate, which duly appeared that Sunday in the *Herald,* cost be damned. Discovering too late that the *Post*'s announcement amounted to free advertising for his enemy, Meyer was forced to make his own expensive stop-the-presses change by killing the notice and resetting the Sunday *Post*'s front page.

Shortly afterward, LeFort, Cissy's hapless chauffeur, arrived at the Meyer residence on Crescent Place with a magnificently wrapped floral box, suggestive of an apology. Upon opening it, Meyer found a note which read "So as not to disappoint you," as well as a smaller box, entwined in orchids. When the *Post*'s publisher opened it, he found that his antagonist at the

Herald had sent him a piece of raw meat. Puzzled, it took a moment for the full ugliness of the Shylock "pound of flesh" reference to impress itself on Agnes and Eugene Meyer—along with the fact that their former friend, notorious as she was for her temper and her vindictiveness, had been capable of a gesture so grotesque and anti-Semitic.

Although seldom troubled by contrition, even Cissy herself would later admit that she "made a mistake that time."

<h2 style="text-align:center">The damndest newspaper
ever to hit the streets</h2>

These past seven years have passed like a dream—the grandest and most brilliant adventure of my life," Cissy wrote William Randolph Hearst in the summer of 1937, as the anniversary of her arrival at the *Herald* approached. "But these last seven years I hope and believe will pale before the next five. Because at the end of five years, I pledge myself to return to you two properties of which you will be justly proud," she added. A year earlier, in August 1936, hearing rumors of Eugene Meyer's efforts to buy the *Post*'s morning rival, Cissy had wheedled, pleaded, and even wept over the transcontinental telephone line to a still-reluctant Hearst to lease the *Herald* to her instead. He had little choice but to agree.

Amidst nationwide protests against yellow journalism generally and the Hearst chain in particular, the Chief's imminent financial cataclysm had forced him, as he put it painfully, to turn "the conduct of my papers over to my representatives." Indeed, so close to the precipice had the Hearst organization come that Marion Davies and Cissy together quietly pledged some $2 million of their own money over the course of one desperate weekend in 1937 to permit the Chief the dignity of meeting his most pressing obligations on Monday morning. Plagued by ill health while forced to loosen his grip over his jealously hoarded newspaper properties, Hearst had been deeply affected by the death of Arthur Brisbane in December 1936 (notwithstanding accounts that he had sat through the editor's funeral "impassive as a basilisk"). Cumulatively the *Herald* had lost some $13 million since 1920—nearly $1,116,000 of that figure during the previous fiscal year, 1936.* With Cissy further liberated from the Hearst stylistic and

*Between 1920 and 1936 the paper had lost nearly $200 million as measured by the Consumer Price Index or nearly $911 million according to nominal GDP per capita.

political formulas by her lease, the Chief was reported to be "displeased" by the "play" the *Herald* gave the *News* and *Tribune* comics and features once Cissy pounced on them upon the expiration of the *Post*'s contract. In his financial predicament Hearst could not argue with their success, however. It must have been with mixed emotion, therefore, that he received news of the *Washington Herald*'s circulation reaching its "all-time peak" of 110,000 daily and 223,432 on Sundays—after it began running the *Chicago Tribune* and New York *Daily News* features.

Shortly after Brisbane's death, Hearst general manager T. J. White revived the late editor's often-repeated suggestion that the two Washington papers should be combined. Having already persuaded the Chief to lease her the *Herald,* by the summer of 1937 Cissy also secured a five-year lease-option contract (offset against Hearst's million-dollar debt to her) on his evening *Washington Times* for a period of five years. Although the agreement also required Cissy to assume part of both papers' considerable annual losses, it was a bargain she was delighted to be able to make at last. "I cannot thank you adequately now for everything that you have done for me, or tell you how much your protection and friendship have meant to me. Please do not cut me loose entirely," she asked Hearst, as her new venture made headlines around the country, "For I will want to turn to you for help and counsel just the same in the future as in the past." Amidst the humiliating liquidation of some of Hearst's newspaper, real estate, and art holdings, Cissy hosted a lavish birthday party at 15 Dupont Circle to lift the publishing baron's flagging spirits as he entered his seventy-seventh year in late April 1939.

To be sure, once Cissy became her own boss, she could still (and often did) demand the attention and advice of her old mentors and counselors. With their own titanic preoccupations, however, Hearst, Patterson, and McCormick took only a panoramic view of affairs at Cissy's diminutive Washington publication. Despite Brisbane's death Cissy was not without a guardian angel. T. J. White's widely regarded acumen in the financial side of the newspaper industry would help her chart the course to the ultimate profitability that Joe Patterson had warned would be the true test of her success.

"When I left Paris," Cissy had written Brisbane from Washington in August 1934, "Mrs. Carmel Snow said to me—'You will surely fall in love with my brother. Everybody falls in love with my brother, Tom.' But two days out, I felt inspired to radio her as follows, 'Well, you should meet my

brother, Joe.'" Cissy had just bolted from Europe—and the retinue of Hearst executives and associates with whom she had been traveling—much as she had fled Paris "just in the nick of time" when she had fallen in love with Bill Bullitt. Cissy and Joe Patterson had not been the only siblings to attract the notice of the Hearst organization. In 1932 the Chief hired Carmel Snow, later the "High Priestess of Fashion," away from Condé Nast's *Vogue,* to edit *Harper's Bazaar.* Born near Dublin, Ireland, in 1887, the former Carmel White had emigrated to the United States with her five siblings in 1893, after their father died suddenly and their mother took his place as the representative of the Irish Woolen Manufacturing and Export Company at the World's Columbian Exposition in Chicago. Carmel's eldest brother, Thomas Justin White, born in 1884, had risen meteorically within the

William Randolph Hearst at 15 Dupont Circle for the seventy-sixth birthday party Cissy threw for him in April 1939, shortly after she bought both of his Washington papers

Hearst organization (or "ar-gan-ay-ZEE-tion" as many remembered him putting it in the Celtic lilt he maintained for the rest of his life). After beginning his career in construction and finance, he was hired by the Hearst newsprint-purchasing department in 1925. Within a decade T. J. White had risen to the position of general manager of the Hearst Enterprises—with its twenty-seven newspapers across the United States; its almost 6 million in nationwide daily circulation (more than 7 million on Sundays); its King Features Syndicate, to which some 2,000 newspapers across the United States subscribed; its extensive domestic and foreign magazine holdings; and the 25,000 employees whom it paid some $50 million annually. A formidable manager of publishing properties, Tom White was also dapper, witty, and kind.

Carmel Snow was perhaps two and a half years late in her prognostication that Cissy would fall in love with her brother. On February 6, 1932, Arthur Brisbane had written a teasing letter from San Simeon in anticipation of her imminent arrival aboard the *Ranger* with her traveling companion and colleague, T. J. White. In it, the elderly editor illustrated his

imaginings of their cross-country journey aboard the "chintz chariot" with a drawing of a "very nice little" female boa constrictor cornering a "White" mouse whose front paws are thrown up in apparent surrender. On May 9, 1932, Brisbane wrote Cissy teasingly once again, remarking that in a recent discussion he had had with the general manager, White had referred to Cissy by her first name: "(He seems to be very intimate since the white mouse trip)." Cissy, White, and Brisbane formed part of the Hearst coterie at the Democratic National Convention in Chicago that summer. Brisbane persisted in his needling correspondence regarding the deepening "friend-ship" between his two colleagues throughout the rest of the summer, cul-minating in mid-September with a tart suggestion: "I think Mr. White will be back from the West pretty soon and I think it would be a pleasant thing to ask him and his wife to luncheon some day in New York at the Colony [Club]. What do you say to that?" He illustrated this awkward "Colony Scene," with drawings of "Cissy," "Tom," "Mrs. Tom," and "Me, neglected."

White had married the former Virginia Gillette in 1915, and she had borne him five children. Despite his national prominence as a Roman Catholic layman and the resulting impossibility of his divorce (had the Whites in fact wished to end their marriage), Cissy persisted in the encir-clement of her prey, informing Arthur Brisbane in October 1932 that she had taken an apartment in the Ritz Tower for the coming six months at least. Brisbane's multifarious duties for Hearst were, in effect, only his day job. He conducted a second, extremely lucrative career in real estate devel-opment on the side. In this capacity Brisbane had conceived of and com-missioned the first residential skyscraper, on Park Avenue and 57th Street in Manhattan, in 1926. In 1928, Hearst bought the luxurious forty-one-story Ritz Tower, notwithstanding his burgeoning financial difficulties, and would maintain a magnificent apartment there for Marion Davies until the building was foreclosed upon in 1938 as the result of the Chief's failure to pay the mortgage. In the meantime, the Arthur Brisbanes continued to occupy their own eighteen-room duplex in the building, which was rapidly becoming home to a number of other high-ranking Hearst execu-tives and their families, the T. J. Whites among them. It was likely during the term of Cissy's Ritz Tower apartment lease in 1932–33 that White's young daughter (and her aunt's namesake), Carmel, answered a knock on their door to find the editor of the *Washington Herald* (even more exquis-itely soignée than usual) asking to see the girl's mother. Although ill at the time, Virginia White received her rival graciously, if sadly, and turned down Cissy's purported offer of $1 million to divorce her husband. Cissy persisted that she loved Tom White, to which Virginia White replied, "So do I." Whatever the truth of the tale, the Whites remained married.

. . .

Despite her personal losses of more than $1 million* during the year and a half that she leased Hearst's Washington properties, by January 30, 1939, Cissy had scraped together an additional $500,000 in cash to exercise her option to buy both the *Herald* and the *Times* (already housed, conveniently, in the same building) and merged them. As editor Frank Waldrop put it, the resulting Washington *Times-Herald* was "something not previously seen in metropolitan journalism." Eleanor Medill Patterson single-handedly ushered in the era of twenty-four-hour news in the capital; with five editions daily and five nightly. The Washington *Times-Herald* became the capital's first round-the-clock newspaper. The paper maintained consistent editorial content, comics, features, gossip columns, "women's pages," classifieds, and the like over the course of the day. Its multiple editions gave it an almost unprecedented flexibility, not only to remake its news columns in response to unfolding events, but also to make the daily more available to the reader. "Some of our readers want their paper with their morning coffee," as Cissy put it in her announcement of the merger on January 30, 1939, "while others prefer theirs around noon or when they get home at night." She had "decided to pull up the sluice gates which artificially divided" the two former Hearst papers, for fiscal as well as editorial reasons. In streamlining operations the merger allowed the *Times-Herald* to maintain the lowest advertising rates among its competitors, while offering merchants access to what had become the widest readership in Washington. Merging two staffs into one, however, resulted in the loss of thirty-seven jobs. Amidst rumblings of a Newspaper Guild strike, Cissy explained to assembled *Times* and *Herald* staff members that the redundancies and inefficiencies of running two papers would result in losses which even she could not sustain. Several hundred jobs had in fact been saved by merging the papers rather than closing one, she argued. "I want to save this paper for you and myself because I think you love it as I do. If there is a strike, I will lock the doors and they will never be opened." There was no strike.

In her first decade in newspaper publishing Eleanor Medill Patterson had taken Hearst's "lackluster *Herald,* a chronic tail-ender in circulation and advertising," as *Newsweek* described it, and transformed it into the dynamic, salacious, opinionated, eye-catching *Times-Herald.* The "damndest newspaper to ever hit the streets" would hold a decisive and unassailable lead in the capital market during her lifetime. The effect of the merger

*Nearly $15 million according to the CPI or more than $65 million in terms of nominal GDP per capita.

in 1939 was "electric," one veteran reporter remembered; "Washington went for the combined product like a trout for a fly." At the close of 1940, the combined circulation of the two former Hearst papers allowed her *Times-Herald* to dominate the local daily newspaper market with some 187,090 in circulation to the *Star*'s second-place 144,762. The following year, Cissy noted with satisfaction, "a few dashes of black ink were appearing on the ledger." Eugene Meyer's *Washington Post* followed in third place with 126,708. Although the *Post* was reported to have lost an estimated $200,000 in 1941 (a considerable improvement over the $300,000 in red ink on its books the year before), *Time* magazine would declare Meyer's resurrected *Post* to be "the Capital's sole big-league newspaper . . . a journal of national importance, a reading must on Capitol Hill, an institution of high character and independence, a force for good in its bailiwick." The Scripps-Howard papers' *News* ran fourth in the now four-paper local market with a daily circulation of 81,593. If Cissy had fulfilled beyond anyone's wildest dreams her early stated goals of raising the *Herald*'s circulation and advertising numbers, she would far surpass her brother's even stricter measure of success, by operating the *Times-Herald* not only in the black, but at a profit, initially of some $44,152* in 1944. Within twelve months the *Times-Herald*'s antiwar, anti-Roosevelt, anti-vivisectionist tabloidism would net more than $1 million† in 1945.

Although Cissy Patterson's *Times-Herald* shared the vitriolic isolationism of the other family papers (prompting charges of the existence of a "McCormick-Patterson Axis" from both rival press outlets and the Roosevelt administration), it did not share their ownership structures. Whereas the Tribune Company effectively owned both the *Chicago Tribune* and the New York *Daily News,* Cissy alone owned the *Times-Herald.* In many regards the paper's success was a direct result of its unique corporate structure—or lack of it. As sole proprietor, the tempestuous redhead (who, according to one veteran reporter, "sported an equally red pedicure and temper to match") had no board of directors, no trustees, no stockholders, either to scrabble with or to hold her accountable. As editor Frank Waldrop put it, she owned the *Times-Herald* in "exactly the same way in a legal sense as she owned her clothes and her houses. She wore it and ran it that way, too, and every day we risked her entire property and her very stubborn neck." As publisher, Cissy enjoyed none of the protections that the incorporation of the paper would have afforded. The salty *Times-Herald* led the

*Some $520,000 in the first decade of the twenty-first century according to the Consumer Price Index or nearly $1.3 million as measured by nominal GDP per capita.
†Some $11.5 million or nearly $29 million, measured by the same standards.

capital newspaper market not only in circulation and revenues, but also in the number and size of the libel judgments rendered against it. These Cissy paid out of her own deep pocket, as she did the torts liabilities the paper's staff incurred in the course of doing business. The civil dockets of the District of Columbia from the 1940s are as much a testament to Cissy's devil-may-care attitude toward defamation as to the zeal of Happy Robinson's burly truck drivers and circulation hustlers in completing their appointed rounds, whatever or whoever might stand in their way: other vehicles, pets, elderly pedestrians, or children.

Cissy had placed herself in a position to produce exactly the paper she had long envisioned, editorially and aesthetically. The *Times-Herald* was a pungent hybrid of the most irresistible characteristics of the rival Hearst and Medill family publications, combined with other syndicates' material and her own unique touches. Hearst editorials and regular columns ran alongside Tribune-News Service items; the latter's syndicate provided the bulk of the *Times-Herald*'s comic strips and much of its commentary. In makeup and typography the *Times-Herald* was unique. Cissy scrapped most of the old Hearst typefaces in favor of the lighter Ryerson (later almost renamed "Patterson" in her honor), increased white space in the paper, and printed it in dark gray (rather than black) ink for the sake of elegance and readability. Before Jackie Martin's time, Cissy recalled, "I was forever quarreling with the managing editor's choice of pictures, poor man. I try to have a clean paper." To clarify that she did not refer to the *Times-Herald*'s content, she added, "Clean in typography only."

In her constant efforts to keep the paper entertaining and to boost circulation, Cissy devised countless beauty contests, giveaways, and publicity stunts. At her insistence, several members of her personal staff began writing for the paper. A culinary column (ghostwritten in a folksy southern dialect) appeared under the byline of Cissy's cook, Rebecca. To the renewed astonishment of the old Hearst crew, the equine column penned by Cissy's Prince George's County neighbor and sometime barn manager, Rhoda Christmas, proved to be extremely popular in the capital, situated as it is between the Maryland and Virginia horse countries. It was Cissy's own journalistic contributions that gave the paper much of its notorious bite — and drew much of its readership. She continued to indulge her piques in print by attacking old friends who had fallen away. Likewise, as her patience with the New Deal and Franklin Roosevelt wore thin, particularly as American intervention in the European war appeared increasingly likely, few members of the administration escaped the *Times-Herald*'s excoriation.

· · ·

Cissy's "Hen House": "Pugnacious, pug-nosed Publisher Eleanor ('Cissie'
[*sic*]) Patterson, whose Washington Times-Herald is sometimes referred to as
'The Hen House,' last week wound up one of her mussiest barnyard fights,"
Henry Luce's *Time* magazine remarked in May 1942 of the intensifying
public feud between the publisher and columnist Drew Pearson. "Cissy's
Hen House" included not only popular local postdebutantes or fixtures on
the capital's official party circuit, but some of Cissy's particular friends,
household employees, and favorites as well, whom she often hired to write
the several gossip columns that the *Times-Herald* published concurrently.

Having ignored her brother's warning to avoid that "publisher's grave-
yard," Washington, D.C., Cissy had gone on to disregard Arthur Brisbane's
counsel against producing a women's paper. While the *Times-Herald* trum-
peted its hostility to American intervention abroad, its true focus (its
detractors noted accurately) was predominantly on matters closer to
home—or actually in the home. The fusty incumbents of the Hearst-era
city room found themselves besieged by the gaggles of dewy postdebu-
tantes, local It Girls, sought-after young matrons, "society leaders," and
gentle, Pollyannaish spinsters whom Cissy hired to review local dramatic
productions, cover the parties they attended, and gossip about their friends
in print. She hired society reporter Ruth Jones away from the *Post* in 1930.
In 1932, Cissy added to the *Herald*'s rolls an attractive Lake Forest divorcée
recently arrived in the capital. Martha Blair's "These Charming People"
column soon attracted a devoted following for its uncannily penetrating
coverage of high political society, especially after the author became roman-
tically involved with Arthur Krock, the *New York Times* Washington bureau
chief. In 1937, Cissy succeeded in persuading Evalyn Walsh McLean to

write a regular column, "My Say," in parody of Eleanor Roosevelt's nationally syndicated "My Day." Kathleen (or "Kick") Kennedy, the daughter of Cissy's friend Ambassador Joseph P. Kennedy, began work at the *Times-Herald* as an assistant and graduated to write the paper's "Did You Happen to See?" column in the early 1940s. The tradition would continue even after Cissy's death. Kick Kennedy's future sister-in-law, Jacqueline Bouvier, the slim doe-eyed brunette whom the *Times-Herald* crowned "Debutante of the Year" in 1947, would go on to become the paper's Inquiring Camera Girl in 1951. Although untutored as journalists, the growing ranks of female staff members were cheap to employ and drew a wide following.

Not all of Cissy's many gossip columnists were women, however. "More than anyone I hated to have to ask her for a favor," the Countess Marguerite Cassini confessed after returning to the United States with her two sons before the Second World War, impoverished and humbled. "But I swallowed my pride and went to see her at her office." Cissy welcomed her girlhood friend, touring her around the *Times-Herald* building and introducing her to the staff as "the famous Marguerite Cassini who used to have all Washington on its ear," purring (in what Countess Cassini interpreted as "a mocking tone"), "I used to envy her terribly." "I could not wonder," Maggie Cassini admitted:

> We were about the same age but I looked and felt much older. Cissy, now rich and powerful, was still slender, red-haired, smartly dressed, still rode horseback every morning though she may not have gone to bed until dawn, still gave off a kind of electric zest.

Whatever tension lingered between these two old rivals, Cissy managed to persuade Maggie to allow her memoirs to be ghostwritten and serialized in the *Times-Herald* as "I Lived for Love" (to the countess's enduring embarrassment), in exchange for some $600 and a gossip columnist's job for her elder son. It proved to be a calling which Igor Cassini pursued with such flair and "absolute fearlessness" that, while attending a horse show dance in genteel Warrenton, Virginia, one evening in June 1939, the columnist found himself naked, sticky, and alone in the woods after being waylaid, tarred, and feathered by the angry male relations of a young lady he had covered ungallantly in his "Petit Point" column. Eventually Count Cassini would marry another of Cissy's young society commentators. The beautiful Austine (or "Bootsie") McDonnell Cassini would take over her husband's column after his deployment in 1943. After divorcing Cassini and marrying William Randolph Hearst, Jr., she would graduate from the *Times-Herald* to write the nationally syndicated "From the Capital" column for the Hearst chain.

So pronounced (and, at the time, unusual) was the trend at the *Times-Herald* that by March 1940 Henry Luce's *Time* magazine had begun making wry reference to "Cissie [*sic*] Patterson's Hen House." Enraged as much by the magazine's dismissive epithet as by the unflattering photograph that accompanied it ("it makes me look like a gorilla"), Cissy sought vengeance. Twenty-five-year-old Mary Johnson, the only female member of *Time*'s Washington staff, had been away skiing at the time and had not, in fact, contributed to the offending piece. Nevertheless, determined to suggest that the magazine's publisher was keeping a "hen" of his own, Cissy issued a blistering (and, many contended, libelous), front-page, signed retort insinuating that Johnson was "Henry Luce's Poulette." Before the young reporter had returned from her Canadian holiday, Luce called his Washington bureau to say, "Tell Mary I don't know about her, but I'm flattered." The henhouse reference was perhaps not the true root of Cissy's irritation. Indeed, it had only appeared in passing as part of a larger account of the publisher's unceremonious termination of the *Times-Herald*'s "These Charming People" columnist. "Martha Blair bores me—kill the column," *Time* reported Cissy to have drawled over the phone in mid-February 1940. Although the publisher changed her mind later that evening, Martha Blair had tired of Cissy's growing capriciousness. Having married Arthur Krock, she no longer depended on her $100-a-week *Times-Herald* salary to put her two sons through school. Popular and well-connected in any case, Blair continued to be among the first to hear interesting tidbits of society gossip, which she proceeded to make available to Eugene Meyer's *Washington Post,* free of charge, for the next several days.

Martha Blair's experience of Cissy's volatility was by no means unique. "At the paper, she was always firing, re-hiring, firing, re-hiring. I mean, she was like a bomb, just about to blow up, at any time. Everybody was scared to death of her," one of Cissy's (large) number of former secretaries recalled. "Oh, she'd get very nasty, and some gal at the office she'd fire, or be nasty with, would burst into tears. I'd just stand quietly, and wait till she got through. She'd finally get a twinkle in her eye, then she'd quiet down, and turn her back, and change the subject." Collectively, the *Times-Herald* staff remembered numerous instances of "the Lady's" firing employees on a moment's notice, seemingly for the least infraction. There are well-documented instances of Cissy's terminating staff members for incompetence, shirking their duties, on-the-job drunkenness, theft, embezzlement, and other serious offenses—or, indeed, crimes. At other times, however, she took exception to failings far less grievous, or indeed more aesthetic than anything else. Several old *Times-Herald* staffers remembered Cissy firing a young lady reporter for having eyes too close together. A number of employees remembered colleagues being dismissed for hav-

ing body odor, for getting out of the elevator before the publisher, for not patting her unpredictable poodles when she swept into the office at any hour, night or day. Just as the Swedish maid Aasta had been unceremoniously let go and then kept on at the time of Felicia's angry departure from Flat Creek Ranch in 1924, so Aasta's husband, longtime chauffeur LeFort, was fired and rehired repeatedly, once reportedly for slamming the door of Cissy's limousine on her foot. "One reporter was fired over the telephone when he mistook her voice for a subscriber," the *New York Times* reported. "He was halfway across the country with his wallet full of severance pay when frantic editors intercepted him. It seems Mrs. Patterson dropped in a few days later and noted he was missing. When told she had fired him, she replied blandly, 'Oh, I didn't mean him.'" It was not only the *Times-Herald*'s rank-and-file or Cissy's hapless domestic staff who found themselves constantly on the chopping block. "She fired quite a few of her executives regularly," night managing editor Mason Peters remembered, "including this one. I believe I was fired at least half-a-dozen times, and probably a good many more—for a variety of high crimes, misdemeanors, and various other infractions of Mrs. Patterson's private law."

Inasmuch as the *Herald* had been the only Washington newspaper to support Franklin Roosevelt's candidacy in 1932, Eleanor Medill Patterson was occasionally referred to, even by New Dealers, as the local publisher with the closest White House connections. Increasingly, the reputation came by default rather than by inclination. In September 1932, she had been invited to Hyde Park, New York, to lunch with the Roosevelts, whom she had known, as had her brother and her cousins, almost since childhood. Before leaving Washington, she received a note from Arthur Brisbane, remarking that during his own recent meeting with the Democratic nominee, Governor Roosevelt had spoken "with a great deal of admiration" of his fellow old Grotonian, Joe Patterson. The Pattersons' enthusiasm was mutual, at least for the time being; Cissy wrote in glowing terms of the candidate, of his formidable mother, of his energetic wife, of his attractive children, and of the patrician family seat in the Hudson Valley. Indeed, upon departing Hyde Park, Cissy told readers, "I felt even prouder of my country than I ever felt before, and convinced that this time we are going to have a real American of the finest type once more in the White House— Franklin Roosevelt." Before the inauguration in March 1933, she boarded the *Ranger* to travel to Warm Springs, Georgia, to visit the president-elect. If she enjoyed too much champagne during the dinner she hosted there (and grew aggressive toward some members of the Roosevelt inner circle as a result), it did not affect her feelings for the new chief executive. "Surely there is a special radiance about this man which makes you feel better just

to be around him," she said. He had a " 'bonnie,' frank manner. A high, free spirit. And natural warmth and understanding." At President Roosevelt's inaugural, she chaired the patroness committee and invited the Brisbanes to Washington to attend the festivities with her.

Leasing the *Herald* in 1936 had afforded Cissy only slight autonomy and relief from the tensions that had arisen in the past from expressing editorial opinions divergent from Hearst's. Once again she would follow her brother in supporting Roosevelt's bid for a second term editorially, but with more ambivalence this time. "She isn't for Roosevelt, although she isn't strongly against him," her friend Secretary of the Interior Harold Ickes contended. "She said that she was pulled both ways between Hearst and her brother Joe." Joe, however, was unwavering and outspoken in his support of the New Deal and the president's reelection effort. His campaign donation of $20,000 was one of the largest the Roosevelt coffers received that year from any individual.* His New York *Daily News* was widely touted as the very "bellwether of New Deal newspapers." "I do not think I need to tell you how very splendid you have been throughout," the president, newly reelected in a landslide, wrote the publisher on November 9, 1936. "I have a very strong feeling that the NEWS was worth more to us in the city in the way of votes than all the political meetings and speeches put together." The president was touched that the publisher had organized a nationwide newspaper drive to raise money for a White House swimming pool to allow the polio survivor to exercise while in office. Joe visited the executive mansion frequently during Roosevelt's first two terms; the two old Grotonians enjoyed a renewed cordiality, notwithstanding Joe Patterson's declining the honor of becoming secretary of the navy in May 1940. Indeed, although Cissy was troubled by the proposed "packing" of the Supreme Court in 1937, both brother and sister would be almost alone among American publishers in their continued editorial support amidst the outrage that the attempt generated nationwide.

Cissy grew increasingly skeptical of the chief executive, speaking with a candor the president took for presumption during an ill-advised meeting in April 1938. Her native irascibility perhaps enhanced by the speeding ticket she had received on the way from the Dower House, the lady publisher told the president of the United States plainly not only that fear among businessmen had prompted the renewed recession, but moreover that it was incumbent upon him to re-inspire them with confidence. "All

*Nearly $300,000 in the first decade of the twenty-first century according to the CPI, or some $1.4 million as measured by nominal GDP per capita.

right," the president agreed (in a tone she found patronizing). "Write out exactly what you think I should do to banish fear!" She took up the gauntlet and laid it down, once again, on the *Herald*'s front page. "You once said, with eternal truth, that the only thing to fear is fear itself," she reminded him in a boxed editorial headlined "What You Could Say, Mr President"

> Fear is depressing industry. With due respect, you should concede the obvious. This fear is fear of you.
>
> It is fear of shifting policies; of a hostile attitude toward legitimate business, of insistence on discredited tax methods and other laws which prevent the earning and retaining of fair and honest profits.
>
> It is fear that, if you work out a constructive plan, you won't stay put. It is fear that if a plan of yours is proved bad, you will stick to it stubbornly because you are unwilling to admit that, like all the rest of us, you make mistakes.
>
> Mr. President, you can eliminate this basic cause of the Depression very simply. You command an instant audience of the whole nation. Through a message to Congress or some other vehicle, you should address yourself at once and convincingly to remove the fear that keeps applicants for loans away from banks full of money, and prevents us from turning into profits the greatest store of natural resources and industrial ingenuity in the world.
>
> The chief thing is to eliminate fear and thus restore confidence. You alone can do that. But you must do it thoroughly, forsaking hate and vanity, and resuming that patience with which you so nobly and courageously conquered an illness that would have broken the spirit of most of us.

She concluded by insisting, "You have been a great leader and a great man. You can be again."

After her open letter was reprinted in newspapers across the country, relations between the president and the publisher were further strained by their escalating dispute over Washington's cherry trees. As Democrats suffered crushing defeats on Capitol Hill in the fall of 1938 (the repudiation, according to the *Herald*, of the administration's paternalism), Cissy launched a campaign of her own against that "meaningless, useless, hideous scramble of cold marble and bronze" that the late John Russell Pope had designed as a neoclassical memorial to Thomas Jefferson. In particular, she protested the destruction of the magnificent Japanese cherry trees that the construction would entail at the chosen site along the banks of Washington's Tidal Basin (likewise the site of Cissy's vigorous daily incognito constitutionals, poodles in tow). Although the *Herald*'s editori-

als had created a formidable groundswell of local opposition that had in turn resulted in revised plans to chop down fewer trees, on November 13 she published another editorial, demanding that no trees be harmed at all. After little satisfactory response from the administration, on November 17 Cissy led several dozen outraged local women in intoning poet Joyce Kilmer's "Trees" while marching on the White House with a petition signed by some sixty thousand like-minded citizens. After an altercation with presidential secretary Marvin McIntyre, Cissy and her followers were informed curtly that the chief executive was not available to see them.

Matters escalated on November 18, when the *Herald* declared that "militant District citizens—fighting mad over the threat to hack down the Japanese cherry trees—will take their stand this morning at the south Tidal Basin . . . and defy workmen to so much as break a twig." At this call to arms, some 150 genteel Washington matrons and "club women" bearing chains and padlocks duly thronged the Tidal Basin and began shackling themselves to the threatened trees, while Civilian Conservation Corps engineers and gardeners looked on, agog. "Ignoring the cries of the workmen," some ladies began shoveling dirt back into the site's recent excavations, the *New York Times* reported. Others launched a "frontal attack" by seizing shovels and picks from gardeners engaged in transplanting a tree; the militancy of these particular ladies withered, however, when someone pointed out that the disputed specimen was not a cherry, but a longleaf pine.

At the White House press conference that was taking place simultaneously, Roosevelt pronounced the demonstration to be "one of the most interesting cases of newspaper flimflam" he had ever witnessed. "Webster defines 'flimflam' as 'a deception; a trick; now, especially a trick by which one is swindled,' " the *Washington Post* reported the following morning for the benefit of any readers who had failed to grasp the president's jibe at the *Herald*'s journalistic integrity. It went on to note, however, that the president had engaged in no little flimflam of his own on the subject of the Tidal Basin's Japanese cherries. At the press conference the president had asserted "evasively" that he was powerless to stop or even alter construction plans and warned that anyone interfering with the construction of the memorial would be "gently but firmly transplanted in some other part of Potomac Park." Once the executive ultimatum arrived at the Tidal Basin by courier, the majority of the protesters resentfully laid down their shovels and extricated themselves from their shackles, vowing to seek an injunction against the project. "It is our campaign, so we accept the slap on the wrist proudly," the *Herald* proclaimed the following morning in what had come to be called the "Cherry Tree Rebellion" in the national press. "Though as workers in words, we may shudder at 'flimflam,' " it added,

unable to resist at least a stylistic dig at the chief executive. Cissy's editorial counterattacks notwithstanding, construction continued and a number of the disputed trees met their ends. On December 15, no protesters disrupted the groundbreaking ceremony. "In the days to come," Franklin Roosevelt told a nationwide radio audience from the construction site, "the millions of American citizens who each year visit the national capital will have a sense of gratitude that at last an adequate permanent national memorial to Thomas Jefferson has been placed at this beautiful spot."

If Joe was an enthusiastic supporter of Roosevelt and his agenda and Cissy was at least a supporter through the late 1930s, their cousin in Chicago had been hostile to the president, the administration, and the New Deal almost since the start of the first term. Even at Groton, it was said, relations between Bert McCormick and Franklin Roosevelt had been at best cool. The colonel was skeptical of the administration's "first hundred days." He objected to the National Industrial Recovery Act (or, to use his own term, the "Dictatorship Bill") because of those newspaper-licensing provisions that he took as a threat to freedom of the press, setting himself—and the Midwest's most widely read daily—irreconcilably against the administration, its policies, and its programs by 1934. He decried the government's public spending or "economic dissipation" as a

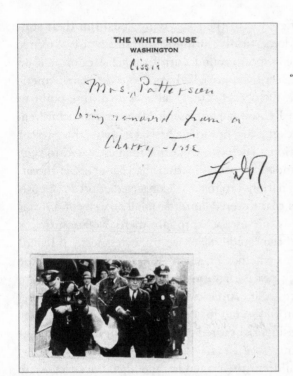

THE WHITE HOUSE
WASHINGTON

Cissie

Mrs. Patterson
being removed from a
Cherry-Tree

FDR

"Mrs. Cissie [*sic*] Patterson being removed from a Cherry-Tree—FDR." Although Cissy fomented, rather than participated in, the Washington "Cherry Tree Rebellion" of November 1938, Franklin Roosevelt's wry (if not wishful) memorandum on the affair augured the souring of relations between the publisher and the president that was to take place over the next three years, as war and the prospect of American intervention loomed closer.

panacea for the Depression. He assailed the multifarious and multiplying New Deal agencies' "interference" in the lives of the individual. He denounced the administration and its programs alike as alternatively fascistic, communistic, and monarchial—in short, as abominably un-American.

The colonel's aversion to the president's foreign policy was not simply an outgrowth of personal or philosophical antipathy; rather it was the reflection of the anti-interventionism, the disdain for northeastern elitism, and the suspicion of Great Britain, her class system, and her geopolitical aims, which he and his cousins had learned at their grandfather's knee. Much like his old rival William Randolph Hearst, the colonel viewed the president as a sneaking Wilsonian internationalist who sought ultimately to entangle the United States in the conflicts raging across the globe. The philosophical incompatibility between the two old schoolfellows played itself out in their private interactions as well. In correspondence, Colonel McCormick refused to salute his commander in chief as anything more august than "Frank." For his part, President Roosevelt insisted whenever possible on using and repeating the childhood diminutive by which he had first come to know his high-ranking enemy. "Tell Bertie McCormick he's seeing things under the bed," the president suggested in response to a reporter's question about the colonel's stance on the NIRA's newspaper code "dictatorship" provisions.

Though the Pattersons differed with their surviving cousin in their support of the administration domestically during Roosevelt's first two terms, they quickly found more common ground with Colonel McCormick on foreign policy as the 1940 election approached. As it did for many Americans of an isolationist bent, October 5, 1937, came as a turning point in relations between Franklin Roosevelt and Joseph Medill's grandchildren. Speaking that day in Chicago, the president asserted that "the present reign of terror and international lawlessness" abroad had escalated to such an extent that "the very foundations of civilization" had come under threat. He called for "peace-loving nations" to make a "concerted effort in opposition" to those governments that fostered "international anarchy and instability from which there is no escape through mere Isolationism or Neutrality" to "quarantine" the "epidemic of world lawlessness." If listeners retained any doubts as to whether President Roosevelt considered the United States to be one such peace-loving nation, the speech did much to erase them: "America hates war. America hopes for peace. Therefore, America actively engages in the search for peace." To many, Joe and Cissy Patterson included, the president appeared to be retreating from the neutrality he had been professing since 1932.

Joseph Medill's grandchildren, their agendas and their loyalties, were

likewise subject to mounting suspicion—and revived charges of "pro-Germanism"—nationwide. "Thank God for Munich!" the *Washington Herald* cheered after the fateful partition of Czechoslovakia in September 1938; Neville Chamberlain's appeasement of German aggression in securing what would prove to be an uneasy and short-lived "peace for our time" at the Munich Conference had rendered the British prime minister "almost Christ-like." Joe Patterson's *News* editorials (which Cissy reprinted in Washington) urged American military preparedness and a peacetime draft, particularly in light of mounting Japanese aggression, although along with continued American neutrality generally. "Teamed up together, the Tribune and the News make up what is perhaps the most effective Isolationist bloc in the daily press. They are supported in Washington by the capital's most widely circulated paper, the Times-Herald . . . ," the *Saturday Evening Post* ventured by the summer of 1941.

When Poland was mowed under by blitzkrieg in September 1939, Cissy was horrified to see the country invaded, overrun, and enslaved once again. She was active in Polish relief throughout the war. She was desperate for news of the lifelong friends she had made there, and particularly of those who had helped in Felicia's retrieval. She sent much-needed food, clothing, and money whenever possible over the course of the war and even made provisions in her will to continue assisting her Polish friends after her death. She offered the Dower House as a home to Ambassador Count Jerzy Potocki (a nephew of her former neighbor, the reformed gambler Count Jozef) when he was unable to return to his homeland after resigning in 1940. But Cissy would not sanction the loss of American lives to settle the European conflict.

Joe continued his friendship with the president through 1939 and 1940, notwithstanding his mounting reservations about his old schoolmate's intentions. "There is a predominant Isolationist sentiment in the United States, I believe, and Roosevelt is acting contrary to the wishes of most of his followers in his present foreign policy," Joe told his friend the Anglo-Canadian press baron Lord Beaverbrook in early 1939. "Of course, in the event of war, our sympathies would get aroused as they did before and we too might be in it." Nevertheless, Joe supported Roosevelt's Destroyers-for-Bases arrangement with Britain. And again, both Pattersons lent editorial support to his campaign for a third term in 1940.

"While I am talking to you mothers and fathers, I give you one more assurance," Roosevelt declared to the American public from the Boston Garden on the Friday before election day:

> I have said this before, but I shall say it again and again and again:
> Your boys are not going to be sent into any foreign wars.

They are going into training to form a force so strong that, by its very existence, it will keep the threat of war from our shores.

"The purpose of our defense is defense," he concluded. Less than a week later, on November 5, Franklin Roosevelt would win reelection to an unprecedented third presidential term with nearly 55 percent of the popular vote.

Cissy's mistrust notwithstanding, several weeks later the president and the first lady received the publisher's warm holiday greetings, a photo card of War Chief, her magnificent palomino stallion, galloping across his paddock at the Dower House: "Here I come! Bringing every best wish for a Happy New Year—1941." Although the Roosevelts would receive Cissy's Christmas wishes a year hence as well—for the last time—in the intervening months relations between the president and the publisher of the capital's most widely read daily soured irremediably. On December 29, 1940, Roosevelt gave perhaps his most important and persuasive Fireside Chat, in which he exhorted America to rouse itself from neutrality, take on an active, if defensive, role in world affairs, and emerge as "the great arsenal of Democracy." "The experience of the past two years has proven beyond doubt that no nation can appease the Nazis," he observed:

No man can tame a tiger into a kitten by stroking it. There can be no appeasement with ruthlessness. There can be no reasoning with an incen-

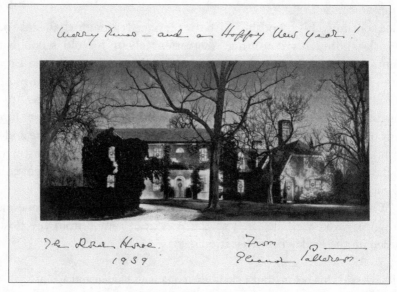

Cissy's holiday card, 1939

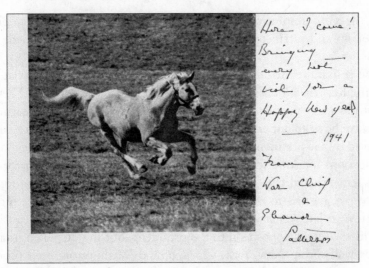

Here I come! Bringing every hot tid for a Happy New Year
—— 1941
From War Chief & Eleanor Patterson

New Year's greetings for the watershed year that would be 1941 from
War Chief and the publisher of the Washington *Times-Herald*

diary bomb. We know now that a nation can have peace with the Nazis
only at the price of total surrender . . .

With the Lend-Lease debate scheduled to begin on Capitol Hill immedi-
ately after the holiday recess, he argued, "The people of Europe who are
defending themselves do not ask us to do their fighting. They ask us for the
implements of war, the planes, the guns, the freighters which will enable
them to fight for their liberty and for our security." Insisting that provid-
ing material assistance would preserve American neutrality by keeping
"war away from our country and our people," the president nevertheless
expressed not merely his admiration of the beleaguered underdog, but his
explicit partiality: "Great Britain and the British Empire are today the
spearhead of resistance to world conquest. They are putting up a fight
which will live forever in the story of human gallantry." He assured the
American public, however:

> There is no demand for sending an American Expeditionary Force outside
> our own borders. There is no intention by any member of your Govern-
> ment to send such a force. You can, therefore, nail any talk about sending
> armies to Europe as deliberate untruth.

The assertion was one that Joseph Medill's grandchildren—and the führer
himself—would seek to hold him to. "We must apply ourselves to our task

with the same resolution, the same sense of urgency, the same spirit of patriotism and sacrifice we would show," the president concluded, "were we at war."

"We're issuing Britain a blank check. We ought to know what we're fighting for," the *News* and the *Times-Herald* worried in response. "Very few of our war party people expect to do any fighting, but they do yearn to see our brave boys go out and fight other people's boys." Feeling deceived and betrayed by the president's invocation of an "Arsenal of Democracy" and its implications for American neutrality (Joe, so much so, that Senator Shipstead remembered the publisher breaking down in tears, charging, "He lied to me, he lied to me!"), by the time the Lend-Lease debate raged in Congress in late January 1941, brother and sister joined their cousin not only in vociferous opposition to the president, but in outspoken isolationism as well. From New York, Chicago, and Washington, each promptly launched editorial assaults on the president and the administration for the apparent postelection reversal on foreign affairs. On January 24, 1941, the *News* and the *Times-Herald* charged that the Lend-Lease bill "gives the President virtual power to take us into war on the side of any country or countries he thinks we should be allied with, and to run our entire war effort without consulting Congress." Brooding on these broad new discretionary powers, the once-laudatory New York *Daily News* and Washington *Times-Herald* now echoed the *Chicago Tribune*'s earlier musings on the NIRA: "Its right name is the 'dictatorship bill' instead of the 'lend-lease bill.'"

In return, the cousins were subjected to a nationwide hail of denunciation in rival press outlets and syndicated columns sympathetic to the administration, which labeled them isolationists and appeasers, impugned their patriotism, and resurrected the specter of "pro-Germanism" that had lingered about them since World War I. "Some few of us think the President has always intended to get us into war," Cissy hissed to her old Jackson Hole friend Rose Crabtree on April 21, 1941, "and that he has led this country as if it were a blindfolded little child—little step by little step along the road into the kind of hell this war will surely be."

In the early 1930s, Ernest Cuneo, a young lawyer who would later become the owner of the North American Newspaper Alliance, arrived in Washington as a legal assistant to Congressman Fiorello LaGuardia. In 1940, Cuneo became an associate counsel to the Democratic National Committee; during the war he would serve in the Office of Strategic Services. Like Bill Bullitt, Drew Pearson, and others before him, Ernest Cuneo was just the sort of intelligent, up-and-coming young man whom Cissy typically "took up" (in this case, platonically)—and eventually broke with over the

issue of intervention. In the course of his legal work in the District, Cuneo would draft one of Cissy's many wills. In his work for the Democratic National Committee, he served as counsel to "a hell of a lot" of syndicated political columnists, whom the administration enlisted to help sway public opinion in favor of the president's evolving foreign policy objectives. Despite Cuneo's own interventionism, he was moved by Joe Patterson's late appearance at a formal dinner attended by Bernard Baruch, Herbert Bayard Swope, and other notables one night at Cissy's home in Port Washington in the spring of 1941. Casually dressed amidst dinner jackets, the tousled Captain Patterson explained that he had been at West Point that day, "lying up in the rocks," watching his nineteen-year-old son Jimmy in training. Not wanting to interrupt the exercises, the elder Patterson had not made his presence known. In the mounting likelihood of American involvement in the global conflict, the decorated veteran of the "war to end all wars," who had known the horrors of the trenches, mortar fire, and mustard gas, had simply wanted to catch a glimpse of his only son.

"When Mr. Roosevelt entered into his third term campaign of 1940," recalled Frank Waldrop, then the *Times-Herald*'s political and foreign editor, "party lines were beginning to blur as the domestic character of the New Deal lost meaning and the partisans of Intervention and Isolation had firm foundations for struggle to control national policy." After Roosevelt's victory, as passions and recriminations mounted on both sides of the debate, particularly in Washington, Cissy severed a number of old friendships. Although she had written William Randolph Hearst of Bill Bullitt's "sincere and powerful effort to face this country toward reality" in August 1940, four years later the man she once found to be the most fascinating in the world assumed a place in that coterie she derided as the "pantywaist brigade": the "assortment of rich, able-bodied and unmarried boys of no particular use to anyone," who served their country without subjecting themselves to the dangers of combat. Bill Bullitt "might have lost his insatiable appetite for intrigue before the present disaster," she snapped, had he "risked his young blood and guts and tears in the last World War instead of cutting dramatic capers at the Versailles Peace Conference."

"How the Hell can you go on with this?" Cissy demanded of Ernest Cuneo in the mounting likelihood of American bloodshed abroad. "*I* wake up screaming!" After what Cuneo described as many pointed "comments" about his work for the administration, Cissy eventually ceased contact with him as well. Cuneo appears not to have been bitter, however. Recollecting a dinner at 15 Dupont Circle in 1941, at which the ardent interventionist Bernard Baruch and the adamant isolationist Senator Burton Wheeler had almost come to blows, Cuneo reflected, "There is no tragedy quite so great as those of great honor who honestly believe opposite things." Although

Cissy might seldom have boasted "great honor" in publishing her increasingly lurid ad hominem attacks on those with whom she disagreed, as with all of Joseph Medill's progeny, her isolationism was the expression of that strain of patriotism with which she had been raised. In the cousins' eyes, it was those who sought to overturn the separatist aspirations of the earliest pilgrims to American shores, flout the revolutionary fervor that had spurred the colonists to throw off the yoke of monarchy, and ignore Washington's and Jefferson's admonitions against entangling foreign alliances, who were contemptibly unpatriotic and un-American.

"Patriotic or Treason"

For all of its success and malevolent appeal, the Washington *Times-Herald* suffered from the distinct handicap of exclusion from Associated Press membership. As Colonel McCormick had warned as long ago as 1928, when Cissy first investigated the possibility of embarking on a publishing career: "The Associated Press is much more necessary to a Washington newspaper than to one in any other city because the Associated Press collects practically all the news of Washington and furnishes it to its Washington members while in all other cities the local newspapers collect the local news and furnish it to the Associated Press." Immediately after the merger in 1939, therefore, Cissy had set about to secure membership for the *Times-Herald*. "But before she was done with the matter," her editor Frank Waldrop mused in retrospect, "her cousin, Robert in Chicago, not to mention a great many other people, could have wished Hearst had never had the impulse to let such a woman loose on journalistic premises."

At the start of the 1940s the AP was operated by its member publications as a self-governing cooperative. New members were admitted by a vote of current members, although according to its bylaws it was possible to withhold admission from applicants in markets already served by the association. The proprietors of Washington's two existing AP member papers—Frank B. Noyes and Samuel H. Kauffmann, co-owners of the second-place *Star,* and Eugene Meyer, of the third-place *Post*—would surely veto any application Cissy made on behalf of the first-place *Times-Herald.* Bearing this in mind, Cissy pestered her friend, Assistant Attorney General Thurman Arnold, with demands to know why the federal government had not pursued the Associated Press on antitrust charges. Initially,

Attorney General Robert Jackson evinced little enthusiasm for bringing suit, but the administration would change its position as 1942 dawned.

On December 4, 1941, the *Chicago Sun* published its inaugural issue, firing the first shot in what journalists nationwide—and, indeed, across the English-speaking world—began to call the "Battle of Chicago." There, Marshall Field III (the grandson of the dry goods merchant who had loaned Joseph Medill the funds to gain the majority stake in the *Tribune* in 1874) launched his explicitly Democratic, pro-Roosevelt daily with the intention of loosening the isolationist *Tribune*'s circulation (and, by extension, news and opinion) stranglehold over Chicagoland. The morning *Sun*'s support of the administration was mutual, in that it had tacit "backing of everyone from the President on down," as Frank Knox, secretary of the navy and owner of the *Chicago Daily News,* put it. It was a double blow to Cissy to discover that former members of her own staff had not only joined the ranks of the *Tribune*'s new rival, but were attempting to recruit former colleagues from her city room as well. The *Sun* and the *Times-Herald* had more in common than a few employees, however. Much as Cissy faced the foregone conclusion of Eugene Meyer's rejection of the Washington *Times-Herald*'s membership bid at the upcoming Associated Press annual meeting, so Marshall Field III faced the certainty of Colonel McCormick's veto of the *Chicago Sun*'s.

"Thanks pal," a waspish Cissy wired Jackie Martin, the former photographic and art department head for whom she had harbored a uncharacteristically maternal affection, on December 11, 1941, care of "The Chicago Setting Sun, Press Bldg Wash DC." The same day, Cissy sent a similarly dyspeptic wire to her former managing editor, George DeWitt, likewise in care of the *Sun,* although at the newly launched daily's home office in Chicago. "I have been told by several people who should know that you have said that you would not raid this office," Cissy snapped.

> I thought this was very fine and generous of you but now in a sly and underhanded way Jackie is trying to take over the best men from our photographic staff sending for them on the quiet with the old business of quote well if ever at any time you are not satisfied and they don't treat you right come to work for me will give you fifteen or $20 raise etc. . . .

The momentous events of the past week, not only at the *Times-Herald,* but nationally and indeed globally, had delayed these outpourings of Cissy's bile.

If Cissy was livid at what she considered to be the perfidy of her former staff members, hers were not the only charges of sedition being bandied about. On the same morning that the *Sun*'s first issue came rolling off the presses—and sold out by ten o'clock—the *Chicago Tribune* and the Washington *Times-Herald* jointly published another first of sorts. In Chicago, their "monumental scoop" appeared to furnish the *Tribune* with "one to put in Marshall Field's eye on his first day out," as Frank Waldrop put it. Nationwide, the story seemed to place both isolationist newspapers in the long-hoped-for position of "show[ing] up Roosevelt for good and all," by revealing—despite the president's many public statements to the contrary—his secret plans to enlist the United States in the global struggle against totalitarian aggression.

At around eight o'clock on December 3, 1941, the evening before the *Sun*'s inaugural issue hit the streets of Chicago, Frank Waldrop finished his dinner at the National Press Club and returned to the *Times-Herald*'s offices to help Chesly Manly, the *Tribune*'s Capitol Hill correspondent, write a story based on the top-secret document that had come into Hanley's possession clandestinely only hours before. The report, "Army and Navy Estimate of United States Overall Production Requirements," code-named "Rainbow Five," was the War and Navy Departments' response to President Roosevelt's July 1941 request for a joint service report detailing the military and strategic requirements for the United States to "defeat our potential enemies." It was the considered opinion of army and navy strategists that Germany and her satellite states could not be beaten by the dwindling number of European powers united in bloody struggle against it. "It will be necessary," Rainbow Five predicted, "for the United States to enter the war, and to employ a part of its armed forces offensively in the eastern Atlantic and in Europe and Africa." This "supreme effort" would require some 10,045,658 American boys to put their lives on the line abroad; nearly half of these troops were to be deployed as part of an American Expeditionary Force in Europe by July 1943. In short, the report was "a blueprint for total war on a scale unprecedented on at least two oceans and three continents," Chesly Manly would reveal in the *Chicago Tribune* and the Washington *Times-Herald* the following morning.* As Waldrop, Manly, their respective publishers, and others as far away as Berlin saw it, Rainbow Five appeared to be

*The New York *Daily News* chose not to reprint the story, reporting instead *about* Manly's scoop in the Chicago and Washington publications. Although the *News* had, of course, received Manly's story over the wire in New York, "some cool head refused it and didn't even bother to tell Captain Patterson," Frank Waldrop would recall. "A few days later I heard [Joe] Patterson say the man had done the right thing both ways, in not printing and not bothering him. That was what he paid editors for, he said, to have sense."

"irrefutable proof that Mr. Roosevelt was lying the United States into war with Germany."

The route by which the document came into Manly's hands remains obscure. Few copies of the original were ever made, and although the report was top secret, the FBI would later determine that the number of suspects within the War and Navy Departments who might have taken it was "legion." However the report left military custody, Republican senator Burton Wheeler of Montana later revealed that on December 3, 1941, an unnamed Army Air Corps captain delivered a thick document wrapped in brown paper, labeled "Victory Program," to his home. In the heat of the Lend-Lease debate eleven months earlier, the president and the senator had come to verbal fisticuffs when Roosevelt condemned as "the most untruthful, as the most dastardly, unpatriotic thing that has ever been said" Wheeler's assertion that the administration's proposed aid to Britain would eventually "plow under every fourth American boy." Confirmed in these fears by the content of the report, and reasoning that more American lives were likely to be saved by passing the secret document to a like-minded reporter than by bringing it before his colleagues on the Senate Committee on Foreign Relations, the staunch isolationist called Chesly Manly of the *Chicago Tribune.* As if by kismet, in accepting the leaked Rainbow Five plan and publishing its contents, Manly likewise fulfilled Colonel McCormick's recent edict to produce "the hottest stories he could find" to eclipse the dawn of Marshall Field's new *Sun.*

As readers eager for a look at the newly launched Democratic organ began lining up at newsstands across Chicago on the morning of December 4, 1941, their attentions were diverted by the astounding banner headline that sprawled across the rival *Tribune*:

FDR'S WAR PLAN!
GOAL IS 10 MILLION ARMED MEN;
HALF TO FIGHT IN AEF

Similarly, readers in the nation's capital awoke to find "F.D.'s Secret War Plan Revealed," according to the *Times-Herald.* Presaging something of the furor that the *New York Times*'s publication of the Pentagon Papers would generate three decades later and that WikiLeaks's release of classified diplomatic dispatches and secret military documents would provoke nearly three decades after that, the leak of Rainbow Five ignited a firestorm in the press; a campaign of finger-pointing and leak-plugging in the military; extensive FBI investigations and interviews over the coming months; and denunciations of treason, conspiracy, and deceit on all sides.

On Capitol Hill, the motion of Republican George Holden Tinkham of the 10th Massachusetts Congressional District, to enter the story into the *Congressional Record* won his colleagues' unanimous support on the House floor. Tinkham's contention that the United States had been betrayed by the Oval Office itself was seconded by his Republican colleague William Lambertson of the 1st Kansas Congressional District, who demanded to know, "If it isn't true, why doesn't the President deny it?" The *Chicago Tribune* and the Washington *Times-Herald* had likewise been quick to note that "the White House did not venture a denial." Indeed, Roosevelt had declined to discuss the story at a press conference on December 5, 1941, leaving White House press secretary Stephen Early to face the onslaught of questions instead. In response to queries on the propriety of republishing the secret war plans in other newspapers across the country, Early ventured pointedly, "It depends entirely on the decision of the publisher or the editor or the reporter whether printing the story would be patriotic or treason." Arthur Sears Henning retorted equally pointedly in a story that ran nationwide in the Chicago Tribune Press Service's member papers, "Early did not explain what he considers treason in time of peace, or whether it would be treason to the persons making the secret war plans, or treason to the people entitled to the information."

If Early had left it to journalists nationwide to ponder whether it was patriotic or treasonable to further disseminate the secret war plans the president had ordered, curiously the United States Office of War Information exhibited no hesitation in transmitting Manly's story to Europe by shortwave radio the following day, December 6, 1941. Battered and standing alone now, Britain received Manly's account of the American plan to intervene as a ray of hope and encouragement, reprinted as it was beneath banner headlines across England, Ireland, Scotland, and Wales. The Office of War Information's transmission had also reached the continent, now under the Axis lash from the Breton coastline to the outskirts of Moscow. The details of Rainbow Five had already arrived in Berlin, however; the German embassy in Washington had cabled a full transcript of the *Times-Herald*'s account of the "Roosevelt War Plan" to the Third Reich's Foreign Office immediately after its publication two days earlier. The German high command was already hard at work, scrutinizing the "Anglo-Saxon war plans which became known through publication in the Washington *Times-Herald*" for the consideration of the führer himself.

While the Office of War Information transmitted Manly's story to Europe, Cissy's former friend, Secretary of the Interior Harold Ickes, pressed President Roosevelt to indict those responsible for the publication of the Rainbow Five plan on conspiracy charges. At the same cabinet meeting in Washington, Attorney General Francis Biddle called for prosecuting

Eleanor Medill Patterson, Robert Rutherford McCormick, and members of the *Times-Herald* and *Tribune* staffs under the Espionage Act of 1917. Although there were murmurings that Secretary of War Stimson was investigating the possibility of court-martialing Colonel McCormick as a reserve officer, Ickes was baffled to find that despite his anger, the president did not seem "particularly interested" in pursuing the matter legally.

For his own part, Frank Waldrop would be "horrified" at his role, not only in bringing the plans to light, but moreover in setting in motion the epochal chain of events that followed—so much so that "three days later I felt like cutting my throat." More than two decades afterward, he would reflect to former attorney general Biddle, "I have always thought I, personally, and we, collectively, of the McCormick & Patterson papers, deserved the strictest sort of non-legal censure for our recklessness and impassioned single-mindedness." There had been little time for reflection in the immediate aftermath of the revelation of Rainbow Five, however.

According to his custom, Waldrop arrived at the Times-Herald Building early on the morning of Sunday, December 7, 1941, intending to get a jump on the following week's business. When he finished around noon, he stopped by the wire room before leaving for the day. "What the hell?" he wondered upon reading the Reuters dispatch that reported the presence of two southbound Japanese battleships in the Gulf of Siam. "Things are right at the flashpoint. I believe I'll stick around." Waldrop was in his office at about two o'clock when the city editor on duty came "belting in," thunderstruck, with the news that "the police radio says that the Japanese have bombed Pearl Harbor!"

Waldrop and the small weekend dog-watch staff sprang to confirm the story at the White House. By the time the larger *Times-Herald* staff assembled breathlessly at the office, Waldrop had written much of the story according to the available information, to which other reporters added as developments unfolded and more details became available. In the composing room, the typographical foreman, Irving Belt, set the piece up so quickly that the *Times-Herald*'s account of the shocking attack and the Japanese declaration of war on Britain and the United States was on the streets of Washington before that of any of its rivals—some four hours, Waldrop would later estimate, before any other newspaper in the United States. Cissy would spend the day and much of the night in her office listening for the latest developments on the radio when she wasn't meeting with her editors, to whom she hissed with a gesture toward the nearby White House, "Do you think *he* arranged this?"

American intervention at last would only intensify the hostilities in which Joseph Medill's surviving grandchildren already found themselves em-

broiled on several domestic fronts—with their colleagues in the press, with the administration and both houses of Congress, with old friends, and, increasingly, with the American public. Henry Luce's magazines had been especially damning. *Time,* for example, had charged in October 1941 that the "Three Furies of the Isolationist press increased their howls" in the nine months since the start of the Lend-Lease hearings. That is, in Chicago, McCormick's *Tribune* had "bombarded the Midwest with Isolationist propaganda." For their part, the colonel's Patterson cousins in New York and Washington had "ground out their daily gripes at the risks involved in the Administration's policy of trying to stop Hitler." Citing Henry Luce's birth in China to American missionary parents, Joe responded in a two-part series, "Family Portrait," which appeared in the *News* and the *Times-Herald* on October 7 and 8, that it was "natural for Mr. Luce to feel that the United States ought to rescue China from the Japanese and the French, Dutch, Belgians, Russians, etc. from the Germans."

> The likelihood that these rescue adventures will gut the United States of much of its real wealth and produce a ruinous inflation because of an astronomical national debt does not cut overmuch ice with Mr. Luce.
>
> But it is also natural for us, with our Midwestern background, to think first of America in times like these, and to hate to see Americans kidded and cajoled into impossible crusades to remake the whole world.

Although Cissy had been friendly with the Luces in former days, the growing number of *Time*'s cracks about "Cissie's Hen House," Martha Blair's unceremonious dismissal from the *Times-Herald,* and the like had soured relations between them. Following Pearl Harbor, Luce's socialite, satirist, playwright, and journalist wife, who would be elected to the House of Representatives as a Republican from the 4th Connecticut Congressional District in the coming midterm elections of 1942, was unable to resist the temptation to send Cissy a lavish bouquet of roses. In a gesture worthy of Cissy herself, the flowers were accompanied by a note demanding, "How do you like everything now?"

True to form, Cissy spat back both privately and publicly with a torrent of scorn. "Roses are beautiful," she replied to Clare Boothe Luce, a famous beauty in her own right. Admitting, "I still think you have the Great Catherine, Athene, and that [Gene] Tierney girl fried to a crisp," she continued, "How do I like it? I hate it. How do you and Henry like it? The terrible thing about you two is that you neither hate nor like very much. You just go on having a wonderful time." Indeed, "Having a Wonderful Time" would become the name of Cissy's latest rancorous brainchild, this one more vitriolic than even the most venomous of its elder siblings.

Two of the "Three Furies of the Isolationist Press": Cissy
and Joe Patterson at 15 Dupont Circle in the late 1930s

Throughout the war Cissy reserved the "light and deadly" gossip column
(written by the New York *Daily News*'s George Dixon under the pseudo-
nym Georgina X. Preston) almost exclusively for the treatment of her
interventionist enemies and her family's detractors. "In his career of prof-
itable malice he has a wonderful helpmeet," Dixon noted both maliciously
and, it would turn out, profitably, on the pages of the Sunday *Times-Herald*.
"A friend," Dixon continued (referring to Cissy herself), "once referred to
Mrs. Luce as 'that lovely asp.' They make a remarkable pair. In all this
country, it would probably be difficult to find another ostensibly patriotic
American woman who thought the attack on Pearl Harbor was a matter for
light banter."

As ever, more measured in his reactions than his tempestuous sister, Joe
acknowledged, "Well, we're in it," in an editorial on December 9, 1941,
the morning after the president signed Congress's declaration of war
against Japan. "God knows Americans didn't want it. But let's get behind
our President and fight for America first." As anti-interventionist senti-
ment evaporated nationwide and Americans found themselves united in
shock, outrage, and support of the commander in chief, Franklin Roo-
sevelt's last meeting with Joe Patterson would prompt Cissy to abandon
any previous personal or editorial restraint.

. . .

When Joe Patterson learned of the attack on Pearl Harbor, he left the hunting lodge where he had been vacationing in North Carolina with his family, and drove north to Washington. In light of recent developments, he intended to meet with the *News* Washington bureau before making his way home to New York. On December 10, 1941, at the age of sixty-two, he applied to the War Department "for re-admission to the United States Army for service in any capacity," stating that he was willing to accept demotion in order to serve his country, now that war had come. At eleven thirty the following morning, December 11, Captain Patterson entered 1600 Pennsylvania Avenue through a secret entrance to avoid alerting reporters to his presence—"this, of course, at the request of the White House," he recorded in the memorandum he made of the meeting. Mistakenly believing the appointment (arranged by a member of the *News* staff through White House press secretary Stephen Early) to be a "command performance" intended to bring about a reconciliation between the president and his former staunch ally in the press, Joe presented himself at the Oval Office at noon sharp.

While Cissy vented her spleen telegraphically on those turncoats who had abandoned the Washington *Times-Herald* (along with its increasingly venomous and isolated owner) for the *Chicago Sun,* Joe entered the president's office to find his commander in chief signing documents. Roosevelt did not look up or acknowledge his old schoolfellow for some ten minutes. "I am here, Mr. President, to tell you that I wish to support your war effort," Joe said finally, extending his hand once Roosevelt put down his pen. Although the president shook it, he did not offer his visitor a seat, Joe noted. Rather, he launched directly into "pretty severe criticism for the way the News had conducted itself during the year 1941," after which the chief executive assigned the publisher "a task": to reread the *News*'s editorials for the previous twelve months. Then, confirming the visitor's long-held suspicions, Roosevelt took up the subject of intervention, inveighing

that as a result of our conduct we had delayed "the effort" by from sixty to ninety days. That Congress had read the editorials, which are also published in the Times-Herald in Washington, and had been encouraged to resist and slow up "the effort." He did not specify what he meant by "the effort," whether it was the war or preparations for the war.

Throughout the fifteen minutes Joe estimated he spent in the presence of his commander in chief, he stood at attention, responding only "Yes, sir," except in the single instance when he ventured to remind the president that "those editorials were written in peacetime, not in wartime." As their

tense encounter drew to a close, Roosevelt "seemed a bit mollified and told me to pass on the word to Cissy to behave herself also." Joe did as he had been commanded and reread the *News*'s editorial condemnations of intervention, but would afterward abandon any remaining geopolitical or interpersonal neutrality. "All I want to do now is outlive that bastard Roosevelt," he growled to his family. For her part, Cissy received the presidential command to behave herself as fighting words.

In the five days since cabinet members had called for prosecuting those responsible for revealing Rainbow Five, Secretary of the Interior Harold Ickes continued to be puzzled by the president's inaction. The massive FBI investigation that would drag on through 1942 would close without reaching any public conclusions. Nevertheless, years later, over lunch with the agent who had questioned him about his role in the leak, Frank Waldrop wondered whether the bureau had ever discovered Senator Wheeler's source for the top-secret plan. To Waldrop's surprise, the agent informed him matter-of-factly, "We had the whole thing inside 10 days." Unwilling to divulge the name of the culprit, who had by then died, Waldrop affirmed only that it was "a great military name, justly honored, a general of high renown and of invaluable importance to the war," and mused on "what this eminent gentleman and Mr. Roosevelt had to say to one another in their many private meetings during the war."

Some reasoned that Cissy Patterson, Bert McCormick, and their respective staffs escaped (legal) charges of treason in the confusion that followed Pearl Harbor. Others took a different view of Roosevelt's inaction—particularly in light of information that Secretary of War Henry L. Stimson confided to his diary nine days before the publication of Rainbow Five. In a meeting with the secretary of state and high-ranking military officials on November 25, 1941, the president addressed the imminence of a Japanese surprise attack. "The question was how we should maneuver them into the position of firing the first shot without allowing too much danger to ourselves," Stimson recalled. "It was a difficult proposition." In their zeal to expose Franklin Roosevelt and overshadow the *Chicago Sun,* had Bert McCormick and Cissy Patterson been maneuvered into assisting the president's stealthy push toward intervention? Could the leak of Rainbow Five by a high-ranking military official (who was likewise never punished) have served as a diversion by which two of the administration's most vitriolic isolationist enemies inadvertently entangled the United States in the very hostilities they sought to avoid—by provoking Hitler to "fire the first shot" that the president so urgently needed? The reasons for Roosevelt's mysterious inertia in punishing those who—intentionally or unwittingly—set in motion the chain of events that unleashed the full force of the "arsenal of democracy" upon the Axis at last will perhaps never be known.

. . .

Even before Joe Patterson left the Oval Office for the last time on December 11, 1941, some four thousand miles away in Berlin an especially outraged and red-faced Adolf Hitler had risen before the Reichstag to shout that, as a result of the revelations published in the United States a week earlier, his forbearance with Franklin Roosevelt had ceased: "Germany has always tried to prevent a break with the United States. But when it heard of the American plan to attack Germany in 1943, its patience reached a breaking point and war was necessary."

"This young lady says that young lady is a German spy," a harried Frank Waldrop announced the following afternoon, December 12, 1941, the first day of the United States' full participation in the global war, as he arrived at the Federal Bureau of Investigation's Washington field office, two of the young fixtures of Cissy's "Hen House" in tow. Exhausted by keeping abreast of recent global events editorially, by the barrage of hate mail that daily flooded the *Times-Herald,* the official investigation, and the public and private attacks that the revelation of Rainbow Five had unleashed—and still on tenterhooks over the threat of prosecution for the role he himself had played in its publication—Waldrop explained the situation before leaving Inga Arvad and her accuser, Page Huidekoper, in the charge of Special Agent C. A. Hardison, and hurrying back to the office.

This was not the first occasion on which Arvad, the *Times-Herald*'s beautiful blonde Danish-born columnist, had been brought to the bureau's attention. Thirteen months earlier, in November 1940, amidst mounting fears of war and suspicions of potential enemy aliens, Fifth Columnists and Nazi sympathizers, the FBI's New York field office received a letter from a student at the Columbia University School of Journalism, suggesting that the author's classmate, one Inga Arvad, might have been sent to the United States as a German agent "to influence morale." After several months of investigation, the New York office reported in June 1941 that the subject had indeed been "friendly with Adolf Hitler and Goering in the 1930s." These astounding findings, along with voluminous reports and memoranda based on information soon to be developed through surveillance, burglary, wiretapping, and postal interception, would likely have been filed away indefinitely for lack of conclusive evidence following the war. On July 14, 1960, nearly two decades after its initial entry was written, however, the file, captioned "Mrs. Paul Fejos, née Inga Arvad; Internal Security—Espionage—G," would be reopened when the director, J. Edgar Hoover himself, recalled it quietly to his desk. The same day, to hoopla and fanfare in Los Angeles some 2,600 miles away, the Democratic Party nom-

inated on the first ballot its charismatic young candidate, Senator John Fitzgerald Kennedy, for the upcoming presidential election in November.

In the late fall of 1941, Charles Latin, the *Times-Herald*'s purchasing agent, had been reading through old Berlin newspapers, he whispered soon afterward to reporter Page Huidekoper, when he happened upon a photograph of Hitler in his box at the 1936 Olympic Games in Berlin—accompanied by none other than the paper's own unmistakable "Did You Happen To See . . . ?" columnist, Inga Arvad. Why the purchasing agent—who functioned in an entirely extra-editorial capacity (responsible, as Frank Waldrop would later put it, for "how many sheets of toilet paper is in a roll and how much does a coir [*sic*] of copy paper weigh")—had taken it upon himself to peruse German newspapers several years old, or how he was able to understand the caption beneath the photograph in question, which noted that Inga Arvad of Copenhagen was currently employed by the German propaganda ministry, would not be clear for some time.

Nearly three decades later, Frank Waldrop would learn through the Freedom of Information Act that Latin had been one of three informants planted by the bureau over the course of 1941 to monitor not only the increasingly anti-administration Washington *Times-Herald* and its isolationist (to some, treasonous) publisher, Cissy Patterson, but Waldrop himself as well. He was staggered by the revelation. Cissy had typically been on cordial, if not warm, personal terms with J. Edgar Hoover. Even if the paper did not always practice what it preached, the law-and-order *Times-Herald* had expressed overwhelming editorial enthusiasm for the FBI (indeed, so much so that the bureau had reciprocated by lending the publisher wiretapping equipment for her own use). Further, Frank Waldrop himself had served as one of the bureau's informants on matters he learned of in the course of his work on the paper—anonymous tips on dope rings, illegal local gambling operations, the movements of high-ranking officials, and the like. "God damn it, see how clever they were!" he would later muse. "I give Hoover full credit. They planted this thing—this 'third man' planted it with Page Huidekoper to start an embarrassment, harassment, what have you."

Although only twenty-one when Frank Waldrop marched her down to the Washington field office with Inga Arvad, Page Huidekoper had already enjoyed an eventful working life. After finishing school in 1938, the genteel native Virginian, who was nevertheless a modern girl, had ventured to London to take a job as a clerk at the American embassy. Her parents' friend, the Pulitzer Prize–winning *New York Times* Washington bureau chief Arthur Krock, had helped arrange the position through his friend,

the incoming American ambassador to the Court of St. James's, Joseph P. Kennedy. Returning to the United States in June 1940, Page Huidekoper began looking for work once again, and, once again through the good graces of Arthur Krock, landed a job as a cub reporter on the Washington *Times-Herald*.

A year later, in the summer of 1941, learning that the former ambassador's daughter, Kathleen Kennedy, was herself entering the workforce, Page suggested she come to Washington. Kathleen and the *Times-Herald* would be a good fit in many regards. Fun-loving, attractive, and well-connected, Kick was exactly the sort of girl whom Cissy typically culti-vated for the paper. In the meantime, there had been another new arrival at the *Times-Herald* thanks, once again, to Arthur Krock. During a trip to New York for a meeting of the Pulitzer board, the *Times'* Washington bureau chief found himself approached on Broadway by a recent graduate of the Columbia School of Journalism, who wondered if he might help her find a job in Washington. "Stupefied by the beauty of this creature," Krock gibbered that he would, and shortly afterward Inga Arvad traveled to the nation's capital, where publisher Eleanor Medill Patterson personally interviewed the candidate regarding her fluency in four languages and her considerable experience writing features and interviewing high-ranking officials and celebrities in Europe, despite her mere twenty-eight years. While looking for a place of her own, the *Times-Herald*'s new "Did You Happen To See . . . ?" columnist moved in with her new colleague, Page Huidekoper, in Georgetown.

"Jack went to the Fight For Freedom with Page last night," Kick Kennedy wrote her father, recounting the highlights of the rollicking social life she and her young set led in the fall of 1941. Yet another recent arrival to the nation's capital was one of Kick's elder brothers, Ensign John Fitzgerald Kennedy, who had reported for duty at the Office of Naval Intel-ligence in late October. Having graduated from Harvard College in 1940, over the course of the previous year Jack Kennedy had reworked his senior thesis and published it as *Why England Slept*. Cissy Patterson wished the best-selling twenty-four-year-old author to be interviewed, and on November 27, 1941, the *Times-Herald*'s "Did You Happen To See . . . ?" columnist duly exclaimed, "The 24 years of Jack's existence on our planet have proved that here is really a boy with a future."

During her interview with Special Agent Hardison on December 12, 1941, Page Huidekoper insisted that, despite the suspicions she had voiced about Inga Arvad, she bore her colleague "no animosity whatever." Never-theless, her motivations were perhaps not exclusively patriotic. In the weeks since Inga Arvad's interview with Jack Kennedy had appeared in the

Times-Herald, author and subject had become almost inseparable outside of working hours. Reportedly proclaimed a "perfect Nordic beauty" by Adolf Hitler, Inga Arvad had found high-ranking partisans among the Allies as well. When she learned from Kick Kennedy that Page Huidekoper had been wondering aloud whether she was a German agent, therefore, Inga rushed to consult with another admirer, Bernard Baruch. During the First World War, when Baruch had been chairman of the War Industries Board, the presidential adviser told Inga, an earlier lady friend, the beautiful May Ladenburg, had likewise fallen under suspicion of being a German agent. Listening devices had been planted under her bed (with the eager assistance of Alice Roosevelt Longworth and her kinsman, Assistant Secretary of the Navy Franklin Delano Roosevelt). The lovers' trysts were recorded and the contents of their pillow-talk bandied about the capital by high-ranking officials and loquacious hostesses alike. Baruch's young paramour was "cut" remorselessly by diplomatic and social Washington. Only after May Ladenburg suffered a nervous breakdown as a result did Secretary of State Robert Lansing issue a letter officially clearing her of all suspicion.

Armed with this knowledge, "vexed and mad as a hatter," and increasingly "cut" in her own right by her colleagues and acquaintances, Inga Arvad promptly appealed to her boss, an old friend of May Ladenburg's whose own sympathies had once again come under suspicion. "I can still see Cissy Patterson sitting in her office disgusted with the rumors, wishing very much to help me, and seeing a wonderful story in the whole thing," Inga remembered. Given the ongoing furor over the revelation of Rainbow Five, however, Cissy was conscious that she needed to tread carefully. The publisher's continued employment of a number of German-born individuals on her newspaper and domestic staffs had already attracted public scorn (indeed, a "starving Russian refugee" whom she had hired as a photographer would shortly be exposed as a former SS agent). Moreover, the *Times-Herald*'s unalloyed isolationism before Pearl Harbor and its unabated truculence toward the administration in the few days since, had renewed the old whisperings of "pro-Germanism" and intensified the more recent charges of anti-Semitism. It was best, Cissy concluded, to face head-on charges that the *Times-Herald* might be harboring a German spy.

In agreeing to go to the FBI's Washington field office on Cissy Patterson's order, Inga Arvad believed that, like May Ladenburg before her, she would be cleared of suspicion and then exonerated with some sort of official "certificate." Instead, the picaresque account she gave of herself to Special Agent Hardison served only to invite heightened scrutiny both covert and public, not only of Inga herself, but moreover of her intimates, her coworkers, and her employer.

Born in Copenhagen in 1913, Inga Arvad had attended school in En-

gland briefly and studied ballet and piano before being crowned a beauty queen in Denmark at the age of sixteen. She had been discovered by film director and archaeologist Paul Fejos, but had renounced a career in the movies for journalism, moving to Berlin in 1935 as a correspondent for a Danish newspaper. In the course of the following, heady year she married Fejos (having divorced the Egyptian diplomat with whom she had eloped in 1930) and commuted between Copenhagen and Berlin for work. She wrote and filed "human interest stories" and conducted what she insisted to Special Agent Hardison were strictly apolitical interviews ("their viewpoint on marriage, what they ate for breakfast, etc.") with an astonishing array of high-ranking German officials. Among these were the Reichschancellor and Minister of Public Enlightenment and Propaganda Joseph Goebbels; Reichsführer-SS Heinrich Himmler; the many-titled and lavishly decorated Hermann Göring; the chancellor's deputy, Rudolf Hess; and—both in his office and in his box at the 1936 summer Olympic Games—the führer himself, Adolf Hitler. "Miss ARVAD advised that she had visited Germany on numerous other occasions when she was a child and that her parents frequently visited there on vacations," the memorandum of her interrogation recorded. Nevertheless,

> she denied having any relatives or ties whatever in Germany and very heatedly stated that she had the utmost contempt for the German people, except that she must admit that they were cunning and clever in many respects. She stated that, as a newspaper woman, it was necessary for her to be agreeable with the German officials and members of Mr. GOEBBEL's [sic] office in order to arrange for interviews with the various politicians in Germany. She insists, however, that she has no close friends in Germany and only associated with them as a matter of expedience.

Jaw-dropping as these revelations were on the day after Germany declared war on the United States, of even greater interest to the bureau—and, indeed, to the other well-placed figures who would shortly seize upon the information—were Inga Arvad's associates since her arrival in the United States.

Her plan in sailing for New York in February 1940, she stated, had been to meet up with her husband before he embarked on his new project, financed by the Viking Foundation, filming archaeological explorations among the Incan ruins at Machu Picchu. Fejos had been forced to depart on his expedition to Peru before Inga docked in New York, however; she remained in Manhattan in the meantime, where she applied to journalism school. Nazis aside, it was her allusion to her husband's benefactor which particularly captured the attention of her interrogator. The "Swedish

sphinx," the mysterious international industrialist and entrepreneur Axel Wenner-Gren, had founded the Viking Fund, purportedly to foster anthropological research. The owner of Electrolux and one of the wealthiest men in the world at the time, Wenner-Gren's unwelcome and ham-fisted efforts to make use of his extensive international contacts in the years leading up to the war in brokering some sort of understanding between the German, British, and American governments had only served to cast doubt upon him in all quarters. Suspected of Nazi sympathy, he had recently found himself economically blacklisted in the United States. In this light, his Viking Fund, with its "film expedition" to the Andes, appeared to be a possible strategic vehicle for the Nazi infiltration of South America.

"The air in Washington reeked with poison and suspicion in those frightful hours," Frank Waldrop remembered. The early months of 1942 saw an expansion of May Ladenberg's and Countess Gizycka's experiences during the previous war as the content of private, often amorous conversations and interactions, recorded because of their possible bearing on national security, became fodder for gossip—not simply in Washington but far beyond as well, thanks to the rise of the syndicated column. Although an affronted Inga Arvad left the Washington field office on December 12, 1941, without the official certification of her innocence that she had demanded, the FBI, for its part, had not been left empty-handed in the wake of her interview. Armed with her astonishing revelations, agents began tailing her. By late January 1942, Attorney General Francis Biddle authorized the "technical surveillance" (wiretapping) of her telephone. On May 4, Franklin D. Roosevelt himself advised J. Edgar Hoover that Inga Arvad should be " 'specially watched' in view of her connection with the Wenner-Gren expedition's leader (her husband) and in view of certain other circumstances which had been brought to his attention."

More immediately, however, news of the relationship between the naval ensign with the bright future and the *Times-Herald* columnist with the murky past had spread quickly. On the morning of January 13, 1942, Inga arrived at the *Times-Herald* to find herself the subject of a tidbit in Walter Winchell's column that day: "One of Ex-Ambassador Kennedy's eligible sons is the target of a Washington gal columnist's affections. So much so that she has consulted her barrister about divorcing her exploring groom. Pa Kennedy no like." Like a growing number of Winchell's columns in recent years (which had struck Cissy as excessively interventionist, unjustifiably laudatory of the Roosevelt administration, and needlessly alarmist in their relentless condemnations of Nazism), his January 13 submission would be pulled from the next edition of the *Times-Herald* and, indeed, from all others that day. Nevertheless, the piece had already been published in the hundreds of newspapers coast to coast that had made Winchell the

most widely read American syndicated columnist of the era. The following day, Ensign Kennedy received word that he was to be reassigned to the Charleston, South Carolina, naval base. Inga Arvad remained in Washington, writing her *Times-Herald* column, but visiting her beau at Charleston hotels on weekends until spring (as FBI surveillance and wiretapping reports would attest in intimate detail). In the meantime, through her own investigations Cissy learned that J. Edgar Hoover himself had been Walter Winchell's confidential source, and set about wreaking her revenge.

Eleanor Medill Patterson's editorial tone had grown so bilious and vengeful in recent months that it occasioned ever-louder whisperings throughout the capital that the lady publisher—always quixotic—was becoming unhinged. Indeed, on the very morning on which Winchell's insinuations about Inga Arvad and Jack Kennedy appeared, Cissy filled her own front-page signed box with "A Letter to a Young Man." Without mentioning the *Times-Herald*'s city editor, Dick Hollander, by name, she not only scoffed at his recent decision to join the Office of Strategic Services, but ridiculed this "personal SACRIFICE for the defeat of Hitlerism," snapping, "It seems to me that you, among many others, are a rather mixed-up young man—mentally, emotionally, spiritually." Cissy's tone was no more reserved on January 17, when she published her retort to Walter Winchell and J. Edgar Hoover for their treatment of Inga Arvad. In "Singing for Their Supper," she revisited the unfounded suspicions that had prompted May Ladenburg's breakdown a quarter century earlier. Without direct reference to the wiretapping of her own compromising wartime conversations with the kaiser's last ambassador to Washington at the time or to the more recent suspicions that had fallen on Inga Arvad, Cissy noted pointedly, "In those days, of course, we had no F.B.I., no glamorous J. Edgar and his organization of brilliant and romantic young men." As before, the editor (whose *Times-Herald* ran multiple gossip columns simultaneously) insisted, the suspicions and rumors were baseless:

> What story? Intrigue? Incriminating documents? International spy business? Oh, no. No. Not a shred of evidence did he or his assistants discover. Not by conscious or unconscious act could this girl be accused of disloyalty to her country. But the gossips were almost as well pleased as if a first-class international melodrama had come to light. For he dug up a fascinating romance between this young woman and one of the most celebrated men of the day.

"Washington society was just as pleased with his new scandal as with the other and, happily packed together," Cissy sermonized, "went yipping and yapping down the fresher trail."

. . .

In these first dark days that followed Pearl Harbor there were nevertheless a few rays of mirth—if not for Joseph Medill's surviving grandchildren, then at least for the president, the administration, and their recently enlarged legions of supporters nationwide. Humorless and domineering, whatever he called the commander in chief ("dictator," "liar," "Frank"), Colonel Robert Rutherford McCormick would insist that others address him by his rank until his death in 1955. Although McCormick's claim that he had "tasted the wine of death" at the Battle of Cantigny had become the subject of some doubt (and hilarity), he was nevertheless extremely well-versed in military history—independent of the degree to which he had actually participated in it. "The fact is that I introduced the R.O.T.C. into the schools," the colonel crowed in a February 1942 letter to Jake Sawyer, a former *Tribune* employee and Christian Scientist who had urged the colonel to let bygones be bygones and lend himself to supporting the war effort. But neither the colonel's loudly proclaimed patriotism nor his contributions to American military prowess and preparedness in the interest of keeping the country resolutely *out* of war had stopped there:

> I introduced machine guns into the army . . . I introduced mechanization; I introduced automatic rifles; I was the first ground officer to go up in the air [in a hot-air balloon] and observe artillery fire. Now I have succeeded in making that the regular practice of the army. I was the first to advocate an alliance with Canada. I forced the acquiring of the bases in the Atlantic Ocean.

Lamenting that "the most powerful propaganda organization in the world" (the Roosevelt administration) was engaged in an ongoing "campaign of hatred" against the *Tribune* for its unapologetic criticism of the president (Pearl Harbor and its aftermath notwithstanding), the colonel declared, "Campaigns such as I have carried on inevitably meet resistance, and great persistence is necessary to achieve results." The "opposition," he sniffed, had charged him with fomenting disunity—"hatred and so forth"—in the current crisis. Nevertheless, "in view of the accomplishment, I can bear up under it," he concluded.

"This surely will give you a laugh," Mayor Fiorello LaGuardia of New York wrote the colonel's former schoolmate at the White House, enclosing the reprint of the astonishing "Letter to Sawyer" under the headline of "Whatta Man!" from the *Tribune*'s rival *Chicago Daily News*. "What would we have done without McCormick?" the Little Flower chortled. When the poet and historian Carl Sandburg, then writing editorials for the *Chicago*

Daily News, read McCormick's letter he was reported to have shaken his head and sighed, "And on the seventh day he rested."

On April 20, 1942, Eleanor Medill Patterson rose to address the more than six hundred newspaper publishers, editors, and owners who had convened for the forty-second annual meeting of the Associated Press at the Starlight Roof of New York's Waldorf-Astoria Hotel. Although not a member of the cooperative herself, in light of her eminent newspaper heritage and the fact that her brother and cousin published member papers (indeed, Colonel McCormick was one of the organization's six directors) the body had extended her the unusual courtesy of addressing her colleagues before they voted on whether to admit 1942's applicants: her own Washington *Times-Herald* and Marshall Field III's *Chicago Sun.* Referring to her old friend the assistant attorney general in charge of the antitrust division from the podium, Cissy reminded her colleagues of the delicate position in which they found themselves:

> Thurman Arnold sent for me two years ago and said: "If you want A.P. membership I can get it for you. I won't start it myself, but if you will send a member of your staff around the country and get some complaints from newspapers in your situation—that is, without A.P. memberships—I'll guarantee to break that monopoly and get you that membership.

Having thus threatened her colleagues with the suggestion of antitrust prosecution, government regulation, and the overhaul of their bylaws—in short the loss of the cooperative's collective autonomy—she added, "I come from four generations of newspaper people, and I didn't like it— I didn't like the smell of it. I went home and thought it over and I refused to act."

Ever the editor, she had cut from her narrative the fact that Thurman Arnold's offer had come as the result of her own repeated complaints about the *Times-Herald*'s exclusion from AP membership. However genuine the sense of journalistic solidarity that had prompted Cissy to reject Arnold's assistance, with or without her cooperation the administration had arrived at its own reasoning for pursuing the AP for antitrust violations. In anticipation of the *Chicago Sun*'s application for membership, Colonel McCormick had busily set about to assure its rejection—and the threatened government regulation of the AP that he took for a flagrant incursion upon a free press—at the upcoming meeting in New York, by securing his colleagues' proxies or, whenever they proved reluctant, by threatening to withhold Tribune-News features from their publications. Likewise, in the

weeks preceding the annual meeting, FBI agents had paid visits to pub-
lishers of member papers across the country, strongly encouraging support
of the *Chicago Sun*'s bid for admission, suggesting the possibility of
antitrust prosecution, and demanding the names of any members who
might have lobbied their fellows to reject the recently launched pro-
Roosevelt daily.

When the votes were tallied, the application of Marshall Field's *Chicago
Sun* was nevertheless voted down 684 to 287. "Some of the members were
so apprehensive they asked the ballots be burned so they would not fall
into the hands of the FBI," Colonel McCormick insisted darkly. Eleanor
Medill Patterson's bid for the Washington *Times-Herald*'s membership was
rejected as well, although less resoundingly, 514 to 424. In light of the
Times-Herald's circulation dominance in the nation's capital, the *Washing-
ton Star*'s co-owner Samuel H. Kauffmann insisted (somewhat mislead-
ingly) to reporters that Cissy Patterson's paper was "not desperately in need
of the A.P. service." Despite his cousin's bitter disappointment before her
industry colleagues (indeed, even the ordinarily impartial *New York Times*
was unable to resist proclaiming "Mrs. Patterson Is Loser" in its headline
the following morning), Colonel McCormick was generally delighted with
the meeting's outcome, especially since his colleagues had reelected him to
his seat on the AP directorate. The headline of the *Chicago Tribune*'s own
postmortem crowed "New Deal Fails to Purge Critics from AP Board."

Bert McCormick's victory in the AP fight would be short-lived. By the
summer of 1942, the Department of Justice would make good on its threat-
ened antitrust action, ultimately overturning the AP's membership rules,
ending its erstwhile autonomy and ultimately allowing both the Washing-
ton *Times-Herald* and the *Chicago Sun* to join by November 1945. Hoist by
his own petard once again in his efforts to undermine his old schoolmate,
Colonel McCormick's sense of persecution grew unchecked as his family's
tax records came under scrutiny and their newspapers (along with many
others nationwide—although, curiously, not Marshall Field III's *Chicago
Sun*)—faced wartime newsprint rationing.

"Of course the President read the *Times-Herald,* and so did I. And we knew
what Cissy was saying about us, and writing about us, but we were too
busy with other things to worry whether she would tie herself to a tree
with her friends or anything like that. There were too many more impor-
tant things going on," Grace Tully, Franklin Roosevelt's longtime personal
secretary, later declared. "Besides," she added faithfully, having seen her
boss through catastrophic illness, worldwide financial cataclysm, and now
global war, "the President was not the kind of man who would comment
too much on members of the press who disagreed with him." Though

Franklin Roosevelt cultivated insouciance in the face of the Lilliputian journalistic slings and arrows directed at him from New York, Chicago, and the capital itself, at closer range the unruffled presidential façade began to show cracks by the early months of the war. "We are both menaced by the so-called interpretive comment by a handful or two of gentlemen who cannot get politics out of their heads in the worst crisis, who have little background and less knowledge, and who undertake to lead public opinion on that basis," Roosevelt commiserated with Prime Minister Winston Churchill on March 14, 1942. "My own press," the president continued,

> the worst of it—the McCormack [sic]—Patterson people, the Hearst papers and the Scripps-Howard chain—are persistently magnifying relatively unimportant domestic matters and subtly suggesting that the American role is to defend Hawaii, our east and west coasts, do the turtle act, and wait until somebody attacks our home shores. Curiously enough these survivors of Isolationism are not attacking me personally except to reiterate that I am dreadfully over-burdened, or that I am my own strategist, operating without benefit of military or naval advice. It is the same old story. You are familiar with it.

Three weeks later, on April 10, 1942, Joseph P. Kennedy confided to his diary the details of the tense meeting he had had that day with his former boss. Although "his voice and manner were gay" at first, the president launched into a "tirade" when he touched upon the subject of Joseph Medill's intractable grandchildren, insisting, "Cissy, Joe and Bert were a little crazy—they'd always been." Roosevelt reiterated his sad diagnosis to poet, Librarian of Congress, and Director of the Office of Facts and Figures Archibald MacLeish on July 12, 1942: "The trouble is that Bertie, Joe Patterson and Cissie [sic] deserve neither hate nor praise—only pity for their unbalanced mentalities." If the president had earlier chuckled at the fantastical boasts of military innovation that Colonel McCormick had made in his infamous "Letter to Sawyer," Roosevelt had nevertheless taken the precaution of instructing General Henry Harley Arnold (the FBI's prime suspect in the leak of the Rainbow Five plan) to investigate the veracity of the claims, adding, "I personally can take care of the other allegations." Whatever the degree to which the White House justified the colonel's mounting sense of persecution and paranoia, the president would be actively assisted in discrediting the Patterson-McCormick axis by its own members.

On May 29, 1942, Cissy received a slap on the wrist from the Office of Censorship. In his column that morning, "These Charming People"

columnist Igor Cassini had confided to *Times-Herald* readers that "Uncle Sam is planning to open a branch of the War Department in London very soon. Two thousand one hundred U.S. officers will leave, in three shifts of 700 each, from the middle of June to the middle of July . . ." At the White House, presidential secretary Stephen Early promptly forwarded the piece to Byron Price, director of censorship (and a former AP bureau chief), who wasted no time in taking the publisher to task. Not only, Price scolded, had Count Cassini's colorful blurb generally run afoul of "every sensible conception of responsible journalism in wartime," but moreover,

> it specifically violated two clauses in the Code of Wartime Practices, issued by the Office of Censorship on January 15 and placed in the hands of every publisher. It violated the request asking that nothing be printed about the movements, strength, destination, routes and schedules of troops in transit. It also violated the request that nothing be printed about the movements, routes and schedules of official military missions.

The *Times-Herald*'s uncharacteristically obsequious response was indicative of the degree to which they believed themselves to be under scrutiny and hoped to avoid trouble.

If the movements of American troops were off-limits to newspaper publication, surely the enemy's movements (not specifically addressed in the Office of Censorship's Code of Wartime Practices and no secret, of course, to the enemy itself) were not. Or were they? The following weekend, on Sunday, June 7, 1942, that very question arose when the *Chicago Tribune,* the Washington *Times-Herald,* and the New York *Daily News* printed "Navy Had Word of Jap Plan to Strike at Sea." The jointly published account of the recent Battle of Midway was probing enough to convince the enemy that its codes had been compromised and the American naval high command that its intelligence-gathering capability in the Pacific had been crippled. Stanley Johnston, the principal author, had assembled his account of the heavy Japanese losses in the Pacific not only from witnessing the events first-hand and from an extensive knowledge of international fighting ships but also from information garnered as a result of his friendship with one of the surviving commanders. Moreover, Johnson had surreptitiously copied the text of what appeared to be a decoded secret Japanese naval transmission. Once Johnston returned from the Pacific theater to Chicago, his story was altered by the *Tribune*'s managing editor, J. Loy Maloney, given a false Washington dateline, deliberately misattributed to "an anonymous staff officer," and published without prior submission to naval censors.

This time, Franklin Roosevelt would demonstrate none of the baffling

apathy toward pursuing the publishers that had characterized his reaction to the Rainbow Five story six months earlier. Rather, in August 1942, the president directed Attorney General Francis Biddle to convene a grand jury in Chicago to investigate whether the recently published "confidential information concerning the Battle of Midway" had violated the Espionage Act of 1917—Biddle's own reservations about the merits of the government's case notwithstanding. Cissy and Frank Waldrop traveled to Chicago to answer the subpoena. "We had dinner together in her compartment and talked for a long time about the case, our astonishment at being involved, our lack of understanding as to what it revolved upon, in fact, though we understood very well what the government's aims and interests were." With insufficient evidence despite the thousands of pages of documentation that had been compiled on both the Midway story and Rainbow Five along with the testimony of Frank Waldrop and others in the proceedings, the government dropped its case before concluding it, leaving Attorney General Biddle to admit, "I felt like a fool."

Almost simultaneously, Cissy and Joe Patterson found their loyalties and patriotism questioned on Capitol Hill as well. On Monday, August 3, 1942, freshman congressman Elmer J. Holland, a Democrat from the 33rd Pennsylvania Congressional District who had recently been elected to fill an unexpired term, excoriated the publishers as "America's No. 1 and No. 2 exponents of the Nazi propaganda line" in his maiden speech on the House floor. In fulfillment of a campaign promise to "deal firmly with the defeatists, the sowers of dissention . . . who are working with the Axis warlords to . . . hamper our country's war effort," Holland had wasted no time in launching what *Time* magazine characterized as "a seven-day-a-week study of Captain Joe's News and Cissie [*sic*] Patterson's Washington Times-Herald" immediately after his election in May 1942. Both Pattersons, Holland had concluded from his research, "would welcome a victory by Hitler in preference to a democratic government headed by Franklin D. Roosevelt." Moreover, Holland thundered from the House floor, "Cissy and Joe Patterson are using their columns to repeat the propaganda broadcast direct from the Nazi shortwave radios of Berlin and Vichy," demanding: "The Pattersons and their ilk must go. We want no Quislings in America."

"Congressman Holland's statement was made in Congress and is therefore privileged," Joe Patterson shot back in a *News* editorial, headlined "You're a Liar, Congressman Holland," on Wednesday, August 5, 1942, which, contrary to the publisher's self-effacing custom, was signed.

The following statement is not privileged, but unlike Holland's is true: What Holland said about me and my sister is a lie. We are not "Hitler fol-

lowers." We do not seek to bring about a Fascist victory, hoping to be rewarded afterward.

One of our grandfathers was born of Scotch-Irish parents in New Brunswick, Canada, whence he was removed as an infant to the United States. The families of the other three grandparents had been in the United States for several generations. Members served in the Revolutionary, Civil and World Wars. There is no German, Italian or Japanese blood in us. We are of Irish extraction (both North and South), with a trace of Holland Dutch.

This country has treated us well—superlatively well. What could we gain by having it fall?

We do not know whether you were inspired to your lie by higher-ups. But we do know that servile fawning upon this or any other Administration is not a test of love of America.

We again suggest to other newspapers that they watch out for encroachment on freedom of the press. Their turn will come if they don't.

To repeat: Congressman Holland: You are a liar. Make what you like of that.

At the bottom of the *Times-Herald*'s reprint, Cissy added, "To the above statement, I heartily subscribe. You are a liar, Congressman Holland. And you know it."

"We are not of those who believe that, because the country is in danger and all private interests are threatened," the *Times-Herald* retorted in reprinting "The Duty of Newspapers," which Joseph Medill had composed during the darkest days of the Civil War, "or because military power overrides civil law, it is the province of journalism of the better sort to keep silence when incompetency, when unblushing rascality under the guise of patriotism is doing its deadly work." Not content to let the matter rest, Cissy also wrote Congressman Holland directly:

Wednesday afternoon, reporters asked you whether you would care to repeat your lies about us anywhere off the floor of Congress. You replied you would not because you "don't intend to spend all my time in the courts defending my remarks."

To reiterate: you are a liar, Congressman Holland, and by your refusal to give my brother and myself a chance to prove in every court in the country that you are a liar, you show yourself up not only as a liar, but also as a yellow-bellied coward.

The *Times-Herald* likewise took up the gauntlet by publishing "Elmer's Tune":

With unique courage Elmer took the floor
Assured against intrusion by the guard at the door.
He stood there roaring his tune,
Drawing inspiration from his political moon.
Without pulling his punches, he lashed away,
Heaping charges at his a b s e n t Prey.
Of the people Elmer drew privilege to drone as he would
And to the People, as return, he showed his viper's hood—
Espousing Democracy, abusing Democracy,
Imploring Unity, Daring Unity, Commending
Freedom, Bemoaning Freedoms—In the Halls of a People's Congress—

"Caroling Elmer's Tune," the ditty concluded, "the Swoon Song of the Jackass who supposes he invented a new kind of Democracy with a big 'I' in it somewhere."

Congressman Holland was not content to leave matters as they were, either. On Monday, August 10, 1942 (before a mere 11 of his 435 colleagues, the *Chicago Tribune* hastened to add in its coverage of the oration), Holland took the floor once again to accuse the Pattersons and their papers—along with their cousin and the *Chicago Tribune,* this time—of "moral sabotage," that is, of preaching "defeatism among our civilians and mutiny among our soldiers; to spread dismay among our allies, and to create joy in the hearts of our enemies." Alluding to the execution of six Nazi agents in Washington, D.C., the previous weekend, Holland continued, "All the physical sabotage they planned, had it been successfully executed, could not accomplish one-half the damage done by the moral sabotage committed by Joseph Medill Patterson, Eleanor Patterson and Robert McCormick. Daily these publishers rub at the morale of the American people," he expounded. "Daily they sow suspicion. Daily they preach that we are a nation of fools, led by rascals into a hopeless struggle. Daily they wear at the moral fiber of the people, softening it, rotting it, preparing us for defeat." The same afternoon, an FBI internal memorandum made note of Holland's statements on the House floor accusing Cissy and Joe Patterson of Nazi sympathy.

So vitriolic had the attacks and counterattacks grown, both on the House floor and in the national press, that even Henry Luce's *Time* magazine would qualify its usual, gleeful burlesque of the "Three Furies of the Isolationist Press" to allow that Joe Patterson, at least, was

a different sort of journalistic bird from Bertie McCormick. Unlike the *Tribune,* the tabloid *News* plays the news straight—except for queer

capers in some "feature" stories. Having long ago graduated from reliance on a cheesecake and scandal diet, it now commands respect from its contemporaries for its enterprise and alertness. Equally respected is Captain Patterson, who distinguished himself in combat in World War I, has espoused many a liberal cause. But his pre–Pearl Harbor Isolationism and editorial changes of pace on the conduct of the war have prompted many to tar him with the same brush as Colonel McCormick.

"That any one could accuse Patterson of any sympathy with the enemies of his country is just proof that somebody is losing his mental balance in the excitement of the war, because Patterson's family is strictly American from 'way back,' " Westbrook Pegler, the (then) outspokenly anti-fascist Pulitzer Prize–winning syndicated columnist, contended on August 23:

> He isn't a Nazi or a pro-Nazi and he is a rugged 100 percent of the purest and most vigorous American patriotism, but when such a man with such a record can be so accused you begin to look for guys under the bed and behind doors.

"As a matter of fact," Pegler concluded, "that kind of stuff is Hitlerism, for Hitler himself wrote that the way to get an opponent was to tell a big lie about him and keeping on telling it."

Other, more intimate authorities felt compelled to weigh in as well. "I know him perhaps better than most daughters know their fathers," Alicia Patterson Guggenheim ventured in a Long Island *Newsday* editorial, which Cissy reprinted in the *Times-Herald.* Nearly a decade before, Joe Patterson had remarked to Arthur Brisbane that his middle daughter, once the tomboy of the family, had grown up to be "intent on having a newspaper like Cissy." At the helm of the tiny Nassau County, New York, sheet that her third husband, Harry F. Guggenheim, had bought for her in 1940, Alicia had begun to demonstrate that she had something of her father's distinctive gift for publishing a successful tabloid. Working initially out of a garage in Hempstead, Long Island, some forty minutes from Manhattan, Alicia transformed the former *Nassau Daily Journal* into *Newsday.* Eye-catching and almost entirely devoted to covering local news, the tabloid would grow phenomenally in the postwar period, along with the population of Long Island itself. Alicia had received little encouragement from her father. Relations between Joe and his daughters had been strained, not only by their learning of the existence of their half brother, but moreover by suspicions that Jimmy was their father's favorite. "I couldn't help being a girl," Alicia pleaded bitterly in July 1943. "I tried to overcome that handicap." When she persisted that "we used to have such a helluva time,"

and wondered, "Are them days really gone forever?" her father replied only that he was too old to fight with her. Family differences had extended into the public arena as well. Although Alicia, like many of the members of her generation among Joseph Medill's descendants, had differed with her father's generation over the issue of intervention, in light of the attacks to which Joe Patterson and his patriotism had recently been subjected, she felt compelled to defend his views and his personal history:

> We have hunted and fished together. I have seen him under all sorts of circumstances: when he enlisted as a private and went to the Mexican border in 1916; when he joined up with the Rainbow Division in the last war, although he was 38 years old with a wife and three children; when he came back from France in 1918 looking older and grimmer; when he fought for the Roosevelt Administration because he believed that the underprivileged of the country should get a better break; when he pounded week after week in his editorials for a two-ocean navy so that we might never have to bow to an aggressor nation; when he opposed our entry into this war because he thought that we were unprepared. As long as I can remember he was carrying the torch for the U.S.A.
>
> After the Japs bombed Hawaii—and I was with him at the time—his one thought was that we must win at all costs—that nothing must stop us. He tried to enlist but was told that he was too old.
>
> Isolationism was a dead issue so far as my father was concerned, but it apparently wasn't with a lot of pre–Pearl Harbor interventionists . . . [These] fanatics stumped the country from end to end denouncing anyone who happened to have believed before the war that America should look before she leaped.
>
> It is true that my father has from time to time criticized the Administration. Does that make him a traitor? If it does, then anyone who questions the policies laid down in Washington is likewise treasonable.
>
> Are we no longer allowed to disagree with the elected "servants of the people"?

"If that is so," Alicia reflected in conclusion, "we have lost our democracy before we have begun to fight for it."

While the sparring and retaliation between Congressman Holland and the cousins escalated throughout the summer of 1942, the Associated Press antitrust suit began lumbering through the federal district court system. "Marshall Field is not a legitimate newspaper man and The Sun is not a legitimate newspaper," Colonel McCormick grumbled when he learned of the government's petition on behalf of the *Tribune*'s new rival, to force the

AP to serve any newspaper willing to pay its cost. Without reference to the AP's other aspiring member that year, Colonel McCormick went on to fulminate that the *Sun* and its efforts to join the AP were "part of an alien and radical conspiracy against our republican form of government. It is subsidized by the government to the extent that its losses, running into millions of dollars a year, are deducted from the owner's income tax." Many of his journalistic colleagues regarded the aspersions he cast on Field and his *Sun* as equally applicable to the colonel's cousin and her *Times-Herald,* and indeed the two upstart AP applicants did find themselves in a similar position with regard to the Bureau of Internal Revenue—at least until the *Times-Herald* began to turn a decisive profit in 1943.

On August 29, 1942, the FBI added to its widening file on Eleanor Medill Patterson an internal memorandum speculating on her financial situation. Although she netted a "nice income" from her interests in the *Tribune* and the *News,* the publisher was losing "approximately $400,000 per year in the operation of the *Times-Herald*," Agent Carter ventured to Agent McGuire. "However, she saves money in the long run, of course, for by losing the $400,000 in the operation of the *Times-Herald* her income tax is lowered considerably." The first glimmerings of the mounting profits the paper was to show from the following year until the end of Cissy's life were already evident. "Strange as it may seem the circulation is increasing," an almost disappointed Agent Carter observed. "This is explained by the war news and the way it is played up in the headlines by the Times-Herald." Nevertheless, advertising linage and revenues—never Cissy's strong suit—had declined precipitously. "The leading advertisers in Washington are predominately Jewish," Agent Carter explained, "and the policy of the Times-Herald in recent months (against Winchell, for instance) has not been particularly favorable to these merchants."

"My speech before the Jewish Society yesterday was a great success," Cissy had crowed to Arthur Brisbane a decade earlier, her new prominence as the capital's only lady publisher having occasioned her greater civic participation in the life of the city.

> The Chairman made a speech in praise of the retiring President. Everybody cried. The retiring President made a speech in praise of the new President. Everybody cried. The Toastmistress proposed a moment of silence in memory of a defunct member. Everybody cried.

"I made a most touching speech about inter-marriage between the Jews and the Christians . . . and everybody cried," she continued, reflecting nostalgically on the late Elmer Schlesinger. "This time I cried too." For neither

party had this spirit of interfaith fellowship and mutual goodwill endured long beyond 1932, however. Given the rising stridency of the *Times-Herald*'s anti-Roosevelt, isolationist tone, Cissy's speeches to local Jewish organizations, her teas and luncheons at 15 Dupont Circle for the Sisterhood of the Washington Hebrew Congregation, and her lavish (and broadly publicized) contributions to the United Jewish Appeal had rung hollow to the very advertisers she hoped to cultivate as a result. Despite her ever-higher circulation numbers, on September 11, 1939, she confessed to her cousin in Chicago her suspicion that she was "a flop in business." In an effort to counteract the *Times-Herald*'s growing reputation for editorial anti-Semitism, she had hired Arthur Newmyer, formerly publisher of the New York *American* and assistant general manager of the Hearst chain, as associate publisher, "because of his close connections with the Jewish merchants in town," she declared unabashedly.

> The trouble is I gave him a heck of a contract, which has three years to run.
>
> Besides being a wasteful and extravagant operator, he has recently made no sincere effort to increase our advertising revenue. Truthfully, I suspect him of sabotage both inside and outside of the office.

"Mrs. Patterson has been trying to break the contract for some time, but Newmyer has been smart enough to prevent it," Drew Pearson, no longer in his former mother-in-law's good graces, divulged quietly to Morris Ernst, his lawyer and the co-founder of the American Civil Liberties Union, in February 1942. Newmyer enjoyed "quite a following among big advertisers in Washington, and it is feared that they might cancel their contracts." While the *Times-Herald* was on better terms with the FBI, the columnist continued, the bureau had lent wiretapping equipment to allow Cissy to eavesdrop on her associate publisher's phone calls. "It was suspected that he had been disloyal to her, and she wanted to get ammunition to force a breaking of the contract. However, the cleaning woman noticed an apparatus connected with Newmyer's telephone and reported it to him," Drew revealed.

In her own right Cissy had been one of the capital's preeminent social arbiters almost since her arrival at Dupont Circle as a perennial debutante at the turn of the century. The many society gossip columns she had printed and engendered in the course of her publishing career had also given her a formidable reputation for thrusting those lesser-known hostesses and socialites whom she favored into the spotlight of local celebrity. More than occasionally, she indulged herself by wielding this same power to withhold, embarrass, or belittle as well. The source of her objection to Perle Mesta, the

LEFT: Hearst columnist and editor Arthur Brisbane (left) with his colleague, editor Walter Howey, at 15 Dupont Circle. Brisbane, Cissy's self-proclaimed "godfather in journalism," had persuaded William Randolph Hearst to allow her to take the helm of the *Washington Herald* in 1930. Howey, Hearst editor and organizational assistant, had also served as one of Cissy's journalistic mentors (and lovers) as well as the model for the gruff city editor, Walter Burns, in Hecht and MacArthur's 1928 Broadway smash hit, *The Front Page.*

ABOVE: William Randolph Hearst (left) with T. J. White, general manager of the Hearst Enterprises and, according to some, the great love of Cissy Patterson's life

RIGHT: William Christian Bullitt, Jr.: United States ambassador to the Soviet Union, 1933–36, and to France, 1936–40

Tobacco heiress, philanthropist, and, briefly, Hearst International News Service reporter Doris Duke dancing in the ballroom at 15 Dupont Circle

Washington socialite
Gwen Cafritz with
FBI director
J. Edgar Hoover

Wyoming cowboy,
tracker, big-game
hunter, and reputed
former horse thief
Cal Carrington on a
visit to 15 Dupont
Circle in the 1940s,
where, it was said,
he encountered an
elevator for the first
time in his life

Luvie Pearson, Drew Pearson's second wife, with an unidentified companion. She was an intimate of Cissy's until tensions with Drew Pearson over the issue of intervention and the transfer of his "Washington Merry-Go-Round" column from the *Times-Herald* to the *Post* severed their friendship.

Democratic Party publicist Charles Michelson with another of Cissy's close friends, Evie Robert, author of the *Times-Herald*'s "Eve's Rib" column. After Cissy's death, "The glamour girl of the New Deal" would inherit both Cissy's famous Yousoupoff black pearl necklace and her lucrative commercial properties on Connecticut Avenue.

The *Times-Herald*'s "Under My Hat" society columnist, Count Igor Cassini, and his wife, the former Austine ("Bootsie") McDonnell, chatting with the isolationist-turned-internationalist Senator Arthur H. Vandenburg. Cassini was the elder son of Cissy's girlhood friend Marguerite Cassini, daughter of the last imperial Russian ambassador to the United States. Bootsie Cassini took over her husband's column when he shipped out for active duty in 1943. In the aftermath of the war, Igor Cassini moved to New York to become the Hearst papers' society gossip columnist, "Cholly Knickerbocker." His wife remained in Washington, writing for the *Times-Herald,* however. After their divorce Bootsie Cassini would marry William Randolph Hearst, Jr.—the same week that Cissy died in July 1948.

Ambassador Warren Austin, Cissy Patterson, and Senator Burton Wheeler at one of
Evalyn Walsh McLean's Easter luncheons at Friendship in Georgetown

future American ambassador to Luxembourg (whom Irving Berlin and
Ethel Merman would later immortalize as "the Hostess with the Mostes' on
the Ball" in *Call Me Madam*), would go unrecorded. Whether the Oklahoma
oil heiress and Pittsburgh machine-tools magnate's widow had offended the
publisher with her much-ballyhooed defection (and large donations) to the
Democratic Party in 1940 or with the zeal with which she laid siege to
Washington society upon settling there in 1941, Cissy saw to it that this
upstart dowager from the hinterland did not find the capital so "easy to
break into" as it had been when Nellie Patterson arrived from Chicago four
decades before. Seating Perle Mesta with the evening's hired crooner at a
card table in the corner, while tantalizing notables dined at magnificently
set rounds of eight nearby, failed to produce in Cissy's ambitious victim
anything less than delighted gratification at having scored an invitation to
one of 15 Dupont Circle's legendary soirées. Cissy escalated her hostilities,
therefore, to forbid all mention of Perle Mesta in any of the *Times-Herald*'s
multiple society columns. Nonplussed at having attracted so little atten-
tion for the lavish hospitality of her "Mesta fiestas," in the city's most
widely read newspaper (her hired publicity agent notwithstanding), the
interloper countered by proffering a variety of enticements—cash among
them—in exchange for favorable write-ups, to the *Times-Herald*'s fearful
social commentators, who found themselves pawns in a battle of wills
between two of the capital's titanic doyennes.

As Perle Mesta and others like her grappled with Cissy's social and editorial spite, so Arthur Newmyer shared the brunt of Cissy's long-held bigotries, as well as her frustrations with the *Times-Herald*'s dwindling advertising figures. As merchants became ever more unwilling to buy space in the pages of the ever more shrilly isolationist *Times-Herald* by the late 1930s, so did Cissy grow more flippant—and, indeed, malicious—in her contradictory efforts to cultivate them. If several of her advertisers added to their litany of complaints the fact that the society matrons Cissy launched to prominence were for the most part of Anglo-Saxon descent, as war approached the publisher at last granted spectacular play on the *Times-Herald*'s society pages to a Jewish socialite.

After a personal inspection conducted at the candidate's sprawling "Art Moderne masterpiece" on bucolic Foxhall Road (which, according to Cleveland Amory's *International Celebrity Register,* boasted a marble entrance hall complete with "bronze zodiac design and neon lights" as well as a private "supper club" on the terrace whose glass dance floor was illuminated from below), Cissy was satisfied that she had located a particularly, even hilariously gauche specimen. If, as *Time* magazine observed, "a few fusty Washington grandes dames were inclined to sneer at Mrs. Cafritz' ambitions," the publisher of the *Times-Herald,* by contrast, was inclined to exploit them in pursuit of advertising linage and revenues—all the while snickering at them in gratification of her own increasingly perverse sense of comedy. "Cissy saw I had potential," Gwen Cafritz herself later declared, not perhaps fully aware of the accuracy—or, indeed, the irony—of the assertion.

Born in Budapest in 1912, by 1928 Gwendolyn Detre de Surany had married Morris Cafritz, whom the *Washington Post* later characterized as "the most influential real-estate developer in the District's history and the man who almost singlehandedly created that monster of architectural ugliness and cynical influence-peddling, K Street." Following her apparently successful interview with Cissy over caviar and champagne, the "vivacious," "dynamic," "stunning," Gwen Cafritz, an "exotic type with heavenly white skin," received exuberant coverage as the *Times-Herald*'s Beauty of the Week. Afterward, the paper's many social commentators trumpeted the details of the rising hostess's every lavish gathering, down to the place settings and the increasingly formidable guest lists. They lovingly chronicled the minutiae of her opulent wardrobe and toilette, gushing that she was "always so smart and exquisitely groomed." They enumerated her generous charitable gifts, particularly her many kindnesses toward America's servicemen and -women. And they broadcast and immortalized the sort of malapropisms, nonsequiturs, and quotable bons mots on Washington high society ("I ALWAYS invite Senators, but I seldom play around with the Lower House," and the like) for which Gwendolyn Cafritz had already

become notorious without Cissy's assistance among Washington's supercilious cavedwellers and chuckling society matrons.

Although Morris Cafritz responded to the *Times-Herald*'s attentions to his wife with ever-larger advertising spreads touting his real estate and construction concerns, his fellow Washington businessmen and co-religionists did not. Indeed, by the summer of 1942 Cissy began to suspect in the *Times-Herald*'s ever-diminishing advertising statistics a quiet but concerted boycott fostered by the likes of Marshall Field III's other recent publishing venture, the "experimental" liberal New York tabloid *PM,* and the Anti-Defamation League, which she took for a front for more radical organizations such as the Anti-Nazi Non-Sectarian League.

Her deteriorating relations with Washington's Jewish community notwithstanding, those lingering feelings of suspicion and betrayal from close at hand that she had experienced upon learning of the defections of former staff members to the *Chicago Sun* would only be revived when the line "Shit on Eleanor Jew Patterson" appeared in the *Times-Herald,* inserted surreptitiously into a classified ad by a culprit whom yet another FBI investigation failed to discover.

Cissy had been infected by her cousin Bert's rising paranoia; intermittent threats of prosecution for treason; wartime newsprint rationing; floods of hate mail; threats of bodily harm; mounting suspicions, both of the existence of a hostile cabal of Jewish advertisers and of FBI infiltration of the *Times-Herald* itself. These unrelenting attacks and betrayals from all sides conspired to cause Cissy's physical and emotional health to give way under the strain. In the early years of the war, the indeterminate nervous complaints of her adolescence began to resurface. Many within her circle believed she was growing more erratic than ever, the result, they speculated, of the rising quantities of alcohol (and other mood-altering substances, it was whispered increasingly) in which she indulged.

> But that is the way wars start.
> They creep up on you and you are in them
> before you realize it.
>
> — DREW PEARSON TO TYLER ABELL, JUNE 28, 1936

Drew always was a bastard of the world. I have tried my best with him, but he has a queer, cruel streak that is just too much," Cissy complained of her former son-in-law at the outset of the Second World War. "I have always known it, but for Ellen's sake I have tried not to let that make

trouble. Now it is all over." A month to the day before the Japanese attack on Pearl Harbor, the Pearsons threw the last in a succession of convivial birthday parties for Cissy (or "Mom," as Drew had come to call her). Although she had long ago altered her vital documents to state otherwise, it was her sixtieth. Many had remarked on the peculiarity of the publisher's maintaining so close a relationship with her former son-in-law while growing steadily more distant from the daughter who had divorced him. Even Cissy's own brother had dismissed this makeshift kinship as nothing more than a "sand family." Much as Joe Patterson opened an old wound by informing his adoring younger sister, "You've reached an age where nobody will love you for yourself any more," so it was with characteristic lack of ceremony or cushion that he forecast that the "sand family" Cissy had fashioned would "dissolve in the first storm." The force that would ultimately obliterate this small refuge from the vicissitudes of her multiplying anxieties, ailments, and feuds was no less a disturbance than the Second World War. Felicia's almost total, hostile absence from her mother's life by the mid-1930s notwithstanding, the little tribe with which Cissy surrounded herself (only one of whose members was in fact her blood relation) doubled over the same period to include not only Drew and Ellen Pearson, but Luvie and Tyler Abell as well. Although largely self-inflicted, the pain Cissy sustained in losing them would have perhaps the most devastating impact of the many blows and shocks her fights, infirmities, and fears were to deal her.

"I was 15 years old then, and I had no idea that a world war was starting. And I think very few other people in the United States ever thought that we would come into that war," Drew mused in a letter to Tyler, then not yet four years old, on June 28, 1936, the twenty-second anniversary of the assassination of Archduke Franz Ferdinand. It was a testament to the affection the columnist had developed for the son of his old friend and former colleague that he now sent the child the sort of self-revelatory epistolary ruminations—almost without exception more appropriate to a far older correspondent—that he had reserved previously for his own small daughter. "But that is the way wars start," he continued. "They creep up on you and you are in them before you realize it." If Drew had written the newborn Ellen of his elation at the moment of her birth, the infant Ellen of his adoration of her mother, and the toddler Ellen of the heartbreak of his divorce, it was in part because, as her father, he anticipated both a shared future and the eventuality of his daughter's coming to comprehend their shared past. By the mid-1930s, he had begun to campaign for a shared future not only with Tyler Abell, but also with the boy's mother. Indeed, seized by intima-

tions of his own mortality—and seizing the opportunity to cast himself in a flattering light—in December 1935 Drew had typed up a will, "in case of an accident," before rushing off to catch a plane. Although the fact that the document was unwitnessed would have rendered it invalid in the event of his death, in it he bequeathed $5,000 of his life insurance payout to Tyler. By quietly asking Luvie's brother, Dan Moore, to oversee the bequest in the event of his death Drew calculated correctly that news of his honorable, unspoken intentions would soon be transmitted to the object of his affections. Continuing his reminiscences to little Tyler about the romance of performing relief work in the aftermath of the Great War, Drew mused about eventually returning to the Balkans and the difficulty—given his growing prominence as a columnist, radio personality, and political commentator—of finding the time. "But someday I shall go," he resolved, "someday perhaps when you are older and your mother will let you go with me—then we shall go together and I shall show you a country—such a country—a country of minarets, and Turkish gardens, and snow-capped mountains and veiled women, and forest and fields and—I can hardly wait for you to grow up," Drew closed. Within a year, he would end similar letters to Tyler by signing himself, "Daddy Drew."

George and Luvie Abell's marriage had grown no more harmonious or stable after Tyler's birth in 1932 than it had been before. George found it difficult to maintain consistent employment. The occasionally charming, if erratic epicure had been fired from the Baltimore *Sun,* even though he was the founder's grandson. Neither had his uncle's position as the paper's chief counsel prevented his dismissal from the *Washington Post.* His tenure at the *New Yorker* had been similarly cut short. The tabloid he launched, the Santa Fe, New Mexico, *Sun,* folded after only a few months. There were rumors of darker shortcomings as well. These would soon be enumerated, elaborated upon, and codified in a series of legal affidavits to which a host of eminent Washingtonians—among them military officers, elected officials, tenured professors, and respected journalists—signed their names (the documents having been helpfully drafted for them by the subject's old intimate, that formidable muckraker Drew Pearson). George Abell had been "forced to leave Baltimore because of abnormal sex practices," one contended. He had "indulged in abusive language" in the presence of his wife and child, another revealed. He kept company with unsavory characters, many asserted; indeed, his unnamed "closest friend" had been charged with "exposing his person to schoolgirls on a bus." George Abell decorated his walls with pictures of nude women. He composed and recited bawdy verse. His library was filled with "neurotic literature." He was given to

"playing with guns." He was "erratic," "selfish," "irresponsible," and "niggardly," especially where his child's care and well-being were concerned. And, several affidavits attested, George Abell had repeatedly and casually flouted his marriage vows.

On April 18, 1935, after five years of matrimony, Luvie Abell had been awarded a decree of absolute divorce in Reno, Nevada, which granted the Abells joint custody of Tyler, six months to each parent. Plagued by chronic ill health, in the late summer of that year, Luvie rented a house near an aunt in Santa Fe, New Mexico, where she and Tyler were soon joined by George, who took a solemn vow, once again, to stop drinking. He continued to visit and stay intermittently over the course of the coming year, during which he made several attempts to persuade Luvie to reconcile with him so that they might ultimately remarry. Unbeknownst to George, however, he was not his beautiful young ex-wife's only suitor.

"This is a funny kind of a letter to be getting from an ex-husband, but for about two weeks I have been wondering what the hell is the matter with me," Drew Pearson ventured in one of the unsent letters he scribbled from Rome to Felicia Gizycka, who was in Paris, on December 11, 1936. "I have been going over the days when we were married and trying to figure out the mistakes I made, because somehow or other I think I am making them all over again."

> I have only loved two women in my life, and if things don't go a little better it looks as if the second marriage might be botched as well as the first. As you probably know I have been looking forward to marrying Luvie for a good many years now. We have known each other very intimately, we ought to be able to get along together, but frankly this honeymoon, instead of being the trip I had dreamed about, has been unmitigated hell. It started out all right. In fact it was wonderful. Then we got this cable about George coming over and Luvie went all to pieces.

Over the previous summer Luvie's health had grown worse. Plagued by lower abdominal pain, in late October 1936 she had traveled to Tulsa, Oklahoma, for an operation intended to correct the "serious pelvic disturbance" from which she suffered. Even before being released from the hospital, however, she received a call from her ex-husband, demanding that she return to Santa Fe immediately to care for Tyler. George suddenly needed to depart for New York, even though his legal custody of their child would not expire for another week. Upon returning to New Mexico two days later, Luvie found herself "immediately subjected to a two hour grilling" by her

ex-husband. Still weak after her surgery, "to get rid of him" she finally capitulated to George's demands that they remarry upon his return from the East Coast. Until then she had not been wholly persuaded to remarry anyone, Drew Pearson's attentions to her and his many kindnesses to her small son notwithstanding. Upon discovering snapshots George had left behind of his mistress, however, Luvie took Tyler and returned to Washington—and to Drew. George learned of his former friend's marriage to the former wife he thought he had browbeaten into reconciliation when he read about it in the press during his precipitous jaunt to the East Coast. Despite her close friendship with both the bride and the groom, Cissy was surprised (and therefore rankled) by the news as well. As the *Washington Herald* reported the secret wedding (on its front page, two weeks after the fact), "what a columnist may write in his column may not always be news. But when a columnist elopes with another columnist's wife—even though the lady has been duly divorced—that IS news. And when both the columnists as well as the lady are known and popular in Washington society and are known to have formed a little friendship-trio all to themselves—then the story becomes intriguing."

At the close of 1936, just as Drew and Luvie embarked on a new life together—and a European honeymoon fraught with anxiety and intermittent illness, ten-year-old Ellen, four-year-old Tyler, and their nanny in tow—Felicia was emerging officially from her second divorce. "Felicia has cabled that she is going to be married to Edward [*sic*] de Lavigne," Cissy had informed Arthur Brisbane on April 11, 1934. "I have never heard the young gentleman's name before—if he is young," the incredulous mother of the bride added. Growing daily more deeply mired in alcoholism, Felicia had returned to Europe in the wake of the previous year's painful break with Roger Makins. Talk of marrying her "cousin," Count Alfred Potocki, master of the magnificent neo-baroque Lancut Castle and park a hundred miles east of Krakow, had been quickly stifled by Cissy's affronted refusal to grant the Pole the dowry he demanded. Then twenty-eight, Felicia continued her wanderings across the continent and the British Isles, falling in with highborn, cosmopolitan, and increasingly Dionysian companions. "From London comes one of the most interesting announcements of the season, that of the marriage of Countess Felicia Gizycka, daughter of Mrs. Eleanor Patterson of Washington, and the late Count Gizycka [*sic*], and Mr. Dudley de Lavigne, brother of Lord Castlerosse's wife, which took place yesterday morning at Caxton Hall registry in London," the *Washington Post* noted on April 15, 1934, echoing ominously its earlier, unenthusiastic report of her parents' fashionable international wedding. "The countess

met her fiancé two years ago and again in London a month ago. A rapid courtship followed, culminating in the marriage yesterday in the presence of a small group of friends."

Whether Felicia was conscious of it or not, this latest impetuous union between a putative American newspaper heiress and a well-connected if penniless foreign adventurer, had fallen on the thirtieth anniversary of her parents' wedding. "I guess Felicia's new husband is pretty bad news," Cissy wired Joe four days later, having made an investigation of the impecunious insurance broker, Bright Young Thing, and intimate of the Prince of Wales through the latter's brother-in-law, Viscount Castlerosse, the Anglo-Irish gossip columnist and intermittent director of *The Evening Standard, The Daily Express,* and *The Sunday Express.* Although Valentine Castlerosse, dishing scandal as "Cholly Knickerbocker" for *The Sunday Express,* had characterized Dudley de Lavigne as "tall, slim and not very energetic," Felicia would not find her new husband to be so languid. Continuing to follow fatefully in her mother's footsteps, if at an accelerated pace, Felicia recalled that during their honeymoon in Egypt, "he cuffed me around quite a bit, and subsequently he hit me some more. I can't blame him. My tongue had become increasingly skilled at venomous home truths. He had not developed this art and had no recourse but his fists." In hindsight she concluded, "What we had in common was alcohol." The couple had been married on April 14, 1934; by April 30, newspapers across the United States began receiving reports off the European wires of the newlyweds' rupture.

In the course of the subsequent two years' "deadlock required by the English divorce laws," Felicia's alcoholism grew more pronounced. Although aware that "during this time, you are supposed to behave yourself," she embarked nevertheless on "a little wine-tasting tour through France, all by my lone, with car and chauffeur." Having begun one evening at a celebrated Burgundian restaurant, she ended it on a park bench in the town square where she awoke to find a stranger hovering over her.

When he reached for me, I rose and smote him. He, in turn, kicked me so I fell to the ground. Bruised, and deadly ashamed, I told no one. I began, here and now, to fear the answer to the question—what is the matter with me? I had already been to one analyst at home. We had not gotten anywhere. Was my mental state more serious than he said? Was I insane? What was it? I did not dare to think.

"I drank and I kept drinking," she admitted. Old friends fell away, alienated and confused by Felicia's immoderation, her imprudence, her chronic lateness, her unreliability, her raucous "naughtiness" and hilarity on inap-

propriate occasions, and her general disregard for those around her. "I passed out frequently in my home, alone."

"Sorry delay unavoidable miss Ellen terribly can you send her now till school starts meantime arrangements can be made agree it should be settled writing," Felicia cabled two months after her second marriage, not having responded before to Drew's repeated letters, telegrams, and transatlantic telephone calls attempting not only to settle their seven-year-old daughter's plans for the rest of the summer of 1934, but moreover to revisit the issue of the child's joint custody generally. If Drew had been amenable to an impromptu alteration to the terms of their divorce agreement in the summer of 1932, by allowing Ellen to remain at the Swiss boarding school where Felicia had placed her (although he had asked a friend then traveling in Europe to keep an eye on them surreptitiously), the intervening two years had instilled in him a strong unwillingness to be flexible with his ex-wife where their child was concerned. Following one of a mounting number of disputes over visitation, Drew wrote Felicia with "mingled bitterness and affection":

> I warn you that this is the last time that I shall give in to you. I am determined that our daughter shall have a father. I know that you agree to this in theory. But in practice you are inclined to put the material things of life ahead of the spiritual. I think if your mother had given you less of luxury and comfort and more of love and companionship you could have been happier today.
>
> I know that you are already giving Ellen the finest physical care she could hope to have. I believe and hope you are giving her other things.
>
> Probably I shall not be able to give her much luxury. Even if she visits her father in a hovel, however, she shall get some things which only a father can give and in the end she shall know she had a father.
>
> Please remember that when you refuse to send her to me that it is not always the bodily things in life that count most.

By the mid-1930s, a growing carelessness led Felicia to submit those stories she still managed to write without first proofreading them or assuring that their pages were sequential or even complete. She showed a similar inattention toward Ellen, despite her ongoing insistence that she wished to have her daughter by her side as often as possible. "I am more disappointed in you than you ~~could begin to~~ may know for your negligence ~~in not informing me failing to inform me~~ regarding Ellen's health ~~& future plans & failure inform me~~," Drew scrawled on a Western Union telegram form, almost incoherent with rage. "Unless I am $\overset{\text{thoroughly}}{\wedge}$ satisfied with medical

Ellen Pearson in the late 1930s

report other steps you've taken I shall use legal measures prevent her removal from United States."

Indeed, Felicia had given Drew more than sufficient cause to fear their child's removal from American legal jurisdiction. Growing increasingly willful and erratic, on one occasion Felicia had taken Ellen and sailed for Europe the day before the child was scheduled to return to her father's custody. Since her own father's death, Felicia had been in friendly contact with a number of her central and eastern European "cousins." She would seek their help and protection, she informed Cissy in a message she left before departing, in keeping Ellen with her in Europe and preventing her from returning to the United States with Drew. Notwithstanding Cissy's recent pronouncement that "a child belongs to its mother" in the custody battle over little Gloria Vanderbilt, as a grandmother she was aghast that Felicia, once the "most kidnapped child in the world," had grown up to abscond with her own daughter. Pursuing mother and child to Europe, Drew had eventually persuaded Felicia to allow Ellen to return to the United States, but in the process he acquired a sense of deep unease on the subject of allowing minor children to travel abroad with their divorced parents and developed an insistent attitude toward ironclad legal custody agreements.

By December 1936, when a bewildered Drew weighed soliciting his first wife's advice on how to avoid spoiling his second marriage, Felicia was

living—and managing to work—in Paris. Family differences notwith-standing, she told friends she hoped to follow her mother into publishing. While Felicia accepted from Cissy the sort of generous allowance that Cissy had received from Nellie in years past, whether fully aware of it or not Felicia was also the beneficiary of more subtle forms of support from her mother. "Felicia de Lavigne has been doing some good work for Carmel, at least Carmel says so," T. J. White ventured to Richard Berlin, president of Hearst Magazines, after receiving a report from his sister at *Harper's Bazaar*'s Paris office in April 1936. Carmel Snow had been so impressed by a recent article Felicia had written that she hoped to hire Cissy's daughter on a more permanent basis. "Would you feel justified in giving her the assignment—more an address, a reason to be there?" Tom White wondered. "It is there she wants to live. Therefore, sir," he cajoled, venturing out on to an unfamiliar limb, "probably for the first time you have ever known me, you see me putting in a strong plea." Although Felicia's professional prospects were improving, her health was not. While living in Paris, she learned from an American doctor that her liver was enlarged. "You're an alcoholic and there's nothing I can do for you," he informed her. She later remembered, "This went in one ear and out the other. I did not know what he meant."

Luvie Pearson spent much of early 1937 in what her second husband described as a "knock-down drag-out fight" with her first in the Nevada court system, attempting to alter those terms of her divorce decree that concerned the joint custody of Tyler. As a result of the dozens of affidavits Drew had solicited from "reputable people" attesting to George Abell's profligacy, debauchery, and general unfitness as a parent, on June 28, Luvie was duly granted primary legal custody, with the exception of the six weeks each year between July 1 and August 15. Almost immediately after becoming her son's primary legal guardian, therefore, Luvie duly handed Tyler into his father's care, as ordered by the court. At no time would the child be permitted to travel with either parent beyond the borders of the United States, the modified decree stipulated, without the consent of the other.

"I hope George won't really take Tyler," Felicia wrote Drew three weeks later, adding hopefully, "I bet he doesn't now he's won his point." Much of what had fueled George Abell's belligerency in the "harrowing battle" he had recently fought with Luvie in Reno was a simmering resentment at being blindsided by her remarriage to his former close friend. Indeed, "he was for 'raising holy hell' at once, but decided he had better wait until her six months period of custody of Tyler had expired before starting any-

thing," a New York *Journal American* reporter would soon divulge. On August 2, 1937, a week before Tyler's fifth birthday, Luvie contacted George's attorney in Washington to find out where to send her son's present. The lawyer's "queer manner" in informing her that he did not know filled her immediately with dread that "something untoward had occurred." Nursing his grudge, as soon as George had taken Tyler into his care in Reno, he set about to overturn the "desert justice" that had granted Luvie primary custody. Discovering upon his return home, however, that the Washington courts were in recess he determined to take matters into his own hands. "I did not want my son brought up in that atmosphere," he would soon grumble to the London *Daily Mail,* "so I came to England, hoping to get justice in the English courts."

Just as newspapers nationwide announced that Mrs. Eleanor Medill Patterson, the mercurial lady editor and publisher of the *Washington Herald,* had negotiated a lease to operate both of the Hearst papers in the nation's capital, the newlywed Pearsons embarked on a frantic international search for Tyler. "I had no intention of returning the boy to Nevada, I simply wanted to get him away from that jurisdiction into some state where I could get a square deal in court," George Abell admitted to friends. Luvie's anxiety was heightened by the evasive responses she had received from George's cohorts as to where he and Tyler might be vacationing. Unbeknownst to her or Drew in the early days of August, after leaving Washington Tyler and George had stayed briefly with friends in New Hampshire before George declared it impossible to concentrate on the book he was writing, and then moved on. On August 6, 1937, following exhaustive inquiries with dozens of steamship companies in the United States and Canada, Luvie learned that George and Tyler had sailed from Montreal to Liverpool aboard the SS *Montcalm* on August 1, in flagrant violation of the terms of the recently amended divorce decree. Having lost nearly a week, the Pearsons sailed after the Abells on the first available steamer, which was scheduled to dock in England on August 16, the day after George's legal custody was set to expire. In the meantime, Drew prepared to mount a formidable international recovery operation. He secured the cooperation of Scotland Yard through FBI chief J. Edgar Hoover. He alerted the British Home Office to the situation through the State Department. He hired a squad of "flat-feet" to pursue leads in Britain through an old London-based former movie industry associate of Maritime Commission chairman Joseph P. Kennedy. He assembled a British legal team that included "one of the most distinguished members of the London bar," Ronald Rubenstein (or "Ruby" as he came to be known in Drew's rollicking correspondence on the subject), through his own attorney, co-founder and general counsel of the American Civil Liberties Union, Morris Ernst.

After several days of fruitless inquiries among English hotel clerks, porters, and taxi drivers, the Pearsons were "desolate." Although the many dead ends they encountered in Liverpool, London, Southampton, and Yarmouth far outnumbered the few encouraging clues they developed, the Pearsons and their team were drawn haltingly but unmistakably toward the Channel Islands. Luvie remembered an old rhyme her ex-husband had often recited during their marriage about the Isle of Sark and his many musings on the possibility of one day moving there to write. Soon afterward, a friend of Drew's managed to dupe an associate of George's into a slip of the tongue—and a confirmation of Luvie's hunch. The Abells, father and son, were indeed staying on the tiny, remote Isle of Sark.

On Sunday, August 22, 1937, after more than three weeks with no news of her child, Luvie, Drew, and Ruby, their enthusiastic barrister turned detective, chartered a biplane and made several passes over the island ("on Luvie's suggestion, to get the lay of the land, as do all experienced criminals before pulling a job," Drew reported to her grandmother afterward). The party then landed on the larger island of Guernsey in anticipation of returning stealthily to Sark by sea, aboard a fishing vessel. "Sark rises out of the water, almost sheer rock. And from the rear harbor, where we landed, we had to climb a cliff, in some places with the help of iron steps, hand over hand," Drew remembered. With the assistance of the Channel Islands police force, the small party concealed themselves behind a hedge at the edge of a windswept cow pasture for "three long hours," after learning that Tyler and his nurse had taken their daily walk in that direction. By evening, the little band had almost given up when the boy and his nurse trudged up the path at last on their way back to their lodgings for dinner. Luvie stepped out from behind the hedge to Tyler's surprise and delight. Ruby and the local constable attempted to persuade the befuddled nurse of the legality of the strangers' making off with her charge by pointing to court papers from distant Reno, Nevada. Meanwhile, Luvie and Drew (with Tyler riding piggyback) set off at a run for the cliff, at the bottom of which their fishing boat awaited in the darkening surf. By the time the breathless nurse burst into George Abell's study to tell him what had happened, the Pearsons and Tyler had left the Isle of Sark in their wake. "The trip back to Guernsey was lovely," Drew remembered with satisfaction.

Luvie sat in the stern with Tyler, wrapped up in coats. The poor child kept wanting to know why he couldn't have brought some of his toys along, and his clothes. I gave him the binoculars I had used at Yarmouth, and I hope he never knows that I bought them for the express purpose of searching for him on the beach. He has been wearing them proudly ever since.

"The first thing we saw at Guernsey was a police officer standing at the dock. We veered around to land at another dock, but he followed us, and asked us to come up to the police station, which we did." George had raised the alarm. Authorities along the British and French coastlines had been alerted to be on the lookout for the kidnappers and the American boy they had snatched. The BBC had been scheduled to issue a general alarm throughout the British Isles within minutes of the party's landing. These safeguards were canceled once the Pearsons produced legal documentation of their claims, which Scotland Yard duly corroborated (as Drew had arranged in case of trouble). It would be several hours before the party was released, however, after explaining and repeating their story to the satisfaction of a succession of skeptical island grandees. At the end of a long day, the Pearsons, Tyler, and Ruby drove across the island to the airstrip, where a large crowd had gathered. Although it was a moonlit night, in the darkness it was necessary to train car headlights onto the field in order for the party's plane to take off. By eleven o'clock they had touched down at Croydon and made their way back to their London hotel while Tyler slept.

By two o'clock the following morning the first calls from Fleet Street began to trickle in. Drew spoke to Lord Rothermere's two *Daily Mail* reporters to ensure "it was the right story." By daylight the hotel was besieged by reporters and photographers from the raucous London tabloids, who thronged the reunited family wherever they went, their feints and dodges, their changes of taxicabs and hotels notwithstanding. "Luvie says I got a good dose of my own profession and that it served me right," Drew recalled. The *Daily Mirror* cheered the frantic "Air Dash to Reclaim Baby." "Mother Hides 'Stolen' Boy, Issues Writ; Father's 'I'll Fight to the End,' " the *Daily Mail* shrieked. "Mother Flies from Isle by Night with Son: Ex-Husband in Pursuit, 3,200-Mile Search Ends in Britain," the *Daily Express* recounted in fulsome prose. "Mother's Air-Sea Dash With 'Kidnapped' Child: Father Beaten in Race to London After Ambush on Island," gasped the *Daily Sketch*.

While George Abell, desperate to seek redress and revenge by securing his son's return in the British courts, made maddeningly slow progress by boat from Sark to Guernsey to Jersey on August 22, 1937, Ruby made a legal end-run around him by procuring a temporary injunction restraining the disgruntled father from "molesting" his ex-wife or their child once he reached London by air at last on August 23. The following day, Drew, Luvie, and Tyler boarded the SS *DeGrasse*, a small French Line steamer due to dock in New York on September 1. "Luvie said she wanted to come on the slowest steamer afloat, and she now has her wish. It is very pleasant, but personally I should like to get back to work and Washington at the earliest possible moment," Drew confided to Luvie's grandmother.

George's surprisingly dilatory return to the United States in pursuit of his ex-wife and child two weeks later permitted Drew ample time to continue to booby-trap his rival's path with legal snares and pitfalls. "I want to take up your suggestion and get busy right away with a move for full custody in Reno," Drew notified Luvie's attorney as soon as the latter returned to Washington on September 3, 1937. "Abell Is Eager to Regain Boy; Returns from England to Resume Battle with Former Wife, Now Mrs. Pearson," the New York *World Telegram* warned as George docked in New York on September 14, almost a month after the State of Nevada had required him to return Tyler. George had grown voluble during his passage aboard the *Westernland,* vowing to reporters, "If I catch up with Pearson, it's going to be just too bad for him. I would have punched his nose if I had caught him in England, and I'm going to keep right after him now."

George returned to Washington to find himself served with a restraining order and facing contempt of court charges as well as a renewed custody battle in Reno (buttressed by the additional, embarrassing affidavits Drew had collected, which naturally included the threats of violence made aboard ship); also awaiting him was the Pearsons' petition to seek reimbursement for the considerable expenses they had incurred in the course of "L'Affaire Sark," as Drew had come to style it. George responded by slapping Luvie with a restraining order preventing her from taking Tyler out of Washington, pending a decision in the local courts as to whether Nevada or the District of Columbia would have ongoing legal jurisdiction in the matter. In ruling that Nevada would maintain its jurisdiction, Justice Daniel W. O'Donoghue took issue with both parents. "You are unfit," he scolded in terms that were perhaps more applicable to the child's father and stepfather than to his mother. "Your minds are poisoned with selfishness to such an extent that you are using the child to satisfy your ill will and hatred of one another." On October 13, 1937, the Second Judicial District Court of the State of Nevada granted Luvie Pearson exclusive care, custody, and control of her son.

"I haven't heard from you, so I guess Ellen arrived safely," Felicia had ventured to Drew from Paris two weeks earlier, in the midst of the legal wrangling between Washington and Reno. "I got a very cute letter from the boat. She said, 'Mummy, how can you write a book without me to say Sssh! to?'" Felicia had finished her second novel, *Flower of Smoke,* whose dust jacket would proclaim it to be "a romance of two contrasting worlds— American society and exhausted Europe—and of a modern woman's quest for peace of heart." The novel's heroine, Virginia von Goeningen, is orphaned when her father, an Austrian count and cavalry officer, is mobilized and killed in the Great War, her American mother having prede-

ceased him. The girl's maternal aunt Flavia arrives to tear the young Countess Virginia away from her beloved Vienna in order to raise her in inhospitable New York high society. Seeking escape from Flavia (who has revealed herself over the years to be a "sly, cold-blooded, worldly, dried-up bitch"), Virginia enters into a pair of rash, unsuccessful marriages, first to an American newspaperman, Jerry Cartwright, and later to the dissolute Comte Paul Thibault in Paris. Although war has utterly transformed Vienna from the lighthearted, pleasure-seeking city of her few happy childhood memories, eventually Virginia finds peace and contentment upon returning there alone as a divorcée.

In 1939 Charles Scribner's Sons would release *Flower of Smoke,* seven years after its predecessor, *The House of Violence.* Felicia would enjoy only a fraction of the success and celebrity of some of the eminent house's other authors, among them George Santayana, Henry James, Edith Wharton, Thomas Wolfe, F. Scott Fitzgerald, and Ernest Hemingway. T. J. White's generous efforts on her behalf notwithstanding, Felicia had only managed to remain at *Harper's Bazaar* until she "got drunk and had a row with the Paris editor." With Drew's help and encouragement, she sold a few articles on the darkening European outlook from the perspective of the man (or, rather, woman) in the street, but beyond freelancing there was little left to keep her in Paris. In the autumn of 1937, as Drew and Luvie emerged victorious from the combat over Tyler's custody and Cissy accustomed herself to publishing both a morning and an evening paper, Felicia put the finishing touches to *Flower of Smoke* and made ready to return to the United States in time for the holidays. "Drew sat there like a pouter pigeon," Cissy later complained of the ill-advised Thanksgiving dinner that followed. "He had his present and former wives and each wife's child—not to mention me, his mother-in-law—all looking up at him, the cock of the walk, the goddamned boss of the barnyard!"

Although such outbursts were not uncommon, Cissy enjoyed generally warm relations with her "sand family," its female members especially, as the 1930s drew to a close. After reestablishing herself in New York, Felicia saw little more of her mother than she had while living in Europe. At the same time, Cissy developed a tight, almost maternal bond with Luvie in Washington. As with many of her current favorites, Cissy hired Luvie to write regular film reviews for the *Times-Herald.* In like fashion, she hired Drew's younger brother, Leon Pearson, to write the *Times-Herald*'s Latin American affairs column, "Below the Rio Grande." Luvie often accompanied Cissy on her brisk, incognito constitutionals along the banks of the Potomac, surrounded by fractious, yapping poodles. The two traveled together, both alone and in the company of the older woman's two other beautiful young protegées, Evie Robert and Ann Bowie Smith.

Just as Felicia and Nellie had formed a tight, commiseratory bond nearly three decades before, so Ellen developed a close relationship with her grandmother in her mother's physical and emotional absence. From her father's home in nearby Georgetown, Ellen was able to visit Cissy regularly in Dupont Circle. Cissy was by many accounts more affectionate toward Ellen than she had been to Felicia, although she continued to express her love with gifts as of old. Ellen was the lucky recipient of a variety of pets, including several puppies, not to mention the ponies Felicia lamented that Cissy had never given her. Cissy lavished beautiful clothing and expensive jewelry on Ellen. As a girl, Ellen frequently graced the society pages of the *Herald,* the *Times,* and eventually the *Times-Herald*—in riding clothes, in period costume, in her school uniform—between glowing headlines and affectionate captions. For her tenth birthday in 1936, Ellen even received from her doting grandmother the extraordinary gift of "Beall Mount," a 280-acre tract of land, spectacularly situated along the bluffs of the Potomac River in Montgomery County, Maryland. Inasmuch as the new landowner would not reach the age of majority for more than a decade, the property was held in trust by her enterprising father, who promptly built a modern stone house on the parcel (later renamed "Merry-Go-Round Farm") and converted the land into a working dairy operation while continuing to co-author his daily column, make his weekly broadcasts, and publish occasional books.

"She was a beautiful woman, witty, charming, and with great pride," Louise Ireland remembered of her girlhood friend Felicia Gizycka. "Her life saddens me greatly." After returning to New York, Felicia saw Louise only occasionally. Their lives had diverged. Felicia was single again and led a frenetic social life; Louise, now married with children, continued to pursue her studies in psychology at Barnard with a particular interest in early childhood development and family relations. On those occasions when the two old friends met, it was evident that, despite their continued affection, an awkwardness had crept between them. Louise found Felicia to be "uncommunicative" about her past since their school days together in Washington, especially on the subject of her two failed marriages. Nevertheless, to Louise, who had once known her so well, Felicia appeared "obviously unhappy." At the small dinner parties where the two typically encountered each other, Louise recalled, "I began to realize that she was drinking excessively—and I undertook to persuade her of this fact." Felicia was not receptive. Eventually, "almost all my former friends had dropped me," Felicia realized. "All but my faithful Louise. Now I avoided *her* most of the time, since she is very conventional and I was afraid I'd lose her, too."

Felicia embarked instead upon a "dandy" new escape route. "It combined running away from my world, and drinking all I wanted to." In Greenwich Village she met a coterie of "gay young Bohemians" engaged in "sowing their wild oats." Inasmuch as most of Felicia's old friends had, like Louise, settled down to marry and have children, her new, fun-loving, hard-drinking circle was younger than she. "This was the life! I was the center of attention, just what my sick ego craved," she remembered later.

> They said I was so funny, and told me, with shrieks of laughter, what I'd done the night before. Ribaldry was the substance of the conversation, and I set out to be the funniest and most ribald of them all.
>
> They woke up with hangovers, but with no remorse. I woke up filled with secret guilt and shame. Underneath, I knew this was all wrong. Now it was semi-blackouts every night, outrageous behavior, passing out in some friend's Village studio or not knowing how I got home. The horrors of increasing hangover sickness to occupy the entire day; nausea, dry heaves, the rocking bed, the nightmare-filled mind.

Felicia resumed analysis with the same chatty pulmonary specialist, self-styled psychiatrist, and man-about-town who had treated and charmed Cissy intermittently since the late 1920s. Ever boastful, quick to volunteer intimacies divulged on the psychiatric couch, and, as ever, blithely trampling the boundaries between his personal and professional relationships, Dr. Alvan Barach would later reminisce about having dated his beautiful but troubled young patient during her treatment. Nevertheless, he would pooh-pooh any suggestion that excessive alcohol consumption had been one of Felicia's problems. Barach, as Felicia recalled him, was "a brilliant doctor who was a lousy psychoanalyst." She had no more success with a new analyst, and continued to wake up violently hungover at midday, making resolutions to stop drinking that she abandoned by evening.

Who's Loony?

—*TIME*, NOVEMBER 12, 1945

Walter Winchell, Luvie reported in the newsy bulletin she sent Drew on April 30, 1941, would be joining the naval reserve on August 1. "Cissy's circulation took an unprecedented jump during the Lend Lease controversy and has gone up steadily ever since," Luvie continued, adding that for the moment at least, "she thinks you are striking a fairer note about the administration." Joe Patterson had not been alone in influencing

By the early 1940s, Cissy's erratic behavior, her animus toward
those with whom she disagreed over intervention, and her
increasingly shocking editorial decisions prompted wide-
spread rumors of alcoholism and drug abuse.

his sister to continue her editorial support of the Roosevelt administration
throughout the late 1930s, despite her growing personal doubts. Drew
Pearson had been, and would remain, a staunch supporter and defender of
the president's domestic and foreign agendas, notwithstanding Franklin
Roosevelt's testy dismissal of the columnist as a "chronic liar" at a 1943
press conference. The last of the intimate annual birthday parties Drew
threw for Cissy took place a month to the day before Pearl Harbor in the
company of Undersecretary of State and Mrs. Sumner Welles, Supreme
Court Associate Justice Frank Murphy, Evalyn Walsh McLean, and the for-
mer assistant secretary of the treasury in charge of public works, Mrs.
Lawrence Wood Robert, and Mr. and Mrs. Frank Waldrop. While the cele-
bration itself was a success, the felicities of the evening could not prevent
the rift already present within Cissy's makeshift family from widening.

"I want my paper to give its news honest and unbiased," Cissy had
claimed in a New York *Herald Tribune* interview of November 1939, war
having begun to ravage Europe only two months earlier. "We all say
that—all newspaper proprietors—but I really mean it." In reality the
United States' entrance into the hostilities prompted her to abandon any
remaining pretense of objectivity. In May 1942, she declared to her editor-
ial staff, "To hell with it! If I have to print opinions violently opposed to
my own to stay in business, I'll get out." As fascism metastasized through-
out Europe and Asia, Drew Pearson and Robert Allen, like their colleague
Walter Winchell, had taken an increasingly hard line against American

isolationism in their respective nationally syndicated columns, both of which were published exclusively in the capital by the *Times-Herald*. As the likelihood of American intervention in the European conflict appeared to grow and Cissy, like her brother and cousin, took an increasingly vitriolic personal and editorial stance against American involvement, it fell increasingly to Frank Waldrop to bowdlerize the *Times-Herald*'s content to make it comport with the owner's views. Initially, Waldrop simply excised offending sentences, then entire paragraphs as Winchell's column and the "Washington Merry-Go-Round" (overwhelmingly popular with the *Times-Herald*'s readership nevertheless) appeared farther and farther toward the back of the paper ("among the patent medicine ads," as Cissy later put it)—when they appeared at all.

"Cissy was a powerful enemy to make and I made her a ferocious foe with just one remark," Walter Winchell would exult with characteristic amplification in his autobiography. By the columnist's own account, the incident occurred at one of the sumptuous "gahdamb'd affairs" that Evalyn Walsh McLean hosted at Friendship in Georgetown in May 1941. Winchell, a reluctant guest, found himself seated at the hostess's table with a variety of "Big Shots" ("pro-Nazis plus FDR–New Deal–Haters"), including the dinner partner who published his column locally, Eleanor Medill Patterson. In the version of events he published shortly afterward, Winchell recorded a belligerent Cissy charging that "imitators steal your act while you've been neglecting it to mould public opinion." Three decades later, he described the encounter as even more pyrotechnical. Having "had a few," Cissy turned to him during dinner and demanded, "Why the hell don't you quit looking under the bed for Nazis? I mean," she persisted, now raising her voice, "your column, which is read by only servants down here, is becoming a bore the way you keep after Nazis!" "Mrs. Patterson," Winchell retorted as he rose to leave the table and (he claimed) she ran to the kitchen to hide her tears, "why don't you get yourself another boy?" When Evalyn Walsh McLean pressed him to apologize, he refused. "Apologize?" he demanded in his autobiography. "That'll be the day. My files include a favorite line: 'Only a Fool Apologizes but a Bigger Fool Accepts One.'"

In reality, it was less a single remark that made enemies of the columnist and the publisher (whatever that remark might have been) than it was a single, if multifaceted, issue: Winchell's unwavering personal and editorial "blind adoration for FDR" (as their mutual friend Ernest Cuneo described it) and Cissy's unwavering personal and editorial insistence on American isolationism. Although Winchell's colorful, if self-serving, memoir alone survives to record that Cissy had "romanced" him "(she was lots senior than I)," the publisher had known the vaudeville reporter turned gossip colum-

nist turned political commentator for some time, having accompanied him delightedly not only on his crime beat on occasion in New York in former years, but also to several of the celebrated prizefights of the 1920s with Cuneo. Although she had admired the sort of reporter Winchell was—calculating, mud-flinging, and, with his legendary staccato "slanguage," given to a catchy turn of phrase—she no longer appreciated the increasingly political nature of his commentary, particularly after Cuneo recruited him into the Roosevelt camp at the approach of war.

On December 8, 1941, the director of naval public relations wrote the columnist cum reservist, "While we all appreciate your desire to get into active harness . . . We all feel you are doing better work for the Navy in your present broadcasting and newspaper activities than you would do in some active station of minor importance." Continuing his regular print and broadcast duties, therefore, Winchell began fund-raising for navy relief during his free time (which he styled as "volunteer active duty," in uniform). Neither did the columnist's nationally syndicated insinuations regarding Inga Arvad or Cissy's printed retorts to "Lieutenant Commander Peep-hole Winchell" of January 1942 improve relations between the two. Such personal jibes, along with many others like them, both printed and shouted, were at bottom only indicative of the ill will brewing over the *Times-Herald*'s mounting cuts from his column, themselves the result of the columnist's and the publisher's increasingly divergent and forcefully declared views.

By dismantling his writings stylistically, Winchell complained, Cissy defused their political charge. "Mrs. Patterson began chopping my column to splinters. She instructed her editors to kill the punchline of all paragraphs. You can lose a lot of readers that way." By the first months of the war, at least one faithful, long-term Winchell reader in Washington began to notice the cuts by comparing columns that appeared in the *Times-Herald* with those published by the columnist's home paper, the New York *Mirror.* Eventually, the *Times-Herald* omitted entire columns from its pages; of the twenty-eight Winchell submitted to the King Features Syndicate in February 1942, for example, only nine ran in Washington. The concerned reader phoned Winchell personally to relate that when he had called the *Times-Herald* to ask why the daily column now only appeared a few days a week at most, he had been informed that the "naval duties" the columnist had so widely publicized prevented him from writing more often.

"Attention, Mr. and Mrs. Washington, D.C.," Winchell declared in an advertisement he placed in the *Times-Herald*'s rival, the *Washington Daily News,* on March 4, 1942, leaving little to the imagination: "A certain newspaper whose initials are Washington T-H omits considerable material from the column I write for King Features Syndicate. The omissions are

usually about certain so-called Americans, pro-Nazis and pro-Japs." The next of Winchell's columns to run in Washington did so under an editor's note: "Walter Winchell's column is part of a general purchase of features the Times-Herald makes from King Features Syndicate. We are under no compulsion to print any of it at any time. Winchell writes six times a week," Cissy admitted, adding hastily, "If anyone told you that Winchell 'writes three times a week,' he was not speaking for the *Times-Herald*." Cissy further clarified the situation in an interview in which she issued something of a dare to the powerful columnist: "Winchell, unless he breaks his contract with King Features, will run in the *Times-Herald* when and as we decide. Who runs the paper anyhow—the editor or the columnists?" Having already attempted for several months to wriggle out of his obligations to the *Times-Herald,* Winchell duly determined to sue Cissy for breach of contract. "First time a reporter fired his publisher," he crowed in the New York *Mirror* on February 24, 1942. Unbeknownst as yet to the general public, on that score Winchell had in fact been beaten to the punch by his colleagues Pearson and Allen of the "Washington Merry-Go-Round" nearly three weeks earlier.

Appearing in some 616 newspapers nationwide and reaching an estimated 20 million readers by 1944, the "Washington Merry-Go-Round" was the most widely distributed syndicated column in the United States— with the exception of Walter Winchell's. By the end of the 1930s, Ernest Cuneo estimated, "Nine out of ten American adults heard or read Walter Winchell between his 9:00 P.M. Sunday night broadcast and his famed Monday morning column. His readers per day averaged 50,000,000, a column reading total of 300,000,000 per week." Winchell had boasted of making a powerful enemy of Cissy Patterson by assuming the scrappy underdog's guise that he had in reality outgrown years before. By the early days of the war, however loath she might have been to admit it, Cissy Patterson had made an even more powerful enemy in Walter Winchell. With a circulation of 209,105 daily and 210,925 on Sundays as of 1942, the Washington *Times-Herald* would maintain its insurmountable lead in the capital market throughout the war years and afterward.* The combined circulation (along with the pooled isolationism and anti-Roosevelt vitriol) of the "McCormick-Patterson Axis" papers—even when coupled with that of the smaller papers from coast to coast that ran the *Tribune-News* features—was no match for the expansive reach of Winchell's and Pearson and Allen's interventionist support of the administration in print and over

*For the same year the *Star* could only boast circulation figures of 162,104 daily and 163,955 on Sundays. The *Post* followed in third place with 142,182 and 127,315, respectively. The *News* lagged far behind with a mere 85,046 daily in what attrition had made a four-paper market.

the airwaves nationwide, whether or not the *Times-Herald* permitted an outlet for their opinions in Washington.

"Fond as I am of Winchell," Drew Pearson wrote Jack Lait, managing editor of the New York *Mirror,* the day after his fellow columnist's denunciation of the *Times-Herald* appeared in the Washington *Daily News,* "I would be grateful if you would keep an eye open to see that he doesn't involve us in the controversy with Cissy Patterson."

> For personal reasons, which I know you understand, I want to keep out of this row. We are having some differences of opinion with Mrs. Patterson, purely on a professional basis, but we don't want it to be personal. In other words, if Winchell says we have declared war on Cissy, or anything like that, we would appreciate your using the old editorial meat axe.

"I don't want to hurt Walter's feelings in this—because I am 100% for him," Drew insisted, "so keep this to yourself." Pearson and Allen's pro-administration "Washington Merry-Go-Round" had been another wartime victim of the *Times-Herald*'s orthodoxies. As with Winchell, over the course of 1941, professional and—inevitably—personal relations between the partners and their Washington publisher had become "somewhat strained, chiefly over the question of Isolationism and whether or not the United States should aid the allies. Mrs. Patterson was increasingly in disagreement over certain columns written by my partner and me which were critical of the Isolationist stand of her close friends, Senator Wheeler of Montana, Senator Shipstead of Minnesota, et al.," as Drew remembered it.

In the immediate aftermath of Pearl Harbor, Drew had sailed with Luvie to cover a conference in Rio de Janeiro, Brazil. He returned home in January 1942, to find not only that the "Washington Merry-Go-Round" had continued to be subjected to the same evisceration as Walter Winchell's work in the *Times-Herald,* but moreover that his exasperated partner, Bob Allen, wished to transfer the column to the paper's old rival, the *Post,* as a result. On February 4, "upon the insistence of the authors of the column, who complain of the cuts made in their copy and of their dissatisfaction with the position given to the column when it is published," United Feature Syndicate general manager George Carlin notified Eleanor Medill Patterson by registered mail of the cancellation of the *Times-Herald*'s publication rights, effective (in keeping with the original contract's terms) six months hence.

"Regarding the TIMES-HERALD, I confess that I have not been terribly happy about the situation for some time, and am not terribly happy now that we have made a decision. I sort of hate to sever old ties, but per-

haps a clean break is the best," Drew reflected to Carlin the day after Cissy received notice. "After all, we have been harping against the State Department's appeasement policy for some time, so maybe we had better follow the advice meted out to others." Bob Allen shipped out for active army duty shortly afterward, leaving his partner to continue turning out the column single-handedly—and to face his former mother-in-law alone.

Cissy took the news of the cancellation—and, more particularly, of Drew's role in it—as an act of personal and professional perfidy tantamount to a declaration of war. The United States' first months of engagement in the global conflict saw Cissy engaged in intensifying combat with the administration, Walter Winchell, and her detractors both in the press and on Capitol Hill. She was still bracing for the aftershocks of the publication of Rainbow Five. She was livid at the recent discovery of the FBI's surveillance of Inga Arvad (and, likely, other members of the *Times-Herald*'s staff). She railed against the "great upset" that newsprint rationing, manpower shortages, and mobilization generally had visited upon the paper, along with the resulting wholesale reshuffling of its female staff from gossip columns and features to hard news. "Eleanor Medill (Cissie [*sic*]) Patterson, publisher of The Washington Times-Herald, predicted that soon women would be found 'even on city desks,'" the *New York Times* reported in the early spring of 1942. "'It's inevitable,' she said, referring to employing women in large numbers in city rooms. 'We're looking for bright young women now.'" At the same time, Cissy began marshaling her arguments and resources for the *Times-Herald*'s upcoming assault on the Associated Press at its annual meeting in New York. At almost the same moment that Adolf Hitler committed the fatal miscalculation of refusing to withdraw from the eastern front in light of the United States' entrance into the global fray, Cissy not only persisted in her multiple embroilments, but began to mobilize against a new enemy as well.

"When Hitler rose to power in Europe, a collection of un-American crackpot intellectuals, intrigue-lovers, revolutionaries and plain crooks saw an opportunity to get rich over here and at the same time build up their apparent importance," Cissy wrote in the preamble to one of the many diatribes the *Times-Herald* would print over the course of the war (and afterward) on the topic of the publisher's former son-in-law.

> Pearson is just one example but we use him here because he worked out of Washington and we know him. And how. For years he was both undercover agent and mouthpiece for the Anti-Defamation League, a powerful Jewish organization which, seized by war hysteria, sought to force free Americans to change their way of thinking. He taught many a Jew and

non-Jew to fear and hate his fellow Americans. And he added to that his apology and special pleading for Communist Russia, an old line he had been peddling from the day the United States recognized the Soviet Regime in 1933.

This racket made him rich. It put in his pocket money beyond his wildest dreams. More than that, it satisfied his natural and overpowering lust for lying, intrigue, character assassination and spying. All of which, next to money, are the aims of his life. We will say for him that he played his part with obnoxious art and success. He and Winchell screeched back and forth to one another on the radio in fine, hair-raising style, and in their various columns peddled to small newspapers all through the country they planted their strychnine cleverly.

Walter Winchell's public boasts of having fired his publisher in late January 1942 notwithstanding, the commentator was in fact no closer to securing his column's contractual release from the *Times-Herald* more than a month later. "I think we have been too kind to Cissie [*sic*]," Winchell mused to his protégé, Herman Klurfeld. "No more jabs. Let's try to retaliate with a knockout blow." While Cissy enjoyed a convivial respite from her wartime vexations at a rented villa in Palm Beach, Florida, Winchell launched a surprise attack on the publisher over the airwaves from coast to coast. Speculating on "how the pieces of the jigsaw puzzle fit together," in his Sunday night broadcast of March 15, 1942, the commentator formed a deft (if flimsy) connection between the unapologetically isolationist publisher and the poet, journalist, and Nazi sympathizer George Sylvester Viereck, who had recently been convicted in Washington, D.C., of violating the Foreign Agents Registration Act, by rehashing a prewar *Times-Herald* editorial hostile to intervention by the late, vitriolicly anti-British senator Ernest Lungreen. Three days later, Cissy retaliated by suing Walter Winchell, the National Broadcasting Company, and the show's sponsor, the Andrew Jergens Company, for damages totaling $400,000. "My biggest libel suit," Winchell gloated, even after Cissy dropped the suit in May 1943, having discovered to her dismay that "Winchell's contract with his radio sponsor . . . allows him to escape payment of any judgment that may be rendered against him . . ."

"If you are going to send a reporter up here to dig into Winchell's past," a colleague at the New York *Daily News* suggested to Frank Waldrop at the Washington *Times-Herald* on April 7, 1942, " . . . I can steer him to a dozen sources and if he does a thorough job, he could get enough on Winchell to hang him." Of Winchell's own fearsome capacity to delve into his enemies' backgrounds, Waldrop's helpful correspondent went on to

remark, "There are several around here who knew him well in the past and could give valuable information, but wouldn't talk unless officially requested to do so as, like most people (including publishers), they are afraid to." In the meantime, Cissy's preparations to seek AP membership had not prevented her from continuing to compose the sort of jaw-dropping, boxed front-page editorials for which she had been notorious for more than a decade. On the morning of April 2, 1942, the streets of Washington echoed with the familiar refrain of Happy Robinson's newsboys when the *Times-Herald*'s owner and publisher was in high dudgeon: "Have you heard what Mrs. Patterson says today?" In "Pearson and Allen, the Headache Boys" Cissy did not disappoint. She amazed readers by offering "sincere apologies" to a prominent New Dealer, Secretary of Commerce Jesse Jones, for the "maliciously distorted" facts and "innuendoes" which the co-authors of the "Washington Merry-Go-Round" had disseminated about him over the years—never alluding to the fact that those same offending columns had appeared locally in her own newspapers.

In "The Headache Boys and General MacArthur," published on April 13, 1942, Cissy resurrected a controversy now more than a decade old.

Our readers may inquire WHY Pearson and Allen, over a period of years, have by false and sneering innuendo attempted to smear the reputation of a great man, General MacArthur.

. . .

Well WHY a Winchell?

. . .

WHY a Cockroach?
— E.P.

The article went on to quote at length from *More Merry-Go-Round*'s depictions of both Douglas MacArthur's "swaggering" decoration seeking and the general's pitiless dispersal of the destitute Bonus Marchers from their Hooverville on the Anacostia Flats in 1932. Nowhere in what would grow into the *Times-Herald*'s long and venomous series on "the Headache Boys" did Cissy so much as hint at any positive references that Pearson and Allen had made to the chief of staff of the United States Army in their writings over the years. While she made frequent, scandalized allusion to the general's 1934 libel suit against Pearson and Allen for the "Washington Merry-Go-Round's" purportedly "false, scandalous, defamatory and malicious" characterizations of him she referred only once—in passing—to the suit's third defendant, the "unrealizing" *Washington Times*. In the midst of the glowing series on the same "ablest soldier in the English speaking world," which the *Chicago Tribune,* the New York *Daily News,* and the

Washington *Times-Herald* published concurrently in early 1942, Cissy did not disclose, either, that MacArthur had dropped his libel suit abruptly in December 1934 after Pearson and Allen succeeded in locating not only a cache of compromising love letters that the general had written several years earlier, but his alluring young Eurasian correspondent as well.

Stung by the defeat of her bid to secure AP membership for the *Times-Herald* in the spring of 1942, Cissy seized the opportunity to launch a renewed assault on her dissenting columnists by circulating her own imaginative version of recent events. "Early in February, I fired Pearson and Allen off the editorial page of this paper," she claimed on April 28, 1942, in yet another installment of "Pearson and Allen: The Headache Boys."

> It was my feeling then just to act and say nothing—it just seemed kinder to hold the peace. But there continue to be inquiries and stories from people needed by as slick a pair of publicity hounds as ever tapped a typewriter. They, and Winchell and the rest of their subterranean gang have vilified the Times-Herald just once too often, and they have yapped at me personally, just a little too loudly.

The publisher who had come to lead the Washington market not only in circulation, but also in the number of defamation judgments rendered against her papers over the course of her twelve-year career, expressed her righteous indignation:

> I bounced Pearson and Allen for just one reason, because the libel suits and threats of libel were such a standard feature of their career we on the Times-Herald had more or less adjusted ourselves to them. The challenges to their inaccuracy naturally made us flinch, but we endured those, too. Through all the years, up to December 7, 1941, it was my feeling that Pearson and Allen, as New Deal hatchetmen, were on their own and represented a part of the interplay of forces that a good newspaper ought to allow as far as its nerves and honesty could bear.
>
> But on December 7, 1941, there came an end to all that. It was time to shut up the snipers' posts and get down to the big business of war.
>
> That's what everybody around the Times-Herald wanted to do, and tried to do.
>
> Not so, the headache boys.
>
> Far across the Pacific there rose up a great figure to trouble them—Douglas MacArthur. Pearson and Allen have always had a kind of crazy phobia involving this man MacArthur. He is so much everything they are not, it seems they cannot resist throwing mud at him.
>
> They always throw it underhand, too . . .

"I won't have them assassinating people's character on the editorial page of this newspaper. Or, for that matter, even back among the patent medicine ads," Cissy concluded before signing her name to the latest of the ad hominem wallops that had drawn an expanding audience since she had taken her first spiteful jabs at Alice Roosevelt Longworth in the summer of 1930.

Cissy's attacks were by no means limited to the pages of the *Times-Herald*. She ensured that reprints of the paper's excoriations of the "Headache Boys" blanketed congressional offices on Capitol Hill, in hopes that members might be infected by her ostensible outrage at the decade-long litany of Pearson and Allen's "scurrilous lies." The ventriloquism of the *Times-Herald*'s denunciations that soon issued from the privileged floors of both houses would have the happy consequence of further disseminating Cissy's outlandish, typically unsubstantiated personal attacks on her former columnists—under blanket congressional immunity from libel or slander. Indeed, the very afternoon of the publication of "The Headache Boys and General MacArthur" the Honorable Martin L. Sweeney of Ohio (then in the fourth year of his own mammoth libel suit concerning the "Merry-Go-Round's" imputations of his anti-Semitism) obligingly leapt to his feet on the House floor to defend the recent Medal of Honor recipient (MacArthur's ongoing reversals in the Philippines notwithstanding) and to proclaim:

> In presenting this exposé of attacks by Messrs. Pearson and Allen, authors of the Washington Merry-Go-Round, the publisher of this prominent newspaper performs a service to the community and the Nation, in defending the reputation of the man of the hour, Gen. Douglas Mac-Arthur, and without comment registers a scathing indictment against these anemic patriots, who heretofore have made their living smearing public characters like Gen. Douglas MacArthur and others.

In like fashion, Cissy pressed the Justice Department to prosecute Drew for criminal libel and went so far as to notify *Who's Who* and other biographical publications that her former son-in-law had made gross and self-aggrandizing misrepresentations in the entries he had submitted to them.

Cissy's recriminations against Drew would outlast even the war that had engendered them. As intimates and strangers alike throughout the capital came increasingly to question the mental stability of the *Times-Herald*'s owner and publisher, Cissy, back in her reporter's guise, paid a visit to St. Elizabeth's Hospital for the insane in late October 1945. Shortly afterward, based on the observations she made during her tour, Cissy once again

indulged her animus toward her former son-in-law and other unbalanced "poor jerks" who shared his political leanings in a full-page article, "Crazy—Crazy Like Foxes." She likened Drew to Robespierre (complete with illustrations to underscore even their physical similarities) and turned her scorn once again upon those she deemed to have perpetrated leftist excesses, whether during the French Revolution or the New Deal. "Cataloguing the better-known 'liberals' according to various types" of mental illness, Cissy diagnosed the former secretary of agriculture and vice president, Henry Wallace, as a "crystal-gazing crackpot," albeit a "harmless kind of nut." As for Walter Winchell, she mused, "Hard to tell just what's biting this middle-aged ex-chorus boy. False shame of his race . . . may be at the root of it all," she suggested, referring to his Jewish heritage. "Anyhow . . . he suffers from a chronic state of wild excitement, venom and perpetual motion of the jaw." By contrast, "Poor puppet-king Marshall Field rightly belongs in the 'harmless' ward, . . . trailing his dirty sheet behind him." Even these insults were nothing compared to the vitriol she reserved for her assessment of her former son-in-law, that "rose-sniffing, child-loving, child-cheater, sentimental Drew." Continuing her rant, Cissy announced, "Incidentally, you G.I. Joes, when you happen to listen to the Phony Quaker Pearson on a Sunday night—Bleeding-Heart Drew—never forget that, although he was 20 and in prefect health in 1917, he managed to 'thee and thou' himself out of World War I. Then, as now, Drew was a yellow-bellied slacker . . ."

Giving voice to the suspicions that many Washingtonians had held since the Lend-Lease hearings of early 1941 (if not longer), Henry Luce's *Time* printed its own bemused assessment of Cissy's "Crazy–Crazy Like Foxes" under the heading "Who's Loony?" To emphasize that Cissy's latest harangue represented "the most vicious personal slander since the days when all journalism was yellow," the weekly also redacted its quotations from the diatribe with the notation "(Eleven more lines, reflecting on Mr. Pearson's personal habits, have been deleted by TIME. To publish them might put TIME into court for disseminating a libel.)" "Very special bulletin!" Walter Winchell alerted his nationwide radio audience on the evening the eight-column barrage appeared in all ten editions of the *Times-Herald*: "The craziest woman in Washington, D.C., is not yet confined at St. Elizabeth's Hospital for the insane. She is, however, expected any edition." In his own national radio broadcast the same night, Drew responded to Cissy with a forced chuckle: "The British have organized a society for protections against mothers-in-law, but what we really need in this country is an organization for protection against ex-mothers-in-law. I would like to be a charter member."

. . .

Witnessing this family brawl, the *Times-Herald*'s wide readership did not long maintain its neutrality. "I like a lot of your editorials but this one defies any explanation in my own mind," one bewildered subscriber ventured to Cissy after perusing "The Headache Boys and General MacArthur," wondering, "If you are such a devotee of MacArthur, as most of us are, why should you use your widespread influence to smear MacArthur by quoting Pearson and Allen on page 1 of your paper?" With some readers, the unrelenting hail of invective that rained down on the Headache Boys only backfired on Cissy and MacArthur. "I had suspected for a long time that General McArthur was more of a stuffed brown shirt," one District resident admitted after reading the *Times-Herald*'s extensive quotations from *More Merry-Go-Round*. "Finally you have given me something on which to fasten this hunch." Overwhelmingly favoring the columnists, most readers who wrote in to express their opinions did so in terms far less polite. Taking umbrage at Cissy's charges that the columnists had subjected the general to "sneering innuendo," one Baltimore reader jeered, "Nuts! E.P. has done the same thing in the editorials concerning Roosevelt—oh, but *that's* different. When you own a paper, you can say almost anything—but if you just work *for* it, you'd better watch your step!" In many instances the controversy cost the *Times-Herald* some of its readership. " 'Why a cockroach?' says 'E.P.' 'Why a housefly?' says 'I,' " one District resident demanded in the course of canceling his family's subscription. "A housefly is noted for its habit of pouncing upon filth and bringing the same into your house much in the same manner as your paper brings in the filth in your 'Sunday Supplement' and other feature articles which I do not care to have in my house." "You evidently thought that you would discourage their readers when you scattered the 'Headache Boys' column all over your paper," another reader charged. "The only headache I get is from looking at the cheap scandal and worthless 'news' that so typifies your paper and which I cannot avoid while searching for this column." "I think I can detect the fine, Borgialike claw of your publisher herself in this editorial blasting at 'Time' and its publisher," ventured an observant *Times-Herald* reader shortly after Henry Luce's weekly printed its wry summary of the brouhaha as "Cissy and Drew" in mid-May 1942. "Winchell writes about skunks in his todays column. Seems to indirectly refer to you," another disgruntled reader took the time and expense to wire in March 1944, throwing in, "I don't think he should be allowed to insult skunks so grossly." Cissy's ongoing editorial vitriol prompted a pair of "concerned readers" to complain that "*even* its sports columns are inaccurate, distorted & misleading in line with the general contents of the paper."

. . .

"Naturally, Cissy would look rather sick if, after her barrage against us, she suddenly sued to recover the column," Drew surmised to George Carlin on May 5, 1942, in the midst of the "Headache Boys" onslaught. The publisher had closed all ten editions of the previous day's front-page diatribe with the line "And so goodbye, Pearson and Allen," although she had ceased printing "Washington Merry-Go-Round" weeks before. Nevertheless, the *Times-Herald* continued to pay $125 per week to the United Features Syndicate, and neither the publisher nor the paper's executives showed any inclination to alter this state of affairs by legally relinquishing the column before the expiration of the six-month termination period in August, still three months off. Drew's attempts to put forth his own version of events in a paid full-page ad in a *Times-Herald* rival, as Walter Winchell had done previously, were summarily squelched by the timorous refusals of both the *News* and the *Star* to accept the copy he submitted.* Although Eugene Meyer was not only willing but eager to snap up the wildly popular "Washington Merry-Go-Round" for the *Post,* with his own vivid experience of the viciousness that contested features provoked from his antagonist at the *Times-Herald,* the publisher "felt that he ought not to get in the middle of the dispute" until the column's legal transfer had been safely consummated.

If retaining the rights to the column afforded Cissy the satisfaction of at least temporarily preventing its being read in what was arguably the market where it was likely to have greatest influence, the *Times-Herald* would soon make clear its other reason for continuing to incur the expense of retaining a feature it no longer published. Cissy's relationships with the other members of her "sand family" became casualties in her war with Drew. By the spring of 1942, Cissy had fired Luvie Pearson from her job writing movie reviews for the *Times-Herald.* She had likewise relieved Leon Pearson of his Latin American affairs column, "Below the Rio Grande." Instead, the publisher made a point of hiring George Abell to write the *Times-Herald*'s "South of the Rio Grande," "Diplomats' Diary," and "Ready, Willing and George Abell" columns. By summer, Luvie's former and current husbands would find themselves at legal odds once again when Drew Pearson filed suit against George Abell, Eleanor Medill Patterson, and Frank Waldrop for willful copyright infringement for profit, after the "Washington Merry-Go-Round" of May 20 appeared in the *Times-Herald*— slightly rearranged with only a few minor changes and additions—as the "Diplomats' Diary" of June 1.

*The *News* subsequently adapted some of the ad as a news story, as did *Newsweek.* In mid-May, true to form, Henry Luce's *Time* published a sardonic version of the Headache Boys saga that was overwhelmingly sympathetic, if not unabashedly flattering, to Drew Pearson.

For her part, Luvie had been especially hard-hit by Cissy's public and private broadsides. While she was still at the *Times-Herald,* Cissy had called her out to answer charges of inconsequential faults and omissions in producing her column during the same trip to Rio de Janeiro with Drew that had immediately preceded the cancellation of the "Washington Merry-Go-Round." Back at home, Luvie found herself answering for a variety of unintended, half-remembered oversights that Cissy insisted the Pearsons had perpetrated against her over the years. Soon after, Luvie was obliged to return the gifts and hand-me-downs that Cissy had given the couple during their marriage (Luvie's embarrassed admissions of having repainted, remodeled, or lopped the legs off Nellie Patterson's old dressing tables and cast-off dining-room chairs notwithstanding). In happier times Cissy had commissioned a bust of Ellen as a Christmas present for Drew. The sculpture's mysterious disappearance from the Pearson household shortly after its holiday arrival and its unexplained reappearance at Dupont Circle in the midst of the Headache Boys hostilities were to become additional bones of contention. Of greater hurt on both sides were Cissy's accusations—and Luvie's astonished rebuttals—that the latter had deliberately turned sixteen-year-old Ellen against her grandmother. "It is still right difficult for me to realize what a sorry pass things have come to and every now and then I find myself thinking—wait until I tell Cissy that, she will laugh until the tears run down her cheeks," Luvie closed sadly in a letter she wrote her former friend, traveling companion, and boss in the summer of 1942. "Imagine!!!"

Alone among the members of the Pearson household, Tyler appeared to have been unaffected by the family feud. In anticipation of his late christening in June 1944, Tyler, then nearly twelve, asked Cissy to be his godmother. "Nobody quite knew why he chose her," Drew mused to Ellen, "unless it was inspired by George . . ." For his own part, Tyler would remember simply that, Cissy's differences with his mother and stepfather aside, as a godmother "she maintained a very wonderful relationship with me."

In February 1986, an eighty-year-old Felicia Gizycka found herself in tears at the International Quarter Horse Futurity and Auction in Augusta, Georgia. Whether or not she knew that her parents' fateful courtship—and ultimately, the painful trajectory of her own life—had begun at a Thoroughbred yearling auction in distant Moravia eight and a half decades before is unclear. Loving horses since childhood even if she had not inherited her parents' fearlessness in the saddle, it saddened the elderly Felicia to think of the young cutting horses that paraded before her being sold off to the highest bidders, of their having no agency or choice in their lots in life.

She comforted herself, however, with the thought that in all likelihood these horses, carefully bred and well-started, would find good homes among the able horsemen who filled the stands around her—many of them "beautiful, lean, long-legged, flat-bellied men" out of Cal Carrington's mold. She realized, "I'm crying because I love horses so, and I can't afford a horse." Long resenting that her mother had never given her a pony of her own as a child, with the $40,000 tax-free yearly allowance she received from Cissy after her divorce from Drew, Felicia had indulged her-

Eleven-year-old Ellen Pearson and her mother, Felicia Gizycka, hacking out of the Dower House stable, 1937. Ellen's aged pony (originally a gift from Cal Carrington) was the same animal on which Felicia had run away from Cissy thirteen years earlier following the screaming, hair-pulling fight between mother and daughter at Flat Creek Ranch in Jackson Hole.

self with a succession of field hunters in early adulthood. The luxurious, heedless way of life she had led at the time and the substantial income that supported it had come to a tumultuous end when, at the age of thirty-eight, she had had "one last drunken row" with Cissy. Through the auctioneer's drone Felicia found herself revisiting the night more than four decades earlier, when, as she put it, "I finally shook myself loose, and this enabled me to find my sobriety, and . . . saved my life."

Though Felicia's visits to her mother had become unusual by the early 1940s, on the rare occasions when she and Cissy were alone together again they fell quickly into old habits. On that decisive wartime evening at the Dower House, mother and daughter finally rose from the dinner table "in the middle of the night, both of us drunk as skunks," Felicia remembered. Despite the lateness of the hour, the two ladies repaired to the living room where they continued to drink and argue with a growing volubility. "I think I'll leave the Dower House to Luvie," Cissy suddenly declared, the spectacular public demise of her relationship with the Pearsons notwithstanding.

"You said you'd leave me the Dower House, and now, suddenly, you say you're going to leave it to Luvie," Felicia slurred incredulously. "And that's just like you—always dangling things in front of people, and almost always changing your mind," she blustered on. "And I was looking forward to the Dower House, and a really good groom—and a decent stable with box stalls for my horses!"

"While a worm is eating my cheek," Cissy hissed in response.

"There you go, that's just like you! Damn you," Felicia shouted, unleashing a torrent of pent-up rage the force of which the combined blows inflicted by the Roosevelt administration, hostile members of Congress, the FBI, a derisive national press, a rising tide of hate mail, an unwelcoming Associated Press, Walter Winchell, Robert Allen, and Drew Pearson had been unable to equal: "God damn you and may you roast in Hell. If there *is* a Hell. You've already made my life one long Hell from the time I was a baby, you stupid bitch! You stupid, stupid bitch, with your aging body, and not having learned one Goddamned thing on this earth! Nothing. You can't even run a decent newspaper. You're the joke of this town. You're the joke of this whole country—with your petty feuds superseding front-page news. Fighting with Drew like an Irish fish wife!! What's all this about suddenly giving the Dower House to Luvie? Just to make me mad, I suppose.

"Well, God damn it, I *am* mad, and I'll tell you how mad I am. You can take the Dower House and stuff it. And you can take all your Goddamn fucking money and stuff it. All I ask," Felicia continued, rising unsteadily

to leave, "all I ask is that you take my horses and keep them." Cissy agreed. A lifetime's experience of maternal unpredictability and spite had taught her to count only on her mother's unwavering devotion to her fellow creatures. "That was one thing about my mother," Felicia allowed. "She loved animals—she would do anything for an animal." If Felicia had doubted her mother's love almost since the dawn of her memory, she trusted implicitly that Cissy would keep her two horses impeccably and indefinitely after her departure, whatever hostility lingered between them. And, indeed, Cissy would duly keep her word.

As Felicia swayed toward the door, Cissy called after her with an old refrain: "You're overweight. When you make a speech like *that* you shouldn't look like *that*. You're *much* too fat." Licking the wound her daughter had opened, Cissy continued, "I run a very *successful* paper, and you know it. You're the one that's a failure. Always chasing after men that you don't get, like Averell Harriman."

"That was *years* ago!" Felicia protested.

Laughing derisively, Cissy punctuated with "my dear" her enumeration of Felicia's old flames and her recitation of what a fool her daughter had made of herself in romance. In her characteristic menacing purr she then moved on to the topic of Felicia's literary endeavors: "As for your writing, you've written the same book twice, about how awful I am and how awful the family is, and what a poor little *abused* girl you are!"

Felicia wheeled around and let loose once again: "Well, that's better than being a scrawny old bag like *you*. What man would *look* at you *now*? Like Uncle Joe said . . . 'You'll never again be loved for yourself alone.' And that's a *fact*!" Felicia added in more muted tones as she stalked beyond her mother's earshot. Ignoring both Cissy's "whiskey drenched" protests of being "straight and thin" and her outlandish taunts offering to prove it ("I challenge you to stand in front of a mirror in bathing suits!"), Felicia rang for the butler and demanded that he call the chauffeur to drive her into Washington. "I didn't care that it was the middle of the night and that somebody had to get up to drive me. Of course, I was very drunk."

Once safely in the Lindbergh Bedroom's four-poster at 15 Dupont Circle, however, Felicia was conscious only that a strange, white patch of welts had arisen on her left arm ("the stigmata of the Devil?") and that she was reliving "the same feelings I had had when I'd run away from our ranch in Wyoming when I was eighteen." After a lifetime of strife with her mother, any regret at what she had done or fear of what might result evaporated in elation and relief: "Now I was 38 years old, and free! Free!"

Shortly afterward, Felicia's two horses arrived at the Dower House from upstate New York, where she had ended the lease on her country house.

Once Felicia sold her townhouse in Manhattan, let go her small staff, and put aside what remaining money she had as a small nest egg, she notified Cissy's accountant that she would no longer accept her allowance. Falling back, as she had two decades earlier in San Diego, on the small trust fund her grandmother had established, Felicia rented a cheap walk-up apartment and took up housekeeping for herself once again. Whereas Cissy had found a channel for her restlessness and her underused abilities in newspaper work, Felicia approached her own middle age with no such lodestone. To be sure, she continued to write; inasmuch as her $3,600 a year was less than one-tenth of her accustomed income, she supplemented her bottom line with those short stories she was able to sell. "These things were carried out in moments of less severe hangover or short stretches on the wagon," however. Gradually, alcohol encroached even upon her productive daylight hours.

Having "divorced" her mother, as Felicia put it, her remaining relationships suffered as well. Ellen, now a teenager, was most deeply affected. "My child was being exposed to all this," Felicia acknowledged later. "She was also the victim of my scolding and incessant nagging. I was really scolding my mortal enemy, the inner me. My poor child could not know this." After renewed legal wrangling with Drew and the intercession of a child psychologist, Ellen was "duly sent to school, away from me," Felicia remembered.

The former spouses' differences over their daughter were outweighed, however, by a new wartime commonality. "In the course of drunken arguments," Felicia recounted, "I found my own views and a sense of responsibility as a citizen." It was perhaps not coincidental that her new political activism developed in the aftermath of her last argument with Cissy—and took the form of joining the Democratic Party and becoming an active Roosevelt supporter. While she publicly repudiated the shared editorial views of her mother's generation within the extended family, she bore no personal malice toward Joseph Medill's other surviving grandchildren. Felicia found Colonel McCormick to be both "grandiose" and, like his newspaper, "politically hideous." Understanding his background and sharing many of his forebears, however, she would eventually arrive at a sense of amazed pity at the thought of him: "I think it's marvelous that Bertie didn't end up in a padded cell. I think it's great that he was able to function at all, let alone run the *Tribune*." Bert McCormick's mother, like his father, had "ended up nutty as a fruitcake herself." Uncle Joe, Felicia acknowledged readily (and, indeed, gratefully), had been "very good" to her throughout her life, their differences over intervention notwithstanding. "He would occasionally stab me with some mean remark," she recalled. "But he was kind more often than not."

With Drew's surreptitious assistance Felicia passed compromising information on leading isolationist, anti-administration figures both in Washington and nationwide to the Reverend Dr. L. M. Birkhead in New York. She had become an active member of the liberal Unitarian (if agnostic) minister's Friends of Democracy, a grassroots organization whose support of the administration and the war effort sought to bring about "an early and lasting peace." To this end, in 1943 Dr. Birkhead urged the public, along with like-minded organizations such as the Jewish War Veterans of the United States, "to assist in the discipline of the 'obstructionist press,' among which he named The New York Daily News, The Chicago Tribune and The Washington Times-Herald, to destroy subversive groups now in existence and to defeat the 'bad' Senators and Representatives coming up for re-election," the *New York Times* reported.* Although Felicia would remain committed to progressive and liberal causes for the rest of her life, like so many of her relationships and endeavors, in the last years of the war her "attempts at community service ended in a drunken and abusive row with a fellow volunteer."

Even Felicia's tolerant bohemian friends from Greenwich Village had grown tired of her antics. "By this time I had ceased to be the life of the party. I became a menace, the fish-wife, the common scold. I took everybody else's inventory. Finally, my new friends told me, one by one, that I could not come around any more."

"Now came the black and endless dismal night." In her descent Felicia had managed to retain two unshakable friends who exerted opposing influences on her. One was stalwart Louise, whom she now avoided; the other was her new "drinking buddy," Charlotte. Although Felicia would never

*In leaving the Republican Party and rejecting her philosophical heritage, Felicia had joined ranks with several of Joseph Medill's other great-granddaughters. While her first cousin Alicia Patterson Guggenheim had supported intervention both personally and editorially in her increasingly successful Long Island *Newsday,* she had nevertheless loyally defended her father against the personal attacks that his vitriolic isolationism had occasioned in recent years. Felicia and Alicia's second cousin, Katrina McCormick Barnes, had taken a less deferential and affectionate view of the previous generation within the McCormick branch of the family. "I've always hated Uncle Bertie," Ruth and Medill McCormick's daughter admitted freely to *Time* in March 1944, adding that she deplored the *Chicago Tribune*'s political leanings, as well as its distortions and omissions of fact. After marrying in 1935, "Triny" had repudiated her family's politics, become a socialist, and set about to divest herself of her share of the Medill Trust by offering her *Tribune* stock to her uncle at whatever price he named. Castigating his niece as "completely cuckoo," the colonel paid her an estimated $3 million nevertheless. When he discovered that she intended to donate the huge sum to worthy charities, he "hit the ceiling." Although, like Felicia, Triny Barnes was "personally fond" of Joe Patterson and thought of him as "a nice considerate gentleman," she was unable to reconcile the young socialist he had been with the reactionary isolationist he had become. "I asked him once why he had turned his paper into what it is and he acted surprised and said he wasn't conscious of any change. I don't believe he is." Triny saw even less of Cissy, but maintained "civil" relations with her on those occasions when they met.

be certain, she believed she must have dissipated the small nest egg she had set aside on drink. Cast out of their bohemian circle, she and Charlotte became obstreperous barflies at a Greenwich Village dive. "Fat, bloated, dirty and unkempt," Felicia passed out routinely, awakening the following morning to discover that her pockets had been picked by the cab drivers who (she presumed) had delivered her home.

"My dearest friend," Felicia wrote, "whom I'd grown up with, stuck by me when nobody else did. Yes, Louise Ireland almost helped to save my life, because she got me to a psychiatrist." In the course of Louise Ireland Grimes's studies in child psychology and education she had come into contact with Dr. Florence Powdermaker, with whom she co-authored *The Intelligent Parents Manual,* "a practical guide to the care and understanding of children from infancy to adolescence," in 1944. A former Rockefeller Fellow and medical professor, who was currently serving as a lieutenant commander in charge of merchant seamen suffering from post-traumatic stress (or, in the contemporary phraseology, "war neuroses") for the United States Public Health Service, Dr. Powdermaker continued to take private patients as well.

"At first nothing happened. I went to her once a week, and I was either terribly hungover or a little tight." In this state, her work with Dr. Powdermaker proceeded haltingly at best: "the more we found out about why I drank, the more I drank." After a burly Irish barkeep caught Felicia trying to steal a bottle from behind his bar, knocked her to the sawdust with an elbow to the face, threw her and Charlotte unceremoniously into the street and threatened to call the police, Felicia began to contemplate suicide. "I felt abysmally ashamed—as far as humiliation goes, I think I hit bottom. How could I behave like this? I was crazy and Florence didn't want to tell me so."

In 1943, after hearing Dr. William Griffith Wilson, or "Bill W.," speak from personal experience on the almost entirely medically uncharted subjects of alcoholism and recovery, Dr. Powdermaker had been "instantly sold" on the course he suggested. She urged Felicia to read the unobtrusive navy blue volume that Bill Wilson's burgeoning "Fellowship" had published in 1939 as *Alcoholics Anonymous.* The compendium of unsigned personal accounts, both harrowing and moving, was intended to "show other alcoholics *precisely how we have recovered.*" Although Felicia balked at the "Big Book's" exhortation to surrender to a higher power as a critical step along the path to recovery (or "all the God stuff," as she put it), almost to humor Dr. Powdermaker she agreed to attend one of the group's meetings. Although mortified, Felicia ventured down to Hell's Kitchen, where the organization's offices were located at the time. "Bill was tall, grey haired,

with the kind of asymmetrical good looks and pleasant easy manner that inspire confidence in the shaken and afraid," Felicia was relieved to discover.

He was well dressed; he was easy going. I could see he wasn't a quack or a fanatic.

He did not take out a folder and say, "What is the nature of your problem?" He said to me, gently and simply, "Do you think that you are one of us?"

Never in my entire life had anyone asked me "are you one of us?" Never had I felt a sense of belonging. I found myself nodding my head.

He now said that *we* had a physical allergy combined with a mental obsession, and he explained this so that I saw for the first time how this could be. He asked me if I had any spiritual belief, and when I said No, he suggested that I keep an open mind.

"I've got a dame here with a name I can't pronounce," he told someone whose number he dialed on Felicia's behalf at the end of the meeting. When he hung up, he told her he had arranged for her to meet somebody called Marty. "Aha, he's passing the buck," Felicia suspected inwardly. "Now comes the questionnaire."

"I felt like a gangster's moll about to be interviewed by the Salvation Army," she remembered of her arrival at the address Bill W. had given her. Instead, Felicia found herself welcomed into what turned out to be a tasteful midtown Manhattan apartment filled with books and artwork, by a woman named Priscilla, who told her that Marty was on her way. With her own matted hair and threadbare clothing, smelling of "booze and ancient sweat," her leg crudely bandaged after a recent fall, Felicia was surprised to find that, like Priscilla, Marty, once she arrived, was welcoming, genteel, and well-groomed: "She was attractive; she was like the friends I once had. Indeed, she had known my cousin in Chicago." Without asking Felicia to explain herself or account for her condition, without asking anything at all, Marty "went right into her own story, which was much worse than mine. I couldn't believe my ears. I tried to interrupt. She wouldn't let me."

If this new acquaintance reminded Felicia of former friends who had fallen away, she had even more in common with Felicia herself. A native of Chicago the same age as Felicia, Mrs. Marty Mann was a "tall, smart-looking blonde" who had married briefly and unsuitably in the late 1920s. Though her marriage had ended within a year, her incipient alcoholism had progressed unchecked long afterward. "Years of drinking and general high jinks had cut her off from old friends. She too had gone to cheap bars

to drink," Felicia learned, amazed. "With more physical courage than I had possessed, she had twice tried to take her life." Marty only began to consider seeking help after learning that she had been heaved bodily down the gangplank of the *Queen Mary* upon docking in New York Harbor in December 1936; her only hazy memory of the four-day transatlantic crossing had been of Edward VIII's abdication speech. Unable to control her drinking, she had been unemployed for three years in the late 1930s, during which she began the detoxification process, first on the locked-down neurological ward of Bellevue Hospital in Manhattan and later at Blythewood Sanitarium in Greenwich, Connecticut. Returning to Manhattan in 1939 after more than a year of in-patient treatment, she became Alcoholics Anonymous' first woman member when she began attending small meetings on Sutton Place. Then she took up her life in recovery.

In 1944, the year after she met Felicia, Marty Mann would become executive director of the National Committee for Education on Alcoholism, which was sponsored by the Yale Plan for Alcohol Studies and headquartered in Manhattan. An "intense exhorter for the cause," she maintained a feverish lecture schedule for much of the rest of her life, imparting to audiences at medical conferences, PTA meetings, VFW halls, lodges, churches, and town meetings nationwide the radical news that "alcoholism is a disease and the alcoholic is a sick person; the alcoholic can be helped and is worth helping and this is a public health problem." The iconoclasm of her message was not simply clinical, however. Beginning her talks with the startling opening line, "My name is Marty Mann, and I am an alcoholic," she dispensed with her own anonymity in the interest of public health, admitting freely to her personal struggle with dependence to audiences utterly unaccustomed to intimate public self-revelation. "I made a speech to the Maine PTA and the gasps shook the walls." Felicia had found not only a sponsor, but a committed lifelong friend. "A load weighing a thousand pounds came off my back. I wasn't insane. Nor was I the 'worst woman who ever lived,' " she remembered thinking after her introduction to Marty Mann and the latter's roommate and fellow recovering alcoholic, Priscilla Peck. "I was an alcoholic, with a recognizable behavior pattern."

After attending her first Alcoholics Anonymous meeting with Marty and Priscilla, Felicia counted herself "sold, intellectually." Taking the group's Twelve Steps toward sobriety would prove to be more difficult, however. Felicia found such an unaccustomed and immediate sense of community and acceptance at the growing New York group's weekly meetings that she began to feel "lonesome" during the six nights she was forced to wait until the next one. Falling back on habit, therefore, her visits to a variety of her old Village haunts quickly saw her passing up tea and soft drinks for harder

stuff. From this, Felicia's initial "off-again on-again" sobriety, Priscilla sensed that her new friend was a "stubborn case" and suggested that she would benefit from feeling a sense of responsibility for a fellow member.

"Anne was bigger than I and strong. Her idea of fun on a bender was to hit sailors and insult cops," Felicia remembered of her charge. Assuring that Anne, who was then on just such a bender, would safely reach AA's recently opened retreat, High Watch Farm in Kent, Connecticut, would have much of the desired effect: "I was so busy keeping her out of trouble, and so scared she'd swing on me, that I had my last two drinks that night." Fearing that Anne would relapse immediately after their return to Manhattan, Felicia had called ahead to the New York office for advice. The two women were met at Grand Central by "a couple of normal, sober, attractive men," who took them to dinner. John and Bud displayed no embarrassment at being seen publicly with companions clad in the same "dirty, bedraggled ski clothes" that winter cold and lack of central heating had prompted Felicia and Anne to wear night and day throughout their stay at rustic High Watch. Although strangers, the two men (who would become Felicia's close friends) had taken "the trouble to try and help. Why? I was astonished and deeply moved."

In the face of the death from alcoholism of a close friend eight dry months later, Felicia experienced "an angry 'the world can't do this to me' reaction" and relapsed. She called Marty after downing two double brandies, expecting her new friend to demand the name and address of the bar in order to come rescue her. "Not at all. My smart and wise sponsor simply said, 'Well, Honey, what can I do about it?' "

That deflated me, but it didn't stop me. I drank all that night. I don't know where I went or what I did. The next morning I called John D., a wonderful old timer who had taken me to a lot of meetings. He came right over to the apartment. I greeted him at the door and said, "I just wanted to do the honesty bit. I'm telling you honestly: I'm waiting for my stomach to settle. As soon as it does, I'm going right out and tie on another one."

John said, "All right. Go ahead. But when are you going to stop?"

Marty hadn't let me dramatize myself, and John was scaring me. I thought, "My God, maybe I can't stop."

Somewhere in my mind I must have reached for the brakes. Marty has told me since that I kept calling from various bars down in The Village. Each time she'd say, "Call me when you're ready to stop," and hang up. I don't remember any of this.

John named my slip, "Custer's Last Stand." I spent three days and

nights in the old familiar haunts, drunk as a doxy and hating every minute of it. On the fourth morning I called Marty and said, "Help!"

Shortly afterward, Marty appeared at Felicia's apartment, and literally spoon-fed her until she was able to hold down solids. Though the experience would prove only to be "one short slip," Felicia would continue to make occasional, histrionic attempts to test Marty with threats of relapse or self-inflicted injury over the coming years. Unlike Cissy, however, Marty never allowed herself to be provoked into responding with flippancy, argument, or escalation. Instead, she wondered patiently, "Just what is there about this situation that a drink is going to solve," or reminded Felicia firmly, "Just keep plodding along, put one foot in front of another."

Having felt profoundly out of place for most of her life, particularly within her own family, Felicia found herself almost immediately at ease with Marty Mann and her circle. Her new friend and sponsor was well-educated, well-read, well-spoken, well-traveled, magnetic, purposeful, and sympathetic. In beginning to help and counsel others new to the movement with their own struggles, Felicia discovered an unaccustomed, but nonetheless cherished sense of purpose. And she began spending much of her free time with Marty, Priscilla, and their circle, both at the apartment the women shared in Manhattan and at their summer cottage in Cherry Grove on Fire Island.

Dr. Podunk from Toonerville

I called him because I could not think of any other name, and I was a little woozy. I only knew I had fainted," Cissy remembered later of the events of the evening of June 28, 1943. It had been an exceptionally hot day in an already "terrible June." Cissy had been swimming in the morning. She had spent a busy afternoon at the office. Now sixty-two, the exertions of the day conspired with the strain of the previous several years and a lifelong history of nervous "spells" to cause the controversial publisher to collapse that evening at her home on Dupont Circle. "I was not just all there," she remembered of coming to. The many physicians with whom she now consulted for a growing list of ailments had either been mobilized or were on vacation. To her housekeeper's frantic questions about which doctor to call, therefore, Cissy gasped, " 'Savitsch. We can always get him'—and he was here in five minutes."

. . .

"Some people have the quality of making life seem more vivid and interesting because of their presence. Mrs. John Wiley, wife of our Minister to Latvia, is one of those beguiling creatures," Martha Blair had trilled in the *Times-Herald*'s "These Charming People" installment of March 16, 1939. "Dr. Eugene de Savitsch," the society columnist continued, "newly arrived in Washington, and a great friend of the Wileys, is asking a few friends in on Friday, for them at his apartment." Born in 1903, during Robert Sanderson McCormick's ambassadorship, Eugene Constantine de Savitsch had been forced to leave his native St. Petersburg amidst growing Bolshevik fervor in 1917. He had arrived in Chicago in late 1921 by way of Japan, and had been naturalized as a United States citizen in 1934. In the meantime, he had received medical training at the universities of Denver and Chicago; the Pasteur Institute and Laennec Hospital in Paris, France; and the Bunge Institute in Antwerp, Belgium. He had honed his surgical technique in the Belgian Congo, treating natives suffering from African sleeping sickness and, when he was unsuccessful, collecting and preserving their brains as specimens for further study. He claimed to have published papers on a wide variety of medical subjects ranging from eye and thoracic surgery to the "Surgical Treatment of Elephantiasis of the Scrotum and Penis" (unfortunately, back issues of European medical journals were difficult to procure in wartime). The doctor's broad-ranging professional interests would show no sign of curtailment over time, either; after the war, Savitsch offered himself as a successor to the late "sexologist" Havelock Ellis, by publishing a tome titled *Homosexuality, Transvestism, and Change of Sex* in 1958. As a lifelong consumptive, however, Eugene de Savitsch took a particular and proactive interest in the study and treatment of tuberculosis.

Having made a splash in Washington social circles since his arrival, at the age of only thirty-seven the White Russian saw fit to publish his colorful memoirs, aptly named *In Search of Complications,* in the summer of 1940, to considerable local fanfare and respectable sales. Urbane, cosmopolitan, and unmarried, if Savitsch cut a Humbertian figure in wartime Washington, his proclivities (or rather, his ambitions) drew him not to nymphets, but instead to their grandmothers. He put his medical training and credentials (his power to prescribe, in particular) at the disposal of these aging ladies, especially if they were rich and well-connected. At luncheons, dinner parties, and charity balls, word spread among Washington's fading matrons, social arbiters, and rich widows of the obliging Dr. de Savitsch's unusual willingness to minister not only to the body, but moreover to the psyche as well. His preparations reputedly restored an instant pep to those in the grip of lassitude or malaise. They banished pain and left only euphoria in its place, at least temporarily. They whittled away at middle-age

spread. They acted as a balm to frayed nerves and calmed anxious tempera-
ments. They brought sleep—catatonia even—to the insomniac. Whatever
the components of the intravenous cocktails for which the doctor devel-
oped a quiet but extensive reputation (among them cocaine, vitamin B-12,
a panoply of opiates and barbiturates, and, reportedly, many other psy-
chotropic substances), his private practice flourished.

Savitsch's local celebrity (as *Time* put it in 1940, in addition to his select
female clientele, "he now takes care of Congressional stomachs") had done
little to further his efforts in the field of tuberculosis treatment and
research, however. In light of the wartime drain of experienced medical
personnel from hospital staffs nationwide, he had offered his services to his
adoptive country—or, more specifically, to Washington's Glenn Dale san-
itarium and its poor and indigent patients—free of charge in exchange for
freedom to conduct research and draw up a "scientific report of some kind"
in the field of thoracic surgery. To the doctor's surprise, however, the sani-
tarium's board had not leapt at the opportunity he presented. Fed up after
receiving "the runaround for three years" from Glenn Dale's directorate
with their niggling requests for proof of his qualifications and copies of his
published medical papers, by early 1943 Savitsch had sought to make use
of his impressive connections to go over their heads. Through his friends
Minister and Mrs. Wiley (as a naturalized Pole, Irina Wiley evinced a par-
ticular sympathy for her fellow Slav), Savitsch sought to interest Joseph F.
Guffey, Democratic senator from Pennsylvania, in his case. The charming
Russian had also succeeded in enlisting publisher Eleanor Medill Patterson
in his efforts to become Glenn Dale sanitarium's chief of thoracic surgery.
In the spring of 1943, *Times-Herald* editor Frank Waldrop duly arrived at
the clinic to make inquiries on the doctor's behalf.

As to when Cissy first met Dr. Eugene de Savitsch, she would later
admit only to a vague memory of having received a letter from Bill Bullitt
some time before the war, "written at the instigation of Mrs. Wiley, I
think," recommending the émigré as "an agreeable man and a nice and
amusing man to have to parties." Cissy had indeed found Eugene de Sav-
itsch to be "an agreeable man, rather witty and amusing, always on tap,
always free, always a Society Doctor—in other words a man who got his
business by being seen at luncheons, cocktail parties, dinners and suppers,
wherever he could get free food and drink in the town—there are not so
very many single men . . . in town," she would later protest defensively,
"and it's only natural to ask a man of that kind very frequently."

Mixing business and pleasure as ever, Dr. de Savitsch arrived at 15 Dupont
Circle on the evening of June 28, 1943, to pronounce Cissy's collapse and
her subsequent hyperventilation and incoherence the result of coronary

thrombosis. He immediately prescribed a strict and indefinite regimen of bed rest and potent sedatives. "I was doped to the ears—to the eyes," Cissy remembered hazily afterward, with the antiseizure hypnotic Luminal (better known, perhaps, as phenobarbital), a close chemical relative of those barbiturates that had claimed the lives of her father and cousin. "Maybe if I didn't live in this outrageous house with cupids stringing marble wreaths and flowers all over the G.D. place (excepting for the back side—plain brick garbage cans and old rubbage [*sic*] cans out there), he wouldn't try to keep me an *invalide*," Cissy managed to scribble suspiciously to Rose Crabtree in Jackson Hole in early July. "Anyhow, I feel perfectly well this morning and as if I had given birth to that baby 'under the heart,' which is where the little darlings are supposed to grow, according to what my mother told me," she continued, reminiscing, though "she never got as far as to tell me how they ever got *in* there, she being very refined. And of course I was too smart to ask her, knowing all about 'it' anyway." Despite the patient's self-reported improvement, Savitsch persisted in administering intravenous sedatives nevertheless, warning Cissy's anxious friends and staff members that she was in imminent mortal danger from the least excitement.

"Everyone in town thought I was about to die," Cissy discovered later with horror. "You might have thought I was Queen Victoria on her death bed—what with the hourly bulletins he issued." Indeed, Savitsch had informed the management of the *Times-Herald* that their publisher had "suffered a massive heart attack," adding darkly, "You will have to run the newspaper on your own. I do not think you will see Mrs. Patterson again." Doctor's orders notwithstanding, Bill Shelton, the *Times-Herald*'s business manager, continued sending daily editions to 15 Dupont Circle: "Otherwise, we'll catch hell when she comes out." Savitsch grudgingly permitted a few friends to visit, "some weeping . . . to say good-bye." On one such occasion, before being put under again—possibly for the last time—a lachrymose Cissy pleaded with T. J. White to make the sign of the cross over her. She called her brother Joe in from New York to "beg" him to take over the *Times-Herald* after her passing; although unwilling, he agreed. In light of both the unusual control Dr. de Savitsch exerted over the otherwise ungovernable patient and the latter's groggy disapproval of the growing liberties the doctor took with her household ("Savitsch had a habit of bursting into my room without knocking when I was in bed up there"), her brother also offered to fire him. Inasmuch as Cissy's other physicians were still unavailable, she demurred, however, even more fearful of being left without medical care. "I did not know which way to turn," she lamented. Believing in the imminence of her demise, in her befuddlement and growing suspicion she redrew her will. In the meantime, while Sav-

itsch was not assiduously tending to his patient during the several visits he made to her bedside daily or equally assiduously controlling access to her, "he used to get hold of one of my temporary secretaries or butlers and had himself served quart bottles of champagne in the library . . . by himself," Cissy would later charge—a particular outrage in light of wartime rationing measures. "Although I am ordinarily hospitable, I regret it because it was about the last of my good champagne."

"Please come see me. I'm sick, I don't know what's happened," Cissy managed to scrawl clandestinely to her friend Evie Robert in early August 1943, after nearly six weeks' confinement to her bed in a twilight state. "You, you get out of here!" Dr. de Savitsch shrieked when he burst in and discovered the unapproved visitor. "I left orders that nobody was to disturb my patient!" Cissy next appealed covertly to her secretary to call Frank Waldrop from the *Times-Herald*. "Get me a doctor, this man is trying to kill me," she breathed fearfully when the faithful editor arrived, repelling the angry Russian. Dr. de Savitsch's ministrations had left Cissy uncharacteristically cowed, to the point of timorousness. On August 8, 1943, "the very night I knew Dr. Huffman would be back, and would be here in the morning was the night I sent a very polite note, a very kind and polite note to Savitsch," she bleated later. "I did not want any more bursting in scenes of Doctor Savitsch, and I dismissed him."

Suffering what she described as "a severe nervous breakdown" in the wake of her ordeal, Cissy's convalescence in Port Washington and, later, in Sarasota, Florida, lasted until early 1944. "The bedpan *burns* me up!" she complained to Rose. "I don't mind anything much but that." In the meantime, once Dr. de Savitsch had been taken off the case, Dr. Paul Dudley White of Massachusetts General Hospital and other coronary notables concluded that she appeared to have been the victim of "cardiac neurosis associated with nervous prostration which has been recurrent, the first attack having been treated . . . at the age of 19." Examining the patient as well as the electrocardiograms taken both immediately after Cissy's collapse in June 1943 and ten days later—from which Savitsch had arrived at his diagnosis of "massive heart attack"—White and his colleagues determined that the organ was "normal in size, sounds, rate and rhythm." In short, Savitsch had been grossly mistaken in his diagnosis and subsequent treatment: "There was no evidence of congestive heart failure."

Though Cissy never fully recovered her physical health (as she would soon insist energetically under oath), the receipt of Dr. de Savitsch's $10,000 bill for services rendered snapped her out of her doldrums. "Really, Ma Reed was a beauty compared to me now," she lamented to Rose Crabtree of the gnarled innkeeper of whom she and Felicia had run afoul

during their first summer in Jackson Hole a quarter century before, "and what's more, she hasn't got a doggone thing on me today for unadulterated meanness." Although overshadowed by her sudden illness, Cissy's earlier efforts to assist Dr. de Savitsch in his quest to become Glenn Dale sanitarium's chief of thoracic surgery (or rather, Frank Waldrop's investigations into the reasons for the institution's dawdling in making the appointment) had turned up unanticipated results. While Cissy had remained in bed, dazed, in the summer of 1943, Savitsch's other patron, Joseph F. Guffey, Democrat of Pennsylvania, that stalwart of Franklin Roosevelt in the United States Senate, had charged ahead in support of the doctor's patriotic efforts to offer his services to the clinic in wartime.

"Cissy, who seems to have quarreled with her doctor, now slaughters him daily in her newspaper; a noble spectacle for all good liberals" Savitsch's fellow Russian émigré Isaiah Berlin, then working at the British embassy near Dupont Circle, noted wryly on February 11, 1944, to Franklin Roosevelt's kinsman, the syndicated columnist Joseph Alsop, then serving with the 14th Air Force in China. Although Eleanor Medill Patterson was never mentioned in connection with Eugene de Savitsch in the *Times-Herald,* it was obvious even to lesser minds than Berlin's that personal animus, at least as much as concern for public safety, fueled the newspaper's sudden eruption of invective. "Threats That Failed," the *Times-Herald*'s front-page headline had boomed on January 25, 1944. "Guffey's Efforts to Handpick D.C. Hospital Doctor Bared; Senator's Letters Asking Appointment of Dr. Eugene de Savitsch Revealed." Neither one of the "threats" Guffey mailed to the Board of Commissioners (at the time the District of Columbia's governing body) demanding the appointment of "suave Eugene de Savitsch . . . whose social graces have won him many feminine clients" to a permanent post as Glenn Dale's chief thoracic surgeon had been successful, however, the paper reassured Washingtonians. Continuing its lurid coverage of the "now notorious 'Savitsch Case' " two days later, the *Times-Herald* published its second front-page excoriation not only of the presumptuous young physician to whom it had come to refer simply as "Dr. Savitsch," "(he has admitted he has no right to the prefix 'de')," but of that "New Deal henchman," Senator Guffey, as well. In "Guffey's Doctor Denied Post Because Skill Was Doubted," the *Times-Herald* applauded the Glenn Dale Sanitarium's protracted efforts to give Dr. Savitsch "the run around," thereby shielding its poor and indigent patients from the menace presented by the bumbling alien. Savitsch had demonstrated a flagrant lack of surgical proficiency, the *Times-Herald* charged. He had misrepresented his credentials, it insinuated. He was not an attending surgeon at any of the city's hospitals as he claimed to be, it alleged. Rather, he was a mere mem-

ber of the "courtesy staff" of a few local private institutions (and not very prominent ones at that), the paper did not fail to remark. "Dr. Podunk from Toonerville can apply for membership on such a staff, and it is customarily granted after a perfunctory examination of his papers. However, one can never be sure of the validity of such papers," sniffed District of Columbia medical officer Dr. George C. Ruhland, whom the *Times-Herald* saluted as having repeatedly and courageously deflected Savitsch's offers to "perform experimental surgery" on Glenn Dale's hapless charges and "braved Senator Guffey's ire" as a result. The newspaper's sensational and unrelenting coverage of the affair ("D.C. Medical Group to Back Ruhland," "Very Bad Medicine," "District Heads Slam Last Door on Dr. Savitsch," and the like) continued until mid-February 1944, when the senator was replaced as chairman of the Democratic Senatorial Campaign Committee in the midst of the brouhaha and the doctor brought suit against the *Times-Herald*'s publisher for libel. The publisher was delighted to respond immediately with the threat of a legal complaint of her own—to recover $500,000 damages for malpractice and malicious injury.

Cooler heads did not prevail. On Valentine's Day 1944, Eugene de Savitsch charged in the complaint for libel he filed in the District Court of the District of Columbia that the publisher of the Washington *Times-Herald* had maliciously printed, published, and circulated statements of "purported facts prejudicial" to the plaintiff in his capacity as a physician. Dr. de Savitsch had taken umbrage at the *Times-Herald*'s repeated insinuations that any professional preferment he had enjoyed in Washington was due not to his medical qualifications but rather to his dubious "social graces." He objected not simply to the newspaper's disparagement of his professional credentials and abilities, but moreover to its derision of his personal qualities—its insistence that he was a "suave" favorite among lady patients of a certain age, in particular. Bristling at even the least of the *Times-Herald*'s jibes, he insisted, furthermore, that the use of the disputed "de" in his name was neither mere affectation nor (as the newspaper had contended) an exclusively French prefix indicating noble birth. "It is a classification which I did not devise," the doctor blustered under oath. "It is devised by the Imperial Russian Government, the former Russian Government itself, and the title is known [*sic*] as hereditary noblemen." He persisted indignantly that the "de" had been added to his name on his passport upon his departure from his native Russia on the eve of revolution, and that like all of his aristocratic countrymen he was entitled to the distinction abroad. However silly the *Times-Herald*'s even raising the issue—or pompous the doctor's contradictions—the use of the *particule* among highborn Russian subjects was a prerevolutionary custom not unfamiliar to the publisher, who had traveled to the United States with her recently recov-

ered daughter more than three decades before under the auspices of the imperial ukase issued to "Madame de Gizycka."

In threatening to countersue for malpractice, charging that, as the result of his misdiagnosis and his "negligent and careless" resulting treatment, "Dr. Savitsch" had inflicted permanent injury on her, Cissy was entering dangerous (and, indeed, self-incriminating) territory for a variety of reasons. First and foremost, despite her legal protestations of serving only the public interest by exposing Savitsch's purported chicanery at the Glenn Dale sanitarium, the *Times-Herald*'s ad hominem attacks had, in fact, served as a fig leaf for punishing the doctor for the ill-advised private care he had given Cissy (just as it had provided a serendipitous instrument for inflicting collateral damage on that odious New Dealer, Senator Guffey). At the same time, the paper's focus on Savitsch had served to deflect attention not only from Cissy and her deteriorating physical and mental health, but more especially from the exact nature of some of the doctor's previous, unorthodox ministrations to her. Once depositions began in the "now notorious Savitsch case," however, the *Times-Herald* was no longer in a position to control the nature or scope of the revelations concerning the various parties, especially in light of the contributions offered by the publisher herself.

Over the course of the first half of 1944 the prodigious efforts of Rudolph Yeatman, Cissy's counsel, to stall the discovery process by repeatedly postponing his client's deposition on the grounds (certified by several notable physicians) that she was unable to submit to examination as a result of the harm she had suffered at the plaintiff's hand, proved to be successful only temporarily. Indeed, the *Times-Herald* itself repeatedly undercut Cissy's claims that Savitsch's treatment had "permanently injured" her. Several of the unusually lavish two-page "These Charming People" photo spreads that appeared in the paper's features during the same period depicted Cissy hosting a large Sunday luncheon at the Dower House, energetically meeting and greeting her many guests—and even returning from a stroll, arm in arm, with the old rival with whom she had recently buried the hatchet, Alice Roosevelt Longworth. Another showed the publisher mingling with similar vigor, and even drinking a toast (her new doctors' orders to avoid alcohol notwithstanding), while filling in as hostess at Friendship one afternoon for that other old enemy and renewed friend, Evalyn Walsh McLean. Cissy would be obliged to submit herself to examination shortly afterward. Although his efforts to forestall this eventuality had fallen through, Rudolph Yeatman had succeeded at least in arranging for his client to be deposed at her home on Dupont Circle and in limiting the scope of the questioning to which Savitsch's attorney might subject her

exclusively to "certain matters" in an effort to shield the invalid from "annoyance, embarrassment or oppression."

"I never saw him alone as a guest, in my life," Cissy insisted of Dr. Savitsch, under oath. They had not been "very close friends" before her illness, she protested. "I looked upon him as just another foreigner coming to town." If she had invited him to the magnificent birthday party she had thrown William Randolph Hearst in 1939, to cocktails following the 1941 Gridiron Dinner, or to the engagement party she had given for Maggie Cassini's younger son, Oleg, and his betrothed, the Hollywood starlet Gene Tierney, on Valentine's Day 1942; if the urbane physician had been her guest at teas and dinners at Dupont Circle, at the judging of the *Times-Herald*'s Golden Mirror beauty contest, or, indeed, during entire weekends at the Dower House with the Wileys, Eugene Savitsch had always been one among many (sometimes hundreds of other) guests. "Savitsch was never either a close or an intimate friend of mine, because I never respected him."

Cissy had never respected him, she insisted, and had never sought his professional care or advice—at least for any serious illness or affliction—because she had no confidence in his medical abilities. As the train of questioning hurtled ever closer to the subject of Cissy's emotional and physical health generally and the nature of the care she had received from the plaintiff even before her 1943 medical crisis specifically, Rudolph Yeatman leapt in repeatedly both to remind his client of her ongoing frailty and to bark at opposing counsel for his attempts to annoy, embarrass, and oppress her. So eager and delighted was Cissy to disparage Dr. Savitsch and to expand upon his purported quackery, however, that she brushed off Yeatman's efforts to safeguard her privacy, often glibly volunteering information not even requested. In her filibusters she even began to vociferate over opposing counsel's efforts to redirect her by moving on to new questions.

On only one occasion had she ever ventured to Savitsch's office ("full of all kinds of African trophies and other oddities"), she protested. Even then, she had not sought *Savitsch's* treatment for the sty in her eye, she insisted. Rather, she had come only for assistance in locating one of her other physicians. She had eventually relented, permitting Dr. Savitsch to operate on her inflamed eye (notwithstanding "a lot of Latin talk . . . I knew it was all nonsense"), only because all of his more able colleagues had proved to be incommunicado. She allowed that on another occasion, in July 1940— disfigured, itchy, and desperate—she had called Savitsch in while suffering from poison ivy because of the distinct local reputation he enjoyed for providing "sleeping dope" and other such "queer things." "Whatever it was he gave me he gave it to me two or three times a day," she remembered. Similarly, once when she had a sore throat in the middle of the night, she

admitted, she had likewise called Dr. Savitsch because of his hushed renown as a "great dopester and he gave me something to quiet me."

As her deposition drew to a close, Cissy continued to fulminate above her attorney's pregnant warnings not to excite herself and scoffed volubly at opposing counsel's claims that before her 1943 collapse Savitsch had treated her eighty-five to one hundred times professionally, often serially for days or even weeks running, sometimes repeatedly on the same day. She suddenly grew reticent, by contrast, and was unable (or unwilling) to account for the dozens upon dozens of documented visits that that "faker," that "phoney," that "great dopester," had paid her—and for which there was abundant documentation that she had paid him. Not coincidentally, many friends, colleagues, staff members, readers, and enemies alike had remarked, it was during this same period that the publisher had demonstrated a mounting capriciousness, combativeness, and volatility, both in person and in print.

On July 12, 1945, Cissy's motion for summary judgment in the United States District Court for the District of Columbia won the day; Savitsch's libel suit was dismissed as being without merit. The doctor's appeal of this dismissal would find more traction, however, in the Court of Appeals, where Associate Justice Bennett Champ Clark asserted for the majority, "We would be the last to deny that the public interest in information, particularly on matters of public health and welfare is so great as to create a 'privilege' for the press." He added, however, "We think it well established that this privilege is not unqualified." Rather, in light of the *Times-Herald*'s "clear misstatements and erroneous interpretations of official reports, the question of malice becomes a significant one." Indeed, in the same pleadings and affidavits that had failed to persuade the district court of the unsubstantiated injury the *Times-Herald* had inflicted on the doctor's reputation, Judge Clark perceived that Cissy's deposition had lent "considerable support" to Savitsch's claim of her malice toward him. In what was to become one of the most cited libel and federal civil procedure opinions in American legal history, on December 16, 1946, the District of Columbia Court of Appeals reversed the decision of the district court and remanded Savitsch's case for trial on its merits. Mired in ongoing litigation, *DeSavitsch v. Patterson* would eventually be dismissed years later, the defendant having died and the plaintiff absconded from the United States, reportedly in the midst of an FBI narcotics inquiry.

Although *DeSavitsch v. Patterson* had reinvigorated Cissy to some degree by rekindling her native love of a fight, her 1943 illness, her temporary inca-

pacity, and the control that Savitsch had exerted over her left her with both a new fixation on her mortality and a pronounced anxiety that parties close to her might take advantage of some future incompetence. Over the next several years she repeatedly made alterations to her will. More immediately, however, she drew up specific directives should she become impaired once again. The signed, notarized instructions that she placed in the safe at 15 Dupont Circle for just such an occasion, barred her daughter, Felicia Gizycka; her granddaughter, Ellen Pearson; and her former son-in-law, Drew Pearson, from her house should she become incapacitated either mentally or physically. She insisted also that she should under no circumstances be removed from her home. Her reasoning, as she stated it in the document, had been to spare her family the pain of seeing her in an advanced state of deterioration.

The fact that Cissy was by then no longer even on shouting terms with Felicia, and would soon bring suit not only against Drew but against young Ellen as well, appears to undercut this ostensible concern for her loved ones. To those to whom she had entrusted copies of the document— her editor and right-hand man, Frank Waldrop; her personal accountant and the *Times-Herald*'s treasurer, Charles Bell Porter; her Prince George's County neighbor and the paper's equine columnist, Rhoda Christmas; and her attorney (and her niece Alicia Patterson's ex-husband), Joe Brooks— Cissy confessed her true motives: she now lived with a "strong fear" that her relatives or others would "take over her property and effects and would put her in some sort of mental hospital."

NO PRISSY IS CISSY

> To her closest friends she is an enigma; they have long since ceased trying to understand her. But on three things they will agree: Cissy is never dull, never happy and one of the greatest newspaper editors this country has produced.
>
> — DICKSON HARTWELL, *COLLIER'S*, NOVEMBER 30, 1946

Why, you've got a nice little heart!" Dr. Paul Dudley White of Massachusetts General Hospital assured Cissy in confuting Dr. Eugene de Savitsch's grim diagnosis of coronary thrombosis. Despite treatment, the recurrent "cardiac neurosis" to which White instead attributed Cissy's 1943 medical crisis (or her "spells," as she herself called them throughout her life) would continue intermittently afterward, albeit in a milder form.

The publisher at home in Dupont Circle in the 1940s

"I know that one of my spells is going to take me one day," she lamented to a friend in the midst of one such episode, urging, "Pray that there will be someone around. I don't want to die alone."

Indeed, death preyed increasingly on Cissy's mind, as the result not only of her recent medical crisis and its aftermath, but also of the mounting losses she was to experience afterward, especially of those who, some said, had her best interests at heart. Cissy's fearful malaise had other sources as well. Many who surrounded her remarked that in the last years of the war she lost much of her characteristic vitality. Friends and staff members observed that her consumption of alcohol continued to rise; the capital was rife with wisecracks about her erratic behavior and bizarre editorial decisions and whisperings of her ongoing intravenous drug use. Her long-established hands-on approach to publishing the *Times-Herald* began to give way to a more remote form of editorial control. Less and less often did she sweep into the city room at unpredictable hours as of old—in riding clothes, surrounded by a phalanx of snapping poodles at noon, or spectacularly arrayed in evening dress on the way home from a dinner or ball in the small hours of the morning. Still, she continued to keep in close touch with her editors and staff—albeit increasingly by telephone, or the harried runners and chauffeurs who shuttled her scrawled edits and edicts from Dupont Circle to H Street. During the same period, that "great elegance of line" that Alice Roosevelt Longworth ascribed to the "great friend" of her teenage years slackened and bulged; Cissy had let herself go. Without exception, those who knew Cissy when they were children, remembered

her as utterly "charming" and "delightful," even in the last years of her life. She was happy to hear the same riddles repeated over and over, eager to coo to babies, delighted either to hide or to seek. Although she could be similarly companionable and obliging toward adults, she had grown more unpredictable in recent years, lashing out without warning, as former friends and acquaintances dropped away, puzzled and smarting. As she entered her sixties, descriptions of her memorable, predatory grace gave way—even in accounts left by friendly contemporaries—to comparisons with an imperious, wizened, and remote Elizabeth I, long past virginal girlhood. Taking into account the publisher's well-known changeability and her off-with-their-heads attitude toward human resources, less well-disposed observers compared her with a growing frequency to Lewis Carroll's capricious Red Queen.

The rising torrent of hate mail that flooded the *Times-Herald* during the war had forced upon Cissy an awareness of the public's growing hostility toward her. She herself had opened the floodgates. The very piquancy of the *Times-Herald,* the pointed insider gossip, the unabashed ad hominem attacks that had made the paper an irresistible guilty pleasure to its ever-increasing readership, had combined with its unapologetic criticism of the administration and the conduct of the war to confirm its publisher as a figure the public—and the rival press outlets, often fed by the White House—loved to hate. Judging by Cissy's unbeatable and still-rising circulation numbers (the *Times-Herald* enjoyed a particular following among active servicemen, curiously), the paper's outlandish pugilism appears to have touched a chord among the war-weary, and provided much-needed entertainment in the gloom of the uncertain international situation. Nevertheless, Cissy felt keenly the sting of nationwide public opprobrium. At the same time, she was growing suspicious, she told incredulous friends and staff members, that the FBI had her under surveillance. After a small bomb had been lobbed through the front door of the Times-Herald Building, she grew fearful for her safety. Still a superb shot as the result of her many years of avid big-game hunting, she began carrying a loaded revolver in her handbag and insisted that loaded firearms be kept at all times in her cars and on her bedside tables. Armed night watchmen kept vigil outside her bedroom door while she slept. Inside, an increasingly ill-mannered and incontinent pack of poodles maintained their own jealous watch over their mistress.

With victory in both Europe and Japan in sight at last by late 1944, Franklin Roosevelt, by then in the eleventh year of his presidency (and, like his gadfly in Dupont Circle, much aged by the battles—geopolitical, philosophical, domestic, and personal—that he had endured), offered him-

self as a candidate for reelection to an unprecedented fourth term. When Dr. Alvan Barach mentioned in passing his continued support for the president while lunching one day with Eleanor Medill Patterson and Evalyn Walsh McLean, both ladies were struck dumb at his pronouncement and put down their forks. As he recounted it later, after Barach finished his steak he bade his companions good-bye and never saw either again. Even Cissy's stalwart circulation manager, Happy Robinson, questioned her continued vituperation generally and the wisdom of reprinting her brother's editorial on the subject of the upcoming election, "No Fourth Term for Caesar," specifically. That November, the president was returned to office with more than 53 percent of the popular vote. Not long afterward, Cissy ushered in 1945 by publishing a gruesome photo spread of fallen American soldiers centered on Roosevelt's campaign pledge of more than four years before: "I shall say it again and again and again: your boys are not going to be sent into any foreign wars." Several hours after the earliest editions of the *Times-Herald* appeared on the streets and front porches of Washington that day, Franklin Roosevelt opened his first press conference of the New Year by offering good wishes to the assembled members of the press corps—with a few pointed exceptions. The following day, the *Times-Herald*'s "beefy, stogie-smoking" managing editor George DeWitt, whose objections to the ghoulish photo spread had gone unheeded, quit his job for good (having been fired and rehired by Cissy on several occasions over the previous decade). He was joined by the paper's advertising manager, whose only son had died under General MacArthur's command in New Guinea.

Having long dismissed as mere propaganda the persistent reports of enormous, systematized facilities dedicated to the elimination of Jews and others the Third Reich deemed undesirable, Cissy was staggered by the first photographs of the liberated German concentration camps over the winter and spring of 1945. Horror-struck at the images of the well-oiled mechanisms of mass extermination, piled corpses, barbed wire, emaciated children, disease, devastation, wasted bodies, and sunken eyes, she seized upon one photograph in particular and breathed, "Look at that face, that could be Christ on the cross," before bursting into unaccustomed tears. When the president died on April 12, 1945, the *Times-Herald*'s front page was uncharacteristically mute on the subject of the publisher's former candidate and more recent enemy, printing only Franklin Delano Roosevelt's photograph above the dates of his birth and death. Cissy began work the next morning by declaring, "Fill up the paper with Truman—he's the story now."

"Please tell Ellen that there is no need to be worried. Tell her that so far her grandmother, although attacking me in the newspapers almost every other

day, hasn't gone further with the suit," Drew Pearson wrote Felicia Gizy-
cka on January 25, 1945.

> The suit could be quite embarrassing and cause a lot of trouble if we had
> to appear in court, but I am quite sure that Cissy will never get the prop-
> erty away. The only disagreeable part is the gossip it causes on the part of
> our friends and the nasty publicity. However, tell Ellen that most people
> in Washington have discounted the whole thing and feel that it is just
> part of Cissy's mental aberrations.

Cissy had filed suit in the Montgomery County, Maryland, Circuit Court,
arguing that Drew had violated the terms of the deed of trust under which
he was to hold the 280-acre parcel overlooking the Potomac that she had
given Ellen as a tenth-birthday present. Indeed, according to Cissy's com-
plaint, in paying an annual "rent" of $700 to a trust fund established for
Ellen, Drew had "mismanaged" the property, which he and Luvie used,
Cissy insisted, both "as a country home for themselves the same as if it was
their own property, entertaining their friends and holding social parties"
and as a working dairy farm, "for their sole use and benefit." Cissy under-
cut her purported concern for Ellen (who had come of age the previous
July) and her assets, however, by naming her granddaughter as a co-
defendant. Between 1945 and 1948, Cissy pursued Drew relentlessly in
the county court system. Cissy's suit to expose her former son-in-law's
alleged mismanagement would end fruitlessly in 1948, just as the defen-
dant received Father of the Year honors from General Dwight D. Eisen-
hower to nationwide fanfare.

Unwilling to choose between her father and her grandmother, Ellen had
rejected Cissy's offer to buy the land at several times its market value—a
move intended to evict Drew and Luvie Pearson from their country home
and void their personal investment in improving the property. The rejec-
tion only served to amplify tensions between grandmother and grand-
daughter that had arisen from earlier squabbles over another of Cissy's
gifts: an expensive, misplaced necklace. In the spring of 1946, shortly
before Cissy redrew her will once again, nineteen-year-old Ellen married
George Arnold, the son of Thurman Arnold, the eminent former Yale law
school professor, assistant attorney general, and judge who had initiated
the government's antitrust suit against the AP. The Pearsons sent Cissy's
invitation too late to make it possible for the bride's grandmother to attend
the ceremony.

"What wonderful news to think at last we have a boy in the family and a
beautiful great big eight pound darling," a delighted "Great Grandmother
Cissy" gushed to Ellen eighteen months later, nevertheless. She would be

considerably less enthusiastic when she learned the child was to be christened Drew Pearson Arnold. For Ellen, there would be lifelong repercussions for seemingly taking her father's part in the feud with her grandmother. "I hope that the 'rent' you receive for the farm is satisfactory," Cissy declared in March 1948, after her legal efforts to prove her former son-in-law's breach of trust had fallen through in the Montgomery County court system and she began toying with the idea of remaking her will once again, adding, "It's all you will ever get out of that last present from me to you."

Despite Felicia's having "divorced" Cissy after their last "knock down drag out fight" at the Dower House, mother and daughter would, in fact, meet once again. On May 11, 1946, as Joe Patterson made ready to attend his fiftieth Groton reunion, failing health instead forced his admittance to Doctors Hospital in New York. He had made good on his angry pledge to "outlive that bastard Roosevelt." Decades of heavy drinking had taken their toll on the publisher, however. He had been in obvious decline during his visit to the South Pacific and occupied Japan at the invitation of his World War I division commander, General Douglas MacArthur, in the autumn of 1945. In early 1946, his characteristic vitality dwindling, Joe Patterson had been forced into bed with pneumonia at "Eagle Bay," his unadorned estate in Ossining, New York. By spring, rumors reverberated not only among the members of the News's anxious staff, but throughout the newspaper industry generally, of the publisher's imminent death, of his possible successor or successors, and of family infighting. Indeed, his hospital room had been the scene of fearsome squabbles between his female blood relations and his second wife and son.

On May 17, Alicia Patterson Guggenheim wrote Bert McCormick that her father's "turn for the worse" had prompted her early return from a Newsday business trip to the West Coast. She hoped his "iron constitution" would see him through to recovery, but feared that the malnutrition brought on by the deterioration of his liver would soon necessitate force-feeding him by tube. "It is terrible to see him so miserable," she said. Although Colonel McCormick had been shocked to see his cousin's condition at the annual meeting of the Associated Press that spring and had found Joe unable to recognize him more recently during a hospital visit, he was less given to sentimentality. Already on April 13, he had returned a marked draft to his managing editor at the Tribune with the general (if uncharacteristically self-effacing) complaint, "There is too much McCormick in this Patterson obit."

Less than two weeks later, on the morning of May 26, 1946, Joseph Medill Patterson died at Doctors Hospital at the age of sixty-seven, sur-

LEFT: Parents of the bride, Felicia Gizycka and her ex-husband, Drew Pearson, on Ellen Pearson and George Arnold's wedding day in March 1946

BELOW: Ellen Pearson weds George Arnold.

rounded by his wife, Mary King Patterson; his daughter Alicia Patterson Guggenheim; and his son, First Lieutenant James Patterson. Nationwide comment was unanimous in acknowledging the profound impact the late publisher of the nation's first and most successful tabloid had had not only on American journalism, but on American culture. Opinions were polarized, however, as to whether Captain Patterson's phenomenal influence had ultimately been for good or for ill. At the New York *Daily News* itself, Ed Sullivan, then one of the paper's Broadway columnists, grandly invoked Walt Whitman's lament for the fallen Abraham Lincoln: "O Captain! My Captain!" Fanny Butcher—neither dispassionate nor incorrect—concluded in the *Chicago Tribune* that "he was a great newspaper man because he knew what the men and women who read his paper were thinking." Henry Luce's *Time* mustered grudging admiration, likening Joe Patterson's death to the "Passing of a Giant":

> The News's headlines crackled; its pictures were good, and masterfully played; its news stories were models of clarity, conciseness and coarse wit. Joe Patterson's journalism owed more to P. T. Barnum than to Adolph Ochs. No story in the News was "important but dull"; if the news was important, there was no need for it to be dull. In world affairs, the News could tell in two columns most of what the New York Times took eight to tell. But the News did best on what the Times aloofly did not consider Fit to Print.

"Always he sought to find out what the people were thinking and what they liked," the New York *World Telegram* agreed. "A student of human nature, he often rode the subways, walked the streets, and went to the movies to keep in touch. His talent for transferring his findings to newsprint for mass appeal obviously was second to none." "None could ever say that he was ever the tool of any interest; he served nothing but the light as he saw it," the *Washington Post* concluded.

In the *New Yorker,* by contrast, A. J. Liebling lamented the publisher's many contributions to the creation of "the wayward press" of the modern age. "The Master of American Tabloid Journalism Dies at 67, Arch-Isolationist to a Bitter End," was *Life*'s verdict. "The *News*'s phenomenal growth is easily explained," sniffed Marshall Field III's struggling *PM*; "It played up the gaudiness of the post-war period, purveying in the forbidden thrills of sex and homicide, squeezing the last drop of scandal from every divorce, murder, kidnapping, and movie case." In the *Saturday Review of Literature* William Rose Benét lamented the symbiotic fascination that had existed between the publisher and the masses:

As for the tabloid he later founded, to debase the taste of the American public, and finally to espouse the cause of Isolationism when the world was confronted by its greatest menace, the American people have made it the newspaper with the largest circulation in the country, and mainly those very people whose best interests it never had at heart. No American citizen is compelled to buy the *News*; but it is they who support it. Therefore, it is apparently what most of them want.

"But the man in the street needs education in rational thinking, not a lot of trash and sensational mush," the highbrow Benét insisted; "Patterson was a soldier and a fighter, and it is a colossal pity that he did not continue to fight on the better side. Instead he will go down in history, I believe, as a lesser Hearst." In the aggregate, the postmortems on Joe Patterson's character and career would reflect and set his posthumous reputation. By and large, the obituaries glossed over, if not entirely effaced, the rough-and-tumble child of privilege, the young radical, the reformer, the hyperegalitarian millionaire and the unpretentious war hero. In like fashion, even the journalistic visionary would be overshadowed by the vitriolic isolationist and the bitter reactionary he became in the last years of his life.

His body having outgrown the old captain's uniform in the years since the Great War, Joe Patterson was dressed for burial instead in war correspondent's attire. Hundreds of mourners—*News* employees, business associates, newsboys, readers, and well-wishers, "some of them friends made during Patterson's casual wanderings thruout the city," the *Chicago Tribune* noted with characteristic simplified "speling"—gathered at Frank Campbell's funeral home on Madison Avenue. Afterward, Joe Patterson's body was removed to the library at "Eagle Bay" in order to permit some five hundred friends and relatives to pay their respects as well. The following afternoon, May 27, 1946, the coffin was taken to Grand Central Station to be transported to Washington, accompanied by some thirty intimates of the deceased—among them extended family, old associates, several Annenbergs, and a variety of high-ranking *News* and *Tribune* executives and editors—traveling in three extra train cars. That evening, like his cousin Medill McCormick before him, Joe Patterson lay in repose at his sister's home on Dupont Circle.

Arriving there that evening, Felicia was unsure how to react when she stepped tentatively from the elevator on the way to her old bedroom to find herself "enveloped" by her mother's unaccustomed "kisses, hugs and affection." "It frightened me," she remembered. Despite their years of estrangement, Cissy had tried to keep abreast of the most basic events and changes in Felicia's life. Several friends had attempted to bring about reconciliation

between mother and daughter. "I thought of giving up all my money and living like you," Cissy confessed to Felicia that evening as the mansion remained open past midnight to receive others who wished to pay their respects. "But it's too late." She also admitted that she had considered following Felicia's example in renouncing alcohol and joining AA, but that Joe (so recently deceased from complications related to cirrhosis of the liver) had pooh-poohed the idea, telling her unceremoniously that she was too old.

Cissy had been devastated by her brother's death, and when wounded she was typically at her most malevolent. At nine thirty on the morning of May 28, in an effort to reach Arlington National Cemetery in a timely fashion for the burial, which was scheduled to take place at ten o'clock, the party of mourners assembled at 15 Dupont Circle as the hearse and limousines that were to make up the funeral cortege approached. The lady of the house, however, was nowhere to be seen. Cissy had made the suggestion to Mary Patterson that simplicity in mourning would best befit the occasion—and the deceased. Though the widow had duly appeared on time, in discreet black, the grieving sister emerged at last from between the iron portals of Patterson House in full mourning, her long veil billow-

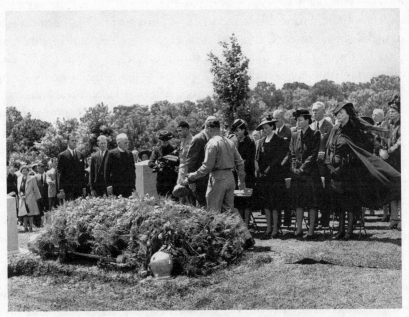

Captain Joseph Medill Patterson's burial at Arlington National Cemetery, May 1946. Cissy, in full mourning, stands in the front row, far right. Her cousin, Colonel Robert Rutherford McCormick, and her estranged daughter, Felicia Gizycka, stand behind her on either side. The occasion marked the last time Felicia ever saw her mother alive.

ing lugubriously in the breeze. With her own car and driver she proceeded to commandeer the first spot in the funeral procession, which had been reserved for her sister-in-law. At Arlington, troops placed the casket on a caisson drawn by six white horses and draped it in an American flag. The United States Army Band, playing "Our Fallen Heroes," along with some fifty-four troops and a color guard of three bearing the flag of the 42nd (Rainbow) Division, led the procession to the hilltop grave near the Tomb of the Unknown Soldier. After the chaplain read the rites and the casket was lowered into the earth, a firing party of eight unleashed three volleys over Joseph Medill Patterson's final resting place.

That evening, Felicia returned with Cissy to the Dower House, the scene of their last tumultuous encounter. For a short time she held out hope that some sort of reconciliation might be possible, until Cissy began grating on her as of old. All too soon, she found her mother "getting boring," and herself increasingly irritated at having to listen to "long tales" about the extraordinary beauty of Cissy's particular young pets, Ann Bowie Smith and Evie Robert (Luvie Pearson having been dropped from their ranks). As if invoked, the dazzling Evie Robert herself "burst in" on mother and daughter, putting a halt to their domestic harmony.

Evelyn Walker Robert, "glamour girl of the New Deal," was the beautiful young wife of the considerably older Lawrence Wood (or "Chip") Robert. A staunch supporter of Franklin Roosevelt from the latter's days in the New York governor's office, Chip Robert had been assistant treasury secretary in charge of public works and treasurer and secretary of the Democratic Party in the 1930s. It was a testament to Cissy's affection for his wife that Robert remained among the handful of New Dealers to escape the routine castigation to which the *Times-Herald* typically subjected them. Effervescent, witty, and blond, Evie Robert was a renowned hostess as well as a sought-after dinner guest in the capital. She had long joined Cissy on the local horse show circuit with her two formidable mounts, John the Baptist and his stablemate, Salomé. Like a number of Cissy's darlings, Evie Robert chronicled her comings and goings in Washington society (as well as her vacations and spa visits) in a regular column for the *Times-Herald* under the banner of "Eve's Rib." In conversation she had a notoriously bawdy sense of humor. By her own breezy admission to many (although perhaps not to Chip Robert, who spent much of his time in his native Atlanta), she possessed an omnivorous sexual appetite, which also endeared her to Cissy. At political dinners she was given to regaling the companions at her table with droll musings, drawn from personal experience, on the predilections, peculiarities, and endowments of the various New Dealers and officials seated nearby. Many, Felicia not least among them, agreed

that the bewitching Evie seemed to hold Cissy quite literally in thrall. As Felicia characterized it, Evie's intrusion at the Dower House gradually caused a "hypnotized expression" to settle over Cissy's features. Forced to witness the care, attention, and affection Felicia had hardly known from her mother lavished on someone else, she remembered, "I left her with Evie." She would never see her mother again.

"It's a queer thing that you and I, who were brought up really as brother & sister, are still today so gawky & shy with each other," Cissy observed two months later to the only other surviving member of her generation. Born only fifteen months earlier, "Bertie the Swipe's" interactions with his unpredictable female cousin had indeed always been awkward and fraught, despite the stilted protestations of affection each occasionally had made for the other over the years. Although they had never been intimate or affectionate (instead, they typically fulfilled both their shared predisposition and their long-ingrained maternal imperative to spar when brought together), in later years Cissy exhibited a certain sympathy—if not empathy—for Bertie and his peculiarities. Well into his seventh decade, the colonel had grown increasingly suspicious, reclusive, bombastic, narrow-minded, xenophobic, and condescending—"the greatest mind of the fourteenth century," many chuckled when referring to him, or as Cissy styled him, "Bourbon Bertie." A "most interesting man whose life was spent in concealing his sense of unease behind a tuba," as Frank Waldrop put it figuratively, in private Colonel McCormick was agonizingly introverted and profoundly (although by many accounts not unhappily) isolated. Like Cissy, over the course of the war years he had grown fearful for his safety and increasingly idiosyncratic (neurotically so, some contended). On the few occasions when he ventured out of his beloved American heartland to "Communist Washington," he stayed with his cousin at Dupont Circle, "as a matter not only of family courtesy, but also as an absolute physical necessity," Cissy's faithful editor, Frank Waldrop (later a McCormick biographer), remembered. Family differences aside, when in her household, Cissy took every precaution not only to make her cousin feel comfortable but also to ensure his safety. She directed her staff to remove any fragile, sharp, or potentially dangerous objects from his room.

In the dark hours, the terror could overtake him so that McCormick's shouts and battles with his demon would echo through the whole house. The next morning servants would find there was nothing to do but strip down and re-assemble the room. As for McCormick, his morning policy was to ignore the whole thing, never apologize and certainly never ex-

plain. His tips to the staff, on departure, were more than generous, so it was all taken as a matter of course by everybody. Mrs. Patterson, herself, was both discreet and sympathetic in saying it was "Bertie's affliction," something he could not help and, therefore, something for which he must never be embarrassed. Nor was he.

One such visit had taken place at the same time as a gathering Cissy threw for her cousin and his new bride in January 1945. Complete with riderless horse, troop detachment, three-gun salute, and the mournful strains of "Taps," the makeshift military funeral the colonel had orchestrated when his first wife, Amie, died of cancer in 1939, was a source of unbounded hilarity to Cissy for years afterward. Sensitive to the scandal their marriage had occasioned—especially in Lake Forest circles—the colonel and the first Mrs. McCormick had made their principal residence Joseph Medill's farm, "Red Oaks," nearly fifty miles away in Wheaton, Illinois. The Colonel renamed the estate "Cantigny," in honor of the town in the Somme where he claimed to have "tasted the wine of death" with his First Division.

Although largely solitary as a widower, the colonel had not been lonely. Indeed, re-creating in some measure the circumstances that had originally united him with the departed, he had taken up with his wife's best friend. Seventeen years younger than her lover, the vivacious former Maryland Mathison was unhappily married with two daughters to the impecunious Henry Hooper, president of the Lake Shore Fuel Company of Chicago (and like Amie's first husband, Ed Adams, before him, a debtor of Bert McCormick) when she secured a hushed Mexican divorce in early December 1944. Under circumstances only slightly less quiet, in a small Chicago ceremony with Joe Patterson as best man, the colonel took a new bride before the end of the year.

Pointing to wintertime travel difficulties, Cissy had not attended (although friends attributed her absence to a peevish despondency over Roosevelt's recent reelection to a fourth term). Instead, she threw the newlyweds (or "the Royal Family" as she styled them) a lavish reception at 15 Dupont Circle in the New Year, for which even Cal Carrington had come east, washed, and buttoned himself stiffly into evening clothes. "Where did she pick him up?" the groom was overheard to wonder of the crotchety old cowboy before leaving his bride, their two hundred assembled well-wishers, and his cousin and hostess for an early night. When they did not follow his lead, a disgruntled colonel reappeared in pajamas and bed jacket to thunder over the banister, "Don't these people know when to go home?" Receiving only chuckles and applause in response, he shouted louder still, "Why don't you all go home? You're keeping me awake! Maryland, when are you com-

ing to bed?" to the general approval and hilarity of the partygoers, who continued their celebration of his second marriage late into the night.

"Maybe you don't feel ill at ease with me but I sure do with you. That's a pity, especially now that Joe has gone," Cissy admitted to her cousin, having been unsuccessful during a recent meeting at pinning him down on the subject of the new responsibilities Joe's death had imposed upon her. "Once I *know* what my duties are I will not shirk them, believe me. But up to date no clear picture has been presented to me . . . Really Bert, you didn't give me much of a chance, for you took but about three steps from your finger-bowl to your waiting car." In journalist A. J. Liebling's reckoning, at Joe's death "the paper with the largest circulation in America (over two and a quarter million weekdays and twice that Sundays) was left like a steam roller . . . whose operator has gone off for a beer and forgotten to come back." In an effort to bring control (or at least some semblance of it) not only to the gargantuan engine the *News* had become, but moreover to its anxious (and potentially mutinous) staff, Roy C. Holliss, the faithful, fifty-nine-year-old second vice president, assistant treasurer, general manager, and company director had been appointed president. Holliss's own demise in an automobile accident within three months—which came on the heels of the natural deaths of two other *News* executives high up in the line of succession—saw Cissy's unsought election as chairman of the newspaper's board of directors on September 1, 1946.

Drooping after her wartime travails and laid low by the more recent effects of what she described as "this doggone D.D.T. poisoning," Cissy longed to be replaced in this new capacity at the earliest available opportunity. Nevertheless, "I would force myself, whether I liked it or not, to get into this new set-up and do my level best to make an acceptable figurehead, or whatever else was required of me, were I not so sure that Joe did not want to have the real control of the News pass into your hands," she informed her cousin bluntly. "He did not want to have the News operated (largely through fear) from Chicago. I know this to be true, because he told me so. Exactly." She was perturbed also by the letters that had been pouring in from eminent editors and publishers all over the country, congratulating her variously on her new position as "head," "president," "publisher," or "chairman" of the paper her brother had launched to unsurpassed success:

> All of these exaggerated reports of my rise to power are bad for the News.
> They are pure joy for our competitors and ill-wishers all over the country.
> It is bad for the News to have the idea get across that a tired, and already
> over-worked old woman like myself, is either Head of the News, or
> Figure-head of the News, or, in fact, at the head of any job on the News of
> great authority.

For these reasons she had been particularly dismayed by the many "goofy stories" that her ascendancy had inspired in publications nationwide. Of these, the lengthy profile that appeared in the November issue of *Collier's* magazine was perhaps the most outsized. "One day the movies will doubtless get around to filming the fabulous life of Eleanor Medill Patterson," Dickson Hartwell trumpeted in "No Prissy Is Cissy."

> As newly elected chairman of the New York Daily News, which has the largest circulation in the country, as outright owner of the raucous Washington Times-Herald, and as a principal shareholder in the Chicago Tribune and affiliated news syndicates, Cissy Patterson—no one calls her Eleanor—is probably the most powerful woman in America.

"And perhaps the most hated," Hartwell added.

The colonel counted himself "very much discouraged" by Cissy's letter. In response, he protested that, whatever Joe's wishes, he had no choice but to intervene in the management of the *News.* His situation and his responsibilities were complicated by circumstances beyond his control: the "uncertainties and rivalries" generated in-house by the various deaths along the *News*'s line of succession, the widening rift within Joe's family, and the dilemma Joe's executors faced in attempting to keep the decedent's trust holdings intact despite the fact that the estate's illiquidity made borrowing heavily the only means of paying death duties. "These are not my immediate problems but I cannot escape from them, either officially or personally," the colonel protested in light of the indissoluble financial and editorial entanglements that linked the *News* and the *Tribune.* "I cannot help thinking that Alicia has stirred you up to this," he concluded suspiciously. The visit Cissy paid to Cantigny shortly afterward, in late September 1946, to resolve their disagreements did nothing to improve relations between the cousins. "I was somewhat bewildered by your violence," Cissy scolded Bert afterward. "You were possessed by a queer kind of rage, all out of proportion to the discussion at hand. I won't forget your lunging across the dark verandah at me, gripping the arms of my chair, baring your lower teeth (very odd indeed) and bellowing in my face—'Joe's dead.' "

Beyond the huge revenues they generated, Cissy had traditionally taken little interest in her Tribune trust holdings, which had initially been slightly larger proportionately than those of her fellow beneficiaries as the result of her adoring grandfather's favoritism in the form of the ten shares she had inherited outright. Indeed, her surviving correspondence contains decades' worth of regular, perfunctory notes of apology for not having attended recent board of directors' meetings. Joe's death, however, refocused her attention on the role that the Patterson branch of the family—

by blood, not marriage, she insisted—would play in the *Tribune,* the *News,* and eventually the *Times-Herald,* going forward. The absence of Joe's buffering influence within the family allowed for a reawakening of the old combativeness that had been largely dormant since the deaths of Kate McCormick and Nellie Patterson during the previous decade—especially amidst the comparative wartime harmony that had reigned among the strong-minded cousins.

In the last weeks of his life, Joe had converted to the Roman Catholic faith of his second wife and her forebears. Mary King Patterson's influence over the deceased, some within the family regretted vociferously, had extended beyond matters of religion and redemption. Before his death, Joe had substituted his wife for his sister as the one who would succeed him as the trustee representing the Patterson family. Cissy capitalized on dissension among Joe's daughters generated by the division of the estate between their branch of the family and their stepmother's, and backed Alicia's candidacy for the trusteeship instead. Regretting as of old that "not one but *two* attacks of flue [*sic*]" had prevented her from attending a recent board meeting where they might have spoken face-to-face, in February 1947 Cissy wired her cousin that she hoped to consult with him regarding "Some personal worries of importance to me: I do hope you and Maryland will not fall for Marys extremely adroit intrigue she managed finally to separate Joe from his daughters," she declared, adding accurately in light of the lifetime of awkwardness and intermittent hostility Joseph Medill's two surviving grandchildren had known in each other's company that her sister-in-law would likely have, "an easier task to separate you and me." As it would turn out, it was Alicia's politics rather than the intrigues of any in-law that would separate the cousins. Although they had fought over many matters in the past, Cissy and Bertie were now pitted against each other in the very forum their grandfather had so carefully erected to promote unanimity as the safeguard to his progeny's sovereignty over his beloved "Tribune Kingdom" for posterity.

"Mrs. Patterson's willingness to bestow forgiveness on people she has belabored only a moment before is one of the pleasant surprises in her character," journalist Dickson Hartwell further ventured in his *Collier's* profile of 1946.

> That they are sometimes unwilling to accept such benevolence with good
> grace or at all is disturbing to her. She feels that it is her privilege to hold
> the grudge if any is to be borne, and that once she decides to smile then
> the world should smile with her. It is probable that she has in one way or
> another—and always impulsively—extended the olive branch to every-

one with whom she has ever fought, with the exception of Pearson and Winchell.

Although perhaps overly charitable, the assessment was not entirely untrue. Since the war Cissy had demolished her relationships not only with Felicia, Ellen, Drew, and Luvie, but also with many old friends and associates beyond Franklin Roosevelt, Bill Bullitt, Ernest Cuneo, Alvan Barach, and Harold Ickes. As these figures were expelled from her life, however, she took steps to repair (at least in some measure) the damage she had inflicted on other friendships over the years.

"Washington is at its worst," Alice Roosevelt Longworth had lamented to her old friend, Ruth Hanna McCormick Simms, in the early days of the war. Having lost her bid for her late husband's Senate seat in 1930, Ruth had returned to running her dairy farm in Rockford, Illinois, and to publishing the Rockford Consolidated Newspapers. Within two years she had remarried. When her second husband and former congressional colleague, Albert Gallatin Simms, was diagnosed with tuberculosis, the couple returned to his home state of New Mexico in hopes that its dry climate would have a curative effect. Ruth's trials had not ended with her first husband's suicide in 1925. In 1938, Medill's namesake and Ruth's only son was killed in a mountain-climbing accident at the age of twenty-one. Ruth herself died of complications resulting from pancreatitis in December 1944. Before her death, however, her faithful correspondent Alice kept her abreast of developments back in Washington. The two old friends' long-shared isolationism had put Alice at odds with her kinsman the president, among many others. "As for Frank," she reported to Ruth, "it is a strain to keep the peace."

> He says "you are anti-British" which in his state of mind is an accusation on par with saying "you are an Ogress, you eat little children." That is the emotional stage he is still in. A little dated, don't you think, considering the present condition of the erstwhile British Empire. He doesn't like it when I say Now you have you [*sic*] war—explains that he didn't want it, only thought that it was inevitable. To which the obvious answer is—Of course you knew it was inevitable because every measure you advocated made it so. Whereat he leaves in a flounce of fury . . .

"Isn't Joe Pat. doing great stuff?" Alice enthused of the *Daily News*'s take on intervention and its proponents, "I've seen him here and in New York." If the war had made for strange political bedfellows, it had also helped to soothe old piques and resentments among the like-minded. "And that

reminds me," Alice added, "I see Cissy again—too long to tell you about, at least to write."

Like the details of the rupture between Alice and Cissy, the reasons for their reconciliation would go unrecorded. Their renewed relationship, however distant or perfunctory in reality, was duly immortalized in one of the *Times-Herald*'s "These Charming People" photo spreads that ran during the "notorious 'Savitsch Case'" in the spring of 1944. In it, the two grandes dames walked arm-in-arm once again, laughing extravagantly as they no doubt revisited capers committed during the halcyon days of the turning century, before the two celebrated debutantes had known marriage, childbearing, or war. If the mawkish Adela Rogers St. Johns is to be believed, it was she who effected a surprisingly tender and tearful reconciliation between the two steely doyennes at 15 Dupont Circle shortly after Nick Longworth's death. "I should have believed you about the champagne," Alice reportedly assured her old friend, "that was your weakness, not men." "I don't remember how old you are, lovie," Cissy replied with a damp twinkle in her eye, "but you don't look it." All that had sundered them forgiven and forgotten, the reconciled friends then laughed and hugged, a self-congratulatory St. Johns contended. The fact that Cissy's editorial aggression toward Alice continued undiminished long after Nick's death, however, suggests that if the meeting took place at all its effects were ephemeral. Whether Cissy ever in fact apologized for her years of front-page insinuations and calumnies is also unclear (and unlikely). Nevertheless, in the wake of the much-photographed Sunday luncheon at the Dower House in 1944, an ingratiating Cissy took care to send Alice those images of her still "exquisite profile . . . against the Maryland sky" that Jackie Martin (also returned to the fold from her defection to Marshall Field's *Chicago Sun*) had taken of the event.

Cissy's many attacks notwithstanding, with Arthur Brisbane's encouragement she had in fact extended an offer to the newly widowed Alice to serialize her memoirs in the *Herald* in 1931. When Charles Scribner's Sons instead published Alice Roosevelt Longworth's *Crowded Hours* the following year, the *Washington Herald* lambasted both the autobiography and its author. Other than Cissy's vindictiveness, the episode suggests that in some cases she was capable of putting aside her pique, at least temporarily, in the interest of journalism. Indeed, she appears to have done so where Eugene Meyer was concerned as well.

"Relations between Mrs. Patterson and our family naturally had ceased after the 'pound-of-flesh' incident relating to the comics," Meyer's daughter Kay Graham remembered. Local newspaper accounts of social and civic events in the small town that was the nation's capital record that although the two publishers had not spoken for years afterward, they had often been

thrown together. At one such encounter, observers noted that Cissy Patterson and Agnes Meyer appeared to have recognized at the same awkward moment that they were wearing identical dresses. After a dinner hosted by Undersecretary of State and Mrs. Sumner Welles ("a lady unconscious of strains in relationships"), Luvie had reported with some surprise to her friend Kay that the publishers of the *Times-Herald* and the *Post* had "sat down together and talked most of the night." Despite the deep hurt Cissy's ugly Shylock reference had caused, Eugene Meyer proved to be willing to let bygones be bygones for the sake of journalism as well. In the mid-1940s, in the course of passing the *Post*'s torch to his son-in-law, Philip Graham, who was at the time chairing the committee empowered to negotiate with the local craft unions on the collective behalf of the city's newspapers, Meyer acknowledged pragmatically, "If you are in this position, you really should know Cissy."

Phil Graham took the suggestion as an opportunity to "get the two old rivals back together," and called Frank Waldrop at the *Times-Herald* to conspire over the details. Although Waldrop initially feared that, in light of all that had passed between the two publishers (most recently, the contentious disappearance of the "Washington Merry-Go-Round" from the *Times-Herald* and its reappearance months later in the *Post*), any attempt at reconciliation would devolve into "something like two scorpions in a bottle." He soon took up the gauntlet, however, telling Graham, "You handle your man, I'll handle mine." Waldrop arrived at 15 Dupont Circle an hour before the appointed time to find Cissy and her household staff in a frenzy of preparation. "I don't want Eugene to go away from here saying I'm drunk," she fretted, ordering the butler to put away the alcohol. Once Phil Graham and his father-in-law duly arrived, and conversation lagged in the wake of the concluded preliminaries, Eugene Meyer ventured to ask for a drink. Cissy rang, and the butler reappeared to fulfill her countermand to "get it out." Slightly lubricated, everyone "behaved in a perfectly grown up fashion," to the relief of all. Moreover, Phil Graham utterly delighted Cissy. "Oh, Eugene, you're so lucky to have this charming son-in-law," she announced approvingly. "Think of the son-of-a bitch I got."

Repaired friendships could not make up for Cissy's continued losses, however. The reasons for Evalyn Walsh McLean's classification among the "little *bêtes noires*" of Cissy's whimsical taxonomy in 1930 are as obscure as the causes for the former's redesignations, first as the author of the *Times-Herald*'s "My Say" column in 1937, and then as Cissy's "best friend" sometime during the following decade. The kindly, doddering mining heiress and "capital society leader," who was by her own admission as addicted to morphine as she was to collecting important diamonds, had become to Cissy "one of the few people in the world with as much money as I

have . . . I can trust her. She doesn't want anything from me." On April 26, 1947, Cissy rushed back to Washington from a trip to New York to join Supreme Court Justice Frank Murphy, Judge Thurman Arnold and his wife Frances (now Ellen's in-laws), former senator Robert Rice Reynolds, and Frank Waldrop at the new Friendship in Georgetown to keep a sad vigil over their mutual friend. Evalyn Walsh McLean had been languishing in an oxygen tent for several days with pneumonia. There was little more that Dr. Bernard J. Walsh could do for his patient. Her confessor, Father Edmund Walsh, vice president of Georgetown University (and no relation either to the physician or to the patient), administered last rites. The death came as a "terrible shock" to Cissy, who had been convinced that her friend had "at last got over the hump and was well on her way to recovery." Three weeks later, Cissy continued to be deeply troubled by the loss, regretting darkly to her cousin in Chicago, "I can't help feeling that had I not been up in New York at the time, she would not—either intentionally or by accident—have killed herself, because that is what it amounted to."

Exactly what Cissy meant by this is unclear; press reports listed the cause of death as pneumonia. Without doubt, Evalyn Walsh McLean had lived a life of opulence and self-indulgence counterbalanced by an equally lavish generosity of spirit, amidst violent tragedy. She had lost her brother and one of her sons to automobile accidents. She had endured trauma, addiction, and repeated attempts to swindle her. She had witnessed the dissolution of her marriage and her husband's descent into alcoholism and madness. By many accounts, however, the last year of her life had been, if possible, even more difficult to bear. Seven months earlier, on the afternoon of September 20, 1946, Dr. Walsh had paid another visit to Friendship; on that occasion, to tend to the knee that the lady of the house had recently injured. After showing the doctor in, the butler noticed a frantic barking coming from Mrs. McLean's daughter's room. He became alarmed when he found the door locked and was unable to elicit any response from within. Breaking down the door, he found Evalyn McLean Reynolds, the twenty-four-year-old wife of Senator Robert Rice Reynolds, Independent of South Carolina, stretched across her bed, unconscious, her frightened dog at her side. Dr. Walsh's efforts to revive her proved fruitless. Although the coroner issued a temporary death certificate listing "acute congestive heart failure" as the cause, the official verdict was delayed for several days because of the alcohol and the empty bottle of sleeping pills that had been discovered at the scene. On the evening her body was discovered, she had quarreled with her husband as he left for a dinner engagement elsewhere. She left no suicide note. Evie Reynolds's daughter turned four a month later.

Evalyn Walsh McLean had been devastated by the loss. Although she had doted on her small, motherless granddaughter, she had by many

accounts lost the will to live. Even as the intimates who had assembled around her deathbed watched Father Walsh administer extreme unction on that Saturday evening, practicalities began to intrude. What was to be done to safeguard the almost peerless collection of gemstones and jewelry that the dying woman had so lovingly amassed over the course of her life? And, in light of her devil-may-care attitude toward insurance and the casual way in which she had handed the pieces around at parties (amazingly, they had always been returned)—where was all of her jewelry? The executors of the McLean estate, Justice Murphy and Judge Arnold, were obliged to act quickly. In "Haunted House," a fragmentary recollection of the many curiosities he had witnessed at Friendship over the years, Frank Waldrop recalled,

> I have seen a judge of the Supreme Court lead a sort of Easter egg hunt through vases, hatboxes and all the secret places of a lady's bedroom and come up with roughly half a million dollars' worth of rubies and diamonds while a renowned Jesuit scholar recited to the lady herself the ritual words of hope and consolation as she gave up a life that had, for all its splendors, been of little pleasure to her.

According to other accounts, the hunt continued throughout the sprawling mansion and saw mourners plucking brooches out of the toes of old shoes; bracelets glimmering under sofas; necklaces eased, stone by stone, out of flower vases; and the Hope Diamond itself liberated from its hiding place behind a wireless radio. For lack of a more fitting container, the notorious gemstone was taken from the death room of its most recent owner and placed (along with the rest of her jewelry, including the 94.8-carat Star of the East, the 31-carat McLean, the 15-carat Star of the South, and a 9-carat green diamond) in an Uppman cigar box.

By late afternoon Thurman Arnold, Frank Waldrop, and lady's maid Ingrid Langerkuist set off in Evalyn Walsh McLean's Cadillac in search of an open bank or jewelry store willing (and, indeed, sufficiently well insured) to safeguard the cigar box until Monday morning. The beleaguered trio would eventually appear at the Federal Bureau of Investigation's Washington field office after a beseeching pay phone call to director J. Edgar Hoover, a frequent visitor to Friendship on more festive occasions. In the meantime, Cissy made her way to the Dower House to join her houseguests T. J. White and Evie Robert, and to receive her second "pretty bad shock" of the day. "When I got back after Evalyn's death, I found Tom practically unconscious and Evie herself feeling no pain," she confided to Colonel McCormick.

I thought Tom had just been celebrating a little private wake of his own, but the next day his condition was no better. Two doctors, who came out to see him, agreed that he is suffering from advanced Cirrhosis of the liver, probably Cancerous, complicated further by a greatly enlarged heart. I knew that he had been failing for some time, but never knew his real condition.

Evie, bless her heart—she's a wonderful friend—stuck with me through the whole sorry business. Tom was unable to leave my house until after Evalyn's funeral. Finally went on his way, accompanied by a doctor and quite a little retinue.

I remember your mother was always saying that I was a "blab-mouth," and I think she was right. But I know how very discreet you are, and that you will not repeat this.

"Even if Tom were to know how serious his condition is—and he doesn't yet," she went on, "he would continue to want to slug the thing through, and will probably work at his desk until the day he dies."

Cissy would shortly receive a third shock as well. Although the receipt of a telegram from Felicia was by now a surprise in itself, it was the import of the communication that arrived from her estranged daughter that filled Cissy with a squeamish dread. In light of Mrs. Marty Mann's upcoming lecture engagements in Washington, Felicia wondered, could her close friend and AA sponsor stay at 15 Dupont Circle? "Marty Mann was for a time the head of the Women's Division of Alcoholics Anonymous and the only person I ever knew who had great influence on Felicia," Cissy explained in the litany of recent tribulations she dispatched to her cousin shortly afterward. "Well, that would be all right, too," she continued, betraying her anxiety over the exact nature and extent of the proposed guest's sway over her daughter, "if Marty were not a notorious lesbian, and that is rather hard to swallow."

Perhaps honoring the many efforts the grieving Evalyn Walsh McLean (among others) had made over the last year of her life to reconcile mother and daughter, perhaps for other reasons, Cissy did invite Marty Mann to stay at Dupont Circle, graciously placing her household staff as well as her personal secretary at her guest's disposal. For reasons that go unrecorded, however, the hostess was absent while the friend and mentor who had so profoundly changed her daughter's life was in town.

On May 26, 1947, a month to the day after Evalyn Walsh McLean died and T. J. White fell ill at the Dower House, the latter joined a storied, if oddly assorted, fraternity of eight American editors and publishers, among them Colonel Robert Rutherford McCormick and Marshall Field III, in

receiving honorary degrees from the Medill School of Journalism at Northwestern University on the occasion of the twenty-fifth anniversary of its founding in memory of Joseph Medill. On June 15, at the Mayflower Hotel in Washington, the Veterans of Foreign Wars presented Cissy Patterson with one of its "awards in the fields of Americanism and community service" for the *Times-Herald*'s recent, dogged efforts to "expose the Communist party and fellow travelers." In July, on the eve of her twentieth birthday, Ellen Pearson Arnold received a telegram from her mother, then on her way to New Haven with Marty Mann in connection with the latter's alcohol studies program, which read: "Enroute to Yale thinking of you with a great deal of love so glad you came into this old world and especially so that you came into our lives God bless you." Accolades and gestures of apparent maternal atonement aside, more rancor and loss were to follow.

Cissy's newfound interest in the McCormick-Patterson Trust had prompted her to inundate her cousin, as well as both her own and the *Tribune*'s counsels, with demands increasingly pointed and suspicious in the months following Joe's death. On Thursday, June 22, 1948, Colonel McCormick received a telegraphic alert from *Tribune* attorney Weymouth Kirkland that trouble was brewing in Washington. Contrary to her long-established custom, Cissy had resolved to banish excuses and tend to McCormick-Patterson Trust business personally by attending the directors meeting the following Saturday.

Cissy Patterson's Angry Memo to M'Cormick Sparks Will Fight

— *NEW YORK STAR*, SEPTEMBER 20, 1948

In the name of God, Bert, why did you pull that 'ham' act at the last Directors' meeting in Chicago, and at the stock-holders' meeting a few minutes later, go into the same kind of song and dance?" Cissy demanded on July 2, 1948. She had found the colonel's incursions into the management of the *Daily News* over the two years since Joe's death to be irksome. By his treatment of her niece, however, her cousin had thrown down the gauntlet. Delighted by Alicia's successes at *Newsday* and determined to fill her brother's former seat on the board of the Tribune Company with one of his daughters, Cissy had proposed Alicia's name at the recent board meeting. Family ties notwithstanding, the candidate was far too liberal and internationalist for the colonel's taste or comfort. As Cissy remembered it, he had rebuffed the proposal unceremoniously, indeed vociferously, by dis-

missing Alicia as having "nothing to contribute." "There you stood," Cissy continued, wagging an epistolary finger, "putting on the six-four-four business, waving your arms about, glaring like a maniac, shouting your denunciations of Alicia." Cissy saw much of herself in that "smart little cookie," her favorite niece, and spat back that Alicia was not simply her chosen candidate to fill the trusteeship. Contriving to nettle her cousin as she had done so often since their childhood, Cissy informed the colonel that she intended to make Alicia not only "principal heir" to her estate generally (presumably leaving her niece the *Times-Herald*) but moreover to her Tribune Company holdings as well.

Alicia Patterson Guggenheim was nowhere mentioned in the will that Cissy had most recently remade after Joe's death in 1946, however. Indeed, estranged from her only descendants and stirred by nostalgia for her late brother's radical egalitarianism, at the time Cissy had not intended to leave the *Times-Herald* to any of her relatives or close friends. Rather, if it was ever executed, her most recent will would make the unprecedented bequest of a profitable major metropolitan daily to members of the newspaper's own workforce, or, more specifically, to Cissy's seven-man executive staff, "share and share alike." The latest of the cousins' clashes had not only convinced Cissy to "sue Bertie right out of his britches," it had spurred her to take measures to change her estate plan yet again. "You should realize," she warned Colonel McCormick, "that you have never, and can never, *stampede* me off my chosen ground."

Still fierce: Cissy and Butch relaxing at 15 Dupont Circle in the 1940s

. . .

Indeed, in the spring of 1948 the servants' quarters at Dupont Circle and the Dower House were already abuzz with rumors of Mrs. Patterson's intention to make a new will. By many accounts, her wishes for her posterity had become a frequent topic of conversation. Cissy regaled flabbergasted dinner guests with insistent talk of the terms of her current will, its provisions and bequests, its heirs and legatees, as well as any thoughts she had of altering it and why. Whisperings of the proposed changes, in turn, intensified toadyism, backbiting, bootlicking, and infighting among those who surrounded her. As Ann Bowie Smith (whom Felicia Gizycka took to be one of her mother's principal flatterers) put it, Cissy's open talk of her will and the changes she considered making to it allowed her circle to "know when they were being favored and when they were cut out." The embattled publisher was given to buttonholing her latest favorites to impart news of the bequests that—for the moment at least—she intended to make. The *Times-Herald*'s supervising managing editor, Michael Flynn, recalled that she had informed him he would be a major beneficiary of the new will she envisioned when he visited her in Sarasota, Florida, in the spring of 1948. Photographer Jackie Martin claimed to have seen a draft of a will which left the *Times-Herald* to her, as well as to Flynn and Happy Robinson jointly.

If Cissy was prone to dropping her latest notions for huge bequests on stunned friends or gratified sycophants, she marshaled the threat of losing out to equal effect. "She played one person off against the other all the time," Frank Waldrop's wife, Eleanor, remembered. During the last years of her life Cissy had often promised her priceless Youssoupoff black pearl necklace to Evie Robert; at other times she spoke of leaving it to Ann Bowie Smith. As *Chicago Tribune* Washington bureau chief Walter Trohan, remembered it, "When Evie acted up, Cissy would say, 'Now, now, Evie!' fingering her black pearls, and Evie would shut up."

Cissy began to seek solace from grief and loneliness in a variety of sources. She attended séances. She flirted with converting to Catholicism as her brother had done, taking catechism from the late Evalyn Walsh McLean's friend and confessor, Father Edmund Walsh. Suspicious of the motives of those who surrounded her, she became increasingly devoted to animals. Having renounced big-game hunting she began devoting more column space in the *Times-Herald* to the coverage of pets, horses, and anti-vivisectionism. She donated ever larger sums of money to local animal rescue leagues and shelters, and to the dog owners' "Tail-Waggers Club" that she had established in 1937. "Cissy loved animals. Maybe it's because animals never wanted anything from her," Ann Bowie Smith suspected. Cissy's horses were lovingly and carefully kept; many had extraordinarily long lives. Her increasingly fractious poodles seemed to be aware of their

mistress's slackening standards, and took full advantage. If their forebears and predecessors had been indulged and coddled, by the late 1940s Cissy's pack was running amok. Visitors to her various homes arrived to find the public rooms festooned with the rolls of toilet paper the dogs stole from the powder rooms. The cleaning staff struggled to keep up with the chewed, sodden lumps that lay about underfoot. "Oh, look!" one secretary remembered the ordinarily formidable publisher exclaiming as the poodles darted by, yards of toilet paper streaming behind. "Isn't that cute!" The animals chewed expensive shoes, relieved themselves on Cissy's Aubussons and Persian rugs, and lifted their legs on her Louis XV furniture as the urge seized them. Like their mistress, they lashed out with impunity. Cissy's favorite, Butch, was given to snapping not simply at guests and staff members unexpectedly, but also at the hand that fed him. "He bites me every once in a while," Cissy admitted, nonplussed.

True to her word, having threatened to make Alicia her principal heir both at the recent board meeting and in her screed to the colonel of Friday, July 2, Cissy summoned attorneys Weymouth Kirkland and Joseph Brooks (Alicia's second husband) to the Dower House on the next business day, Monday, July 5, to discuss drafting a new will. Although the terms that she envisioned would never be made public, in the coming weeks and months Washington would be rife with speculation that over the intervening weekend her affection for her niece had grown in proportion to her bile toward her cousin. "Cissy Patterson recognized Alicia's talent," a *Time* interoffice memorandum asserted. Cissy Patterson, it went on to say, "was in fact on the verge of willing the *Times-Herald* to her [niece] . . . She had dictated a will making Alicia sole heir." Further, Cissy, it was said, had told many people that she was anxious not to allow the *Times-Herald* to fall into Colonel McCormick's clutches, and had gone so far as to suggest that if she were to meet her end under strange circumstances, any role that her cousin might have played should be closely investigated.

On July 9, Cissy received another devastating blow. T. J. White, still active, despite declining health, as president and general manager of the Chicago *Herald-American* and vice president of the Hearst Publishing Company, died at the Chicago Club at the age of sixty-three. Eleanor Medill Patterson's name did not appear among the published lists of mourners who attended the funeral at St. Patrick's Cathedral in New York City or who accompanied the White family to the gravesite in Smithtown, Long Island, on July 12.

Walter Trohan knew, or claimed to know, not simply from scuttlebutt around the capital but from Cissy herself, that changes to her will were

imminent. Offering counsel, strategy, and, occasionally, newsprint from the *Tribune*'s Canadian mills, the Washington bureau chief had often acted as an ambassador from the *Tribune* to the *Times-Herald* when the two papers' interests were aligned, and as a spy when they were at odds. On Tuesday, July 20, 1948, Cissy summoned Trohan to 15 Dupont Circle. Enraged and bereaved as she had been lately, Cissy was further aggravated by the excavation going on immediately outside her front door. In an effort to ease growing postwar congestion, the capital was in the process of constructing an overpass that would allow Connecticut Avenue to run beneath Massachusetts Avenue at the point where the two major thoroughfares converged: Dupont Circle. Her sleep compromised as a result, Cissy complained to Trohan of being "very, very tired." Pleasantries concluded, the publisher turned her attention to the matter on which she had sought counsel: she was reconsidering the disposition of the *Times-Herald* to her executives. Or, as Trohan recalled it, "she had let that gang of thieves turn her against her own flesh and blood." By now, he contended, Cissy regretted deeply her estrangement from Felicia and Ellen. Nevertheless, she made no mention of leaving the paper to either of them. She was still uncertain as to whether to make Alicia her principal heir and suggested, Trohan claimed, that she might appoint Trohan himself her successor in the event of her death. "I really felt sorry for her that day," Trohan recalled, "she was almost sane—she could see what a fool she had been." Before departing he suggested that Cissy call her old friend, former senator Burton Wheeler, to seek further advice. Trohan left with the distinct impression that Cissy's dissatisfaction with the current disposition of the *Times-Herald* to its executives was at least partly the result of her fear that business manager Bill Shelton would "outsmart all the others and get it all."

Given the publisher's propensity for hair-trigger firings, Bill Shelton was (according to his colleague and fellow putative *Times-Herald* legatee, managing editor Mason Peters) "astonishingly" lucky to have survived so long in Cissy's employ. A Northern Virginia native, Shelton had begun his career at the age of ten as a newsboy for the *Washington Post*. With a facility for numbers, he had graduated to the lofty position of circulation manager before he was twenty. When Cissy met him in 1930, he had served in that capacity at both of Hearst's Washington papers simultaneously since 1922. Upon Happy Robinson's arrival in 1930, Shelton was moved to the business office, which he headed under one title or another throughout Cissy's tenure. On the face of it, Shelton and Robinson, the purportedly machine-gun-scarred veteran of the bloody Hearst-*Tribune* Chicago circulation wars, were markedly different types. Most of Shelton's *Times-Herald* co-workers

remembered him as "straight, an established man," a "family man," "he lived an orderly life, wasn't a rough-and-tumble." But a tiny number, who knew more about the financial history of the newspaper, saw him differently.

Among Cissy's most innovative legacies (as well as the *Times-Herald*'s most divisive and badly kept secrets) were the sizable, profit-based annual bonuses she established for management in the latter years of World War II. It was Bill Shelton who was directly behind the implementation of the publisher's radical idea. As head of the business office, it had fallen to him to develop the formula by which Cissy arrived at what she considered to be an appropriate dollar amount for each member of management to receive at Christmastime; moreover, it was Shelton's own conduct and practices that had spurred her to implement the system in the first place. In Cissy's ceaseless efforts to keep the paper fresh and entertaining—ever larger photo spreads, new columns and columnists, more appealing comic strips, circulation-boosting contests, giveaways, and stunts—it became part of Shelton's job to work out how to finance her whims, directives, and edicts. According to Mason Peters, Shelton became "remarkably good at doing it, mostly because . . . he was quite adroit at hiding [cash flow] figures," managing for the most part "to remain just a few jumps ahead of Mrs. Patterson. She would catch him, invariably, but by then he would have worked out an even more artful dodge."

As the nation mobilized for war and able-bodied, draft-age men shipped out in increasing numbers in the early 1940s, female readership in the District of Columbia and its environs surged proportionately. That fact, coupled with the public's growing war-weariness, did much to boost the circulation of Cissy's unflagging and unapologetic anti-Roosevelt, antiwar message—independent of Happy Robinson's own energetic efforts. Wage caps and price freezes kept production costs low and allowed wartime revenues to soar. In the name of patriotism, Bill Shelton instituted additional cost-cutting measures at the paper, all the while refining and honing his formidable skills as a creative accountant. Not only did he find the means of funding the publisher's latest schemes, but, by manipulating the numbers, he quietly managed to sock away "a *colossal* nest egg" for himself as well. As Peters recalled it, upon discovering what Shelton was up to, Cissy became "truly angry, truly distressed that Bill would have squirreled away a great deal of money which she felt belonged to the people who worked on her paper." "This," Peters went on to assert, "was the origin of the celebrated will, in which she bequeathed the paper to the seven executives" in 1946.

Influenced additionally by her beloved brother's early socialist sympathies and his legendary common touch, during the war years Cissy began

musing aloud about how happy it would make her to permit those responsible for the *Times-Herald*'s rising revenues to share in its profits. Having discovered Shelton's depredations, Cissy gave him a blistering tongue-lashing and immediately put into effect the unprecedented bonus system she had long been contemplating. Like so many of his colleagues, Shelton had been fired on several occasions before and, like many of them, had been rehired. For reasons that remain unclear, instead of turning Shelton out after discovering his embezzlement, she allowed him to remain both in the employ of the *Times-Herald* and, at least for the time being, in her will. From now on, however, his work would be monitored directly by treasurer Charles Bell Porter and Cissy herself, as well as indirectly by his fellows in management—who suddenly had a vested interest in ensuring (and enforcing) Shelton's accurate reporting of the highest yearly revenues.

Taking Walter Trohan's advice, on Wednesday, July 21, 1948, Cissy called her friend Burton Wheeler. The progressive, isolationist former senator from Montana had been voted out of office in the last election and had recently joined his son in private practice in the capital. Enlisting the services of yet a third lawyer to redraft her will, Cissy invited the elder Wheeler to dinner at the Dower House to discuss the changes she was mulling over, the following Sunday evening, July 25. After settling the receiver in its cradle, she readied herself for her dinner engagement at George Abell's in Georgetown. Immediately afterward, she planned to escape the noise and heat of Dupont Circle by heading to the Dower House for a long weekend. "I guess I was one of the last people to talk to Cissy," her host later reflected. At the end of an enjoyable evening, George escorted Cissy out to her waiting car, when a man suddenly sprang out of the shadows. "What's this?" she asked as the stranger pressed an envelope into her hand. "A subpoena" was the answer. Over the preceding two years Cissy had staunchly refused to pay the Manookian brothers, either for the expensive Persian carpet the local rug merchants had delivered to 15 Dupont Circle nearly two years earlier on approval, or for services they had rendered in the cleaning and repair of others she already owned. "She simply dropped it into the gutter, and said, 'Shit,' and walked into the car," Abell remembered. "That was the last thing I heard her say."

Now sixty-six, Cissy worried about her health and the possibility of injury and consequently no longer rode. Nevertheless, out at the Dower House, she was able to visit her barn full of beloved horses, walk with friends through the woods, and relax while reading and marking the next day's copy on a pool float as her poodles paddled faithfully behind, all the while keeping in close touch with her editors and staff back on H Street. Although she had managed to rest and unwind to some degree since

leaving town, on Thursday afternoon, July 22, she complained during a phone call to Frank Waldrop that she felt "very, very tired." Nevertheless, she suggested that Waldrop and his wife, Eleanor, "just . . . pack and leave with her, August 1" on a trip out west to Flat Creek Ranch, which she had not visited in sixteen years, and afterward pay a visit to Mr. Hearst in California.

That evening, Cissy dined with her old friend and neighbor, Emily Hoover Stafford, whose pastels hung throughout the Dower House despite the quarrel the two women had had in 1945. The evening's invitation had been an attempt to reconcile, and had apparently gone successfully. Stafford stayed until two o'clock in the morning. Cissy sent her guest home with "an armful of books" and a small antique painting that she had plucked from her own wall. Despite the pleasures of the evening, afterward Stafford would remember being "shocked at the color of her face that night. It was a purple-red face, and it looked so strange against her dyed hair."

At ten o'clock the following morning Frank Waldrop called from the office. He found Cissy livid after reading former public works administrator and interior secretary Harold Ickes's series launching his new book, *My Twelve Years with FDR,* in the *Saturday Evening Post.* She ordered her associate editor to prepare at once the sort of blistering riposte that her readership had come to expect from the *Times-Herald* on the subject of New Dealers. Not long afterward, Cissy received another call, this one from Mrs. Julian Bach, Jr., the former Halle Schlesinger, who was visiting friends in Baltimore for the weekend and hoped to introduce Cissy to her new husband. Despite Cissy's successful legal efforts to prevent the two Schlesinger children from inheriting the mansion she had shared with their father in Port Washington, relations had remained cordial, if distant. Cissy invited the newlyweds to lunch on Saturday.

After completing his Ickes editorial, Frank Waldrop called Cissy back for her comments. "Don't read it to me over the 'phone," she protested. "I'm just too tired to listen." Instead, she asked him to send it, along with the "first edition of the next day's papers which were by regular order always delivered to her each night as soon as the presses started." Cissy was nocturnal by nature; it was her custom to read whatever her chauffeur, LeFort, brought her from the *Times-Herald* until the early hours of the morning.

That evening, Friday, July 23, Cissy dined with some of her other Prince George's County neighbors, Mr. and Mrs. Edwin S. Holloway. Those who believed they knew the mercurial, cosmopolitan publisher well were mys-

tified by her friendship with the couple. Ordinarily attracted to brilliance, beauty, and eccentricity—seemingly in any form—over the course of her life, Cissy had numbered among her friends press barons, aristocrats, statesmen, moguls, writers and artists, actors and actresses, cowboys, circus acrobats. A neighbor from Sarasota, Florida, where she had taken to wintering after her 1943 medical crisis in the vicinity of the Ringling Brothers headquarters, remembered her particular fondness for "a transvestite trapeze artist named Barbette, a man who ran a snake farm named Texas Jim, who took wax out of his ears with a pin, . . . and a circus troubleshooter named Tommy Farrar." Often, those whom she most admired possessed qualities in which she was (or believed herself to be) lacking. By many accounts, the people she had most revered were her brother and his rival (her friend and mentor), William Randolph Hearst. The lady editor had demonstrated a deep respect and admiration for J. Irving Belt, an imperturbable, self-taught classicist from a family of skilled cabinetmakers, who served her as mechanical superintendent, in charge of all matters related to printing. She had never forgotten the kindness of Isabel Bates Morris, the matron of the women's shelter where she had taken refuge disguised as Maude Martin while covering the plight of women during the Depression. Afterward Cissy had made frequent donations to the shelter and remembered Morris in a number of her wills.

Although Cissy typically surrounded herself with singular, unusually gifted, or colorful figures, her dinner guests on the evening of July 23 neither fit that mold nor shared their hostess's eclectic tastes. As Frank Waldrop remembered him, Mr. Holloway "never showed interest in politics, international affairs, bedroom gossip, Washington social intrigue or anything else, much, except his farm and his business." Nevertheless, Holloway made "superb mint juleps" and was "a gentleman." Mrs. Holloway was, in every way, "his counterpart." Whatever their outward differences, the Holloways were Cissy's "close friends and intimates" and enjoyed each other's company on "the simplest and homeliest terms of plain neighborly interest." The evening passed enjoyably; Cissy had been "in fine spirits," the Holloways remembered. Over dinner, according to her custom and her particular preoccupation of late, the hostess spoke of her dissatisfaction with her current will, her thoughts on making another, and the appointment she had arranged with Senator Wheeler two evenings hence to begin implementing the changes she envisioned. In particular, the Holloways contended afterward, she was rethinking the disposition of the *Times-Herald* to her executives.

Bidding the Holloways good night, Cissy retired at about 10:30 and settled down to read. At about one o'clock on Saturday morning, she

emerged to let Butch out for his walk. Handing the dog over to the new night watchman stationed outside her bedroom door, she left strict instructions that she was not to be disturbed. She was exhausted, she said.

The night of July 23–24, 1948, was a troubled one at the Dower House. Cissy's lady's maid, Eva Borowick, remembered being jolted awake some time in the early hours of the morning when the poodles "set up a terrific howl." At about nine o'clock the next day, Cissy's cook, Bea Brouchard, wryly asked Butch, "Who spilt your milk?" when he wandered into the kitchen with his tail between his legs, and would accept no treats or pats. With no sign of the lady of the house by ten o'clock, Brouchard tried to persuade the butler, Archie Lye, to knock on Mrs. Patterson's bedroom door. "Do you want to get me fired?" he demanded, understandably.

Still awaiting comments on his Ickes editorial, Frank Waldrop had expected to hear from his boss no later than ten thirty that morning. Before hanging up the previous afternoon, he had told Cissy that he would be working late at the *Times-Herald*. Aware of her custom of reading into the early hours of the morning, he had assured her that she could call anytime with her comments. But she had not called. He had considered phoning her himself around 11:00 p.m., but had thought better of it. "I felt that she might have gone to sleep and yet I was uneasy about her without any firm idea of why."

When Halle and Julian Bach called to confirm their luncheon, the butler gave what they would later discover was the "standard answer" regarding a lady who wished people to think "she was still a vigorous woman in her older years": Mrs. Patterson was out riding. Having heard nothing from Cissy by 11:15, Frank Waldrop called once again and spoke to Bessie Brown, the chambermaid. With something "queer" in both her tone and her choice of words, she informed him that, uncharacteristically, Madame hadn't rung for her tray yet. When the Bachs called back to say they would soon be leaving Baltimore for their luncheon at the Dower House, they were told by another maid that Mrs. Patterson was asleep.

At 12:15, Frank Waldrop finally received a call from the Dower House on his private extension at the *Times-Herald*. Confounding his expectations, however, he did not find his publisher on the other end of the line. Rather, it was her butler, Archie Lye, who stammered, "I think Mrs. Patterson is dead."

V

Seven Dwarves

MRS. E. M. PATTERSON, PUBLISHER, IS DEAD

Head of Washington Times-Herald, Member of Family Noted in Journalism
BEGAN AS EDITOR IN 1930
Director of Chicago Tribune Was Former Board Chairman of New York Daily News

— *NEW YORK TIMES*, JULY 25, 1948

Frank Waldrop was shocked. After collecting himself, he called Margaret Barney, one the few secretaries to survive long-term in the clerical hardship post that was 15 Dupont Circle, and asked her to contact Mrs. Patterson's physicians, Dr. Bernard Walsh and Dr. Carl Keyser. As he hurried out of the Times-Herald Building, Waldrop ran into Mike Flynn. After a breathless account of what had happened, he cautioned the supervising managing editor to remain "absolutely quiet" on the subject until he had seen Mrs. Patterson with his own eyes. Then Waldrop sped to Dupont Circle to pick up Margaret Barney, and the two raced up Massachusetts Avenue, past Union Station and the white dome of the Capitol, over the Anacostia River and out of the District of Columbia into the Maryland countryside.

When they arrived at the Dower House an hour later, they found Ann Bowie Smith and her husband Ed; Archie Lye, the butler; and Cissy's lady's maid, Eva Borowick, in the living room. With no sign of Mrs. Patterson after Frank Waldrop's call at 11:15 that morning, the household staff had grown worried. Braced for invective and imminent dismissal, Lye and Borowick had opened the door and tiptoed into their employer's bedroom to check on her. When the butler touched her hand, he found it cold and stiff. The two crept out of the room, they would later attest, without touching anything else.

Once Frank Waldrop and Margaret Barney arrived, the entire party ventured tentatively into the master bedroom. The windows were "all either heavily screened or barred." The room had two doors. Fearful as Cissy had become of late, the one leading to the lawn outside had a "heavy screen plus

a separately locked collapsible iron gate such as jewelers use to protect doors and show windows from break-ins." The outside door itself was of solid wood, with no glass panes, as was the one that gave access to the house through which the small party entered. "There was no evidence that any person had come in to the room by any entrance except the inside door," Waldrop would later conclude. Cissy's recent anxieties notwithstanding, no lock had been installed on this inside door. Instead, she preferred to have it watched over by the armed security guard who sat outside in the hallway while she slept.

As Julian Bach remembered it, on the drive to the Dower House for their luncheon, his new wife grew "almost paranoiac." Since her father's death in 1929 the former Halle Schlesinger had followed the events in her stepmother's life closely enough to fear that Cissy had become "a lonely old woman without any friends." After her telephone conversations with members of the Dower House staff that morning, Halle had been unable to shake a feeling of unease. Turning onto the long, serpentine Dower House drive in the full bloom of summer, she gave free rein to her suspicions, wondering aloud to her husband whether some harm might have befallen their hostess, whether Cissy might, for example, be "under the power and sway of someone like her butler."

Inside the Dower House, the small party had crossed the threshold to find Cissy's bedroom ablaze with incandescent light. She had been reading, apparently, at the moment of death. To their left stood Cissy's canopy bed, strewn with documents. On it—or rather, almost hanging out of it, in flowered pajamas—was Cissy herself. After handing Butch over to the night watchman for a walk at one o'clock that morning, she had climbed back into bed, tucked herself in as best she could, propped herself up on a mound of pillows and continued reading. The first Saturday edition of the *Times-Herald* lay on the floor to the right of the bed. Falling toward it when stricken, Cissy had been suspended in her sheets, arms dangling over the side of the bed, since the early hours of the morning. Hennaed in recent years to the point of near-purpleness, the glorious mane of red hair that she had always kept neatly tucked in a chignon cascaded over her head to the floor, obscuring her face almost entirely. Cissy's face itself lay at the very edge of the mattress, pressed into an open copy of *The Golden Violet,* a favorite mystery novel by Joseph Shearling. Heavily imprinted with saliva and lipstick, pages 216 and 217 had become so deeply crumpled under the weight of her head that after the body was removed the volume would no longer close flat.

Although Cissy appeared to have died "without preparation of any kind,

unknowing, and while reading," Frank Waldrop was struck by the fact that she had not been wearing her glasses at the time. Despite the staff's assurances that they had touched nothing after discovering she had no pulse, the editor was unable to shake the feeling that someone other than the deceased had placed her spectacles neatly on the bedside table.

No one noticed any unusual odor in the room. All those who witnessed the scene later agreed that, beyond the contortions Cissy had evidently suffered in dying, there appeared to have been no struggle, no disarray. On her night table to the right of the bed lay her .32 automatic pistol and her .38 revolver, both of which were loaded. The drinking glass next to the weapons was dry and free of residue. The water in the thermos by the bed was stoppered and appeared likewise to be in "normal condition," although it would not later be tested for contamination. On one of the chests of drawers was a small brown glass bottle of sleeping pills, which, all assembled would later insist (too vehemently, others would contend), was almost full. At the foot of the bed lay Cissy's unlocked briefcase, with "papers partly in and out." A copy of Waldrop's Ickes editorial lay on the coverlet; although unmarked, it appeared to have been read.

On another chest of drawers by the door leading to the lawn, there was a letter from the law firm of Jackson, Nash, Brophy, Barringer & Brooks, of which only a few lines were visible. Following up on Cissy's threats to Colonel McCormick to make Alicia Patterson Guggenheim her principal heir, Joseph Brooks had begun committing Cissy's intentions to paper. From what Frank Waldrop could make out, the letter "indicated that it had accompanied draft ideas of a new will Mrs. Patterson had requested." The draft itself, however, was nowhere to be found. Soon, in the flurry of postmortem accounting, inventorying, and packing-up, Brooks's cover letter referring to the proposed changes disappeared as well.

Still speculating about possible skulduggery afoot at the Dower House, the newlywed Bachs pulled into the circle at the end of the drive, stopped at the front door, got out, and rang the bell. A maid answered. "I will never forget the look on her face," Julian Bach remarked; visibly shaken, she seemed to look through the couple. When asked if the lady of the house was in, she responded only, "Mrs. Patterson isn't here any more." Incredulous, Halle Schlesinger Bach blurted, *"WHAT?!"* Still glassy-eyed, the maid replied only, "Mrs. Patterson is dead." Stunned, the Bachs found themselves ushered into the living room, where they encountered the even more bewildered party who had just emerged from examining the death scene. "I remember how silent the room was, everybody whispering almost inaudibly, if at all," Julian Bach remembered. "It was all terribly awkward and uncomfortable—and moving—at the same time. We all just sat there."

. . .

That afternoon, the tying up of loose ends began. Ed Smith called the Prince George's County Coroner's Office. Frank Waldrop called his colleague Mike Flynn at the *Times-Herald* to confirm that "the Lady" had indeed gone to her final reward. As the news spread, friends, associates, and employees converged upon the Dower House. Over the course of the afternoon, Doctors Walsh and Keyser arrived, along with the county's deputy medical examiner; members of the county police force; Eleanor Waldrop; the deceased's spiritual adviser, Father Walsh; and the Holloways, Cissy's guests at what had turned out to be her last meal the evening before. The *Times-Herald*'s equine columnist Rhoda Christmas was scandalized to find Cissy "exposed, with all these men in and out of the room," and took it upon herself to cover the body with a sheet.

Margaret Barney took on the task of trying to locate Felicia, without success. The last address Cissy had had for her daughter was the modest LaFayette Hotel in New York City. Felicia had moved on at some point, however, without leaving forwarding instructions. Cissy's address book yielded no further leads; she had not known her daughter's whereabouts, evidently, for some time. Late that afternoon, however, Felicia called the Dower House. Margaret Barney answered. In response to her condolences and offers to make any arrangements the countess should require before her arrival, Felicia wondered aloud, "Should I come down?" before resolving to do nothing without first consulting her attorney.

At the time of Cissy's death, Felicia had had little firsthand experience of lawyers or legal matters. Her mother and uncle had supplied the attorneys who had handled the routine contractual issues associated with the publication of her two novels in the 1930s. Likewise, Joe Patterson had dispatched George Townley, a New York *Daily News* lawyer, to extricate her from her rash, short-lived second marriage fourteen years before. Now Felicia turned to family once again for legal guidance. Offering their condolences, Alicia Patterson and her third husband, Harry Guggenheim, warned her that the other likely beneficiaries would "be after you like a pack of vultures." In light of the toadyism Felicia had witnessed at 15 Dupont Circle over the years, her interactions with Cissy's friends and staff members began with misgivings bordering on open hostility. After informing the astonished Margaret Barney that she would decide nothing without her lawyer, that Saturday afternoon Felicia contacted George Townley once again.

In the presence of local police officers, the doctors and medical examiner completed their inquiry, determining, without an autopsy, that the cause of death had been "acute congestive heart failure due to cardiovascular

renal disease." An undertaker from Gawler's Funeral Home arrived from the District to collect the body. Margaret Barney, Frank Waldrop, and Father Walsh looked through all of the drawers in the master bedroom to secure papers and valuables. Repeating precautions taken after Evalyn Walsh McLean's death fifteen months earlier, with Father Walsh as witness the lady's maid handed Miss Barney Cissy's famous black pearl necklace and earrings for transmission to the safe at 15 Dupont Circle. Margaret Barney then gathered together all of the papers strewn about the room and the bed in order to bring them back to Washington with her that evening.

Later that afternoon, Felicia duly called back to inform Frank Waldrop of her plans to travel to Washington the following day, Sunday, July 25. For reasons he could not make out, she demanded that the time of her arrival be kept "a complete secret." She would be accompanied at all times by her attorney; George Townley, she insisted, was to "stay with me, and I mean by that, with me." She instructed the editor to inform Sibilla Campbell, the housekeeper at 15 Dupont Circle, of the arrangement, reiterating, "I want Mr. Townley to stay exactly with me." During their brief discussion of funeral arrangements, Felicia remembered that "about ten years ago she told me she wanted to be cremated. Of that I am sure." Felicia then inquired about rites and pastors. Waldrop responded that the only man of the cloth with whom her mother had been in regular contact over the past few years was Father Edmund Walsh, the founder of the Georgetown School of Foreign Service. Repeating her warnings and instructions, Felicia hung up.

Other relatives were becoming aware of Cissy's passing as well. It turned out that Colonel McCormick had never read the final, incendiary communication that had arrived from his cousin three weeks earlier. Instead, anticipating its tone and import, he had handed it off to his counsel and promptly departed with his second wife to inspect *Tribune* holdings in Europe. The McCormicks returned to their suite at the Ritz Hotel in Paris late on the afternoon of Saturday, July 24, to find the telephones ringing in every room. The colonel himself answered. Dressing for dinner, Maryland McCormick overheard her husband say, " 'This is a surprise,' as though they were conferring a wonderful honor on him." Remembering that he was on the record, however, the colonel added hastily to the reporters on the other end of the line that it was all "a terrible blow." After hanging up, he turned to his wife with "a glint in his eye" and announced, "Cissy's dead." As he dressed, his wife heard him singing softly to himself, "I'm the last leaf on the tree . . ."

"We're not going to the funeral, you had no great feeling for her," Maryland McCormick reminded her husband, who needed little persuading. Cissy would prevail one last time in confounding Bertie, however. Deco-

rum demanded that the McCormicks cancel their luncheon at the American embassy the following day, Maryland reflected; someone might accuse them of "celebrating with champagne."

Leaving the Smiths, the Holloways, and Rhoda Christmas at the Dower House, Frank Waldrop, Margaret Barney, and Father Walsh returned to 15 Dupont Circle as evening approached. Miss Barney placed the black pearl necklace and other valuables in the safe in the presence of Father Walsh, and began searching through its drawers and compartments for directives her late employer might have left for this very occasion. Although Miss Barney located the instructions Cissy had drafted in the aftermath of the (de) Savitsch affair five years earlier, barring the doors of 15 Dupont Circle to Felicia, Drew, and Ellen in the event of any renewed incapacity, the safe contained neither Cissy's burial instructions nor her last will and testament. Frank Waldrop requested that the District police force station plainclothes officers at Patterson House with orders to "forbid removal of any papers or other property." He finished his long, bewildering day by dropping the maid at Gawler's Funeral Home with the clothes that Eleanor Medill Patterson was to wear to her funeral.

The next morning, Sunday, July 25, Frank Waldrop stopped by Dupont Circle on his way to the Times-Herald Building. He found the housekeeper, Sibilla Campbell, putting the house in order in anticipation of Felicia's arrival and the impending wake and funeral. Margaret Barney had arrived earlier to handle the rising flood of telegrams, flowers, and calls. Under the circumstances, Miss Barney had been joined by her close friend and former colleague, Betty Hynes. Miss Hynes would remain faithfully at Dupont Circle for more than a week, helping Miss Barney, receiving and acknowledging condolences, making arrangements and lists, and generally doing whatever was necessary. Assuring himself that the three women had matters under control at the house, Waldrop made his way back to Gawler's to select a temporary casket, and do whatever he could to "spare Felicia."

When he met with attorney Joe Brooks at the office later that day, the *Times-Herald*'s business manager, Bill Shelton, joined them. Brooks informed them that according to her last will and testament of June 21, 1946, Cissy had named Shelton, Waldrop, attorney Willis Nance, and former *Times-Herald* treasurer C. B. Porter as her executors. Inasmuch as Nance had died and Porter had been fired and stricken from her will by codicil in the interim, only Shelton and Waldrop remained to execute Cissy's last wishes. Then Brooks went on to reveal the will's terms and bequests. It was true: Cissy had made good on her dinner-party talk by taking the unprecedented step of leaving the Washington *Times-Herald,* the

principal asset in her estate (soon to be valued at some $17 million),* not to any of her relatives but rather to the newspaper's own executives. Still in the employ of the *Times-Herald* at the time of the publisher's death as stipulated, general manager William C. Shelton, associate editor (now acting editor in chief) Frank Waldrop, advertising director Edmund F. Jewell, supervising managing editor Michael Flynn, circulation director H. A. Robinson, mechanical superintendent J. Irving Belt, and night managing editor Mason S. Peters were to inherit the *Times-Herald,* "share and share alike," as soon as Eleanor Medill Patterson's will was accepted for probate in the District of Columbia. "When the terms of the will gradually leaked through the *Times-Herald* City Room," *Time*'s Washington reporter George Bookman recorded, "the excitement was as thick as printer's ink."

At three o'clock that afternoon, Frank Waldrop greeted an icy Felicia Gizycka and her counsel at Union Station. Making their way down Massachusetts Avenue in Cissy's limousine, Felicia asked whether her mother had left any funeral instructions. Waldrop explained that they had found none and that no plans had yet been made, but that Father Edmund Walsh had offered his advice on the matter. She agreed to see the Jesuit at five thirty, but requested that Waldrop "tell everybody at the house please to leave . . . she wanted nobody in the place except members of the family, for the rest of the day." In Father Walsh, the eminent diplomat and academic, Felicia saw only a "Jesuit spellbinder." Walsh informed her that Cissy had recently begun taking instruction from him in anticipation of converting, as her brother had done before his death. In that light, he told Felicia, her mother should be buried according to the rites of the Catholic church. Almost "taken in," as she put it, by Walsh's legendary persuasiveness, Felicia nearly agreed. Recalling her cousin Alicia's dire admonitions, she caught herself, however, and instead gave a final, resolute no; their family had always been Presbyterian. When Waldrop returned to the house at six o'clock as Felicia had requested, she informed him of her conviction that her mother had wished to be cremated. Given Catholic doctrinal discouragement of the procedure, Father Walsh could be of no further use "in any capacity whatsoever," as Waldrop remembered Felicia putting it. Likewise, she suggested "rather pointedly" that Frank Waldrop "leave the house right away," which he did, resentfully.

Although the terms of Eleanor Medill Patterson's will would not be announced publicly until four days later, rumors of the unprecedented dis-

*Roughly $145 million according to the Consumer Price Index, or some $430 million as measured by nominal GDP per capita sixty years later.

position of a leading metropolitan daily to its executives spread rapidly—especially within the newspaper industry, where it was received from coast to coast with mingled admiration and envy. Business manager Bill Shelton began almost immediately to consider converting his inheritance into cash, just as Cissy had suspected he would. Indeed, "hardly 48 hours" after her death, Shelton reported to Waldrop that he had already entertained an overture from Eugene Meyer's son-in-law, Phil Graham, now publisher of the *Washington Post,* "to take up with us as soon as we were ready . . . the matter of buying the *Times-Herald.*" "Deeply affected" by recent events, troubled by Felicia's hostility, and leery of the legal pitfalls that he and Shelton were likely to encounter as executors, Waldrop tried to remain as "noncommittal in reaction" to the suggestion as possible.

The *Post* was not the *Times-Herald*'s only suitor, however. As Cissy's fears for her safety had mounted, she had insisted to friends and hangers-on that if she were to die under peculiar circumstances, they should suspect foul play. Bertie McCormick's machinations to usurp the Washington *Times-Herald*—just as he had lately exerted hegemony over the New York *Daily News*—would be at the root of her death. As if on cue, on July 26, 1948, even before his cousin's funeral had taken place, McCormick contacted the *News*'s president, J. M. Flynn, from Paris. "I do not know anything about the physical plant of the *Times-Herald,*" the colonel admitted, unable to resist touting his own publication to the disparagement of his late cousin's, "but the paper can't be worth much without the *Tribune-News* Syndicate and news service. It may be that we can reach terms with the new owner which will help pay the estate tax and give us a very solid triangle of newspapers."

Whatever the *Times-Herald*'s eventual fate—whether the seven legatees chose to sell or continue its operation themselves—they would be powerless to act until they became the paper's legal owners. And they could only become the paper's legal owners upon the admission of Eleanor Medill Patterson's most recent signed will to probate, without the objection of the next of kin.

LAST RITES

— WASHINGTON *TIMES-HERALD,* JULY 28, 1948

How do you say Good-by?" Frank Waldrop wondered on behalf of his co-workers in the tribute to Eleanor Medill Patterson that ran on the day of her funeral, Tuesday, July 27, 1948. "None of us here at the *Times-Herald* knows quite how to do it."

We are in no position to describe our own feelings, and we are not the ones to give voice to the thoughts of any others. As we see it, Mrs. Patterson founded and built this newspaper to be as interesting and independent and useful to the community of Washington as all the people working here could make it. So far as we are concerned, she set a shining mark for devotion to duty, tireless and intelligent effort, and indomitable character as an editor, publisher and person. We shall miss her in countless ways that simply cannot be described or told. And so we say to her in the only way we know: Good-by. We'll see you one day.

—The Staff

The night before, 15 Dupont Circle had remained open until three o'clock in the morning to enable the rank and file of the capital's first viable twenty-four-hour-a-day newspaper to pay their respects to its late publisher. "Hundreds paused to bow or kneel beside her coffin which was draped with a blanket of yellow roses, her favorite flower, in the drawing room of her home," the *Chicago Tribune* recorded in its own send-off to Joseph Medill's only granddaughter. Friends, hangers-on, relatives, and associates, former and current, assembled from all over the country in the ballroom of "the Lady's" "flower-banked" mansion at eleven o'clock. The Patterson-McCormick Axis was fully represented. The Washington *Times-Herald*'s Waldrop and Shelton were accompanied by their fellow executives and numerous associates and colleagues. Joe Patterson's daughters, Elinor Patterson Baker, Alicia Patterson Guggenheim, and Josephine Patterson Albright, attended as well. Mrs. Marty Mann suspended her demanding travel and lecture schedule as executive director of the National Committee for Education on Alcoholism to support her friend Felicia. Ellen Pearson Arnold, now a young mother and a striking twenty-two-year-old blonde, had come from California to pay her respects to her grandmother, and to accompany her parents and stepmother to the funeral.

It was not true, as the loquacious Maryland McCormick later claimed, that Drew Pearson "threw himself on the casket—all very dramatic." Indeed, the McCormicks did not attend the funeral. By happy accident, engine trouble in the colonel's converted B-17 ("there are so many left over from the war they're glad to have you take one away") lent plausible deniability to the couple's claims that it was impossible to travel from Paris to Washington in time for the ceremony. Nevertheless, many who were present, including *Chicago Tribune* Washington bureau chief Walter Trohan, reported that a general "gasp" issued from the crowd when Drew Pearson appeared in Cissy Patterson's ballroom for the first time in nearly seven years.

. . . .

"You have a keen nose for news—inherited from a great many forebears and parents, dear . . . it's a swell thing to have, but try to have a little mercy on people," Felicia would implore Ellen a month later, in an effort to stifle her daughter's unrelenting "cross-questioning" about the intrigues the death had hatched. On the morning of the funeral service, Frank Waldrop and his wife, Eleanor, had only appeared at 15 Dupont Circle "after explicit invitation" from Margaret Barney; the editor was still chilled by Felicia's disdain. Entering the ballroom, the Waldrops were "greeted" with characteristic bluntness by Ellen. "Congratulations," she told Frank Waldrop. Caught off-guard, he replied, "What?"

"Congratulations. You got it."

"Got what?"

"I mean, about the will."

"Oh."

"That was the end of the discussion," as Waldrop remembered it, appalled. He and Eleanor found themselves seated behind the family—not, he would later record with some bitterness, as the result of any recognition of his fifteen years of faithful service, nor indeed out of any special regard he felt for the deceased or she for him, but simply "because you are a trustee."

Despite Felicia's dismissal of Father Walsh with allusions to her mother's Presbyterian origins, the Reverend Dudley E. Stark of Chicago's St. Chrysostom's Church conducted the "simple Episcopal service." "When the minister was saying these things about her 'wonderful, saintly character,'" one former *Times-Herald* reporter mused, "I thought she'd leap up out of her coffin." Aside from the splendor of the yellow roses, gladioli, and white lilies, the funeral was most notable, perhaps, for its lack of grief. Only the *Times-Herald*'s circulation manager, the old gangster Happy Robinson, wept. Otherwise, according to Felicia, the funeral was "without tears." "There was very little small talk afterward," Walter Trohan recalled. "Everyone scattered and went home, remembering the good times they'd had in that room." Back at the Times-Herald Building on H Street, executors Waldrop and Shelton confirmed the rumors that had been circulating for the past three days by officially informing the paper's five other legatees of their good fortune.

Mourners and gawkers departed from 15 Dupont Circle. Eleanor Medill Patterson's coffin was readied for removal from the magnificent turn-of-the-century mansion from which her mother had launched her social assault upon the nation's capital. The casket rolled out of the ballroom in which both Cissy's beloved cousin, Senator Medill McCormick, and her adored brother, Captain Joseph Medill Patterson, had reposed before her. Cissy was wheeled past the paneled library where she had made her wed-

ding vows with Count Josef Gizycki and carried down the sweeping staircase before crossing over the mansion's threshold and emerging on to Dupont Circle for the last time. Then her body was returned to Gawler's for cremation in preparation for the next morning's transport to her birthplace, where her ashes would be sealed in the vault that her grieving grandmother had taken such care to construct at Chicago's Graceland Cemetery in hopes of reuniting the fractious Medills for all posterity.

As events unfolded over the coming months, it dawned on Felicia that for a variety of interested parties it had been "very convenient" for her mother to die when she did. She would soon regret her insistence on cremating the body; with an urn full of ashes, as she put it plainly, "there was no proving foul play." Although Frank Waldrop would find himself increasingly at odds with Felicia over the coming months, he concurred wholeheartedly, at least, with her conclusions on the cremation of her mother's body: "Well, you don't do many autopsies after that! And later, when this murder theory set up—it was a little late in the game."

On the morning after the funeral, Wednesday, July 28, 1948, a small crowd assembled at the chapel at Graceland Cemetery. An oddly assorted coterie of Felicia Gizycka, Ellen Pearson Arnold, Alicia Patterson Guggenheim, Marty Mann, and the now-decrepit field marshal of the Chicago circulation wars, Max Annenberg, had arrived from Washington. Supervising managing editor Mike Flynn represented the *Times-Herald,* while Frank Waldrop and Bill Shelton remained in Washington, grappling with legal matters related to the execution of the estate. Night managing editor Mason Peters, the youngest of the *Times-Herald*'s putative legatees (who were rapidly becoming known in newspapers coast to coast as the "Seven Dwarves"), manned the helm of the paper itself. Out of respect for the late owner, he temporarily suspended publication of the infamous, titillating and lucrative page three "sex stories," but otherwise adhered to Cissy's proven formulas. Back in Chicagoland, true to form, the "World's Greatest Newspaper" called attention both to itself and to its publisher's contributions to the rites (despite the latter's conspicuous absence from them): "The cemetery chapel, where brief services were held, was banked with flowers, including a large circular wreath of white lilies from Mrs. Patterson's cousin, Col. Robert R. McCormick, editor and publisher of THE CHICAGO TRIBUNE, and Mrs. McCormick."

Touching down at National Airport after a long day, Felicia was met, to her surprise, by Joe Brooks, whom she neither liked nor trusted. Her cousin's former husband and one of the several lawyers whom Cissy had lately

engaged to redraft her will had been sent by the seven *Times-Herald* executives, he told her as they followed the banks of Potomac on the drive back to Dupont Circle. As the executors named in her mother's most recent signed will of 1946, Frank Waldrop and Bill Shelton hoped to submit the document for probate the following morning. Through Brooks they encouraged Felicia, as next of kin, to assent to this formality by signing off on her mother's will, thereby waiving the court's appointment of a collector—that is, an administrator who would otherwise assume the executors' duties pending the admission of the will to probate. Without her agreement neither Waldrop nor Shelton could legally undertake his executorial duties and the estate itself (including the *Times-Herald*) would be placed under the collectorship and administration of a neutral outside party—likely a bank, given the size and complexity of Cissy Patterson's estate.

"Sign the will tonight," Brooks pressed as Felicia remembered it. "All the money is held up. The paper can't pay its employees." Then he added (gratuitously, Felicia thought), "We'll take good care of you and Ellen." "Why should you?" she demanded. "I have money and property coming to me." Arriving at 15 Dupont Circle, the two resumed their conversation in the library. Felicia thought Brooks acted oddly or perhaps nervously; he kept looking behind his chair, as though he felt somehow threatened. Fearing that her attorney, George Townley, had joined the ranks of those pressuring her to sign off on her mother's will and waive the appointment of a collector, she informed Brooks that she needed to seek further legal advice. Brooks left disappointed and the *Times-Herald*'s executives were left to scramble in order to meet the paper's daily operating costs.

Scenting avarice among her mother's associates, Felicia failed to recognize the fiduciary quagmire into which she was throwing Waldrop and Shelton. Like Joe Patterson's executors before them, the two were burdened with the conundrum of attempting to keep Cissy's trust holdings intact, while finding some means of raising sufficient funds to pay her staggering estate taxes—that is, if either man ever assumed his executorial duties. More immediately, as *Times-Herald* executives they faced the looming crisis of maintaining cash flow in the legal limbo into which Cissy's death had pitched the newspaper—a predicament only aggravated by Felicia's hesitation over waiving the appointment of a collector.

Felicia took her dinner that night at a card table in the corner of the room where she had spent so many evenings alone as a girl—Cissy having departed for her own dinners, parties, and receptions about the capital. Throughout Felicia's meal the telephone in the library rang incessantly with pleas from *Times-Herald* employees to sign off on the will, "now, now, now!" as she recalled it. The paper would otherwise be unable to meet pay-

roll, they implored. Some calls were harassing; one consisted only of inarticulate screeching noises. "Thank God I was sober and a member of the outfit," she remarked later. To each call, Felicia responded only that she would do nothing without further legal advice. From the evening's experiences, she took away an inchoate sense of the "other side's" desperation, but remained mystified as to what fueled it and impervious to its demands.

Hoping to clear her head and evade subsequent callers, Felicia left for the Dower House rather than remain at Dupont Circle for the night. Exhausted, she went straight to the bedroom she had always used, unlike her mother whose restlessness had prompted her to sleep all over the house. Sometime in the middle of the night, Felicia woke with a start, believing she heard Cissy bellowing at her from somewhere in the darkness: "Leave my things alone and get out of here!" Steeling herself, Felicia replied aloud, "I'm sorry, Mother, but you're gone now, and I'm doing the best I can. This is my card game now." Having spoken her piece, she fell back to sleep immediately. Afterward Felicia remembered feeling only relief: "I had no fear at all, somehow."

Lucky Seven

—*TIME*, AUGUST 9, 1948

Felicia's hesitation to sign off on the appointment of a collector notwithstanding, the following day, Thursday, July 29, 1948, Frank Waldrop and Louis Caldwell of the *Tribune*'s Chicago law firm, Kirkland, Fleming, Green, Martin & Ellis, convened a press conference at the National Press Club auditorium in Washington. There they announced publicly the terms of the last will and testament that had been the source of so much rumor and speculation about town and in media outlets nationwide in the five days since Eleanor Medill Patterson's death.

The first several bequests assigned the personal property and real estate of the deceased. To her friend and barn manager, *Times-Herald* equestrian columnist Rhoda Christmas, Cissy left all of her dogs and horses—on two conditions: first, that Christmas make "proper provision for their care and treatment" and second, that if it became necessary to "dispose" of any of the animals she should ensure they be "put to death painlessly" rather than sold. Although comfortable, Christmas was not rich; Cissy had not (as many observed) provided her legatee with a means of providing for a pack of poodles and a barn full of horses (many of which were aged and had pro-

nounced, and expensive, special needs). To her Prince George's County neighbor and dear friend, Ann Bowie Smith, the publisher left her Maryland estate, the Dower House. As the mother of seven young children, Smith had been chronically short of cash during Cissy's last years. As a result, the will also directed her trustees to establish a trust fund for Smith that would furnish her with some $5,000* in cash annually for five years. The American Red Cross would inherit Patterson House at 15 Dupont Circle. To her friend Evie Robert, Cissy left substantial and lucrative commercial properties along Connecticut Avenue. Additionally, the "glamour girl of the New Deal" was to receive not only the famous Youssoupoff black pearl necklace and matching earrings at last, but Cissy's sable scarf as well.

Cissy rewarded several of the members of her forbearing domestic staff with cash bequests—if they continued to be in her employ at the time of her death. Margaret Barney was to receive $10,000.† Jerry LeFort—the son of Cissy's chauffeur and Aasta, the same lady's maid whose (temporary) firing had contributed to Felicia's flight from Flat Creek Ranch in 1924— would inherit $5,000. Many were surprised to find Rose Crabtree, Cissy's old friend from Jackson Hole, listed among "the Lady's" employees; she was to receive (what the same parties observed to be) the unexpectedly niggardly sum of $3,000.‡ Sibilla Campbell, the formidable German housekeeper of 15 Dupont Circle, would receive $1,000.§ Cissy had often spoken of her intention to bequeath to Betty Hynes a sum sufficient to pay off the mortgage on her modest Georgetown townhouse. But the former personal assistant who later served as both drama and society editor of the *Times-Herald* was absent from the list of those receiving cash bequests when the testament was read.

Although rumors of the most stunning bequest, Cissy's gift of the *Times-Herald* to its management, had been rife for days, Caldwell put an end to the speculation about which of the paper's executives were now its presumptive owners. Bill Shelton, Frank Waldrop, Ed Jewell, Mike Flynn, Happy Robinson, Irving Belt, and Mason Peters, the attorney announced to the assembled reporters, would, upon the will's admission to probate, become the owners of Washington's most profitable and widely read daily newspaper, "share and share alike." Anticipating inevitable delays in the legal transfer of ownership even under the best of circumstances, the late publisher had entrusted special powers to her executors in order to permit

*Nearly $45,000 according to the Consumer Price Index, or more than $120,000 as measured by nominal GDP per capita sixty years later.
†More than $89,000 or some $258,000 by the same measures.
‡Nearly $27,000 or more than $77,000 by the same measures.
§Almost $9,000 or nearly $27,000 by the same measures.

the continued "business and publication" of the Washington *Times-Herald* in the event of her death. The will empowered Waldrop and Shelton to "do any and all acts incidental to the carrying out of such business," including borrowing on the *Times-Herald*'s behalf and using any of the paper's property as collateral.

And what of Cissy Patterson's relatives? Her threats to Colonel McCormick had gone unfulfilled; nowhere in the will was Alicia Patterson Guggenheim mentioned. Despite the abundant evidence that Cissy had been reconsidering her estate plan in the last weeks of her life, no document had emerged to supersede the will she had made after her brother's death in 1946. To Alicia's sister, Josephine Patterson Albright, however, Cissy left all of her property in Teton County, Wyoming, including her beloved Flat Creek Ranch. Despite Cissy's many differences with her daughter over the years, Felicia made out handsomely as well. She was slated to inherit the mansion her mother had shared with Elmer Schlesinger in Port Washington, Long Island. Felicia would receive all personal property and any household furnishings not otherwise assigned. She was heir, also, to the substantial landholdings in Renville and Ward Counties, North Dakota, which until then she had had no idea her mother owned. Further, out of her McCormick-Patterson Trust holdings, Cissy directed her trustees to establish a trust fund for Felicia to provide her with an annual income of $25,000, tax-free, for the rest of her life.

In the event that the trust should generate sums exceeding Felicia's annuity, the surplus was to fund a number of bequests that would prove to be devilishly problematic to validate and carry out. "For a long time I have made a practice of paying certain friends of mine sums of money, either weekly or monthly, as will be indicated by my books," the decedent revealed in her will. She directed her trustees to continue paying "annuities in weekly or monthly installments" to those otherwise unnamed persons who had been receiving her assistance for at least "a period of thirty (30) days" prior to her death. In the event that the trust fund generated any income over and above the amounts designated for Felicia and these "certain friends," the remainder was designated for distribution to charities serving needy and orphaned children.

In spite of the pain that mother and daughter had inflicted on each other over the course of their lives, the testator had nevertheless maintained sufficient feeling and concern for her only child to provide for her posthumously. Eleanor Medill Patterson's other descendant, who was not yet twenty at the time the document was signed, had not fared so well. The 1946 will fulfilled the veiled threat Cissy had issued upon the unsatisfactory conclusion of her legal skirmishes with Drew Pearson over the farm in

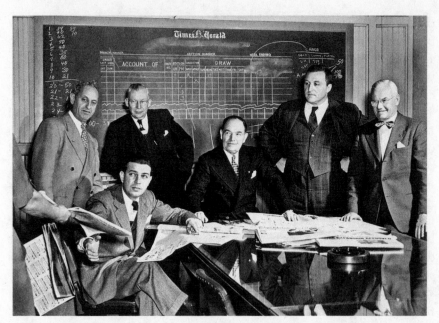

Six of the seven dwarves. Standing, left to right: business manager Bill Shelton, mechanical superintendent J. Irving Belt, associate editor Frank Waldrop, advertising director Edmund F. Jewel. Seated: night managing editor Mason Peters, circulation director Happy Robinson.

The seventh dwarf: the Washington *Times-Herald*'s supervising managing editor, Mike Flynn

Potomac that had been her granddaughter's tenth birthday present. "I am making no provision in this Will for my granddaughter, ELLEN PEARSON ARNOLD," Article 12 stated with cold finality, "inasmuch as I have made a substantial gift to her during my lifetime."

Once Caldwell had finished reading the will, Frank Waldrop read a prepared statement and invited his assembled colleagues in the press to "fire away" with questions. "Mrs. Patterson left a paper that is in excellent shape," he announced ebulliently. "It's full of life and vigor, and we intend to keep it just that way." Hazarding his own commentary on legal matters (well aware that Felicia Gizycka would soon be reading his comments), he added, "For the moment, the executors are the publishers, and we will carry out the will's bequests as rapidly as is practicable." At the close of the press conference, Waldrop and five of his fellow legatees (mechanical superintendent Irving Belt, it was reported, had taken to his bed with heart palpitations upon learning the good news) invited their colleagues to join them in the bar. "For once the drinks are on the *Times-Herald*," Waldrop chortled.

Press coverage continued with the paper's proud new presumptive owners giving impromptu interviews over drinks. Recent behind-the-scenes inquiries regarding the *Times-Herald*'s possible sale notwithstanding, Bill Shelton suggested to reporters that the seven executives intended to run the paper collectively, crowing, "This might show the Russians that capitalists in this country treat workers right fine." When asked how his new status as a millionaire would affect his life, Mason Peters, a handsome young bachelor, replied simply, "Oh, I'm not interested in the money. It's my pencil—my career in the newspaper—that interests me." True to his word, he left the celebration shortly afterward, to put out the evening's last edition.

Anticipating continued difficulties in persuading Felicia Gizycka to accept the will, Frank Waldrop took a calculated step toward testing the document in the court of public opinion. Printing the terms of the will in the *Times-Herald* the following morning made the document—along with its bequests, stipulations, appointments, and exclusions—appear to be more of a fait accompli than it was in fact. Replete with jewels; colorful, glamorous, and even titled characters; big money; mansions and sudden death, Cissy Patterson's last will and testament made for exactly the sort of story in which she herself had delighted and for which her readership clamored. "I put the headlines in two lines of 96 [point type]," Peters told a colleague at *Time* afterward. "I smashed the hell out of it. I played it the way The Lady would have wanted it."

The Disinherited

—*TIME*, SEPTEMBER 27, 1948

Amidst the bonhomie and hoopla that followed the press conference on Eleanor Medill Patterson's legacy, apart from the disappointed Betty Hynes, there was, as a *Time* interoffice memorandum made note, one more "poor unfortunate to consider." "You will have seen that Cissy died," the *Times-Herald*'s former treasurer, Charles Bell Porter, wrote a friend shortly after the bequests were published. "I was left not a cent," he lamented, adding, "I was lucky I was left with my life."

Cissy had evidently become dissatisfied with her testamentary plan almost immediately after remaking it in June 1946. In a first codicil signed only five months later, she changed some of her executors. In a second, dated May 29, 1947, she pointedly excised one of her beneficiaries. "Being of sound disposing mind, memory and understanding," Cissy asserted in this later amendment, "I hereby revoke the appointment of C. B. Porter, Washington, D.C., as . . . executor and trustee" along with "all devises and bequests made to him." Not only did the 1947 codicil deny Porter a $5,000 cash bequest, but it struck his name from the original list of eight executives to whom Cissy had bequeathed the *Times-Herald* itself. And then there were seven.

As his passport and immigration papers revealed, Charles Bell Porter had docked in New York Harbor to begin life anew at a supremely inauspicious moment: October 29, 1929, Black Tuesday, as panic swept the financial markets, share prices on the New York Stock Exchange plummeted, and the nation hurtled over the precipice into financial cataclysm. It was a testament to his competence that despite the crash, Porter was able to find work at the New York accounting firm of Arthur, Young & Co. shortly after his arrival. A native of Edinburgh, he had served with a Scottish regiment in Greece during the Great War and had earned both a law degree and a doctorate in criminal psychology at the University of Edinburgh. He met Cissy in 1931, when she engaged Arthur, Young to reconstruct her financial records for her suit to wrest part ownership of the Port Washington estate from the late Elmer Schlesinger's children. After hiring Porter away to be her personal accountant, Cissy made him treasurer of her newspaper interests in 1937.

One colleague remembered that Porter, a cherubic five feet, two inches and 140 pounds, was "like some wound-up German toy." His co-workers agreed that he was "very competent," "a nice old guy," a "good man." In general—or at least at first—Frank Waldrop believed, Cissy "really liked

Porter, and trusted him. He was meticulous and careful, worried about [her] dogs." The treasurer shared his boss's fondness for animals. In addition to his accounting duties, he helped her establish the animal rescue leagues so dear to her in her last years. "He was a fussy little man," Waldrop added. "Mrs. Patterson said she liked having him around because she could swish around in her bathrobe, and didn't think it made any difference to him." Bald and rubicund, Porter "didn't look like he even shaved," one colleague recalled. Other co-workers remembered, or guessed, that according to the parlance of the day the treasurer had "a lot of female genes."

Porter's efficiency and amiability were not sufficient to immunize him against his boss's fearful temper, however. For the most part he escaped Cissy's wrath for nearly a decade, then he, too, found himself caught in the cycle of firing and rehiring so familiar to many of his colleagues. Shortly after redrafting her will in June 1946, Cissy fired Porter, "complaining bitterly" that despite the accountant's anxious efforts with several local fumigators and an arsenal of noxious powders and gases, the Louis XV furniture in the ballroom at 15 Dupont Circle continued to be infested with buffalo moths.

When Cissy's anger cooled several weeks later, Porter was rehired, only to be fired once again in the spring of 1947. The reasons for his second dismissal go unrecorded, but, whatever his offense or omission, Cissy considered it sufficiently egregious to expunge him from her will. A sensitive soul, the accountant was deeply shaken by the event. He disappeared. "In 1947 when Mrs. Patterson put him out," Sibilla Campbell, Porter's friend and Cissy's housekeeper, would later explain under oath, "he went away then I guess for six weeks or two months and nobody knew where he was until . . . he sent me a telegram from Miami and asked me to send him some money." Porter returned to Washington and reentered the *Times-Herald*'s rolls. In the meantime, he began to create for himself "a measure of safety" should he run afoul of Cissy Patterson once again.

Porter signed up for a correspondence course in writing. He began squirreling away legal files, correspondence, and financial records from both the publisher's office in the Times-Herald Building and 15 Dupont Circle. He recorded his observations at work and compiled articles on his notorious employer and her circle, all of which he filed carefully in cabinets and in an old army trunk in his efficiency apartment at the Kennedy-Warren, the monumental Aztec–Art Deco luxury apartment building overlooking the National Zoo, a twenty-minute walk up Connecticut Avenue from DuPont Circle. Then he set to work on his manuscript, *The Most Unforgettable Character I Have Ever Met.*

Inevitably, Porter found himself at odds with his employer once again. Colleagues and friends would remember that the accountant appeared to

be under intense strain, even before the final break came in May 1948. "I think he just wore out on the job," Frank Waldrop ventured, "just to where it was drivin' him up the wall . . . He'd have hysterical fits and cryin' spells—just like the secretaries . . ." Although many of Porter's *Times-Herald* colleagues recalled the dressing-down he received from Cissy in her office for its particular ferocity, none admitted to overhearing the details. Even Porter's close friends, many of whom would find themselves besieged by the press in the coming months or testifying under oath, never knew (or at least never revealed) the reason for his third and final termination. The consensus, however, was that Cissy had discovered—and had been deeply affronted by—matters relating to her treasurer's personal life.

Had Cissy discovered that Porter was secreting documents that belonged to her? Both the accountant's friends and his own correspondence would reveal that, in the course of her last blistering dismissal, she had accused him of breaking into her apartment at the Carlton House in Manhattan and making off with some of her personal effects. Had the mounting pressure to which the publisher subjected him in his last months at the *Times-Herald* induced him to threaten her with revelations from his manuscript? Harold Kertz, one of the members of the legal team Felicia hired to replace George Townley, was of two minds. Porter "wasn't the type"; he lacked "the guts to produce anything," Kertz contended, albeit with a qualification: "But, indirectly, blackmail, in the sense that, 'You better not do this to me; kick me out, or anything like that—'cause I have things on *you*, which I can produce.' " Whether or not Porter had threatened to expose Cissy with his research, the seed for his "measure of safety" appears to have been planted by personal experience. From evidence Drew Pearson developed, it would soon emerge that Porter himself was being blackmailed.

In the late 1940s, the District of Columbia's reading public found the *Times-Herald* to be in uncharacteristic editorial agreement with the *Post* on at least one matter of local import. When Congress ended the failed three-year experiment that was home rule in 1874, the capital was left without its previous anti-sodomy laws on its books; the new congressional code's silence on the matter effectively legalized sodomy in the District of Columbia. By 1947, the *Post* lamented that the city had become "more or less a haven for sexual perverts and degenerates." Riding a wave of virulent postwar homophobia, the *Times-Herald* treated the subject of homosexuality in a series titled "SICK, SICK, SICK," and joined its old rival the *Post* in prodding Congress to "correct the sodomy problem" by enacting a statute "to provide for the treatment of sexual psychopaths in the District of

Columbia." The measure took effect on June 9, 1948, shortly after Porter's third and final firing.

In the aftermath of his ordeal Porter consulted a doctor for nervous prostration before scurrying into hiding as he had done before. Dr. Carl Keyser considered his patient's resolution never to return to the employ of Eleanor Medill Patterson or the *Times-Herald* "wise indeed, for the next time you would be destroyed." Porter's correspondence from the period reflects a state of mind that was confused and fearful. Whatever had prompted the publisher to fire him for good—his research, his sexual orientation, or other, unrecorded reasons—he left the *Times-Herald* in terror. "E.P. was out to destroy me," the accountant divulged to a friend. "Her death stopped it." To another, he wrote of returning home to Scotland for a much-needed rest; there had been "a lot of slander and defamation at her hands . . . and I want to get away for a while amongst folks who feel differently about me and where I am not talked about." Although unemployed, Porter counted himself "relieved": "E.P. would have hounded me throughout my life as long as I remain here. She was forever asking why I did not get out of the country." It is unclear whether the emotional strain under which he labored left him with delusions of persecution, or whether his unnamed fears were in fact justified. In any event, Porter felt a clear need to document his worries, just in case. "Please keep this letter," he implored another correspondent. "I might want to end it some day in the future."

Mrs. Patterson Wills Property to Daughter, Friends, Charities; 7 Employees Given Times-Herald

— WASHINGTON *TIMES-HERALD*, JULY 30, 1948

After rising from her preternaturally noisy night at the Dower House, Felicia Gizycka began seeking further legal advice on her late mother's will from members of her extended family, finally hiring Lloyd Garrison, a partner at the firm of Paul, Weiss, Rifkind, Wharton & Garrison, vice chairman of the American Civil Liberties Union, and a great-grandson of the abolitionist William Lloyd Garrison. The younger Garrison, "that kind and good man," immediately flew from New York to meet Felicia in Washington. On Monday morning, August 2, 1948, the *Washington Post* (having its own reasons for following the *Times-Herald*'s fortunes, separate and apart from reporting on a matter of local interest)

noted on its front page that "action on admission of the will for probate was held up in District Court . . . at least temporarily, when Countess Gizycka failed to waive appointment of collector." Judge Edward M. Curran had thus been forced to nominate the Riggs National Bank as collector for the Patterson estate, which an initial estimate valued at $16,586,571.*

Felicia, Lloyd Garrison, and the latter's Washington-based partner, Randolph Paul, spent much of that day on the telephone with Shelton and Waldrop, "bargaining," threatening implicitly to challenge the validity of her mother's 1946 will as a whole if the executives did not accede to her demands. Rather than adhere strictly to the terms of her mother's purported last wishes, Felicia proposed a cash settlement of $400,000.[†] Of this she intended to keep $300,000[‡] for herself and donate the remainder[§] to St. Philip's Church in Harlem, where she had helped launch some of the first integrated Alcoholics Anonymous meetings in the country. The long debate ended fruitlessly. As Felicia and her attorneys sat in the conference room, uncertain about how to proceed, Drew Pearson called to volunteer the money to mount a legal challenge to her mother's will. As Felicia put it, "The fight was on."

At the time of Cissy's death, Felicia continued to live on her grandmother's small trust fund, supplemented by whatever she was able to earn from writing. She had loaned Drew money when he needed it as a fledgling political columnist; now that their fortunes were reversed, he reciprocated. Felicia could expect to inherit nothing from her mother's estate until a will was probated; delay (including any legal challenge she herself might mount) would only prolong her penury. It was Drew, hoping, like a number of other parties, to "get hold" of the *Times-Herald* with a consortium of interested investors, who encouraged her to follow her hunch that the will was illegitimate. Long-smoldering mistrust, recently fanned by legal antagonism, fueled Felicia's conviction that her mother—sick, drunk, and drug-addled in recent years—had fallen "among thieves." Besides money, with his myriad sources in the capital and his own staff of seasoned investigators, Drew would furnish much of the evidence to underpin her case that Eleanor Medill Patterson had been of unsound mind and that unnamed parties had made the publisher the victim of undue influence, coercion, and fraud in drafting her 1946 will.

*Approximately $150 million six decades later according to the Consumer Price Index, or some $425 million according to nominal GDP per capita sixty years later.
[†]Nearly $3.6 million or more than $10.2 million according to the same measures.
[‡]Nearly $2.7 million or almost $7.7 million.
[§]Nearly $900,000 or almost $2.6 million.

Although formal litigation was not yet under way, from this point onward two distinct camps emerged among the parties interested in the Patterson estate. On one side stood all those presumptive legatees who backed the 1946 will and its codicils for probate; on the other stood Felicia Gizycka, assisted by Drew Pearson and her able legal team, but essentially alone. Each side would share only a mutual suspicion and an abiding conviction that Cissy's fondest last wishes mirrored their own interests.

Of all those involved, it was Frank Waldrop who found himself in the most difficult position. While Bill Shelton faced what Waldrop would later call a "three-way problem of obligations" as an officer of the *Times-Herald* as well as both an executor and a beneficiary of Cissy's will, Waldrop himself faced a "four-way problem." In addition to the same three roles that Shelton played in the unfolding drama, Waldrop was a trustee of Cissy's McCormick-Patterson trust holdings. Offering support, Dick Clarke, Waldrop's opposite number at the New York *Daily News,* wrote on August 20, that in assigning these tangled obligations, Cissy had imposed responsibilities on him that would make his "job prior to her death seem simple in comparison." Waldrop felt the pressure keenly. In the wake of his protracted telephone conferences with Felicia and her lawyers, he confessed to Joe Brooks on August 6,

> I am, for all practical purposes, not at the paper. Bill [Shelton] is holding the ship on course while I work with the collector, the lawyers for the estate, *ad nauseam,* at all their various melancholy and distasteful duties. I fear that I will be, when it is all done, unfit for any useful newspaper work for months. I will need to go away and not think, not work, not do anything at all until I have found my equanimity again, if I ever do, which I doubt.

Waldrop had long resented the pain he had watched Felicia cause her mother. Like most of Felicia's Washington acquaintances, he had little awareness or understanding of the changes she had undergone since joining the nascent Alcoholics Anonymous movement in 1943. Rather, to them she remained a feckless, spoiled drunk who had disappointed and deeply wounded her mother, while refusing petulantly to apologize or reconcile. Now, amidst Waldrop's myriad new, conflicting duties and the genuine sadness he felt at Cissy's passing, he labored under the additional affront that Felicia's behavior caused him. In Felicia's nebulous suspicion that there was "something fishy" about her mother's will, she viewed its supporters and their "villainy" as monolithic, making no distinction among their characters, actions, or motivations as individuals. "The thing that makes me writhe and burn . . . is that we were not given credit for good

faith, . . . that we were approached in the spirit of fraudulent nuisance," Waldrop railed to Brooks. In proposing an alternative settlement (even if partly in the interest of charity), Felicia had in effect made a "clear suggestion to violate the terms and spirit of the will and a suggestion that we abdicate our assignment from Mrs. Patterson without so much as a try at it."

Unsuccessful at persuading Waldrop and Shelton to agree to Felicia's demands over the phone, Garrison and Paul's subsequent tactic was to question the validity of the instrument as a whole. Cissy Patterson had not been in her right mind in June 1946, they argued. Further, she had been coerced into devising its specific terms and bequests. Whereas Felicia had caught her last fleeting glimpse of her mother—under Evie Robert's spell—after a long, acrimonious absence, Frank Waldrop had spent almost every day of the past fifteen years with "the Lady." "I KNOW in every way a person can know, that Mrs. Patterson was of sound mind and that she was free of anybody's influence, if any was attempted," he insisted to Brooks, "right up to the hour of her death."

On Thursday, August 5, Felicia left town with her ex-husband's help, seeking to avoid the presumptive executors' and legatees' process servers and hurried to New York to consult with Alicia in the wake of the futile telephone conference on Tuesday afternoon. "Drew got a young newspaper man to sneak me out of the District," as Felicia remembered it, "so the boys couldn't subpoena me and drag me into court." Ducking her head and hiding until she crossed over the District of Columbia line into Maryland, she arrived safely in Baltimore that night and registered at the Lord Baltimore Hotel around 9:00 p.m.

While Felicia left the District clandestinely, an anxious Charles Bell Porter packed a suitcase for the journey back to Edinburgh that he hoped would soothe his frayed nerves. Porter also took some of his research materials from the files "scattered through the apartment" in drawers, cartons, closets, and cabinets. These, along with his manuscript, *The Most Unforgettable Character I Have Ever Met,* he packed carefully into his World War I army footlocker. Then he took the trunk by taxi to Smith's Transfer Storage Company at 14th and L Streets, Northwest. Having locked his papers safely away, he paid the first month's fee of $1.50, collected the receipt, wrote, "Please deliver to Mrs. Sibilla Campbell on request" on it, and signed it. Afterward he returned to his efficiency apartment, 1110A at the Kennedy-Warren, fastidiously tidy like its inhabitant, to say good-bye to the old friend who had for so long (and especially of late) helped him through his difficulties.

Born in Aachen, Germany, Sibilla Campbell, Cissy's "blunt but brainy" housekeeper (as she would shortly be styled in the tabloid press), had immigrated to the United States in 1906. In the summer of 1932, Betty Hynes, then moving from her post as Cissy's secretary at Dupont Circle to become a cub reporter on the *Times-Herald,* hired Campbell while Cissy was at the Democratic National Convention in Chicago. Exacting, discreet, and thick-skinned, Campbell got along unusually well with her capricious employer. Almost alone among the legions who served on Cissy's household staff over the years, Campbell was never fired. Rather, when she left to pursue a less demanding and more lucrative career in real estate, Cissy urged her to come back to "help out"—whenever it was convenient. Succumbing to Cissy's lamentations that "the house was falling to pieces" in early June 1948, Campbell had rented out her real estate office and returned to 15 Dupont Circle on a temporary basis.

Even after more than four decades in the United States, Campbell had never lost her accent; all who met her noted her distinctly Germanic manner. Predictably, the two factions now beginning to face off in the Patterson will fight characterized the housekeeper in opposing terms. To Frank Waldrop, for example, Campbell was "a nice woman, honest, meticulous, and nobody's fool . . . she was a native of Deutschland, and an ornament to that unhappy country." "As you see, I liked her," he admitted freely:

> she knew her job, did it, never whined, never lost her nerve, took a hell of a beating in the community [during World War II] as Hitler's mother, was always a lady about it, and wouldn't lie to, for, or about, nobody, no time, no-how. That alone made her unusual.

Felicia, by contrast, found Campbell daunting and unsympathetic. In the *New York Star*'s increasingly breathless and flamboyant accounts of the unfolding "first-class melodrama, jam-packed with all the elements of a whodunit" over the coming months, Sibilla Campbell was cast as a "Washington housekeeper brainy enough to become a military staff operations officer."

Receiving Sibilla Campbell in the tiny but well-appointed efficiency that he had filled with the Chinese porcelains, opera records, and rare stamps he collected, Porter told her for the first time about the book he was writing on Cissy Patterson. Campbell was dismayed: "I told him, I says, 'C.B., don't do that, because you're so full of hate." Speculating later on her friend's reasons for his literary endeavor, Campbell ventured, "I guess it was because she cut him out of the will, or whatever it was," but reiterated that she had made every effort to dissuade him from pursuing his project: "I say, 'Don't do that; let it rest until later. You can always do it when you come

back, later on.'" Possibly seeing her point, or, more likely, trying to cut short their leave-taking in anticipation of the arrival of other friends, Porter agreed, telling her, "I guess you're right." "He says, 'I guess I forget about it.'" "He told me also," she would interject later, under oath, as an afterthought, " 'There are so many people,' he says, 'what are calling me up asking questions. They all have to wait until I get back.' I remember that very well, and I left." Their short visit at an end, Campbell departed with the impression that Porter was "sort of in a hurry to get rid of me." She hailed a cab back to Dupont Circle just as "two friends of Mr. Porter, two young men" entered the Kennedy-Warren's cavernous lobby and made their way upstairs to Apartment 1110A.

Before leaving Washington, Porter wrote two notes. In the first, he thanked Sibilla Campbell for being "sweet" in offering to pick up his mail and magazines during his absence, but the note's closing belied the anxiety he displayed of late: "PLEASE DO TAKE CARE OF YOURSELF." The second was addressed to the manager of the Kennedy-Warren Apartments, announcing his anticipated absence, paying his rent through the end of October, and authorizing Sibilla Campbell to pick up his mail. He added appreciatively that it had been "a joy . . . to occupy that haven of rest, Apartment 1110A," and closed with an emphatic postscript: "*Nobody has my consent to enter my apartment in my absence.*"

On the evening of Thursday, August 5, 1948, Porter arrived at the Hotel Aberdeen in Manhattan in anticipation of his Atlantic crossing aboard the Cunard liner SS *Media* the following day. Waiting for him at the Aberdeen was his young friend and protégé, Roland de Corneille, a twenty-one-year-old postulant for holy orders at the New York General Theological Seminary. Porter had, as the *New York Star* would soon assert in its extensive coverage of the events that followed (characteristically, with considerable reportorial nudging and winking on the subject of Porter's "personal life" and "friends"), "manifested an interest" in Corneille since the latter was fourteen. Well compensated by his *Times-Herald* salary and Christmas bonuses, and childless, the Washington accountant paid the young man's tuition at Amherst, where the latter had been elected a member of Phi Beta Kappa before graduating at the age of nineteen. "He was my best friend and my mother's best friend too," Corneille recalled.

Porter arrived at the Aberdeen in a frenzy of apprehension, "sure he was being shadowed by private detectives." Likewise, he told his young friend, he feared that "the Countess' every move was also being traced." Over the course of the evening of August 5, Porter weighed fitfully his decision to leave the country. Nearly two decades in Cissy Patterson's employ had situated him to observe at close range the evolution (or deterioration, as some put it) of her mental state and the influences that her intimates exerted on

her in her last years. As her longtime personal and business accountant, he had also developed a unique familiarity with her financial records. Aside from business manager Bill Shelton, Porter alone was in a position to detect, expose, or explain away any irregularities that might be camouflaged within her ledgers, particularly now that the Riggs Bank would be conducting a thorough audit. In short, Charles Bell Porter would be a crucial witness in making the case that Cissy had been of unsound mind and the victim of coercion and fraud—or, indeed, its opposite—a fact that both factions in the brewing will contest had already realized.

In the days preceding Porter's departure from Washington, both Drew Pearson and Felicia Gizycka's lawyers had duly made contact with the accountant in an effort to secure his testimony. Porter's private life might work to undermine his credibility on the witness stand, if not impeach it entirely, however. Fear of exposure and possible prosecution under the new District sodomy statutes might persuade him not to come forward at all. Indeed, before leaving Washington, Porter told Corneille, a man "purporting to be a U.S. agent" had questioned some of his male friends about his "personal life."

Other pressures weighed on Porter as well. He revealed to Corneille that he had recently been offered a bribe of some $50,000* to attest falsely to the legitimacy of the gross accounting irregularities that would likely appear during the Riggs Bank's audit of Cissy's estate. As the publisher had been in the unusual position of owning her newspaper outright, there had likewise existed an unusual fluidity between her personal finances and the *Times-Herald*'s. When the paper had required cash to meet payroll, to improve the physical plant, or to secure additional newsprint, for example, she had provided it from her personal funds. When (as was often the case, given the paper's penchant for publishing the most titillating and damning characterizations of its subjects) the *Times-Herald* faced libel or defamation charges, Cissy had paid the many settlements and judgments out of her own pocket. During her nine years as the *Times-Herald*'s owner, a number of large cash infusions had come *from* Cissy *to* the paper, and had been treated for accounting purposes as loans. Porter had recently been pressured, he told Corneille, "to get up a statement" attesting to a single, unprecedented instance of substantial cash flow in the opposite direction. If Porter submitted a signed statement to the effect that the *Times-Herald* had made a loan to Cissy shortly before her death, that she had withdrawn $500,000† from the paper's bank account in order to pay her personal

*Almost $450,000 according to the Consumer Price Index or nearly $1.3 million measured by nominal GDP per capita.
†Almost $5 million adjusted according to the CPI, or nearly $13 million measured by nominal GDP per capita sixty years later.

income tax, he would be rewarded with a one-tenth share of that $500,000 when her estate "repaid" the paper. Although Corneille did not know which party or parties had proffered the bribe, were Porter to perjure himself as demanded, the Seven Dwarves stood to share in the repayment once the 1946 will was admitted to probate and they became the paper's joint owners. "Porter had too much integrity" to accept the bribe, Corneille contended. But the experience only served to heighten the distress the uncooperative accountant had known of late. "I fear for my life," Porter confessed to his young friend, as Corneille later recorded the discussion in a sworn statement. "There is a great deal at stake."

As with much of the information his gumshoes uncovered, in the coming months Drew Pearson quietly ensured that the *New York Star* heard Corneille's account. A studious imitator of Joe and Cissy Patterson's proven formulas, the tabloid had covered the capital's infamous lady publisher relentlessly during its own short existence, subjecting her to the same lambasting that her *Times-Herald* practiced on New Dealers, liberals generally, and former friends. Without its own rich patroness, however, the *New York Star* was considerably more circumspect about possible libel judgments levied against it than was the Washington *Times-Herald,* and therefore it redacted the names of the party or parties by whom Porter felt threatened. In a letter Porter wrote Corneille on July 30, the day after the terms of Cissy Patterson's will were announced, "a man whose identity is being withheld by the *Star*"—but, judging by the fiduciary powers he believed he possessed, one of the two putative executors, and, by his interest in concealing evidence of accounting irregularities and embezzlement, a figure highly placed in the *Times-Herald*'s business office, " 'spoke glibly of getting me the job of being representative of the trustees.' " Porter had demurred, for the time being. "They're going to try to bribe me to give up my papers," he worried, adding, "This would be a good time for them to do this. They'll think I feel safe if they know I'm going abroad and that's why they might strike now."

To calm his friend, Corneille exchanged his own room on the fifth floor for Porter's on the third; the two men took the additional precaution of making the switch via the back stairs. "As a British subject," Porter ventured to Corneille, interested parties might "attempt to keep me from re-entering the country and testifying on behalf of Cissy's daughter. I won't do it," the accountant resolved at last. "I'm going to wait and see how the will case stands." On Friday, August 6, the SS *Media* sailed without Charles Bell Porter.

As Porter arrived at his fateful decision to remain in the United States that morning, back in Washington Bill Shelton and Sibilla Campbell met with officials at the Riggs Bank, the estate's collector, to establish a plan for

closing up Cissy's houses. Making small talk with the business manager while waiting for their meeting to begin, the housekeeper ventured, "Well, I guess Mr. Porter is sailing, he is on the high seas."

When she returned to Dupont Circle around noon, she was greeted, to her surprise, by a telegram from C. B. Porter, noting that he had postponed his trip and was returning to Washington. When Campbell visited her old friend and colleague at his apartment in the Kennedy-Warren two days later, she wondered, "What on earth made you come back?" Porter's response was that Roland de Corneille had persuaded him that returning to Washington and answering "the questions" was the right thing to do. Having disconnected his telephone in anticipation of his extended absence, Porter asked Campbell to do him the favor of contacting Drew Pearson to let the columnist know he had returned.

C. B. Porter was not the only party attempting to contact Drew Pearson with information pertinent to challenging Eleanor Medill Patterson's will, it turned out. Through the columnist a variety of concerned citizens, busybodies, and crackpots offered their services to the Countess Gizycka in proving the unsoundness of her late mother's mind. "That will should be contested," one of Cissy's former Prince George's County neighbors insisted, adding, "At times, when angry, she was not only unbalanced mentally, but was violently insane. When under the influence of liquor, she was of unsound mind, which means very often." The *Times-Herald*'s readership also weighed in on the brewing will fight generally and on Cissy's mental competence specifically. Since the publisher's most consistent characteristic in recent years had been her volatility, one reader, signing himself "Very Trumanly yours, Soph O. Kleez," pinpointed the problem the seven executives were likely to face in defending Cissy's sanity in court: "Judging by the editorials and other examples of 'journalism' that have been appearing for the last 10 years or so, it would seem that the daughter has very strong proofs of her claim."

In the Patterson will contest, the month of August would pass as a sort of cold war, with little overt hostility while both sides considered strategy and marshaled forces and weapons for the fight to come. On Friday, August 13, 1948, attorneys for would-be executors Shelton and Waldrop filed a notice of publication in District Court, which in turn, set the date of September 14 as the last opportunity for interested parties to show cause as to why Eleanor Medill Patterson's 1946 will and its codicils should not be admitted to probate. Failure to do so would result in its admission by default. If contested before that time, however, the caveator (or caveatrix) would have up to one year to challenge particular provisions and submit

supporting evidence. "This notice," the *Washington Post* observed, "apparently is aimed at Countess Felicia Gizycka."

On Sunday, August 22, 1948, Frank Waldrop paid an unexpected visit to the *Chicago Tribune*'s Washington bureau chief, Walter Trohan, which Trohan dutifully documented for his managing editor, J. Loy Maloney, and his publisher, Colonel McCormick. In what would become a series of lovingly prepared bulletins on the plot twists in the unfolding tragicomedy that was the Patterson will contest, Trohan was as unabashed in overstating his own role as he was quick to cast his fellow players—Frank Waldrop, in particular—in the most unflattering light possible. On that Sunday afternoon four weeks after Cissy's death, Waldrop revealed that there had already been several inquiries, one of them from the *Washington Post,* regarding the possible sale of the *Times-Herald.* Should Meyer and Graham's bid succeed, Trohan hardly needed to remind his readers at the Tribune Tower, the dire upshot would be to "blanket Washington with Internationalism and New Dealism." In the same vein, Waldrop described a growing disharmony among the seven putative legatees as to the final disposition of the *Times-Herald;* this fact, Trohan suggested, might be exploited to the *Tribune*'s advantage in its own ultimate acquisition of the paper. Despite their current impotence as executors, Waldrop and Shelton were considering appointing Alicia Patterson Guggenheim to fill one of the vacant trusteeships, and wondered if Colonel McCormick would have any objections.

Finally, Trohan related—fully aware that the Colonel would sit up and take particular notice—Waldrop had let slip that he intended to sell some of Cissy's McCormick-Patterson Trust holdings. Waldrop "played the wise guy with me, a role which delights him and the reason why he is going to have trouble." If Trohan's account is to be believed, having discovered that Cissy's trust holdings were "valued too low" at $500,000, Waldrop proposed "to force upping of the stock," adding that he would tip Trohan off as to when to buy so that the latter could "make a clean up." "I went along to draw him out," Trohan insisted ingratiatingly to his superiors, warning, "Do not disclose my hand as it will dry up this source." Unable to resist taking a final swipe at his *Times-Herald* colleague, Trohan added the postscript, "At our last meeting Mrs. Patterson said Waldrop is stupid but honest. She was exact. He is swelling in his cloak of authority like a fathead who puts on a cop's uniform." On the afternoon following this confabulation in Washington, back at the Tribune Tower in Chicago, "Pat" Maloney instructed his secretary that Colonel McCormick wanted to keep a copy of Trohan's report for his own files. The original was in the hands of Howard

Ellis at the *Tribune*'s law firm, Kirkland, Fleming, Green, Martin & Ellis, who was on notice "not to use the information in any but a discreet way."

Just as the executors were premature in considering the sale of assets not yet theirs, likewise Felicia was dazzled by the thought of all that might ultimately be hers. To Ellen she wrote of Cissy's hundreds upon hundreds of outfits and shoes (some dating from the Civil War), "furniture enough for six houses," a wardrobe "full of furs," "silver enough for Buckingham Palace, jewels enough for a harem." The attic at 15 Dupont Circle probably contained "at least three bodies in trunks," Felicia joked. "I feel as though the Empire State building were a large vase that had tipped its contents on my head!" She hoped that Ellen might be able to return from California with the baby to help her sort through her mother's possessions. To her grandson, two-year-old Drew Pearson Arnold, she offered the portrait of his great-great-great-grandfather, Joseph Medill, which hung prominently at Patterson House. She encouraged Ellen to take everything she might "stagger home with"—so long as the hunt for heirlooms did nothing to devalue the estate. The replacement cost of Cissy's personal possessions, Ellen's father-in-law, Thurman Arnold, had estimated, was "over a million bucks"; a sale might fetch as much as $400,000, Felicia related.

By late August, Felicia had become convinced of the "villainy" of "the other side." Far from bringing Cissy closer to God, Father Walsh's catechism had taken the form of deliberately poisoning relations between mother, daughter, and granddaughter, Felicia believed. Former senator Burton Wheeler, shut out of the action when his estate-planning meeting with Cissy had been canceled by her death (and embittered that his attempts to reinsert himself had been rebuffed) eagerly seconded Felicia's suspicions. As Wheeler described it to the Gizycka legal team, in the last months of her life Cissy had grown rueful about the rift within her family. She laid the blame not on her own brutal changeability but rather on the sycophants who surrounded her. Evie Robert and Frank Waldrop in particular, among many others mentioned in the 1946 will, had encouraged Cissy to drink heavily and plied her with sleeping pills in the last months of her life, Wheeler charged (his own absence from the capital during much of the same period notwithstanding). Perhaps worst of all, Waldrop and Robert had successfully kept the former senator away from the late publisher in an effort to prevent her 1946 will from being superseded by a document less advantageous to them that Wheeler himself might have drafted.

Since the name Countess Gizycka had appeared in headlines nationwide for the past few weeks, Felicia had received a torrent of unsolicited mail—some offering condolences, some congratulations, some demanding money,

one even proposing marriage. Amused at first by her notoriety and the public response it provoked, she soon found the instability of many of her correspondents and their relentless requests to be disconcerting, if not alarming. Nevertheless, she wrote Ellen, "much good" had come of Cissy's death and its aftermath thus far. In closing, Felicia remarked that she did not intend to contest the will, but added "yet," by hand, before sending the letter to Ellen.

Despite her earlier warnings about the rapaciousness of Cissy's legatees, Alicia Patterson Guggenheim had advised Felicia not to resort to an official caveat, but instead to use the threat of a legal challenge to Cissy's will to exact concessions from the opposing side before the September 14 deadline. On Thursday, September 2, Louis Caldwell of the *Times-Herald*'s (and the *Tribune*'s) law firm, Kirkland, Fleming, Green, Martin & Ellis, met with Felicia's legal team. To Colonel McCormick, Caldwell reported afterward that they had made demands, which, although different from those presented the previous month over the telephone, were likewise distinct from the posthumous wishes Cissy herself had clearly expressed in her last known will and testament. No longer asking for a share of the estate for charity, Felicia now demanded a one-eighth interest in the *Times-Herald,* a trusteeship of the residuary estate that was to come from McCormick-Patterson Trust holdings, and an appointment as the trust's executive secretary (for which she was to receive appropriate compensation). Finally, her team demanded that Caldwell provide a copy of the McCormick-Patterson Trust itself, threatening implicitly to question its validity as well should she be refused. Such brinksmanship had little effect, however; to all Felicia's demands Caldwell responded with a cool no.

"It will be up to Louis Caldwell, I guess, to keep those people in Washington from making themselves a lot of trouble," Colonel McCormick mused after reading the attorney's report the following morning. "The heirs are waking up to the tax situation," Walter Trohan reported the same day. The Patterson estate, the Washington bureau chief had heard, was likely to be subject to 65 percent federal, and 5 percent local tax; that is, the nearly $17 million estate was likely to pay some $11 million* in taxes. The remaining $6 million† would be insufficient to fulfill the various bequests listed in Cissy's will. On a more personal note, Trohan added with satisfaction, Frank Waldrop's tangled roles as legatee, trustee, executor, and editor in chief had made for some sleepless nights. Almost any decision

*The rough equivalent of some $98 million adjusted according to the Consumer Price Index, or more than $280 million measured by nominal GDP per capita.
†Some $54 million, or more than $153 million by the same measures.

Waldrop might make (like his recent sale of some of the McCormick-Patterson Trust stock before the market rose significantly) could be subject to legal challenge on the grounds that he was either favoring himself or breaching his fiduciary duties. Colonel McCormick, for his part, was unconcerned about discharging his cousin's wishes for her posterity—at least as she expressed them in 1946. After reading Caldwell's up-to-the-moment account of the situation, the colonel opined that he saw no reason that "Waldrop and his associates" should not accept Felicia's demands; he, for one, found them "very moderate." "I dare say," he ventured shrewdly from his aerie in the Tribune Tower, "[Drew] Pearson knows enough to make a very nasty law suit." Trohan eagerly corroborated his master's conjecture: the "Washington Merry-Go-Round" columnist had been "running a war of nerves against Waldrop" by sending investigators not only to the vicinity of the Dower House to interview anyone familiar with the late Mrs. Patterson, but also to the District's Spring Valley section to chat with residents about their neighbor Frank Waldrop. "It is one hell of a mess," Trohan concluded, delighted.

Frank Waldrop was not alone in contending with mounting pressure. On Sunday, September 5, C. B. Porter called his old friend Sibilla Campbell once again. He was a "sick man," he told her, and had been in the care of his physician. Dr. Keyser confirmed only what the housekeeper knew already: her friend was "just despondent." Over dinner a few weeks earlier, Porter had mentioned that he had met with Drew Pearson, but he had not made Campbell privy to the details. Porter also revealed that he had been in contact with the opposing side in the will contest. The previous Thursday, while Louis Caldwell wrangled with Felicia Gizycka's legal team, Porter had plucked up the courage to call the *Times-Herald* and ask for his old job back. Bill Shelton informed him that there was no opening—at present. The accountant "seemed to be upset," Sibilla Campbell recalled, "very much upset by that."

In the course of their friendship Sibilla Campbell had introduced C. B. Porter to her friend, Father Rizer, a Catholic priest living in Keyser, West Virginia. As Campbell recalled it, Porter visited Rizer "often, especially when something would go wrong with Mrs. Patterson, or when he had some difficulty, and he would go to church." Father Rizer had recently told Campbell that the upheavals of the previous months had brought Porter to the verge of converting to Catholicism. With Porter despondent over recent developments and Campbell increasingly at a loss to know how to help him, she suggested that he once again unburden himself to the priest.

On the afternoon of September 7, a week before the deadline to launch any challenge to the Patterson will, Felicia's legal team met for the last

time with Caldwell on behalf of the executors. Once again, the attorney rebuffed all of their proposals for an out-of-court settlement. A public legal challenge to the will now appeared to be inevitable. The following morning, Wednesday, September 8, Sibilla Campbell, still busily packing and inventorying at Dupont Circle, made a brief visit to the Kennedy-Warren Apartments. An overwrought Charles Bell Porter had asked her to find a driver to take him to Keyser, West Virginia; riding the train from Union Station, he feared, was "too public." Meeting her to say good-bye at the hour appointed for his departure that afternoon, however, Porter informed her that he had changed his mind. Increasingly exasperated with her friend's nervous indecision, Campbell saw him back to the Kennedy-Warren before returning to her duties.

The next day, Porter phoned Campbell at Dupont Circle; he was "afraid" to remain in the city and begged her again to find a driver who could spirit him out of Washington as soon as possible. Late the night before, the accountant whispered into the receiver, someone "working with a key in the lock" had tried to break into his apartment while he was alone inside with his papers and files on Cissy Patterson.

Porter Fled Capital in 140-Mile Cab Ride

—NEW YORK STAR, OCTOBER 3, 1948

On the afternoon of Wednesday, September 8, 1948, a taxi arrived at 15 Dupont Circle to pick up a Mrs. Campbell, who directed the driver up Connecticut Avenue to the Kennedy-Warren in search of a Mr. Porter. The cabby loaded Porter's bags—one light tan, one a darker tan, and one (as the driver remembered it) "very heavy" and black, which Campbell had loaned her friend for his journey.

During the ride back down Connecticut Avenue, Porter gave Campbell two keys, the first to his apartment (he had had a new, double lock installed after the previous night's alleged break-in attempt), and the second to the army footlocker in which he stored his manuscripts and research on Cissy Patterson. Earlier that day, he told Campbell, he had entrusted the trunk to another friend to return to Smith's Transfer Storage for safekeeping. Before Sibilla Campbell got out near Dupont Circle, Porter handed her the storage receipt authorizing the release of the army trunk to her and her alone. Before saying good-bye, the two agreed to meet that Sunday in Keyser, West Virginia.

The following morning, Thursday, September 9, the maid at the parish

rectory in Keyser, West Virginia, thought she saw a man outside who bore a striking resemblance to Father Rizer's friend from Washington, C. B. Porter. As the priest was away on vacation at the time, she remarked to one of his brethren that had she not been certain Mr. Porter had no reason to be in Keyser, she might have sworn it was he. Having failed to meet his spiritual adviser, Porter thought better of remaining at his present location. He collected his luggage, therefore, and boarded the next train for the ninety-five-mile journey to Clarksburg, West Virginia. Cabby Junior Aylestock would retain only a hazy impression of the passenger he conducted to the Waldo Hotel, but recalled vividly the man's "unusually heavy luggage."

The furtive, pink-faced foreigner captured the imagination of the Waldo Hotel's staff during his brief stay. Originally assigned room 632, on Friday, September 10, the morning after his arrival, Porter requested another room, one with a clear view of the street below. Arriving to transport Porter's luggage to his new room, 612, bellman Robert Lovelace Winfrey found the room unlocked and the lights off. Flipping the switch, he was startled to find the inhabitant lying on the bed in shirtsleeves with a wet towel over his eyes; Porter rose with a start himself and changed rooms without uttering a word. Chambermaid Anna Bowers remembered that over the next few days the guest seldom left room 612 and did little more than sit in the rocking chair by the window, "clenching and unclenching his hands." Nevertheless, he was polite "despite his obvious distress." Although friends insisted that Porter never drank, he had placed a bottle of sherry on the table by his rocking chair. Full at the time of his arrival, its contents diminished markedly over the course of his stay. Several members of the staff observed Porter's odd habit of opening the door to Room 612 and peering anxiously up and down the hallway, "as though he were expecting someone to arrive."

Although the occupant of room 612 had initially impressed his chambermaid as quiet and courteous (if nervous), his behavior soon began to unsettle her. Unless he paid one of his rare visits to the nearby Hammont & Harper Restaurant, he remained, disconcertingly, rocking silently by the window while she cleaned around him. He never unpacked his three suitcases either, which made it appear that he was about to depart at any moment. Finishing her shift one evening, Anna Bowers told a co-worker that she had "a crazy man in 612." Porter created a similar impression at the Hammont & Harper, where waitress Irma Haddix recalled that his "incessant" hand-wringing made him seem "extremely nervous" and "in a big hurry."

As Porter changed rooms at the Waldo on Friday, September 10, Sibilla Campbell duly made a reservation for a round-trip ticket on the Balti-

more & Ohio Railroad from Washington to Keyser that Sunday. She intended to leave on the 8 a.m. train, meet Porter, pay a visit to Father Rizer at the rectory after mass, and return to Washington on the six o'clock that evening.

Alone in his new room at the Waldo, Porter seated himself at the table by the window before his gradually emptying bottle of sherry, and began to write:

September 10, 1948
 I, Charles Bell Porter, leave all of which I die possessed to Mrs. Alice Milne and Miss Zena Milne [his nieces]. I would like Mrs. Sibilla Campbell to act as my Executrix in the United States of America and the Union Bank of Scotland in Edinburgh as Executor there. In witness whereof, I have written these presents with my own hand.
 —C. B. Porter

Shortly after six o'clock that evening, not yet finished with the day's sorting and packing at Dupont Circle, Sibilla Campbell received a call from Porter. To her amazement, he told her that he was not in Keyser but in Clarksburg, but refused to divulge his whereabouts any more specifically. "When I asked him, 'What are you doing in Clarksburg?'" Porter responded, " 'Oh,' he says, 'it is a little further away from Washington.'" Porter's telephone demeanor suggested, if possible, an intensified level of desperation. "Will you go to my apartment," he pleaded, "and get my bank statement and checks out? I have been so good to some of the boys, and I don't want to get [sic] that into anybody's hands because Wednesday evening somebody was trying to get into my apartment." Fatigued from a long week at 15 Dupont Circle, tiring of perpetually buoying Porter's spirits and snapping to his demands, and growing dubious about the threat— or threats—that he claimed to face, she replied, "C.B., I will do that tomorrow." "No," Porter insisted, as Campbell remembered it later under oath, giving a clipped Germanic underpinning to Porter's Edinburgh burr: "I will please ask that you do that for me tonight."

The night of Friday, September 10, 1948, was an appropriately dark and stormy one. Although Sibilla Campbell would never say so explicitly in the deposition she gave four and a half months later under oath before the legal representatives of all parties interested in the Patterson will, both her account and her actions that evening suggested some fear on her part— although of what, she never revealed. Between seven and eight o'clock, Campbell set off into the "terrible storm," toward the Kennedy-Warren. She took with her an old suitcase she had found in the attic at 15 Dupont

Circle ("I did not know how much would be there") and Eva Lindbergh, a colleague on the household staff ("The only thing I did not want was to go into that apartment by myself").

To Drew Pearson's jaundiced eye, of the dozens of depositions that would eventually be taken in the Patterson will case (some of them rumored to include eye-popping tales of depravity, debauchery, lesbianism, heavy drinking, intravenous drug use, and orgiastic "circuses" conducted in the Dower House pool), the "most sensational . . . of all was given by Mrs. Campbell, the housekeeper." Her sworn account of the events of the evening of September 10—along with information unearthed by the veteran "Washington Merry-Go-Round" investigators and Felicia Gizycka's team—served only to reinforce the columnist's firmly held view of his former mother-in-law's staff and intimates. After they "ransacked" Porter's apartment, Pearson noted to his diary, Campbell and Lindberg made off with Porter's financial records for two reasons, "(1) Porter, a pansy, had been paying off to some young men around town; (2) and probably more important, Porter was the only one who knew about Shelton's chicanery." Pearson's team had discovered that the *Times-Herald*'s business manager had "been milking the tail for some time." "Unquestionably," the muckraking columnist speculated, "Mrs. Campbell persuaded Porter to leave town, then lifted the evidence out of his apartment." Pearson left unanswered the question of whose interests, exactly, the housekeeper's actions served: Porter's, Shelton's, or Campbell's own.

C. B. Porter had used Sibilla Campbell as the conduit for information he wished to convey to the Gizycka camp. Although the housekeeper would only admit to it later, under duress, she had also been relating information about her old friend to Bill Shelton at the *Times-Herald*—a possibility that Porter himself appears to have anticipated. On Saturday, September 11, 1948, the morning after Campbell's late-night expedition to Porter's apartment, Bill Shelton phoned her at Dupont Circle, looking for the former treasurer. A position had become available for Porter at the *Times-Herald* after all, he claimed (the paper's current financial predicament notwithstanding). Did she know where Porter was, so that Shelton could convey the good news? Inasmuch as Porter had thought better of volunteering his whereabouts to her, Campbell answered truthfully that she did not, but "I told Mr. Shelton I expected that maybe Mr. Porter would call again that night." When indeed they spoke that evening, Campbell related Shelton's message and Porter agreed to contact the business manager directly.

Louise Ash, the switchboard operator at the Waldo Hotel, recalled that on that Saturday evening, the nervous Scottish guest "repeatedly asked her to call a Mr. Shelton in Washington," both at the Times-Herald Building and on several other numbers. "Almost frantic to get in touch with Shel-

ton," Porter had piqued Ash's curiosity. Although the hotel was unusually busy that evening, a fact that made for a number of unfortunate interruptions to the operator's determined efforts to listen in, Ash would later relate without embarrassment that she had managed to eavesdrop on at least some of the conversation between the two men. Shelton, she recalled, asked generally about "how things were going" and pressed Porter to give his location. Porter finally relented. About an hour after his first call, Sibilla Campbell remembered, "Mr. Porter called me back and told me he talked with Mr. Shelton and told him he was returning with me Sunday" after the visit they hoped to pay to Father Rizer in Keyser. And, yet, despite the prospect of returning to gainful employment at the *Times-Herald,* Porter's chat with Bill Shelton appeared only to have increased his anxiety. Late that evening, hall porter James Lettridge was struck anew by the oddity of room 612's "occupant peering up and down the hall furtively."

By now C. B. Porter had become the subject of general curiosity to the Waldo's staff. Noting his every move, many reported that the following day, Sunday, September 12, he did not leave his room at all. In the meantime, as promised, Sibilla Campbell rose early, made her way to Union Station, caught the eight o'clock to Keyser and arrived at around eleven thirty. She waited in vain for Porter on the platform and, as Father Rizer was still out of town, returned to Washington on the six o'clock, livid. Thinking that perhaps Porter had changed his mind and returned unexpectedly to Washington, as he had done a month earlier, she called the Kennedy-Warren to leave him a message and a piece of her mind, but did not find him there, either. The following afternoon when he finally called from Clarksburg, she restrained herself, saying only, "You certainly put a good one across me to let me come to Keyser and you are not there." Porter's limp response was "I tried, but couldn't get out of my room." This, Father Rizer told reporters after returning from vacation the following week, was evidence that Porter's mind was "beginning to snap."

The accountant spent most of the following day, Monday, September 13, in the same state. He ate briefly at the Hammont & Harper. Several members of the Waldo's staff observed him, as usual, peeking nervously up and down the hallway outside room 612. His chambermaid, Anna Bowers, remembered making a point of cleaning the room last because she had become "a little afraid" of its inhabitant, about whom there was "something peculiar." Before making the bed she screwed up the courage to ask whether the guest intended to spend the night; he had still not unpacked his bags. Gazing out the window, Porter turned to her as if startled and answered, "I don't know whether I will be here or not, am I? I do not know who to see." She was understandably confused by his answer.

Claims Coercion:
Mrs. Patterson's Daughter Charges Insanity
in Will Fight
Asks Court to Refuse Will to Probate,
Alleging It Was Procured by Fraud

— WASHINGTON *TIMES-HERALD*, SEPTEMBER 13, 1948

On the morning of Tuesday, September 14, 1948, newspapers across the United States carried the story that the Washington *Times-Herald*'s late editions had already begun running the evening before. On Monday afternoon, only a few hours before the deadline established a month earlier, attorney Randolph Paul filed a petition for caveat in District Court on behalf of Felicia Gizycka. In so doing, the former Treasury Department general counsel gave notice that his client intended to mount a formal legal challenge to her mother's 1946 will. Paul's petition assailed the testament on all possible grounds, claiming that Eleanor Medill Patterson had been of unsound mind, as well as the victim of fraud and undue influence on the part of parties who remained, press accounts from coast to coast noted, conspicuously unnamed. Further, the petition requested that the court declare Felicia Gizycka to be sole heir not only to the nearly $17 million estate, but moreover to its principal asset, the Washington *Times-Herald*.

At about eleven o'clock on that same late summer Tuesday morning, Maggie Jones arrived, as usual, at 1217 35th Street, NW, the modest townhouse near the Key Bridge in Georgetown, where she worked as a maid. Her employer, Betty Hynes, had been feeling poorly for the past several weeks, but had nonetheless volunteered her services at 15 Dupont Circle, to help settle the affairs of her own employer—or, rather, former employer—the late Eleanor Medill Patterson. After working as secretary for a number of New York socialites, thirty-two years old and unmarried, Hynes had come to Washington in 1930, like her colleague C. B. Porter, to work for the publisher. Purposeful, efficient, and anxious to please, Hynes had been unable to withstand Cissy Patterson's whimsicality. Rather than fire Hynes, the mercurial publisher simply transferred her to the *Times-Herald*'s staff. With no previous journalistic experience, but aware of her good fortune in finding employment during the darkest years of the Depression, Hynes had started as a general assignments reporter, gradually making her way up the ranks of the women's departments, the paper's mainstay. She had moved back and forth between the drama and society desks, serving as head of both departments at various points between 1934

and 1947. The eighteen years Hynes had spent in Washington gave her an almost unique perspective on her notorious employer. Hynes's brother and some of her friends believed she had been "extremely upset" by the recent discovery that the many promises Cissy Patterson had made over the years to leave her enough money to pay off her mortgage had gone unfulfilled. They also noted that Hynes had been "receiving constant visits from members of the *Times-Herald* staff" in the weeks since the publisher's death. It would soon emerge that Hynes had been in contact with Felicia Gizycka's legal team as well and had agreed to serve as a witness in the suit to break Cissy Patterson's 1946 will.

Making her way upstairs to begin cleaning, Maggie Jones came upon Hynes's pajama-clad body on the bathroom floor. She called the police immediately, but her employer was pronounced dead on arrival at the hospital; Betty Hynes had, in fact, been dead for several hours. The Washington *Times-Herald* reported that its former drama and society editor's death was the result of "natural causes" pending an autopsy the following day. The *New York Star* revealed that after elbowing his way to the death scene, its own hardboiled correspondent had noted the presence of "three empty or almost empty bottles of sleeping tablets." After the removal of the body, Hynes's brother discovered that a robbery had taken place as well: a screened window had been forced open and he was unable to account for some of his late sister's papers.

In Clarksburg, around lunchtime on that same Tuesday afternoon, the big city papers from Pittsburgh, Baltimore, and Richmond began to roll in to the local newsstands, bringing with them lurid tidings from Washington of Felicia Gizycka's challenge to Eleanor Medill Patterson's will. C. B. Porter inquired at the shop in the Waldo Hotel lobby for a Washington paper, but as none had arrived just yet, he settled for a Baltimore publication instead. He took lunch silently and quickly in the hotel dining hall before retreating to the safety of his own room once again. Sometime after three o'clock, her shift almost over, chambermaid Anna Bowers steeled herself, knocked on the door of room 612, and asked whether Porter wished his room to be cleaned. Unfortunately, he did. Porter (barefoot, she noticed) let her in and then took his accustomed seat in the rocking chair, to stare out the window. The sheets on the bed were still warm, as if he had just risen. None of the towels had been used since the day before; all of the soaps in the bathroom were still wrapped. Did he require anything else? "No," he told her, mustering a feeble smile, "everything looks nice, thank you."

Some minutes after Bowers left, police reports would later contend, Porter stood, tidied the $77 in his billfold, and arranged it along with his

change purse, hat, and sunglasses next to the now nearly empty bottle of sherry on the dresser. Then he turned toward the open window of room 612 for the last time. Kicking through the screen, he managed to tear the bottom half loose from its frame and crawled through the flap onto the ledge outside.

At around 3:40 in the afternoon, Glenn Tribett, a thirteen-year-old boy, was waiting at the bus stop on the corner of Fourth Street with some schoolmates when he heard a woman scream. He followed her horrified gaze to the sixth-floor ledge of the Waldo Hotel across the street, where a man stood on one leg, as if poised to jump. Dean Booth, a sixteen-year-old Western Union messenger boy, who was at that moment riding his bicycle around the corner of Fourth and Hewes Streets by the Waldo Hotel, caught sight of a man's body in flight, twisting and turning in the air before hitting the curbstone, head first, with a sickening thud. In its trajectory Porter's body had narrowly missed hitting the awning of the Clarksburg Agency below. He landed only a few feet behind a female pedestrian who had been walking down Fourth Street. Having heard and felt the ominous reverberation, merchants, businessmen, secretaries, hotel staff and guests, shoppers and passersby began to emerge onto Fourth Street. They found Porter's body face up, bleeding from the left eye and temple. The left side of his head, crushed upon impact, rested on the curb. Porter's left shoulder and arm had been broken by the force of his fall.

Mystery Surrounds Suicide Leap

— *CLARKSBURG (WEST VIRGINIA) TELEGRAM*,
THURSDAY EVENING, SEPTEMBER 16, 1948

Detective S. E. Barnett was at the Clarksburg station house when a Fourth Street jewelry shop owner called to report the shocking death. By the time Barnett arrived at the Waldo, Porter's body had been removed, so the detective made his way to room 612, where he found state trooper Paul B. Swiger and the local coroner, Dr. Kenna Jackson. Discerning no evidence of struggle or foul play (beyond the imprint of a man's foot on the broken window screen), the three men made a probing investigation of the suicide's personal effects. They found his three suitcases, two tan and one black, neatly packed and closed. In them they discovered clothing, toiletries, stationery, income tax returns, insurance documents, a passport, photographs (of some oil paintings and of the deceased hiking with friends), personal banking records, a checkbook associated with a Scottish

bank account, the will that Porter had handwritten four days before, and reading material that included a well-thumbed copy of Dale Carnegie's *How to Stop Worrying and Start Living*. True to form, the *New York Star* reported that Porter's luggage also contained "about 18 pairs of ladies' hose" (neglecting to mention, however, that the deceased had purchased these for his nieces in anticipation of an eventual return to Edinburgh). Dr. Jackson found two containers of recently prescribed sedatives. Trooper Swiger noted that the bottle of sherry on the dresser was nearly empty. After reading the will that Porter had left among his effects, Dr. Jackson tracked down the Sibilla Campbell to whom it referred, in Washington, D.C. "He told me that Porter was in a funeral parlor, that I was executrix of his will," she remembered with characteristic sang froid, "and that I should come down and get him."

While Dr. Jackson contacted Sibilla Campbell, news of Porter's death was already speeding toward Washington (and, indeed, across the country) by another route: the Associated Press wire. Rewrite man Sidney Epstein had punched in at the *Times-Herald* around four o'clock that afternoon. About ninety minutes into what had begun as an ordinary workday, the copyboy delivered a three-paragraph short off the AP wire to his desk. Charles Bell Porter, it reported, was dead in Clarksburg, West Virginia. Epstein placed a call to the Clarksburg authorities hoping to expand upon the details of this "very cryptic" wire story. In the version of events that Epstein would recount a quarter century later, the local police informed him that among the dead man's personal effects were three large, heavy suitcases, "one of which was filled with manuscripts."

News of the former treasurer's death swept through the Times-Herald Building. Shock followed that he should have died so soon after the paper's owner and publisher, particularly since the staff was still reeling from the news they had received only that morning of the death of the paper's erstwhile drama and society editor, Betty Hynes, in her Georgetown home. Typically, the sad end of a fifty-one-year-old Scottish immigrant would have translated into short, perfunctory obituary notices in the local papers and attracted little interest in publications farther afield. At the *Times-Herald*, however, the news was greeted with shock and frenzy. Epstein was assigned to rework the wire story into an obituary, not simply of a Washington resident, but more unusually and poignantly, of a well-liked former member of the *Times-Herald* family. Because the death hit so close to home, Epstein approached Mason Peters, the night managing editor, who had recently become one of the paper's seven legatees-apparent, to ask how to proceed in an appropriately respectful manner. "Get the damned suitcase and bring it back!" Peters barked, as Epstein recalled it twenty-five years

later. "Get on the phone and get an airplane. You're going to Clarksburg, West Virginia."

According to the testimony Epstein gave only weeks after the events in question, no sooner had Sibilla Campbell replaced the receiver in its cradle after hearing the terrible news from Clarksburg than the telephone began ringing anew at Dupont Circle. It was Mason Peters, who had just learned not only of the death but of Porter's having named Campbell his executrix in the will found (along with a variety of papers and financial records) among his personal effects. Peters offered both condolences and assistance. The *Times-Herald*'s new treasurer, John T. Barber, would be arriving shortly at 15 Dupont Circle, the editor informed the housekeeper, with a document for her to sign that would relieve her of the responsibility of having to travel to West Virginia to collect her late friend's possessions. Shortly afterward, Barber duly arrived with a letter already typed, as if in Campbell's own voice, with instructions for the Clarksburg authorities; all the document lacked was her signature. Without reference to how the deceased himself (or rather, his mangled corpse) might make his way back to Washington, "Mr. Barber," it read, "has my authorization to take possession of the personal belongings of the late Charles Bell Porter which will be turned over directly to me." Campbell duly signed the letter, which the accommodating Barber then returned to the *Times-Herald*'s offices on H Street to be notarized, likewise irregularly, in her absence.

Without explaining the urgency of the recovery of the dead man's personal effects (beyond pointing to Sibilla Campbell's assertion that she had lent Porter one of the three suitcases in question and wanted it back), Peters requested that Epstein accompany Barber to Clarksburg and cover the story of the death. Before leaving, Epstein called the West Virginia State Police, both to announce his and Barber's imminent arrival and to confirm some of the details of the suicide. In particular, Epstein had been asked (by whom, he attested, he could not remember) to inquire as to whether a pair of keys had been found among Porter's possessions. They had not; as yet, the location of the keys to apartment 1110A at the Kennedy-Warren and the storage space containing the army footlocker that held *The Most Unforgettable Character I Have Ever Met* was known only to Sibilla Campbell, to whom the deceased had entrusted them before his flight from Washington five days earlier.

Unable to contact the National Airport–based charter service that the *Times-Herald* had occasionally used during Cissy's tenure, and unwilling to delay their arrival in Clarksburg by driving over the Appalachians at night, Epstein and Barber took a scheduled commuter flight from National Airport to Pittsburgh. There they were met by a DC-3 that the *Times-Herald* had managed to charter in the meantime to fly them to the

small airstrip outside of Clarksburg. Before takeoff, the DC-3's pilot informed his two impatient passengers that he refused to land on the rudimentary grass runway in the dark. They took off nevertheless and, approaching Clarksburg, found the field sufficiently illuminated by the headlights of the cruisers provided by the hospitable West Virginia State Police and the local funeral parlor wagon, to attempt a landing. Bumping and lurching over the wet grass to a stop, the DC-3 successfully completed Clarksburg's first night landing, to the relief of all.

Asking the pilots to await his return, Epstein sped to the local police station with Trooper Swiger to begin gathering the information for his story. Sergeant W. E. Murphy followed them in his police car. Barber rode with the local funeral director in the mortuary van. On arrival at the Clarksburg police station earlier that afternoon, Porter's bags had been locked in a closet for safekeeping, apparently for the first time since the death of their owner. Even Barber and Epstein, well accustomed to the *Times-Herald*'s rough-and-tumble reportorial tactics, were shocked to discover that, in addition to the official perusal of Porter's personal effects at the Waldo, reporters from the local *Telegram* and *Exponent* had been allowed to "inventory" the contents of the bags that the suicide had kept so neatly packed during his last days. The *Exponent*'s reporters had even been so brazen as to steal a passport photo of the deceased that they found in his luggage. Barber retrieved it indignantly the following morning after seeing it reproduced on the front page.

The troopers then accepted the specious instructions prepared for Sibilla Campbell and notarized in her absence, authorizing them to release the dead man's effects to Barber. After rummaging around in desk drawers and supply closets for something with which to seal Porter's three bags "officially," they settled for Scotch tape and handed the suitcases over—not to the stipulated recipient, Barber, but rather to his colleague, Epstein. Trooper Swiger accompanied Epstein back to the dark airstrip at breakneck speed to reboard the waiting DC-3. The reporter's brief car rides with the state trooper would constitute the whole of his investigation for his story on C. B. Porter's death.

Narrowly making the connection to his red-eye commuter flight in Pittsburgh with Porter's three heavy bags, Epstein was on his way back to Washington by two o'clock in the morning. When he touched down at National Airport, he would maintain in his deposition two months later, he was greeted by Mason Peters. Although it was now nearly four o'clock in the morning, Epstein claimed that his fiancée had invited him to visit when he returned to Washington. Despite the trouble that he, Barber, and the *Times-Herald* had taken to retrieve Porter's luggage for Sibilla Campbell that very night, being now nearly dawn it was too early, Epstein later argued

with Felicia's legal team, to deliver it to her. Arriving at McLean Gardens on Wisconsin Avenue, the two men took the surprising step of lugging the combined 135 pounds of Porter's luggage up to Epstein's fiancée's apartment, rather than leave it locked safely in the car. Over "refreshments" the two couples (Peters's own fiancée had joined the festivities in the meantime) decided to break the official Scotch tape seals and examine the contents of the bags. They were curious, and besides, "everyone in Clarksburg" had already rummaged through them, Epstein reasoned. He admitted later under oath that the bags had contained some financial records and papers, but insisted he had seen nothing like a diary, or a manuscript on Mrs. Patterson—or, indeed, a will more recent than the 1946 document whose validity was now in question. Anyway, Epstein told his questioners, Peters had shown far greater interest in the bags and had looked through Porter's possessions a good deal more thoroughly than he had.

Around seven o'clock that morning, Peters and Epstein heaved Porter's luggage back down to the car and headed for Dupont Circle, where Sibilla Campbell was already at work. Far from betraying anxiety about her late friend's personal effects, however, she "stuck them under a couch, just to get them out of the way" and went on with her duties.

"I had to get down there," Epstein insisted in response to Felicia's legal team's skepticism of the urgency of his late-night journey to Clarksburg. "When you want a story, you don't wait until tomorrow afternoon to learn about things that are happening." That said, however, after leaving Dupont Circle, Epstein went home for a nap before punching in at the *Times-Herald* at four o'clock that afternoon, the regular start of his shift. Only then did he compose and file his story, "Charles B. Porter Killed in Plunge," for the late edition.

Curiously, the account of the events of September 14–15 that Epstein gave under oath on November 9, 1948, differs substantially from the far more sensational version he would relate more than two decades later. Before taking off from the Clarksburg airstrip at two o'clock in the morning as the only passenger on a twenty-one-seat DC-3 that the *Times-Herald* had chartered (sparing no expense despite the executives' current difficulties in generating cash), Epstein revealed in the 1970s, he "called the guys—'the 7 dwarfs' " to inform them that he had Porter's bags and personal effects in his possession and that he would be returning to Washington immediately via Pittsburgh. If the reporter's later account is to be believed, the accommodating Mason Peters did not arrive alone to meet Epstein when he touched down at nearly four o'clock on the morning of Wednesday, September 15, 1948. Instead, "maybe 6 out of the 7" members of the executive staff of the Washington *Times-Herald* (if not "all seven of 'em") were on hand at National Airport, desperately awaiting the red-eye

commuter flight. "They knew from the [AP wire report]—or from me," Epstein explained, "that he had a suitcase full of documents—a diary, in which he apparently used to write down *everything*." Disembarking and quickly collecting Porter's 135 pounds of luggage, Epstein found the *Times-Herald*'s putative new owners in a feverish state. "They can't wait. They want to look at the goddamned contents. They're asking me, 'Where do we go?'"

They headed for the apartment Epstein's fiancée shared with her parents at McLean Gardens. In the predawn darkness, Epstein remembered, "I ring the bell. Her mother comes to the door; she sees me and seven guys out there. I give her some crazy explanation. She knew I was kinda whacky anyhow, at that point." Resigned, his future mother-in-law replied, "Sure, come on in, Sid." After waking his fiancée and taking over her bedroom, "the eight of us sat on the floor, and opened up the damn suitcase. They started rummaging through this stuff and couldn't find a damn thing— just a whole bunch of documents that had no bearing on the case whatsoever."

Speculating in hindsight about what, in his opinion, accounted for the executives' frantic interest in Porter's luggage on that night, Epstein recalled, "they were simply out of their minds with worry that there was something in that suitcase that would prove . . . that she was probably out of her mind—which then could break the will." Why had they taken the precaution of using his fiancée's bedroom, of all places, to examine Porter's effects? "None of them wanted to go to *their* homes," he remembered, adding, "it seemed illegal at the time."

It remains unclear what accounts for the marked disparities between Epstein's two versions of the events that followed Porter's death, particularly the reporter's neglecting to mention under oath on November 9, 1948, the presence of most, if not all of the *Times-Herald*'s likely new owners on the tarmac at National Airport in the small hours of the morning, waiting desperately to hustle the dead man's luggage to a location where they could conceal their ransacking it for material that might corroborate Felicia Gizycka's challenge to her mother's will. Did Epstein succumb to threats from the same party or parties whom Porter himself professed to have feared (now Epstein's employer or employers), and lie under oath as a result? Or did he misremember and embroider those same events after the elapse of a quarter century? Or had the passage of time (and the deaths of many of the principal figures in the affair) liberated Epstein from any earlier obligations or pressures, and allowed him to make a full and accurate accounting at last? It is impossible to know; suffering from pneumonia and Alzheimer's disease, he died in 2002. According to the sworn deposition

Epstein gave shortly after the events in question, however, on that terrible night the *Times-Herald*'s management thought only of honoring a well-liked former staff member and sparing Sibilla Campbell grief, trouble, and expense in the wake of her friend's death. At the time, a number of observers, Drew Pearson chief among them, disputed the Seven Dwarves' magnanimity, citing their actions as proof of the ruthlessness with which they were willing to safeguard their claim to the Washington *Times-Herald* under Eleanor Medill Patterson's 1946 will.

The staff of the *Times-Herald* was not the only party to take particular notice of the sad news that the AP wire transmitted on the afternoon of September 14—or to betray a frantic interest in the dead man's luggage. Drew Pearson had also received the wire report. With his numberless sources throughout the capital (and, apparently, at the *Times-Herald*), he was aware that a reporter had made contact with the Clarksburg police that afternoon. Inasmuch as documents believed to be among Porter's personal effects might corroborate Felicia's claims of her mother's instability and susceptibility to coercion, the "Washington Merry-Go-Round" columnist worried that the staff members the *Times-Herald* had dispatched were likely to abscond with the three suitcases in order to tamper with—if not steal or destroy—evidence potentially damaging to their claim to the newspaper. Fraternal sentiment among law enforcement officers, the columnist feared, might work to the advantage of those who backed the Patterson will against legal challenge. "Washington Merry-Go-Round" sources had revealed that D.C. police chief Barrett, the brother-in-law of *Times-Herald*'s supervising managing editor (and potential joint owner) Mike Flynn, had weighed in with the Clarksburg police department in order to encourage their cooperation with Barber and Epstein.

Both on the evening of September 14, and again the following morning, syndicated political columnist and radio personality Drew Pearson contacted the Clarksburg coroner's office and the West Virginia State Police (Dr. Jackson and Officers Swiger and Murphy would later be forced to admit), repeating breathless tales of blackmail, bribery, and threats in connection with the suicide's role in the Patterson will contest now unfolding in Washington, D.C. "Apparently some people believe he knew too much," Drew claimed, adding darkly that the circumstances surrounding Porter's death were "strange indeed." He had firmly cautioned the West Virginia State Police against releasing any of Porter's personal possessions, especially on the authorization of one Sibilla Campbell. Despite the legal training Porter had received in Edinburgh as a young man, he was evidently unaware that the will he drafted and signed shortly after his arrival at the Waldo (including its appointment of Sibilla Campbell as executrix)

was invalid because it had never been witnessed. The columnist also repeatedly warned the officials to whom he spoke that they would be remiss, either in releasing Porter's personal effects or in failing to fully investigate his peculiar death.

The deaths of two of Cissy Patterson's long-term employees, by apparent suicide on the same day, struck many observers as more than coincidental. As Felicia Gizycka put it, after initiating the formal legal challenge to her mother's will, "my two *principal witnesses* were both dead within twenty-four hours." Porter's young protégé, the seminarian Roland de Corneille, felt "sure Porter was murdered" when he read of his friend's death: "Although it was suicide, apparently, I know he was a man beset by fear and I know, too, that he was hounded to his death." Indeed, along with most of Porter's friends, Drew Pearson suspected that the accountant's fears had been realized and that his death had not been an autonomous act. Harry Costello, one of the "Washington Merry-Go-Round's" veteran investigators, insisted, "when Porter hit the ground one side of his face— the side which did not strike the ground—was bruised from an apparent beating." Neither Drew nor his investigative team (which now included the Clarksburg law firm of Steptoe & Johnson) ever succeeded in corroborating such suspicions that Porter had been assaulted before being defenestrated, however. All official and eyewitness accounts indicated that the deceased had been alone his room on that fateful afternoon. Nevertheless, both in a succession of published statements on the subject and in his weekly national radio broadcasts over the coming months, the pundit kept alive suspicions of murder. Whether Charles Bell Porter "jumped or was pushed" out of his hotel room window, Drew Pearson maintined, his death was directly or indirectly the responsibility of "certain parties."

Roiling at these blanket insinuations, Frank Waldrop insisted, "I don't know why Porter jumped out the window; I didn't push him out." The editor could account for his own actions and intentions in the affair—but perhaps not those of his colleagues: "Maybe Bill Shelton did . . ." Drew Pearson, like his late former mother-in-law, was no stranger to the vagaries of libel law and defamation suits. As a result, he neither made direct accusations nor named the "parties" in question, but took cover instead by intimating nebulously—but unmistakably—that they were the same "parties" who stood to reap the richest rewards from the admission of Cissy Patterson's contested will to probate. The "Washington Merry-Go-Round" columnist also found a willing, if not eager mouthpiece in the *New York Star,* to which he surreptitiously passed information that his own investigators and Felicia's legal team had gathered both on Porter and the Patterson will contest generally. Without mentioning the columnist, the paper enthusiastically echoed his conclusions and trumpeted the fashionable noir

elements of the case in fitting terms: "Police call it suicide. Porter's friends call it murder by remote control."

Mystery Trunk Hunted in Patterson Will Case

—*NEW YORK STAR,* OCTOBER 1, 1948

Taking a short break from her myriad duties at 15 Dupont Circle after receiving Porter's bags on the morning of September 15, 1948, Sibilla Campbell placed a call to a lawyer she knew. Not yet understanding that Porter's unwitnessed last will and testament was invalid, or that she was not therefore his executrix after all, she asked C. F. R. Ogilby, a local attorney specializing in probate matters, to represent her in the settlement of her late friend's estate. In the coming days and weeks, numerous sensational press accounts continued to appear coast to coast on the Patterson will drama (thanks, in large part, to Drew Pearson's efforts). Many of those that ran in late September and early October detailed frantic efforts on both sides to secure the manuscript, research, and notes on Cissy Patterson that Porter had been rumored to possess. Undoubtedly well aware of this fact, Campbell never revealed to any of the interested parties that she had the keys both to the new double lock on Porter's apartment door and to his locker at Smith's storage, where the very documents in question were safely stowed in the dead man's battered army trunk.

On the evening of Monday, September 20, attorney C. F. R. Ogilby removed the footlocker from Smith's Storage and returned it to apartment 1110A at the Kennedy-Warren. As Campbell had refused to divulge the whereabouts or existence of the trunk to anyone else, Ogilby was able to make an extensive survey of its contents unmolested by any of the parties interested in the Patterson estate. He had arranged to meet Theodore Cogswell, the District of Columbia's registrar of wills, whom the court had directed to search for possible previous, witnessed testaments that Porter might have left behind in his apartment. While Cogswell hunted (fruitlessly, it would turn out) through closets, coat pockets, drawers, and filing cabinets, Ogilby made a careful accounting of the contents of Porter's footlocker.

In addition to a number purely personal items that Porter had preserved in his army trunk, Ogilby discovered a trove of material relating, seemingly, to every aspect of Cissy Patterson's life. The documentation covered the publisher's political leanings and pet causes—particularly, as she aged,

those benefiting animals. These included folders with such titles as "America First," "Animals," and "Animal Rescue League." Those labeled "CARE gifts" and "Cissy and Her Pensioners" referred to her regular wartime shipments of food and supplies to loyal friends she had met in Poland during her disastrous first marriage. There were also folders on "Cissy and Anti-Vivisection," "Cissy and the British," "Cissy and Charity," "Cissy and the Jews," "Cissy and Hitler," "Cissy and the Poles," and "Cissy and Her World War II Effort," as well as one on her campaign to create a District of Columbia "School Children's Lunch Fund." Porter had kept careful records on Cissy's friends, lovers, and associates as well. He had likewise carefully documented his former employer's relations with her enemies, personal and professional. There were folders treating "Cissy versus Churchill," "Cissy and FDR," "Cissy and Harold Ickes," and "Cissy and Truman," in addition to several devoted to the public fights Cissy had picked with Walter Winchell and Drew Pearson. Cissy's other personal piques turned public squabbles appeared as well, in folders marked "Alice Roosevelt Longworth" and "Clare Luce." There were folders devoted to a variety of lesser local hostesses, whose social ambitions Cissy had gleefully thwarted by forbidding mention of their names in any of the *Times-Herald*'s society columns.

Porter had squirreled away a substantial amount of information on Cissy's real estate holdings across the country. He had documented her homes, her furnishings, her luxuriously appointed private railway car and the expenses she had incurred in buying, decorating, and maintaining all of these. There were files on members of Cissy's family; several even provided information on Felicia Gizycka's former beaux. The folder marked "Cissy's Instructions, July 12, 1943" included her memorandum barring the doors of 15 Dupont Circle to Drew Pearson and her only descendants, Felicia Gizycka and Ellen Pearson, in the event of her renewed mental or physical incapacity.

There was substantial documentation, naturally, both on Cissy's foray into newspaper publishing and on the *Times-Herald* as well. Porter's research had covered the paper's previous owners ("W. R. Hearst," "Arthur Brisbane—Arthur Brisbane Correspondence"); its revolving-door employment practices; its employees, former and current ("Cissy and Kathleen Kennedy," "Frank C. Waldrop," "W. C. Shelton, Jr.," "TH—Seven Shining Lights," referring, apparently, to the paper's putative new owners); its journalistic practices (including "Wire Tapping"), its finances, and the major milestones in its history under Cissy's ownership (including "*Times-Herald* Printers' Strike").

No detail was too minuscule to escape Porter's documentation, apparently. He had devoted considerable energy and attention to the study of the state of Cissy's body and mind. The trunk contained numerous folders con-

cerning her medical (and in particular, dermatological) history as well as the extensive list of the doctors and specialists she consulted. Given the pronounced hypochondria she displayed in the last years of her life, the accountant had tapped a rich vein. There were folders covering "Cissy and Alcohol," "Cissy and Hay Fever," "Cissy and D.D.T.," "Cissy and Sex—Kinsey Report," "Cissy and Her Imported Dentist," "Cissy and Homosexuality," "Cissy and Poison Ivy," "Cissy and Ticks," "Diet," "Psychoanalysis," and "Alvan Barach," the pulmonary specialist cum Freudian analyst with whom Cissy had broken during the war.

Perhaps the largest category of material in the trunk dealt with Porter's own checkered relations with his former employer, his three terminations and his hopes for alternative employment. Folders and handwritten notes bore such legends as "Three Strikes and I Am Out," "Third Firing," "Cissy's Gifts to Me" (containing photographs of a number of oil paintings), "Magazine Articles—Cissy," "Mrs. Evalyn McLean's Letters in Regard to Employment," "Mrs. McLean—Cissy Tries to Get Me Back," "November 1946 Fuss" (referring to events that preceded his second firing) and a memorandum titled "You Can't Go Home Again." He had evidently taken some consolation from several self-help articles he had collected while in Cissy's employ, among which he filed *Collier's* "Does Your Job Make You Sick?" The trunk contained not only Porter's research on Cissy, but his writings as well. Besides his "Bibliography" folder there were two handwritten manuscripts. Porter had titled one, about thirty pages long, "Conclusions." The other was, of course, *The Most Unforgettable Character I Have Ever Met.*

On Thursday, September 16, lawyers on both sides of the Patterson will contest were busy at work, Betty Hynes's funeral mass notwithstanding. The executors' attorneys submitted their answer to Felicia's caveat, denying categorically all of the charges she had lodged against her mother's will. Felicia's legal team and Drew Pearson were equally busy, counterattacking on several fronts. Taking a page from recent experience, Felicia's lawyers petitioned the court to appoint "some impartial individual or corporation" to act as collector of Porter's estate in the absence of a valid will, in order to safeguard Porter's papers as evidence in the imminent court battle over her mother's estate. Drew publicly excoriated Clarksburg officials for releasing Porter's luggage on Sibilla Campbell's bogus authority. In part because of the public pressure he brought to bear in print and over the airwaves upon the West Virginia State Police and in part because of Countess Gizycka's personal appeal to West Virginia governor Clarence W. Meadows, a more thorough investigation not only of the circumstances of Porter's "strange" death but of the unorthodox, late-night release of the dead man's belongings would begin the following morning.

Porter's cousin and self-proclaimed next of kin (despite his having gone unmentioned in the accountant's holographic will) arrived in anticipation of the funeral services that were scheduled to take place on Saturday morning, September 18. Notwithstanding Father Rizer's assertions that Porter, like his former employer, was on the verge of converting to Catholicism at the time of his death, he too was cremated (at whose direction it was unclear) in contravention of church teaching. Drew reported to his diary (without reference to sources or corroborating evidence) that Porter's cousin had been prevented from viewing the body. Rather, he was "kept in Evie Robert's apartment at the Mayflower while the cremation was taking place. Apparently," Pearson added, "they were in an awful hurry to get the body out of the way."

On Tuesday, September 21, under pressure from West Virginia's Governor Meadows, Trooper Swiger and Sergeant Murphy sulkily released their revised and expanded investigation reports. As to Porter's motive in ending his life, Swiger repeated his original determination that "the victim was mentally unbalanced at the time." Murphy concurred that Porter's death was a "plain case of suicide." Although many of the witnesses whom Murphy had interviewed agreed that the deceased was "under a terrible mental strain for some reason" in his last days, the sergeant determined that despite Porter's numerous calls to the *Times-Herald* and the fear that contact with business manager Bill Shelton appeared to have inspired in him, it could not be determined that Porter was "in fear of anyone from Washington, D.C." Case closed.

In the weeks leading up to the September 14 deadline for legally challenging Eleanor Medill Patterson's will, Alicia Patterson Guggenheim had advised her cousin Felicia Gizycka to use the *threat* of a will contest to full effect in wresting concessions from the other legatees. Alicia had been firmly against actually bringing suit, however. Her sympathy for the *Times-Herald*'s staff and her appreciation of the hardships they faced, given the paper's illiquidity, had been deeply ingrained in her not only by her father's example at the *Tribune* and the *News* during her girlhood, but more recently by her own experience at *Newsday*. Now that Felicia had in fact brought suit, Alicia was appalled that her cousin would so unfeelingly prolong the financial hardship of the *Times-Herald*'s rank and file. Whatever criticisms might be made of the paper's product or methodology, its staff was by all accounts extremely hardworking.

So dismayed was Alicia by her cousin's conduct in the affair that she accepted Frank Waldrop and Bill Shelton's invitation to join them as the third trustee for Cissy's McCormick-Patterson Trust holdings, the post Felicia had recently but unsuccessfully demanded for herself. Notwithstanding

the fact that neither man had yet been legally confirmed as an executor empowered to make such appointments, the move had been calculated by all three presumptive trustees to send a public message to Felicia. In selecting Alicia to fill the trusteeship vacated by the death of Cissy's original choice for the position, Shelton and Waldrop had been motivated, they told the *Times-Herald,* by the fact that the late publisher's relations with her niece (in implicit contrast to those she had endured with her daughter) had always reflected "the deepest affection and sympathy." For her part, Alicia told the press that she counted herself "most happy" to accept the appointment, so "convinced" was she that the 1946 will accurately represented her aunt's last wishes. "I shall support it in every way in my power," she added, by implication dismissing her cousin's suspicions of the document and its supporters. Unwilling to engage in a public family feud on the record, Alicia would write Waldrop privately some months later to say, "It is tragic that you had to go through all of the misery and unpleasantness over Aunt Cissy's will, but I don't think you can blame yourself. Aunt Cissy would have wanted you to fight for her and I somehow believe she would have enjoyed the fight." With regard to her cousin, Alicia added, "I think Felicia made a grave mistake in attempting to drag her Mother and the rest of the family through the mud." She closed by saying that "the only excuse I can make for her is that she was a tool of Drew Pearson *et al.*" The dispute would sever relations between the two cousins. Felicia Gizycka would never again see Alicia Patterson, one of her few living relatives and one of the first friends she made in the course of her lonely, disrupted childhood.*

Thickening Plot

— *TIME,* OCTOBER 4, 1948

In Manhattan, the Countess Gizycka found herself ever more deeply mired in what *Time* described as the "Thickening Plot" that was her challenge to her mother's will. On Tuesday, October 12, fatigued by the ongoing legal skirmishes, the raucous and intrusive press coverage, and the torrent of unsolicited mail that the controversy had generated, she left the city for a rest in upstate New York. During her absence that afternoon, two friends called her apartment. Separately, both later mentioned that her phone had

*The cousins soon did have something of a reconciliation in 1963, shortly before Alicia's death, however, "My friendship with Alicia was at an end," as Felicia herself recalled it. "She died young of complications from ulcers. When she was in the hospital we made up on the phone. But I never saw her again."

been answered by someone who "chatted amiably" with each of them; the woman claimed to be a guest of Felicia's and volunteered, obligingly, that her hostess was away and was not expected to return for some time. The news was chilling: "I had no friend staying there," Felicia said. Only the landlady had a key, and neither she nor the maid had answered the phone that afternoon. "The only thing this woman could have gained is information about who was calling me," Felicia reasoned. "It is all very mysterious."

The situation grew even more disturbing over the coming weekend. After returning from the country to her spartan fifth-floor walk-up on East 35th Street, on Saturday, October 16, Felicia went out to dinner with a friend. In apparent confirmation of the late C. B. Porter's earlier allegations that "the Countess' every move was . . . being traced," Felicia was horrified to find the door unlocked and the window to its small sun porch (accessible from the roof of the building) smashed when she returned to her apartment. Detectives dispatched from the local police station concluded that the break-in was a decidedly "amateur job." Despite the obvious damage to the apartment's only possible points of entry and the disarray into which Felicia's papers had been thrown, however, nothing appeared to be missing.

In the coming week, Felicia hired private detectives. They concluded, after a particularly close examination of volumes "pushed out from the wall" in "unusual positions" and a small, telltale pile of wood shavings in one of the bookshelves, that the break-in had permitted the removal of a concealed recording device that had been planted clandestinely at some earlier time. The deliberate amateurishness, the excessive mess, the almost staged quality of the burglary, seemed intended to send a message to Felicia, underscoring her vulnerability. Like C. B. Porter before her, she had new locks installed immediately. Unlike the hapless accountant, however, she sent her own unflinching message back to the perpetrator (or perpetrators). In "good-naturedly" facing her first interview since bringing suit to break her mother's will, Felicia followed Drew Pearson's example. Explaining the recent invasions of her apartment and her role in the pitched battle over the Patterson estate, she linked the two, and, without mentioning names, implied that those who supported her mother's will for probate could be the only possible candidates for recording her private conversations, ransacking her papers, or eavesdropping on her telephone calls. She also took the opportunity to correct what she felt was the false impression that the many sensational press accounts of the affair had created. "I am an American citizen and a writer by profession and I'm getting damned tired of being called 'Countess' and having my small apartment referred to as a penthouse," she maintained, with a shy smile. "If I had my way, I'd be called Mrs. Gizycka."

· · ·

At the *Times-Herald* no story hit closer to home, or more nearly attained the colorful Pattersonian ideal, of course, than the caveat itself. "Make no mistake about it, I consider this Patterson will story one of the best newspaper stories that ever came down the pike," Frank Waldrop scarcely needed to inform the *New York Star.* "We're extremely anxious to get the case on trial at the earliest possible moment," he added. "Once we get the witnesses there under oath we feel that the news will be accurate and ready to go. You can be sure the *Times-Herald* will give it all the play in its power." The same week that the congenial female intruder took to answering Felicia's telephone in New York, attorneys for those who supported Cissy's will faced off against her legal team once again, in Washington, this time in federal court, to settle legal issues preliminary to the prosecution of the caveat itself.

The entangled questions of setting a trial date and gaining access to relevant documents in the discovery process proved to be particularly difficult to resolve. The opposing side denounced as a mere "fishing expedition" Felicia's request to inspect and copy her mother's papers, which were stored among the files at the Times-Herald Building and in boxes and trunks in the attic at 15 Dupont Circle. Her investigative team retaliated by trumpeting publicly their recent discovery that *Times-Herald* employees, "acting at unusual hours," had been removing "large numbers of documents" from the newspaper's records. These included "several loads of checks and account records" which—Felicia's team still refusing to name names—suggested unmistakably to the press had been taken in disproportionately large quantities from the business office (Bill Shelton's domain) before being hauled away, under cover of darkness, to the District incinerator. As putative executors, Shelton and Waldrop shot back indignantly through a representative that the only destruction that had taken place was the routine incineration of "trash which gathers by the ton at any newspaper" and documents that predated Cissy's tenure as editor of William Randolph Hearst's *Washington Herald.* Furthermore, they declared, "so far as the *Times-Herald* is concerned, there can be no unusual hours—for they work 24 hours a day."

The executors' claims of innocent housecleaning were considerably undermined on Friday, October 29, however, when their counsel, Louis Caldwell, made the sheepish public admission that he had discovered seven of Eleanor Medill Patterson's earlier wills while searching through old files at Kirkland, Fleming, Green, Martin & Ellis the day before. In the aggregate, the documents underscored the fickle publisher's propensity for rethinking her last wishes, and charted which of the members of her circle had succeeded in remaining afloat in what the *Washington Post* described as the "ebb and flow" of her regard.

It was Cissy's own descendants, Felicia and Ellen, whose fortunes had

sunk most dramatically. In the earliest of these recently discovered wills, dated January 11, 1924 (eight months before Felicia ran away to California), Cissy bequeathed the bulk of her estate, jewelry, and trust income to her "beloved daughter." Despite the family tensions that continued to grow over the course of the next two decades, Cissy left all of her real estate holdings (with the exception of Flat Creek Ranch, which she bequeathed to her brother) to Felicia, at least initially. In the testaments of 1924, 1933, 1934, 1942, 1943, 1944, and 1946 (and their numerous codicils, along with two other wills, drawn up in 1920 and 1922, that would shortly come to light and *their* various codicils; in addition to an unsigned 1940 will), the growing estrangement between mother and daughter, and the arrival of others to fill Felicia's place, were sadly manifest.

The disposition of the Dower House, in particular, had been in play over the years. The unsigned 1940 will (now housed at the Franklin Delano Roosevelt Library, both the publisher and the president would no doubt be surprised to discover from beyond the grave) bequeathed the property to Luvie Pearson. In the documents dated 1942 and 1943, the *Times-Herald*'s equine columnist, Rhoda Christmas, stood to inherit the property—until the drafting of the 1944 and 1946 documents, which attest to Ann Bowie Smith's ascendancy in Cissy's affections. Despite the alcohol-fueled final confrontation between mother and daughter at the Dower House, Felicia was slated to inherit 15 Dupont Circle until 1944, when, in a fit of reinvigorated wartime anti-Roosevelt vituperation, Cissy bequeathed it instead to the League of Republican Women of the District of Columbia. In 1946 Cissy changed her mind again, and left Patterson House to the American Red Cross.

The deceased had fondly anticipated becoming a grandmother, apparently. Written two years before Ellen's birth, Cissy's 1924 will dictated that if predeceased by her daughter, her Tribune Trust income was to go "in equal shares, per stirpes" to Felicia's "lawful issue." Cissy's beneficence toward Ellen remained unchanged for nearly two decades. The December 1942 will commemorates the rift between the teenage Ellen (or, more accurately, her father) and her grandmother, however. Ten months after Pearson and Allen's "Washington Merry-Go-Round" column defected from the *Times-Herald* to the *Post,* Cissy excised her granddaughter "from participation in any part of [her] estate, income and/or principal."

Although long discussed, Cissy's anxieties about the disposition of the *Times-Herald* appear to have arisen only in the last four years of her life. Between 1939 and 1944 each of Cissy's wills indicated that she intended to leave the paper—at least jointly—to her brother. The 1942 document provides for it to be "disposed of to and published by or under the control" of Joe Patterson—or, if he proved to be unable, then of Alicia Patterson; or,

as a last resort, of Robert Rutherford McCormick. Cissy struck her niece and cousin from the will she drafted the following year, however, in favor of her brother, alone. By the mid-1940s she had begun to look outside the family for a suitable owner for the paper. Inasmuch as Cissy's relations with Felicia, Ellen, Luvie, and Drew had been severed by the early years of the war, the *Times-Herald* became her nearest substitute for a family. Her 1944 will left Frank Waldrop 51 percent of the paper and Bill Shelton 25 percent. The remaining 24 percent was to be divided equally between two other executives, both of whom she fired shortly afterward. Cissy's most recent known will, the disputed 1946 document, seemed to bear out the whisperings that she was tiring of faithful Frank Waldrop—and indeed, of his wily colleague, Bill Shelton. Within two years, she reduced Waldrop's slightly larger than one-half share in the paper to a mere one-seventh. Although she had by then discovered Bill Shelton's financial sleight of hand, she did not disinherit him; rather she reduced his one-quarter share, likewise, to one-seventh.

Should Felicia's challenge to the 1946 will prove successful, one of Cissy's earlier testaments might ultimately be probated instead. The discovery of the seven wills vastly enlarged the aggregate number of potential legatees, to some 160. The court date, originally projected for late November, would have to be postponed indefinitely—probably until January 1949 or later—while a greatly enlarged number of interested parties were located and notified. In the meantime, pretrial depositions of potential witnesses began.

On Tuesday morning, November 9, an uncomfortable Sidney Epstein found himself facing lawyers for both sides. For more than three hours, Felicia's attorneys, Roberts and Kertz, held the reporter's feet to the fire relentlessly, calling him out to justify his role in the dubious recovery of C. B. Porter's personal effects from West Virginia on the night of September 14–15. The reporter could only have been relieved when the proceedings were adjourned. After lunch, C. F. R. Ogilby, whom the court had recently appointed executor for C. B. Porter's estate when the dead man's unwitnessed will had been ruled invalid, gave his deposition. Originally scheduled to appear only on that afternoon between two and four o'clock, Ogilby's comprehensive account of his recent examination of Porter's army footlocker and myriad files, documents, and manuscripts proved to be more illuminating than anticipated. As a result, Ogilby would be required to reappear for an entire additional day of testimony later that week. After Ogilby's departure, *Times-Herald* treasurer John T. Barber arrived to account for his own role in accompanying Sidney Epstein to Clarksburg.

When Ogilby returned on Friday morning, November 12 to resume his testimony, he encountered not only lawyers for all parties, but also—to

everyone's surprise—reporters from the *Times-Herald*'s local competitors, the *News,* the *Star,* and the *Post,* as well as the International News Service. The resumption of Ogilby's testimony was further delayed, until the following Wednesday, by the impromptu legal wrangling on the merits of press coverage of the depositions. On Felicia's behalf, William Roberts demanded that the court bar the press from the proceedings. Representing the Patterson executors, Louis Caldwell argued for allowing them to remain, noting that Drew Pearson had already fed a large number of damaging "affidavits and statements" to the *New York Star,* which the executors wished to answer publicly. Judge Morris finally offered a compromise: reporters would be barred from the pretrial proceedings, but either party could later request that they be present for parts of depositions relating to particular questions. On behalf of the executors, Caldwell agreed, grudgingly—before releasing transcripts of Epstein's and Barber's depositions, as well as the portion of Ogilby's testimony that had been taken thus far, to the local press and wire services.

Although Ogilby's testimony would not be completed until November 17, at his first sitting he had recounted that two months earlier with the court's sanction, he had removed Porter's army footlocker from Smith's Storage and brought it to the Kennedy-Warren, where he surveyed both its contents and the files Porter had kept in his apartment. By the end of this first installment, however, Ogilby had not completed enough of his account to reveal that after finishing his inventory he had returned Porter's footlocker and files safely to storage. After excerpts of the depositions that Caldwell had released to the press appeared in the local papers and radiated from Washington over the wire services during the weekend, Ogilby's legal offices at 613 15th Street, NW, were—like Felicia's New York apartment four weeks earlier—broken into and ransacked. Although Ogilby expressed "great concern" over the safety of Porter's papers in light of the burglary (never mentioning their actual whereabouts), nothing appeared to be missing from his offices.

Felicia's testimony, originally scheduled to begin on Tuesday, November 23, had to be postponed when she was hospitalized in New York with "paroxysmal hypoglycemia." Still far from well when she was discharged on Thanksgiving Day, she managed nevertheless to appear at the Washington offices of Ward & Paul the following Monday, November 29, where she submitted to questioning on the charged subjects of her mother, her mother's mental health, their painful (occasionally violent) relationship, and her own failings. When Felicia finished her exhausting testimony three days later, on Wednesday, December 1, her attorneys filed a motion to seal

her deposition in the interest of privacy. Although counsel for the opposing side had individually or severally fought almost every motion Felicia's legal team had submitted thus far, this request to seal her testimony went forward conspicuously unopposed. Given the long-standing resentments, jealousies, and suspicions that fueled the Patterson will fight, it is unlikely that the opposition hoped to spare her feelings or reputation. Felicia's own belief (seconded by many, particularly Drew Pearson) was that that the closely observed chronicle she delivered of maternal volatility, dependency, and loneliness had "scared" the opposing side into realizing that on the stand in open court Felicia had a credible chance of persuading a jury of not only of the unsoundness of Eleanor Medill Patterson's mind, but of the latter's susceptibility to undue influence at the time she made the will in question. Releasing the deposition to the press, as Louis Caldwell had done with Epstein's, Barber's, and Ogilby's previously, could only work to reinforce the general impression of instability that had taken shape in myriad media accounts of the lady publisher's antics, eccentricities, and piques over the decades.

From this point onward none of the subsequent depositions taken in the Patterson will challenge would be released to the press; purportedly the most damning to the deceased, Felicia Gizycka's would be permanently sealed by the court. Curiously (or perhaps fittingly) for a case broadly rumored at the time to involve skulduggery of many varieties—"murder by remote control," fraud, coercion, embezzlement, attempted bribery, breaking and entering, witness and evidence tampering, wire tapping and intimidation—the depositions taken in the Patterson will fight have disappeared from their place in the public record. Those that were not sealed remain "out of jacket," to this day. That is, they are missing from their assigned file locations at the District of Columbia Probate Court Archive in Washington, D.C.*

On an apparent high after unburdening herself under oath and witness-

*The fact that the depositions are missing is particularly strange given that all other legal documentation relating to the case, including Cissy's numerous wills and codicils, is present, intact, and accounted for; only those files assigned to the depositions are empty. Many months of searching on the part of the archive's staff (at the author's impatient prodding) failed to locate the documents. Their efforts were hampered by the fact that procedural changes requiring that parties requesting access to the archive's holdings present identification and sign for requested documents went into effect, apparently, only after the Patterson depositions had disappeared. Those that still exist survive either because copies were made when they were released to the press (as was the case with Epstein's, Barber's, and Ogilby's depositions), or because they found their way into the hands of the various interested parties who saved them (as in the case of Sibilla Campbell's deposition, which Drew Pearson filed among his own papers, now housed at the Lyndon Baines Johnson Presidential Library in Austin, Texas).

ing what she believed to be the withering effects of her testimony on her opponents, Felicia convened a press conference the morning after, on Thursday, December 2. Still weak from her recent hospitalization, retiring by nature, and unaccustomed to the glare of publicity, her "unusual 'interview,'" as the *Washington Post* described it, took the form of reading answers to selected questions that had been submitted in writing in advance. Her obvious nervousness notwithstanding, she revealed that she thought it likely the suit would be settled in her favor. This happy prospect had given wing to her long-held literary aspirations. Should the court eventually rule her mother's 1946 will to be invalid and award the paper to her instead, Felicia informed reporters (including members of the *Times-Herald*'s staff, who sat agog at her pronouncements), "I would secure the most competent and liberal newspaper executives possible with due recognition of the members of the staff who have proved genuinely loyal to our family." If her recent deposition had frightened the opposing side, her press conference continued to quicken pulses. Although horrified at the prospect of the paper's threatened lurch to the left, a nevertheless gratified Walter Trohan reported through the *Tribune*'s managing editor to Colonel McCormick that "the Countess threw an awful scare" into Frank Waldrop when she announced her plans for the *Times-Herald.*

Indeed, the outlook appeared to be growing even brighter for Felicia when she and her team learned on Monday, December 13, that after months of legal dickering C. B. Porter's files and manuscripts, as well as her mother's many trunks and boxes full of papers, would at last be available for her team to examine as part of the discovery process.

Mrs. Gizycka "Frozen Out," Lawyer Says

— *WASHINGTON POST*, JANUARY 15, 1949

Felicia Gizycka's challenge to her mother's will continued as 1948 drew to a close. Attorneys for both sides continued to hear depositions from witnesses in anticipation of a court date projected for late January or early February 1949. After Sidney Epstein, John T. Barber, C. F. R. Ogilby, and Felicia Gizycka submitted themselves for questioning, a host of Cissy Patterson's former butlers, housekeepers, maids, cooks, secretaries, and attorneys followed over the course of December and January.

Although all of these depositions later vanished inexplicably from the D.C. Probate Court Archive, suggestions of their content survive in the recollections of those few who heard the testimony or read the closely cir-

culated transcripts immediately afterward. Especially indelible for its sheer lewdness was the account offered by Archie Lye, the butler who had discovered Cissy's body the morning after her death. According to Harold Kertz, the head of Felicia's legal research team, Lye's testimony (like several of the other servants' accounts, reportedly) was rife with wild tales of drug- and alcohol-fueled "sex parties" at the Dower House pool. These purportedly took the form of orgiastic circuses over which Cissy Patterson presided as ringmaster, directing some of her nubile young friends (most notably the *Times-Herald*'s gamine art director, Jackie Martin, and the pretty country matron, Ann Bowie Smith) to participate in aquatic "acts of lesbianism," occasionally involving the use of "dummies," while partygoers ogled the performers, poolside. How Lye and his colleagues managed to glimpse so much of the debauchery and recount it in detail is unclear inasmuch as the butler also reported that domestics were barred categorically from the revelry. Without the depositions themselves, it is likewise uncertain whether Lye or the other deposed members of the Dower House staff reported accurately, whether they took the opportunity to vent old resentments against their querulous employer, or whether they simply gave free rein to lubricious fantasy in their recollections. It is also impossible to know how accurately Kertz recounted his memories of their lost depositions. Having read the transcripts herself, not surprisingly Ann Bowie Smith took umbrage at their contents, sniffing, "There are so many lies." A young *Times-Herald* reporter who, like Smith, had regularly attended Cissy's pool parties over the years recalled that, indeed, the "Dower House saw some wild parties." In her experience, however, these involved "just lots of drinking, and leaping in the pool, strange costumes. Don't think anybody leapt in with their clothes off, though." Cissy Patterson, as she put it, had "a great streak of childishness in her—probably one of her main charms. She seemed to like people who had a childlike quality too—a sense of nonsense and irreverence."

Despite her post-deposition optimism, in the course of the Christmas season of 1948 Felicia Gizycka's calculation of the relative benefits—and costs—of winning her suit brought about a radical change of heart. After the New Year, she informed her team, to their utter amazement, that after five months of legal struggle and investigation, interviews with thousands of potential witnesses, suicides, burglaries, wiretapping, and surveillance, she had simply decided to drop the case. "I didn't want to go to court," she said, "I didn't want to show up Cissy as drunk and crazy." Attorney Randolph Paul's recent "discovery" that her share of the estate would be consumed by taxes, Felicia added, had contributed to her decision. On Friday, January 14, 1949, without betraying his client's baffling decision, attorney

Bill Roberts announced to the press that the Patterson estate, now estimated "conservatively" at some $17,900,000, stood to pay some $10,500,000 in "Federal taxes alone." The heavy estate tax would likely preclude the payment of any of the cash bequests that Cissy had intended, including the $25,000 designated annually for Felicia herself. The supporters of the 1946 will, Roberts charged, had in effect conspired to prevent the only child of the deceased from receiving her inheritance.

No longer speaking of breaking the will and making Felicia Gizycka sole heir to the entire Patterson estate, Roberts instead criticized the document almost as if its admission to probate were a fait accompli, arguing that the fact that Cissy's only daughter would be "deprived" of her inheritance by taxes must have been known not only to Cissy and those who drafted the will, but also to those potential legatees who supported it for probate. And yet, the fact that the estate would be heavily taxed was no secret. Furthermore, it would be taxed at the same rate no matter who stood to inherit. While it was disingenuous of Roberts to suggest that the supporters of Cissy's 1946 will conspired to "freeze" Felicia out of her inheritance, the charge furnished both public cover and scapegoats for her decision to abandon the suit.

Even to her own counsel, Felicia's stated reasons for dropping the case seemed at best "very specious." Harold Kertz suspected that his client was "more concerned with her *own* future and reputation" than with preserving her mother's good name. Indeed, could the reputation of the erstwhile "most hated" woman in America be further tarnished? Although the press had been barred from Felicia's depositions and the transcripts had been sealed, had she gone forward with her suit she would have been reexamined on the same matters—many of them painful, salacious, and compromising. Further, her testimony would have been heard in open court before a gallery of local spectators and a throng of national and international reporters, eagerly anticipating what was widely expected to be "the juiciest, most lurid trial in generations," as one *Time* reporter put it. What was it, then, that Felicia was willing to keep hidden in exchange for a small fortune and her birthright?

According to Kertz, opposing counsel had subjected his client to a barrage of questions relating not simply to her mother's alleged "perversions" but to her own as well. "Felicia never categorically admitted to anything about lesbianism," Kertz rememberd, "but *they* had circumstantial evidence . . . She admitted to sharing apartments with these people, but denied engaging in any acts of lesbianism."

On her rigorous national lecture tours, Mrs. Marty Mann repeated what would become a familiar refrain: "We must overcome the stigma of sin that

has been fastened upon the alcoholic if we are to get anywhere." But while she and her colleagues made sweeping headway in dissociating alcoholism from veniality in the popular mind, Marty Mann was deeply aware that the blossoming organizations to which she had devoted her life stood to be irrevocably blighted by any taint of "sexual deviance." As a result, already burdened with the public relations encumbrances of being a recovering alcoholic and a woman, she took careful steps to prevent her sexual orientation from becoming known outside of her circle of close friends or publicly associated either with her work for the National Committee for Education on Alcoholism or with the Alcoholics Anonymous movement generally. Indeed, as her biographers Sally and David R. Brown put it, in her distinguished professional life "Marty's use of the title *Mrs.* served the purpose of blurring her real orientation." Within the necessarily insular gay and lesbian communities of Manhattan and Fire Island, Marty Mann and Priscilla Peck were known as a committed couple. To outsiders, they were "friends" and "roommates." The couple did nothing to hide the fact that they lived together; indeed, their unmarried, heterosexual counterparts did so customarily for the sake of economy and safety. In 1954 the couple would sell the cottage at Cherry Grove, where Felicia had been a constant presence over the preceding decade. As Fire Island developed a reputation as a gay and lesbian summer retreat during those same years, Marty arrived at the conclusion that she could not risk the exposure that her continued presence there might occasion.

Although Felicia admitted freely that she loved and admired Marty and Priscilla and credited them with saving her health if not her life, she did not share her friends' sexual orientation. Twice divorced, bohemian, and, for the time, uncommonly forthright about her personal troubles, Felicia was unusually—but not entirely—impervious to the sting of public censure. As Charles Bell Porter had understood, the threat of public exposure as a homosexual—or simply as an associate of known homosexuals—was a grave, indeed in many jurisdictions a criminal matter in the late 1940s. Whether the Patterson will case's "unnamed parties" threatened Felicia or her closest friends with public exposure as lesbians if she failed to drop her suit is unclear. Nevertheless, in the six weeks following her pretrial questioning she appears to have apprehended more fully the extent to which her testimony in open court stood to compromise not only her late mother (as she insisted to her lawyers), but herself, her closest friends, and, potentially, the nascent Alcoholics Anonymous movement. "My friends and my sponsors in the outfit begged me to desist," Felicia recalled in the memoir she drafted toward the end of her life. She had always and would always maintain that she had little interest in her mother's money. Whatever her unstated reason, abandoning her suit to break the will had the effect of

leaving her friends' public reputations and privacy intact and allowing both them and herself to continue contributing to the growth and fruition of an organization that would salvage countless lives, as it had theirs already.

Harold Kertz took the news that Felicia intended to drop the suit especially hard. Between September 15, 1948, and January 2, 1949, he estimated that he had devoted "16 to 18 hours a day, Saturdays, Sundays, holidays, Thanksgiving, Christmas," in short, almost all of his waking hours, to proving Felicia's case. Learning of her decision, Kertz and his colleagues Roberts, Paul, and Garrison rushed to confer with their inscrutable client in a desperate effort to persuade her to continue. Their arguments fell on deaf ears until Kertz, pleading that he had staked his professional reputation on her case, managed to beg a two-week grace period in order to attempt to bring about a settlement.

Despite Felicia's (still undisclosed) decision not to pursue her caveat to her mother's will, the deposition of potential witnesses continued with the executors' attorney, Louis Caldwell, giving his testimony on Friday, January 21, 1949. That weekend, Kertz phoned Caldwell; although professionally at odds in recent months, the two attorneys were old friends. The court date had been set for Friday, February 4. "If you want to settle this case let's talk now," Kertz ventured, never divulging that his client was determined to drop her suit entirely. After conferring with attorneys for the various legatees, executors, and trustees on Sunday morning, Caldwell called Kertz, who was then on his way out to church with his wife, asking him to join opposing counsel for a meeting downtown at the Willard Hotel. Kertz arrived within fifteen minutes. The rest of Felicia's legal team joined them shortly afterward and spent all afternoon and the early part of the evening hammering out a settlement.

After his weekly radio show that Sunday night, Drew Pearson received a call from Felicia's attorney Randolph Paul, who was in "high dudgeon." The Patterson will contest, Paul informed him, had been all but settled before Pearson announced over the ABC Radio Network nationwide that the Justice Department was about to investigate and would "probably prosecute a Washington attorney" (that is to say, the executors' counsel, Louis Caldwell of Kirkland, Fleming, Green, Martin & Ellis) for "withholding early copies" of Cissy Patterson's wills. Hearing Pearson's broadcast at the Willard along with the assembled attorneys for both sides, Caldwell had grown "white and shaky" before stammering that, under the circumstances, there could not now be a settlement. Publicly it would appear that Caldwell had capitulated in order to escape indictment.

Despite this near resolution of the case on Sunday, Cissy's "executive

housekeeper" Sibilla Campbell appeared for her deposition during the morning session the following day, Monday, January 24, to be followed in the afternoon by one of Cissy's former personal secretaries, Kay O. McCarter. Behind the scenes, however, Caldwell's wounded professional pride had been soothed. The settlement was reconfirmed and agreed upon, and all depositions scheduled for the days before the appointed court date on February 4 were canceled.

With "dramatic suddenness" at five o'clock in the afternoon on Wednesday, January 28, reporters were called into Bill Roberts's offices in the District Transportation Building. To the surprise and disappointment of the press, the opposing sides in the lurid, five-month Patterson will fight had reached "full agreement." The seven executives would shortly be the *Times-Herald*'s new owners, "share and share alike." Evie Robert would at long last lay hold of the peerless Youssoupoff pearls and Cissy's Connecticut Avenue commercial properties. Ann Bowie Smith was to become the new chatelaine of the Dower House. Although Felicia Gizycka had consented to renounce her claim to an annual tax-free income of $25,000, she had not emerged empty-handed. Rather, the settlement left her with a lump sum of $400,000, after taxes, of which the *Times-Herald*'s seven new owners were to contribute $377,500, Evie Robert $15,000, and Ann Bowie Smith $7,500. All other bequests were to remain as stated in Cissy's 1946 will. In addition to her cash settlement, Felicia would also inherit the Long Island and North Dakota properties along with her mother's personal effects.

"Washington could hardly wait for the trial of Countess Felicia Gizycka's suit," *Time* reported, adding mournfully, "It promised to rattle many a family skeleton." "The settlement was really hush money: by taking much less than she might have gotten in court, Felicia kept her own and her mother's reputations," a *Time* Washington correspondent speculated, incompletely perhaps—but not wholly inaccurately. "By giving up a little of their legacy, the heirs did the same thing for their reputations. The case is history, and everybody is happy," he concluded, adding, "except maybe the press." After months of detailing for Colonel McCormick the latest twists and turns in the Patterson affair, all the while lambasting Frank Waldrop, Walter Trohan hastened to offer felicitations. "Congratulations!" he oozed to Waldrop upon learning of the settlement. "Better late than never."

Although the settlement had precluded Cissy Patterson's 1946 will and its codicils from being challenged in open court, on Wednesday, February 9, a jury was impaneled before Judge Holtzoff of the United States District Court for the District of Columbia to put to rest the issues raised by Felicia Gizycka's caveat. The documents in question were ruled to have been "executed and attested in due form, as required by law." Likewise,

Cissy was determined to have been of "sound and disposing mind" at the time that she made the will and its codicils. Finally, the jury decided that no fraud, deceit, or undue influence had been practiced upon the deceased. Eleanor Medill Patterson's last will and testament, dated June 21, 1946, along with its codicils, could at last be admitted to probate.

The *Times-Herald*'s seven new owners were jubilant. Champagne corks popped on H Street. Felicia Gizycka, cash almost in hand after nearly a decade of poverty and struggle, posed shyly for photographs on the courthouse steps in the cold. Afterward, walking alone past the White House through the slush on Lafayette Square, she reflected that it was she who had triumphed, despite emerging with "the loneliness of a victor." Although she had grown up in Washington, she no longer had friends there. She wished she could call her cousin Alicia, but felt, in light of all that had come between them, that she could not. "I took up my life where I left off, writing and selling stories, helping alcoholics to sober up in our outfit, getting great moral support from my beloved sponsors and my many friends in New York."

EPILOGUE

Remembering the many years he spent in Eleanor Medill Patterson's employ, Frank Waldrop would later reflect that "the companions of my work," his colleagues at the Washington *Times-Herald,* had over the years "scattered in country clubs, lunatic asylums, graveyards and work houses, that is to say, prisons, from one end of the world to the other. A few are even unreformed and respectable, engaged in the old original undertaking," he added of those who had remained in journalism.

Eleanor Medill Patterson, by reputation "probably the most powerful" and the "most hated" woman in America in the 1940s, generated controversy and discord not only in life, but also for some time after her death. Hers was a restless spirit, and, although largely forgotten by the turn of the twenty-first century, seemed to haunt those who had known her for many years after her death. "A funny thing about Mrs. Patterson," one *Times-Herald* veteran reporter remembered, "the memory of her kinda hurts. You feel you wish you could've done something for her, that you'd been more mature, and understood what was making her act in the agonizing way that she did."

In April 1949, Jackie Martin, the *Times-Herald*'s former art director and photographer, slipped a note to Frank Waldrop between the pages of the scrapbook of photographs he had recently commissioned to commemorate Cissy Patterson's tumultuous, spectacular tenure at the helm, first of Hearst's *Washington Herald* and then of her own cherished *Times-Herald,* between 1930 and 1948. "Strange," Martin confided to Waldrop,

> but often as I was working on this job I felt the Boss' presence in my small darkroom . . . sort of looking over my shoulder as she used to do . . . not saying very much . . . knowing I would pick up her wishes and desires out of the air. I think she will often be near you as you pore over this . . . because I am sure that you will do it with compassion and love and affection in your heart for her . . . she needed it so much . . . and somehow I am sure that her spirit is even now returning to the well where she can drink the cool water (wouldn't she howl at this . . . water) she yearned for and yet disdained before. I hope, Frank, that when you are sorely tried and need guidance those around you can't or won't give, that

"This is something I had done for my private, personal remembrance,
at Christmastime, 1948—Butch looking for her. KILLS ME!
This is an *imitation* of her handwriting. Sort of thing she liked to do—"

—FRANK WALDROP, handwritten inscription on the card he had printed
in the style of Cissy's annual Christmas cards, following her death

you will be able to turn to some of these pages and find the answers that
will be right.

For Waldrop—who had in some ways been the son Cissy Patterson
never had, who had honed his journalistic and editorial skills at her knee,
who had been subject to her caprices, who had been the champion of her
public battles and feuds—the loss of "the Lady" would leave a void not
only in his life, not only at the *Times-Herald,* but in the capital generally.
"You have no idea how insufferably puny and dull this town is, now," he
wrote a friend two years after Cissy's death. "Even the feuds are pea-shooter

stuff. I feel as if I had died and see it from afar, all passion spent, and interest detached."

Felicia Gizycka, who believed she had heard her departed mother berating her out of the darkness at the Dower House, would also experience what she felt were the palpable signs of Cissy's continued, haunting presence over the years. During an interview Felicia granted a biographer one evening in the early 1960s on the subject of her colorful mother and their strained relations, she and the researcher heard a loud, inexplicable thud in an airless closet off the room where they sat. Although there was nothing that could have pushed it, a paper bag full of heavy Christmas ornaments had fallen to the ground. Visibly shaken, the man left soon afterward. Recalling that her mother had never approved of having gentlemen callers in her apartment after dark, Felicia apologized aloud for revisiting the tumult of their relationship with a stranger. On another occasion, while Felicia sat with a friend in her apartment, both women witnessed a book "pushing itself" off the bookshelf and landing heavily on the floor. The event drove the friend "nearly out of her wits." Picking up the volume, Felicia found it was a copy of Kipling's *Kim,* from which Cissy had often read to her when she was a child recently arrived at her new home in the United States.

Felicia would marry for a third time ten years after her mother's death. She supplemented the cash settlement she had received from Cissy's estate by continuing to sell her work. A number of her autobiographical pieces, recounting her tempestuous relations with her mother, appeared over the years in *Vogue, Washingtonian,* and *Teton* magazine. After she had been sober for four years, one of her short stories, "Beautiful Summer in Newport" (concerning two rich, warring young sisters and their villainous Fraulein), received considerable acclaim upon its publication in *Story Magazine* in 1947, and would even be reprinted in *Story's* compilation *Fiction of the Forties,* alongside the work of Tennessee Williams, Norman Mailer, J. D. Salinger, Truman Capote, William Faulkner, and Langston Hughes. After the relapse Felicia suffered eight months after her first Alcoholics Anonymous meeting, she would remain sober for the rest of her life. "Every day, I feel a little bit more useful, more happy and more free," she wrote in 1955. "Life, including some ups and downs is a lot of fun. I am part of A.A. which is a way of life. If I had not become an active alcoholic and joined A.A., I might never have found my own identity or become part of anything." Felicia continued to write into old age. Angered by what she considered the gross mischaracterizations that appeared in a published account of her mother's life in the late 1970s, she drafted a memoir of her own over

the next two decades. Although her manuscript would never be published, she believed that "writing this book is an exorcism, the healthiest thing I can possibly do now." Among her various drafts Felicia ventured, "I do forgive her, and wish her well and want her well wherever she is." When Felicia died in Laramie, Wyoming, at the age of ninety-three in April 1999, she was buried in the Aspen Cemetery on Snow King Mountain outside of Jackson, next to Cal Carrington.

For eighteen years, Eleanor Medill Patterson fed the appetites of her readership by following the family recipe of "Dogs! Cats! Murder!" (with "Horses!" thrown in after she launched Rhoda Christmas's equine column in 1938) to manifest success. Encapsulated in two words, the "prescription for a healthy newspaper" that she had inherited from her grandfather was simple: "CIRCULATION and ADVERTISING." By the close of the 1948 business year, the year she died, the *Times-Herald* was healthy indeed. With a reported daily circulation of 260,912, and 313,413 on Sundays, her "American Newspaper for Americans" was, by a wide margin, the leading paper in Washington, D.C. Its closest rival, the *Washington Star,* could only boast a daily circulation of 214,212 and 233,971 on Sundays. The *Washington Post* ran third with a daily readership of 165,554 and a Sunday circulation of 174,310.

If Cissy Patterson had fashioned the *Times-Herald* in her own image— "INTERESTING" (as Arthur Brisbane had predicted), catty, hilarious, sneaky, attractive, lying, inquisitive, infuriating, humane, savage, elegant, truculent, tale-bearing, offensive, progressive, isolationist, quixotic—the relationship between the publisher and the newspaper she had long wished for and lovingly, if fitfully shaped had also been both a symbiotic and a necessary one. That is, neither could flourish—or indeed survive— without the other.

In attempting to make a success of the *Herald,* the *Times,* and eventually the *Times-Herald* over the course of her eighteen-year career, Cissy had joined the ranks of some of the most canny and illustrious, even notorious, figures in early- and mid-twentieth-century American newspaper publishing. Although her tenure had begun as a publicity stunt, the ill-prepared lady publisher came to dominate the circulation figures in the nation's capital, where her eminent mentors had failed. Indeed, Joe Patterson had warned his sister against entering the notoriously difficult Washington market entirely. In his own Washington publishing venture, Arthur Brisbane had succeeded only in unloading his foundering *Times* upon William Randolph Hearst. Steadily hemorrhaging millions of dollars over the course of "the Chief's" ownership, together Hearst's Washington papers

contributed to his near bankruptcy by the end of the 1930s. Despite adhering to the same proven formulas and methodologies that had made the late Eleanor Medill Patterson's *Times-Herald* the most widely read newspaper in the nation's capital for more than a decade, only a year after taking possession of the paper the seven legatees who had helped Cissy run it during her lifetime were forced to sell it amidst falling circulation and advertising revenues. The buyer, as Cissy had suspected and feared, was her cousin, the Midwest's most successful newspaper publisher. With Colonel McCormick at the helm, circulation and revenues only continued their downward trajectory, however, despite (if not because of) his bald efforts to force the *Times-Herald* into the *Tribune* mold. "When she died the *Times-Herald* died with her," Frank Waldrop would later reflect. "Certainly, for all its apparent vigor and frenzy for life, it did not survive her very long."

On St. Patrick's Day 1954, the *Times-Herald* was sold again, this time to a buyer whom Cissy would, at least at one point, have considered even more odious than her cousin: the *Washington Post.* With much of the old *Times-Herald* veteran staff dispersed, its presses and typefaces scrapped, its building sold and its morgue subsumed, the once-dominant daily survived for two more decades as a wraith of its former self. Until the Watergate era, the paper that had absorbed it was published as the *Washington Post* (and beneath it, in considerably smaller typeface) *Times-Herald.*

"Nobody with sensitive intelligence can be happy for any length of time," Cissy had brooded in one of her boxed front-page editorials. In a momentous, often anguished life, the Washington *Times-Herald* was Cissy Patterson's great, perhaps her only, success. She had died in luxury, albeit alone. Many of those to whom she had once been closest were either dead or estranged from her. If, in her characteristic fitfulness, she had ever found contentment in a relationship with another human being it was typically short-lived. Spoiled and headstrong, the charming girl had flouted her parents' dire warnings and bound herself to the titled parasite who was to brutalize her far from home and make her notorious internationally. After the struggle to retrieve the daughter he had stolen from her, Cissy had found little satisfaction in acting, fiction, blood sports, or remarriage and perhaps less in motherhood. Once gratified, her long-held attraction to (or, as some characterized it, predisposition for) newspaper publishing not only channeled her native restlessness and belligerence, but also captivated and held her fickle attentions as nothing else ever had, or would again. As the *Times-Herald* would survive the loss of its publisher and animating spirit only briefly, so newspaper publishing had been a vital necessity to Cissy Patterson. "If you cannot find peace by losing yourself in work for the common good, try losing yourself in work for your own good. But, one way or

another, lose yourself in work," she counseled from her particular podium, a signed box on the front page of her *Times-Herald,* as ever universalizing her own unique experience:

If you try losing yourself in play, you will find yourself neither peaceful nor happy.

I know, for I have tried.

—ELEANOR PATTERSON

ABBREVIATIONS

For the sake of simplicity and clarity in the notes that follow, Cissy is referred to throughout as EMP, no matter what her name was (Elinor Josephine Patterson, Countess Eleanor Gizycka, Mrs. Elmer Schlesinger, etc.) at the time the document cited was written. References to her published writings, however, cite the name she signed to the work. Likewise, citations for legal documents and depositions refer to her name at the time.

AAB	Baron Aleksandr Aleksandrovich Budberg
AB	Arthur Brisbane
ABS	Ann Bowie Smith
AHP	Alice Higinbotham Patterson
APG	Alicia Patterson Guggenheim
ARL	Alice Roosevelt Longworth
CBP	Charles Bell Porter
CC	Cal Carrington
CDN	*Chicago Daily News*
CT/CDT	*Chicago Tribune* (pre-1860)/*Chicago Daily Tribune* (1860–1948)
CFRO	C. F. R. Ogilby
CGJ	Dr. Carl Jung
CJM/P	Jackie Martin/Papers
DP	Drew Pearson
DPP/LBJL	Drew Pearson Papers, Lyndon Baines Johnson Presidential Library
E&P	*Editor & Publisher*
EMP/P	Eleanor Medill Patterson/Papers
EPA/P	Ellen Pearson Arnold/Papers
ERMP/S	Nellie Medill Patterson/Scrapbook
FCW/P	Frank Waldrop/Papers
FDR/L	Franklin Delano Roosevelt/Presidential Library
FF	*Fall Flight*
FG/P	Felicia Gizycka/Papers
F&S	*Field & Stream*
GA	George Abell
GH	*Glass Houses*
HB	*Harper's Bazaar*
HMFP	Hanna-McCormick Family Papers
JB	Joseph Brooks
JG	Count Josef Gizycki
JHHSM	Jackson Hole Historical Society and Museum
JLM	J. Loy ("Pat") Maloney
JM	Joseph Medill
JMMcC	Medill McCormick
JMP/P	Captain Joseph Medill Patterson/Papers

KPM	Kitty Patrick Medill
KMMcC	Kate Medill McCormick
LAT	*Los Angeles Times*
LMP	Luvie Moore Pearson
LoC	Library of Congress
MM/P	Marty Mann/Papers
MSP	Mason Peters
MWMGR	*More Washington Merry-Go-Round*
NARA	National Archives and Records Administration
NYDN	New York *Daily News*
NYS	*New York Star*
NYT	*New York Times*
PFH	Paul Healy
RC	Rose Crabtree
RdeC	Roland de Corneille
RGIA	*Rossiiskii Gosudarstvennyi Istoricheskii Arkhiv*
RGM/P	Ralph G. Martin/Papers
RHMcC	Ruth Hanna McCormick
RRMcC/P	Colonel Robert Rutherford McCormick/Papers
RSMcC	Ambassador Robert Sanderson McCormick
RWP	Robert Wilson Patterson, Jr.
SC	Sibilla Campbell
SE	Sidney Epstein
SEP	*Saturday Evening Post*
T&C	*Town & Country*
TA	Tyler Abell
TJW	Tom ("T. J.") White
TR	Theodore Roosevelt
WCH	Walter Howey
WH	*Washington Herald*
WJT	Walter Trohan
WMGR	*Washington Merry-Go-Round*
WP	*Washington Post*
WT	*Washington Times*
WT-H	Washington *Times-Herald*
WRH/P	William Randolph Hearst/Papers
WRS	Bill Shelton
WW	Walter Winchell

NOTES

PROLOGUE

3 "Our patience"; "a plan"; "insane"; "particularly despicable"; "work of hatred": Adolf Hitler quoted in "Textual Excerpts from the War Speech of Reichsfuehrer in the Reichstag," *NYT,* Dec. 12, 1941, 4.

3 "President Roosevelt was lying"; "monumental scoop": Frank C. Waldrop, "A 'Scoop' Gave Axis Our World War II Plans," *WP,* Jan. 6, 1963, E5.

4 "Anglo-Saxon war plans": *Oberkommando der Wehrmacht* to Adolf Hitler, quoted in Thomas Fleming, "The Big Leak," *American Heritage,* December 1987, vol. 38, issue 8, http://www.americanheritage.com/articles/magazine/ah/1987/8/1987_8_64.shtml.

4 "the damndest newspaper": William P. Flythe, Jr., "A Fabulous Era Was Ended When the Times-Herald Died," in "The Thirty Club," fifth annual reunion of the staff of the Washington *Times-Herald,* commemorative booklet, March 17, 1959, 3, CJMP, box 1, "Autobiographical."

4 "printer's ink blood": Stanley Walker, "Cissy Is a Newspaper Woman," *SEP,* May 6, 1939, vol. 21, no. 45, 22.

4 "One day"; "Cissy Patterson"; "And perhaps": Dickson Hartwell, "No Prissy Is Cissy," *Collier's,* Nov. 30, 1946, 21.

5 "everlasting problem child": Walker, "Cissy Is a Newspaper Woman," 22.

6 By 1936, the green: In 1929, the year before Patterson became publisher of the *Herald,* the paper's daily circulation was 51,861. In 1936, after her first five and a half years on the job, daily circulation had reached 101,234. J. Percy Johnson, ed., *N. W. Ayer & Sons' Directory: Newspapers and Periodicals 1929* (Philadelphia: N. W. Ayer & Sons, 1929), 167. J. Percy Johnson, ed., *N. W. Ayer & Sons' Directory: Newspapers and Periodicals 1936* (Philadelphia: N. W. Ayer & Sons, 1936), 140.

6 "a chronic tail-ender": "The Passing of Cissy," *Newsweek,* Aug. 2, 1948, 52.

6 "electric"; "Washington went"; "sported": Bill Flythe, commemorative plaque presented by members of the Thirty Club (former *WT-H* employees), n.d., RGMP.

8 "know when they were": ABS interview, transcribed tape recording, n.d, RGMP.

8 "It was the kind": "Thickening Plot," *Time,* Oct. 4, 1948, 51.

8 "When your grandmother": JM and EMP quoted in DP to FG, Sept. 15, 1932, 3, DPP/LBJL, G210, 1 of 5, "Family."

PART I: ELINOR JOSEPHINE PATTERSON

GO WEST, YOUNG MAN

13 "One winter night"; "I saw"; "were left"; "to pay": JM quoted in unidentified clipping, n.p., n.d.(ca. 1895), "Scrapbook Kept by Mrs. Robert Patterson," FCWP, Box 25, Topical File, "Patterson, Eleanor—Scrapbook Kept by Mother," hereafter cited as ERMPS, 18.

13 "read only"; "vigorous and analytical mind"; "decided opinions"; "sterling moral

qualities": Margaret Corbett Medill obituary, n.p., n.d. (Dec. 14, 1889), unidentified clipping, in ERMPS, 20.

14 Change in spelling of family name: On a visit to Dublin, Ireland, in 1938, JMP met his Madill relatives and informed his cousin RRMcC back in Chicago that "grandpa's father changed his name from Madill to Medill after he went to the new world." JMP to RRMcC, July 24, 1938, RRMcCP.

14 "a little more": JM to Henry Donovan, Dec. 23, 1889, reproduced in *The Eagle,* Summer 1914, n.p., in ERMPS, 5.

14 "came by self-denial": JM, quoted in Richard Norton Smith, *The Colonel: The Life and Legend of Robert R. McCormick, 1880–1955* (Boston: Houghton Mifflin, 1997), 5.

15 "Journal of Politics": *New York Tribune,* quoted in John Tebbel, *The Compact History of the American Newspaper* (New York: Hawthorn, 1969), 105.

15 Account of the Patrick family household in New Philadelphia: Katherine Patrick Harper, written reminiscences, July 1931, FGP.

15 "the comfort of his old age": FG, "List of What to Add and What to Insert—Book Redo—April 1988–Aug. 1991," unpublished memoir draft, 3, FGP.

16 "That would settle it": Ibid.

16 "the privilege"; "Elliot had me"; "Well, I worked"; "got mad"; "I liked it": JM quoted in "Mr. Medill's Career," *CDN,* May 7, 1890, n.p. in ERMPS, 6.

17 "I was launched": Ibid.

18 KPM exchanging one tyrant for another: FG, "List of What to Add and What to Insert—Book Redo," 4.

18 "The honor"; "I began": JM quoted in "Joseph Medill Is Dead," *CDT,* March 17, 1899, 7.

19 "No more slave states": National Republican Party platform quoted in "Joseph Medill Is Dead."

20 "Were you ever"; "done everything"; "I was once"; "finished elegance"; "turmoil of the prairie metropolis": "Joseph Medill Is Dead."

20 "laying aside": *Illinois State Journal* quoted in Lloyd Wendt, *Chicago Tribune: The Rise of a Great Newspaper* (New York: Rand McNally, 1979), 74.

21 JM's account of Lincoln's Bloomington speech comes from "Mr. Medill's Career," *CDN,* May 7, 1890, n.p., in ERMPS, 6–7.

21 "Every other newspaperman": JM to Ida Tarbell quoted in Wendt, *Chicago Tribune,* 76.

22 "to put an end": Wendt, *Chicago Tribune,* 86.

23 KPM's respiratory problems as psychosomatic: FG, "Start of the Book Chapt. III—February 25, 1986," unpublished memoir draft, 32, FGP.

23 "It is pleasant"; "For pity's sakes"; "Are you demented?": KPM to JM, quoted in Wendt, *Chicago Tribune,* 109.

24 "as far outside"; "It was the meanest": JM, quoted in Newton MacMillan, "Reflections of Lincoln Furnished by Joseph Medill," *CDT,* April 21, 1895, 47.

24 "H-how d-d'ye know?": David K. Cartter, quoted in ibid.

24 "I know": JM, quoted in ibid.

24 "Mr. Chairman!": David K. Cartter, quoted in Wendt, *Chicago Tribune,* 122.

25 "delirious cheers": "The Scene at the Wigwam," *CDT,* May 19, 1860, 1.

26 The respective holdings of the five Tribune Company owners: Wendt, *Chicago Tribune,* 143–44.

26 "the cruel vindictive millions"; "no forgiveness": JM to Abraham Lincoln, April 14, 1865, quoted in Smith, *The Colonel,* 23.

26 circulation of about 4,000: Wendt, *Chicago Tribune,* 86.

26 *Press and Tribune*'s circulation: Tebbel, *Compact History of the American Newspaper,* 130.

CHEER UP

28 1871 Chicago fire-preparedness statistics: Donald L. Miller, *City of the Century* (New York: Simon & Schuster, 1996), 145.

28 Chicago as the fastest-growing city: Ibid., 144.

28 "miserable alley": Joseph Edgar Chamberlain quoted in David Garrard Lowe, ed., *The Great Chicago Fire* (Mineola, N.Y.: Dover, 1979), 7.

28 "scene of desolation"; "sea of fire"; "stood like a mailed warrior"; "Long after": "The Tribune," *CDT,* Feb. 15, 1873, 2.

29 "crawled under the sidewalk": William Bross, quoted in Mabel McIlvaine, ed., *Reminiscences of Chicago During the Great Fire* (Chicago: Lakeside Press, 1915), 81.

29 "haven of refuge": "Joseph Medill Is Dead," 7.

29 "CHEER UP.": *CT,* Oct. 11, 1871, 2.

30 "old rheumatic troubles": JM, quoted in Wendt, *Chicago Tribune,* 245.

31 "Once more"; "The paper passed"; "On the 9th": JM to Elihu Washburne, Nov. 1, 1874, quoted in Wendt, *Chicago Tribune,* 247. Emphasis in original.

BEFORE THE ALTAR

32 "I *told you*": KMMcC quoted in Alice Albright Hoge, *Cissy Patterson* (New York: Random House, 1966), 7. Emphasis in original.

32 "Is it my fault": JM quoted in Ralph G. Martin, *Cissy* (New York: Simon & Schuster, 1979), 15.

32 "the two biggest bitches in Christendom": FG, "Start of the Book Chapt. III," 19.

32 "caught the smell": JM quoted in "Joseph Medill Is Dead," 7.

33 "He was a hell of a good newspaperman," EMP quoted in Hoge, *Cissy Patterson,* 6.

33 JMP on RWP as editor: Paul Healy, *Cissy* (New York: Doubleday, 1966), 20.

33 "the unproductiveness": Robert Wilson Patterson, "Autobiography and Questions Private and Public in Which I Have Been Specially Interested," unpublished ms., December 1891, JMPP.

34 JMP on RWP as an editor: Hoge, *Cissy Patterson,* 5.

35 "an institution of learning": "Articles of the Lake Forest Association, Adopted February 28, 1856," quoted in Franz Schulze, Rosemary Cowler, and Arthur Miller, *30 Miles North: A History of Lake Forest College* (Lake Forest, IL: Lake Forest College, 2000), 15.

35 "moderate"; "expedient": Ibid., 19.

35 "sylvan features": Rev. Robert W. Patterson, Sr., quoted in ibid., 10.

35 RWP hired at *Tribune* despite his associations with the South: Wendt, *Chicago Tribune,* 279.

36 "actually enjoyed themselves": Unnamed reporter quoted in Martin, *Cissy,* 16.

36 ERMP's childhood fear of JM's authoritarianism: FG, "List of What to Add and What to Insert—Book Redo," 5.

36 "hopeless drag": ERMP, quoted in Martin, *Cissy,* 16.

36 "leading editorial writers": Unidentified newspaper clipping, n.d. (Feb. 1883), ERMPS, 3.

37 "a journalist of a very high order": Ibid.

37 "not to worry"; "nothing could break": ERMP, quoted in Smith, *The Colonel,* 39. Emphasis in original.

37 "Like all white trash": "The Distinguished Exile," *CDT,* June 7, 1863, 1.

38 $400,000: Smith, *The Colonel,* 25.

38 KMMcC as more intelligent and vitriolic than ERMP: FG, "List of What to Add and What to Insert—Book Redo," 7.

38 "The nights she honors me": ERMP to Belle Moffit, September 21, 1871, "Dictation 11, Box 2, Envelope 5," digest of Medill family correspondence found in the attic at 15 Dupont Circle after EMP's death, 2, RRMcCP.

39 JM chaining KMMcC's leg to the bedpost: FG, "Start of the Book Chapt. III," 32.

39 "dreadfully squeamish"; "very bad habits"; "in which she said"; "everyone"; "on account": ERMP to KMMcC, July 27, 1879, RRMcCP.

39 Having carefully saved: Frank C. Waldrop, *McCormick of Chicago* (Englewood Cliffs, NJ: Prentice-Hall, 1966), 20.

40 KMMcC as giving birth to RRMcC at ERMP's home: Smith, *The Colonel,* 40.

40 Though his mother dressed him: A number of sources both published and unpublished cite KMMcC's dressing RRMcC as a girl, among them Waldrop, *McCormick of Chicago,* 22, and FG, "List of What to Add & What to Insert, Book Redo," "The Family," 8–9.

40 "sneering"; "dirty Bertie": KMMcC quoted in FG, "List of What to Add & What to Insert, Book Redo," 8–9.

40 "Judge Lynch is": *CDT* quoted in Wayne Andrews, *Battle for Chicago* (New York: Harcourt, 1946), 68.

40 "libel him": JM quoted in Smith, *The Colonel,* 34.

41 "I am *deadly*": KMMcC to KPM, Aug. 11, 1881, HMFP. Emphasis in original.

41 "rather outside"; "associate with swells": ERMP to Mrs. Robert W. Patterson, Sr., December 13, 1893, HMFP.

42 "Mrs. Nixon": ERMP to KPM, Oct. 20, 1893, RRMcCP.

42 "The Kelloggs' ": ERMP to KPM, Oct. 30, 1893, RRMcCP.

42 "Mrs. MacVaugh"; "for the first time"; "Kate is always"; "her dinners": Ibid.

42 "It is a long time": Ibid.

43 "already *fierce*": EMP quoted in Hoge, *Cissy Patterson,* 9. Emphasis in original.

43 RWP singing "Tit-Willow" to EMP: RGM, "Some Notes After a Talk with Felicia," unpublished interview notes, RGMP.

44 "My worst recollections"; "She got well": ERMP to RHMcC, Jan. 4, (1916?), HMFP.

44 EMP making herself sick: RGM, "Some Notes After a Talk with Felicia."

44 EMP ruining coat: Hoge, *Cissy Patterson,* 10.

44 ERMP pushing EMP: RGM, "Some Notes After a Talk with Felicia."

45 "CIRCULATION"; "ADVERTISING": EMP, "Answers," *WH,* Aug. 8, 1930, 1.

45 "My hens, my pup": EMP, quoted in Hoge, *Cissy Patterson,* 11.

46 "Your affectionate daughter": EMP to KPM (in KMMcC's hand), n.d. (July 1887), RRMcCP.

46 "she didn't exactly": FG, "List of What to Add and What to Insert—Book Redo," 7.

46 "Bertie and I"; "Kate whiped"; "the thing": EMP to JM, n.d., FCWP, Box 25, Topical File, "Patterson, Eleanor: Research for Biography."

46 "Uncle Rob took Joe"; "and they thought"; "I have written": EMP to JM, Nov. 3, 1889, RRMcCP.

47 "tell her": Ibid.

47 "We were glad": RRMcC, *Memoirs,* 7, RRMcCP.

SPLENDID DIPLOMATS

47 "My parents"; "My father": RRMcC, *Memoirs,* 9.

48 "'old throne'": JM to Elihu Washburne, Nov. 1, 1874, quoted in Wendt, *Chicago Tribune,* 247.

48 "Her father": RRMcC, *Memoirs,* 9.

48 "The social system": JM to ERMP, July 17, 1889, quoted in "Second Dictation, Box 5, Envelope 3," digest of Medill family correspondence found in the attic at 15 Dupont Circle after EMP's death, 1, RRMcCP.

48 JM's gouty fingers: "Second Dictation, Box 5, Envelope 3," digest of Medill family correspondence found in the attic at 15 Dupont Circle after EMP's death, 2, RRMcCP.

48 "It is splendid": JM to ERMP, July 17, 1889.

49 "a perpetual picnic": Ibid.

49 "even if he was a Republican"; "He always sprinkles us": KPM to KMMcC, January 14, 1889, quoted "Dictation 10, Envelope 5, Box 2," digest of Medill family correspondence found in the attic at 15 Dupont Circle after EMP's death, 1, RRMcCP.

50 "half-promise": ERMP to KMMcC, June 27 [1890], "Joseph Medill McCormick, General Correspondence, 1890," HMFP.

50 "real work": RSMcC quoted in Smith, *The Colonel,* 45.

50 "she is always"; "(at $5.00 a visit)"; "one of these fashionable"; "dismal apprehension"; "You never saw anything"; "My maid waits"; "I like American institutions": ERMP to KPM and JM, Nov. 18, 1889, quoted in Dictation 11, Box 2, Envelope 5," digest of Medill family correspondence found in the attic at 15 Dupont Circle after EMP's death, 2–3, RRMcCP.

51 "Pa is indignant": ERMP to KMMcC, June 27, 1890, "Joseph Medill McCormick, General Correspondence, 1890," HMFP.

51 "I don't think we had better": ERMP to KMMcC, June 27, 1890, "Joseph Medill McCormick, General Correspondence, 1890," HMFP.

51 "with *all our family anxious*"; "Rob can resign, of course"; "but then": ERMP to KMMcC, June 27, 1890, "Joseph Medill McCormick, General Correspondence, 1890," HMFP. Emphasis in original.

BON VOYAGE, MR. MEDILL!

52 "nothing"; "stupendous fortunes"; "two lunatic asylums"; "This exciting life": KPM to ERMP, April 6, 1879, quoted in "First Dictation, Box 5, Envelope 3," digest of Medill family correspondence found in the attic at 15 Dupont Circle after EMP's death, RRMcCP.

52 "miserable rheumatic back": JM to ERMP, Dec. 9, 1891, quoted in "Third Dictation, Box 5, Envelope 3," 1, RRMcCP.

52 "old and consumptive, coughing people": JM to ERMP, Dec. 21, 1891, quoted in "Third Dictation, Box 5, Envelope 3," digest of Medill family correspondence found in the attic at 15 Dupont Circle after EMP's death, 1, RRMcCP.

52 JM's "interesting physiological theories" appear in "Chicago's Scientiest Editor," n.d., n.p., in ERMPS, 28.

53 The descriptions of Josie Medill in the last years of her life come from "A Prominent Chicago Young Lady," n.p., March 7, 1891, and other unidentified, undated clippings in ERMPS, 13.

53 "severe bronchitis": KMMcC to KPM and JM, January 8, 1892, quoted in "First Dictation, Envelopes 6 and 7, Box 2," digest of Medill family correspondence found in the attic at 15 Dupont Circle after EMP's death, 1, RRMcCP.

53 "Josie worse": KMMcC to KPM and JM, January 8, 1892, telegram, quoted in "First Dictation, Envelopes 6 and 7, Box 2," 1.

53 "Consulting doctor says": KMMcC to KPM and JM, n.d., quoted in "First Dictation, Envelopes 6 and 7, Box 2," 1.

53 McCormick family at funeral: "Miss Medill's Funeral," *New York Herald,* Jan. 14, 1892, n.p., in ERMPS, 13.

53 "terrible, gnawing grief": JM to ERMP, April 9, 1892, quoted in "Third Dictation, Box 5, Envelope 3," 2.

54 "that saintly old man"; "But Nellie"; "I will build": KPM to ERMP, Jan. 18, 1892, quoted in "First Dictation, Box 5, Envelope 3," digest of Medill family correspondence found in the attic at 15 Dupont Circle after EMP's death, 2, RRMcCP.

54 $60,000; "the nicest house": JM to ERMP, May 25, 1892, quoted "Third Dictation, Box 5, Envelope 3," 2.

54 "My desire is that"; "The house is": JM to ERMP, May 25, 1892, quoted in "Third Dictation, Box 5, Envelope 3," 2.

54 "I have been"; "Oh, my love Josie": KPM to ERMP, March 23, 1892, quoted in "First Dictation, Box 5, Envelope 3," 3.

55 "Do be good"; "I think": Ibid.

55 thousands of dollars on each: FCW interview transcript, n.d. RGMP.

55 "This is the programme"; "Governess comes"; "after lunch": ERMP to KPM, Oct. 30, 1893, RRMcCP.

55 "There's nothing": KMMcC, quoted in Hoge, *Cissy Patterson,* 13.

57 "a number of New York's": "Trips of the Coach Tempest," *NYT,* May 5, 1894, 8.

57 "saw at a glance"; "By 2:30 a.m."; "dry as punk"; "gentle wind": JM to RWP, Nov. 23, 1892, quoted in "Third Dictation, Box 5, Envelope 3," 3–4.

58 "ozone generating machine"; "grasped at": JM to ERMP, Dec. 5, 1892, quoted in "Fourth Dictation, Box 5, Envelope 3," digest of Medill family correspondence found at 15 Dupont Circle after EMP's death, 1, RRMcCP.

58 "The remaining milestones"; "I am not tired": JM to ERMP, April 8, 1893, quoted in "Fourth Dictation, Box 5, Envelope 3," digest of Medill family correspondence found in the attic at 15 Dupont Circle after EMP's death, 2, RRMcCP.

58 "Mamma is going": EMP to JM, Sept. 19, 1890, RMMcCP.

58 "an original mind": Rev. Endicott Peabody quoted in KPM to ERMP, Oct. 4, 1890, quoted in "First Dictation, Box 5, Envelope 3."

58 "That question": JMP quoted in KPM to ERMP, Oct. 4, 1890, quoted in ibid.

59 "a big bully named Sullivan": KPM to ERMP, Oct. 4, 1890, quoted in ibid.

59 Midwesterners snubbed at Groton: RRMcC, *Memoirs,* 21.

59 "delightful rows"; "I have just finished": JMMcC to JM, April 22, 1894, HMFP, Box 139, F10, "Medill, Joseph, 1893–97."

59 "chronic revolutionary": Smith, *The Colonel,* 55.

59 "truly did convert me": JMMcC to KPM, March 4, 1893, HMFP, Box 1, "JMMcC Family Correspondence, 1888–1901."

60 "the world's most unrelenting Anglophobe": "The Press: Mellowed Colonel," *Time,* April 6, 1953, http://www.time.com/time/magazine/article/0,9171,818161,00.html.

60 "caste system"; "sectional patriotism"; "all the rest of their heroes": RRMcC, *Memoirs,* 23.

60 "Tell them they are descendants": RSMcC quoted in ibid., 21.

61 "I am awfully proud"; "the new wild"; "New York would": JM to ERMP, April 30, 1893, quoted in "Dictation, Box 5, Envelope 3," 2.

61 "three or four visits"; JM's resolution to step down as editor of the *Tribune:* JM to ERMP, June 25, 1893, quoted in "Fourth Dictation, Box 5, Envelope 3," 2–3.

61 "If there is ambition": JM quoted in "Mr. Medill at the Fair," *Chicago Times,* n.d., n.p., ERMP, 28.

WHAT IS THE NEWS?

61 "*I like the school*"; "I suppose the family": EMP to JM, April 26, 1896, RRMcCP. Emphasis in original.

62 "Friendships are often formed": Margaret E. Sangster, *Harper's Bazar* [*sic*], June 9, 1900, 375.

63 "a damp, crowded, crooked"; "I don't like it": EMP to JM, May 21, 1896, RRMcCP.

63 "late bloomer"; "fully developed": Hoge, *Cissy Patterson,* 12.

63 thirty-two pupils and EMP as tallest girl in the school: EMP to JM, April 26, 1896, RRMcCP.

63 "Yankeeland is noted"; "but you do not look": JM to EMP, quoted in Healy, *Cissy,* 23.

63 "The thermometer stands at 91"; "I begged off": EMP to JM, May 10, 1896, RRMcCP.

63 "We are given": EMP to JM, April 26, 1896, RRMcCP.

63 "all"; "devoted": EMP to JM, April 26, 1896, RRMcCP.

63 "the land of schools": F. Scott Fitzgerald, *This Side of Paradise* (New York: Modern Library, 2005), 22.

64 "skilled at the art"; "sense of proportion": Heloise E. Hersey, *To Girls: A Budget of Letters* (Boston: Ginn & Co., 1902), 3.

64 "ability to love": "To Girls," *NYT,* Nov. 9, 1901, BR5.

64 "lovable": Hersey, *To Girls,* 18.

65 "especially intended": "Annual Circular of Miss Heloise E. Hersey's School for Girls, at 25 Chestnut Street, Boston, 1897–1898," n.p., RGMP.

65 "look up notes"; "This may seem": EMP to JM, May 21, 1896, RRMcCP.

65 "There was a freedom"; "your mother always": JM to EMP, May 4, 1896, quoted in Healy, *Cissy,* 22.

65 "Or rather"; "from Mr. Billing's": EMP to JM, May 21, 1896, RRMcCP.

65 "*princesse lointaine*": JMMcC quoted in Hoge, *Cissy Patterson,* 14.

66 "Bertie the Swipe": EMP quoted in Smith, *The Colonel,* 45.

66 "pure bunkum"; "She always thought": RRMcC quoted in "Interview with Mrs. Robert McCormick," n.d., n.p., unpublished transcribed tape recording, RGMP.

66 JMMcC discouraging EMP's suitors: Hoge, *Cissy Patterson,* 14.

66 "Why is it"; "For a few minutes": EMP/ERMP diary, June 4, 1896, RRMcCP.

66 "When I get back to Boston": EMP/ERMP diary, July 3, 1896, RRMcCP.

66 "Like most people"; "As it curtailed": EMP to JM, Jan. 20, 1899, RRMcCP. Emphasis in original.

67 "Some people love to live": "Chicago" [JM], "Our Washington Letter," *CDT,* March 16, 1861, 1.

67 Postrevolutionary fears of a fixed U.S. capital: Fergus Bordewich, *Washington: The Making of the American Capital* (New York: Amistad, 2008), 4.

67 RWP's inheritance and subsequent independence from ERMP: ERMP to RRMcC, Sept. 1, 1919, RRMcCP.

67 "Many people called": EMP to JM, Jan. 20, 1899, RRMcCP.

68 "I fear": Ibid.

68 "enough silk"; "pearls by the bushel"; "most admirably gowned": Unidentified newspaper clippings in ERMPS, 89/49.

68 "She is tall"; "when she made": unidentified newspaper clippings in ERMPS, 68.

68 "Lots of people"; "Perhaps when you": EMP to JM, Jan. 20, 1899, RRMcCP.

68 "*one* college trained woman"; "*narrow,* arrogant"; "infuse the spirit"; "I do not believe": Sarah Porter quoted in Ilana DeBare, *Where Girls Come First: The Rise, Fall, and Surprising Revival of Girls' Schools* (New York: Jeremy P. Tarcher/Penguin, 2005), 78. Emphasis in original.

68 "without exception"; "worst, pokey, humdrum": KMMcC to ERMP, Feb. 17, 1870, quoted in "Dictation 11, Box 2, Envelope 5," 2.

69 "Ruth Hanna"; "I envy her": EMP to JM, March 1, 1899, RRMcCP.

70 "The Republicans"; "bad money"; "Mrs. P. Palmer": JM to ERMP, July 24, 1896, quoted in "Fourth Dictation, Box 5, Envelope 3," 3.

70 "shuffling off": JM to ERMP, July 29, 1898, quoted in ibid., 4.

70 "faded out": JM to ERMP, Jan. 1899, quoted in ibid., 4.

71 "diabolical insult": JM, quoted in Smith, *The Colonel,* 59.

71 "Tell Robert"; "Bertie is here"; "He is good"; "I would feel": JM to ERMP, Jan. 1899, quoted in "Fourth Dictation, Box 5, Envelope 3," 4.

71 "My last words": JM, quoted in "Joseph Medill Dead," *WP,* March 17, 1899, 3; see also "Joseph Medill Is Dead," *NYT,* March 17, 1899, 2.

COLONY OF PALATIAL HOMES AROUND DUPONT CIRCLE

72 JM's estate valued at $4.5 million: "Joseph Medill's Will," *NYT,* March 26, 1899, 12; see also "Will of Medill," *LAT,* March 29, 1899, 5.

72 "only some cats": JM quoted in ERMP to RRMcC, September 1, 1919, RRMcCP; estimates of JM's bequests: "Joseph Medill's Will," *NYT,* March 26, 1899, 12; see also "Will of Medill," *LAT,* March 29, 1899, 5.

72 "a party organ": JM, quoted in Wendt, *Chicago Tribune,* 350.

73 RWP's insistence on JM's making RSMcC the third trustee: ERMP to RRMcC, September 1, 1919, RRMcCP.

74 "tied up tightly": Ibid.

74 $83,406: Deed, March 30, 1900, Liber 2490 folio 31, quoted in Historic American Buildings Survey/Historic American Engineering Record of 15 Dupont Circle Northwest, Washington, District of Columbia, HABS No. DC-270, Wash. 212, 1, http://memory.loc.gov/pnp/habshaer/dc/dc400/dc0436/data/002.tif.

75 "of Washington's half hundred": "Colony of Palatial Homes Around Dupont Circle," *WT,* December 21, 1902, section 3, 1.

75 Size of Camp Bird Mine's gold vein: "Evalyn Walsh M'Lean Is Dead," *CDT,* April 27, 1947, 1.

75 "That portion of the city": "Colony of Palatial Homes Around Dupont Circle," *WT,* Dec. 21, 1902, section 3, 1.

77 Estimate of Mary Leiter's dowry: Kathryn Allamong Jacob, *Capital Elites: High Society in Washington, D.C., After the Civil War* (Washington, D.C.: Smithsonian, 1995), 184.

77 Estimates of Daisy and Nancy Leiter's dowries: P. Harvey Middleton, "Dukedoms for Ducats," *Washington Herald Literary Magazine,* May 30, 1909, 3rd Part, 10.

77 Estimates of the number of Euro-American weddings: Middleton, "Dukedoms for Ducats" and "The Gay Musician," *WT,* Nov. 22, 1908, 3, 360.

77 "where soiled and frayed": Congressman Charles Garvin quoted in Middleton, "Dukedoms for Ducats."

77 "far too many": Margaret E. Sangster, "Margaret Sangster Talks on Home Circle Questions," *WT,* March 26, 1905, 6.

77 "It is said"; "always runs grave danger"; "the remedy for future happiness": Betty Bradeen, "From Woman's Viewpoint," *WH,* Dec. 7, 1906, 7.

78 "deplorable failures"; "the socially ambitious": Booth Tarkington, quoted in "Blames the Mother," *WH,* Sept. 20, 1908, 5.

78 "by our little fracas": Middleton, "Dukedoms for Ducats."

78 "probably exaggerated"; $900 million; "titles for treasure": Ibid. Other commentators place the figure considerably lower.

79 "synonymous with vast fortunes," Middleton, "Dukedoms for Ducats."

80 "Of the American": "Society," *WH,* Oct. 21, 1906, 5.

80 "full of violent praise or blame": Princess Julia Cantacuzène Countess Speransky, née Grant, *My Life Here and There* (New York: Scribner's, 1921), 200–201.

81 "Amoral and cynical": Countess May Baltazzi von Wurmbrand-Stuppach, quoted in "Etti Plesch," *Sunday Times* (London), May 1, 2003, http://www.timesonline .co.uk/tol/comment/obituaries/article874013.ece?token=null&offset=0&page=1.

82 "caused a sensation": "Gizyckis Are Parted," *WP,* April 26, 1908, 3.

82 "great consternation": "Count Gizycki Asks Separation," *WT,* April 25, 1908, 2.

82 "nearly broke up": "Countess Seeks Only to Regain Her Child," *NYT,* June 1, 1908, 4.

82 "A little later": "Throws Money at Musicians," *St. Albans (Vt.) Daily Messenger,* Oct. 13, 1899, 2.

MISS PATTERSON, OF CHICAGO, GETS THE FIRST BRUSH

82 "that horse": "Some Notes After a Talk with Felicia," RGMP.

82 "good enough to be a Virginian": "Pink Coats at Bethesda," *WP,* March 4, 1904, 5.

83 ERMP discouraging Freddy McLaughlin's attentions to Cissy: Hoge, *Cissy Patterson,* 20.

83 Freddy McLaughlin trying to kiss EMP through her riding veil: FG interview, RGMP.

85 "The young ladies": J. S. Culpeper to RWP, March 10, 1900, RRMcCP.

85 "She seems": J. S. Culpeper to RWP, Dec. 18, 1900, RRMcCP.

87 "The papers all published"; "I saw"; "A lovely": KMMcC to ERMP, n.d. (April 24, 1901), quoted in "Second Dictation, Box 5—Envelope 2," digest of Medill family correspondence found in the attic at 15 Dupont Circle after EMP's death, RRMcCP.

88 "just for the experience": KMMcC quoted in Smith, *The Colonel,* 77.

88 "In a couple of months"; "loafing": JMP to ERMP, April 22, 1901, RRMcCP.

89 "Aunt Kate strongly"; "Don't think me"; "If you leave"; "That is all"; "I certainly feel": JMP to ERMP, April 22, 1901, RRMcCP.

LABOUCHERE'S VIEW OF AMERICA

90 "Vienna is the prettiest": EMP quoted in Hoge, *Cissy Patterson,* 21.
90 "frightfully lonely": KMMcC to EMP, undated (autumn 1901), quoted in Smith, *The Colonel,* 79.
91 "No dinners": Ibid.
91 "The Hungarians": KMMcC to unidentified recipient, June 1, 1901, quoted in "Second Dictation, Box 5—Envelope 2," 3.
91 Pattersons' view of McCormicks' misrepresentations: RWP and ERMP quoted in Hoge, *Cissy Patterson,* 21.
91 ERMP commissioning RSMcC to purchase Austro-Hungarian antiques: RSMcC to ERMP, Nov. 17, 1901, quoted in "Second Dictation, Box 5—Envelope 2," 3; see also RSMcC to ERMP, Nov. 27, 1901, telegram, quoted in ibid.
91 RSMcC suffering acute attacks of gout: RSMcC to ERMP, Nov. 27, 1901, telegram, quoted in ibid.
92 "the heaviest player": "Game That Wins and Loses Thousands," *San Francisco Sunday Call,* April 27, 1902, 14.
93 "confiscated lands": Andrew Steen, *Count Jozef Potocki: The Man Who Bred Skowronek* (Seville: Escandón Impresores, 2001), 118.
93 Jockey Club members as syphilitic: Countess May Baltazzi von Wurmbrand-Stuppach interview, RGMP.
93 "Baccarat is a game"; "but in Europe": "Game That Wins and Loses Thousands," *San Francisco Sunday Call,* April 27, 1902, 14.
93 two million crowns: "Austrian Emperor Punishes Gamblers," *NYT,* Dec. 28, 1901, 1; three million crowns: "High Rollers in Vienna," *NYT,* May 4, 1902, 9; $800,000: "Game That Wins and Loses Thousands," 14; $500,000: "Titled Vienna Gamblers Fined," *NYT,* April 11, 1902, 9, and *San Francisco Call,* April 17, 1902, 2; $800,000: New York *World,* Jan. 4, 1902, 16.
93 "Nothing like it": "$800,000 Lost in One Game of Baccarat," New York *Sunday World,* Jan. 5, 1902, 10.
93 Potocki threatening suicide: RRMcC, *Memoirs,* 110–11.
94 "odd metamorphosis": Eleanor Gizycka, *Fall Flight* (New York: Minton, Balch & Co., 1928) (hereafter cited as *FF*), 99.
94 "with the greatest éclat"; "Exquisitely bred": "Society as Seen by Odette," Oct.19, 1902, n.p., unidentified newspaper clipping in ERMPS, 62.
94 "the little countesses"; "a herd of simple sheep": EMP quoted in Hoge, *Cissy Patterson,* 21; "a great belle": "Society as Seen by Odette," Oct. 19, 1902, ERMPS, 62.
95 The headlines concerning the Medill family and its circle come from the unidentified newspaper and magazine clippings that appear throughout ERMPS.
98 The account of EMP and JG's first meeting comes from "Countess May Wurmbrand: 12 pages of Notes," RGMP, and Hugo Vickers, ed., *Horses & Husbands: The Memoirs of Etti Plesch* (Stanbridge, Wimborne Minster, Dorset, UK: Dovecote Press, 2007), 31–33. Though later press reports place the couple's first meeting variously in Vienna, St. Petersburg, and Paris, given her family's long connection with Gizycki as well as her own childhood friendship and eventual intimacy with him, Countess May Baltazzi von Wurmbrand-Stuppach's insistence that it took place at Napajedla is likely the most accurate account.

THE BRIDESMAID

99 "brave days"; "period of glamour"; "in Roosevelt's first term": JMP to EMP, October 19, 1932, JMPP, "Patterson, Eleanor Medill, Estate," Series 5, Subseries 3, Box 74, Folder 3.

99 "most brilliant": "Fashionable Throng at Grace Church Witnesses the Event," n.p., n.d. ("Nov. 19, 1902"), unidentified newspaper clipping, ERMPS, 58.

99 "Fired, doubtless, by the success"; "Medill McCormick": "Society as Seen by Odette," n.p., n.d. ("Oct. 19, 1902"), unidentified newspaper clipping, ERMPS, 58.

100 "Well, I see you got your ad in": Mark Hanna quoted in Kristie Miller, *Ruth Hanna McCormick: A Life in Politics, 1880–1944* (Albuquerque: University of New Mexico Press, 1992), 27.

100 "Ruth, I think, is able"; "Mother must not": JMMcC to RSMcC, n.d. (fall 1902), quoted in Miller, *Ruth Hanna McCormick,* 27.

101 "My Dear Daddy"; "I have worked hard"; "This does not mean"; "very competent": JMMcC to RSMcC, Dec. 24, 1901, HMFP, Box 1, "Joseph Medill McCormick Family Correspondence, 1888–1901."

101 "some regrets"; "brightening the faded": "Society as Seen by Odette," n.p., n.d. ("Oct. 19, 1902"), ERMPS, 58.

102 "darkest Russia"; "The McCormicks do not seem"; "Mrs. McCormick": KMMcC quoted in "Society as Seen by Odette," ibid.

102 "Watch the way": TR to ARL, quoted in Hoge, *Cissy Patterson,* 24.

102 "I can be President": TR quoted in Owen Wister, *Roosevelt: The Story of a Friendship, 1880–1919* (New York: Macmillan, 1930), 87. Emily Spinach as "affectionate": ARL quoted in Michael Teague, *Mrs. L.: Conversations with Alice Roosevelt Longworth* (New York: Doubleday, 1981), 69.

102 "detached malevolence": ARL quoted in Stacy A. Cordery, *Alice: Alice Roosevelt Longworth, from White House Princess to Washington Power Broker* (New York: Viking, 2007), ix.

103 "Our friendship"; "a common taste": Countess Marguerite Cassini, *Never a Dull Moment* (New York: Harper, 1956), 188.

103 "I pray for *money!*": ALR quoted in Cordery, *Alice,* 64. Emphasis in original.

103 "the President scolded"; "my father raged": Cassini, *Never a Dull Moment,* 188.

104 "so everything we said"; "Yellow journalism": Ibid., 95.

104 "an elaborate charade"; "a Vaudeville performer": Oleg Cassini, *In My Own Fashion* (New York: Pocket Books, 1987), 9.

104 "legal but unacknowledged wife"; "lived beyond": Cassini, *Never a Dull Moment,* 6.

104 "Mme. Schalle": "Society," *WT,* Sunday, April 2, 1905, 5.

104 "near ruin"; "a cloud that hung over us": Cassini, *Never a Dull Moment,* 6.

105 "I know": Tsar Nicholas II, quoted in Cassini, *Never a Dull Moment,* 137.

105 "During his stay": "Social and Personal," *WT,* Oct. 30, 1900, 5.

105 "In those days"; "if you didn't": ARL quoted in Teague, *Mrs. L.,* 129.

106 to Alice's enduring mirth: ALR interview, RGMP.

106 "It became more and more fun": Cassini, *Never a Dull Moment,* 188.

107 "before deodorants"; "being clutched": ARL quoted in Teague, *Mrs. L.,* 76.

107 "young and popular bachelors": "Summer Plans of Foreign Diplomats," *NYT,* July 17, 1904, 2.

107 "My father"; "a foreigner": ARL quoted in Teague, *Mrs. L.,* 129.

107 "Titles in continental Europe": Mrs. E. B. Duffey, *The Ladies' and Gentlemen's Eti-*

quette: A Complete Manual of the Manners and Dress of American Society (Philadelphia: Porter and Coates, 1877), 185.

107 "Cissy was"; "She had": ARL quoted in Teague, *Mrs. L.,* 176.
108 "Everybody said"; "'despite her looks'": Ibid.
108 "If any man ever": ARL quoted in Hoge, *Cissy Patterson,* 82.
108 "bad egg": *FF,* 89.
108 "drop him the hint"; "didn't have a cent": *FF,* 91.

AMERICAN GIRL'S SUCCESS

109 "I think you owe it to yourself": RRMcC to EMP, Dec. 29, 1936, RRMcCP.
109 "The truth is": EMP to RRMcC: Jan. 2, 1937, RRMcCP.
109 "the author's description"; "valuable chiefly": "International Marriage," *NYT,* Oct. 14, 1928, A6.
109 "tiresome, tiresome, tiresome": *FF,* 5.
109 "Mrs. Shawn's reasonable ambition"; "to despise her husband": *FF,* 3.
110 "nose turns up so much": *FF,* 71.
110 "I would be glad": RRMcC to EMP, n.d. (Jan.–Feb. 1903), RRMcCP.
110 he had had no direct word: Smith, *The Colonel,* 83–84.
110 "I have been complaining": RRMcC to EMP, n.d. (Jan.–Feb. 1903), RRMcCP.
111 "Tsar Nicholas Was Real Nice": "Makes Intentional Display of Friendship for America," *Decatur (Ill.) Herald,* Feb. 20, 1903, 1.
111 "Cables to the AP and Hearst papers": JMMcC to KMMcC and RSMcC, February 16, 1903, HMFP, Box 1, Joseph Medill McCormick Family Correspondence, 1902–1912.
111 "finger of conspicuousness": *Fort Wayne (Ind.) Morning Journal,* Feb. 15, 1903, 4.
112 "McCormick's cocked hat"; "The costume is gorgeous": "M'Cormick's Court Dress," *St. Louis Globe-Democrat,* Jan. 25, 1903, 3.
112 "It occurs to us"; "Mr. McCormick's costume": "Ambassador McCormick's Legs," *WP,* Jan. 31, 1903, 6.
112 "AMBASSADOR APES ROYALTY": Cedar Rapids (Ia.), *Evening Gazette,* Jan. 27, 1903, vol. 21, no. 15, 1.
112 "As I prophesied"; "The Russians are"; "balls, calls": RRMcC to ERMP and RWP, Feb. 12, 1903, quoted in "Second Dictation, Box 5—Envelope 2," 3.
112 "Miss Eleanor Patterson": "The Tsar's Good Will," *WP,* Feb. 20, 1903, 4.
112 "the time of her life"; "Wonderful fancy dress": "American Girl's Success," *Philadelphia Inquirer,* March 1, 1903, 12.
113 "she has danced": Ibid.
113 "front rank without effort": RRMcC to ERMP(?), Feb. 12, 1903, quoted in "Second Dictation, Box 5—Envelope 2," 3, RRMcCP.
114 "in his wildest dreams": Nadine Wonlar-Larsky, *The Russia That I Loved* (London: Women's Printing Society, 1937), 101.
114 "never could bring back": *FF,* 104.
114 "long waiting"; "in silent unison"; "A man below"; "taller than he": *FF,* 106.
114 "Alexandra of the stricken face": Ibid.
114 "long to disappear under the ground": Alexandra Fedorovna quoted in Toby Faber, *Fabergé's Eggs* (New York: Random House, 2008), 59.
114 "close to tears": *FF,* 107.
115 "as scared as we are!": *FF,* 108.

115 "We even learn that": JMMcC to KMMcC and RSMcC, February 16, 1903, HMFP, Box 1, "Joseph Medill McCormick Family Correspondence, 1902–1912."

115 "terror of jealous husbands": David Chavchavadze, *The Grand Dukes* (New Delhi: Atlantic International Publications, 1989), 235.

115 "afraid to believe": *FF,* 113.

115 "he meant to touch her": *FF,* 98.

115 "repellent chill": *FF,* 84.

115 "over, as if with tiny brush": *FF,* 84.

115 "two or three"; "inner being": *FF,* 74.

115 "an awful gambler": *FF,* 89.

116 "Remember this"; "no foreigner of Slavinsky's type": *FF,* 101.

116 EMP as believing herself to be in love with JG: Eleanor Gizycka deposition, *Gizycki v. Gizycki,* Gen. No. 303,481 87 (Cir. Ct. Cook County, Ill., June 19, 1917).

116 "You see, he was always different": Eleanor Gizycka deposition, *Gizycki v. Gizycki,* 97–98.

116 "extreme": Countess May von Wurmbrand-Stuppach, quoted in "12 pages of Notes," RGMP, Correspondence Files: "Cissy Letters," "Paul Letters," Box 210, F8.

116 "I think it was": Countess May von Wurmbrand-Stuppach quoted in "Etti Plesch," 1.

116 "ruin him": Countess May von Wurmbrand-Stuppach quoted in "12 pages of Notes."

116 "splendid castles": JG quoted in EMP to Nicholas II, Jan. 20, 1909, *Rossiiskii Gosudarstvennyi Istoricheskii Arkhiv* (hereafter RGIA), Fond 1412 (Imperial Chancellery for Receipt of Petitions), Inventory 215, File 32, Year 1909, 1.

117 *"beau ténébreux"*: *FF,* 100.

117 "THE RUSSIAN WAY": *Montgomery (Ala.) Advertiser,* March 14, 1903, 1.

117 "Ambassador McCormick Gives a Function": *Charlotte (N.C.) Observer,* March 14, 1903, 5.

117 "AMBASSADORSHIP HAS DRAWBACKS": *Philadelphia Inquirer,* March 14, 1903, 1.

117 JG as requesting EMP's hand from KMMcC: "Chat of Well-Known People," *WP,* April 28, 1908, 7.

118 KMMcM and EMP's request for visas to travel outside the Russian Empire: RRMcC to Count Lamsdorff, March 24, 1903, NARA, RG84, Records of Foreign Service Posts, Union of Soviet Socialist Republics, vol. 123, "American Embassy, Notes Sent, Tower, McCormick, 1900–1903."

118 "In an apparent desire"; "Mr. McCormick went": "Taken to Task," *Boston Daily Globe,* June 5, 1903, 11.

118 "Unwise": ERMP, n. d., handwritten annotation, ERMPS, 61.

118 "Ambassador McCormick is in"; "The Russians have hypnotized him": "Confiding Cheerfulness of an Ambassador," *Philadelphia Inquirer,* June 4, 1903, 8.

118 "When Mr. McCormick left": "Taken to Task," *Boston Daily Globe,* June 5, 1903, 11.

119 "Probably not in the history": "President at Hanna Wedding," New York *World,* June 10, 1903, 3.

119 "there's only one life": Mark Hanna quoted in Kristie Miller, *Ruth Hanna McCormick,* 23.

119 Sale of Medill mansion: "Historic Residence to Be Converted into Hotel," Chicago *Inter-Ocean,* Saturday, Sept. 26, 1903, n.p., ERMPS, 40.

120 "more 'dog' than anyone": Eleanor Lake interview, RGMP, Box 213, F6.

120 ERMP's suspicions of KMMcC's reports on JG: Hoge, *Cissy Patterson*, 23.

120 "Mrs. Robert W. Patterson and her daughter": "Social News and Gossip of the Day," *WT,* Sept. 2, 1903, 4.

121 "I just saw Mama"; "I suppose"; "There is nothing": JG, quoted in Healy, *Cissy,* 29.

121 "The bridegroom—having less control": JG quoted in Healy, *Cissy,* 29, and Martin, *Cissy,* 71–72.

122 "satisfied after"; "income sufficient": RSMcC to ERMP and RWP, Oct. 16, 1903, quoted in "Second Dictation, Box 5—Envelope 2," 4.

122 "Robert McCormick's opinion": ERMP, handwritten annotation on RRMcC to ERMP and RWP, telegram, Oct. 16, 1903.

123 JG representing himself as a millionaire: RGIA, Fond 1412 (Imperial Chancellery for Receipt of Petitions), Inventory 215, File 32, Year 1909, 1–2v.

123 JG's landholdings, debts and income: Henry Cachard of Coudert Brothers to RWP, Dec. 5, 1903, RRMcCP.

123 "bad debts, arrears"; "In jest": Henri Cachard of Coudert Brothers to RWP, Dec. 5, 1903, RRMcCP.

124 "would not read": *FF,* 149–50.

124 "very eccentric": Eleanor Gizycka deposition, *Gizycki v. Gizycki,* 97–98.

124 "Miss Eleanor Patterson": "Social and Personal," *WP,* Feb. 21, 1904, E8.

124 "saving his life"; "awful difficulties": JG quoted in Martin, *Cissy,* 73.

125 "conceited, overbearing": RWP quoted in ibid., 72.

125 $10,000; RWP's refusal to give JG a dowry: Eleanor Gizycka deposition, *Gizycki v. Gizycki,* 87.

125 As EMP would later summarize it: *"J'ai épousé le comte Joseph Gizycki le 14 Avril 1904 contre l'opposition de ma famille qui avait, afin de romper, dit au Comte Gizycki que je n'aurais ni dot ni rente, à quoi celui-ci avait répondu qu'étant lui-même millionaire il me prendrait dans la robe dans laquelle je me trouverais. Toutefois lorsque mon marriage fut tout à fait proche ma mère me promit 10,000 Dollars par an et augmenta ensuite cette rente jusqu'à 20,000 dollars."* EMP, testament, n.d. (Jan. 20, 1909), RGIA, Fond 1412 (Imperial Chancellery for Receipt of Petitions), inventory 215, file 32, 12. Later, Cissy would add, "I think he knew I belonged to a family that had a great deal of money, and that I was the only daughter, there were only two children, and that he would get hold of our fortune . . ." Eleanor Gizycka deposition, *Gizycki v. Gizycki,* 87.

125 "Most Americans"; "I must say"; "to make life"; "Someone has": Cassini, *Never a Dull Moment,* 203.

125 "I must confess"; "It is all very well": JG quoted in Martin, *Cissy,* 74.

MERRY PARTY OF GIRL FRIENDS BID COUNTESS GIZYCKI GODSPEED

126 Gizycki's self-characterizations: *Kaiser Wilhelm II* List or Manifest of Alien Passengers for the U.S. Immigration Officer at the Port of Arrival, March 8, 1904, Passenger Lists of Vessels Arriving at New York, New York, 1820–1897; (National Archives Microfilm Publication M237, 675 rolls); Records of the U.S. Customs Service, Record Group 36; National Archives, Washington, D.C. Year: *1904;* Microfilm serial: *15;* Microfilm roll: *715_435;* Line: *16;* Page Number: 56 Ancestry.com-New York Passenger Lists, 1820–1957, http://search.ancestry.com/iexec/?htx=View&r=an&dbid=7488&iid=NYT715_435-0108&fn=Count+Joseph&ln=Gizycki&st=r&ssrc=&pid=4040004592.

126 "daring, if not reckless": "Pink Coats at Bethesda," *WP,* March 3, 1904, 5, in ERMPS, 58.

126 "American Bride for Count": *NYT,* April 15, 1904, 5; "Social and Personal" *WP,* April 15, 1904, 7; "Miss Patterson to Wed": *NYT,* March 30, 1904, 9; "Russian Noble": "In Society's Circle," *WT,* March 30, 1904, 4.

126 "During his visit to Washington"; "Count Gizycki": "Chat of Well-Known People," *WP,* April 28, 1908, 7.

127 "I gave up my journalistic ambitions": RRMcC quoted in Wendt, *Chicago Tribune,* 374.

128 "I have been surprised": JMMcC to KMMcC & RSMcC, March 9, 1904, HMFP.

128 "If I were not"; "I should like": Ibid.

128 "though sorely needed"; "Gizycki is in Washington"; "& Uncle Rob": JMMcC to RHMcC, March 22, 1904, HMFP.

128 "flying trip to New York": "In Society's Circle," *WT,* April 4, 1904, 7.

128 "I have seen": JG to ERMP, n.d. [Friday, April 8, 1904], FGP.

129 "I am very pleased"; "& I hope": Ibid.

129 Verbal and telegraphed invitations: "Social and Personal," *WP,* April 7, 1904, 7.

129 a variety of blandishments: The enticements Nellie offered vary according to the teller. Walter J. Trohan, a former *Chicago Tribune* Washington bureau chief, contended that Nellie slipped a check for $250,000 under the door, which Cissy promptly tore to pieces. WJT interview, n.d., RGMP, Box 213, F3; Eleanor Waldrop believed it was a "big diamond ring": Eleanor Waldrop interview, RGMP.

129 "Suppose he is marrying": EMP quoted in Hoge, *Cissy Patterson,* 26.

129 "My God": EMP quoted in WJT, interview, n.d., RGMP, Box 213, F3.

129 "improvised chancel": "Town & Country Life," *T&C,* April 23, 1904, 18.

129 RWP refusing to shake JG's hand: Eleanor Gizycka deposition, *Gizycki v. Gizycki,* 87.

129 "Mrs. Patterson had quite properly:" Catherine Eddy Beveridge, *The Chronicle of Catherine Eddy Beveridge: An American Girl Travels into the Twentieth Century* (Latham, Md.: Hamilton, 2005), 78.

130 "rounder"; "so *friendly*": ARL interview, RGMP, Box 213, F9. Emphasis in original.

130 "a quiet affair"; "one of the most brilliant": "In Society's Circle," *WT,* April 15, 1904, 6.

130 "It was a merry party": Ibid.

130 "the fireworks began": Cassini, *Never a Dull Moment,* 202.

130 "We waited and waited": Beveridge, *Chronicle,* 78.

130 "I always felt that Cissy": Cassini, *Never a Dull Moment,* 202.

130 "depressing climax": ARL quoted in Martin, *Cissy,* 90.

131 "white with rage": Beveridge, *Chronicle,* 78.

131 "Darling, remember": ERMP quoted in Martin, *Cissy,* 81.

PART II: THE COUNTESS GIZYCKA

AN INTERNATIONAL ROMANCE

135 "Perhaps I will": *FF,* 176, see also Eleanor Gizycka deposition, *Gizycki v. Gizycki,* 88.

135 "had taken": *FF,* 176. On JG's brutality on his wedding night see also FCW interview tape transcriptions and WJT interview, RMGP.

135 "the scene of an interesting marriage": "Social and Personal," *WP,* April 15, 1904, 7.

135 "Miss Eleanor Patterson": "Bad Business," *LAT,* April 16, 1904, 6.

136 "The newly married Countess"; "She was in a box": "Vienna Society at the Races," n.p., n.d. (May 1904), ERMPS, 68.

136 "Well, the first trouble"; "very serious": Eleanor Gizycka deposition, *Gizycki v. Gizycki,* 59.

136 "Of course I can get some money"; "I will have"; "Just give it to me": JG quoted in EG deposition, *Gizycki v. Gizycki,* 59–60, see also ERMP to Nicholas II, Jan. 20/7, 1909, RGIA, Fond 1412 (Imperial Chancellery for Receipt of Petitions), inventory 215, file 32, 1–2v.

136 "model dwelling houses": "Russian Takes American Bride," *WT,* April 14, 1904, quoted in Waldrop, "Patterson, Eleanor, Research for Biography," unpublished outline, n.d. p. 70, FCWP, Box 25, Topical File, "Patterson, Eleanor, Research for Biography."

136 "the touch of dirty fingers": *FF,* 158.

137 Child at railway station resembling JG: Maryland McCormick interview, RGMP. Daisy Slavinsky has a similar experience during her first visit to the Proskurov railway station: see *FF,* 158.

137 "miserable mud and thatched huts": *FF,* 164.

137 "Coming around a corner"; "a wide bare": *FF,* 166.

138 "tumbling down": Eleanor Gizycka deposition, *Gizycki v. Gizycki,* 61–62.

138 "covered to the last inch": *FF,* 168. See also Eleanor Gizycka deposition, *Gizycki v. Gizycki,* 61–62.

139 "Why, that is cruelty": Eleanor Gizycka deposition, *Gizycki v. Gizycki,* 61–62.

139 "exceedingly run down"; "unfurnished & uninhabitable": EMP to Nicholas II, Jan. 20/7, 1909, RGIA, Fond 1412 (Imperial Chancellery for Receipt of Petitions), inventory 215, file 32, 1–2v.

139 "You know, I'm not"; "and I can't": EMP to RSMcC, n.d. [July 1904], RRMcCP. Emphasis in original.

139 "*Do please come!*"; "I wish I could": EMP to RSMcC, n.d. [July 1904], RRCcCP. Emphasis in original.

139 "Since becoming a respected": EMP to RSMcC, n.d. [July 1904], RRMcCP. Emphasis in original.

139 "I thought that was very wrong"; "But I did it": Eleanor Gizycka deposition, *Gizycki v. Gizycki,* 63.

140 "he did not like me to read"; "I was nothing": Eleanor Gizycka deposition, *Gizycki v. Gizycki,* 68.

140 "furious fits of temper": Ethel Mary Gernat deposition, *Gizycki v. Gizycki,* Gen. No. 303,481, 69 (Cir. Ct. Cook County, Ill., June 19, 1917).

141 "one of the most daring": "Social and Personal," *WP,* April 15, 1904, 7.

141 On the severity of JG's training techniques see John De Rosen interview, RGMP, Box 213, F3.

141 "Dear Mama"; "very few": JG to ERMP: Nov. 7, 1907, FGP.

141 "Here we found"; "very elaborate French Château . . .": Vita Sackville-West quoted in Nigel Nicolson, *Portrait of a Marriage* (New York: Bantam Books, 1974), 25–26.

142 still-legendary Arabian horses: A number of Antoniny's stallions, most notably that "perfect," if controversial, specimen of the breed, Skowronek (foaled 1909) and his sire, Ibrahim, continue to figure prominently in Arabian pedigrees a century later.

142 "miles and miles": Eleanor Gizycka, "And Now," *HB,* August 1922, 30.

142 "for hunting over"; "How I hated"; "the stag": Ibid.

143 "And when this interesting"; "everybody smiled": Ibid.

143 "Although set out of balance": *FF,* 202.

143 "Who is the daring": RRMcC to EMP, March 2, 1935, RRMcCP.

144 "It was sweet of you"; "and broke": EMP to RRMcC: March 19, 1935, RRMcCP.

EUROPE APPREHENSIVE OF RUSSIAN REVOLUTION

145 "I still continued": EMP to Nicholas II, January 20/7, 1909, RGIA, Fond 1412 (Imperial Chancellery for Receipt of Petitions), inventory 215, file 32, 1–2v.

145 "it was only their physical union": *FF,* 177.

145 "neither true lovers": *FF,* 177.

145 "treatment by the world's best physicians": "Countess Gizycki Critically Ill," *WP,* Jan. 8, 1905, 1.

145 "rumors of dissention": "Countess Seeks to Regain Her Only Child," *NYT,* June 1, 1908, 4.

145 "How I did worry": ERMP to AHP, n.d (spring 1905), JMPP Box 4 of 4, "Typescripts, Elinor (Medill) Patterson to Alice (Higinbotham) Patterson, 1908–23."

145 while she doled out some $15,000: According to Nellie's diary of expenses,
> Furnished flat in Vienna — taken winter 1904–05
> Furniture $15,000
> This furniture removed (& flat given up) to Nowosielica [*sic*] in 1907 or 8 Gizycki kept it. (EMP/ERMP Diary.)

146 "the physical sex"; the count seemed bored: Countess May von Wurmbrand-Stuppach quoted in "12 pages of Notes," RGMP.

146 "the climate of St. Petersburg": RSMcC to ERMP, March 11, 1905, quoted in "Second Dictation, Box 5—Envelope 2," 4, RRMcCP.

146 "serious agrarian outrages": "Three Day Massacre," *WP,* May 9, 1905, 3.

146 "Rumor says": "Mrs. Robert Patterson," unidentified clipping, n.p., n.d. [June 1905], ERMPS, 71.

147 "urgent business" ("*à cause d'affaire urgente*"): EMP, "Testament," n.d. [Jan. 1908], RGIA, Fond 1412 (Imperial Chancellery for Receipt of Petitions), inventory 215, file 32, 12–13.

147 "house of ill-repute" ("*la maison mal famée de Mme Rosa à Vienne*"): EMP, "Testament," ibid.

147 He demanded to know: JG quoted in EMP, "Testament," ibid.

147 "rather ignorant": Eleanor Gizycka deposition, *Gizycki v. Gizycki,* 65.

147 "he knew that I had no doctor": Eleanor Gizycka deposition, *Gizycki v. Gizycki,* 101.

147 "You slipped out": "Some Notes After a Talk with Felicia," RGMP, Box 213, F3; see also FG, "Beginning," in "Introduction to My Book, August 1987(?)—And the Beginning of the Book," unpublished memoir draft, 36, FGP.

148 "It was first in September 1905": EMP to Nicholas II, Jan. 20/7, 1909, RGIA, Fond 1412 (Imperial Chancellery for Receipt of Petitions), inventory 215, file 32, 1–2v.

148 he had never cared for her: See Eleanor Gizycka deposition, *Gizycki v. Gizycki,* 99–101

148 "wretched health": EMP to Nicholas II, Jan. 20/7, 1909, RGIA, Fond 1412 (Imperial Chancellery for Receipt of Petitions), inventory 215, file 32, 1–2v.

148 "from the moment": RGIA, Fond 1412 (Imperial Chancellery for Receipt of Petitions), inventory 215, file 32, 12–13.

149 *"en toilette de serge blanche"*: "A Varsovie," n.p., n.d., in ERMPS, 69.

150 "Dancing Girl's Son Made Prince": Marquise de Fontenoy, "La Marquise de

Fontenoy," n.p., n.d. [1913], ERMPS, 73; "Eleanor Beattie, Accused of Larceny, Charmed Fellow Passengers on Voyage Home," *Philadelphia Press,* Oct. 4, 1909, n.p., ERMPS, 74/70; "Austrian and Prussian Titles Are Investigated," n.p., n.d., ERMPS, 74/70.

150 "some thousand Polish nobles": "Austrian and Prussian Titles Are Investigated," n.p., n.d., ERMPS, 74/70.

150 a long-awaited opportunity to chuckle that Kate was likely to be murdered in her bed out by far-flung Rock Creek Park: FG, "Shaft—The Beginning, Notes, Comments, the Present San Diego, How I Met Drew, Will Contest," unpublished memoir draft, 8, FGP. See also Felicia Gizycka, "15 Dupont Circle: The Most Beautiful Palace of Them All," *Washingtonian,* August 1970, 80.

150 "Cissy's baby"; "She has strength": ERMP to AHP, June 8, 1907, JMPP, Patterson Family Papers, Box 4 of 4, "Typescripts, Elinor (Medill) Patterson to Alice (Higinbotham) Patterson, 1908–23."

PATTERSON, JR., BELIEVES HE HAS TOO MUCH MONEY

151 "I am to be 56"; "and I think"; "where I have"; "either resign": RWP to JMMcC, November 29 [1907], HMFP, Box 138, F8, Correspondence, McCormick, Joseph Medill, 1891, 1906–15. With regard to JMMcC and RWP's disputes, see, for example, William G. Beale to JMMcC, March 7, 1907, HMFP, Box 138, F8, Correspondence: McCormick, Joseph Medill, 1891, 1906–15.

152 "It most certainly": "Patterson, Jr. Believes He Has Too Much Money," *NYT,* March 4, 1906, 5.

152 "young Patterson appeared": "Socialists Are Fanatics, Says Patterson, Sr.," *New York Examiner,* n.d. [March 1906], n.p., ERMPS, 72; "had no valet!": ERMP, handwritten annotation, ERMPS, 72.

152 "Joe has a touch": ERMP to AHP, July 20 [1907], JMPP, Patterson Family Papers, Box 4 of 4, "Typescripts, Elinor (Medill) Patterson to Alice (Higinbotham) Patterson, 1908–23."

153 "he will come back": Fortune-teller quoted in FG, "List of What to Add and What to Insert—Book Redo," 33, FGP. See also FG, "Start of the Book Chapt. III," 52, FGP, and FG interview, RGMP, Box 213, F3

153 ERMP's advance to JMP of $20,000: EMP/ERMP diary, RRMcCP.

153 "I do get"; "When I see": ERMP to AHP, July 20[, 1907], JMPP, Patterson Family Papers, Box 4 of 4, "Typescripts, Elinor (Medill) Patterson to Alice (Higinbotham) Patterson, 1908–23."

154 "poor Minna": Ibid.

154 "special abhorrence"; "*divorced* people": Ibid. Emphasis in original.

CUPID IN MOURNING

155 These accounts of the JG's financial affairs and ERMP's contributions are drawn from RGIA, Fond 1412 (Imperial Chancellery for Receipt of Petitions), inventory 215, file 32, 12–22, as well as from the EMP/ERMP diary.

155 "urgent request"; "needed the money": EMP/ERMP diary, RRMcCP. Though Nellie recorded the sum that she wired Gizycki as "$3,000" retrospectively in 1926, it was more likely in fact the $30,000 soon to be mentioned in the official legal documentation of the Gizyckis' domestic situation: EMP/ERMP diary, RRMcCP; RGIA, Fond 1412 (Imperial Chancellery for Receipt of Petitions), inventory 215, file 32, 12–22.

156 "beastly temper": Eleanor Gizycka deposition, *Gizycki v. Gizycki,* 70.

156 Madame R.: In none of the surviving documentation does Cissy refer to her husband's "semi-respectable" Pau mistress any more fully.

157 "Look what I have got": Eleanor Gizycka deposition, *Gizycki v. Gizycki,* 86.

157 "The game was up"; "He had lost": Eleanor Gizycka deposition, *Gizycki v. Gizycki,* 73–74. See also DP, "Felicia's Kidnapping," handwritten notes, n.d., DPP/LBJL, G210, 1 of 5, "Gizycka, Felicia."

157 "Aren't you pleased": Eleanor Gizycka deposition, *Gizycki v. Gizycki,* 73–74.

158 "I am going now"; "I am only too glad": Ibid.

158 $2,000: EMP/ERMP diary, RRMcCP.

158 JG not attempting to discover where FG and EMP had gone: Eleanor Gizycka deposition, *Gizycki v. Gizycki,* 89.

158 "perfectly distracted": Ibid., 74–75.

159 "Now I am going to kill you"; "Why should I go to jail": JG quoted in ibid., 75–76.

159 "It is impossible"; "I can't go on"; "I was so distracted": Ibid.

159 "He knew it was to be": Ibid., 76.

159 "I was in a distracted": Ibid., 92–93.

159 "like a fool"; "drop all this": Ibid.

159 "The match was": "Eleanor Patterson, Publisher, Is Dead," *NYT,* July 25, 1948, 19.

160 "Shall I put"; "Don't trouble": Ethel Mary Gernat deposition, *Gizycki v. Gizycki,* 28.

160 "Felicia is all right": JG, quoted in Ethel Mary Gernat deposition, *Gizycki v. Gizycki,* 27–28.

160 "My Dear Cissy": JG to EMP, *Gizycki v. Gizycki,* 81.

161 "I knew exactly": Eleanor Gizycka deposition, *Gizycki v. Gizycki,* 85.

COUNT GIZYCKI ASKS SEPARATION

162 "the most sensational": "Divorce Case International," *LAT,* April 25, 1908, 13.

162 "English statesman": *New York Evening World,* May 1, 1908, 8.

162 "titled rake": "Grand Commandery," *Hopkinsville Kentuckian,* May 16, 1908, 2.

162 "Society never fancied"; "although Eleanor Patterson": "Chat of Well-Known People," *WP,* April 28, 1908, 11.

162 As Nellie Patterson saw it: See ERMP to Nicholas II, Feb. 19/6, 1909, RGIA, Fond 1412 (Imperial Chancellery for Receipt of Petitions), inventory 215, file 32, 68–69.

163 "How can I do anything"; "Sometimes (that is, for a few moments)": ERMP to AHP, Nov. 3, 1908, JMPP, Patterson Family Papers, Box 4 of 4, "Typescripts, Elinor (Medill) Patterson to Alice (Higinbotham) Patterson, 1908–23."

164 "The girl's family"; "the cause of": "Countess Seeks to Regain Her Only Child," *NYT,* June 1, 1908, 4.

164 " 'amicable' enough": The account of RWP's meeting with JG appears in RWP to ERMP, June 16, 1908, RRMcCP. Emphasis in original.

165 by applying to the American embassy: NARA, RG 59 (Department of State Central Files), Passport Division 1906–1925, Emergency Passport Applications, Box No. 1583, Austria, Vol. 1, Application Nos. 293–710; 1–131 (8/20/07–1/28/11) (Bound Volume "Aug 20, 1907/Jan 28, 2907" [*sic*]).

165 "offered to steal the child": EMP to Nicholas II, Feb. 19/6, 1908, RGIA, Fond 1412 (Imperial Chancellery for Receipt of Petitions), inventory 215, file 32, 67.

166 "Dear Sir—": RWP to William Howard Taft, August 15, 1908, NARA, RG 59, Numerical and Minor Files of the Department of State, 1906–10, File 3255/9 (Microfilm M-862, Reel 306).

168 "CHARACTERS ARE NOT REAL": "Patterson's Book a Literary Topsy," *NYT,* Sept. 6, 1908, 5.

168 six printings and sold a hundred thousand copies: advertisement, *NYT,* Sept. 26, 1908, BR533.

168 "a slender, red-covered edition": "Socialist Campaign Book," *NYT,* Sept. 13, 1908, 6.

168 "*un très grand Malheur*"; "*Joseph n'a jamais*": Princess Maria Lubomirska quoted in EMP to Nicholas II, Jan. 20/7, 1909, RGIA, Fond 1412 (Imperial Chancellery for Receipt of Petitions), inventory 215, file 32, 1–2v.

168 "everybody in Poland"; " 'cracked,' 'crazy,' 'eccentric' "; "Also a beast": ERMP to AHP, Nov. 3, 1908, JMPP, Patterson Family Papers, Box 4 of 4, "Typescripts, Elinor (Medill) Patterson to Alice (Higinbotham) Patterson, 1908–23." Emphasis in original.

168 "In my whole experience": Gizycka, "And Now," 84.

169 she paid her sister some $2,000: EMP/ERMP diary, RRMcCP.

THAT "BALTIC CHANCELLERY TYPE" BARON BUDBERG

169 "To the extent"; "we helped render": Vasilii Mamantov quoted in Barbara Alpern Engel, "In The Name of the Tsar: Competing Legalities and Marital Conflict in Late Imperial Russia," *Journal of Modern History* 77 (March 2005): 78.

169 "I beseech": EMP to Nicholas II, Jan. 20/7, 1909, RGIA, Fond 1412 (Imperial Chancellery for Receipt of Petitions), inventory 215, file 32, 2v.

171 "a disgrace": Maria Fedorovna quoted in DP, "Felicia's Kidnapping," handwritten notes, n.d., DPP/LBJL, G210, 1 of 5, "Gizycka, Felicia."

171 "my daughter": ERMP quoted in FG, "List of What to Add and What to Insert— Book Redo," 19A–19B.

171 "Make urgent arrangements": Nicholas II, order written to AAB, Chancellery for Receipt of Petitions memorandum, RGIA, Fond 1412 (Imperial Chancellery for Receipt of Petitions), inventory 215, file 32, 39.

171 "Baltic chancellery type": Sidney Harcave, trans., ed., *The Memoirs of Count Witte* (Armonk, NY: M. E. Sharpe, 1990), 485.

171 On Nicholas and Alexandra's reverence for domesticity, see Richard S. Wortman, *Scenarios of Power,* vol. 2 (Princeton, NJ: Princeton University Press, 2000), 333. On Budberg's views on family life see Engel, "In the Name of the Tsar," 82.

171 "very much in love": JG to Countess May von Wurmbrand-Stuppach, Nov. 24, 1911, RGMP, Box 212, F10.

172 "*conseilles intimes*": JG to AAB, January 20, 1909, RGIA, Fond 1412 (Imperial Chancellery for Receipt of Petitions), inventory 215, file 32, 24–24v.

172 "my sister feels"; "For the rest": KMMcC to AAB, January 10, 1909, RGIA, Fond 1412 (Imperial Chancellery for Receipt of Petitions), inventory 215, file 32, 25–27.

172 Kate's counteroffer: Ibid.

173 "*petit chou*"; "*diplomatie féminine*": Countess Gorska to AAB, Nov. 13, 1909, RGIA, Fond 1412 (Imperial Chancellery for Receipt of Petitions), inventory 215, file 32, 7–8v.

173 On Countess Zamoyska's efforts to locate FG see Baron Accurti to Maximilian

Ivanovich Trusevich, Feb. 12, 1909, RGIA, Fond 1412 (Imperial Chancellery for Receipt of Petitions), inventory 215, file 32, 63–63v.

REALLY A QUITE DISAGREEABLE COMPLICATION

174 "Fate, which evidently"; "This case": CJG to Sigmund Freud, March 7, 1909, William McGuire, ed., *The Freud/Jung Letters* (Princeton, NJ: Princeton University Press, 1974), 133J.

174 "a relationship": RHMcC quoted in Miller, *Ruth Hanna McCormick,* 35.

174 Medill was more high-strung: The couple's granddaughter and RHMcC's biographer, Kristie Miller, believes JMMcC to have been manic-depressive.

174 "The doctors"; "It is astonishing"; "I was terribly": KPMcC to JMMcC and RHMcC, n.d. ["Tuesday eve"], HMFP, Box 138, F4, "Correspondence, McCormick, Katherine Medill, 1892 ca., 1908 ca.–1914." Emphasis in original.

175 "We don't want": KMMcC quoted in Kristie Miller, "The Letters of C. G. Jung and Ruth McCormick," in *Spring* 50 (Dallas: Spring Publications, 1990), 5.

175 Medill checked into the Burghölzli clinic: According to Kristie Miller, JMMcC's initial psychiatric treatment in Europe likely took place at the Burghölzli clinic in Jung's care as well. Miller, *Ruth Hanna McCormick,* 45.

175 "cure"; "so-called brilliant case": Quoted in Deirdre Bair, *Jung: A Biography* (New York: Back Bay, 2003), 158.

175 "almost affectionate"; "cure"; "future intellectual development": JMMcC to RHMcC, March 10, 1909, in Miller, "Letters," 11.

175 "delicate": Bair, *Jung,* 700; "resistance": See CJG to JMMcC, April 2, 1909 in Miller, "Letters," 11.

176 he sped gallantly: On JMMcC's efforts on EMP's behalf generally see JMMcC deposition, *Gizycki v. Gizycki,* Gen. No. 303,481, 38 (Cir. Ct. Cook County, Ill., June 19, 1917).

176 "both at that time": ERMP to AHP, Nov. 22, 1911, JMPP, Patterson Family Papers, Box 4 of 4, "Typescripts, Elinor (Medill) Patterson to Alice (Higinbotham) Patterson, 1908–23." Emphasis in original.

176 "a most unconventional": William McGuire, "Firm Affinities: Jung's Relations with Britain and the United States," *Journal of Analytical Psychology* 40 (1995), 305.

176 "a power devil": CJG quoted in Bair, *Jung,* 158.

176 "= infantile relations"; "a wild and immoral life"; "the devil became"; "the devil whispers"; "alkohol"; "*Au fond*"; "this desir": CJG to RHMcC, July 9, 1909, in Miller, "Letters," 16–17.

176 "disease [was] not": CJG to JMMcC, April 2, 1909, in ibid., 11.

177 "vile scandal": CJG to Sigmund Freud, March 7, 1909, in McGuire, *Freud/Jung Letters,* 133J.

HOW MUCH WILL YOU PAY FOR YOUR BABY GIRL?

178 "endless negotiations": Eleanor Gizycka deposition, *Gizycki v. Gizycki,* 82.

178 "She is so worn out": ERMP to AHP, May 18, 1909, JMPP, Patterson Family Papers, Box 4 of 4, "Typescripts, Elinor (Medill) Patterson) to Alice (Higinbotham) Patterson, 1908–23." Emphasis in original.

179 "thinking over": Major-General K. K. Leontiev to AAB, "Top Secret" report, May

21/8, 1909, RGIA, Fond 1412 (Imperial Chancellery for Receipt of Petitions), inventory 215, file 32, 106.

179 "absolutely in everything": JG, Statement to K. K. Leontiev, May 20, 1909, RGIA, Fond 1412 (Imperial Chancellery for Receipt of Petitions), inventory 215, file 32, 108.

179 "the whole affair": RGIA, Fond 1412 (Imperial Chancellery for Receipt of Petitions), inventory 215, file 32, 125–27.

180 "Public opinion"; "crack of the whip": Ibid.

180 successful legal challenges to the Chancellery for Receipt of Petitions rulings: See Barbara Alpern Engel, "Marriage and Masculinity in Late-Imperial Russia: The Hard Cases," in Barbara Evans Clements et al., eds., *Russian Masculinities in History and Culture* (New York: Palgrave, 2002), 113.

181 "all future differences": EMP to AAB, telegram, June 23, 1909, RGIA, Fond 1412 (Imperial Chancellery for Receipt of Petitions), inventory 215, file 32, 141.

181 "*sincerité incontestable*": JG to AAB, telegram, July 11, 1909, RGIA, Fond 1412 (Imperial Chancellery for Receipt of Petitions), inventory 215, file 32, 171.

181 "compromising": AAB to JG, July 14/1, 1909, RGIA, Fond 1412 (Imperial Chancellery for Receipt of Petitions), inventory 215, file 32, 193v.

181 "I sometimes wonder"; "never out of": ERMP to AHP, July 26, 1909, JMPP, Patterson Family Papers, Box 4 of 4, "Typescripts, Elinor (Medill Patterson) to Alice (Higinbotham) Patterson, 1908–23." Emphasis in original

181 "My mother"; "*No one* loves": ERMP to AHP, July 11, 1909, JMPP, Patterson Family Papers, Box 4 of 4, "Typescripts, Elinor (Medill Patterson) to Alice (Higinbotham) Patterson, 1908–23." Emphasis in original.

182 "G. took"; "I wish": ERMP to AHP, May 18, 1909, in ibid.

182 "Everyday [*sic*] when we thought"; "It was always": Eleanor Gizycka deposition, *Gizycki v. Gizycki*, 94–95.

182 "I submit": JG to AAB, telegram, n.d. (late July 1909), RGIA, Fond 1412 (Imperial Chancellery for Receipt of Petitions), inventory 215, file 32, 213.

182 "with a very bad grace"; "never again"; "act": ERMP to AAB, Aug. 2, 1909, RGIA, Fond 1412 (Imperial Chancellery for Receipt of Petitions), inventory 215, file 32, 218.

182 "the Emperor of Russia"; "the Baron de Budberg": ERMP to AAB, October 17, 1910, RGIA, Fond 1412 (Imperial Chancellery for Receipt of Petitions), inventory 215, file 32, 329.

182 "& made himself conciliatory": ERMP to AAB, August 2, 1909, RGIA, Fond 1412 (Imperial Chancellery for Receipt of Petitions), inventory 215, file 32, 218.

183 "Child delivered": JG to AAB, Aug. 1, 1909, telegram, RGIA, Fond 1412 (Imperial Chancellery for Receipt of Petitions), inventory 215, file 32, 215.

183 "I wrote a form"; "which in effect": JMMcC deposition, *Gizycki v. Gizycki*, 40–41.

184 "furious passion"; "with an armful"; "adjectival embellishments"; "I was so overwhelmed": JMMcC deposition, *Gizycki v. Gizycki*, 40–42.

184 "He was amiable": Eleanor Gizycka deposition, *Gizycki v. Gizycki*, 78.

184 "negotiations for all": Ibid., 80.

184 "very frightened"; "sort of walking around": Ibid., 79.

184 *très inquiétée*: EMP to AAB, Aug. 3, 1909, telegram, RGIA, Fond 1412 (Imperial Chancellery for Receipt of Petitions), inventory 215, file 32, 218.

184 "most decisively against": JG to AAB, telegram, Aug. 8, 1909, RGIA, Fond 1412 (Imperial Chancellery for Receipt of Petitions), inventory 215, file 32, 152–55v.

185 JG's complaints about the Pattersons' treatment of Miss Bride appear in JG to

AAB, Aug. 8, 1909, RGIA, Fond 1412 (Imperial Chancellery for Receipt of Petitions), inventory 215, file 32, 230–32.

CHICAGO COUNTESS WILL RETURN HOME

187 "this whole world": FG, "List of What to Add and What to Insert—Book Redo," 14.

187 "I don't remember"; "and I don't know"; "I am on a street": Ibid., 15A–15B.

188 "screams of laughter": Ibid., 16.

188 "I didn't love the woman": Ibid., 17.

188 "Everybody else": FG, "Introduction to My Book," "Beginning," 43, FGP.

188 "shocking"; "without any preliminaries"; "Stop singing!": FG, "List of What to Add and What to Insert—Book Redo" 18.

188 "I bet I'm the only": Ibid., 19A–19B.

188 "marvelous, intelligent"; "Nasty meat-meat!": Ibid., 20.

189 "I didn't feel cute": FG, "Introduction to My Book," 42.

189 "Did she pick me up"; "I rather think not": FG, "Start of the Book Chapt. III," 17.

189 "It was like Mother": FG interview, RGMP, Box 213, F3.

THE TITLED MATCH

190 JG's financial situation in late 1909: EMP/ERMP Diary, n.d. ("Sep. 1903"), RRMcCP.

190 "The present whereabouts"; "Neither [the countess's] name . . .": "Countess Has Won Her Fight," *LAT,* Aug. 12, 1909, 15.

191 "I am weary"; "I do not wish"; "placed her arm"; "closely to her mother": "Woman Who Married Russian Count Just Home with Daughter Long Stolen," *New York World,* Aug. 18, 1909, 16.

191 "furnished a sensation": "Countess Brings Daughter," *NYT,* Aug. 18, 1909, 9.

191 "I am here"; "Now that I": EMP quoted in "Brings Stolen Child," *WP,* Aug. 18, 1909, 7.

192 "inasmuch as the regular tribunals": JMMcC, quoted in "Tsar's Aid to American," *NYT,* Sept. 1, 1909, 4.

192 "Not one cent": JMMcC quoted in "Brings Stolen Child," *WP,* Aug. 18, 1909, 7.

193 "in the after*noon*!": "Notes from Felicia," Research Files, "Business Women"— "Death & Will," Box 211, f 9, RGMP.

THE MOST KIDNAPPED CHILD IN THE WORLD

194 "My mother drifted": FG, "List of What to Add and What to Insert—Book Redo," 29A–29B.

197 "I am not sure"; "His advice": ERMP to JMMcC, n.d., HMFP, Box 139, F14, "Correspondence, Patterson, Elinor Medill, 1915–21."

198 "the protecting arm": "Count Gets a Decree," *WP,* March 3, 1911, 1.

198 "when we played"; "Our weekly programme"; "bosom companion": Arthur Meeker, *Chicago, with Love* (New York: Knopf, 1955), 92.

199 "I adored our place": FG, "Start of the Book Chapt. III," 49.

199 FG's early fascination with flush toilets: Eleanor Lake interview, RGMP, Box 213, F6.

199 "hauled off": FG, "List of What to Add and What to Insert—Book Redo," 26.

199 "black and blue": FG, "Cissy Patterson: The Countess of Flat Creek," *Teton Magazine,* vol. 10, 1977, 38.

199 FG abused by German nanny: FG, "The Red Hot Miracle," unpublished memoir draft, 2, FGP. See also EPA interview with the author, Nov. 11, 2004.

199 "poor little orphan": ERMP quoted in FG, "Shaft," 6; FGP.

199 "You don't want me"; "I wouldn't trade"; "it was so wonderful": FG, "Start of the Book Chapt. III," 28.

200 "My God": Ibid., 47.

200 "He had wanted a boy": APG as told to Hal Burton, "This Life I Love," *SEP,* Feb. 21, 1954, 45.

200 "Poppy"; "He was the closest": FG, "List of What to Add & What to Insert, Book-Redo," "Libertyville," 28.

200 "joined forces": Ibid., 30A.

200 "forever giving us hell": FG, "Start of the Book Chapt. III," 58.

200 " 'Damn,' Grams would say": FG, "15 Dupont Circle," 80.

200 "disgrace": FG, "Shaft," 27.

201 "Shame on you!"; "Stop that music": FG, "Start of the Book Chapt. III," 64.

201 "I was a stranger"; "Naturally, since": Ibid., 29.

201 "Cissy hated me": FG, "Countess of Flat Creek," 38.

201 "extraordinary inability": FG, "Shaft," 51.

201 "Overhead was the constant": FG, "Start of the Book Chapt. III," 30.

201 "I remember Grandfather Patterson": Ibid., 61.

202 "I've just heard": KMMcC to RRMcC, n.d., quoted in Smith, *The Colonel,* 128.

202 "Nellie sure": KMMcC quoted in Hoge, *Cissy Patterson,* 7.

202 "neurasthenic"; "I feel good": EMP to AAB, n.d., RGIA, Fond 1412 (Imperial Chancellery for Receipt of Petitions), inventory 215, file 32, 325–26.

202 "I think Cissy": ERMP to AHP, February 14, 1912, JMPP, Patterson Family Papers, Box 4 of 4, "Typescripts, Elinor (Medill) Patterson to Alice (Higinbotham) Patterson, 1908–23." Emphasis in original.

203 "rotten": Ibid.

<div align="center">WHISKERED SABOTEUR</div>

204 "Travellers": Imperial German Embassy's Lusitania warning quoted from "GERMAN EMBASSY ISSUES WARNING," *NYT,* May 1, 1915, http://query.nytimes.com/mem/archive-free/pdf?res=F70915F8395B17738DDDA80894DD 405B858DF1D3.

204 "Mrs. Townsend's dinner"; "72 at dinner": ERMP to AHP, Feb. 16, 1915, JMPP, Patterson Family Papers, Box 4 of 4, "Typescripts, Elinor (Medill) Patterson to Alice (Higinbotham) Patterson, 1908–23."

205 "Kate went out": Ibid.

206 "successful after-dinner speaker"; "Above middle height": "Personalities," *Hampton's Magazine,* March 1909, 405.

206 "an extremely good mixer": "Bernstorff Told Propaganda Plan at a House Party," *NYT,* Dec.21, 1918, 1.

207 "a lovable, matronly": William J. Flynn, "Tapped Wires," *Liberty,* June 2, 1928, 20. Though Secret Service chief Flynn gives her a pseudonym twelve years later in print, a comparison of the transcripts reproduced in JMP's *Liberty* with the originals in the National Archives indicates that Mrs. Townsend was the "Eunice Hanford" Flynn describes.

207 Allied diplomats avoiding 15 Dupont Circle: see ERMP deposition, *Ford v. Tribune,* Jan. 24 and Feb. 10, 1919, n.p., RRMcCP.

208 "As I was in Munich"; "It is not 'cricket'": ERMP to AHP, Sept. 4, 1914, JMPP, Patterson Family Papers, Box 4 of 4, "Typescripts, Elinor (Medill) Patterson to Alice (Higinbotham) Patterson, 1908–23."

208 "I didn't want": ERMP deposition, *Ford v. Tribune,* Jan. 24 and Feb. 10, 1919, n.p., RRMcCP; see also ERMP to RRMcC, n.d. ("Copy made 7–16–91"), RRMcCP.

208 On *Town Topics'* claims that Countess Gizycka provided Bernstorff with a floral send off: See Jonathan Daniels, *The End of Innocence* (New York: DaCapo Press, 1954), 195.

208 "whiskered saboteur's": Percy Hammond, "Count Bernstorff Tells His Story," n.p., n.d. (July 2, 1920), RRMcCP.

209 "stood in the way": "Ford Charges Are Answered by War Record," *CDT,* May 17, 1919, 1.

209 "talked almost to death": Judge James G. Tucker quoted in John Tebbel, *An American Dynasty* (Garden City, NY: Doubleday, 1947), 97.

210 "You told me once": EMP ("X") quoted in Flynn, "Tapped Wires," 21.

210 "my poor little": EMP quoted in transcript of Ambassador Count Johann von Bernstorff's telephone conversation of June 18, 1915, 9:35 a.m., 5, "Telephone conversations tapped by agents, May 30–Sept. 2, 1915, of calls of Bernstorf [*sic*], Boy-Ed, Mrs. Archibald White, et al., NARA, RG 59, Office of the Counselor/Undersecretary and Chief Special Agent, Classified Case Files, Human Espionage Activities, Box 3.

210 "I want to tell you": EMP quoted in transcript of Ambassador Count Johann von Bernstorff's telephone conversation of June 19, 1915, 10:08 a.m., 1, in ibid.

210 "I am sorry": EMP quoted in transcript of Ambassador Count Johann von Bernstorff's telephone conversation of June 18, 1915, 10:40 a.m, 5, in ibid.

210 "that Englishman"; "one bad leg"; "helpless husbands": Mrs. Richard Townsend ("Mrs. Eunice Hanford") quoted in Flynn, "Tapped Wires," 21.

211 "She seemed so disappointed": Ambassador Count Johann Heinrich von Bernstorff quoted in Flynn, "Tapped Wires," 21.

A PEARL OF A SUMMER

211 "So she sold it": ERMP quoted in FG, "Start of the Book Chapt. III," 49. For ERMP's notations on the financial details of the sale see Dec. 11, 1912, entry in EMP/ERMP Diary, RRMcCP.

213 "My mother was spoiled": FG, "Forgiveness at Flat Creek."

213 "bastard of East and West": Nathaniel Burt, "Early Days of the Bar BC," *Teton,* vol. 14, (1981), 19.

214 "He might as well": Arline Davis Ireland quoted in Louise Ireland Grimes Ireland, *Ligi: A Life in the Twentieth Century* (privately published, 1999), 39.

214 "That was a pearl": Louise Ireland Grimes Ireland quoted in FG, "Cissy Patterson: The Countess of Flat Creek," 40.

214 "I was puzzled": Ireland, *Ligi,* 36.

214 EMP bribing CC: FG, "Cissy Patterson: The Countess of Flat Creek," 41.

215 "At sixteen": CC quoted in Earle F. Layser, *I Always Did Like Horses and Women* (Alta, WY: Booksurge, 2008), 30.

216 "Lank, sardonic, prune-faced" : Nathaniel Burt, *Jackson Hole Journal* (Norman: University of Oklahoma Press, 1983), 58.

216 "surrounded by the aura": Ibid., 53.

216 "treated horses"; "grave deliberation": Ibid., 54.

216 "he could see the sheriff": Jackson Hole Land Trust, "Flat Creek Ranch History," unpublished ms., 1, JHHSM.

216 "it was time to get respectable": CC quoted in FG, "Jackson Hole, 1916–65: A Reminiscence," *Vogue,* April 1, 1965: 203.

216 "There wasn't a horse": Struthers Burt, "The Most Unforgettable Character I've Met," *Reader's Digest,* Oct. 1948, 83.

217 "strong, healthy and unwashed": EG, *Glass Houses* (New York: Milton, Balch, 1926) (hereafter cited as *GH*), 187.

217 "certainly appeared to be"; "Cal would openly mock": Burt, *Jackson Hole Journal,* 58.

217 "my God, *the count!*": Martin, *Cissy,* 159. Emphasis in original.

217 "indiscretion"; "git out": FG, "Jackson Hole, 1916–65," 205.

218 "A handsome young woman": EMP quoted in Martin, *Cissy,* 175.

218 "The men had made just a mess": RC quoted by EMP in Martin, *Cissy,* 175.

218 "Back East": FG, "Jackson Hole, 1916–65," 205.

<div align="center">WORLD'S GREATEST NEWSPAPER</div>

219 "paralysis or mania": Emma Jung to Sigmund Freud, quoted in McGuire, *Freud/Jung Letters,* 1974, 301.

219 "the rich yield": Sigmund Freud to CJG quoted in McGuire, "Firm Affinities," 308; on CJG's diagnosis of JMMcC see Smith, *The Colonel,* 127n.

220 "In the year 1909"; "One day a friend": RRMcC, *Memoirs,* 233, RRMcCP.

220 as many as twenty-seven dead: Smith, *The Colonel,* 134.

220 "If inventive genius is hereditary": RRMcC quoted in Smith, *The Colonel,* 10.

221 "According to its traditions": "To the Public," *CDT,* Aug. 23, 1914, A1.

222 "Things seem"; "I guess"; "I don't mind": JMP to JMMcC, April 10, 1910, HMFP, Box 139, F15, "Patterson, Joseph Medill, 1910–1922."

222 "dealing with": "News and Gossip of the Plays and Players," *CDT,* Dec. 7, 1913, G1.

223 JMP impressed by early twentieth century German social welfare services: FC, *McCormick of Chicago,* 139.

223 "You've now"; "Make friends": KMMcC to JMMcC, Jan. 16, 1916, HMFP, Box 138, F4, "Correspondence, Katherine Medill, 1915, ca. 1915."

224 "entirely befuddled and dull"; "very giggly [and] silly": Amie Irwin Adams deposition, *Adams v. Adams,* Gen. No. 306,927, 3 (Cir. Ct. Cook County, Ill., February 20, 1914). Though the spelling of her first name varies slightly in the surviving documentation ("Amy," "Aimée"), I have used "Amie," the version that appears in the legal and civil record, throughout.

224 "There are so many things"; "Did Ed Adams": ERMP to AHP, Sunday, Sept. 6, 1914, JMPP, Patterson Family Papers, Box 4 of 4, "Typescripts, Elinor (Medill) Patterson to Alice (Higinbotham) Patterson, 1908–23."

225 "By getting"; "We are also": RRMcC to KMMcC, June 25, 1914, RRMcCP. See also Smith, *The Colonel,* 150.

225 "I've been terribly upset": KMMcC to JMMcC, March 10, 1915, HMFP, Box 138, F4, "Correspondence, Katherine Medill, 1915, ca. 1915."

225 "My sister did not receive"; "but that is": ERMP to AHP, March 19, 1915, JMPP, Patterson Family Papers, Box 4 of 4, "Typescripts, Elinor (Medill) Patterson to Alice (Higinbotham) Patterson, 1908–23." Emphasis in original.

226 "the former Mrs. Adams"; "the old tart"; "the old strumpet": KMMcC to JMMcC,

"Saturday" [May 8, 1915], HMFP, Box 138, F4, "Correspondence, McCormick, Katherine Medill, 1915, ca. 1915."

226 "the female inmate": KMMcC to JMMcC, Aug. 13, 1923, HMFP, Box 138, F7, "Correspondence, McCormick, Katherine Medill, ca. 1919–ca. 1925."

226 "Death is very easy"; "Please bear": RRMcC to KMMcC, May 1, 1915, HMFP, Box 139, F2, "Correspondence, McCormick, Robert Rutherford, 1910–19."

226 "Let Joe run the paper": RRMcC to KMMcC, May 6, 1915, HMFP, Box 139, F2, "Correspondence, McCormick, Robert Rutherford, 1910–19."

227 "You said last spring"; "pompous pretense"; "As a matter of fact": EMP to KMMcC, n.d., HMFP, Box 139, F13, "Patterson, Eleanor Medill ('Cissy'), 1919, and n.d."

227 "certain asparagus": RRMcC to JMMcC, n.d. (June 1921), HMFP, Box 139, F5, "Correspondence, McCormick, Robert R., n.d."

227 "Vanity, as you said today": EMP to KMMcC, n.d., HMFP, Box 139, F13, "Patterson, Eleanor Medill ('Cissy'), 1919, and n.d."

228 *CDT* WWI circulation figures: Wendt, *Chicago Tribune,* 434.

228 *NYDN* circulation figures: Frank Luther Mott, *American Journalism* (New York: Macmillan, 1941), 668.

229 "His Harun-al-Rashid sojourns": A. J. Liebling, "The Wayward Press," *New Yorker,* June 8, 1946, 98.

AND WHAT'S MORE, I'M GOING TO SEDUCE YOUR SISTER!

229 "I am impressed"; "It is impossible": ERMP to JMMcC, Sept. 8, 1919, HMFP, Box 139, F14, "Correspondence, Patterson, Elinor Medill, 1915–21, n.d." Emphasis in original.

230 "We have won the fight": Sen. Henry Cabot Lodge to JMMcC, Nov.13, 1920, HMFP, Box 7, Joseph Medill McCormick, "General Correspondence, Nov.–Dec. 1, 1920."

230 "my respectable": JMMcC to RHMcC, Dec. 1920, HMFP.

230 JMMcC as presidential timber: See, for example, Will Dila to JMMcC, November 3, 1919, HMFP.

230 "More than any other": Jack Alexander, "The Duke of Chicago," in *Post Biographies of Famous Journalists,* ed. John E. Drewry, (n.p.: University of Georgia Press, 1942), 228.

231 "Dear Mr. Patterson"; "I address you": WCH dictation to Frank Wesley Carson, quoted in Martin, *Cissy,* 179.

231 "And what's more": WCH quoted in Healy, *Cissy,* 110.

231 "You are a common"; "I shall": WCH dictation to Carson, quoted in Martin, *Cissy,* 179.

232 "I was not much": Walter Howey, "Introduction," *Fighting Editors,* ed. Walter Howey (New York: David McKay, 1948), vi.

232 "roared into Chicago": Charles MacArthur quoted in "Walter C. Howey, Boston Editor, 72," *NYT,* March 22, 1954, 27.

232 "silent, tight-lipped"; "knew the best": Burton Rascoe, *Before I Forget* (New York: The Literary Guild of America, 1937), 236.

232 "two months of burglary": "The Press: Hearst's Howey," *Time,* June 17, 1935, http://www.time.com/time/magazine/article/0,9171,754886,00.html.

233 "We went out and arrested"; "Our policemen"; "convenience": Charles MacArthur quoted in "Walter C. Howey, Boston Editor, 72," 27.

233 "a profane romanticist": "Hearst's Howey."

233 "as poisonous a political mess": Edna Ferber quoted in Hoge, *Cissy Patterson,* 72.

233 "cleverest editor": WRH quoted in Martin, *Cissy,* 180.

234 "Every reporter must"; "What you must": Lafayette Young quoted in Howey, "Introduction," *Fighting Editors,* viii.

234 "Sister of the Editor": Eleanor Gizycka, "Eleanor Gizycka Admires Borah," *Chicago Herald-Examiner,* June 9, 1920, 1.

234 "Every one loves courage"; "faced his difficult audience"; "And pretty soon"; "just fun": Ibid.

234 "the great senator smiled": Ibid., 2.

234 "Although ostentatiously avoiding": *Vanity Fair,* quoted in Claudius O. Johnson, "Very Personal Notes on Senator William E. Borah," April 1939, cage 214, Claudius Osborne Johnson Papers, University of Washington.

235 "I have divine rooms here"; "Have about come": EMP to KMMcC, n.d., HMFP, Box 139, F13, "Patterson, Eleanor Medill ('Cissy'), 1919 and n.d."

235 "During the last": EMP, "Singing for Their Supper," *WT-H,* Jan. 17, 1942, 1.

236 "She became": Ibid.

236 "So what happened?": Ibid.

237 "We were doing"; "it was sheer": ARL quoted in Cordery, *Alice,* 270. Emphasis in original.

237 "upon sweeping up"; "Many thanks": EMP quoted in *WMGR.*

237 in flagrante delicto: Reporter Adela Rogers St. Johns (among others) claimed that both ARL and EMP told her the anecdote: Adela Rogers St. Johns interview, RGMP, Box 213, F4.

238 "Washington is only": *GH,* 8.

238 "handsome"; "mature": *GH,* 9.

238 "cautioned her against": *WMGR,* 13.

238 "Senator Borah seems"; "Perhaps he ought not"; "Has the siren": "Borah and Bolt," *CDT,* June 13, 1920, 8.

239 "Alice Longworth, even then"; "thought she said": *WMGR,* 14.

MAIS VOUS N'AVEZ PAS CHANGÉ DU TOUT!

240 "Her continued sobbing"; "Weeping—hysteria": ERMP to JMMcC, June 9, 1921, HMFP, Box 139, F14, "Correspondence, Patterson, Elinor Medill, 1915–21, n.d."

240 "she weighs *clothed*": KMMcC to RHMcC, June 14, 1921, HMFP, Box 138, F7, "Correspondence, McCormick, Katherine Medill, ca. 1919–ca. 1925." Emphasis in original.

240 "I believe it is the result": KMMcC to JMMcC, June 16, 1921, HMFP, Box 138, F8, "Correspondence, McCormick, Katherine Medill, Undated."

241 "a vast sky": Eleanor Gizycka, "Diary on the Salmon River (Part 1)," *F&S,* May 1923, 19.

241 "devouring sun": Eleanor Gizycka, "Diary on the Salmon River (Part 2)," *F&S,* June 1923, 276.

241 "There is always something": Eleanor Gizycka, "Diary on the Salmon River (Part 2)," 188.

241 "Vienna and Warsaw": Editor's note on Eleanor Gizycka's "Polonaise," *HB,* Dec.1921, 23.

241 "is worse than I expected": EMP quoted in Healy, *Cissy,* 77.

242 "I boarded the night train": Eleanor Gizycka, "And Now," *HB,* August 1922, 29.

242 *"Mais vous n'avez pas changé"*: Ibid.

242 "It was a long and horrible list": Ibid.

242 " 'No,' [Potocki] answered": Ibid.

243 "very young": Ibid.

243 "Between Polish men and women"; "He goes his"; "Some are banking": Ibid.

244 "Paris has changed": Eleanor Gizycka, "News of Chicago Society," *CDT,* March 19, 1922, F4.

245 "Yes—yes—yes": EMP quoted in Healy, *Cissy,* 85. Emphasis in original.

DEBUT IS DECLINED BY FELICIA GIZYCKA

245 "What can I tell you"; "I had a": EMP quoted in Healy, *Cissy,* 88.

246 "Cissy went to Poland"; "and came back": FG, "Cissy Patterson: The Countess of Flat Creek," 38.

246 "Mama loves it here": FG to ERMP, June 9, 1920, FGP.

247 "should see more"; "It's time"; "But had the": EMP to RC, May 26, 1922, quoted in Healy, *Cissy,* 80.

247 "pleased and satisfied"; "much more attractive"; "Felicia's friends look": EMP to RC, quoted in ibid., 81.

248 "a Jew": Ibid., 81.

249 "I must say"; "he is the cleverest": EMP to RC, Dec. 4, 1923, quoted in ibid., 85.

249 "much improved"; "He is so smooth": EMP to RC, Feb. 26, 1924, quoted in ibid., 89.

249 "and with my": EMP to RC, Dec. 4, 1923, quoted in ibid., 81.

249 "After keeping a few engagements": ERMP to AHP, Feb. 6, 1923, JMPP, Patterson Family Papers, Box 4 of 4, "Typescripts, Elinor (Medill) Patterson to Alice (Higinbotham) Patterson, 1908–1923."

249 "in consideration": Historic American Buildings Survey, Patterson House (Washington Club), HABS No. DC-270, WASH, 212-, "Part 1, Historical Information."

250 "It is more important": JMP to EMP, July 25, 1923, JMPP, Patterson Family Papers, Series 5, Subseries 3, Box 74, Folder 3, "Patterson, Eleanor Medill Estate."

250 "I am not suspicious": EMP to JMP, Aug. 8, 1923, ibid.

250 "open rebellion": EMP to JMP, Sept. 13, 1924, ibid.

250 Mrs. Robert W. Patterson: "Social Notes: Washington," *NYT,* April 1, 1923, S6.

250 "(who is not fit to come out)"; "and when Felicia is married": EMP to JMP, Aug. 8, 1923.

250 I don't know"; "I wonder if": FG, "Shaft" 52.

251 "Drew Pearson, Special Correspondent": Enge (?) to DP, DPP/LBJL, G 316, 3 of 5, "DP Personal Letters" (2 of 2).

251 "chronic liar": FDR quoted in "Drew Pearson Branded Chronic Liar by President," *Milwaukee Sentinel,* Sept. 1, 1943, 1.

251 "an infamous liar"; "a dishonest, ignorant": Senator Kenneth McKellar, quoted in Oliver Pilat, *Drew Pearson: An Unauthorized Biography* (New York: Harper's Magazine Press, 1973), 20.

252 "Drew Pearson on the Orient of To-Day": advertisement, Around The World Syndicate, n.d., DPP/LBJL.

252 "more correct newspaper style"; "Sunday supplement stuff": DP to Paul Pearson, March 2, 1923, DPP/LBJL, G316, 3 of 5, "Old Family Letters" (2 of 3).

252 "Oh shut up!": RC quoted in Martin, *Cissy,* 222.

254 "old bear": EMP quoted in Healy, *Cissy,* 88.

254 "Just think": Ibid., 83.

254 "self-indulgent"; "headed straight"; "her elusive"; " 'put her on the market' ": EMP

to JMP, Sept. 13, 1924, JMPP, Patterson Family Papers, Series 5, Subseries 3, Box 74, Folder 3, "Patterson, Eleanor Medill, Estate."

254 "disconcerting, inspiring influence"; "forget most everything": DP to FG, Nov. 3, 1924, DPP/LBJL, G316, 3 of 5, "Old Family Letters" (3 of 3).

254 "Cissy never invited": FG, "Shaft," 31.

254 "She has grown": EG to JMP, Sept. 13, 1924, JMPP.

255 "What's that"; "Oh—that's": FG, "Start of the Book Chapt. III," 39.

255 "queer, ghastly change": EMP quoted in Healy, *Cissy*, 77.

255 "I've gained ten pounds": Ibid., 76.

255 "She left Banff": "Trip in Wilds Begun by Countess Gizycka," *WP*, Aug. 21, 1924, 1.

256 "What I wanted"; "Have had drunken": EMP to JMP, Sept. 13, 1924.

256 "I really think": EMP quoted in Healy, *Cissy*, 85.

256 "I have been deeply hurt"; "laziness, trashiness"; "she told me"; "yearned 'to live'"; "Get out"; "She would get": EMP to JMP, Sept. 13, 1924.

257 "Now she can": Ibid.

257 "this was hardly": FG, "Cissy Patterson: The Countess of Flat Creek," 43.

257 "roundups"; "pitched battle": FG, "Jackson Hole, 1916–65: A Reminiscence," 205.

257 "knock-down drag-out": FG, "Cissy Patterson: The Countess of Flat Creek," 43.

257 "worldly possessions"; "in a rage"; "I'm not a great horsewoman": Ibid., 43.

257 "would send someone": Ibid., 43.

257 "As I rode down to town": FG, "Book Redo II—Stuff to Be Written, Notes August 1988, San Diego—After Ctss of Flat Creek," unpublished memoir draft, 1A, FGP.

257 "How did you": RC, quoted in Martin, *Cissy*, 208.

258 "Now I've got": FG, "Book Redo II," 1A.

258 "terribly shocked": Ibid., 1B.

258 "a very mild": Ibid., 2A.

258 "You bore me": FG quoted in Pilat, *Drew Pearson*, 73.

259 "at least Mama": FG, "Book Redo II," 2A.

259 "In some ways": Ibid., 5.

260 "without her dress on!": Ibid., 8.

260 "My education": Ibid., 7.

260 "Marion, you're too innocent"; "Don't you know": Alice Green quoted in ibid., 8.

260 "the next best thing"; "rented a room": Ibid., 8.

260 "Finally he grabbed me": Ibid., 9.

260 "this was a cry": Ibid., 10.

260 "I had no empathy": FG, "Shaft," 42.

261 "If you ever expect": JMP to FG, Jan. 31, 1925, DPP/LBJL, G316, 3 of 5, "Old Family Letters" (3 of 3).

261 "Somehow I felt depressed"; "The animal stirred": Eleanor Gizycka, "Who's the Goat?" *Liberty,* Oct. 24, 1925, 54.

261 his sister's heart was breaking: FG interview, RGMP, Box 213, F3.

262 "for certainly I will be lonesome": EMP to AHP, October 18, 1924, JMPP, Patterson Family Papers, Series 5, Subseries 3, Box 74, Folder 3, "Patterson, Eleanor Medill, Estate."

262 "At Christmastime": FG, "Book Redo II," 11.

262 "I always tell [friends]": FG to EMP, Jan. 16, 1925, JMPP, Patterson Family Papers, "Patterson, Eleanor Medill, Estate," Series 5, Subseries 3, Box 74, Folder 3.

262 "I am so proud!": Ibid.

262 "Now I was nineteen": FG, "Book Redo II," 12.

262 "Pretty Felicia": Dolley Madison [pseudo.], "Dolley Madison's Intimate Comments," *WP,* Dec. 28, 1924, SO3.

263 "to a different side": Ireland, *Ligi: A Life in the Twentieth Century,* 52.

263 "How do you know?": Ibid.

264 "You're a crazy little fool": DP to FG, Oct. 29, 1924, DPP/LBJL, G316, 3 of 5, "Old Family Letters" (3 of 3).

264 "Your mother will get you back": FG, "Shaft," 44.

264 "didn't want to kiss, even": Ibid., 45.

264 "an out"; "I could marry this man": Ibid., 45.

265 "confident in my youthful conceit": DPP/LBJL, G211, 1 of 3, "Memoirs," 2.

265 "The ceremony was performed": "Steals March on Friends in East: Countess's Daughter Wed," *Los Angeles Sunday Times,* March 15, 1927, 1.

265 "I hated the wedding night": FG, "Shaft," 46.

PART III: MRS. ELMER SCHLESINGER

HEIRESS IS WEDDED AFTER ADVENTURES

269 "Alright I think": JMP to EMP, March 13, 1925, telegram, JMPP.

269 "As she grew up"; "She wanted": "Miss Gizycka Weds; Career Is Romantic," *CDT,* March 14, 1925, 1.

269 "Felicia Gizycka Becomes Bride": *San Francisco Examiner,* March 21, 1925, n.p., DPP/LBJL, F58, 4 of 4, "Memory Book."

269 " 'MOST KIDNAPED GIRL IN WORLD' IS A BRIDE": *St. Louis Post Dispatch,* March 15, 1925, n.p., DPP/LBJL, G314, 1 of 2, "Diary and Other Notes."

269 "My Pa-in-law"; "One was a picture": FGP to EMP, quoted in Martin, *Cissy,* 228. Emphasis in original.

270 "Well, you know": Ibid.

270 "from the mountain of elation": Paul Pearson to DP, April 1, 1925, DPP/LBJL, G73, 2 of 3, "Gizycka, Felicia–DP Marriage."

270 JG's declining health: Baron Charles Freudenthal to DP, Feb. 23, 1926, DPP/LBJL, F59, 4/4, "Count Gizycki."

270 "Dearest Boy—"; "Cissy telephoned"; "Ruth left": KMMcC to RRMcC, March 1925, RRMcCP.

271 "prodigal and corrupt"; "a lot of good church people": JMMcC quoted in Miller, *Ruth Hanna McCormick,* 141.

272 "in the act": "Senator M'Cormick Found Dead in Bed in Hotel in Capital," *NYT,* Feb. 25, 1925, 1.

272 "She believed"; "He knew": Katrina McCormick quoted in Miller, *Ruth Hanna McCormick,* 151.

272 "He kept referring": Ibid.

272 "I was walking on air"; "she wasn't particularly"; "It was too early": DP, "Drew's Diary 1949," DPP/LBJL, G 208, 1 of 2: "Drew's Diary 1949."

272 FG not remembering her second reunion with EMP: FG interview, RGMP.

272 "Cissy got us back": FG, "Shaft," 46.

273 "Cissy kept hugging me": FG, "Book Redo II," 19.

273 "He was crazy about her"; "He was Jewish": FG, "Shaft," 46.

273 RRMcC sorry for Elmer Schlesinger: Paul Green to RGM, Jan. 9, 1977, 1, RGMP.

273 Felicia recalled: FG interview, RGMP.

274 "I'm happier": EMP quoted in Martin, *Cissy,* 231.

274 "He is the kindest": EMP to RC, June 16, 1925, RGMP.

274 "I've thought—": EMP quoted in Healy, *Cissy,* 96.

274 "Felicia is really happy": EMP to RC, June 16, 1925, RGMP.

274 "numerous surrogate mothers": FG, "Shaft," 53.

274 "Apply the seat of the pants": Sinclair Lewis quoted in FG, "Book Redo II," 31.

275 "My whole idea"; "It was the day": Ibid., 21.

275 "didn't really like"; "no interest": Ibid.

275 "hang on"; "waiting for the day": Ibid., 22.

275 "I had induced"; "although she did not": DP to EPA, November 16, 1928, "press telegram," DPP/LBJL, G210, 1 of 5, "Ellen Pearson Arnold."

275 "deep silence": FG, "Shaft," 47.

276 "So beautiful": Ibid.

276 "I thought that I couldn't": Ibid.

276 "This is something": FG, "Book Redo II," 25.

276 "Felicia still seems"; "I'm not sure": DP to EMP, Jan. 21, 1926, JMPP.

277 "something I certainly": FG, "Book Redo II," 27.

277 "Now Drew said": Ibid. 27.

277 "tore around": EMP quoted in Martin, *Cissy,* 235.

278 "bright as Technicolor"; "exact moment": EMP quoted in Ruth Montgomery, "The Result: Medium to Baffling," n.p., n.d., RGMP.

278 "the Count, who was long noted": "Count Josef Gizycki Dies," *NYT,* Jan. 30, 1926, 15.

278 "Payments charged": JMP to R. J. Darby, Jan. 29, 1926, JMPP.

279 "I got your letter": JMP to Mary King, quoted in Robert F. Keeler, *Newsday: A Candid History of the Respectable Tabloid* (New York: Arbor House, 1990), 47.

279 "I never had a good idea": JMP quoted in Ronald S. Marmarelli, "Joseph Medill Patterson," *Dictionary of Literary Biography,* vol. 29, 280.

279 "I always thought of him as a father": James Patterson quoted in Keeler, *Newsday,* 48.

279 "didn't have any money": JMP quoted in ibid., 48.

280 "TO A.B.": Eleanor Gizycka, dedication, *GH.*

280 Many readers: See, for example, Arthur Train, "Society Here Shown as in Glass House," *WP,* March 14, 1926, F5.

280 "I read your story"; "It is unusual"; "It is extremely": JMP to EMP, April 1, 1925, JMPP.

280 "Novel finished": EMG to JMP, Jan. 1, 1923, JMPP, Series 5, Subseries 3, Box 74, Folder 3, "Patterson, Eleanor Medill Estate." Paul Healy, one of Cissy's earlier biographers, dates the writing of *Glass Houses* to the winter of 1924–25. Surviving documentary evidence in the form of letters and travel documents suggests that the novel was written two years earlier, in the winter of 1922–23, although it was not published in the United States until March 1926. Despite the fact that Cissy did not write the year on the January 1 letter to Joe in which she informed him that she had finished her novel, she included with it "dear Cal's cute letter and X-mas present" (a bill of sale for "one Spoted [*sic*] cow four years old"), both of which were dated December 1922. Further, numerous newspaper reports place her in the United States in the winter of 1924–25, rather than in Paris.

281 "I fell in love": EMP quoted in Healy, *Cissy,* 90.

282 "Leclartier is a pin-head"; "fought over every simple word"; "mean & rotten about America!": EMP to JMP, Jan. 1, 1923, JMPP, Series 5, Subseries 3, Box 74, Folder 3, "Patterson, Eleanor Medill Estate."

282 "savage and tore up"; "said he was going to commit suicide": EMP quoted in Martin, *Cissy,* 211–12.

282 "*admirable*"; "*moins beau*": EMP to JMP, January 1, 1923, JMPP, Series 5, Subseries 3, Box 74, Folder 3, "Patterson, Eleanor Medill Estate."

282 "I will translate": EMP to RC, n.d., quoted in Healy, *Cissy,* 90.

283 "just in the nick of time"; "I didn't suppose": Ibid.

283 "My book is an outgrowth"; "My purpose was": "Mrs. Elmer Schlesinger, Once Wife of Gizycka, Paints Life in Ironic Novel," *WH,* Feb. 28, 1926.

283 "Judged by any standards": Fanny Butcher, "Books," *CDT,* Feb. 20, 1926, 13.

283 "few people": "Official Washington Satirized in a New Novel," *NYT,* Feb. 21, 1926, BR8.

283 "many astounding virtues": Arthur Train, "Society Here Shown as in Glass House," *WP,* March 14, 1926, F5.

284 "Have started work"; "God": EMP to JMP, Sept. 21, 1926, JMPP.

FROM MARYLAND COMES WORD . . .

284 "She was a little lonesome"; "so in love"; "could have sworn": DP to EPA, Oct. 21 [1927], DPP/LBJL, G210, 1 of 5, "Family."

284 "boiling hot": FG, "Book Redo II," 27.

284 six-pound baby girl: JMP to E. S. Beck, July 27, 1926, telegram, JMPP.

284 "I can't conceive": DP to EPA, Oct. 21, [1927], DPP/LBJL, G210, 1 of 5, "Family."

285 "I had wanted a boy": FG, "Book Redo II," 28.

285 "I didn't want to suckle": FG, "Start of The Book Chapt. III," 25.

285 "Felicia had little girl": G. L. Burke, EMP's secretary, to JMP, July 27, 1926, telegram, DPP/LBJL, G210, 1 of 5, "Family."

285 "So glad": ERMP to FG, telegram, July 27, 1926, DPP/LBJL, F58, 4 of 4, "Ellen, Memory Book."

285 "My warmest congratulations": JMP to FG, July 27, 1926, telegram, JMPP.

285 "Much delighted": KMMcC to FG, July 31, 1926, telegram, DPP/LBJL, F58, 4 of 4, "Ellen, Memory Book."

285 "half as charming": Senator Henrik Shipstead to DP, Aug. 4, 1926, DPP/LBJL, F58, 4 of 4, "Ellen Cameron Pearson."

286 $15,000 "Thanksgiving Day present": JMP to EMP, Nov. 24, 1926, JMPP.

286 "Why, that's the most ridiculous": EMP quoted in Stanley Walker, "Cissy Is a Newspaper Lady," *SEP,* vol. 21, no. 45, May 6, 1939, 22.

286 EMP's estimated income in the late 1920s: "Notes: Cissy Patterson," RGMP, Box 213, F3.

286 "Sunday night": EMP to RC, Nov. 9, 1926, RGMP.

287 "three quadroom girls": Ibid.

287 "Elmer got [Cal] a cabin": Ibid.

288 "roars of enthusiastic acclaim": "Flier Draws Crowd to Coolidge Home," *NYT,* June 12, 1927, 2.

288 Black pearl necklace anecdote: Hoge, *Cissy Patterson,* 78.

288 The staff of the *Ranger:* "Notes," RGMP.

289 "The family fought"; "That is, my Grams": FG, "Shaft," 6.

289 "Kate is soon going": ERMP to EMP, May 22, 1926, JMPP.

289 "Joe is a pure Patterson"; "I can't bear the 'Liberty' ": KMMcC to RRMcC, Feb. 7, 1928, RRMcCP.

289 "Sir—we of the North": KMMcC to Gov. David Bibb Graves, Oct. 17, 1927, RRMcCP.

289 "Someone remarked"; "My reply was"; "I like the idea"; "My son the Colonel": KMMcC to Charles Lindbergh, Sept. 24, 1927, RRMcCP.

290 "I really think": FG to EMP, n.d., DPP/LBJL, G210, 1 of 5, "Countess Felicia Gizycka."

290 "It never occurred to me"; "Felicia (the proud)": EMP to JMP, Sept. 7, 1926, JMPP.

291 "He finds it entirely impossible": "And your Mother!": DP to EPA, Aug. 8, 1926, DPP/LBJL, F58, 4 of 4. "Ellen Cameron Pearson."

291 "For most of my life": FG, "Start of the Book Chapt. III," 25.

291 "I wasn't able to do this": Ibid., 24.

292 "you and I": Eleanor Gizycka, "What Do You Know of the Soul of an Indian?" *NYDN,* May 3, 1927, 10.

292 "a dim-living kind of serf": Gizycka, "And Now," 84.

292 "wolfish Jaws"; "grows thickly down": Gizycka, "What Do You Know of the Soul of an Indian?" 10.

292 *"make them see it"*: AB, "How to Be a Better Newspaper Man: Famous Editor Gives the Ten Most Important Newspaper Rules," pamphlet (New York: King Features Syndicate, n.d.), 3.

292 "Probably he has hairy arms"; "What do we know": Gizycka, "What Do You Know of the Soul of an Indian?" 10.

293 "I don't mean to be unkind"; "A situation": FG to DP, February 26, [1927], DPP/LBJL, G210, 1 of 5, "Felicia's Letters."

293 "Felicia after a two month": EMP to JMP, June 8, 1927, JMPP.

293 "We both want to tell you": EMP to DP, Aug. 5, 1927, DPP/LBJL, G210, 1 of 5, "Patterson, Eleanor."

293 "dumping"; "everything": FG, "Shaft," 49.

293 "I love you worse than ever": Ibid., 48.

293 "I really felt nothing": Ibid., 49.

294 "I continued to live in Washington": DP, memoirs, DPP/LBJL, G211, 1 of 3, "Memoirs," 4.

294 "After the divorce"; "They were too wise": Ibid.

294 "I have decided"; "So I am going": DP to EPA, Oct. 14, 1927, DPP/LBJL, F58, 4 of 4, "Personal Letters—Very Personal."

294 "To-night I came home": DP to EPA, Oct. 21, [1927], DPP/LBJL, G210, 1 of 5, "Family."

295 "Just a slim": Ibid.

295 "I went out to-day"; "I suppose"; "That would be disagreeable": DP, "I went out to-day . . . ," n.d. DPP/LBJL, F58, 4 of 4, "Personal Letters-Very Personal."

295 "I have seen your fine photo": Anonymous to FG, March 20, 1928, DPP/LBJL, F58, 4 of 4, "Felicia."

296 "I hope you will not think me"; "I am now working": DP to FG, June 8, 1928, DPP/LBJL, F58, 4 of 4, "Personal Letters—Very Personal."

MAYBE I'LL HAVE A HAPPY AND USEFUL OLD AGE

296 "Now what shall I do?"; *"for myself"*: EMP to JMP, May 1, 1928, JMPP. Emphasis in original.

297 "plenty of advice"; "failures"; "(take them away)"; "Maybe I'll have": Ibid.

297 "it is hard": JMP to EMP, May 2, 1928, JMPP.

297 1928 circulation statistics for *WH* and *United States Daily:* N. W. Ayer & Sons,

American Newspaper Annual and Directory (Philadelphia: N. W. Ayer, 1929), 167, 171.

297 *Washington Star* circulation statistics for 1928: Ibid., 170.

297 1928 *WT* circulation statistics: Ibid., 171.

297 1928 *WP* circulation statistics: Ibid., 170.

297 *Washington News* 1928 circulation statistics: Ibid., 169.

298 "did not seem very enthusiastic": AB to EMP, May 7, 1928, EMPP, Series 1, Box 1, "Incoming Correspondence, Brisbane, Arthur 1924, 27–30."

298 "not for sale": See, for example, "Eleanor Patterson New Herald Editor," *WP,* July 23, 1930, 3.

298 "Take the advice": AB quoted in ES to RRMcC, July 11, 1928, JMPP.

298 "What's the use?"; "Maybe the old scallywag": EMP to RRMcC, July 11, 1928, JMPP.

298 "foreigner's objective view": David Gray, "The Early Arthur Brisbane," unpublished ms., Brisbane Family Papers, Box 2, "Brisbane Biographical Material," 4.

299 "deliberately cultivated": Oswald Garrison Villard, "Issues and Men," *The Nation,* Jan. 9, 1937, 45.

299 Brisbane had a particular penchant: Oliver Carlson, *Brisbane: A Candid Biography* (New York: Stackpole Sons, 1937), 256.

299 "the best newspaper work"; "Mr. Hearst would be very glad"; "Hearst pays me": AB to ERMP, Oct. 28, 1916, JMPP.

300 "It is no joke"; "This particular thing"; "the two young": AB to JMP and RRMcC, June 30, 1917, JMPP.

300 "one, two or a dozen pages": Ibid.

300 Brisbane made a second attempt: AB to JMP, Dec. 1, 1919, telegram, JMPP.

300 "You are now": WRH quoted in Stanley Walker, "They Tell Me He's a Big Man," in John E. Drewry, ed., *Post Biographies of Famous Journalists* (New York: Random House, 1941), 15.

300 "somehow offended"; "Patterson is no genius": AB quoted in ibid.

300 "Eleanor Gizycka's second novel"; "When a second novel": "Books," *CDT,* Oct. 6, 1928, 16.

301 "the effect of 'Fall Flight' "; "It holds the interest": "International Marriage," *NYT,* Oct. 14, 1928, A6.

301 "bright remarks": Alvan Barach interview, RGMP, Box 213, F7.

301 "The dramatic conflict": Alvan L. Barach, M.D., "Preface," in *FF,* xiii–xiv.

302 "Made continually conscious"; "she developed first": Ibid., xi.

302 "Perhaps more important": Ibid., xi.

302 "What a fool": FG interview, RGMP, Box 213, F3.

304 "pathetic man": ARL quoted in Katharine Graham, *Personal History* (New York: Vintage, 1998), 56.

304 "Although realizing 'puffickly' ": EMP to RRMcC, July 11, 1928, JMPP.

304 "that sweet intonation": FG, "Start of the Book Chapt. IV—Cissy Starts Putting Me Down," unpublished memoir draft, 39, FGP.

304 "go into"; "I told Joe"; "Gee Bertie!": EMP to RRMcC, July 11, 1928, JMPP.

304 "bad"; "if I could buy the Washington POST": RRMcC to EMP, July 16, 1928, RRMcCP.

305 "I cannot conceive"; "snappy weekly": Ibid.

305 "I don't know what": RRMcC quoted in Healy, *Cissy,* 126.

305 "I am very much amused": KMMcC to RRMcC, Aug. 16, 1928, RRMcCP.

306 "TITLES SLUMP": Carol Bird, "Titles Slump in Marriage Market," *WP Sunday Magazine,* Jan. 13, 1929, SM7.

306 "International marriages"; "If an American girl"; "But if she": EMP quoted in ibid.

306 "We marry"; "Thus our marriages"; "How often": Ibid.

307 "We actually": Ibid.

307 "all in the space": EMP to JMP, n.d., JMMP.

307 Elmer's rumored involvement with another woman: Veda Ward Marcantonio interview, RGMP.

308 "patted me on the ass": Elmer Schlesinger, Jr., quoted in Paul Green to RGM, Jan. 9, 1977, 1, RGMP.

308 "Write a book"; "Then, if you can": AB to EMP, Dec. 24, 1929, EMPP, Series 1, Box 1, "Incoming Correspondence, Brisbane 1924, 27–30."

308 "Tell him"; "Then you": AB to EMP, March 11,1930, EMPP, Series 1, Box 1, "Incoming Correspondence, Brisbane, A, 1924, 27, 30."

309 "Mama was very very sad": FG to ERMP, May 23, 1919, FGP.

309 "It's so difficult to"; "The situation is simply this"; "Alice Longworth is trying": EMP to JMP, n.d., JMPP.

309 "Her opponents argued"; "The leaders": "The Head of the Table," *Time*, Feb. 9, 1953, www.time.com/time/magazine/article/0,9171,889620,00.html.

310 "they had seen you"; "the result of it all"; "Alice, my dear": EMP to ARL, March 31, {1930}, The papers of Joanna Sturm, privately held.

310 "I enjoyed seeing you"; "in a way that I almost resented": AB to EMP, June 10, 1930, EMPP, Series 1, Box 1, "Incoming Correspondence, Brisbane, A, 1924, 27–30."

310 "I have a terribly fine trader"; "How would you like": AB to EMP, June 20, 1930, EMPP, Series 1, Box 1, "Incoming Correspondence, Brisbane, A, 1924, 27–30."

310 "If she wants": WRH quoted in AB to FDR, September 6, 1930, EMPP, Series 1, Box 1, "A. Brisbane—Outgoing 32–35."

310 "I would be delighted": WRH to EMP, July 8, 1930, telegram, EMPP, Series 1, Box 1, "Incoming—Hearst, '30–'35."

311 "in accordance": AB to EMP, July 11, 1930, EMPP, Series 1, Box 1, "Incoming Correspondence Brisbane, A, 1924, 27–30."

311 "The 'hiring' "; "since each trip": AB to FDR, September 6, 1932, EMPP, Series 1, Box 1, "A. Brisbane—Outgoing 32–35."

PART IV: ELEANOR MEDILL PATTERSON

INTERESTING, BUT NOT TRUE

315 "Looks like final"; "Double event": JMP to EMP, Nov. 7, 1933, telegram, JMPP.

315 "very suddenly": Mary Kennedy to EMP, Sept. 5, 1933, telegram, JMPP.

315 "*My God*": KMMcC quoted in Hoge, *Cissy Patterson,* 77.

316 There was an old story: Paul Mickelson, "Brisbane's Death Reveals His Unique System for Beating Races by X-Rays and Good Guess," WP, Dec. 26, 1936, X12.

316 "Mrs. Eleanor Medill Patterson"; "Mrs. Patterson, who was formerly": "Announcement," WH, July 23, 1930, 1.

317 "The Washington Herald feels": Ibid.

317 "systematized ignorance": Carlson, *Brisbane,* 252.

318 "groggy *Washington Herald*": Beverly Smith, "Herald Angel," *American Magazine,* Aug. 1940, 28.

318 Anne Royall and John Quincy Adams: George H. Douglas, *The Golden Age of the Newspaper* (Westport, Conn.: Greenwood, 1999), 175.

318 "pretty little witch": Edgar Allan Poe, quoted in Madelon Golden Schilpp and Sharon M. Murphy, *Great Women of the Press* (Carbondale: Southern Illinois University Press, 1983), 62.

318 By the mid-1930s: Ishbel Ross, *Ladies of the Press* (New York: Harper & Brothers, 1936), 458.

319 "I suppose you think"; "Even if you do": EMP quoted in Smith, "Herald Angel," 110.

319 "You will have to work"; "It would however": AB to EMP, July 28, 1930, EMPP, Series 1, Box 1, "Incoming Correspondence, Brisbane, A, 1924, 27–30."

319 "The news is": "Interesting, but Not True," *WH,* Aug. 4, 1930, 1.

319 "Washington gasped": Ross, *Ladies of the Press,* 503.

319 "Coming out of the blue"; "But for the barbed final sentences": "Amazonian War Livens Capital: Feminine Editor Challenges "Princess Alice"—McCormick Alliance Denial Barbed with Venom—Official Washington Waits Longworth Comeback," *LAT,* Aug. 5, 1930, 7.

320 "Be careful": AB to EMP, Aug. 7, 1930, EMPP, Series 1, Box 1, "Incoming Correspondence Brisbane, A, 1924, 27–30."

320 "I wrote a little piece": EMP to WRH, Aug. 17, 1930, telegram, EMPP, Series 1, Box 1, "W. R. Hearst, Incoming Correspondence, B."

320 "very amusing": ARL quoted in Cordery, *Alice,* 351.

320 "one of my oldest": EMP to Nicholas Longworth, Aug. 9, 1930, Joanna Sturm Papers, privately held.

321 "There isn't any use"; "It has been said": Ibid.

321 "But remember"; "You know that": Ibid.

321 "Some weeks ago": EMP, "Will She? Can She?" *WH,* Oct. 4, 1930, 1. Emphasis in original.

322 "All kinds of people"; "Everyone should understand": "Answers," EMP, *WH,* Aug. 8, 1930, 1. Emphasis in original.

322 "Men have always"; "The ideal"; "I've only to remember": Ibid.

323 "journalistic godfather": AB to EMP, March 14, 1931, EMPP, Series 1, Box 1, "Incoming, Brisbane, 1931."

323 "ought not to be used": Calvin Coolidge quoted in Robert Sobel, *Coolidge: An American Enigma* (Washington, DC: Regnery, 2001), 251.

323 "I think you are wise"; "BUT, there is something": AB to EMP, Jan. 28, 1933, EMPP, Series 1, Box 1, "Incoming Brisbane, A. 1933." Emphasis in original.

323 "I never was taught"; "Yes, that double negative": EMP to AB, Jan. 30, 1933, EMPP, Series 1, Box 1, "Outgoing."

324 "get somebody": AB to EMP, March 28, 1934, EMPP, Series 1, Box 1, "Incoming, Brisbane, 1934."

324 "There is nothing"; "I think you will": AB to EMP, July 3, 1931, Series 1, Box 1, "Incoming, Brisbane, 1931."

324 "You have real talent"; "Too bad": AB to EMP, March 14, 1931, EMPP, Series 1, Box 1, "Incoming, Brisbane, 1931."

324 "chintz chariot": AB to EMP, Sept. 19, 1930, Series 1, Box 1, "Incoming Correspondence, Brisbane, A, 1924, 27–30."

324 "chintz boudoir on wheels": EMP to WRH, Dec. 6, 1930, EMPP, Series 1, Box 1, "Outgoing."

326 "good little tabloid"; "a little too much"; "by issuing some": WRH to WCH, Nov. 30, 1931, WRHP.

326 Al Capone story: EMP quoted in Healy, *Cissy,* 206–208.

327 Einstein story: EMP quoted in Healy, *Cissy,* 203–205.

328 "People read your stuff": WRH to EMP, quoted in Martin, *Cissy,* 289.

328 "My colleagues": "Perhaps this is"; "I do not mean": Nicholas Longworth quoted in "Nicholas Longworth," *WP,* April 10, 1931, 6.

328 "You know, Mr. Speaker"; "By golly": Quoted in E. Raymond Lewis, "The House Library," *Capitol Studies* 3 (Fall 1975): 125.

329 "a serious condition": "House Speaker Stricken on Visit to Friends in Aiken, S.C.," *WP,* April 8, 1931, 1.

329 "oxygen was administered"; "grown rapidly worse"; "the outlook is extremely unfavorable": "State 'Much Worse Than at Any Time,' Night Bulletin Says," *WP,* April 9, 1931, 1.

329 "I want to send"; "One might as well apologize": EMP to Laura Curtis, April 14, 1930, from the papers of Joanna Sturm, privately held.

329 "effervescent": "Peter Carter," *WH,* April 9, 1931, 13.

329 "FORTY-SIX REPUBLICAN"; "LAURA CURTIS"; "beautiful"; "coquettish"; "friendships"; "Nick": "Peter Carter" [DP], "Peter Carter Says," *WH,* April 11, 1931, 9.

329 "such disgusting bad taste"; "People seem to think"; "This, of course": EMP to Laura Curtis, April 14, 1931.

330 "a slight 'toot' "; "with either the sense"; "Nick would": Ibid.

330 "If you believe"; "dishonest"; "you have proved": EMP to Laura Curtis, April 24, 1931, from the papers of Joanna Sturm, privately held.

330 DP as "Peter Carter": EMP to DP, August 7, 1931, telegram, DPP/LBJL, G210, 1/5, "Patterson, Eleanor."

WASHINGTON MERRY-GO-ROUND

331 "You remember"; "I confess"; "That is"; "comforts of home": DP to FG, April 9, 1930, DPP/LBJL, F58, 4 of 4, "Personal Letters to Be Saved."

331 "As I told you"; "I have a lot": Ibid.

331 "divorced, and really directionless": FG, "Shaft," 54.

332 "I realized"; "But this didn't.": FG, "Shaft," 55A.

332 "Go away!": EPA quoted in ibid.

332 "I left her alone": Ibid.

333 "the gulf": Ibid.

333 "Felicia was tough competition"; the attic was repudetly haunted: Ireland, *Ligi,* 64–65.

334 "little lost debutante": [FG], "Stars Don't Fall," *Alcoholics Anonymous,* 3d ed. (New York: Alcoholics Anonymous World Services, 1976), 402–403.

334 "Haven't you done enough?"; "You're a terrible girl!": EMP quoted in Pilat, *Drew Pearson,* 152.

334 "The reading public": [FG], "Stars Don't Fall," 403.

334 "she is alert and bright": FG to DP, Jan. 20, 1932, DPP/LBJL, F58, 4 of 4, "Felicia."

334 "I will miss her": FG to DP, Aug. 16, 1932, DPP/LBJL, F58, 4 of 4, "Felicia."

334 "I do wish": FG to DP, Jan. 20, 1932, DPP/LBJL, F58, 4 of 4, "Felicia."

334 "dream prince": [FG], "Stars Don't Fall," 403.

334 "I, who did not know": Ibid.

335 "got tight": Ibid.

335 "Even then": Ibid.

335 FG's belief that she was a bad mother: FG, "Shaft," 55A.

335 "dead drunk": Ibid.

335 "I think"; "A drink": [FG], "Stars Don't Fall," 402.

335 "hard-riding"; "I merely endured": Ibid., 404.

335 "butler or footman"; "Cissy very often": FG, "Shaft," 58–59.

336 "Once or twice": Ibid.

336 "Luvie has a surprise"; "tiny baby boy": DP to EPA, August 17, 1932, DP, F58, 4 of 4, "Ellen III."

337 "caused considerable": Charlotte Childress Foster deposition, September 1937, DPP/LBJL, G117, 2 of 3, "Tyler Abell—Custody Fight, 1937."

337 On the circumstances surrounding TA's birth in July 1932, see affidavit of Harold J. T. Moran, DPP/LBJL, G41, 2 of 3, "Tyler Abell—Custody Fight," and Charlotte Childress Foster deposition, September 1937, DPP/LBJL, G117, 2 of 3, "Tyler Abell—Custody Fight, 1937."

337 "I have achieved"; "The only thing": DP to Paul and Edna Pearson, Dec. 12, 1930, DPP/LBJL, G209, 1 of 4, "Parents."

337 "I rather enjoy": Ibid.

337 "chief joy": DP to his "European mistress" May 22, 1930, DPP/LBJL, G316, 3 of 5, "Early Love Letters, 1 of 2."

338 Amy Charak's "deserting" DP: Ibid.

338 "I am having": DP to FG, Aug. 17, 1932, DPP/LBJL, F58, 4 of 4, "Felicia."

338 "Perhaps the fact"; "The author finds": Arthur Krock, "As the 1932 Race Looms Large," *NYT,* July 26, 1931.

338 "His whole record": *WMGR,* 54.

338 "perhaps the most important": Ibid., 55.

338 "big, husky, pompadoured": Ibid., 208.

338 "individualism": Ibid., 210.

338 "lazy"; "He rarely prepares": Ibid., 209.

339 "Debate in the House"; "It is a shambles": Ibid., 221.

339 "Drew Pearson, the *Sun*'s expert"; "Because of his independence"; "there is no": Ibid., 350.

339 "well over two hundred pounds"; "determined": Ibid., 86.

339 "half dozen": Ibid., 10.

339 "through the prestige": Ibid., 11.

339 "Although she left": Ibid.

340 "one of the most gifted"; "dissipated": Ibid.

340 "a wow"; "be content": Ibid., 15.

340 "The evaluations": "Mirrors of 1932," *Charleston (WV) Gazette,* Aug. 2, 1931, 2.

340 "the wrath visited": Fiorello LaGuardia quoted in "LaGuardia Says Hoover Trying to Suppress News Men," *Wisconsin State Journal,* Oct. 6, 1931, 3.

341 "The actual author"; "The best opinion": WW, "On Broadway," *Wisconsin State Journal,* July 29, 1931, 3.

341 "Whoever wrote"; "few approved"; "But this crusader": Krock, "The 1932 Race Looms Large."

341 "If you are sincere": FG to DP, September 6, 1932, DPP/LBJL, F58, 4 of 4, "Felicia."

342 "About the libel suit"; "It would create": AB to EMP, Sept. 8, 1932, EMPP, Series 1, Box 1, "Incoming, Brisbane, 1932."

342 "mad as a snake": Pilat, *Drew Pearson,* 132.

342 "flouncing"; "witty social satirist"; "language which would have": [Drew Pearson and Robert S. Allen], *More Merry-Go-Round* (New York: Liveright, 1932), 17. Hereafter *MWMGR.*

342 Anecdote about Ralph Palmer: *MWMGR,* 18–20.

344 "sympathetic"; "For a long time"; "Of course, I am pretty mad": EMP to RRMcC, Sept. 21, 1932, RRMcCP.

344 "Nothing that our mothers"; "Somehow, I feel": Ibid.

344 "I am not much interested"; "When I hear"; "Yes": RRMcC to EMP, Sept. 24, 1932, RRMcCP.

344 "smart enough": EMP to RRMcC, Sept. 21, 1932, RRMcCP.

345 "There is only": DP to FG, Sept. 15, 1932, DPP/LBJL, G210, 1 of 5, "Family."

345 "I wanted to take out": Ibid.

345 "but the publishers"; "orders for important": Ibid.

345 190,000 copies: "Drew Pearson," *Current Biography Yearbook* 1941 (New York: H. W. Wilson Co., 1941), http://search.epnet.com.proxau.wrlc.org/login.aspx ?direct=true&db=cgh&an=BWBD980894.

345 "showed a certain amount": FCW, "An Appraisal of Eleanor M. Patterson by Frank C. Waldrop, Made in the Fall of 1948 in Anticipation of Trial of Felicia Gizycka's Caveat of Her Mother's Will," unpublished memorandum, fall 1948, FCWP, Box 26, "St. Johns, Adela Rogers, 1935–41," 10.

A POUND OF FLESH

346 which Cissy insured for some $20,000: Betty Hynes to Col. Joseph Willicombe, Jan. 20, 1932, WRHP.

346 "I'd rather": EMP quoted in Thomas L. Stokes, United Press wire report, Aug. 1, 1931, RRMcCP.

346 "She is not only": WRH to AB, Aug. 16, 1931, telegram, EMPP, Series 1, Box 1, "Arthur Brisbane."

346 "Mrs. Patterson could not do": WRH to AB, Sept. 26, 1931, EMPP, Series 1, Box 1, "Incoming, Hearst, '30–'35.

346 "WE ARE RUNNING": EMP to WRH, telegram, Oct. 11, 1931, EMPP, Series 1, Box 1, "Outgoing."

347 January 1932 newspaper circulation statistics for Washington, D.C.: "Circulations, Rates and Personnel of U.S. Daily Newspapers," *E&P,* Jan. 30, 1932, 28.

347 *WH* April 1932 circulation figures: EMP to WRH, April 17, 1932, telegram, WRHP.

347 "perfectly satisfied"; "do not think": WRH to EMP, Feb. 5, 1932, telegram, ERMP, Series 1, Box 1, "Incoming—Hearst '30–'35."

347 "How, how": EMP, handwritten note on ibid.

348 "a genial, soft-spoken": Harry Gabbett, " 'Mike' Flynn Is Dead," *WP,* May 11, 1962, B12.

348 "Flynn, it is probable": Walker, "Cissy Is a Newspaper Lady," 64.

348 "a natural newspaperwoman": Mike Flynn quoted in ibid.

348 "I can see": AB to EMP, Sept. 19, 1930, EMPP Series 1, Box 1, "Incoming Correspondence, Brisbane, A, 1924, 27–30."

350 "every editorial job"; "and little else": FCW, untitled ms. ("For twenty years . . ."), n.d., FCWP, Box 6, "Writings, Undated (2 of 2)."

351 FCW as the son EMP never had: Andrew Waldrop, interview with the author, Feb. 11, 2005.

351 Circulation statistics: *E&P,* vol. 65, no. 10, July 23, 1932, 1.

351 "the profit prospects": Ibid., 38.

351 Hearst chain's losses of $1.5 million on the *WT* and *WH:* Merlo J. Pusey, *Eugene Meyer* (New York: Knopf, 1974), 242.

351 *WH* pay cuts: Flythe, "A Fabulous Era Was Ended When the Times-Herald Died," 3.

351 JMP on putting the *WH* in the black: See EMP to Joseph Willicomb, n.d., telegram draft, EMPP, Series 1, Box 1, "Outgoing."

352 "Happy came out of"; "Any problems": Bill Flythe interview, transcribed tape recording, n.p., March 31, 1976, RGMP.

352 "He impressed me": Veda Ward Marcantonio interview, RGMP.

352 "I been tru dis": Happy Robinson quoted in Joseph Borkin interview, transcribed tape recording, n.p., n.d., RGMP.

352 Happy Robinson's hiring; "Folly tru": Martin, *Cissy,* 305.

353 "She was tops": Harry A. "Happy" Robinson interview, transcribed tape recording, n.p., n.d., RGMP.

353 "I am very imprudent"; "it inspires": AB to EMP, May 25, 1931, EMPP, Series 1, Box 1, "Incoming, Brisbane, '31."

354 "perfectly phenomenal"; "help in Washington"; "I should": AB to EMP: July 22, 1933, ERMP, Series 1, Box 1, "Incoming, Brisbane, 1933."

355 "The merchants really know": Ibid.

355 "FLAT DEAD"; "CANNED STUFF": EMP to WRH, Aug. 17, 1930, telegram, EMPP, Series 1, Box 1, "W. R. Hearst, Incoming Correspondence—B."

355 "stir up"; "excellent writers": EMP to Col. Joseph Willicombe, n.d., telegram draft, EMPP, Series 1, Box 1, "Outgoing."

355 "We have done"; "I would have submitted": EMP to WRH, Sept. 11, 1935, EMPP, Series 1, Box 1, "Outgoing."

356 "Happy Robinson says"; "WE ARE NOW RUNNING": EMP to WRH, Oct. 3, 1935, telegram, EMPP, Series 1, Box 1, "Outgoing."

356 "I would rather"; "serious-minded"; "But I already have": EMP to RRMcC, Sept. 11, 1939, RRMcCP.

357 EMP's purchase of War Chief and assistance to cowboy Dave Nimmo: Testimony of David Nimmo before a Special Master, Vol. IX, at 651–55, in *Shelton, Waldrop and Brooks v. Gizycka,* Civil Action No. 3158-49 (D.D.C. Sept. 20, 1950), Second Amended Complaint of Executors for Construction of Will and Instructions, in NARA RG21/230/78/40/5-6/834 (Accession #021-71B1347, Box 46, 1949), College Park, Md.

358 "two toddies": "N'Gi Is Winning Fight with Pneumonia; Gorilla Likes German Ambassador's Wine," *NYT,* Feb. 29, 1932, 2.

358 "With that amazing": EMP, "The American Chameleon," quoted in Walker, "Cissy Is a Newspaper Lady," 55.

359 "They became"; "Don't you think": Ibid.

359 "You've got"; "play-acting"; "We never": EMP, quoted in Martin, *Cissy,* 315–16.

360 "Please let me tell you"; "You are the only leader"; "Maybe I am": EMP to WRH, Oct. 27, 1931, telegram, EMPP, Series 1, Box 1, "Outgoing, '30–'36."

360 "He seems to be": Edmund F. Jewell to Col. Joseph Willicombe, Jan. 29, 1932, WRHP.

360 "not worth a warm bucket of piss": John Nance Garner quoted in Sydney Blumenthal, "The Imperial Vice Presidency," *Salon,* June 6, 2007, available online at http://www.salon.com/opinion/blumenthal/2007/06/28/cheney/.

360 "a good thing": Edmund F. Jewell to Col. Joseph Willicombe, Jan. 29, 1932, WRHP.

360 "I am glad": AB to EMP, July 5, 1932, ERMP, Series 1, Box 1, "Incoming, Brisbane, 1932."

360 "If we want to accomplish": WRH to Victor Watson, quoted in David Nasaw, *The Chief* (New York: Houghton Mifflin, 2000), 455.

361 "It makes little difference"; "neither party": AB to Phoebe Brisbane, June 29, 1932, EMPP, Series 1, Box 1, "Arthur/Phoebe, Mar./Aug.-32."

361 "I am so glad"; "It makes life": EMP to WRH, Dec. 6, 1930, EMPP, Series 1, Box 1, "Outgoing."

361 "I love you": EMP to WRH, April 15, 1932, WRHP.

362 "constructive criticism"; "for a period"; "we have never regretted"; "we have been in sympathy": *NYDN* quoted in John Chapman, *Tell It to Sweeney* (Garden City, N.Y.: Doubleday, 1961), 191.

362 "I am afraid that"; "But that is not fair"; "Don't you remember": EMP to WRH, March 25, 1937, WRHP.

363 "You were looking": Ibid.

363 "I am not mad"; "I did want to warn you"; "I admire Joe": WRH to EMP, March 28, 1937, WRHP. Emphasis in original.

363 "wild behavior"; "was at last": Evalyn Walsh McLean with Boyden Sparkes, *Father Struck It Rich* (Ouray, CO: Bear Creek Publishing Co., 1981), 326.

363 "The great thing now"; "When you don't use": AB to EMP, March 25, 1931, EMPP, Series 1, Box 1, "Incoming, Brisbane."

363 "I am afraid"; "Somebody will have intelligence"; "one of the cowed Wall Street crowd": AB to EMP: March 25, 1933, EMPP, Series 1, Box 1, "Incoming, Brisbane, 1933."

364 "a great pity"; "I could have got it": Ibid.

364 "I am sure"; "Since we could not": AB to EMP, June 15, 1933, EMPP, Series 1, Box 1, "Incoming, Brisbane, 1933." Emphasis in original.

364 "Pugnose, red hair"; "As she is extremely feline": Agnes Meyer quoted in Graham, *Personal History*, 26.

365 "knew one important thing": Ibid., 58.

365 "That we have not got the paper": WRH to EMP, June 1, 1933, telegram, EMPP, Series 1, Box 1, "Incoming Hearst '30–'35."

366 "Certainly we need": Ibid.

366 "It is a great opportunity": Agnes Meyer quoted in Pusey, *Eugene Meyer*, 244.

366 July 1933 circulation numbers: AB to General Wood, July 22, 1933, EMPP, Series 1, Box 1, "A. Brisbane '32–'35."

366 "Everybody is happy"; "I know": WRH to EMP, July 15, 1933, telegram, EMPP, Series 1, Box 1, "Incoming Hearst '30–'35."

367 "cut off The Post's supply": "Comic Strips Kept in Paper by Court," *NYT,* July 28, 1933, 18.

367 "Dear Eugene": EMP, "You Asked for It, Eugene," *WH,* Feb. 14, 1935, 1.

368 As witnesses would later attest: see Harold Kertz interview, RGMP, Box 213, F5.

368 "Cissy, if you don't stop": Eugene Meyer quoted in Graham, *Personal History,* 62.

368 *Tribune* comics controversy: see "Comics & Courtesy," *Time,* April 22, 1935, http://www.time.com/time/magazine/article/0,9171,762256,00.html, and Graham, *Personal History,* 62.

369 "made a mistake": EMP quoted in Martin, *Cissy,* 331.

THE DAMNDEST NEWSPAPER EVER TO HIT THE STREETS

369 "These past seven years"; "But these last": EMP to WRH, July 19, 1937, WRHP.

369 "the conduct of my papers": WRH to EMP, June 14, 1937, WRHP.

369 quietly pledged some $2 million: See Waldrop, *McCormick of Chicago*, 250.

369 "impassive as a basilisk": Stanley Walker, "They Tell Me He's a Big Man," in Drewry, ed., *Post Biographies of American Journalists*, 28.

369 $13 million; nearly $1,116,000 in 1936: see Hoge, *Cissy Patterson*, 162.

370 March 1937 circulation figures: see EMP to WRH, March 2, 1937, WRHP.

370 "I cannot thank you"; "For I will want": EMP to WRH, July 19, 1937, WRHP.

370 "When I left Paris"; "Mrs. Carmel Snow": EMP to AB, Aug. 18, 1934, EMPP, Series 1, Box 1, "Outgoing."

371 Hearst publishing figures: "T. J. White, 63, Dies; Hearst Executive," *NYT*, July 10, 1948, 15.

372 "very nice little": AB to EMP, Feb. 6, 1932, EMPP, Series 1, Box 1, "Incoming, Brisbane, 1932."

372 "He seems very intimate": AB to EMP, May 9, 1932, EMPP, Series 1, Box 1, "Incoming, Brisbane, 1932."

372 "I think Mr. White"; "Colony Scene": AB to EMP, Sept. 16, 1932, EMPP, Series 1, Box 1, "Incoming, Brisbane, 1932."

372 "So do I"; accounts of EMP's meeting with Virginia White: John Michael White to the author, email, June 17, 2006; EMP's reported offer of $1 million for White's divorce: Martin, *Cissy*, 397.

373 "something not previously seen": FC, *McCormick of Chicago*, 250.

373 "Some of our readers"; "decided to pull": EMP, "Announcement," *WTH*, Jan. 30, 1939, 1.

373 "I want to save"; "If there is a strike": EMP quoted in Healy, *Cissy*, 150.

373 "a chronic tail-ender": "The Passing of Cissy," *Newsweek*, Aug. 2, 1948, 52.

373 "the damndest newspaper": Flythe, "A Fabulous Era Was Ended When the *Times-Herald* Died," 3.

374 "Washington went for": Flythe, commemorative plaque.

374 1940 Washington, D.C., newspaper circulation statistics: J. Percy Johnson, ed., *N. W. Ayer & Son's Directory: Newspapers and Periodicals 1940* (Philadelphia: N.W. Ayer & Sons, 1940), 146.

374 "a few dashes": EMP quoted in Hoge, *Cissy*, 165.

374 *WP* circulation: Johnson, *N. W. Ayer & Son's Directory: Newspapers and Periodicals 1940*, 145.

374 1940 and 1941 *WP* losses and "the Capitol's sole big-league newspaper": "Sharing the Progress," *Time*, July 14, 1941, http://www.time.com/time/magazine/article/0,9171,849438,00.html.

374 *News* circulation: Johnson, *N. W. Ayer & Son's Directory: Newspapers and Periodicals 1940*, 145.

374 "sported an equally red": Flythe, commemorative plaque.

374 "exactly the same way": FCW, untitled ms., n.d., FCWP.

375 (later, almost renamed "Patterson"): Flythe, commemorative plaque.

375 "I was forever quarreling"; "Clean in typography": EMP quoted in Smith, *The Colonel*, 368.

377 "More than anyone"; "But I swallowed my pride"; "the famous Marguerite Cassini"; "a mocking tone"; "I used to envy"; "I could not wonder"; "We were about": Cassini, *Never a Dull Moment*, 337.

378 "it makes me look": EMP quoted in Hoge, *Cissy Patterson*, 144.

378 "Tell Mary": Mary Johnson interview, n.d., RGMP.

378 "Martha Blair bores me": EMP quoted in "The Press: In Washington," *Time*, March 4, 1940, http://www.time.com/time/magazine/article/0,9171,763587,00.html.

378 "At the paper"; "Oh, she'd get": Carolyn Hagner Shaw interview by PFH, n.p., January 23, 1964, RGMP.

378 young lady reporter fired for having eyes too close together: SE, interview, RGMP; Lee Wade interview, RGMP.

379 LeFort firing: Dep. of Sibilla Campbell at 72, *In re* Estate of Patterson, Admin. No. 71574 (D.D.C. Holding Prob. Ct. Jan. 24, 1949), in DPP/LBJL, F28, 2 of 2, "Deposition of Sibilla Campbell, Jan. 24, 1949."

379 "One reporter was fired"; "He was halfway": EMP quoted in "Eleanor Medill Patterson, Publisher, Is Dead," *NYT,* July 25, 1948, 19.

379 "She fired quite a few"; "including this one": PFH, "Notes and Interview with Mason Peters," August 1964, n.p., unpublished interview notes, RGMP.

379 "with a great deal": AB to EMP, September 6, 1932, ERMP, Series 1, Box 1, "Incoming, Brisbane."

379 "I felt even prouder": EMP quoted in Healy, *Cissy,* 272.

379 "Surely there is": Ibid.

380 "She isn't for Roosevelt": Harold Ickes, *The Secret Diary of Harold Ickes: The First Thousand Days, 1933–1936* (New York: Simon and Schuster, 1954), 553.

380 JMP's 1936 donation of $20,000: See Hoge, *Cissy,* 172.

380 "bellwether of New Deal newspapers": Jack Alexander, "The Duke of Chicago," *SEP,* July 19, 1941, 71.

380 "I do not think I need to tell you": FDR quoted in Healy, *Cissy,* 274.

381 "You once said": EMP, "What You Could Say, Mr. President," *WH,* April 12, 1938, 1.

381 "meaningless, useless": EMP quoted in Healy, *Cissy,* 279.

382 "militant District citizens": Una Franklin, "Army of Citizens to Defy Tree Movers at Basin Today," *WH,* Nov. 18, 1938, 1.

382 "Ignoring the cries"; "frontal attack": "Roosevelt Curbs 'Tree Rebellion,' " *NYT,* Nov. 19, 1938, 19.

382 "Webster defines 'flimflam' "; "evasively": "Memorial Flimflam," *WP,* Nov. 19, 1938, 8.

382 "gently but firmly": "Roosevelt Curbs Tree 'Rebellion.' "

382 "It is our campaign"; "Though as workers": EMP, "Flimflam!" *WH,* Nov. 19, 1938, 1.

383 "In the days to come"; "the millions": FDR quoted in "Some Cherry Trees Gave Their Lives for Jefferson Memorial," *WP,* March 28, 2010, C1.

384 "Tell Bertie McCormick": FDR quoted in Alexander, "Duke of Chicago," 71.

384 "the present reign"; "The very foundations"; "peace-loving"; "concerted effort"; "international anarchy"; "quarantine"; "epidemic of world lawlessness"; "America hates war": FDR quoted in Dallek, *Franklin Roosevelt and American Foreign Policy, 1932–45* (New York: Oxford University Press, 1995), 148.

385 "Thank God"; "almost Christ-like": Hoge, *Cissy Patterson,* 176.

385 "Teamed up together": Alexander, "Duke of Chicago," 71.

385 "There is a predominant"; "Of course, in the event": JMP quoted in Hoge, *Cissy Patterson,* 180.

385 "While I am talking"; "I have said": FDR quoted in "Britain Is Seeking 12,000 Planes of U.S. Make," *Clovis (NM) News-Journal,* Oct. 31, 1940, 5.

386 "Here I come!": EMP to FDR, Christmas 1941, FCWP, Box 25, Topical File, "Patterson, Eleanor, Research for Biography."

386 "the great arsenal of Democracy"; "The experience of the past two years"; "No man": FDR, Fireside Chat, Dec. 29, 1940, in Brian MacArthur, ed., *The Penguin Book of Twentieth-Century Speeches* (New York: Penguin, 1992), 195–97.

387 "The people of Europe"; "war away from our country and our people"; "Great Britain and the British Empire"; "There is no demand"; "We must apply": Ibid.

388 "We're issuing Britain"; "Very few": JMP quoted in Chapman, *Tell It to Sweeney,* 202.

388 "He lied": JMP quoted in Hoge, *Cissy Patterson,* 182.

388 "gives the President"; "its right name": [JMP], "It Isn't a '-Lease Bill,' " reprint from *NYDN, WT-H,* Jan. 24, 1941, 12.

388 "Some few of us"; "and that he has led": EMP quoted in Healy, *Cissy,* 286.

389 "lying up in the rocks": Ernest Cuneo interview, Sept. 8, [1974?], RGMP, Box 213, F3.

389 "When Mr. Roosevelt entered"; "party lines": Waldrop, "A 'Scoop' Gave Axis Our World War II Plans."

389 "sincere and powerful": EMP to WRH, Aug. 17, 1940, telegram, WRHP.

389 "pantywaist brigade" ; "an assortment": EMP quoted in "Cissie Fuss," *Time,* July 24, 1944, http://www.time.com/time/magazine/article/0,9171,791596,00 .html.

389 "How the Hell": Ernest Cuneo quoted in Martin, *Cissy,* 416.

389 "There is no tragedy": Ernest Cuneo interview, Sept. 8, [1974?], RGMP.

<div align="center">"PATRIOTIC OR TREASON"</div>

390 "The Associated Press": RRMcC to EMP, July 16, 1928, RRMcCP.

390 "But before she was done"; "her cousin": Waldrop, *McCormick of Chicago,* 251.

391 "backing of everyone": Frank Knox, quoted in Smith, *The Colonel,* 410.

391 "Thanks pal": EMP to Jackie Martin, Dec. 11, 1941, telegram, RGMP.

391 "I have been told"; "I thought this": EMP to George DeWitt, Dec. 11, 1941, telegram, RGMP.

392 "monumental scoop"; "one to put in Marshall Field's eye"; "show[ing] up Roosevelt": Waldrop, "A 'Scoop' Gave Axis Our World War II Plans."

392 "defeat our potential enemies": FDR quoted in Smith, *The Colonel,* 415.

392 "It will be necessary"; "supreme effort"; "a blueprint for total war": Chesly Manly, "F.D.R.'s War Plans!" *CDT,* Dec. 4, 1941, 1.

392 "some cool head"; "A few days later": FCW, "Walrop plan for Washington Post," n.d. (1962), draft article, FCWP, Box 6, "Writings, Undated" (1 of 2).

393 "irrefutable proof": Waldrop, "A 'Scoop' Gave Axis Our World War II Plans."

393 "the most untruthful"; "plow under": FDR and Senator Burton Wheeler quoted in WJT, "F.D.R. Is Angry; Says Criticism Is Dastardly," *CDT,* Jan. 15, 1941, 2.

393 "the hottest stories": RRMcC quoted in Smith, *The Colonel* , 417.

394 "If it isn't true": Congressman William Lambertson quoted in Fleming, "The Big Leak."

394 "the White House did not": Arthur Sears Henning, "White House Calls Cabinet Aid to Draft Reply," *CDT,* Dec. 5, 1941, 1.

394 "It depends entirely": Stephen Early quoted in ibid., 16.

394 "Early did not explain": Ibid., 16.

394 "Anglo-Saxon war plans": *Oberkommando der Wehrmacht* quoted in Fleming, "The Big Leak."

395 "particularly interested": Ickes, *Secret Diary,* vol. 3, 659.

395 "horrified": FCW to Francis Biddle, Nov. 15, 1963, FCWP, Box 2, "Book: *McCormick of Chicago* Research, Midway Case, Charged with Espionage, 1942–64."

395 "three days later": FCW, "The Importance of Forgetting," n.d., unpublished, FCWP, "Writings, Undated," (1 of 2).

395 "I have always thought": FCW to Francis Biddle, Nov. 15, 1963, FCWP.

395 "What the hell"; "Things are right at the flashpoint"; "belting in"; "the police radio": FCW quoted in Roy Hoopes, ed., *Americans Remember the Homefront* (New York: Berkley, 2002), 56.

395 "Do you think": EMP quoted in Smith, *The Colonel,* 420. Emphasis in original.

396 "Three Furies of the Isolationist press"; "bombarded the Midwest"; "ground out": "War and Peace: Follow What Leader?" *Time,* Oct. 6, 1941, http://www .time.com/time/magazine/article/0,9171,790233,00.html.

396 "natural for Mr. Luce"; "The likelihood that these rescue adventures": JMP, "Family Portrait—II," *NYDN,* Oct. 8, 1941, 2.

396 "How do you like": Clare Boothe Luce quoted in "Georgina X. Preston" (George Dixon), "Having a Wonderful Time," *WT-H,* June 21, 1942, E3.

396 "Roses are beautiful"; "I still think": EMP, n.d., quoted in ibid.

396 "light and deadly": EMP to RRMcC, June 24, 1942, RRMcCP.

397 "In his career"; "A friend": "Georgina X. Preston" (George Dixon), ibid.

398 "re-admission to the United States Army": JMP to the War Department, Dec. 10, 1941, quoted in Chapman, *Tell It to Sweeney,* 183.

398 "this, of course"; "command performance"; "I am here"; "a task"; "that as a result": JMP quoted in ibid., 184.

399 "All I want": JMP quoted in Keeler, *Newsday,* 95.

399 "We had the whole thing"; "a great military name"; "what this eminent gentleman": FCW, "A 'Scoop' Gave Axis Our World War II Plans."

399 "The question"; "It was a difficult": Henry L. Stimson diary entry for Nov. 25, 1941, quoted in Charles Austen Beard, *President Roosevelt and the Coming of War, 1941* (New Haven, Conn.: Yale University Press, 1948), 517–18.

400 "Germany has always": Adolf Hitler quoted in "Textual Excerpts from the War Speech of Reichsfuehrer in the Reichstag," *NYT,* Dec. 12, 1941, 4.

400 "This young lady": FCW, "FDR & JFK & JEH & Inga: A Story of Love and War in Washington," unpublished ms. ("Unpublished Revision of Preceding—Based on Access to FBI Files Not Avail for 1st Version"), 1978, FCWP, 5, Box 5, "Writings."

400 "to influence morale"; "friendly with Adolf Hitler": FBI memorandum from Mr. Callahan to H. N. Bassett, Feb. 13, 1975, FCWP, Box 17, "FBI, Arvard, Inga, a.k.a. Mrs. Paul Fejos, Mrs. Tim McCoy, 1941–."

401 "how many sheets of toilet paper": FCW quoted in Nigel Hamilton, *Reckless Youth* (New York: Random House, 1992), 429.

401 On the FBI's loaning the wiretapping equipment to the *WT-H,* see DP to Morris Ernst, February 9, 1942, DP/LBJL, G78, 3 of 3, "Ernst, Morris, #2."

401 FCW as FBI informant: Agent Edward A. Tamm, "Memorandum for the Director," Sept. 15, 1942, FCWP, Box 17, "FBI, Arvad, Inga, a.k.a. Mrs. Paul Fejos, Mrs. Tim McCoy, 1941–."

401 "God damn it"; "I give Hoover": FCW quoted in Hamilton, *Reckless Youth,* 429.

402 "Stupefied by the beauty": Arthur Krock quoted in ibid., 421.

402 "Jack went": Kathleen Kennedy to Joseph P. Kennedy, n.d., in Amanda Smith, ed., *Hostage to Fortune* (New York: Penguin, 2002), 533.

402 "The 24 years": Inga Arvad, "Did You Happen to See—John F. Kennedy?" *WT-H,* Nov. 27, 1941, 2A.

402 "no animosity whatever": Page Huidekoper quoted in Special Agent S. K. McKee,

"Memorandum for the Director," Dec. 12, 1941, in FCWP, Box 17, "FBI, Arvad, Inga, a.k.a. Mrs. Paul Fejos, Mrs. Tim McCoy, 1941–."

403 "vexed and mad"; "I can still see": Inga Arvad quoted in Hamilton, *Reckless Youth,* 426.

403 "starving Russian refugee": "I had known, very well, a member of his family, either an aunt or cousin in the old days in Russia. I was very sorry for him and took him on as a photographer," EMP would later declare under oath. "I did not know at that time, nor did I know or any of us know until after he had left the paper that he had been a member of Hitler's elite S.S. Guard in Germany before he came here." Dep. of Eleanor Patterson at 304, *DeSavitsch v. Patterson,* Civil Action No. 23114 U.S. (D.D.C., April 5, 1945).

404 "their viewpoint": Inga Arvad quoted in Special Agent S. K. McKee, "Memorandum for the Director," Dec. 12, 1941, in FCWP, Box 17, "FBI, Arvad, Inga, a.k.a. Mrs. Paul Fejos, Mrs. Tim McCoy, 1941–."

404 "Miss ARVAD advised"; "she denied having": Special Agent S. K. McKee, "Memorandum for the Director," Dec. 12, 1941.

405 "The air in Washington": FCW, "FDR & JFK & JEH & Inga."

405 " 'specially watched' ": Memo from Mr. Callahan to H. N. Bassett, Feb. 13, 1975, FCWP, Box 17, "FBI, Arvad, Inga, a.k.a. Mrs. Paul Fejos, Mrs. Tim McCoy, 1941–."

405 "One of Ex-Ambassador"; "Pa Kennedy no like": WW quoted in Neal Gabler, *Winchell: Gossip, Power and the Culture of Celebrity* (New York: Vintage, 1995), 306.

406 "personal SACRIFICE"; "It seems to me": EMP quoted in FCW, unpublished biographical outline, FCWP, Box 25, Topical File, "Patterson, Eleanor, Research for Biography." Para. II, Part 4, c(1). Emphasis in original.

406 "In those days"; "What story?"; "Washington society": EMP, "Singing for Their Supper."

407 "The fact is that" and subsequent quotes: RRMcC to J. H. Sawyer, Feb. 20, 1942, FDRL, PPF 426.

407 "This surely will give": Fiorello LaGuardia to FDR, Aug. 31, 1942, FDRL, PPF 426.

408 "And on the seventh day": Carl Sandburg quoted in D. J. Kelly to Fiorello LaGuardia, Aug. 26[, 1942], FDRL, PPF 426.

408 "Thurman Arnold sent for me"; "I come from four generations": EMP quoted in "New Deal Fails to Purge Critics from AP Board," *CDT,* April 22, 1942, 7.

409 684 to 287: "Great Strides Stressed at Last Session of AP Convention," *WP,* April 22, 1942, 20.

409 "Some of the members": RRMcC quoted in "McLean, Philadelphia Bulletin Publisher, Is Reelected President of A.P.," *WP,* April 23, 1942, 8.

409 514 to 424: "A.P. Vote Is Called Blow to 'Gestapo,' " *NYT,* April 23, 1942, 19.

409 "not desperately in need": "Chicago Sun Plea Voted Down By A.P.," *NYT,* April 22, 1942, 20.

409 "Mrs. Patterson Is Loser": Ibid.

409 "New Deal Fails": "New Deal Fails to Purge Critics from AP Board," *CDT,* April 22, 1942, 7.

409 "Of course the President read": Grace Tully interview, RGMP, Box 213, F7.

410 "We are both menaced"; "My own press": FDR to Winston S. Churchill, March 18, 1942, FDRL.

410 "his voice and manner"; "tirade"; "Cissy, Joe and Bert": Joseph P. Kennedy, diary, April 10, 1942, in Smith, ed., *Hostage to Fortune,* 545–46.

410 "The trouble is": FDR to Archibald MacLeish, July 13, 1942, FDRL, PPF 5068.

410 "I personally": FDR quoted in Smith, *The Colonel,* 422.

411 "every sensible conception"; "it specifically": Byron Price to EMP, May 29, 1942, FDRL.

412 "confidential information": Office of War Information, Department of Justice, press release, Aug. 7, 1942, FCWP, Box 2, "Book: *McCormick of Chicago,* Research, Midway Case, Charged with Espionage, 1942–64."

412 "We had dinner together": FCW to Howard Ellis, Nov. 5, 1963, FCWP, Box 2, "Book: *McCormick of Chicago,* Research, Midway Case, Charged with Espionage, 1942–64."

412 "I felt like a fool": Attorney General Francis Biddle quoted in Fleming, "The Big Leak."

412 "America's No. 1 and No. 2 exponents": Rep. Elmer J. Holland quoted in Willard Edwards, "Daily Worker 'Rigged' Smear—Dies," *CDT,* Aug. 4, 1942, 1.

412 "deal firmly with the defeatists": Rep. Elmer J. Holland quoted in "The Press: Joe," *Time,* Aug. 24, 1942, http://www.time.com/time/magazine/article/0,9171,849939,00.html.

412 "a seven-day-a-week study": Ibid.

412 "would welcome a victory": Rep. Elmer J. Holland quoted in Edwards, "Daily Worker 'Rigged' Smear—Dies."

412 "Cissy and Joe Patterson are"; "The Pattersons and their ilk": "Three Newspapers Accused in House," *NYT,* Aug. 4, 1942, 17.

412 "Congressman Holland's statement"; "The following statement": JMP, "You're a Liar, Congressman Holland," *NYDN* reprint, *WT-H,* Aug. 5, 1942, 8.

413 "To the above statement": EMP quoted in Ibid.

413 "We are not of those": JM, "The Duty of Newspapers," quoted in Martin, *Cissy,* 433.

413 "Wednesday afternoon": EMP to Rep. Elmer J. Holland, n.d. [Aug. 1942], FCWP.

414 *"With unique courage"*: "Elmer's Tune," draft advertisement for the *WT-H*'s "Having A Wonderful Time" column, n.d. (Aug. 1942), FCWP.

414 11 of his 435 colleagues: "Rep. E. J. Holland Renews Attack on the Tribune," *CDT,* Aug. 11, 1942, 5.

414 "moral sabotage"; "defeatism among our civilians"; "All the physical sabotage"; "Daily these publishers"; "Daily they sow": Rep. Elmer J. Holland quoted in " 'Moral Sabotage' Laid to Papers," *NYT,* Aug. 11, 1942, 17.

414 FBI internal memorandum: "Memorandum for Mr. Ladd," Aug. 10, 1942, FCWP.

414 "a different sort of journalistic bird": "The Press: Joe," *Time,* Aug. 24, 1942.

415 "That any one could accuse Patterson"; "he isn't a Nazi or a pro-Nazi": "Pegler on Patterson," *CDT,* Aug. 23, 1942, 14.

415 "I know him perhaps": APG, "What Is Patriotism?" *WT-H,* Aug. 9, 1942, 11.

415 "intent on having a newspaper": JMP quoted in AB to EMP, Oct. 26, 1933, EMPP, Series 1, Box 1, "Incoming, Brisbane, 1933."

415 "I couldn't help"; "I tried to overcome"; "we used to have such": APG to JMP, quoted in Smith, *The Colonel,* 464.

416 "Are them days": Ibid.

416 "We have hunted": APG, "What Is Patriotism?"

416 "Marshall Field is not"; "part of an alien": RRMcC quoted in "McCormick Confident APG Will Get Justice; Call Rival 'Part of Alien, Radical Plot,' " *NYT,* Aug. 29, 1942, 8.

417 internal memorandum: R. K. Carter to Mr. McGuire, Aug. 29, 1942, FCWP, Box 19, "FBI, Times-Herald, 1942–44."

417 "My speech before"; "The Chairman made a speech"; "I made a most touching speech"; "This time I cried too": EMP to AB, May 9, 1932, EMPP, Series 1, Box 1, "Outgoing."

418 "a flop in business"; "because of his close connections"; "The trouble is": EMP to RRMcC, Sept. 11, 1939, RRMcCP.

418 "Mrs. Patterson has been trying"; "quite a following"; "It was suspected": DP to Morris Ernst, Feb. 9, 1942, DP/LBJL, G78, 3 of 3, "Ernst, Morris, #2."

424 EMP's spite toward Perle Mesta: Frank Waldrop interview tape transcriptions, RMGP, Box 213, f2.

425 "Art Moderne masterpiece": Sarah Booth Conroy, "The Cafritz Largesse," *WP,* Nov. 30, 1988, C1.

425 "bronze zodiac design": "Cafritz, Gwen" in Cleveland Amory, *International Celebrity Register* (New York: Celebrity Register, 1959), 120.

425 "Cissy saw I had potential": Gwen Cafritz quoted in Burt Solomon, *The Washington Century: Three Families and the Shaping of the Nation's Capital* (New York: HarperCollins, 2004), 42.

425 "the most influential": Jonathan Yardley, "The Washington Century," *WP,* Nov. 21, 2004, BW02.

425 "vivacious"; "dynamic"; stunning"; "exotic type": "Beauty of the Week, No. 7: Mrs. Morris Cafritz," *WT-H,* Feb. 12, 1940, 12.

425 "always so smart": "Peter Carter Says," *WT-H,* June 29, 1942, 10.

425 "I ALWAYS invite Senators": Gwen Cafritz quoted in Amory, *International Celebrity Register,* 120. Emphasis in original.

426 Cissy began to suspect: "Memorandum for Mr. Tolson," Sept. 24, 1942, FBI; Eleanor Medill Patterson File. See also EMP to Mr. Maxwell, Aug. 18, 1943, FCWP.

BUT THAT IS THE WAY WARS START

426 "Drew always was"; ""I have always known it": EMP quoted in FCW, "An Appraisal of Eleanor Patterson," 12.

427 DP calling EMP "Mom": See, for example, DP to LMAP, Oct. 28, 1936, DPP/LBJL, G209, 2 of 4, "Pearson, Luvie—Personal from Drew."

427 "You've reached an age": "Some Notes After a Talk with Felicia," RGMP, Box 213, F3.

427 "sand family"; "dissolve in the first storm": JMP quoted in Pilat, *Drew Pearson,* 152.

427 "I was 15 years old then"; "But that is the way wars start": DP to TA, June 28, 1936, DPP/LBJL, G314, 1 of 2, "Reno."

428 "But someday": Ibid.

428 "Daddy Drew": DP to TA, May 27, 1937, DPP/LBJL, G210, 4 of 5, "Letters from Drew to LMP."

428 "forced to leave Baltimore": Dan T. Moore (DP), ghostwritten affidavit draft, n.d. (1937), DPP/LBJL, G41, 2 of 3, "Tyler Abell—Custody Fight, 1937."

428 "indulged in abusive language": Charlotte Childress Foster (DP), ghostwritten affidavit draft, n.d. (1937), DPP/LBJL, G41, 2 of 3, "Tyler Abell—Custody Fight, 1937."

428 "closest friend"; "exposing his person": Dan T. Moore (DP), ghostwritten affidavit draft, n.d. (1937), DPP/LBJL, G41, 2 of 3, "Tyler Abell—Custody Fight, 1937."

429 "neurotic literature"; "playing with guns": LMP, memorandum, June 18, 1937, DPP/LBJL, G41, 2 of 3. "Tyler Abell—Custody Fight."

429 "This is a funny kind of a letter"; "I have been going over the days"; "I have only loved": DP to FG, December 12, 1936, DPP/LBJL, G210, 1 of 5, "Gizycka, Felicia."

429 "serious pelvic disturbance": Dr. W. R. Lovelace, "To Whom It May Concern," June 1, 1937, DPP/LBJL, G210, 4 of 5, "Letters to Drew from LMP."

430 "immediately subjected"; "to get rid of him": DP, memorandum of evidence against GA, n.d. (1937), DPP/LBJL, G41, 2 of 3, "Tyler Abell—Custody Fight." On the events surrounding George Abell's departure to New York from Santa Fe in November 1936, see also *George Abell v. Luvie Moore Pearson* at 4, Bill of Complaint for Injunction and Determination of Custody of Child, Admin. No. 65634, (D.D.C. 1937); and Dan T. Moore (DP), ghostwritten affidavit draft, n.d. (1937), DPP/LBJL, G41, 2 of 3, "Tyler Abell—Custody Fight, 1937."

430 "what a columnist may write"; "But when a columnist": "Drew Pearson Weds Geo. Abell's Ex-Wife," *WH,* Nov. 23, 1937, 1. Emphasis in original.

430 "Felicia has cabled"; "I have never heard": EMP to AB: April 11, 1934, EMPP, Series 1, Box 1, "Outgoing."

430 "From London"; "The countess met her fiancé": "Two Holidays Observed Here; Both Are Latin: Spanish and Pan-American Days Celebrated at Dinner," *WP,* April 15, 1934, 51.

431 "I guess Felicias new husband": EMP to JMP, April 18, 1934, telegram, JMPP.

431 "tall, slim and not very energetic": "Cholly Knickerbocker" (Lord Castlerosse) quoted in Adrian Dannatt, "Obituary: Felicia Gizycka," *The Independent,* May 18, 1999, http://www.independent.co.uk/arts-entertainment/obituary-countess-felicia -gizycka-1094303.html.

431 "he cuffed me around"; "What we had in common"; "deadlock"; "during this time"; "a little wine-tasting": [FG], "Stars Don't Fall," 405.

431 "When he reached for me": Ibid., 405–406.

431 "I drank"; "naughtiness": Ibid., 406.

432 "I passed out": Ibid.

432 "Sorry delay unavoidable": FG quoted in DP to Weymouth Kirkland: July 10, 1934, DPP/LBJL, G314, 1 of 2, "(Confidential) Ellen C. Pearson III (Personal)."

432 "mingled bitterness and affection"; "I warn you": DP to FG, n.d., draft letter, DPP/LBJL, F58, 4 of 4, "Personal Letter—Very Personal."

432 "I am more disappointed"; "Unless I am": DP to FG, n.d., telegram draft, DPP/LBJL, F58, 4 of 4, "Correspondence re: Ellen—Clippings."

433 The anecdote about FG's "kidnapping" EPA comes from Pilat, *Drew Pearson,* 92.

434 "Felicia de Lavigne has been doing"; "Would you feel"; "It is there": TJW to Richard Berlin, April 23, 1936, EMPP, Series 1, Box 1, "Incoming."

434 "You're an alcoholic"; "This went in one ear": [FG], "Stars Don't Fall," 406.

434 "knock-down": DP to FG, June 24, 1937, DPP/LBJL, G210, 1 of 5. "Gizycka, Felicia."

434 As a result of the dozens of affidavits Drew had solicited from "reputable people": See, for example, DP to Gov. O. Max Gardner of North Carolina and to Major (?); June 9, 1937, draft letters DPP/LBJL, G41, 2 of 3, "Tyler Abell—Custody Fight" (1 of 2).

434 "I hope George won't"; "I bet": FG to DP, July 22, 1937, DPP/LBJL, G210, 1 of 5, "Gizycka, Felicia."

434 "harrowing battle": DP to FG; June 24, 1937, DPP/LBJL, G210, 1 of 5. "Gizycka, Felicia."

434 "he was for 'raising holy hell' ": James P. Lanehart, affidavit, Sept. 28, 1937, 26–27, DPP/LBJL, F58, 4 of 4, "Divorce and Custody Cases, Affidavits and Correspondence, 1937–39."

435 "queer manner"; "something untoward": Luvie Pearson deposition, Sept. 6, 1937, DPP/LBJL, G41, 2/3, "Tyler Abell—Custody Fight (1 of 2)."

435 "desert justice"; "I did not want my son brought up": GA, quoted in "Mother Hides 'Stolen' Boy," (London) *Daily Mail*, quoted in affidavit, *Luvie Moore Pearson v. George Abell*, No. 49245, Dept. No. 1, n.d., (1937), DPP/LBJL, F58, 4 of 4, "Divorce Custody Cases, Correspondence, 1937–41," 1.

435 "I had no intention": GA quoted in James P. Lanehart affidavit, Sept. 28, 1937, 27, DPP/LBJL, F58, 4 of 4, "Divorce and Custody Cases, Affidavits and Correspondence, 1937–39."

436 Drew's rollicking correspondence on the subject: "One of the most distinguished" and subsequent quotes come from the extensive and colorful account of the episode that DP addressed to LMP's grandmother on Aug. 25, 1937, DPP/LBJL, G210, 1 of 5, "Family—Tyler's Kidnapping."

438 "I want to take up your suggestion": DP to John Donovan; Sept. 3, 1937, DPP/LBJL, F58, 4 of 4, "Divorce, Custody Case Correspondence, 1937–41."

438 "If I catch up with Pearson": GA, quoted in New York *World Telegram:* "Abell Is Eager to Regain Boy" quoted in Affidavit, *Luvie Moore Pearson v. George Abell*, No. 49245, Dept. No. 1, n.d., 1937, DPP/LBJL, F58, 4 of 4, "Divorce Custody Cases, Correspondence, 1937–41," 1.

438 "You are unfit"; "Your minds are poisoned": Judge Daniel W. O'Donoghue quoted in Pilat, *Drew Pearson*, 149–50. See also "Judge Scolds Abell in Custody Battle," *WP*, Oct. 26, 1937, 3.

438 "I haven't heard"; "I got a very cute letter": FG to DP, Sept. 30, 1937, DPP/LBJL, G210, 1 of 5, "Felicia's Letters."

439 "sly, cold-blooded": FG, *Flower of Smoke* (New York: Charles Scribner's Sons, 1939), 86.

439 "got drunk and had a row": [FG], "Stars Don't Fall," 405.

439 "Drew sat there"; "He had his present": EMP quoted in Pilat, *Drew Pearson*, 153–54.

440 "She was a beautiful woman"; "Her life": Ireland, *Ligi,* 67.

440 "obviously unhappy"; "I began to realize": Ibid., 66.

440 "almost all my former friends"; "All but my faithful Louise": "Delia Ophelia Dulany" (FG), "How A.A. Saved My Life," lecture notes, 1990, FGP. Emphasis in original.

441 "dandy"; "It combined"; "gay, young Bohemians"; "sowing their wild"; "This was the life!": [FG], "Stars Don't Fall," 407.

441 "a brilliant doctor": FG, "Questions—the Book; Notes, Chapter Headings," unpublished memoir draft, 24, FGP.

WHO'S LOONY?

441 "Cissy's circulation"; "she thinks you are striking": EMP to DP, April 30, 1941, DPP/LBJL, G207, 1 of 3, "Misc. Letters (3 of 3)."

442 "chronic liar": "Drew Pearson Branded Chronic Liar by President," *Milwaukee Sentinel,* September 1, 1943, 1; "U.S. at War: Chronic Liar," *Time,* Sept. 13, 1943.

442 "To hell with it!": EMP quoted in Hartwell, "No Prissy Is Cissy," 78.

443 On FCW cutting syndicated columns that represented viewpoints divergent from EMP's, see FCW, "An Appraisal," 11.

443 "among the patent medicine ads": EMP, "Pearson and Allen: The Headache Boys," *WT-H,* April 28, 1942, 1.

443 "Cissy was a powerful enemy"; "gahdamb'd affairs"; "Big Shots": Walter Winchell, *Winchell Exclusive* (Englewood Cliffs, NJ: Prentice Hall, 1975), 128–29.

443 "imitators steal your act": EMP quoted by WW, *New York Mirror,* May 23, 1941.

443 "had a few"; "Why the hell"; "your column"; "Mrs. Patterson"; "Apologize?"; "That'll be the day": WW, *Winchell Exclusive,* 128–29.

443 "blind adoration for FDR": Ernest Cuneo, Introduction, ibid., xi.

443 "(she was lots senior than I)": WW, *Winchell Exclusive,* 129.

444 "While we all appreciate": Rear Admiral Arthur J. Hepburn quoted in Herman Klurfeld, *Winchell: His Life and Times* (New York: Praeger, 1976), 104.

444 "Mrs. Patterson began chopping": WW, *Winchell Exclusive,* 130.

444 By the first months of the war: On the *T-H* reader's reporting the omissions to WW see Anon., "To Director, FBI Re: Special Inquiry—Lawsuit Between Walter Winchell and Washington Times Herald Newspaper," Feb. 5, 1943, FCWP, Box 19, "FBI, Times-Herald, 1942–44."

444 "Attention, Mr. and Mrs. Washington": WW quoted in Klurfeld, *Winchell,* 105.

445 "Walter Winchell's column": EMP quoted in Healy, *Cissy,* 248.

445 "Winchell, unless he breaks his contract": Ibid.

445 Appearing in some 616: Charles Fisher, *The Columnists: A Surgical Survey* (New York: Howell, Soskin, 1944), 216.

445 "Nine out of ten": Cuneo, Introduction, in WW, *Winchell Exclusive,* iv.

446 "Fond as I am of Winchell"; "For personal reasons"; "I don't want": DP to Jack Lait, March 5, 1942, DPP/LBJL, G210, 1 of 5, "Patterson, Cissy."

446 "somewhat strained": DP, "Relations with Mrs. Eleanor Patterson," n.d., memorandum, FCWP, Box 20, "FBI, Waldrop and Patterson, 1945–55."

446 "upon the insistence of the authors": George Carlin to EMP, Feb. 4, 1942, DPP/LBJL, G210, 1 of 5, "Patterson, Cissy."

446 "Regarding the TIMES-HERALD": DP to George Carlin, Feb. 7, 1942, DPP/LBJL, G210, 1 of 5, "Patterson, Cissy."

447 "After all": Ibid.

447 "Eleanor Medill (Cissie [sic]) Patterson"; "It's inevitable": "Women Publishers View War Changes," *NYT,* April 21, 1942, 15.

447 "When Hitler rose"; "Pearson is just": EMP quoted in Pilat, *Drew Pearson,* 169.

448 "I think we have been too kind"; "No more jabs": WW quoted in Klurfeld, *Winchell,* 109–10.

448 "My biggest libel suit": WW quoted in ibid., 110.

448 "Winchell's contract": "The Press: News Notes," *Time,* May 24, 1943, http://www.time.com/time/magazine/article/0,9171,933056,00.html.

448 "If you are going"; "I can steer him": Dan Walker to FCW, April 7, 1942, FCWP.

449 "There are several": Ibid.

449 "maliciously distorted"; "innuendoes"; "Our readers may inquire": EMP, "The Headache Boys and General MacArthur," *WT-H,* April 28, 1942, 1. Emphasis in original.

449 "false, scandalous"; "unrealizing"; "ablest soldier in the English speaking world": "MacArthur in Command," *CDT,* March 18, 1942, 16.

450 "Early in February"; "It was my feeling"; "I bounced": EMP, "Pearson and Allen: The Headache Boys," *WT-H,* April 28, 1942, 1.

451 "I won't have them": Ibid.

451 "In presenting this exposé": Hon. Martin L. Sweeney, Extension of Remarks, *Congressional Record,* vol. 88, no. 82, April 28, 1942, A1707.

452 "poor jerks" and subsequent quotations: EMP, "Crazy—Crazy like Foxes," *WT-H,* Oct. 28, 1945, D3.

452 "the most vicious personal slander"; "(Eleven more lines)": "Who's Loony?" *Time,* Nov. 12, 1945, http://www.time.com/time/magazine/article/0,9171,792540.00 .html.

452 "Very special bulletin!": WW quoted in "Who's Loony?"

452 "The British have organized": DP quoted in Healy, *Cissy,* 246.

453 "I like a lot of your editorials"; "If you are such a devotee": A. E. Smith to EMP, April 28, 1942, FCWP.

453 "I had suspected"; "Finally you have given me": Anonymous to EMP, April 28, 1942, FCWP.

453 "sneering innuendo"; "Nuts!": Mrs. Sam Simonton to EMP, April 28, 1942, FCWP. Emphasis in original.

453 " 'Why a cockroach?' "; "A housefly is noted": James R. Morrell to EMP, April 29, 1942, FCWP.

453 "You evidently thought"; "The only headache": Lee Morgan to EMP, April 30, 1942, FCWP.

453 "I think I can detect": Frank Doak to FCW, May 15, 1942, FCWP.

453 "Winchell writes about skunks": "Jno Swarm [sic]" to EMP, March 23, 1944, telegram, FCWP.

453 "*even* its sports columns": "Two Concerned Readers" to FCW, May 22, 1942, FCWP. Emphasis in original.

454 "Naturally, Cissy would look rather sick": DP to George Carlin, May 5, 1942, DPP/LBJL, G210, 1 of 5, "Patterson, Cissy."

454 "felt that he ought not": DP to George Carlin, May 5, 1942, DPP/LBJL, G210, 1 of 5, "Patterson, Cissy."

455 Luvie's astonished rebuttals: LMAP to EMP, undated, DPP/LBJL, DP, G207, 1 of 3, "Misc. Letters (1 of 3)."

455 "It is still right difficult"; "Imagine!!!": LMAP to EMP, June 29, 1942, DPP/LBJL, DP, G207, 1 of 3, "Misc. Letters (2 of 3)."

455 "Nobody quite knew"; "unless it was": DP to EPA, June 2, 1944, DPP/LBJL, G117, 2 of 3, "Pearson, Ellen, 1944."

455 "she maintained": TA, interview with the author, Nov. 22, 2005.

456 "beautiful, lean long-legged": FG, "Start of the Book, Chapt. III," 1.

456 "I'm crying because"; "one last drunken row": Ibid., 3.

457 "I finally shook": Ibid., 3v.

457 Though Felicia's visits to her mother had become unusual: FG's account of her break from EMP and subsequent quotations come from two main sources, both of them drafts of the unpublished memoir FG was writing at the end of her life: FG, "List of What to Add & What to Insert; Book Redo," 35–39B, "Big Fight with Cissy," and FG, "Start of the Book, Chapt. III," 3–9. A summary of the quarrel appears in [FG], "Stars Don't Fall," 409.

459 "My child was being exposed"; "She was also"; "duly sent to school": [FG], "Stars Don't Fall," 408–409.

459 "In the course of drunken"; "I found my own": Ibid.

459 "grandiose"; "politically hideous"; "I think it's marvelous": FG, "Start of the Book, Chapter IV," Feb. 25, 1986, draft memoir, 34, FGP.

459 "ended up nutty": Ibid., 36.

459 "very good"; "He would occasionally"; "But he was kind": FG, "Shaft," 18.

460 "an early and lasting peace"; "to assist in the discipline": "Dr. Birkhead Scores Obstructionist Press," *NYT,* Oct. 17, 1943, 18.

460 Katrina McCormick Barnes had taken a less deferential and affectionate view: Katrina McCormick Barnes quoted in "The Press: Niece v. Uncle," *Time*, March 13, 1944, http://www.time.com/time/magazine/article/0,9171,932421,00.html.

460 "attempts at community service": [FG], "Stars Don't Fall," 410.

460 "By this time"; "Now came the black": Ibid.

460 "Fat, bloated, dirty and unkempt": Ibid., 411. See also FG, "List of What to Add & What to Insert—Book-Redo," 38–39B, FGP.

461 "My dearest friend: "Delia Ophelia Dulany" (FG), "How A.A. Saved My Life," lecture notes, FGP.

461 "At first nothing happened": Ibid.

461 "the more we found out"; "I felt abysmally ashamed": FG, "List of What to Add & What to Insert—Book Redo," 39A-39B.

461 "Fellowship"; "show other alcoholics": Anonymous, "Foreword to the First Edition," *Alcoholics Anonymous* (New York: Alcoholics Anonymous World Services, 1976), xiii. Emphasis in original.

461 "all the God stuff": FG quoted in Sally Brown and David R. Brown, *A Biography of Mrs. Marty Mann* (Center City, Minn.: Hazelden, 2001), 148.

461 "Bill was tall": [FG], "Stars Don't Fall," 413.

462 "He was well dressed": Ibid.

462 "I've got a dame": William Griffith Wilson quoted in Brown and Brown, *A Biography of Mrs. Marty Mann*, 149.

462 "Aha, he's passing"; "Now comes"; "I felt like": [FG], "Stars Don't Fall," 413.

462 "booze and ancient sweat": "Delia Ophelia Dulanty" (FG), "How A.A. Saved My Life."

462 "She was attractive": [FG], "Stars Don't Fall," 414.

462 "went right into": "Delia Ophelia Dulany" (FG), "How A.A. Saved My Life."

462 "tall, smart-looking"; "Years of drinking": [FG], "Stars Don't Fall," 414.

463 "With more physical courage": Ibid.

463 Marty only began: "Founder of National Council on Alcoholism Dies at 75," *LAT,* July 28, 1980, n.p., MMP, box 14, "Obituaries."

463 MM as the first woman member of AA: "Medicine: Help for Drunkards," *Time,* Oct. 24, 1944, 15.

463 "intense exhorter": "She Crusades Against Alcoholism," *New York World-Telegram,* n.d. (Jan. 1945), MMP, Box 14, "Obituaries."

463 "alcoholism is a disease": MM quoted in "Medicine: Help for Drunkards," *Time,* Oct. 24, 1944, 15, http://www.time.com/time/magazine/article/0,9171,932497 ,00.html.

463 "I made a speech": MM quoted in "Founder of National Council on Alcoholism Dies at 75."

463 "A load weighing"; "I was an alcoholic": [FG], "Stars Don't Fall," 414.

463 "sold, intellectually"; "lonesome": Ibid.

464 "off again, on again"; "stubborn case": Ibid.

464 FG's experience at High Watch Farm with Anne: Ibid. 415.

464 "Not at all"; "That deflated me": FG quoted in Brown and Brown, *A Biography of Mrs. Marty Mann*, 149–50.

465 "one short slip": [FG], "Stars Don't Fall," 416.

465 "Just what is there"; "Just keep plodding": MM quoted in Brown and Brown, *A Biography of Mrs. Marty Mann*, 150.

DR. PODUNK FROM TOONERVILLE

465 "I called him"; "terrible June"; "I was not just"; "Savitsch. We can always": Dep. of the Defendant [EMP] at 267, *DeSavitsch v. Patterson,* Civil Action No. 23114 (D.D.C. April 5, 1945).

466 "Some people have"; "Dr. Eugene de Savitsch": Martha Blair, "These Charming People," *WT-H,* March 16, 1939, 3.

467 "he now takes care": "Medicine: Adventurous Doctor," *Time,* July 1, 1940, http://www.time.com/time/magazine/article/0,9171,764154,00.html.

467 "scientific report of some kind": Dep. of the Plaintiff [Eugene de Savitsch] at 64, *DeSavitsch v. Patterson.*

467 "written at the instigation"; "an agreeable man": Dep. of the Defendant [EMP] at 264, *DeSavitsch v. Patterson.*

467 "an agreeable man, rather witty"; "and it's only natural": Ibid., 284–85.

468 "Maybe if I didn't live"; "Anyhow, I feel"; "she never got": EMP to RC quoted in Healy, *Cissy,* 371. Emphasis in original.

468 "Everyone in town"; "You might have thought": Dep. of the Defendant [EMP] at 319, *DeSavitsch v. Patterson.*

468 "suffered"; "You will have": Eugene de Savitsch quoted in Hoge, *Cissy Patterson,* 202.

468 "Otherwise, we'll catch hell": Bill Shelton quoted in Hoge, *Cissy Patterson,* 202.

468 "some weeping": Dep. of the Defendant [EMP] at 280, *DeSavitsch v. Patterson.*

468 "Savitsch had a habit"; "I did not know": Ibid., 277.

469 "he used to get hold": Ibid., 289.

469 "Although I am ordinarily hospitable": Ibid., 290.

469 "Please come see me": EMP to Evie Robert quoted in ibid., 202.

469 "You! You get out": Eugene de Savitsch quoted in ibid., 203.

469 "Get me a doctor": EMP quoted in ibid.

469 "the very night"; "I did not want any more": Dep. of Defendant [EMP] at 277, *DeSavitsch v. Patterson,*

469 "a severe nervous breakdown": Ibid., 281.

469 "The bedpan"; "I don't mind": EMP to RC, quoted in Martin, *Cissy,* 446.

469 "cardiac neurosis": Dr. Paul Dudley White to Dr. Bernard J. Walsh, June 29, 1944, evidence, *DeSavitsch v. Patterson.*

469 "normal in size"; "There was no evidence": Ibid.

469 "Really, Ma Reed was a beauty": EMP to RC, quoted in Martin, *Cissy,* 446.

470 "Cissy, who seems to have quarreled": Isaiah Berlin to Joseph Alsop, Feb. 11, 1944, in Henry Hardy, ed., *Isaiah Berlin, Letters 1928–1946* (Cambridge: Cambridge University Press, 2004), 487.

470 "suave Eugene de Savitsch": J. Earle Moser, "Guffey's Efforts to Handpick D.C. Hospital Doctor Bared," *WT-H,* Jan. 25, 1944, 1.

470 "the now notorious 'Savitsch Case' ": J. Earle Moser, "Guffey's Doctor Denied Post Because Skill Was Doubted," *WT-H,* Jan. 27, 1944, 1.

470 "he has admitted"; "New Deal henchman": Moser, "Guffey's Efforts to Handpick D.C. Hospital Doctor Bared," *WT-H,* Jan. 25, 1944, 1.

471 "Dr. Podunk from Toonerville": Dr. George C. Ruhland quoted in ibid., 1.

471 "perform experimental surgery"; "braved Senator Guffey's ire": Moser, "Guffey's Doctor Denied Post," 1.

471 "It is a classification"; "It is devised": Dep. of the Defendant [Eugene de Savitsch] at 91, *DeSavitsch v. Patterson,*

472 "permanently injured": "Complaint to Recover $500,000.00 Damages for Mal-

practice and Malicious Injury," evidence in *Patterson v. DeSavitsch* (D.D.C. 1945), 2.

473 "I never saw him alone"; "I looked upon him": Dep. of the Defendant [EMP] at 248, *DeSavitsch v. Patterson.*

473 "Savitsch was never": Ibid., 252.

473 "full of all kinds of African trophies"; "a lot of Latin talk": Ibid., 266.

473 "sleeping dope"; "queer things": Ibid., 268.

474 "great dopester": Ibid., 270.

474 "We would be the last"; "We think it well established": Associate Justice Joel Bennett Clark, 159 F2d 15, 81 U.S. App. D.C. 358.

475 "strong fear"; "take over her property": FCW, "An Appraisal," 46.

NO PRISSY IS CISSY

475 "a nice little heart!": Dr. Paul Dudley White quoted in Martin, *Cissy,* 446.

476 "I know that one of my"; "pray that there will be someone": EMP quoted in Healy, *Cissy,* 372.

476 "great elegance of line": ARL quoted in Teague, *Mrs. L,* 174.

478 mentioned in passing: Dr. Alvan Barach on his break with EMP and Evalyn Walsh McLean: Dr. Alvan Barach interview, n.d., RGMP.

478 "beefy, stogie-smoking": "The Press: Appointments to Chicago," *Time,* Oct. 29, 1941, http://www.time.com/time/magazine/article/0,9171,851340,00.html. See also "The Press: Greetings," *Time,* January 15, 1945, http://www.time.com/time/magazine/article/0,9171,775426,00.html.

478 joined by the paper's advertising manager: Martin, *Cissy,* 450.

478 "Look at that face": EMP quoted in ibid.

478 "Fill up the paper with Truman": EMP quoted in Healy, *Cissy,* 296.

478 "Please tell Ellen": DP to FG, January 25, 1945, DPP/LBJL, G210, 1 of 5, "Countess Felicia Gizycka."

479 paying an annual "rent" of $700: DP to EPA, Feb. 2, 1946, FGP.

479 "mismanaged"; "as a country home for themselves"; "for their sole use": Bill of Complaint, *Patterson vs. Pearson,* Circuit Court for Montgomery County, Maryland, No. 11,506, Jan. 1945, DPP/LBJL, G314, 1 of 2, "(Confidential) Ellen C. Pearson (personal)."

479 The Pearsons sent Cissy's invitation too late: EPA interview with the author, Sept. 14, 2006.

480 "I hope that the 'rent' "; "It's all": EMP to EPA, "March 13" (1948), FGP.

480 mother and daughter would, in fact, meet once again: FG, "Start of the Book, Chapt. II," draft memoir, Feb. 25, 1986, 9, FGP.

480 "turn for the worse"; "iron constitution"; "It is terrible": APG to RRMcC, May 17, 1946, RRMcCP.

480 "There is too much McCormick": RRMcC to JLM, May 13, 1946, RRMcCP.

482 "he was a great newspaper man": Fanny Butcher, "The Literary Spotlight," *CDT,* June 16, 1946, B5.

482 "The News's headlines": "The Press: Passing of a Giant," *Time,* June 3, 1946, http://www.time.com/time/magazine/article/0,9171,797865,00.html.

482 "Always he sought"; "A student of human nature": New York *World Telegram* quoted in "N.Y. Papers Praise Patterson as 'Unique' Force," *CDT,* May 28, 1946, 4.

482 "None could ever say": "Joseph M. Patterson," *WP,* May 28, 1946, 8.

482 "The *News's* phenomenal growth"; "it played up the gaudiness": Eleanor Moore-

head quoted in A. J. Liebling, "The Wayward Press," *New Yorker,* June 8, 1946, 90–98.

483 "As for the tabloid"; "But the man in the street": William Rose Benet, "The Phoenix Nest," *Saturday Review of Literature,* June 15, 1946, 46.

483 "some of them friends": "Hundreds Pay Last Tribute at Patterson Bier," *CDT,* May 28, 1946, 4.

483 "enveloped"; "kisses, hugs": FG quoted in "Some Notes After a Talk with Felicia," interview notes, RGMP.

483 "It frightened me": FG quoted in Hoge, *Cissy Patterson,* 219.

484 "I thought of giving"; "But it's too late": EMP quoted in FG, "Introduction, Question—the Book, Notes, Chapter Headings," draft memoir, "Introduction," 24–25, FGP.

484 She also admitted: FG, *Shaft,* 15.

485 "getting boring"; "long tales"; "burst in": FG, "Introduction, Question—the Book, Notes, Chapter Headings," "Chapter Headings and a Precis," 30.

486 "hypnotized expression": Ibid., n.p.

486 "I left her with Evie": "Notes from Felicia on the Will," RGMP.

486 "It's a queer thing": EMP to RRMcC, Aug. 1, 1946, RRMcCP. Emphasis in original.

486 "Bertie the Swipe's": EMP quoted in Smith, *The Colonel,* 45.

486 "most interesting man": FCW to Francis Biddle, Nov. 15, 1963, FCWP, Box 2, "Book: *McCormick of Chicago* Research, Midway Case, Charged with Espionage, 1942–64."

486 "In the dark hours": Waldrop, *McCormick of Chicago,* 163–64.

487 "Where did she"; "Don't these people"; "Why don't you": RRMcC, quoted in Martin, *Cissy,* 449.

488 "Maybe you don't feel"; "Once I *know*": EMP to RRMcC, Aug. 1, 1946, RRMcCP. Emphasis in original.

488 "the paper with the largest circulation": A. J. Liebling, "The Wayward Press," *New Yorker,* June 8, 1946, 90–98.

488 "this doggone D.D.T. poisoning": EMP to RRMcC, Sept. 7, 1946, RRMcCP.

488 "I would force myself"; "He did not want"; "All of these exaggerated reports": Ibid.

489 "goofy stories": Ibid.

489 "One day the movies"; "As newly elected chairman": Hartwell, "No Prissy Is Cissy," 21.

489 "These are not my immediate problems"; "I cannot help thinking": RRMcC to EMP, Sept. 9, 1946, RRMcCP.

489 "I was somewhat bewildered"; "You were possessed": EMP to RRMcC, July 2, 1948, FCWP, Box 25, "Topical File, Patterson, Eleanor, Research for Biography."

490 "not one but *two*": EMP to RRMcC, Feb. 8, 1946, RRMcCP.

490 "Some personal worries"; "an easier task": EMP to RRMcC, Feb. 15 (1947), telegram, RRMcCP.

490 "Mrs. Patterson's willingness": Hartwell, "No Prissy Is Cissy," 78.

491 "Washington is at its worst"; "As for Frank"; "it is a strain"; "He says 'you are anti-British' "; "Isn't Joe Pat doing?"; "I've seen him here"; "And that reminds me": ARL to RHMcC, April 10, [1944], HMFP, Box 138, F3, "Correspondence, Alice Roosevelt Longworth, 1912, 1927–28, 1937–44."

492 "I should have believed": ARL quoted by Adela Rogers St. Johns in Martin, *Cissy,* 294.

492 "I don't remember": EMP quoted by Adela Rogers St. Johns in ibid.

492 "exquisite profile": EMP to ARL, June 17, [1944], Joanna Sturm Papers, privately held.

493 "a lady unconscious"; "sat down together": Graham, *Personal History,* 62.

493 "If you are in this position": Eugene Meyer quoted in ibid., 62.

493 "get the two old rivals back together": The account of EMP's reconciliation with Eugene Meyer is drawn from Graham, *Personal History,* 164–65.

493 "one of the few people": Martin, *Cissy,* 444.

494 "terrible shock"; "at last got over the hump"; "I can't help feeling": EMP to RRMcC, May 17, 1947, RRMcCP.

494 "I have seen a judge": FCW, "Haunted House," fragment, n.d., FCWP, Box 6, "Writings," undated (2 of 2).

495 According to other accounts: On the hunt for Evalyn Walsh McLean's jewelry on April 26, 1947, see Edgar H. Brenner, "Thurman Arnold, the Hope Diamond and the Cigar Box," *Yale Law Report,* vol. 27, no. 2, Winter 1980–81, 10.

495 "When I got back after Evalyn's death": EMP to RRMcC, May 17, 1947, RRMcCP.

496 "I thought Tom": Ibid.

496 "Marty Mann was for a time"; "Well, that would be"; "if Marty were not": EMP to RRMcC, May 17, 1947, RRMcCP.

497 "awards in the fields"; "expose the Communist party": "VFW Warned Communism Is Real Danger," *WP,* June 16, 1947, 11.

497 "Enroute to Yale": FG to EPA, July 25, 1947, telegram, EPAP.

CISSY PATTERSON'S ANGRY MEMO TO M'CORMICK SPARKS WILL FIGHT

497 "In the name of God": EMP to RRMcC, July 2, 1948, 1, FCWP, Box 35, Topical File, "Patterson, Eleanor, Research for Biography."

498 "nothing to contribute"; "There you stood": Ibid.

498 "smart little cookie"; "principal heir": EMP to RRMcC, July 2, 1948, 1.

498 "share and share alike": EMP, will, June 21, 1946, 6, Accession #21/73/0013, Location #19–91–28–7–2, Box #26, District of Columbia Archives and Records Center, Washington, D.C.

498 "sue Bertie right out": EMP quoted in Waldrop, *McCormick of Chicago,* 64.

498 "You should realize": EMP to RRMcC, July 2, 1948. Emphasis in original.

499 abuzz with rumors of Mrs. Patterson's intention to make a new will: Dep. of SC at 230, *In re* Estate of Patterson, Admin. No. 71574 (D.D.C. Holding Prob. Ct. Jan. 24, 1949).

499 By many accounts: Healy, *Cissy,* 397.

499 "know when they were": ABS interview, n.d., n.p., transcribed tape recording, RGMP.

499 Michael Flynn, recalled: Healy, *Cissy,* 398.

499 Photographer Jackie Martin: Ibid., 396–97.

499 "She played one person": FCW interview, n.d., RGMP.

499 "When Evie acted up": WJT interview, n.p., n.d., RGMP.

499 "Cissy loved animals": ABS interview.

500 "Oh, look!": EMP quoted in Kay O. McCarter interview, transcribed tape recording, n.p., n.d., RGMP. A number of other staff members and guests remember the poodles' penchant for playing with toilet paper. See, for example, Veda Ward Marcantonio interview, transcribed tape recording, n.p., April 19, [1977?], RGMP.

500 "He bites me": EMP quoted in Martin, *Cissy,* 461.

500 Cissy summoned attorneys: Dep. of SC at 232, *In re* Estate of Patterson.

500 "Cissy Patterson recognized"; "was in fact": Oulihan, *Time* inter-office memorandum, n.d., RGMP.

500 Walter Trohan knew: WJT quoted in John M. Henshaw to DP, "personal and confidential memorandum," October 16, [1949], 1, DPP/LBJL, G210, 1 of 5, "Patterson, Cissy."

501 "outsmart all the others": WJT to JLM and RRMcC, Aug. 23, 1948, 1, RRMcCP.

502 "straight, an established man"; "family man": Marcantonio, interview, RGMP.

502 "he lived": Wade, interview, RGMP.

502 "remarkably good at doing it"; "to remain just": MSP, interview by PFH, n.d. (1964), transcribed tape recording, RGMP. Emphasis in original.

502 "a *colossal* nest egg"; "truly angry"; "This was the origin": Ibid.

503 "I guess I was one"; "What's this?"; "A subpoena"; "She simply dropped"; "That was the last": GA, interview by Paul Green, transcribed tape recording, n.p., n.d., RGMP.

504 "very, very tired": WJT to JLM and RRMcC, "Memo—Mrs. Patterson," Sept. 1, 1948, 1, RRMcCP.

504 "just . . . pack and leave": FCW, "An Appraisal," 37.

504 "an armful of books"; "shocked at the color": Emily Hoover Stafford interview, transcribed tape recording, n.p., n.d., RGMP.

504 She ordered her associate editor: WJT to JLM and RRMcC, "Memo—Mrs. Patterson," Sept. 1, 1948, 1, RRMcCP.

504 "Don't read it to me"; "I'm just too tired": EMP quoted in FCW, "An Appraisal," 37.

505 "a transvestite trapeze artist": William Lawson interview, transcribed tape recording, n.p., n.d., RGMP.

505 "never showed interest"; "superb mint juleps"; "a gentleman"; "close friends"; "the simplest": FCW, "An Appraisal," 36–37.

505 "in fine spirits": ABS interview, RGMP.

506 "set up a terrific howl": Eva Borowick quoted in WJT to JLM and RRMcC, "Memo—Mrs. Patterson," Sept. 1, 1948, 1, RRMcCP.

506 "Who spilt your milk?": Bea Brouchard quoted in Healy, *Cissy,* 383.

506 "Do you want": Archie Lye quoted in ibid.

506 "I felt that she": FCW, "An Appraisal," 38.

506 "standard answer": Julian Bach, Jr., interview, transcribed tape recording, n.p., n.d., RGMP.

506 "queer": FCW, "An Appraisal," 38.

506 "I think Mrs. Patterson": Archie Lye quoted in FCW, "An Appraisal," 38.

PART V: SEVEN DWARVES

MRS. E. M. PATTERSON, PUBLISHER, IS DEAD

509 "absolutely quiet": FCW, "An Appraisal," 39.

509 the entire party ventured tentatively into the master bedroom: Ibid., 40.

510 "almost paranoiac"; "a lonely old woman"; "under the power": Bach interview.

510 Inside the Dower House: FCW, "An Appraisal," 42.

510 "without preparation": Ibid.

511 "normal condition"; "papers partly in"; "indicated that it": Ibid.
511 "I will never forget"; "Mrs. Patterson isn't"; *"WHAT?!"*; "Mrs. Patterson is dead"; "I remember how silent"; "It was all": Bach interview. Emphasis in original.
512 "exposed, with all": Mrs. John Bolling (Rhoda Christmas), interview, n.p., n.d., RGMP.
512 "Should I come down?": FG quoted in FCW, "An Appraisal," 45.
512 "be after you": APG quoted in "Notes from Felicia on the Will."
512 "acute congestive": Maryland State Department of Health, Certificate of Death for Eleanor Medill Patterson, July 24, 1948, Maryland State Archives, Annapolis, Maryland.
513 "a complete secret": FCW, "An Appraisal," 45.
513 "stay with me"; "I want Mr. Townley"; "about ten years ago": FG quoted in ibid., 45.
513 "'This is a surprise'": RRMcC quoted in "Interview with Mrs. Robert McCormick," n.d., n.p., transcribed tape recording, RGMP.
513 "a terrible blow": RRMcC quoted in "Eleanor M. Patterson Is Dead at 63, Granddaughter of Joseph Medill," *CDT,* July 25, 1948, 2.
513 "a glint in his eye": "Interview with Mrs. Robert McCormick."
513 "I'm the last leaf"; "Cissy's dead": RRMcC quoted by ibid.; see also Hoge, *Cissy Patterson,* 227.
513 "We're not going": "Interview with Mrs. Robert McCormick."
514 "celebrating with champagne": Ibid.
514 "forbid removal": FCW, "An Appraisal," 47.
514 "spare Felicia": Ibid., 48.
515 "share and share alike": EMP, will, June 21, 1946, 6.
515 "When the terms"; "The excitement was": George Bookman to Robert Hagy, *Time* inter-office memorandum, July 30, 1948, 1.
515 "tell everybody": FCW, "An Appraisal," 48.
515 "Jesuit spellbinder"; "taken in": FG interview, transcribed tape recording, n.p., n.d., RGMP.
515 "in any capacity": FG quoted in FCW, "An Appraisal," 48.
515 "rather pointedly"; "leave the house": Ibid., 48.
516 "hardly 48 hours"; "to take up": FCW to Merlo Pusey, April 7, 1972, 2, FCWP, Box 24, "Topical File, Patterson, Eleanor, Death (1948–72)."
516 "Deeply affected"; "noncommittal in reaction": Ibid.
516 Bertie McCormick's machinations: Hoge, *Cissy Patterson,* 209.
516 "I do not know": RRMcC to J. M. Flynn, July 26, 1948, RRMcCP.

LAST RITES

516 "How do you say": FCW for "The Staff of the Washington *Times-Herald,*" "Eleanor Medill Patterson," *WT-H,* July 27, 1948, 10.
517 "Hundreds paused"; "flower-banked": "Private Rites Conducted for Mrs. Patterson," *CDT,* July 28, 1948, A2.
517 "threw himself": "Interview with Mrs. Robert McCormick."
517 "there are so many": RRMcC quoted in "The Press: Cissy," *Newsweek,* Aug. 2, 1948, 52.
517 "gasp": WJT interview.
518 "You have a keen"; "cross questioning": FG to EPA, Aug. 24 [1948], 1–2, FGP.
518 "after explicit invitation"; "greeted": FCW, "An Appraisal," 49.
518 "Congratulations": EPA quoted in FCW, "An Appraisal," 49.

518 "because you are": FCW, "An Appraisal," 49.

518 "simple Episcopal service": WJT interview.

518 "When the minister": Page Huidekoper Wilson interview, transcribed tape recording, n.p., April 20 [1976], RGMP.

518 "without tears": PG, "Some Notes after a Talk with Felicia," RGMP.

518 "There was very little"; "Everyone scattered": WJT interview.

519 "very convenient"; "there was no proving": FG, "Shaft," "Cissy—Will Contest," 6.

519 "Well, you don't": FCW interview.

519 "The cemetery chapel": "Final Tribute Paid to Eleanor M. Patterson," *CDT,* July 29, 1948, 20.

520 "Sign the will tonight"; "We'll take good care": JB quoted in FG, "Shaft," "Cissy—Will Contest," 8.

520 "Why should you"; "I have money": FG, "Shaft," "Cissy—Will Contest," 9.

521 "Thank God I was sober": Ibid., 9.

521 "Leave my things alone"; "I had no fear": EMP and FG quoted in "Some Notes After a Talk with Felicia."

LUCKY SEVEN

521 "proper provision"; "dispose"; "put to death": EMP, will, June 21, 1946, 2.

522 "share and share alike"; "business and publication": Ibid., 6.

523 "do any and all": Ibid.

525 "I am making no": Ibid., 17.

525 "fire away"; "Mrs. Patterson left": "It's full of vigor"; "For the moment": FCW quoted in "A Trust to Us," *WT-H,* July 30, 1948, 1.

525 Irving Belt . . . had taken to his bed: "Lucky Seven," *Time,* Aug. 9, 1948, 63.

525 "For once": FCW quoted in ibid.

525 "This might show": WRS quoted in "Lucky Seven."

525 "Oh, I'm not": MSP quoted in "Lucky Seven."

525 "I put the headlines"; "I smashed": MSP quoted in Notes from the *Time* morgue, n.d., RGMP.

THE DISINHERITED

526 "poor unfortunate": Notes from the *Time* morgue, RGMP.

526 "You will have seen": CBP to Michael Smith, n.d., quoted in Dep. of Campbell at 169, *In re* Estate of Patterson.

526 "Being of sound": Second Codicil to the Last Will and Testament of Eleanor Medill Patterson, May 29, 1947, 1, D.C. Probate Court Archive.

526 As his passport: The details and date stamps on Porter's passport and immigration documents were noted in the "Excerpt from Report of Investigation by P. B. Swiger, of the State Police of West Virginia," Sept. 1948, included among the official reports and documentation in Dep. of SC, *In re* Estate of Patterson.

526 "like some wound-up": Lee Wade, interview by Paul Green, transcribed tape recording, n.p., n.d., RGMP.

526 "very competent": Ibid.; "a nice old guy"; "a good man": Marcantonio interview, RGMP.

526 "really liked Porter": FCW interview.

527 "He was a fussy"; "Mrs. Patterson said": Ibid.

527 "didn't look like": Wade, interview.

527 "complaining bitterly": Dep. of Campbell at 124, *In re* Estate of Patterson.

527 "In 1947"; "he went away": Ibid., 115.

527 "a measure of safety": Harold Kertz interview, transcribed tape recording, n.p., April 13 [1976], RGMP.

528 "I think he just": "Just to where": FCW interview, RGMP.

528 she had accused him: Dep. of Campbell at 103, *In re* Estate of Patterson.

528 "wasn't the type"; "the guts"; "But indirectly": Kertz interview.

528 "more or less a haven": *WP*, Aug. 27, 1947, 10:4.

528 "to provide for": 62 Stat. 346, ch. 428, enacted June 9, 1948.

529 "wise indeed"; "E.P. was out"; "Her death stopped": CBP quoted in "Cissy 'Out to Destroy Me,' Porter Wrote to Friend," *NYS*, Sept. 27, 1948, 1.

529 "a lot of slander": CBP to RdeC, July 30, 1948, excerpted in "$500,000 Plot Charged in Patterson Will Case," *NYS*, Sept. 26, 1948, 3.

529 "relieved"; "E.P. would have": CBP quoted in "Cissy 'Out to Destroy Me,' " 1.

529 "Please keep"; "I might want": Ibid.

MRS. PATTERSON WILLS PROPERTY TO DAUGHTER

529 "that kind and good man": FG, "Shaft," "Cissy—Will Contest," 11.

530 "action an admission"; Judge Edward M. Curran: "Mrs. Patterson's Daughter Considers Contesting Will," *WP*, Aug. 3, 1948, 1.

530 "The fight was on": FG, "Shaft," "Cissy—Will Contest" 11.

530 It was Drew, hoping: Ibid.

530 "among thieves": FG to EPA, n.d. (July 1948), FGP.

531 "three-way problem"; "four-way problem": FCW to Merlo Pusey, April 7, 1972, 2, FCWP, Box 24, "Topical File, Patterson, Eleanor, Death (1948–72)."

531 "job prior to her": FCW to Richard Clarke, Aug. 20, 1948, 2, FCWP, Box 6, "Writings, 1933–57."

531 "I am, for all": FCW to JB, Aug. 6, 1948, 2, FCWP, Box 6, "Writings, 1933–57."

531 "something fishy"; "villainy": FG, "Shaft," "Cissy—Will Contest," 8.

531 "The thing that makes": FCW to JB, Aug. 6, 1948, 2.

532 "clear suggestion": Ibid.

532 "I KNOW in every way"; "right up to": Ibid. Emphasis in original.

532 "Drew got a young"; "so the boys": FG, "Shaft," "Cissy—Will Contest" 12.

532 Ducking her head: "Notes from Felicia on the Will."

532 "scattered through": Dep. of Campbell at 170, *In re* Estate of Patterson; U.S. District Court for the District of Columbia, see also Dep. of C. F. R. Ogilby at 35, *In re* Estate of Patterson, Admin. No. 71574, (D.D.C. Holding Prob. Ct. Nov. 12, 1948).

532 "Please deliver": Dep. of Ogilby at 37, *In re* Estate of Patterson.

533 "blunt but brainy": "Porter Fled Capital in 140-Mile Cab Ride," *NYS*, Oct. 3, 1948, 4.

533 "the house was falling": EMP quoted in Dep. of Campbell at 59, *In re* Estate of Patterson.

533 "a nice woman"; "As you see"; "she knew her job": FCW to RGM, Feb. 29, 1976, 2, FCWP, Box 26, "Magruder, Felicia, 1979."

533 "first-class melodrama"; "Washington housekeeper": Guy Richards, "3 Mysteries May Hold Key to Patterson Case," *NYS*, Oct. 6, 1948, 6.

533 "I told him": Dep. of Campbell at 171, *In re* Estate of Patterson.

533 "I guess it"; "I say": Ibid.

534 "I guess you're right": CBP quoted in ibid., 171.

534 "'There are so many'": CBP quoted in ibid., 173.

534 "sort of in a hurry": Ibid., 171.

534 "two friends of Mr. Porter": Ibid.

534 "sweet"; "PLEASE DO TAKE CARE": CBP to SC, Aug. 5, 1948, quoted in ibid., 175. Emphasis in original.

534 "a joy . . . to occupy": CBP to "the manager of the Kennedy-Warren," Aug. 5, 1948, quoted in ibid., 175. Emphasis in original.

534 "manifested an interest": RdeC quoted in "$500,000 Plot Charged in Patterson Will Case," *NYS*, Sept. 26, 1948, 3.

534 "He was my best friend"; "sure he was being"; "the Countess' every": RdeC quoted in "$500,000 Plot," 3.

536 "I fear for"; "There is a great deal": CBP quoted by RdeC quoted in "$500,000 Plot," 3.

536 "a man whose identity"; "spoke glibly of getting": CBP to RdeC in "$500,000 Plot," 3.

536 "They're going to try"; "This would be": CBP quoted in "$500,000 Plot," 3.

536 "As a British subject": Ibid.

537 "Well, I guess": Dep. of Campbell at 179, *In re* Estate of Patterson.

537 "What on earth": Ibid., 181.

537 "That will should be": Percy Duvall, interview transcript by Harry Costello for Drew Pearson, Upper Marlboro, Maryland, Aug. 13, 1948, DPP/LBJL.

537 "Judging by the editorials": "Soph O. Kleez" to Frank Waldrop, n.d. (Aug. 1948), FCWP, Box 26, "Pearson, Drew, 1938–70."

538 "This notice": "Executors Act to Probate Patterson Will," *WP*, Aug. 14, 1948, B1.

538 "blanket Washington"; "played the wise guy"; "valued too low"; "to force upping"; "make a clean up"; "I went along"; "Do not disclose"; "At our last": WJT to JLM and RRMcC, Aug. 23, 1948, RRMcCP.

539 "not to use": JLM to Miss Burke, Aug. 23, 1948, RRMcCP.

539 To Ellen she wrote: FG to EPA, Aug. 24, 1948, FGP.

539 Wheeler charged: FG to EPA, n.d. (Aug. 24, 1948), FGP.

540 "much good": FG to EPA, Aug. 24, 1948, FGP.

540 "yet": Ibid.

540 On Thursday, September 2: Louis Caldwell quoted in M. C. Martin to Howard Ellis, Kirkland, Fleming, Green, Martin & Ellis memorandum, Sept. 2, 1948, RRMcCP.

540 "It will be up"; "The heirs are waking up": WJT to JLM and RRMcC, Sept. 3, 1948, RRMcCP.

541 "Waldrop and his associates"; "very moderate"; "Pearson knows": RRMcC to Howard Ellis, Sept. 3, 1948, RRMcCP.

541 "running a war"; "It is one hell": WJT to JLM and RRMcC, Sept. 3, 1948, RRMcCP.

541 "just despondent": Dr. Carl Keyser quoted in Dep. of Campbell at 186, *In re* Estate of Patterson.

541 "seemed to be upset": Ibid., 187.

541 "often, especially": Ibid., 189.

542 "afraid"; "working with a key": CBP quoted in ibid., 205.

PORTER FLED CAPITAL IN 140-MILE CAB RIDE

542 Porter installing a double lock on his apartment door: Dep. of Ogilby at 111–12, *In re* Estate of Patterson, Admin. No. 71574 (D.D.C. Holding Prob. Ct. Nov. 9, 1948).

543 "unusually heavy": Junior Aylestock quoted in "The Last Days of C. B. Porter," *NYS*, Sept. 27, 1948, 3.

543 "clenching and unclenching"; "despite obvious distress": Anna Bowers quoted in "Porter Under Great Strain During Last Days of Life," *NYS*, Sept. 26, 1948, 4.

543 Although friends insisted: "Mystery Surrounds Suicide Leap," *Clarksburg Telegram*, Sept. 16, 1948, 8.

543 "as though he were": "Porter Under Great Strain," *NYS*, Sept. 26, 1948, 4.

543 "a crazy man in 612": Anna Bowers quoted in "The Last Days of C. B. Porter," 3.

543 "incessant" hand-wringing; "extremely nervous"; "in a big hurry": Irma Haddix quoted in "The Last Days of C. B. Porter," 3.

544 "I, Charles Bell Porter": CPB, unwitnessed holographic will, Sept. 10, 1948, supplementary documentation included in Dep. of Campbell at n.p. *In re* Estate of Patterson.

544 "When I asked him"; "Oh, he says": Dep. of Campbell at 204, Ibid.

544 "Will you go": Ibid., 200.

544 "C.B., I will do that": Ibid.

544 "I will please ask": CBP quoted in ibid.

544 "terrible storm"; "I did not know": Dep. of Campbell, 206.

545 "most sensational"; "ransacked": *Drew Pearson, Diaries 1949–1959*, ed. Tyler Abell (New York: Holt, Rinehart and Winston, 1974), 16.

545 "(1) Porter, a pansy"; "been milking"; "Unquestionably, Mrs. Campbell": Ibid., 17.

545 "I told Mr. Shelton": Dep. of Campbell at 189–90, *In re* Estate of Patterson.

545 "repeatedly asked her"; "Almost frantic": Louise Ash quoted in "The Last Days of C. B. Porter: Cissy's Aide Phoned Ex-Boss Before Leap," *NYS*, Sept. 28, 1948, 3.

546 "how things were going": Ibid.

546 "Mr. Porter called": Dep. of Campbell at 189–90, *In re* Estate of Patterson.

546 "occupant peering": James Lettridge quoted in "The Last Days of C. B. Porter," *NYS*, Sept. 28, 1948, 3.

546 "You certainly put": Dep. of Campbell at 190, *In re* Estate of Patterson.

546 "I tried": CBP quoted in Guy Richards, "Curtain Ready to Lift on Patterson Will Drama," *NYS*, Sunday, Oct. 10, 1948, 17.

546 "beginning to snap": Father Rizer quoted in ibid.

546 "a little afraid"; "something peculiar": Anna Bowers quoted in "The Last Days of C. B. Porter," *NYS*, Sept. 28, 1948, 3.

546 "I don't know": CBP quoted by Anna Bowers in ibid., 3.

CLAIMS COERCION

547 After working as secretary: "Funeral to Be Held Tomorrow for Betty Hynes," *WT-H*, Sept. 15, 1948, 8.

548 "extremely upset"; "receiving constant visits": Guy Richards, "3 Mysteries Hold Key to Patterson Case," *NYS*, Oct. 6, 1948, 6.

548 "natural causes": "Funeral to Be Held Tomorrow," 8.

548 "three empty": Richards, "3 Mysteries," 8.

548 After the removal: Martin, *Cissy,* 471.

548 "No, everything looks nice": CBP quoted by Anna Bowers in "The Last Days of C. B. Porter: Cissy's Aide Phoned Ex-Boss Before Leap," *NYS,* Sept. 28, 1948, 3.

548 Some minutes after: Sergeant W. E. Murphy, State of West Virginia Department of Public Safety Report of Investigation, Detachment File Number C-1216, Sept. 21, 1948, 1, supplementary documentation included in Dep. of Sydney Epstein, *In re* Estate of Patterson, Admin. No. 71574 (D.D.C. Holding Prob. Ct. Nov. 9, 1948).

549 At around 3:40: An extensive description of the scene, as well as eyewitness accounts of Porter's death, appear in both "Cissy Patteson's Ex-Employee Ends His Life in Six Floor Plunge," *Clarksburg Exponent,* Sept. 15, 1948, 1–2, and "Porter Under Great Strain During Last Days of Life," *NYS,* Sunday, Sept. 26, 1948, 4.

MYSTERY SURROUNDS SUICIDE LEAP

550 "about 18 pairs": "The Last Days of C.B. Porter," *NYS,* Sept. 28, 1948, 3.

550 "He told me"; "and that I": SC quoted in "Cissy's Housekeeper Named in Ex-Treasurer's Unsigned Will," *NYS,* Sept. 21, 1948, 3.

550 "very cryptic"; "one of which was filled": SE interview, transcribed tape recording, n.p., March 24, 1974, RGMP.

550 "Get the damned suitcase": MSP quoted in SE interview.

551 "Get on the phone": Ibid.

551 "Mr. Barber has my": SC to Clarksburg authorities, Sept. 14, 1948, quoted in Dep. of Campbell at 221–22, *In re* Estate of Patterson.

552 The *Exponent's* reporters had even been so brazen: Dep. of John T. Barber at 63, *In re:* Estate of Patterson, Admin. No. 71574 (D.D.C. Holding Prob. Ct. Nov. 9, 1948), RGMP.

553 the two men took the surprising step: Dep. of Epstein at 71, *In re* Estate of Patterson.

553 "refreshments"; "everyone in Clarksburg": Ibid., 70.

553 "stuck them under": Dep. of Campbell at 74, *In re* Estate of Patterson.

553 "I had to get down there"; "When you want": Dep. of Epstein at 27–28, *In re* Estate of Patterson.

553 "called the guys": SE interview.

553 "maybe 6 out of 7"; "all seven of 'em"; "They knew": Ibid.

554 "I ring the bell": Ibid.

554 "the eight of us": Ibid.

554 "they were simply"; "None of them"; "it seemed illegal": Ibid.

555 "Washington Merry-Go-Round" sources: Abell, ed., *Drew Pearson Diaries,* 17.

555 "Apparently some people"; "strange indeed": DP quoted in "Mystery Surrounds Suicide Leap," *Clarksburg Telegram,* final edition, Thursday evening, Sept. 16, 1948, 8.

556 "my two *principal witnesses*": FG, "Shaft," 12. Emphasis in original.

556 "sure Porter was murdered": RdeC quoted in "$500,000 Plot," *NYS,* Sept. 26, 1948, 3.

556 "when Porter hit": Abell, ed., *Drew Pearson Diaries,* 17.

556 "I don't know why"; "maybe Bill Shelton did": FCW, interview, RGMP.

557 "Police call it": "The Last Days of C. B. Porter," 3.

MYSTERY TRUNK HUNTED IN PATTERSON WILL CASE

557 In addition to a number: The long enumeration of the folders and documentary material contained in Porter's coveted Army trunk comes from C. F. R. Ogilby's depositions on the subject, which, because of the extensive amount of information he related, took place in three installments over the course of the week of Nov. 8–12, 1948. Dep. of Ogilby at 36–116.

559 "some impartial individual": FG quoted in "Seeks Seizure of Hotel Leap Victim's Papers," *CDT,* Sept. 17, 1948, 23.

560 "kept in Evie Robert's apartment"; "they were in an awful": Abell, ed., *Drew Pearson Diaries,* 17.

560 "the victim was": Trooper P. B. Swiger, State of West Virginia Department of Public Safety Report of Investigation, Detachment File Number C-1216, Sept. 19, 1948, 1.

560 "plain case of suicide"; "under a terrible"; "in fear of anyone": Sergeant W. E. Murphy, State of West Virginia Department of Public Safety Report of Investigation, Detachment File Number C-1216, 1.

561 "the deepest affection": FCW and WRS quoted in *"Happy to Serve:* Mrs. Patterson's Niece Joins Trustees Under Aunt's Will," *WT-H,* Sept. 22, 1948, 1.

561 "most happy"; "I shall support": APG quoted in "Happy to Serve," *WT-H,* Sept. 22, 1948, 1–2.

561 "It is tragic"; "I think Felicia"; "the only excuse": APG to FCW, March 22, 1949, 1, FCWP, Box 9, "Correspondence, 1949."

THICKENING PLOT

562 "I had no friend"; "The only thing"; "It is all": FG quoted in "Ransack Apt. of Cissy's Kin," *NYS,* Oct. 19, 1948, 4.

562 concluded that: Guy Richards, "Cissy's Daughter Probes Ransacking," *NYS,* Oct. 20, 1948, 12.

562 "I am an American"; "If I had my way": FG quoted in ibid.

563 "Make no mistake"; "We're extremely": FCW quoted in "Porter Fled Capital," 4.

563 Her investigative team retaliated by trumpeting: William E. Leahy quoted in Murray Marder, "Late Publisher's Daughter Must Specify Papers She Seeks for Evidence," *WP,* Nov. 2, 1948, B1.

563 "ebb and flow": "Patterson Papers Order to Be Asked," *WP,* Oct. 31, 1948, M11.

564 In the earliest: EMP, will, Jan. 11, 1924, Accession #21/73/0013, Location #19–91–28–7–2, Box #26, District of Columbia Archives and Records Center, Washington, D.C., 1.

564 "in equal shares": EMP, will, Jan. 11, 1924, 3.

564 "from participation": EMP, will, Dec. 31, 1942, Accession #21/73/0013, Location #19–91–28–7–2, Box #26, District of Columbia Archives and Records Center, Washington, D.C., 4.

564 "disposed of": Ibid., 10.

566 "paroxysmal hypoglycemia": "Mrs. Gizycka's Questioning on Will Postponed," *WP,* Nov. 23, 1948, 26.

567 Felicia's own belief: FG, "Shaft," "Cissy—Will Contest," 13; see also Abell, ed., *Drew Pearson Diaries,* 16.

568 "I would secure": FG quoted in "Mrs. Gizycka Indicates Eagerness to Operate the Times-Herald If She Breaks Mother's Will," *WP,* Dec. 3, 1948, 19.

568 "the Countess threw": WJT to JLM and RRMcC, Jan. 17, 1949, RRMcCP.

MRS. GIZYCKA "FROZEN OUT," LAWYER SAYS

569 "sex parties"; "acts of lesbianism"; "dummies": Kertz interview.

569 "There are so many lies": ABS interview.

569 "Dower House saw"; "just lots of drinking"; "a great streak": Page Huidekoper Wilson interview, RGMP.

569 "I didn't want": FG, "Shaft," 14.

570 "conservatively"; "Federal taxes alone"; "deprived": William A. Roberts quoted in "Mrs. Gizycka 'Frozen Out,' Lawyers Say," *WP,* Jan. 15, 1949.

570 "more concerned": Kertz interview.

570 "the juiciest, most lurid": Oulihan, notes from the *Time* morgue, n.d. [Jan. 1949], RGMP.

570 "perversions"; "Felicia never categorically"; "but *they* had circumstantial": Kertz interview.

570 "We must overcome": MM quoted in "She Crusades Against Alcoholism," *New York World-Telegram,* n.d. (Jan. 1945), MMP, box 14, "Obituaries."

571 "Marty's use of the title"; MM and Priscilla Peck: Brown and Brown, *Biography of Mrs. Marty Mann,* 145.

571 As Fire Island developed: Ibid., 225.

571 "My friends and my sponsors": FG, "Shaft," 8.

572 "16 to 18 hours": Kertz interview.

572 "high dudgeon": Abell, ed., *Drew Pearson Diaries,* 15.

573 "Washington could hardly"; "It promised": "The Countess' Cut," *Time,* Feb. 7, 1949, 59.

573 "The settlement was"; "By giving up"; "except maybe the press": Oulihan, notes from the *Time* morgue, n.d. (Jan. 1949), RGMP.

573 "Congratulations!"; "Better late": WJT to FCW, Jan. 29, 1949, 1, FCWP, Box 9, "Correspondence, 1949."

573 "executed and attested": U.S. District Court for the District of Columbia, Order Aligning Parties *In Re: Eleanor Patterson, Deceased,* Case No. 71574, NARA, RG 21, office of Register of Will, Probate Court Proceedings, 1801–1966, vol. 183, 164–65.

574 "sound and disposing": Ibid.

574 "the loneliness": FG, "Shaft," 14.

574 "I took up my life": Ibid., 15.

EPILOGUE

575 "the companions of my work"; "scattered in country clubs": FCW, untitled, type-script, n.d., FCWP, Box 6, "Writings, Undated (2 of 2)."

575 "A funny thing"; "the memory of her": Marcantonio interview.

575 "Strange, but often": CJM to FCW, April 18, 1949, FCWP, Box 9, "Correspondence, 1949." Ellipses original.

576 "You have no idea"; "Even the feuds": FCW to Phelps Adams, August 14, 1950, 1, FCWP, Box 9, "Correspondence, 1949."

577 During an interview: "Some Notes After a Talk with Felicia."

577 "pushing itself"; "nearly out of her wits": FG quoted in "Some Notes After a Talk with Felicia."

577 "Every day"; "Life, including some ups and downs": [FG], "Stars Don't Fall," 417.

577 "writing this book": FG, "Shaft," 16.

577 "I do forgive her": Ibid., 15.

578 "prescription for a healthy newspaper": "Mrs. E. M. Patterson, Publisher, Is Dead," *NYT,* July 25, 1948, 49.

578 1948 circulation figures: J. Percy Johnson, ed., *N. W. Ayer & Son's Directory: Newspapers and Periodicals 1948* (Philadelphia: N. W. Ayer & Sons, 1948), 160.

578 *Washington Star* circulation: Ibid., 160.

579 *WP* circulation: Ibid., 159.

579 "When she died"; "Certainly, for all its apparent vigor": FCW, "Capital Reading: A Guidebook to Cissy Patterson," *WP,* May 14, 1966, A16.

579 "If you cannot find": EMP quoted in FCW, unpublished outline for a biography of EMP, FCWP, Box 25, "Topical File, Patterson, Eleanor, Research for Biography."

580 "If you try": Ibid.

BIBLIOGRAPHY

PRIMARY SOURCES

The papers of Ellen Pearson Arnold, privately held, San Diego, CA.

The Thurman Arnold papers, American Heritage Center, University of Wyoming, Laramie, WY.

The John Boettiger papers, Franklin Delano Roosevelt Library, Hyde Park, NY.

The Brisbane Family Papers, including the papers of Artur Brisbane, George Arents Research Library for Special Collections, Syracuse University, Syracuse, NY.

The Russian Imperial Chancellery for Receipt of Petitions findings, rulings, and correspondence on the Gizycki family, Fond 1412, Inventory 215, File 32, *Rossiiskii Gosudarstvennyi Istoricheskii Arkhiv,* St. Petersburg, Russia.

The Kenneth Colegrove papers, Herbert Hoover Presidential Library and Museum, West Branch, IA.

The Robert S. Considine Papers, George Arents Research Library for Special Collections, Syracuse University, Syracuse, NY.

The papers of Ernest Cuneo, Franklin Delano Roosevelt Library, Hyde Park, NY.

The papers of Stephen T. Early, Franklin Delano Roosevelt Library, Hyde Park, NY.

Redacted Official and Confidential Files of the Federal Bureau of Investigation relating to Eleanor Medill Patterson, Frank Campbell Waldrop, the Washington *Times-Herald,* and Mrs. Paul Fejos, Washington, DC.

The correspondence, papers, and autobiographical manuscripts of Countess Felicia Gizycka, privately held, San Diego, CA.

The Hanna-McCormick Family Papers, including the papers of Senator Joseph Medill McCormick and Ruth Hanna McCormick Simms, Library of Congress, Washington, DC.

The papers of William Randolph Hearst, Bancroft Library, University of California, Berkeley.

The papers of Bourke B. Hinkenlooper, Herbert Hoover Presidential Library and Museum, West Branch, IA.

Jackson Hole Historical Society and Museum files, photographs, interview transcripts, and other historical materials concerning Eleanor Medill Patterson, Cal Carrington, Felicia Gizycka, Rose and Henry Crabtree, Bar BC Ranch, and Flat Creek Ranch, Jackson Hole, WY.

The papers of Joseph P. Kennedy, John F. Kennedy Library, Boston, MA.

The papers of Rose Fitzgerald Kennedy, John F. Kennedy Library, Boston, MA.

The papers of Alice Roosevelt Longworth, Library of Congress, Washington, DC.

The papers of Isidor Lubin, Franklin Delano Roosevelt Library, Hyde Park, NY.

The papers of Mrs. Marty Mann, George Arents Research Library for Special Collections, Syracuse University, Syracuse, NY.

The Cecilia "Jackie" Martin Papers, George Arents Research Library for Special Collections, Syracuse University, Syracuse, NY.

The Ralph G. Martin Papers, Howard Gotlieb Archival Research Center, Boston University, Boston, MA.

The papers of Colonel Robert Rutherford McCormick, Colonel Robert Rutherford McCormick Research Center of the First Division Museum at Cantigny, Wheaton, IL.

The Eleanor Medill Patterson Papers, George Arents Research Library for Special Collections, Syracuse University, Syracuse, NY.

The Joseph Medill Patterson Papers, including the Patterson Family Papers, Donnelley Library, Lake Forest College, Lake Forest, IL.

The papers and diaries of Drew Pearson, Lyndon Baines Johnson Presidential Library, University of Texas, Austin, TX.

The Drew Pearson "Washington Merry-Go-Round" Broadcasts Collection, American University Library, Washington, DC.

The press releases of Drew Pearson, George Arents Research Library for Special Collections, Syracuse University, Syracuse, NY.

The papers of Westbrook Pegler, Herbert Hoover Presidential Library and Museum, West Branch, IA.

The papers of Anna Eleanor Roosevelt, Franklin Delano Roosevelt Library, Hyde Park, NY.

The papers of Franklin Delano Roosevelt, including the President's Personal File, the President's Official File, the President's Secretary's File, and Papers as Assistant Secretary of the Navy, Franklin Delano Roosevelt Library, Hyde Park, NY.

The papers of Louis L. Strauss, Herbert Hoover Presidential Library and Museum, West Branch, IA.

The Papers of Herbert Bayard Swope, Howard Gotlieb Archival Research Center at Boston University, Boston, MA.

Records of the United States Court of Appeals for the District of Columbia, Record Group 276, National Archives, Washington, DC.

Records of the United States District Court for the District of Columbia, Record Group 21, National Archives, Washington, DC, and College Park, MD.

Records of the United States District Court for the District of Columbia Office of Register of Wills, Probate Court Proceedings 1801–1966, Record Group 21, Probate Court Archives and Records Center, Washington, DC.

Records of the United States Legation and Embassy in Vienna, Austria, and St. Petersburg, Russia, Record Group 59, National Archives, College Park, MD.

The papers of Frank C. Waldrop, Herbert Hoover Presidential Library and Museum, West Branch, IA.

<div align="center">INTERVIEWS</div>

Tyler Abell, November 1, 2005.

Alice Arlen, November 22, 2005.

Ellen Pearson Arnold, November 11–12, 2004; October 27, 2005; and September 14, 2006.

Frida Burling, February 15, 2005.

Oleg Cassini, November 23, 2005.

Eugene V. Downer, September 18, 2006.

Andrew C. Waldrop, February 11, 2005.

Page Huidekoper Wilson, September 14, 2004.

ORAL HISTORIES

Allen, Robert S., Herbert Hoover Presidential Library and Museum, West Branch, IA.

Carrington, Cal (Enoch Julin), Jackson Hole Historical Society and Museum, Jackson Hole, WY.

Considine, Robert B., Herbert Hoover Presidential Library and Museum, West Branch, IA.

PUBLISHED WORKS

Abell, Tyler, ed. *Drew Pearson Diaries, 1949–1959.* New York: Holt, Reinhart and Winston, 1974.

Adler, Selig. *The Isolationist Impulse: Its Twentieth-Century Reaction.* New York: The Free Press, 1957.

———. *The Uncertain Giant, 1921–1941: American Foreign Policy Between the Wars.* New York: Collier Books, 1965.

Aldrich, Nelson W., Jr. *Old Money: The Mythology of Wealth in America.* New York: Allworth Press, 1996.

Alsop, Joseph, and Robert Kintner. *American White Paper: The Story of American Diplomacy and the Second World War.* New York: Simon & Schuster, 1940.

Alsop, Joseph W., with Adam Platt. *"I've Seen the Best of It": Memoirs.* New York: W. W. Norton, 1992.

Amelekhina, Svetlana A., and Alexey K. Levykin. *The Magnificence of the Tsars: Ceremonial Men's Dress of the Russian Imperial Court, 1721–1917.* London: V&A Publishing, 2008.

Amory, Cleveland. *International Celebrity Register.* New York: Celebrity Register, 1959.

———. *The Last Resorts.* New York: Universal Library, 1952.

———. *Who Killed Society?* New York: Harper Brothers, 1960.

Anderson, Douglas A. *A "Washington Merry-Go-Round" of Libel Actions.* Chicago: Nelson-Hall, 1980.

Anderson, Jack, with James Boyd. *Confessions of a Muckraker: The Inside Story of Life in Washington during the Truman, Eisenhower, Kennedy, and Johnson Years.* New York: Random House, 1979.

Andrews, Wayne. *Battle for Chicago.* New York: Harcourt, Brace and Company, 1946.

Ascher, Abraham. *The Revolution of 1905: A Short History.* Stanford: Stanford University Press, 2004.

Auchincloss, Louis. *The Vanderbilt Era: Profiles of a Gilded Age.* New York: Charles Scribner's Sons, 1989.

Bair, Deirdre. *Jung: A Biography.* New York: Back Bay, 2003.

Balsan, Consuelo Vanderbilt. *The Glitter & the Gold.* Maidstone, Kent: George Mann Books, 1973.

Barnett, Correlli. *Hitler's Generals.* New York: Quill, 1989.

Beard, Charles Austin. *President Roosevelt and the Coming of War, 1941.* New Haven, CT: Yale University Press, 1948.

Beaver, Daniel R. *Newton D. Baker and the American War Effort, 1917–1919.* Lincoln: University of Nebraska Press, 1966.

Becker, Seymour. *Nobility and Privilege in Late Imperial Russia.* DeKalb: Northern Illinois University Press, 1985.

Berbova, Nina. *Moura: The Dangerous Life of the Baroness Budberg.* Translated by Marian Schwartz and Richard D. Sylvester. New York: New York Review Books, 2005.

Berg, A. Scott. *Lindbergh.* New York: G. P. Putnam's Sons, 1998.

Berlin, Isaiah. *The Proper Study of Mankind: An Anthology of Essays.* New York: Farrar, Straus and Giroux, 2000.

Beschloss, Michael R. *Kennedy and Roosevelt: The Uneasy Alliance.* New York: Norton, 1980.

Beveridge, Catherine Eddy. *An American Girl Travels into the Twentieth Century: The Chronicle of Catherine Eddy Beveridge.* Latham, MD: Hamilton Books, 2005.

Blobaum, Robert E. *Rewolucja: Russian Poland, 1904–1907.* Ithaca, NY: Cornell University Press, 1995.

Blum, John Morton. *From the Morgenthau Diaries.* Boston: Houghton Mifflin, 1959.

Blumberg, Arnold. *Great Leaders, Great Tyrants?: Contemporary Views of World Rulers Who Made History.* Westport, CT: Greenwood Press, 1995.

Bordewich, Fergus. *Washington: The Making of the American Capital.* New York: Amistad, 2008.

Bourne, Richard. *Lords of Fleet Street: The Harmsworth Dynasty.* London: Unwin Hyman, 1990.

Braudy, Leo. *The Frenzy of Renown: Fame and Its History.* New York: Vintage Books, 1997.

Brinkley, Alan. *The Publisher: Henry Luce and His American Century.* New York: Alfred A. Knopf, 2010.

Brinkley, David. *Washington Goes to War.* New York: Ballantine Books, 1988.

Brown, Sally, and David R. Brown. *A Biography of Mrs. Marty Mann: The First Lady of Alcoholics Anonymous.* Center City, MN: Hazelden, 2001.

Brownell, Will, and Richard N. Billings. *So Close to Greatness: A Biography of William C. Bullitt.* New York: Macmillan, 1987.

Budberg, Baron Michael. *Russian Seesaw.* London: Martin Hopkinson, 1934.

Burling, Frida. *Finally Frida.* Chevy Chase, MD: Prosperity Press, 2004.

Burnett, Whit, and Hallie Burnett, eds. *Story: The Fiction of the Forties.* New York: E. P. Dutton, 1949.

Burns, James MacGregor. *Roosevelt: The Lion and the Fox.* Norwalk, CT.: Easton Press, 1989.

Burt, Nathaniel. *Jackson Hole Journal.* Norman: University of Oklahoma Press, 1983.

Bushman, Richard L. *The Refinement of America: Persons, Houses, Cities.* New York: Vintage, 1993.

Caldwell, Mark. *A Short History of Rudeness: Manners, Morals, and Misbehavior in Modern America.* New York: Picador USA, 1999.

Cannadine, David. *Aspects of Aristocracy: Grandeur and Decline in Modern Britain.* New Haven, CT: Yale University Press, 1994.

Cantacuzène, Princess Julia, Countess Spéransky, née Grant. *My Life Here and There.* New York: Charles Scribner's Sons, 1921.

———. *Revolutionary Days.* Chicago: Lakeside Press, 1999. First published by Small, Maynard & Company, Boston, 1919.

Carlson, Oliver. *Brisbane: A Candid Biography.* New York: Stackpole Sons, 1937.

Cassini, Countess Marguerite. *Never a Dull Moment: The Memoirs of Countess Marguerite Cassini.* New York: Harper & Brothers, 1956.

Cassini, Oleg. *In My Own Fashion: An Autobiography.* New York: Pocket Books, 1987.

Chaney, Lindsay, and Michael Cieply. *The Hearsts: Family and Empire—The Later Years.* New York: Simon & Schuster, 1981.

Chapman, John. *Tell It to Sweeney: The Informal History of the New York Daily News.* Garden City, NY: Doubleday, 1961.

Chavchavadze, David. *The Grand Dukes.* New Delhi: Atlantic International Publications, 1989.

Chernow, Ron. *The House of Morgan: An American Banking Family and the Rise of Modern Finance.* New York: Touchstone, 1990.

Claridge, Laura. *Emily Post: Daughter of the Gilded Age, Mistress of American Manners.* New York: Random House, 2008.

Coit, Margaret L. *Mr. Baruch.* Boston: Houghton Mifflin, 1957.

Colman, Elizabeth Wheeler. *Mrs. Wheeler Goes to Washington.* Helena, MT: Falcon Press Publishing Co., 1989.

Conant, Jennet. *The Irregulars: Roald Dahl and the British Spy Ring in Wartime Washington.* New York: Simon & Schuster, 2008

Considine, Bob. *It's All News to Me: A Reporter's Deposition.* New York: Meredith Press, 1967.

Considine, Milly, and Ruth Pool. *Wills: A Dead Giveaway.* Garden City, NY: Doubleday, 1974.

Cook, Blanche Wiesen. *Eleanor Roosevelt, Vol. I: 1884–1933.* New York: Penguin, 1992.

Coontz, Stephanie. *Marriage: A History.* New York: Viking, 2005.

Cordery, Stacy A. *Alice: Alice Roosevelt Longworth, from White House Princess to Washington Power Broker.* New York: Viking, 2007.

Coventry, Kim, Daniel Meyer, and Arthur H. Miller. *Classic Country Estates of Lake Forest: Architecture and Landscape Design, 1856–1940.* New York: W. W. Norton, 2003.

Dallek, Robert. *Franklin D. Roosevelt and American Foreign Policy, 1932–1945.* New York: Oxford University Press, 1995.

Daniels, Elizabeth A. *Bridges to the World: Henry Noble McCracken and Vassar College.* Clinton Corners, NY: College Avenue Press, 1994.

Daniels, Jonathan. *The End of Innocence.* New York: Da Capo Press, 1954.

———. *Washington Quadrille: The Dance Beside the Documents.* Garden City, NY: Doubleday, 1968.

Davies, Marion. *The Times We Had: Life with William Randolph Hearst.* New York: Ballantine Books, 1975.

Davis, Kenneth S. *FDR: The Beckoning of Destiny, 1882–1928: A History.* New York: Random House, 1972.

———. *FDR: Into the Storm, 1937–1940.* New York: Random House, 1993.

Dayton, Katherine, and George S. Kaufman. *First Lady: A Play in Three Acts.* New York: Random House, 1935.

Dearborn, Mary V. *Queen of Bohemia: The Life of Louise Bryant.* Boston: Houghton Mifflin, 1996.

DeBare, Ilana. *Where Girls Come First: The Rise, Fall, and Surprising Revival of Girls' Schools.* New York: Jeremy P. Tarcher, 2005.

De Bedts, Ralph F. *Ambassador Joseph Kennedy 1938–1940: An Anatomy of Appeasement.* New York: P. Lang, 1985.

———. *The New Deal's SEC: The Formative Years.* New York: Columbia University Press, 1964.

De Mowbray, Stephen. *Key Facts in Soviet History.* London: Printer Publishers in association with J. Spiers, 1990.

Dixon, George. *Leaning on a Column.* New York: J. B. Lippincott, 1961.

Doenecke, Justus D. *Storm on the Horizon: The Challenge to American Intervention, 1939–1941.* New York: Rowman & Littlefield, 2003.

———, and John E. Wilz. *From Isolation to War, 1931–1941,* 3rd ed. Wheeling, IL: Harlan Davidson, 2003.

Doerries, Reinhard R. *Imperial Challenge: Ambassador Count Bernstorff and German-American Relations, 1908–1917.* Chapel Hill: University of North Carolina Press, 1989.

Donald, David Herbert. *Lincoln.* New York: Simon & Schuster Paperbacks, 1995.

Douglas, George H. *The Golden Age of the Newspaper.* Westport, CT: Greenwood, 1999.

Drewry, John E., ed. *Post Biographies of Famous Journalists.* Athens: University of Georgia Press, 1942.

Duffey, Mrs. E. B. *The Ladies' and Gentlemen's Etiquette: A Complete Manual of the Manners and Dress of American Society.* Philadelphia: Porter and Coates, 1877.

Dwyer, Michael. *Images of America: Montgomery County.* Charleston, SC: Arcadia Publishing, 2006.

Edwards, Jerome E. *The Foreign Policy of Col. McCormick's Tribune, 1929–1941.* Reno: University of Nevada Press, 1971.

Elson, Robert T. *TIME Inc.: The Intimate History of a Publishing Enterprise, 1923–41.* New York: Atheneum, 1968.

Engel, Barbara Alpern. "Marriage and Masculinity in Late-Imperial Russia: The Hard Cases." In *Russian Masculinities in History and Culture.* Edited by Barbara Evans Clements, Rebecca Friedman, Dan Healey. New York: Palgrave, 2002, 113–130.

Epstein, Joseph. *Snobbery: The American Version.* Boston: Houghton Mifflin, 2002.

Eubank, Keith, ed. *World War II: Roots and Causes.* Lexington, MA: D.C. Heath and Co., 1975.

Faber, Toby. *Fabergé's Eggs: The Extraordinary Story of the Masterpieces That Outlived an Empire.* New York: Random House, 2008.

Farago, Ladislas. *The Game of Foxes: The Untold Story of German Espionage in the United States and Great Britain during World War II.* New York: David McKay Company, 1971.

Felsenthal, Carol. *Princess Alice: The Life and Times of Alice Roosevelt Longworth.* New York: St. Martin's, 1988.

Fisher, Charles. *The Columnists: A Surgical Survey.* New York: Howell, Soskin, 1944.

Fitzgerald, F. Scott. *This Side of Paradise.* New York: Mass Market Paperback Edition, 2005.

Fleming, Thomas. *The New Dealers' War: FDR and the War within World War II.* New York: Basic Books, 2001.

Frank, Alison Fleig. *Oil Empire: Visions of Prosperity in Austrian Galicia.* Cambridge, MA: Harvard University Press, 2005.

Frankfurter, Felix, and Joseph P. Lash. *From the Diaries of Felix Frankfurter.* New York: W. W. Norton & Co., 1975.

Freidel, Frank Burt. *Franklin D. Roosevelt: A Rendezvous with Destiny.* Boston: Little, Brown, 1990.

Fugger, Nora. *The Glory of the Habsburgs: The Memoirs of the Princess Fugger.* New York: Dial Press, 1932.

Gabler, Neal. *Winchell: Gossip, Power, and the Culture of Celebrity.* New York: Alfred A. Knopf, 1994.

Gardner, Virginia. *"Friend and Lover": The Life of Louise Bryant.* New York: Horizon Press, 1982.

Garraty, John Arthur. *The American Nation: A History of the United States,* 5th ed. New York: Harper & Row, 1983.

Gellman, Irwin F. *Secret Affairs: Franklin Roosevelt, Cordell Hull, and Sumner Welles.* Baltimore: Johns Hopkins University Press, 1995.

Gentry, Curt. *J. Edgar Hoover: The Man and the Secrets.* New York: Norton, 1991.

Gilbert, Martin. *A History of the Twentieth Century,* Volume 1: *1900–1933.* New York: William Morrow, 1997.

———, and Richard Gott. *The Appeasers.* Boston: Houghton Mifflin, 1963.

Gizycka, Eleanor. *Fall Flight.* New York: Minton, Balch & Company, 1928.

————. *Glass Houses.* New York: Minton, Balch & Company, 1926.

Gizycka, Felicia. *Flower of Smoke.* New York: Charles Scribner's Sons, 1939.

————. *The House of Violence.* New York: Charles Scribner's Sons, 1932.

[————.] "Stars Don't Fall." In *Alcoholics Anonymous,* 3rd ed. New York: Alcoholics Anonymous World Services, 1976, 400–17.

Gies, Joseph. *The Colonel of Chicago.* New York: E. P. Dutton, 1979.

Goodwin, Doris Kearns. *The Fitzgeralds and the Kennedys.* New York: Simon & Schuster, 1986.

————. *No Ordinary Time: Franklin and Eleanor Roosevelt: The Home Front in World War II.* New York: Simon & Schuster, 1994.

Graham, Katharine. *Personal History.* New York: Vintage, 1998.

Grant, Julia. *Raising Baby by the Book: The Education of American Mothers.* New Haven, CT: Yale University Press, 1998.

Gray, Francine du Plessix. *Them.* New York: Penguin, 2005.

Green, Walter Cox. *The Book of Good Manners: A Guide to Polite Usage for All Social Functions.* Charleston, SC: Bibliobazaar, 2008. First published 1904 by Social Mentor Publications, New York.

Greenfield, Meg. *Washington.* New York: Public Affairs Books, 2001.

Grenville, J. A. S. *A History of the World in the Twentieth Century.* Cambridge, MA: Belknap Press, 1997.

Gressley, Gene M. *Voltaire and the Cowboy: The Letters of Thurman Arnold.* Boulder: Colorado Associated University Press, 1977.

Gunther, John. *Inside USA.* New York: Harper Brothers, 1947.

Gutheim, Frederick, and Antoinette J. Lee. *Worthy of the Nation: Washington, DC, from L'Enfant to the National Capital Planning Commission,* 2nd ed. Baltimore: Johns Hopkins University Press, 2006.

Habe, Hans. *The Countess.* New York: Signet Books, 1962.

Hall, Coryne. *Little Mother of Russia: A Biography of Empress Marie Feodorovna.* Teaneck, NJ: Holmes & Meier, 1999.

Hamilton, Nigel. *JFK: Reckless Youth.* New York: Random House, 1992.

Handlin, Oscar. *Al Smith and His America.* Boston: Atlantic Monthly–Little, Brown, 1958.

Harcave, Sidney, trans. and ed. *The Memoirs of Count Witte.* Armonk, NY: M. E. Sharpe, 1990.

Hardy, Henry, ed. *Isaiah Berlin: Letters 1928–1946.* Cambridge: Cambridge University Press, 2004.

Harris, Mark Jonathan, Franklin Mitchell, and Steven Schechter. *The Homefront: America During World War II.* New York: G. P. Putnam's Sons, 1984.

Healy, Paul F. *Cissy: The Biography of Eleanor M. "Cissy" Patterson.* New York: Doubleday, 1966.

Hecht, Ben. *A Child of the Century.* New York: Primus, 1982.

Herring, George C. *From Colony to Superpower: U.S. Foreign Relations Since 1776.* New York: Oxford University Press, 2008.

Hersh, Burton. *The Old Boys: The American Elite and the Origins of the CIA.* New York: Scribner's, 1992.

Hersey, Heloise Edwina. *To Girls: A Budget of Letters.* Boston: Ginn & Co., 1902.

Higham, Charles. *Rose: The Life and Times of Rose Fitzgerald Kennedy.* New York: Pocket Books, 1995.

————. *Trading with the Enemy: An Exposé of the Nazi-American Money Plot, 1933–1949.* New York: Delacorte Press, 1983.

Hitler, Adolf, and Max Domarus. *Speeches and Proclamations, 1932–1945: The Chronicle of a Dictatorship.* Wauconda, IL: Bolchazy-Carducci, 1990.

Hodgson, Godfrey. *Woodrow Wilson's Right Hand: The Life of Colonel Edward M. House.* New Haven, CT: Yale University Press, 2006.

Hoge, Alice Albright. *Cissy Patterson.* New York: Random House, 1966.

Hohenberg, John. *The Pulitzer Prizes: A History of the Awards in Books, Drama, Music, and Journalism, Based on the Private Files Over Six Decades.* New York: Columbia University Press, 1974.

Holtzman, Jerome. *No Cheering in the Press Box.* New York: Henry Holt, 1995.

Hoopes, Roy, ed. *Americans Remember the Homefront.* New York: Berkley Books, 2002.

Hopper, Hedda. *From Under My Hat.* New York: McFadden, 1963.

Hough, Donald. *The Cocktail Hour in Jackson Hole.* New York: W. W. Norton, 1956.

Howey, Walter, ed. *Fighting Editors.* Philadelphia: David McKay Company, 1948.

Hulbert, Ann. *Raising America: Experts, Parents, and a Century of Advice about Children.* New York: Vintage, 2004.

Hull, Cordell, and Andrew Henry Thomas Berding. *The Memoirs of Cordell Hull.* New York: Macmillan Co., 1948.

Hunt, Morton. *The Story of Psychology.* New York: Anchor Books, 2007.

Humphry, Mrs. C. E. *Manners for Men.* New York: Cosimo Books, 2008. Facsimile of the first edition. London: James Bowden, 1897.

Huyler, Jack. *And That's the Way It Was in Jackson's Hole,* 2nd ed. Jackson Hole, WY: Jackson Hole Historical Society and Museum, 2003.

Ickes, Harold L. *The Secret Diary of Harold L. Ickes.* New York: Simon & Schuster, 1953.

Ireland, Louise Ireland Grimes. *Ligi: A Life in the Twentieth Century.* Privately published, 1999.

Jacob, Kathryn Allamong. *Capital Elites: High Society in Washington, D.C., after the Civil War.* Washington, DC: Smithsonian Institution Press, 1995.

James, Dorris Clayton. *The Years of MacArthur.* Boston: Houghton Mifflin, 1970.

Janeway, Eliot. *The Struggle for Survival: A Chronicle of Economic Mobilization in World War II.* New Haven, CT: Yale University Press, 1951.

Johnson, Donald Bruce. *The Republican Party and Wendell Willkie.* Urbana: University of Illinois Press, 1960.

Johnston, William M. *The Austrian Mind: An Intellectual and Social History, 1848–1938.* Berkeley: University of California Press, 2000.

Jonas, Manfred. *Isolationism in America, 1935–1941.* Chicago: Imprint Publications, 1991.

Jung, C. G. *Memories, Dreams, Reflections.* London: Fontana Press, 1995.

Kahn, E. J., Jr. *The World of Swope.* New York: Simon & Schuster, 1965.

Kaplan, Justin. *Lincoln Steffens: A Biography.* New York: Simon & Schuster Paperbacks, 2004.

Kammen, Michael. *American Culture American Tastes: Social Change and the 20th Century.* New York: Basic Books, 1999.

Kasson, John F. *Rudeness & Civility: Manners in Nineteenth-Century Urban America.* New York: Hill and Wang, 1990.

Keeler, Robert F. *Newsday: A Candid History of the Respectable Tabloid.* New York: Arbor House, 1990.

Kennan, George F. *American Diplomacy.* Chicago: Univeristy of Chicago Press, 1984.

Kennedy, David M. *Freedom from Fear: The American People in the Depression and War, 1929–1945.* New York: Oxford University Press, 2005.

Klurfeld, Herman. *Winchell: His Life and Times.* New York: Praeger Publishers, 1976.

Kohler, Sue, and Pamela Scott, eds. *Designing the Nation's Capital: The 1901 Plan for Washington, D.C.* Washington, DC: U.S. Commission on Fine Arts, 2006.

Korda, Michael. *Making the List: A Cultural History of the American Bestseller, 1900–1999.* New York: Barnes & Noble Books, 2001.

Krock, Arthur. *Memoirs: Sixty Years on the Firing Line.* New York: Funk & Wagnalls, 1968.

Langer, William L., and Sarell Everett Gleason. *The Challenge to Isolation, 1937–1940.* New York: Harper Brothers, 1952, for the Council on Foreign Relations.

Lapham, Lewis H. *Money and Class in America: Notes and Observations on Our Civil Religion.* New York: Weidenfeld & Nicolson, 1988.

Lash, Joseph P. *Eleanor and Franklin: The Story of Their Relationship.* New York: W. W. Norton, 1971.

Layser, Earle F. *I Always Did Like Horses & Women: Enoch Cal Carrington's Life Story.* Alta, WY: Booksurge, 2008.

Leamer, Lawrence. *The Kennedy Women: The Saga of an American Family.* New York: Villard Books, 1994.

Lesko, Kathleen M., Valerie Babb, and Carroll R. Gibbs. *Black Georgetown Remembered: A History of Its Black Community from the Founding of "The Town of George" in 1751 to the Present Day.* Washington, DC: Georgetown University Press, 1999.

Levin, Linda Lotridge. *The Making of FDR: The Story of Stephen T. Early, America's First Modern Press Secretary.* Amherst, NY: Prometheus Books, 2008.

Levin, Phyllis Lee. *Edith and Woodrow: The Wilson White House.* New York: A Lisa Drew Book/Scribner, 2001.

Levine, Lawrence W. *Highbrow Lowbrow: The Emergence of Cultural Hierarchy in America.* Cambridge, MA: Harvard University Press, 1988.

Lewis, Richard D. "Revolution in the Countryside: Russian Poland, 1905–1906," The Carl Beck Papers in *Russian and East European Studies,* no. 506, University of Pittsburgh, 1986.

Liebling, A. J. *Chicago: The Second City.* Lincoln: University of Nebraska Press, 2004.

Lieven, Dominic. *Nicholas II: Twilight of the Empire.* New York: St. Martin's Griffin, 1993.

———. *Russia's Rulers Under the Old Regime.* New Haven, CT: Yale University Press, 1989.

Linn, James Weber. *James Keeley: Newspaperman.* New York: Bobbs-Merrill, 1937.

Longworth, Alice Roosevelt. *Crowded Hours: Reminiscences of Alice Roosevelt Longworth.* New York: Charles Scribner's Sons, 1933.

Lowe, David Garrard, ed. *The Great Chicago Fire.* Mineola, NY: Dover, 1979.

Luce, Clare Boothe. *Europe in the Spring.* New York: Alfred A. Knopf, 1941.

Luckett, Perry D. *Charles A. Lindbergh.* New York: Greenwood Press, 1986.

Lundberg, Ferdinand. *America's 60 Families.* New York: Vanguard Press, 1937.

Lyons, Eugene. *Herbert Hoover: A Biography.* Garden City, NY: Doubleday, 1964.

Macdonald, Dwight. *Henry Wallace: The Man and the Myth.* New York: Vanguard Press, 1948.

Macleod, David I. *The Age of the Child: Children in America, 1890–1920.* New York: Twayne Publishers, 1998.

McGuire, William, ed. *The Freud/Jung Letters.* Translated by Ralph Manheim and R. F. C. Hull. Princeton: Princeton University Press, 1974.

McIlvaine, Mabel, ed. *Reminiscences of Chicago During the Great Fire.* Chicago: Lakeside Press, 1915.

McJimsey, George T. *Harry Hopkins: Ally of the Poor and Defender of Democracy.* Cambridge, MA: Harvard University Press, 1987.

McLean, Evalyn Walsh. *Father Struck It Rich.* Ouray, CO: Bear Creek Publishing Co., 1981.

McPhaul, John J. *Deadlines & Monkeyshines: The Fabled World of Chicago Journalism.* Englewood Cliffs, NJ: Prentice-Hall, 1962.

McReynolds, Louise. *Russia at Play: Leisure Activities at the End of the Tsarist Era.* Ithaca: Cornell University Press, 2003.

Magocsi, Paul Robert. *Galicia: A Historical Survey and Bibliographic Guide.* Toronto: University of Toronto Press, 1983.

Markovits, Andrei S., and Frank E. Sysyn, eds. *Nationbuilding and Politics of Nationalism: Essays on Austrian Galicia.* Cambridge, MA: Harvard University Press, 1982.

Markowitz, Norman D. *The Rise and Fall of the People's Century: Henry A. Wallace and American Liberalism, 1941–1948.* New York: Free Press, 1973.

Martin, Ralph G. *Cissy: The Extraordinary Life of Eleanor Medill Patterson.* New York: Simon & Schuster, 1979.

Maxwell, Mrs. Sara B. *Manners and Customs of To-Day.* Des Moines, IA: The Cline Publishing House, 1890.

Maylunas, Andrei, and Sergei Mironenko. *A Lifelong Passion: Nicholas and Alexandra, Their Own Story.* London: Weidenfeld & Nicolson, 1996.

Meade, Marion. *Dorothy Parker: What Fresh Hell Is This?* New York: Penguin, 1989.

Meeker, Arthur. *Chicago, with Love: A Polite and Personal History.* New York: Alfred A. Knopf, 1955.

Miller, Arthur H., and Shirley M. Paddock. *Images of America: Lake Forest, Estates, People and Culture.* Chicago: Arcadia Publishing, 2003.

Miller, Donald L. *City of the Century: The Epic of Chicago and the Making of America.* New York: Simon & Schuster, 1996.

Miller, Hope Ridings. *Embassy Row: The Life and Times of Diplomatic Washington.* New York: Holt, Reinhart and Winston, 1969.

Miller, Kristie. *Ruth Hanna McCormick: A Life in Politics, 1880–1944.* Albuquerque: University of New Mexico Press, 1992.

Milton, Joyce. *Loss of Eden: A Biography of Charles and Anne Morrow Lindbergh.* New York: HarperCollins, 1993.

———. *The Yellow Kids: Foreign Correspondents in the Heyday of Yellow Journalism.* New York: Harper Perennial, 1990.

Moley, Raymond. *After Seven Years.* New York London: Harper & Brothers, 1939.

———. *The First New Deal.* New York: Harcourt, Brace & World, Inc., 1966.

Montgomery, Maureen E. *Gilded Prostitution: Status, Money, and Transatlantic Marriages, 1870–1924.* New York: Routledge, 1989.

Morgan, Gwen, and Arthur Veysey. *Poor Little Rich Boy (and How He Made Good): The Life and Times of Robert R. McCormick.* Carpentersville, IL: Crossroads Communications, 1985.

Morris, Edmund. *The Rise of Theodore Roosevelt.* New York: Modern Library, 2001.

———. *Theodore Rex.* New York: Modern Library, 2002.

Morris, Sylvia Jukes. *Rage for Fame: The Ascent of Clare Boothe Luce.* New York: Random House, 1997.

Mott, Frank Luther. *American Journalism.* New York: Macmillan, 1941.

Murdock, Catherine Gilbert. *Domesticating Drink: Women, Men, and Alcohol in America, 1870–1940.* Baltimore, MD: Johns Hopkins University Press, 2001.

Murphy, Jim. *The Great Fire.* New York: Scholastic, 1995.

Muzzy, Frank. *Images of America: Gay and Lesbian Washington, D.C.* Charleston, SC: Arcadia Publishing, 2005.

Nabokov, Vladimir. *Speak, Memory: An Autobiography Revisited.* New York: Vintage International, 1989.

Nasaw, David. *The Chief: The Life of William Randolph Hearst.* New York: Houghton Mifflin, 2000.

Neal, Steve. *Dark Horse: A Biography of Wendell Willkie.* Garden City, NY: Doubleday, 1984.

Nelson, Fern K. *This Was Jackson's Hole: Incidents and Profiles from the Settlement of Jackson Hole.* Glendo, WY: High Plains Press, 1994.

Nicolson, Nigel. *Mary Curzon: A Biography.* London: Phoenix Giants, 1988.

———. *Portrait of a Marriage.* New York: Bantam Books, 1974.

Nissenson, Marilyn. *The Lady Upstairs: Dorothy Schiff and the* New York Post. New York: St. Martin's Press, 2007.

Offner, Arnold A. *American Appeasement: United States Foreign Policy and Germany, 1933–1938.* Cambridge, MA: Belknap Press, 1969.

Ogden, Christopher. *Legacy: A Biography of Moses and Walter Annenberg.* Boston: Little, Brown, 1999.

Patterson, Joseph Medill. *A Little Brother of the Rich.* New York: Grosset & Dunlap, 1908.

———. *Rebellion.* Chicago: The Reilly & Britton Co., 1911.

[Pearson, Drew, and Robert S. Allen]. *Washington Merry-Go-Round.* New York: Horace Liveright, 1931.

[———.] *More Merry-Go-Round.* New York: Horace Liveright, 1932.

Persico, Joseph E. *Roosevelt's Secret War: FDR and World War II Espionage.* New York: Random House Trade Paperbacks, 2002.

Phillips, Roderick. *Untying the Knot: A Short History of Divorce.* Cambridge: Cambridge University Press, 1991.

Pilat, Oliver. *Drew Pearson: An Unauthorized Biography.* New York: Harper's Magazine Press, 1973.

Potocki, Count Alfred. *Master of Lancut: The Memoirs of Count Alfred Potocki.* London: W. H. Allen, 1959.

Powaski, Ronald E. *Toward an Entangling Alliance: American Isolationism, Internationalism, and Europe, 1901–1950.* New York: Greenwood Press, 1991.

Powdermaker, Florence, and Louise Grimes. *The Intelligent Parents' Manual.* Harmondsworth, Middlesex: Penguin, 1956.

Preston, Diana. Lusitania: *An Epic Tragedy.* New York: Berkeley, 2002.

Procter, Ben. *William Randolph Hearst: The Later Years, 1911–1951.* New York: Oxford University Press, 2007.

Pusey, Merlo J. *Eugene Meyer.* New York: Alfred A. Knopf, 1974.

Rascoe, Burton. *Before I Forget.* New York: The Literary Guild of America, 1937.

Renehan, Edward J., Jr. *The Kennedys at War, 1937–1945.* New York: Doubleday, 2002.

Rollins, Alfred B., Jr. *Roosevelt and Howe.* New York: Alfred A. Knopf, 1962.

Roosevelt, Eleanor, and Rochelle Chadakoff. *Eleanor Roosevelt's "My Day": Her Acclaimed Columns, 1936–1945.* New York: Pharos Books, 1989.

Roosevelt, Elliott, and James Brough. *A Rendezvous with Destiny: The Roosevelts of the White House.* New York: G. P. Putnam's Sons, 1975.

Roosevelt, Franklin D., Russell D. Buhite, and David W. Levy. *FDR's Fireside Chats.* Norman: University of Oklahoma Press, 1992.

Roosevelt, Franklin D., and William C. Bullitt. *For the President, Personal and Secret: Correspondence Between Franklin D. Roosevelt and William C. Bullitt.* Boston: Houghton Mifflin, 1972.

Roosevelt, Franklin D., and Elliott Roosevelt. *F.D.R.: His Personal Letters.* New York: Duell, 1947.

Roosevelt, Franklin D., and Samuel Irving Rosenman. *The Public Papers and Addresses of Franklin D. Roosevelt.* New York: Russell & Russell, 1969.

Roosevelt, Franklin D., et al. *Franklin D. Roosevelt and Foreign Affairs, January 1937–August 1939.* Donald B. Schewe, series editor. New York: Clearwater Publishing Company Inc., 1983.

Rosiere, Gabrielle. *Etiquette: An Encyclopedia of Good Manners and Social Usage.* New York: Edward J. Clode, 1923.

Ross, Ishbel. *Ladies of the Press.* New York: Harper & Brothers, 1936.

———. *Silhouette in Diamonds: The Life of Mrs. Potter Palmer.* New York: Harper & Brothers, 1960.

Rowlands, Penelope. *A Dash of Daring: Carmel Snow and Her Life in Fashion, Art, and Letters.* New York: Atria Books, 2005.

Ruane, Christine. "Subjects to Citizens: The Politics of Clothing in Imperial Russia." In *Fashioning the Body Politic: Dress, Gender, Citizenship.* Edited by Wendy Parkins. Oxford, UK: Berg, 2002, 49–70.

Russell, Francis. *The President Makers: From Mark Hanna to Joseph P. Kennedy.* Boston: Little Brown, 1976.

Ruth, John A., and S. L. Louis. *Decorum: A Practical Treatise on Etiquette and Dress of the Best American Society.* New York: J. A. Ruth & Co., 1879.

Savitsch, Eugene de. *In Search of Complications: An Autobiography.* London: Andre Deutsch, 1958.

Sawislak, Karen. *Smoldering City: Chicagoans and the Great Fire, 1871–1874.* Chicago: University of Chicago Press, 1995.

Schilpp, Madelon Golden, and Sharon M. Murphy. *Great Women of the Press.* Carbondale: Southern Illinois University Press, 1983.

Schlesinger, Arthur Meier, Jr. *The Age of Roosevelt.* Boston: Houghton Mifflin, 1957.

———. *The Coming of the New Deal.* Boston: Houghton Mifflin, 1988.

———, Fred L. Israel, and William P. Hansen. *History of American Presidential Elections, 1789–1984.* New York: Chelsea House Publishers, 1986.

Schoor, Gene. *Young John Kennedy.* New York: Harcourt Brace & World, 1963.

Schorske, Carl E. *Fin-de-Siècle Vienna: Politics and Culture.* New York: Vintage, 1981.

Schudson, Michael. *Discovering the News: A Social History of American Newspapers.* New York: Basic Books, 1978.

Schwarz, Jordan A. *The Speculator: Bernard M. Baruch in Washington, 1917–1965.* Chapel Hill: University of North Carolina Press, 1981.

Schulze, Franz, Rosemary Cowler, and Arthur Miller. *30 Miles North: A History of Lake Forest College, Its Town, and Its City of Chicago.* Roanoke, VA: R. R. Donnelley, 2000.

Schwarzlose, Richard A. *The American Wire Services: A Study of Their Development as a Social Institution.* New York: Arno Press, 1979.

———. *The Nation's Newsbrokers, Volume 2: The Rush to Institution, from 1865 to 1920.* Evanston, IL: Northwestern University Press, 1990.

Scott, George. *The Rise and Fall of the League of Nations.* New York: Macmillan, 1974.

Sherwood, Mrs. John M. E. W. *Manners and Social Usages.* Teddington, Middlesex, UK: Echo Library, 2006. First published in 1884 by Harper & Brothers, New York.

Shesol, Jeff. *Supreme Power: Franklin Roosevelt vs. The Supreme Court.* New York: W. W. Norton, 2010.

Shirer, William L. *Berlin Diary, The Journal of a Foreign Correspondent, 1934–1941.* New York: Alfred A. Knopf, 1941.

————. *The Rise and Fall of the Third Reich: A History of Nazi Germany.* New York: Simon & Schuster, 1981.

Singley, Carol J., ed. *A Historical Guide to Edith Wharton.* New York: Oxford University Press, 2003.

Smith, Amanda, ed. *Hostage to Fortune: The Letters of Joseph P. Kennedy.* New York: Penguin, 2002.

Smith, Carl. *The Plan of Chicago: Daniel Burnham and the Remaking of the American City.* Chicago: University of Chicago Press, 2006.

Smith, Richard Norton. *The Colonel: The Life and Legend of Robert R. McCormick, 1880–1955.* Boston: Houghton Mifflin, 1997.

————. *An Uncommon Man: The Triumph of Herbert Hoover.* New York: Simon and Schuster, 1984.

Sobel, Robert. *Coolidge: An American Enigma.* Washington, DC: Regnery, 2001.

Solomon, Burt. *The Washington Century: Three Families and the Shaping of the Nation's Capital.* New York: HarperCollins, 2004.

Spilsbury, Gail. *Rock Creek Park.* Baltimore: Johns Hopkins University Press, 2003.

Spring-Rice, Sir Cecil, and Stephen Lucius Godwin. *The Letters and Friendships of Sir Cecil Spring Rice.* Vol. 2. London: Constable & Co., 1929.

St. Johns, Adela Rogers. *The Honeycomb.* Garden City, NY: Doubleday, 1969.

————. *Love, Laughter, and Tears: My Hollywood Story.* New York: Signet, 1979.

————. *No Good-Byes: My Search into Life beyond Death.* New York: Signet, 1981.

Steel, Ronald. *Walter Lippmann and the American Century.* New York: Vintage, 1980.

Steen, Andrew. *The Man Who Bred Skowronek: Count Jozef Potocki, The Great Polish Breeders and Arabian Horses of Slawuta, Bialocerkiew, Antoniny.* Seville, Spain: Escandón Impresores, 2001.

Steinberg, Mark D., and Heather Coleman, eds. *Sacred Stories: Religion and Spirituality in Modern Russia.* Bloomington: Indiana University Press, 2007.

Streitmatter, Rodger. *Mightier Than the Sword: How the News Media Have Shaped American History.* Boulder, CO: Westview Press, 1997.

Stuart, Lyle. *The Secret Life of Walter Winchell.* Fort Lee, NJ: Barricade Books, 2003.

Swanberg, W. A. *Citizen Hearst: A Biography of William Randolph Hearst.* New York: Scribner, 1961.

Teague, Michael. *Mrs. L.: Conversations with Alice Roosevelt Longworth.* New York: Doubleday, 1981.

Tebbel, John. *An American Dynasty.* Garden City, NY: Doubleday, 1947.

————. *The Compact History of the American Newspaper,* 2nd ed. New York: Hawthorn, 1969.

————. *The Life and Good Times of William Randolph Hearst.* New York: Dutton, 1952.

————, and Mary Ellen Zuckerman. *The Magazine in America, 1741–1990.* New York: Oxford University Press, 1991.

Teichmann, Howard. *Alice: The Life and Times of Alice Roosevelt Longworth.* Englewood Cliffs, NJ: Prentice-Hall, 1979.

Theoharis, Athan G., and John Stuart Cox. *The Boss: J. Edgar Hoover and the Great American Inquisition.* Philadelphia: Temple University Press, 1988.

Tomes, Robert. *The Bazar Book of Decorum.* New York: Harper & Brothers, Publishers, 1870. Facsimile of the 1873 edition by the Scholarly Publishing Office, University of Michigan Library, 2004.

Toynbee, Arnold Joseph, et al. *Survey of International Affairs.* New York: Oxford University Press, 1920.

Trohan, Walter. *Political Animals: Memoirs of a Sentimental Cynic.* Garden City, NY: Doubleday, 1975.

Tuchman, Barbara W. *The Zimmermann Telegram.* New York: Ballantine Books, 1994.

Tugwell, Rexford G. *The Democratic Roosevelt: A Biography of Franklin D. Roosevelt.* Garden City, NY: Doubleday, 1957.

Tully, Grace. *FDR: My Boss.* New York: C. Scribner's Sons, 1949.

Tyrrel, John. *Running Racing: The Jockey Club Years, Since 1750.* London: Quiller Press, 1997.

United States Department of State. *Principal Officers of the Department of State and United States Chiefs of Mission, 1778–1990.* Washington, DC: GPO, 1991.

Vasili, Paul. *Behind the Veil at the Russian Court.* London: Cassell, 1913.

Vickers, Hugo, ed. *Horses & Husbands: The Memoirs of Etti Plesch.* Stanbridge, Wimborne Minster, Dorset, UK: Dovecote Press, 2007.

Vidal, Gore. *The Golden Age: A Novel.* New York: Doubleday, 2000.

———. *Washington, D.C.: A Novel.* Boston: Little, Brown, 1967.

Wagner, William G. *Marriage, Property, and Law in Late Imperial Russia.* Oxford: Clarendon Press, 1994.

Waldrop, Frank C. *McCormick of Chicago: An Unconventional Portrait of a Controversial Figure.* Englewood Cliffs, NY: Prentice-Hall, 1966.

Waller, Spencer Weber. *Thurman Arnold: A Biography.* New York: New York University Press, 2005.

Wander, Meghan Robinson, and Otis L. Graham. *Franklin D. Roosevelt: His Life and Times.* Boston: G. K. Hall, 1985.

Wandycz, Piotr. *Lands of Partitioned Poland, 1795–1918.* Seattle: University of Washington Press, 1975.

Ware, Susan. *Holding Their Own: American Women in the 1930s.* Boston: Twayne Publishers, 1982.

Watt, Donald Cameron. *How War Came: The Immediate Origins of the Second World War, 1938–1939.* New York: Pantheon Books, 1989.

———. *Succeeding John Bull: America in Britain's Place, 1900–1975.* New York: Cambridge University Press, 1984.

Wendt, Lloyd. Chicago Tribune: *The Rise of a Great American Newspaper.* New York: Rand-McNally, 1979.

Wharton, Edith. *A Backward Glance.* New York: Touchstone, 1998.

Wheeler, Burton K., with Paul F. Healy. *Yankee from the West.* Garden City, NY: Doubleday, 1962.

Wheeler-Bennett, J. W. *Munich: Prologue to Tragedy.* New York: Viking, 1964.

White, Graham J. *FDR and the Press.* Chicago: University of Chicago Press, 1979.

Whyte, Kenneth. *Uncrowned King: The Sensational Rise of William Randolph Hearst.* Berkeley, CA: Counterpoint, 2009.

Williams, Paul K. *Images of America: Dupont Circle.* Charleston, SC: Arcadia Publishing, 2000.

Winchell, Walter. *Winchell Exclusive: "Things That Happened to Me—and Me to Them."* Englewood Cliffs, NJ: Prentice-Hall, 1975.

Winfield, Betty Houchin. *FDR and the News Media.* Chicago: University of Illinois Press, 1990.

Wister, Owen. *Roosevelt: The Story of a Friendship, 1880–1919.* New York: Macmillan, 1930.

Wonlar-Larsky, Nadine. *The Russia That I Loved.* London: Elsie MacSwinney, 1937.

Wood-Allen, Mrs. Mary, M.D. *What Every Young Woman Ought to Know.* Philadelphia: Vir Publishing Company, 1913.

Worth, Roland H., Jr. *Congress Declares War: December 8–11, 1941.* Jefferson, NC: McFarland & Company, 2004.

Wortman, Richard S. *Scenarios of Power.* Vol. 2. Princeton, NJ: Princeton University Press, 2000.
Zamoyski, Adam. *The Polish Way: A Thousand-Year History of the Poles and Their Culture.* New York: Franklin Watts, 1987.

NEWSPAPERS AND MAGAZINES

American Heritage
American Magazine
American Mercury
American Press
Baltimore American
Baltimore News-Post
Central European History
Chicago American
Chicago Daily News
Chicago Examiner
Chicago Herald-Examiner
Chicago Sun
Chicago Tribune and *Chicago Daily Tribune*
Christian Science Monitor.
Collier's Weekly
Current History
Daily News (New York, NY)
Editor & Publisher
Esquire
Evening Gazette (Cedar Rapids, IA)
Field & Stream
Fort Wayne (IN) Morning Journal
The Georgetowner
Good Housekeeping
Harper's Bazaar
Independent Woman
Inter-Ocean (Chicago, IL)
The Journal of American History
Ladies' Home Journal
Liberty
Life

Los Angeles Times
The Nation
The New Republic
New York Herald Tribune
New York Times
New York World
The New Yorker
Newsweek
The Oregonian
Outlook
Outlook and Independent
Philadelphia Inquirer
Public Opinion
Redbook
Scribner's Monthly
The Saturday Evening Post
The Saturday Review
Saturday Review of Literature
Seattle Post-Intelligencer
St. Louis Post-Dispatch
The Senator
Time
Times of London
Town & Country
Washington Post
Washington (DC) Times
Washington (DC) Herald
Washington (DC) *Times-Herald*
Washington Magazine
Washingtonian
World's Work

GOVERNMENT DOCUMENTS

Records of the U.S. Customs Service, "Kaiser Wilhelm II List or Manifest of Alien Passengers for the U.S. Immigration Officer at the Port of Arrival," March 8, 1904, Passenger Lists of Vessels Arriving at New York, New York, 1820–1897; (National Archives Microfilm Publication M237, 675 rolls); Record Group 36; National Archives, Washington, D.C. Year: *1904;* Microfilm serial: *15;* Microfilm roll: *T715_435;* Line: *16;* Page Number: 56 Ancestry.com-New York Passenger Lists, 1820–1957, http://search.ancestry.com/iexec/?htx=View&r=an&dbid=7488&iid=NYT715_435-0108&fn=Count+Joseph&ln=Gizycki&st=r&ssrc=&pid=4040004592.

United States Congress. *Congressional Record.* Washington, DC, 1873–.

United States Congress, et al. *Biographical Directory of the United States Congress, 1774–1989.* Bicentennial ed. S. Doc. 100–34. Washington, DC: GPO, 1989.

United States. Department of the Army. *US Army Register.* Washington, DC: GPO, 1957.

United States. Department of State. *Foreign Relations of the United States.* Diplomatic Papers, 1861. Washington, DC: GPO.

United States. Department of State. *Principal Officers of the Department of State and United States Chiefs of Mission, 1778–1990.* Washington, DC: GPO, 1990.

United States. Department of State. *Register of the Department of State, 1870–.* Washington, DC: GPO.

United States. Library of Congress. Legislative Reference Service. *Events Leading up to World War II.* Chronological history of certain major international events leading up to and during World War II with the ostensible reasons advanced for their occurrence, 1931–1944. 78th Cong., 2d sess. H. Doc. 541. Washington, DC: GPO, 1944.

United States. Social Security Administration. *Social Security Death Master File.* Washington, DC: GPO.

REFERENCE WORKS

Ancell, R. Manning, and Christine Marie Miller. *The Biographical Dictionary of World War II Generals and Flag Officers: The U.S. Armed Forces.* Westport, CT: Greenwood Press, 1996.

Anderson, Joy. *The American Catholic Who's Who.* Washington, DC: National Catholic News Service, 1979.

Barone, Michael, Grant Ujifusa, and Douglas Matthews. *The Almanac of American Politics.* Washington, DC: Barone & Co.

Baudot, Marcel. *The Historical Encyclopedia of World War II.* New York: Facts on File, 1980.

Bjorklund, Oddvar. *Historical Atlas of the World.* New York: Barnes & Noble, 1970.

Brodney, Spencer. *Events: A Monthly Review of World Affairs.* New York: Events Publishing Co.

Brune, Lester H. *Chronological History of the United States Foreign Relations.* New York: Garland, 1985.

Buhle, Mari Jo, Paul Buhle, and Dan Georgakas. *Encyclopedia of the American Left.* New York: Garland, 1990.

Buranelli, Vincent, and Nan Buranelli. *Spy/Counterspy: An Encyclopedia of Espionage.* New York: McGraw-Hill, 1982.

Burke, William Jeremiah, et al. *American Authors and Books: 1640 to the Present Day.* New York: Crown Publishers, 1972.

Chase, Harold William. *Biographical Dictionary of the Federal Judiciary.* Detroit: Gale Research Co., 1976.

Colby, Frank Moore, et al. *The New International Year Book: A Compendium of the World's Progress.* New York: Dodd, 1908.

Commire, Anne, and Deborah Klezmer. *Historic World Leaders.* London: Gale Research Inc., 1994.

Crystal, David. *The Cambridge Biographical Encyclopedia.* New York: Cambridge University Press, 1994.

Daugherty, John, et al. *A Place Called Jackson Hole: The Historic Resource Study of Grand Teton National Park.* Moose, WY: National Park Service, 1999.

Dawdy, Doris Ostrander. *Artists of the American West: A Biographical Dictionary.* Chicago: Sage Books, 1974.

Dear, Ian, and M. R. D. Foot. *The Oxford Companion to World War II.* New York: Oxford University Press, 1995.

DeGregorio, William A. *The Complete Book of U.S. Presidents.* New York: Dembner Books, 1989.

Delaney, John J., and James Edward Tobin. *Dictionary of Catholic Biography.* Garden City, NY: Doubleday, 1961.

Downs, Robert Bingham, and Jane B. Downs. *Journalists of the United States: Biographical Sketches of Print and Broadcast News Shapers from the Late 17th Century to the Present.* Jefferson, NC: McFarland, 1991.

Dupuy, R. Ernest, and Trevor Nevitt Dupuy. *The Encyclopedia of Military History from 3500 B.C. to the Present.* New York: Harper & Row, 1986.

Dupuy, Trevor Nevitt, Curt Johnson, and David L. Bongard. *The Harper Encyclopedia of Military Biography.* New York: HarperCollins, 1992.

Edwards, Julia. *Women of the World: The Great Foreign Correspondents.* Boston: Houghton Mifflin, 1988.

Fest, Wilfried. *Dictionary of German History, 1806–1945.* New York: St. Martin's Press, 1978.

Filler, Louis. *A Dictionary of American Social Reform.* New York: Philosophical Library, 1963.

Findling, John E. *Dictionary of American Diplomatic History.* New York: Greenwood Press, 1989.

Foreign Policy Association. *Foreign Policy Reports.* New York: Foreign Policy Association, 1931.

Friedman, Leon, and Fred L. Israel. *The Justices of the United States Supreme Court, 1789–1978: Their Lives and Major Opinions.* New York: Chelsea House, 1980.

G & C. Merriam Company. *Webster's American Military Biographies.* Springfield, MA: G. & C. Merriam Co., 1978.

Garraty, John Arthur, Mark C. Carnes, and American Council of Learned Societies. *American National Biography.* New York: Oxford University Press, 1999.

Garraty, John Arthur, and Jerome L. Sternstein. *Encyclopedia of American Biography.* New York: HarperCollins, 1996.

Gordon, Bertram M. *Historical Dictionary of World War II France: The Occupation, Vichy, and the Resistance, 1938–1946.* Westport, CT: Greenwood Press, 1998.

Graff, Henry F. *The Presidents: A Reference History.* New York: Charles Scribner's Sons, 1984.

Graham, Otis L. Jr., and Meghan Robinson Wander. *Franklin D. Roosevelt: His Life and Times.* Boston: G.K. Hall, 1985.

Green, Jonathon. *The Encyclopedia of Censorship.* New York: Facts on File, 1990.

Grenville, J. A. S. *A History of the World in the Twentieth Century,* Vol. 1: *Western Dominance, 1900–1947.* Cambridge, MA: Belknap Press, 1997.

Ingham, John N. *Biographical Dictionary of American Business Leaders.* Westport, CT: Greenwood Press, 1983.

Ireland, Norma Olin. *Index to Women of the World from Ancient to Modern Times: A Supplement.* Metuchen, NJ: Scarecrow Press, 1988.

———. *Index to Women of the World from Ancient to Modern Times: Biographies and Portraits.* Westwood, MA: F. W. Faxon Co., 1970.

Jackson, George D., and Robert James Devlin. *Dictionary of the Russian Revolution.* New York: Greenwood Press, 1989.

James, Edward T., et al. *Notable American Women, 1607–1950: A Biographical Dictionary.* Cambridge: Belknap Press of Harvard University Press, 1971.

Jentleson, Bruce W., and Thomas G. Paterson. *Encyclopedia of U.S. Foreign Relations.* New York: Oxford University Press, 1997.

K. G. Saur Verlag. *Internationaler Biographischer Index.*

Kane, Joseph Nathan. *Presidential Fact Book.* New York: Random House, 1998.

Keegan, John. *Who Was Who in World War II.* London: Arms and Armour Press, 1978.

Keegan, John, and Andrew Wheatcroft. *Who's Who in Military History: From 1453 to the Present Day.* New York: Routledge, 1996.

Kinnell, Susan K. *People in History: An Index to U.S. and Canadian Biographies in History Journals and Dissertations.* Santa Barbara, CA: Abc-Clio, 1988.

Kirkendall, Richard Stewart. *The Harry S. Truman Encyclopedia.* Boston: G. K. Hall, 1989.

Kuehl, Warren F. *Biographical Dictionary of Internationalists.* Westport, CT: Greenwood Press, 1983.

Lane, Hana Umlauf. *The World Almanac Book of Who.* New York and Englewood Cliffs, NJ: World Almanac Publications; Prentice-Hall, 1980.

Laqueur, Walter. *A Dictionary of Politics.* New York: Free Press, 1974.

Leighton, Isabel, ed. *The Aspirin Age, 1919–1941.* New York: Simon & Schuster, 1976.

Leuchtenburg, William E. *The Perils of Prosperity, 1914–32.* Chicago: University of Chicago Press, 1973.

Lichtenstein, Nelson, et al. *Political Profiles.* New York: Facts on File, 1976.

MacArthur, Brian, ed. *The Penguin Book of Twentieth-Century Speeches.* New York: Penguin, 1992.

Mankiller, Wilma Pearl. *The Reader's Companion to U.S. Women's History.* Boston, MA.: Houghton Mifflin Co., 1998.

Martí, José, and Philip Sheldon Foner. *Political Parties and Elections in the United States.* Philadelphia: Temple University Press, 1989.

McGivena, Leo E., ed. *The News: The First Fifty Years of New York's Picture Newspaper.* New York: News Syndicate Co., 1969.

McGuire, William, and Leslie Wheeler. *American Social Leaders, Biographies of American Leaders.* Santa Barbara, CA: Abc-Clio, 1993.

McKerns, Joseph P., ed. *Biographical Dictionary of American Journalism.* New York: Greenwood Press, 1989.

Moeller, E. Martin, Jr. *AIA Guide to the Architecture of Washington, D.C.* Baltimore: Johns Hopkins University Press, 2006.

Morris, Dan, and Inez Morris. *Who Was Who in American Politics.* New York: Hawthorn Books, 1974.

Mossman, Jennifer. *Pseudonyms and Nicknames Dictionary: A Guide to Aliases, Appellations, Assumed Names.* Detroit: Gale Research Co., 1987.

North, S. N. D., Francis Graham Wickware, and Albert Bushnell Hart. *The American Year Book.* New York: T. Nelson & Sons.

Olsen, Kirstin. *Chronology of Women's History.* Westport, CT: Greenwood Press, 1994.

Olson, James S., ed. *Historical Dictionary of the 1920s: From World War I to the New Deal, 1919–1933.* Westport, CT: Greenwood Press, 1988.

———. *Historical Dictionary of the New Deal: From Inauguration to Preparation for War.* Westport, CT: Greenwood Press, 1985.

Palmer, Alan. *The Penguin Dictionary of Modern History, 1789–1945,* 2nd ed. New York: Penguin, 1983.

Palmer, Robert J., and Council on Foreign Relations. *Foreign Affairs 50-year Index.* New York: published for the Council on Foreign Relations by R. R. Bowker Co., 1973.

Platt, Suzy, and Library of Congress. Congressional Research Service. *Respectfully Quoted: A Dictionary of Quotations Requested from the Congressional Research Service.* Washington, DC: Library of Congress, 1989.

Rees, Philip. *Biographical Dictionary of the Extreme Right Since 1890.* New York: Simon & Schuster, 1990.

Riley, Sam G. *Biographical Dictionary of American Newspaper Columnists.* Westport, CT: Greenwood Press, 1995.

Roberts, Frank Cecil. *Obituaries from the* Times, *1951–1960.* Westport, CT: Newspaper Archive Developments; Meckler Books, 1979.

———. *Obituaries from the* Times, *1961–1970.* Reading, England: Newspaper Archive Developments Ltd., 1975.

———. *Obituaries from the* Times, *1971–1975.* Westport, CT: Newspaper Archive Developments Ltd., 1978.

Ross, Martha, and Bertold Spuler. *Rulers and Governments of the World.* New York: Bowker, 1977.

Roth, Mitchel P. *Historical Dictionary of War Journalism.* Westport, CT: Greenwood Press, 1997.

Schudson, Michael. *Discovering the News: A Social History of American Newspapers.* New York: Basic Books, 1978.

Sicherman, Barbara, and Carol Hurd Green. *Notable American Women: The Modern Period.* Cambridge, MA: Belknap Press, 1980.

Sifakis, Carl. *The Dictionary of Historic Nicknames: A Treasury of More Than 7,500 Famous and Infamous Nicknames From World History.* New York: Facts on File Publications, 1984.

Simpson, J. A., and E. S. C. Weiner. *The Oxford English Dictionary.* New York: Oxford University Press, 1989.

Slocum, Robert B. *Biographical Dictionaries and Related Works: An International Bibliography of Approximately 16,000 Collective Biographies.* Detroit: Gale Research Co., 1986.

Snyder, Louis Leo. *Encyclopedia of the Third Reich.* New York: McGraw-Hill, 1976.

Sobel, Robert. *Biographical Directory of the Governors of the United States, 1789–1978.* Westport, CT: Meckler Books, 1978.

———. *Biographical Directory of the United States Executive Branch, 1774–1977.* Westport, CT: Greenwood Press, 1977.

———. *Biographical Directory of the United States Executive Branch, 1774–1989.* New York: Greenwood Press, 1990.

Taft, William H. *Encyclopedia of Twentieth-Century Journalists.* New York: Garland, 1986.

Teed, Peter. *A Dictionary of Twentieth Century History: 1914–1990.* New York: Oxford University Press, 1992.

Trager, James. *The People's Chronology: A Year-by-Year Record of Human Events from Prehistory to the Present.* New York: Henry Holt, 1994.

Uglow, Jennifer S. *The International Dictionary of Women's Biography.* New York: Continuum, 1982.

Uglow, Jennifer S., Frances Hinton, and Continuum (Firm). *The Continuum Dictionary of Women's Biography.* New York: Continuum, 1989.

University of London. Institute of Historical Research. *Dictionary of National Biography.* London: Oxford University Press.

Van Doren, Charles Lincoln, and Robert McHenry. *Webster's American Biographies.* Springfield, MA: G. & C. Merriam Co., 1974.

Vaughn, Stephen L., ed. *Encyclopedia of American Journalism.* New York: Routledge, 2008.

Wagner, Lilya. *Women War Correspondents of World War II.* New York: Greenwood Press, 1989.

Weatherford, Doris. *Milestones: A Chronology of American Women's History.* New York: Facts on File, 1997.

Wistrich, Robert S. *Who's Who in Nazi Germany.* London: Weidenfeld and Nicolson, 1982.

Young, Peter. *The World Almanac Book of World War II.* Englewood Cliffs, NJ: Prentice-Hall, 1981.

Zentner, Christian, and Friedemann Bedurftig. *The Encyclopedia of the Third Reich.* New York: Macmillan Publishing Co, 1991.

INDEX

Page numbers in *italics* refer to illustrations.

ILLUSTRATION CREDITS

A NOTE ON THE TYPE

The text of this book was set in Garamond No. 3. It is not a true copy of any of the designs of Claude Garamond (ca. 1480–1561), but an adaptation of his types, which set the European standard for two centuries. It probably owes as much to the designs of Jean Jannon, a Protestant printer working in Sedan in the early seventeenth century, who had worked with Garamond's romans earlier, in Paris, but who was denied their use because of Catholic censorship. Jannon's matrices came into the possession of the Imprimerie nationale, where they were thought to have been made by Garamond himself, and were so described when the Imprimerie revived the type in 1900. This particular version is based on an adaptation by Morris Fuller Benton.

Composed by North Market Street Graphics, Lancaster, Pennsylvania
Printed and bound by Berryville Graphics, Berryville, Virginia
Designed by Iris Weinstein